Charles Waterhouse

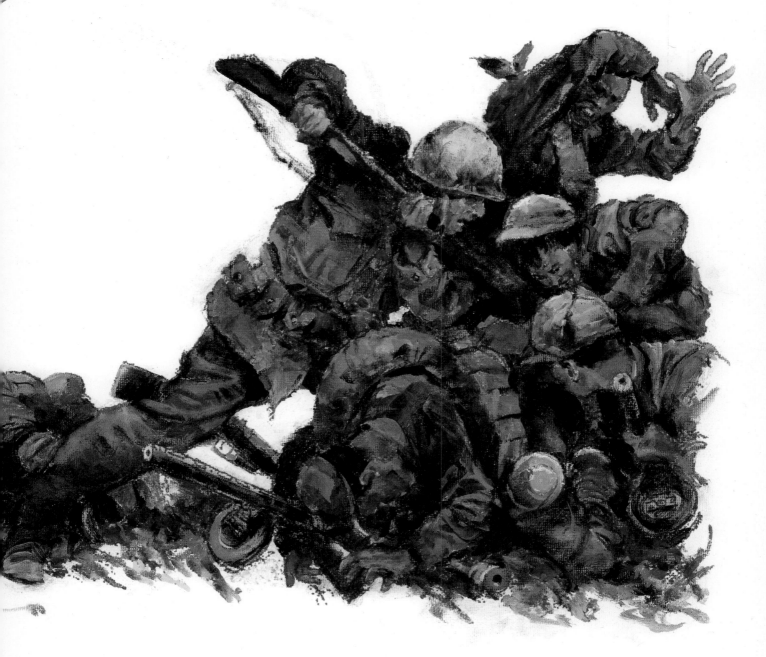

VALOR IN ACTION

THE MEDAL OF HONOR PAINTINGS OF
COLONEL CHARLES WATERHOUSE

JANE WATERHOUSE

SCHIFFER MILITARY
4880 Lower Valley Road Atglen, PA 19310

AUTHOR'S NOTE

A picture might be worth a thousand words, but artist Charles Waterhouse was taking no chances. He left behind a voluminous paper trail of letters, journals, notebooks, and jottings on everything from old invoices to paper towels and napkins. Among this cache, my sister discovered pages from an unfinished memoir called *Time and Chance*. Unless otherwise cited, I have drawn from these unpublished sources—as well as my firsthand recollections and experience—to tell his story.

Book interior design by Justin Watkinson
Cover and slipcase design by Danielle Farmer
Type set in Trajan Pro/Minion Pro/Univers LT Std

ISBN: 978-0-7643-6017-6
Printed in China

Published by Schiffer Publishing, Ltd.
4880 Lower Valley Road
Atglen, PA 19310
Phone: (610) 593-1777; Fax: (610) 593-2002
E-mail: Info@schifferbooks.com
Web: www.schifferbooks.com

For our complete selection of fine books on this and related subjects, please visit our website at www.schifferbooks.com. You may also write for a free catalog.

Schiffer Publishing's titles are available at special discounts for bulk purchases for sales promotions or premiums. Special editions, including personalized covers, corporate imprints, and excerpts, can be created in large quantities for special needs. For more information, contact the publisher.

We are always looking for people to write books on new and related subjects. If you have an idea for a book, please contact us at proposals@schifferbooks.com.

FOR OUR BRAVE
US MARINE
AND NAVY
CORPSMEN
MEDAL OF
HONOR
RECIPIENTS,
PAST, PRESENT
AND FUTURE . . .

And for the dogged artist who,
armed only with a paintbrush,
set out to honor as many of them
on canvas as he could before his
mortal tour of duty ended.

I'm sorry, Dad, if along the
way you became part of the story.
It was the only way I knew how
to get the job done.

Any nation that does
not honor its heroes
will not long endure.

—Abraham Lincoln

CONTENTS

PREFACE

The gravesite stood on a large rectangle of uncultivated land. Around its perimeter, identical granite crosses stretched in orthogonal lines toward a blurred horizon and were multiplied in an infinity mirror of blank sky. An AstroTurf carpet had been rolled out under the funeral canopy. It sat on the shrugged shoulders of last week's snow, looking completely out of place, like a miniature golf course randomly plunked down on the frozen tundra.

In summer, I'd return here—so confident in my ability to locate this spot that I didn't write down the grave number—only to find that, in the space of a few short months, everything had changed. The manicured lawns and undulating green hills disoriented me. Winter's bare sentry trees had sprouted leafy mushroom caps, as if a child's hand had drawn them; they ballooned against the clear blue sky, blocking out familiar landmarks. Arlington National Cemetery had folded itself around the grave that, in my memory, had been set apart, special, incorporating it into its inexorable, geometrically precise ecosystem. This hallowed ground never stays fallow for long. I spent close to an hour on that blazing hot day, wandering through a labyrinth of freshly planted tombstones, softly calling, "Dad? Mom? Where are you?"

But on February 19, 2014, this patch of Section 55 was an empty canvas, framed by a regimental Color Guard, the United States Marine Corps Band, and a detachment of Marines with their rifles sharply angled against their shoulders.

My brother-in-law Gary turned to me and whispered, "Wow. They really turned out for him."

I pointed toward the adjacent hill. More Marines were assembled on its crest: ramrod straight, facing forward, their gaze pinned to the flag-draped casket containing my parents' ashes, which had been mounted on the gun carriage of a black caisson. Four riders, motionless as the figures in an equestrian statue, sat atop the Lipizzaner stallions that were harnessed to the caisson, while alongside them, a pair of caparisoned horses chuffed and pawed at the frozen ground.

Gary's eyes welled with tears. The sight of my steady-as-a-rock brother-in-law overcome by emotion was the tipping point for me. Time stuttered. From that point on, the proceedings unfolded as a series of stop-motion images—our slow procession behind the caisson, the surgical precision of the flag being folded, the sun coming out of the clouds just as the female Marine bugle player was sounding *Taps*, the three deafening volleys in the rifle salute—disjointed frames totally lacking continuity, so that even now I can't say for sure how we got from point A to point B.

I do specifically recall that when the assistant commandant of the Marine Corps, Gen. John M. Paxton Jr., knelt on the frozen ground in front of me, I had to fight the impulse to lean forward and lift him up by the elbows so that he wouldn't soil his beautifully creased uniform trousers. When he presented me with the folded flag, a fat splat of my salt tears and runny eye makeup dropped onto an embroidered star. Breaking with tradition, the general also presented a flag to my sister, Amy. After the service, both flags were put into plastic sleeves, but that blotchy teardrop forever marks one as mine. What ultimately jostled me back into real time was something that the young Navy chaplain said. He was talking about sacrifice: the sacrifices of Marines like Col. Waterhouse, who so bravely served their country; the personal sacrifice that comes from answering the call of duty, even though it means being separated from your loved ones for long periods of time; the sacrifices

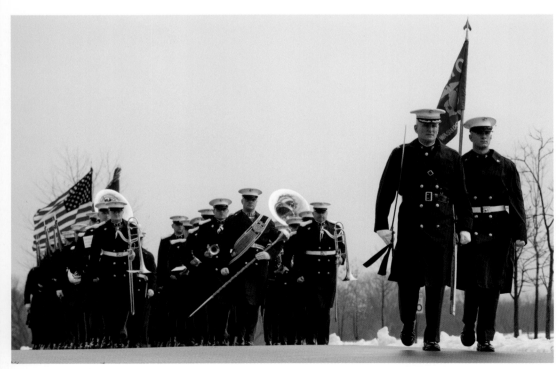

"The President's Own" United States Marine Band marches up the snowy hill during Col. Waterhouse's funeral at Arlington National Cemetery, on February 19, 2014. *Official Marine Corps photograph*

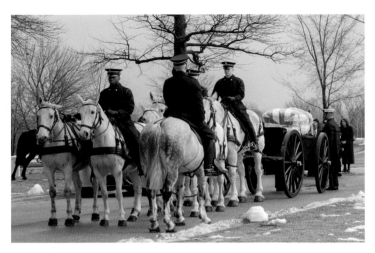

A horse-drawn caisson carries the flag-draped casket containing the ashes of Col. Waterhouse and his wife, Barbara. *Official Marine Corps photograph*

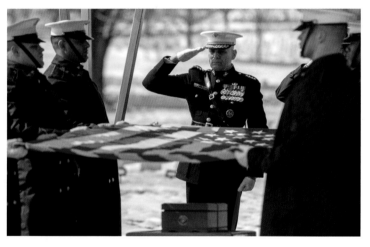

Assistant commandant Gen. John M. "Jay" Paxton Jr. delivers a final hand salute. *Official Marine Corps photograph*

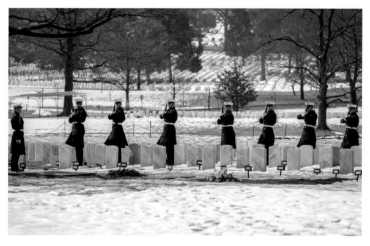

Marines prepare for the rifle salute honoring Colonel Charles Waterhouse. *Official Marine Corps photograph*

that Marine Corps families are called upon to make; and the willingness—should it be necessary—to make the ultimate sacrifice in order to protect the freedoms we cherish.

Hold on, I thought. That doesn't sound like my father . . . my mother . . . like us. The chaplain had presided over hundreds of funerals in Arlington. His words were eloquent and earnest, but this eulogy was for an entirely different kind of Marine.

I looked out over the frozen fields filled with granite crosses, feeling dwarfed, and humbled, by the enormity of the sacrifice that so many of these soldiers, sailors, airmen, coast guardsmen, and Marines had made—during lifetimes that were all too often tragically short—sacrifices through which they'd dearly purchased their tiny plot of consecrated ground. All of them had been buried with respect. But how many had been buried with full military honors?

At that moment I remembered something Commandant Gen. Jim Amos said when he and his wife, Bonnie, graciously called to give their condolences. "Your Daddy was a national treasure," CMC Amos told me. "He lived three lives in one."

This is a book about my father's three lives.

It isn't the book my father wanted, or expected, me to write. It stems from a deathbed promise—a promise offered reluctantly by me because of the crushing responsibility it entailed, and accepted begrudgingly by him, because to the bitter end, he was determined to carry it out himself—a promise to see to it that the series of Medal of Honor paintings he'd been working on during the last eight years of his life were published together, in one volume.

The idea of creating of comprehensive body of work showing Marines and naval corpsmen engaged in the acts of valor that led to them receiving the Medal of Honor had been in the back of my father's mind for years. But it wasn't until the age of eighty-two that he directed his total focus on the project. As the first and only artist in residence of the United States Marine Corps, and throughout the years of his retirement, Col. Charles Waterhouse had dedicated just about every waking hour to pictorializing the history of his beloved Corps. He wanted this series to be his final legacy to the Marines, and he saw this book as a lasting testament in honor of these brave men, and a gift to their families.

It was a quixotic mission from the start. Abraham Lincoln awarded the first Medal of Honor to a Marine back in 1863. Since then, hundreds of Marines and scores of naval hospital corpsmen had become recipients of the medal. The numbers certainly weren't in the aging artist's favor: there were a century and a half of battles to cover . . . hundreds of subjects to depict . . . an ever-growing field of candidates—pitted against the finite and ever-dwindling years he had remaining.

As my father's health declined, his sense of urgency to finish the project escalated. Time and chance had always worked in his favor. Chance had seen him through the volcanic hell of Iwo Jima; nearly 7,000 Marines were killed on that tiny Pacific island, but Cpl. Charlie Waterhouse, although wounded, had been spared. He'd been given the time to develop his talents and the chance to find true love and a true purpose. But now time turned on him, becoming his biggest nemesis.

He painted all day at his easel, getting up frequently in the middle of the night to work on an unfinished canvas. He spent countless hours reading and researching on the computer. During meals he drew sketches on paper napkins. He swore at his own frailties, and on a daily basis, he bargained with God.

The prominent art historian Bernard Berenson, nearing the end of his life, once said, "I would I could stand on a busy corner, hat in hand, and beg people to throw me their wasted hours." My father would have collected their spare minutes, had it meant being able to complete this final task.

And he almost succeeded. I say *almost* because, like many of the heroes he painted, Col. Charles Waterhouse died believing that he'd failed . . . that he had not done enough . . . that his final promise to Corps and country had been left unfulfilled; yet, at the time of his death, he had completed over 220 canvases—including several masterworks, and nearly 120 portraits—and had made a start on every USMC and Navy Corpsman Medal of Honor recipient from the Banana Wars through the war in Afghanistan.

My deathbed promise brought him little comfort; neither of us thought I was the right person for this job.

From an early age, I'd butted heads with my father. When he tried to teach me to draw an anatomically correct figure for the cover of my grade school history report, I'd tell my artist father, "No, daddy, it looks better *this* way." When he was in Vietnam, risking his life while covering the war as a combat artist, I was playing the title role in a decidedly antiwar, high school production of the Greek tragedy *Antigone*. And yet, despite my stubbornness and adolescent hubris, we had a special bond. As I grew older, I worked by his side, editing the copy he'd written for several of his books, including *Marines and Others*, *The Blue Book Illustrations of Herbert Morton Stoops*, and *Illustrations in Black, White and Gray*, his tribute to lifelong mentor and teacher Steven R. Kidd. Our thirsty, creative, never-quite-satisfied souls spoke the same language, although I tended to use more punctuation.

But taking on his final project was something different. I'm not a military historian or strategist. I've never seen combat. What's more, I didn't really share my father's vision of what this book should be. He envisioned it as a collection of Medal of Honor paintings, accompanied by the official citations. The citations, however, record only the bare facts. They don't tell the full story.

For years, I'd listened to my father talk about these men. He was a natural raconteur—one only has to look at a Waterhouse painting to appreciate how skilled he was at translating a complicated narrative into a cohesive picture—and his detailed descriptions of time and place, anecdotal asides, and encyclopedic knowledge of military history drew you in and made you feel as if you were *there*. The more conversations we had about this project, the more I became convinced—and this is where I hear the faint echo of my younger self saying, "No, daddy, it's better *this* way"—that these stories had to be part of the book.

But not only did I want to tell the stories of the Medal of Honor recipients, I also wanted to record the story of my father's three lives: how he went from a young, idealistic—and, yes, scared—PFC landing on the beaches of Iwo Jima . . . to an accomplished, sought-after illustrator . . . to being laid to rest as a full colonel in Arlington National Cemetery, with the highest military honors afforded anyone other than a president or head of state, and how it came to be that—of the approximately 400,000 heroes buried in that hallowed place—his is the only grave marker inscribed with the words ARTIST-IN-RESIDENCE.

I believed that was a story I could tell—that I wanted to tell—that, in many ways, I was born to tell. This conviction gave me the courage to start this project. What gave me the strength to see it through were the men themselves.

As a writer of detective novels and mysteries, I'm driven by the need to ferret out the hidden motives behind what human beings do and why they do it. I wanted to known what makes seemingly ordinary people perform extraordinary acts, in the face of danger, when every primal survival instinct is tugging them in the opposite direction. Was there something about these particular men—their character, upbringing, early experiences, beliefs and values—that predisposed them toward courage, selflessness, and near superhuman stamina?

I went in search for clues. It started with studying the citations and comparing them to my father's paintings of the Medal of Recipients. Then I found myself digging deeper. The more I learned about them, the more I wanted to learn.

But while mystery novels always have a satisfying resolution, that's not always the case in real life. Each of these men had a life before they were Marines, before they became heroes, but many of them were killed in action at the tender ages of eighteen, nineteen, and twenty. They didn't have a third chapter. And yet, though their stories were short, they were *so* worth telling . . . and retelling.

Over time, the promise I made to my father—to see that the paintings he'd created in honor of these valiant men were published—became an obeisance: a deep-felt obligation that I feel strongly to this day, to shine a light on who they were and what they did, a metaphorical act of lighting a candle in their memory.

I can give them nothing more than my words. It seems so little compared to what they gave. But the feeling of falling short, and wishing I could do more, is familiar to me.

I am, after all, my father's daughter.

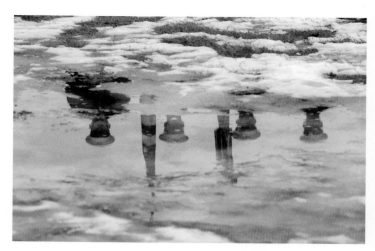

The Marine Corps Color Guard, standing at attention, is reflected in the patchy melting snow at Col. Waterhouse's funeral. *Official Marine Corps photograph*

PART ONE
TIME AND CHANCE

The race is not to the swift
or the battle to the strong . . .
but time and chance happen to them all.

—Ecclesiastes 9:11

THE MISSION

The year was 1946. Twenty-two years old, and fresh out of the Marine Corps, Charlie Waterhouse had an interview with the editor of King Comics. He boarded the train to New York, with high hopes of becoming a famous cartoonist, and ten 16-by-20-inch poster boards of illustrated spreads for an original comic strip tucked under his arm.

At the time, King Comics—part of the print division of the Hearst syndicate King Features—was a comic juggernaut, publishing many popular strips of the day, including *Flash Gordon*, *Beetle Bailey*, *Blondie*, *The Phantom*, and *Buz Sawyer*. Young Waterhouse had an idea that he was sure would take the comic world by storm. He set up his sample boards in the editor's office and unveiled the splash page.

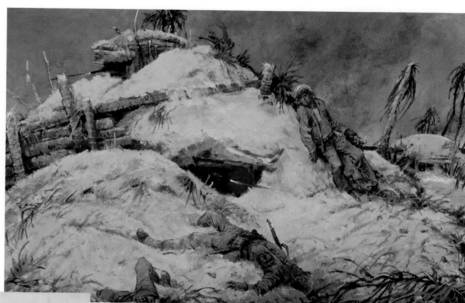

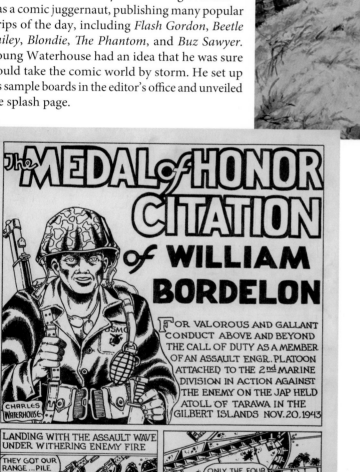

"The Medal of Honor Citation of William Bordelon," one of the sample comic board strips that hopeful cartoonist Charlie Waterhouse brought to King Comics in 1946. *Original pen and ink illustration photographed by Bart Lentini*

S/SGT. WILLIAM JAMES BORDELON USMC
MOH

TARAWA, GILBERT ISLANDS 20 NOVEMBER 1943

Medal of Honor painting *SSgt. William Bordelon, USMC, Tarawa, November 20, 1943,* by Col. Charles Waterhouse. *Art Collection, National Museum of the Marine Corps*

The proposed title of the strip was emblazoned across the top in huge letters: *The MEDAL of HONOR CITATION of William Bordelon*. An awkward illustration of a Marine in full combat gear appeared under the banner, alongside the carefully inked words of William Bordelon's citation.

"This is your idea?" the editor asked.

"Yes, sir," said Waterhouse. "The strip would be about Medal of Honor Marines. I already have two of the stories done."

"Son," said the editor. "The war is over. No one wants to hear about that anymore."

Oddly enough, this disastrous job interview would be an important milestone for Waterhouse in two respects: while he wasn't offered a job, the editor offered some good advice, telling him to come back after he'd been to art school; what's more, although the wannabe cartoonist didn't know it then, this sophomoric comic strip was the template for what, nearly sixty years later, would become an epic series of paintings by the preeminent military artist Col. Charles Waterhouse.

Over those sixty years, the Medal of Honor idea never really went away. A few Medal of Honor recipients wandered onto

Waterhouse's canvases during his tenure as artist in residence or were featured on the covers he created for *Marine Corps League* magazine and other publications during his retirement. While Gunner Ed Sere, the then curator of the Col. Charles Waterhouse Museum, was the first person to actually suggest that he create a Medal of Honor series, the colonel always regarded one specific event—and one extremely reluctant subject—as the catalyst that got the project off the ground.

In later life, my father and mother were often the special guests at Marine Corps birthday balls and ceremonial functions, where they had the opportunity to become personally acquainted with many of the living Medal of Honor recipients. At one such event—an annual fundraiser for the Marine Corps Scholarship Foundation, which was a cause dear to my father's heart—they were seated with Medal of Honor recipient Hector Cafferata Jr. and his wife, Doris.

Cafferata was in his early seventies at the time, but still a bear of a man, with a gravelly voice, a tough-guy Jersey accent, and a handshake that gripped like a vice. Over dinner, my father mentioned that he wanted to create a large painting of Cafferata in action on the Toktong Pass.

"Why me?" Cafferata scoffed. "It would be a wasted effort. No one's interested in that stuff any more. Most people don't even know what the Korean War was. That's all been forgotten."

My father—a man who'd never owned a set of car keys and seldom carried a wallet—always traveled with a fine-point permanent marker and considered any flat surface fair game. He whipped out his pen, turned over the dinner menu, and started sketching a Marine, crouched over and shooting from the hip.

The typical response to one of my dad's on-the-spot drawings was usually an admiring *Wow*, followed quickly by *Can I have it?*

But Hector Cafferata was not your typical guy. He pushed the sketch back. "No, NO, NO!!!" he protested. "I'd never fire off a shot that way! I *aim* at what I want to hit!"

My father nodded and quickly redrew the arm.

Recalling that moment years later, he said this: "Once Hector's interest was aroused, I knew we were in business. We started to talk about other things—the freezing cold, his gear, some of the things that he did up on Fox Hill. His wife, Doris, said she'd send me a photograph of Hector in high school, so I could see what he looked like back then. By the end of dinner, I had all the raw material I'd need to create the first canvas in a series that I wanted to be my final gift to the Marine Corps."

PVT. HECTOR A. CAFFERATA JR., USMCR
The Battle on Fox Hill, Chosin Reservoir, Korea
November 28, 1950

It was only a few days after Thanksgiving. There was a full moon that night. Back home, guys their age would probably be parked in lovers' lane with a pretty girl, gazing up at the stars while the radio played softly in the dark.

Of course, these two particular guys—football players from rival high schools in North Jersey, who'd continued their grudge match into the semipros—were just as likely to be outside some local dive, beating the snot out of each other.

But as chance would have it, Pvt. Hector Cafferata, twenty-one, and PFC Kenny Benson, twenty-two, were dug into the same foxhole,

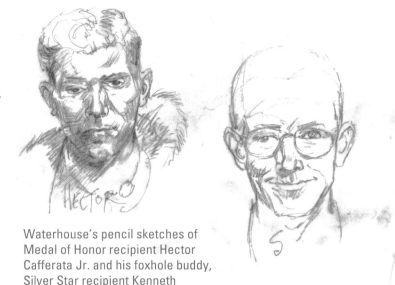

Waterhouse's pencil sketches of Medal of Honor recipient Hector Cafferata Jr. and his foxhole buddy, Silver Star recipient Kenneth Benson. *Photograph by Bart Lentini*

on a cold, godforsaken mountain pass in Korea. Like the majority of the 240 men in Fox Company, the two hole-mates were reservists. Cafferata, in fact, had been placed on inactive status after missing so many reserve meetings back in his hometown of Boonton that he nearly missed being called, period.[1]

Their new commander, Capt. William Barber, who had been in charge for less than a week, found the Marines of Company F to be "not very good, not very well trained."[2] Barber, however, had already earned both a Silver Star and a Purple Heart on Iwo Jima (for his actions in Korea, he would later receive a Medal of Honor) and wasn't easily daunted, so when the order came to secure the Toktong Pass that night, he marched his ragtag band of green Marines up the hill and fanned them out in an oval space along the snowy road, with their machine gun positions set and their mortars ranged.

It was already dark by the time the men scraped out their foxholes, using entrenching tools to chip away at the frozen ground. Cafferata and Benson had set up a makeshift windscreen of pine brush and rocks, but there was only so much you could do against nighttime temps that dipped to 30 below. Only days before, there'd been a rumor going around that the troops would be home by Christmas, and suddenly they're sent to guard this hill. What the hell was going on? Nobody knew, and it was damn spooky up here, with the moonlight sliding into crevasses, turning a sliver of ice into glinting gunmetal, and the fog of your breath into levitating ghosts.

A couple of the men had gotten so nervous they started shooting at shadows, and throwing up flares, but things were quieting down now, so Cafferata and Benson tucked into their sleeping bags, intent on getting some shut-eye. The standard-issue mummy bags weren't made for Marines built like them, and despite the cold, they had to take off their boots and parkas in order to shimmy inside. They conked out around midnight, unaware that they were completely surrounded by a regiment of over a thousand Chinese soldiers, which pretty much made them sleeping—not to mention bootless—sitting ducks.

The shooting started around 0100.

Reacting instinctually, Cafferata unzipped his bag and grabbed his M-1 rifle. The Chinese were all over them. He let loose a round, immediately mowing down five or six of the enemy. Benson had risen and was fumbling in the darkness.

"What are you doing?" Cafferata hissed.

"Putting on my boots," his buddy replied.

"Forget the boots. Start shooting," Cafferata said, grabbing his Browning Automatic rifle. The gun was frozen. "Time to get the hell out of here," he said.

Huddled low to the ground, the two Marines elbowed their way through the snow, trying to work out, amid the darkness and confusion, where the main line of resistance was. A Chinese soldier pitched a grenade at them. Cafferata rolled to the left, while Benson lunged forward, scooping it up for a throw, but before he could lob it away, the thing exploded, breaking his glasses and burning his face.

"I can't see," Benson shouted. "I can't see a damn thing."

Cafferata sidled up beside him. "Hang on to my foot," he said. "And get ready, because we're going to crawl."[3]

They managed to reach a shallow wash cut into the face of the hill. Three members of their squad were huddled inside, all badly wounded. Cafferata realized they'd stumbled into the breach between the Third and Second Platoons. Clearly, somebody needed to fill the hole and plug up the gap, but it wasn't going to be any of these Marines.

Cafferata's feet were telling him to run while the going was still good, but his brain was racing on another track. "Shit," he said. "I guess we're staying."

Immediately, he started collecting M-ls from the wounded Marines. Benson was still flash-blinded, but Cafferata handed him a couple anyway. "Just keep loading," he said. He'd been hunting and shooting since he was twelve, so the drill was second nature—put the gun up to your shoulder and aim dead center, for the chest.

Years later, Hector would tell author Larry Smith, "Some of them I shot I could see their faces real clear. There were times I thought, 'Oh, shit, look at this, the poor son of a bitch.'" He added, "I had to shoot them, you know? It was life or death; that's the name of the game. But I think about it now and I think, what a waste."[4]

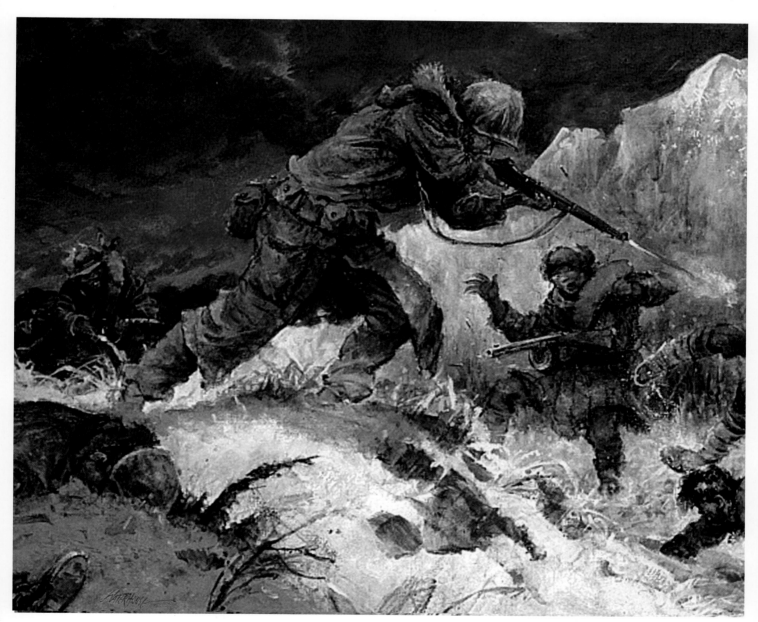

Detail of *Pvt. Hector A. Cafferata Jr., USMCR, Fox Hill, Korea, 28 Nov. 1950* by Col. Charles Waterhouse, launching a one-man counterassault, barefoot, in the snow. He told the artist that nobody cared about that anymore. *From the collection of Jane Waterhouse and Amy Lotano*

That night, however, on the rugged pass thereafter known as Fox Hill, in honor of the company of men who fought there, there was little time for thinking. Cafferata would fire a rifle until it was empty, and Benson would hand him another loaded one. He fired off hundreds of rounds that way—so many that, at one point, the wooden top cover of his rifle barrel turned to charcoal and caught fire, and he had to put it out with snow.

And still the Chinese kept coming, with an arsenal of weapons— burp guns with drum magazines, M-1s, carbines, Enfields, Springfields, Nambus, Thompson submachine guns, and hand grenades. The grenades were flying at him so fast that Cafferata—who'd always stunk at baseball—took to swinging his entrenchment tool like a baseball bat, smacking them back where they came from. If someone came at him, he said he'd just lay his rifle over the shovel handle and pull the trigger.

At one point a grenade landed by the wounded Marines. Cafferata ran over and grabbed it, but his hand was frozen, and it exploded midair before he could complete the throw, blowing the meat off a few of his fingers.[5]

And still he fought on.

As the dawn broke, the Chinese began to pull back, knowing that Corsairs would soon be dropping napalm from the air. By then, Cafferata had taken three unarmed prisoners. Once the fighting slowed, he released them to some Marines and went off looking for his boots.

Just then a bullet caught him in the muscle of his right arm, knocking him down. The Chinese soldier kept firing until one of Hector's fellow Marines filled him with lead; although Cafferata didn't find out until later, in addition to his other wounds, he'd also been hit in the chest.

The first corpsman to attend to him noticed that Hector's feet were blue and swollen. "Where's your boots?" he asked.[6]

Cafferata had fought all night, on treacherous terrain, in 6 inches of snow, in his bare feet. Afterward he would say, "I know I did it. Other people know I did it. But I'll be God damned if I know how I did it."[7]

One of the people who knew that he did it was Third Platoon commander Lt. Robert McCarthy, of Asheville, North Carolina, the officer who nominated Hector Cafferata for the Medal of Honor. "I figured he killed close to a hundred of the enemy," McCarthy said,

Left to right: Mr. and Mrs. Kenneth Benson, Hector and Doris Cafferata, and Col. Waterhouse and his wife, Barbara, pose in front of the Cafferata Medal of Honor painting at the Waterhouse Museum in 2005. *Photograph by Amy Lotano*

"but we only wrote it up for thirty-six because we didn't think they would believe it."[8]

Upon being notified that he would be receiving the Medal of Honor, Pvt. Cafferata told Marine Corps Headquarters to put the damn thing in the mail. It would take a call from the commandant of the Marine Corps to convince him that attendance at the White House ceremony was mandatory.

On November 27, 1952, President Harry Truman presented Cafferata's citation. Bestowing him with the ribbon required an extra effort, because Harry Truman was only 5 feet, 9 inches tall. "I was standing at attention," Cafferata later recounted. "Finally, I had to bend over, but even then the president couldn't get his arms around me to put the Medal of Honor around my neck without standing on my spit-shined shoes. The little bastard ruined my shoes," he said, adding reflectively, "I kept 'em with the smear marks for about twenty years, then I threw them away."[9]

As for the medal, Hector Cafferata decided to keep that in his gun safe.

Years later, his foxhole buddy, Kenneth Benson, was awarded the Silver Star.

SEE YA IN THE FUNNIES

Charles Howard Waterhouse was born on September 22, 1924, in Columbus, Georgia. His father, Harry, had been working at Fort Benning as a mechanic in the aftermath of the First World War; while stationed there, he and his wife, Bertha, had suffered the loss of their firstborn son, Harry Jr., to "baby diarrhea," which was likely a form of infant cholera. When their second child came along and also proved sickly, the couple decided to move back to their hometown of Perth Amboy, New Jersey, as a safeguard, returning when their son Charlie was just a year old.

Situated at the mouth of the Raritan River, just across from Staten Island, Perth Amboy was a strategic stronghold during the American Revolution, serving as one of New Jersey's early capitals. Over the following centuries the city had grown into a bustling commercial hub. By 1925, it had a population of over 40,000 people, including a large number of immigrants from England, Ireland, Denmark, Italy, Poland, Hungary, Czechoslovakia, and the Ukraine, who lived in tightly knit enclaves with names such as Budapest, Dublin, and Chickentown, and worked on the assembly lines at the local terra-cotta factory or the copper works.

"We were poor, but we didn't know it, as everyone was," Waterhouse said, describing his childhood. But while Charlie's family was no better off than the others in the neighborhood, their small home on New Brunswick Avenue was crammed to the rafters with truly magical things: ingenious gadgets and whirligigs that Harry made in his garage . . . wary-eyed cats that followed the movements of the invisible ghosts who haunted the attic . . . the wafting aroma of freshly baked pies . . . and a trove of toys befitting a beloved, only child—armies of lead soldiers, caravans of exotic circus animals, mechanical banks that slyly snatched your coins, and, most magical of all, books.

Harry and Bertha Waterhouse with their son, Charlie, in 1929. *Waterhouse family photograph*

Charlie's dad made weekly trips to the downtown library, returning with an armful of books. During the cold-weather months, father and son would sit around the big coal-burning iron stove, their feet propped on the open oven door, reading the night away, while mom Bertha puttered around the kitchen, making cocoa and cookies, stopping to listen whenever Charlie stuck his head up from his adventure story, to recount some act of derring-do.

Harry Waterhouse had a photographic memory and was a natural speed-reader, with the ability to finish a book in a matter of minutes and recite back the content, chapter and verse, on any given page. Charlie, on the other hand, preferred to take his time, often reading a passage over and over, in order to savor it. Favorite books such as *Tom Sawyer* and *Tarzan* would be started again as soon as he'd read the last word. The only thing that young Charlie loved more than a good book was a good book with illustrations. He was in awe of the wonderful images he found in these publications. He admired the artists and longed to emulate them.

When still just a schoolboy in short pants, Waterhouse remembered paying a penny at the local candy store and scoring a box of three wax crayons. It came with a picture of a Banana Wars Marine that Charlie painstakingly tried to trace until he wore the crayons down to nubs. From that moment on, those two things—drawing pictures and Marines—became inextricably linked in his mind.

At first Charlie was content to draw his pictures, sprawled on the floor of the parlor, next to the heater and the radio set, but it wasn't long before the budding artist felt the need for a more professional environment. His first studio was his small bedroom. He repurposed his mother's old breadboard as a drawing board and taped to it a bottle of India ink. A window, a reading lamp, and an overhead lightbulb provided all illumination needed, and his small cache of art supplies— some brushes, a few pencil stubs, a soap eraser, and some cheap poster board—could be readily hidden under the bed.

In the quiet comfort of this sanctuary, Charlie copied cartoons from the daily and Sunday funny pages, trying to replicate drawings of Mickey Mouse, Little Lulu, Popeye, Bunker Hill Jr., and other famous characters. Some of them, such as Mickey, Dick Tracy, and Dagwood, were fairly easy; others, such as Hal Forster's *Tarzan* and Alex Raymond's *Flash Gordon*, were considerably more difficult to emulate. He didn't try to analyze why, he just kept drawing. His father said, "You're getting pretty good at copying those cartoons, Charlie. Why don't you try to make drawings and characters of your own, and make them do the things you want them to do?"

Charlie started by taking a nose from one character, the eyes from another, and the mouth from somewhere else. But eventually, as he later wrote, he took the leap, "reverting to the practice that all children and all artists use: just look at the paper, imagine what you want to see there, and draw a line around it."[2]

Browsing through the shelves of the school library, twelve-year-old Charlie Waterhouse stumbled upon a book called *Fix Bayonets!* by Capt. John W. Thomason. It was filled with dozens of small drawings, many of them little more than pencil scribbles, showing the Marine Brigade in action during World War I. Inspired by

Thomason's renderings of Devil Dog Marines, marching through Belleau Wood and dodging shells in Mont Blanc, Charlie covered every scrap of paper he could find with his own awkward attempts. To him, Captain Thomason seemed a man of mythic proportions—an amalgam of two marvelous things: Marine and artist. He took out *Fixed Bayonets!* so many times that the librarian flatly refused to put another stamp on it.

Old Hand by Col. John W. Thomason Jr., USMC. *Art Collection, National Museum of the Marine Corps*

Lacking guidance and formal training, Charlie did his best to educate himself by reading about various artistic techniques. He tried his hand at etching, ladling melted candle wax over a piece of copper sheeting and taping his mother's sewing needle onto an old pencil, which he used to draw on the wax surface. All went pretty well until he poured sulfuric acid over the waxen impression, nearly burning down the house in the process. In an attempt to cast a sculpture, he melted down the lead molds from his toy soldiers on the gas stove, misjudging the effect that hot, molten lead tended to have when poured into a cold receptacle. After finding a stockpile of tin cans filled with powder pigment in the town dump, Charlie discovered—through trial and error—that he could make pastels and chalk by baking them in the oven with a binder of curdled milk. And through it all, he kept on drawing.

Charlie's talent soon drew the attention of his teachers and fellow students. He became the art editor for his grammar school newspaper, *The Broadcaster*, and won the art prize—a whopping five dollars—at his eighth-grade graduation. A cynical relative, whom my father always referred to as his "smart" uncle, told the boy's proud parents, "Don't think that he's too hot. Just wait until he gets into high school, where he'll have real competition, then you'll see."

In high school, Charlie continued to serve as newspaper art editor for *The Periscope*, bringing home awards and accolades for his cartoons and drawings. He had grown up during the Great Depression but was coming of age as the war clouds of World War II were gathering. Capt. Thomason's illustrations of World War I

Marines no longer held precedence in his imagination; they were replaced by the gritty, on-the-spot pencil sketches being sent back from the Pacific by USMC combat artist Maj. Don Dickson.

By 1942, Waterhouse didn't have to check out a book to steep himself in the brave exploits of US Marines. What they were doing in faraway places such as Wake Island, Makin, and the Solomon Islands was splashed across the front page of the *Perth Amboy Evening*

Instructions to a Patrol, Guadalcanal, 1942, by Maj. Don Dickson, USMCR. *Art Collection, National Museum of the Marine Corps*

News, dramatized on the radio, and set to swelling music in the United News war films that played before every regular feature at the Ditmas Theater.

A local guy from Raritan, just a few miles away, by the name of John Basilone—a high school dropout who'd done a stint in the Army over in the Philippines before joining the Marine Corps—was making big headlines for his heroics in the Pacific. The press had dubbed him Manila John, the Fighting Sergeant of Guadalcanal.

Charlie Waterhouse wondered—would it ever be his turn?

SGT. JOHN BASILONE, USMC
The Battle for Henderson Field, Guadalcanal, October 25, 1942

The Sendai division intent on retaking the airstrip on Guadalcanal had everything in their favor. They had over 3,000 soldiers, each driven by a code of loyalty and self-sacrifice so strong that, when the charging cry of "Banzai!" came a few minutes after midnight, those in the lead would willingly impale themselves upon the barbed-wire partition, offering up their bodies as a human bridge over which their comrades could leap.[1] Undoubtedly, these were fierce warriors, and only a single US Marine battalion stood in their way, but they hadn't reckoned that among them would be a 5-foot-8, 156-pound sergeant from Raritan, New Jersey, named John Basilone.

If the Marines were looking for a good man to hold the line that night, "Manila John" Basilone fit the bill in every way. He had the right skills: mechanical know-how and a knack with machine guns, honed over the three years he'd spent in the Philippines with the Army. He had the right temperament: a restless, adventurous spirit that caused him to buck the confines of civilian life and enlist in the

Marine Corps before the attack on Pearl Harbor. Most important of all, the tough little sergeant had an innate ability to lead and inspire the men around him.

He'd just completed a check of his guns and was sitting in his foxhole, peeling off his boots and socks to give some relief to his soaked and itching feet, when a hissing sound came over the field phone. "Basilone? There's a large Jap force massing in front of your position. They outnumber you about a hundred to one," said a low whisper. "You've got to hold until we can reinforce."

"Sure," the sergeant replied.

Basilone slapped the Marine next to him on the helmet. "See ya in the funnies," he said, before slogging out through the mud, still bootless, to pass on the word.[2]

His men were ready, squatting in their muddy holes, drenched to the bone, with their rain ponchos protectively draped over their weapons and ammo. A Marine wasn't sugar—he wouldn't melt, but these heavy machine guns needed to be kept cool and dry, so Basilone had made sure ahead of time they were wrapped up, locked and loaded, with the water hoses tight against the machine gun water jackets.

The eerie jungle silence was suddenly broken by the crack of an exploding mortar. A firework display of artillery lit up the sky, triggering ghastly carnival sounds—tooting horns, screeching whistles, and disembodied voices taunting, "Marine, you die!" Another more powerful explosion followed. The Japanese had blown a gap in the defensive wire and were surging through, their triumphant shrieks echoing through the air.

Basilone had directed his boys to hold fire until the enemy advanced to within 30 yards.[3] For the sixteen Marines positioned behind the four heavy machine guns on Lunga ridge—two on the left flank, two on the right—it must have felt like an eternity, from the moment when the smoke of that first softening round of artillery cleared until they saw the full force of the frontal assault coming at them, screaming at the top of their lungs, getting closer . . . closer . . . CLOSER.

"Awright!" Basilone yelled. "Give it to 'em!"

Like sleeping dragons roused, the Leatherneck machine guns let loose great tongues of fire, annihilating the Sendai onslaught. Bodies piled so high in front of the weapons pits that the barrels had to be reset so the Marines could fire over the corpses. But the enemy just kept on coming.

Amid the fighting, a runner stumbled in with bad news for Basilone: the Japanese had knocked out the right machine gun nest, bayoneting two Marines and leaving the guns hopelessly jammed. They were down to just two riflemen. Telling his gunners to keep on shooting, Basilone grabbed a reserve machine gun, looped some extra belts of ammo around his neck, and headed out, dodging grenade blasts, small-arms fire, and an encounter with an enemy patrol.

When he reached the right flank, the man whom Gen. Douglas MacArthur later called "a one-man army"[4] set up his gun and sprang into action. Covered by his team, Basilone assessed the machine guns: one beyond repair, one jammed. As the bullets whizzed around him, the sergeant set to work in the dark, using his fingers and his instinct to troubleshoot the problem, then switching the necessary parts from the knocked-out gun to get the other up and running. Barking orders at his boys to keep the machine guns loaded, Basilone rolled from one machine gun to the other, firing until it was empty, until they were *all* empty. By 0300 they were completely out of ammunition.

Detail of *Sgt. John Basilone, USMC, Guadalcanal, 24–25 Oct. 1942* by Col. Charles Waterhouse. *From the private collection of Jane Waterhouse and Amy Lotano*

"You men hold here!" Basilone yelled.

Shoeless and shirtless, his .45 pistol drawn, he clambered up the muddy ridge and embarked on a harrowing 600-yard run through enemy lines to where the munitions were stashed. The wiry gunnery sergeant returned carrying nearly 100 pounds of ammunition. Reinforcements had arrived, but the machine guns were burning out, the water in their cooling jackets having boiled away from the rapid fire.

Basilone told his men to piss in the jackets to keep the guns going.[5]

When the fighting finally stopped sometime before dawn, the battlefield was strewn with the wounded, dead, and dying. In all, 3,000 Japanese soldiers—an entire regiment—died in the assault on Henderson Field that night. But the Marines had held the airstrip, and its ownership would not be challenged again.

The things John Basilone did during that battle still play across the mind's eye, in cinematic bursts of Technicolor and SurroundSound, all these decades later. They are the stuff of every war drama from *Guadalcanal Diary* to Steven Spielberg's epic series *The Pacific.* Each tough-guy line Basilone uttered is inextricably woven into our national consciousness, resonating with the indomitable spirit that marks the best of us; each selfless act has become a kind of iconography for the word "bravery."

In Waterhouse's Medal of Honor painting, Basilone is perched at the top of a machine gun nest, illuminated by the firefight. Movie star handsome, with his helmet off and a shock of dark, curly hair falling across his forehead, he appears forever young, undeniably courageous—and like the enemy he faced—seemingly invincible.

A PFC from Fayetteville, North Carolina, by the name of Nash W. Phillips, who lost a hand fighting next to Basilone that night, offered another picture. He recalled the sergeant appearing next to his cot the morning after the battle, with his face covered in unburned gunpowder, and his eyes red from lack of sleep. His trusty .45 remained tucked into his waistband, and he was still barefoot.

"He just dropped by to see how I was making out, me and the others in the section," Phillips said, adding, "I'll never forget him. He'll never be dead in my mind!"[6]

In December 1942, just two months after John Basilone's stand near the airstrip on Guadalcanal, Charlie Waterhouse and five of his buddies took the train from Perth Amboy to New York City. Despite the fact that all of the boys were underage, they were heading to the Church Street Recruiting Station, hell-bent on joining the United States Marines.

Of the group, Charlie—affectionately known as Mousie—was by far the youngest and skinniest. He still dreamed of becoming a combat artist like his heroes, John Thomason and Don Dickson, but that lofty goal seemed out of the realm of possibility. Charlie figured the next best thing was to become a Marine—to do his duty and serve his country; then, if God smiled, and he made it back, maybe he'd create his own comic strip. He'd heard that cartoonists were paid fifteen dollars a page. Fifteen bucks a PAGE—rolling in that kind of dough, the world would be his oyster! With any luck, the world would be seeing Charlie Waterhouse in the funnies some day.

Step 1 was to get into the Marine Corps, but moments away from securing the final papers that the seventeen-year-old would need to take back for his parents' signature, the news came in that President Roosevelt had frozen enlistments.

Charlie Waterhouse, a.k.a. the Mouse, was devastated.

On September 19, 1943, 30,000 people—including members of the press, national and local politicians, and many celebrities—swarmed into the tiny town of Raritan, New Jersey, to witness a parade in honor of hometown hero, and Medal of Honor recipient, John Basilone.[7]

Three days later, only a few miles away, Charlie Waterhouse turned eighteen.

Since graduating from high school, he'd been contributing to the war effort in the only way open to him: working as a draftsman in the engineering room of the local copper works, copying drawings onto transparencies that would be hidden deep in the Pocono Mountains in the event of a German bombardment, ticking off the days until he would be old enough to enlist.

As soon as he was, he and his pals tried their luck again. The five friends walked into a selection center in North Jersey as Marine hopefuls. Only Charlie Waterhouse walked out a Marine.

My father loved that story. Every time he told it, it was as though he were being transported back in time. You could see the interplay of youthful pride on his face, the amazed surprise at his own dumb luck—that he, Charlie Waterhouse, should have been deemed worthy of being called a Marine.

As a kid with a vivid imagination, I was putty in a master storyteller's hand listening to the tale. I experienced the same butterflies of anticipation. I suffered the goofy indignity of standing in line, in only boxer shorts, waiting for the physical examination. I struggled through every last question on the written test. I felt the anxiety mounting to a fever pitch. And when the hero of the story emerged victorious (a victory that, God forgive me, seemed all the sweeter when compared to the fates of the supporting characters—my dad's buddies—eternally doomed to the Army and Navy), I reveled in his joy.

But when I grew older and became the mother of an only child—an only son—I saw it all so differently. Instead of identifying with what young Charlie Waterhouse was feeling, I stood squarely in his parents' shoes. What must it have been like for them, when he came back home that day, bursting with the news that he'd enlisted in the Marine Corps? Had a shadow—the flickering face of her lost son, Harry—passed over my grandmother's heart? Did my grandfather regret filling the boy's head with all the tales of those courageous men of derring-do, who'd gone to fight for the glory of God and country?

For eighteen years, Harry and Bertha Waterhouse had focused the entirety of their love and attention on this skinny, bookish, artistic child; yet, to their credit, they'd also given him the freedom to explore, to be adventurous, to be a typical boy. He'd swum like a fish in the old clay pits with the other neighborhood kids. He'd run with a rambunctious crowd, engaged in rubber gun wars, and dived off the roofs of abandoned buildings into piles of autumn leaves. He'd taken reckless chances and double dares. Whatever private fears Harry and Bertha Waterhouse might have had now that their only child was going off to war they kept to themselves, as did so many other parents during World War II, and during the wars before and since.

The military chaplain at Arlington had it right: it *is* about sacrifice.

As Charlie Waterhouse headed out to boot camp on Parris Island, the Marine Corps golden boy, John Basilone, was embarking on a nationwide war bond tour that would splash his handsome face across national newspapers and the pages of *Life* magazine and raise pledges to the tune of a million and a half bucks.[8]

Neither Marine knew that chance would ultimately bring them to the same small island in the South Pacific.

DEATH BEFORE DISHONOR

Iwo Jima, February 19, 1945

It was supposed to have taken place earlier. Preparations for the invasion began in October 1944, but moving 800 ships and enough equipment for three Marine divisions to this volcanic speck in the Pacific, just 600 nautical miles from Tokyo, would prove no simple task, so the plans for Operation Detachment—better known as the battle of Iwo Jima—had been set for February 1945.

In the intervening months, Gen. Tadamichi Kuribayashi and his force of 22,000 Imperial soldiers dug deep into the steaming bowels of the island, doubling the number of underground tunnels and hidden pillboxes.[1]

Then they waited.

The weather, which had been bleak and squally, broke on the morning of Monday, February 19. Skies were clear, with a brisk wind blowing from the north and near-perfect visibility.

The order to land came in at 0630.

At 0900 the first wave of the assault shoved off toward Iwo.

When John Basilone's assault wave landed on Red Beach at 0905, they found little opposition other than the soft, black sand, which sucked hungrily at their boots and immediately erased their footprints as if to say, "Hey, Marine—you don't belong here."

Sgt. William Lansford was one wave after Basilone. That's how it always was with Manila Joe—try as you might to keep up, you were always a step behind the man.

After a yearlong tour across a hero-hungry nation, the Medal of Honor recipient—that "one-man army"[2] who didn't know the meaning of battle fatigue—was tired. Tired of being the biggest draw in the war bond business. Tired of being paraded around, gussied up like some Navy Yard Marine. Tired of being fawned over by politicians and Hollywood starlets, of people crowding around him, everybody wanting to touch the Medal.

The damn medal had become an albatross around his neck.

Basilone complained to the Marine Corps brass that he felt like a museum piece. He missed his men, he wanted back in, and he wasn't taking "no soft assignments" either.[3] And so, after a lot of back and forth, the legendary fighting sergeant of Guadalcanal had been assigned to the 1st Battalion, 27th Marines, in the newly formed 5th Marine Division at Camp Pendleton.

Bill Lansford was his corporal. "Basilone did more than drill us," Lansford would later say. "He taught our recruits the meaning of esprit de corps, and in those of us who had fought, he rekindled a desire to fight again."[4]

On February 19, Lansford was technically no longer one of "Basilone's boys," having already been transferred to headquarters as an intelligence noncommissioned officer, but days before shipping out, he'd gone back to visit his old company. He found his pal Manila John goofing around with his men in the tent area. They were giving each other haircuts. Basilone's famous dark, curly locks had been razored off, leaving his head "clipped bald as a brass ball."

He flashed a movie grin at Lansford, then turned suddenly serious. "It'll be cleaner. There's no barbershops on Iwo Jima," he said.[5]

The waves were coming in faster now, only about five minutes apart.

At 0937, PFC Charles Waterhouse, 3rd Platoon, Company C, 5th Engineer Battalion, was sitting with his platoon mates in a Higgins boat, his face smeared with antiflash cream.[6] The steak and eggs he'd crammed down for breakfast edged halfway up his throat. Their company was supposed to be held as reserve, but due to the lack of onshore resistance, they'd been called in early—loaded up, *zip, zip, zip,* stomachs churning as the coxswain swung the boat around and around in circles, before hitting the line of departure. They were on their way to Green Beach.

The view down in the Higgins was totally different. Up on the ship, the sky had been a gorgeous blue, the ocean calm, picture perfect. To his artist's eyes, the battleships and landing craft had looked like "a theatrical event arranged for our special viewing."[7] But now the wind had switched, turning the sky the color of smoke and ashes, zigzagged with fiery bursts from the artillery and mortars being hurled toward the shore.

As scared as he was, Waterhouse knew that this was where it had all been leading. To Suribachi. All the drills, all the training—*storm the beach . . . go 250 yards inland . . . turn left, and there'll be this big hill—the hill you've assaulted over and over, in your waking hours and in your sleep.* But this time it wasn't just something he'd heard about, or dreamed, or read in a book. The Marine huddled next to him wasn't posing for some penny postcard in a crayon box. This was real.

"They're walking up the beach in formation," the coxswain reported. "The place is secured."

No sooner had the words left his mouth than everything exploded. Kuribayashi had given the order to fire, and the Japanese let loose with everything they had: machine guns, mortars, and a staccato blast of heavy artillery, aimed directly at the exposed troops on the beaches. It came at them from every direction—from the heights of Suribachi, to the northernmost tip, and all along the neck of the island—it was as though Iwo itself had taken up arms against them.

In the confusion, the coxswain of the Higgins boat carrying Waterhouse's group ashore miscalculated his marker, landing—not in the center of the beach as planned—but on the extreme left end, under the shadow of Suribachi. When the ramp went down, they started to move, knowing they were being fired at, but not knowing from where; the air above them spitting lead; the black sand wiping clear the footsteps of the Marine in front of them.

Five hundred yards to the north, Red Beach was a scene of absolute chaos.

Half-tracks lay sideways in the black volcanic ash of the beachhead, encrusted with grainy sand and hammered by crashing waves. The beach was littered with damaged vehicles and dead men. They'd landed in a place with little or no cover, mired in a state of disorganization, without enough heavy equipment onshore to defend against the attack. Platoons and companies had gotten jumbled in

Flotsam and Jetsam on Green Beach, Iwo Jima by Col. Charles Waterhouse. The black sands stand in sharp contrast to the frothy, lapping turquoise waves. *Art Collection, National Museum of the Marine Corps*

the landing. Rendezvous points were balled up, leaving officers and noncommissioned officers searching for their men. It was a perfect storm, but the enemy's presighted weapons had no problem cutting through the confusion and mowing down Marine after Marine, tearing entire battalions to pieces.

Kuribayashi's strategy was brilliant, and it would have ended in wholesale annihilation had the Marines done what he expected them to do, which was to dig into the sand and fire back. But the Marines had learned the hard way, on islands from Guadalcanal to Peleliu, that the only way you survive is to get the hell off the beach and keep moving.

And one Marine, in particular, was making sure that happened. He stood in the open, barking orders at the stalled troops—swinging his arms, swearing, and directing the traffic.

A mortar squad leader named Sgt. Adolph Brusa did a double take and said to himself, "That's John Basilone! What the hell is he doing, standing up when everybody else is hugging the ground?"[8]

A little over six months before, Manila John had been standing next to his new bride, both of them flashing huge, raffish, radiant smiles, as well-wishers pelted them with rice. The Medal of Honor recipient who'd fought off the attentions of Hollywood starlets had fallen hard for a pretty Marine named Lena Riggi while they were stationed at Camp Pendleton. He'd gotten the girl, but she understood that was never going to stand in the way of him being with his boys.

And now it was bullets, not rice, raining down on him. But Basilone tuned out Kuribayashi's cacophony, zeroing in on another kind of sound: the grinding wheeze of water-cooled V-8s, struggling to gain traction on the beach. It was music to his ears.

M4 Sherman tanks. Three of them. He could knock out a lot of bunkers with babies like these.

"Come on," Basilone told his men. "Let's go in and set up them guns for fighting!"

He guided the tanks through a minefield, pointing out targets along the way. One Japanese bunker, in particular, had been shooting off mortars and raging hell on the beach. Without a doubt, this enemy stronghold had to go, pronto.

Basilone assembled a group of machine gunners and a demolition team. He instructed his men to give cover while the demo man climbed up the side of the bunker with enough C2 explosives lashed to his back to blow a hole in the concrete. When the Marine was clear, Basilone gave the order to detonate. The explosion was tremendous.

"Hold fire!" the sergeant shouted, motioning the flamethrower operator forward.

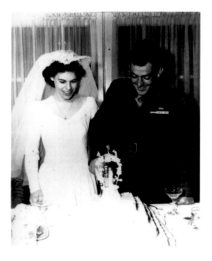

Mr. and Mrs. John Basilone, July 7, 1942. *Official Marine Corps photograph*

Twilight on Sulfur Island, by Col. Charles Waterhouse. The abstract blocks of light and textured darkness convey the nightmarish scenes surrounding the young marines. *Art Collection, National Museum of the Marine Corps*

The flamethrower charged, sticking the nozzle of his weapon as far as possible into the pit before igniting the flame. As the Japanese ran from the bunker screaming, Basilone and his men cut them down with their machine guns.[9]

A young Marine named Charles Tatum—who earned a Bronze Star for his actions on Iwo Jima and would later author the book *Red Blood, Black Sand*, about training under, and fighting alongside, John Basilone—recalled, "For me and others who saw Basilone's leadership and courage during our assault, his example was overwhelming."[10]

After knocking out the bunker, Basilone set off to round up more troops for the assault team he'd started to build near the edge of Motoyama Airfield #1, leaving the tanks on high ground. In order to do this, he had to recross the steep volcanic beach where he'd picked up the Shermans.

It was almost noon. He'd been on the island for almost three hours.

Headquarters cook Roy Eisner and some of his buddies were hunting for their headquarters a few hundred yards from Motoyama Field No. 1. Around noon, they heard a huge explosion. They looked to the right just as Basilone, and the three men with him, fell to the ground.[11]

A few minutes after, Sgt. Bill Lansford, attached to C Company, 1st Battalion, 27th Marines, was advancing through the field, sweeping it clean. They came upon a group of blackened bodies. One of the dead caught Lansford's eye.

The Marine was arched over his combat pack, face up, mouth open, helmet half off. The shell must've landed at his feet, because his groin area, neck, and left arm—with its distinctive tattoo of DEATH BEFORE DISHONOR—were riddled with shrapnel. His right hand was curled near his stomach as though it hurt. With his jacket torn open, he looked incredibly small and thin, like an undernourished kid.

"This was the hero of Guadalcanal," Lansford later wrote. "The joy of a nation, the pride of the Marines, and my friend, Manila John."[12]

He was twenty-nine years old.

They had closed the Green Beaches the afternoon of D-day so that destroyers could come into shore and pump shells at the caves. That first day the men in Waterhouse's platoon worked their way 250 yards up the beach. The second day, with the beaches still closed, they struggled to add another 50. On the third day they went inland another 250 yards and turned left, just like in their drills. But this wasn't a drill. They were within spitting distance of Suribachi, and the young PFC was sitting in one of the two most-forward-facing holes, on the frontline of the beaten zone, with bullets flying fast and thick over his head, and the heat from machine gun fire just inches away.

The platoon sergeant, a tough Marine named Kappel, who'd been tempered by fire on Guadalcanal and Cape Gloucester, ran over to his hole.

"Waterhouse," he said, "We're moving inland. You follow Lt. Hammond. Don't let anything happen to him."

Grabbing his gear, Waterhouse scrambled out of the foxhole in time to see Kappel, climbing up a small slope, heading inland, with Lt. Hammond fast behind. He took off after them, into a nightmare realm where the air sleeted lead, and the earth belched sulfurous steam, and the mountain in front of them seethed with flickering hellfire.

He heard a shout: "Kappel's been hit! Kappel's hit!"

Halfway up the incline, Waterhouse saw the sergeant, slumped in a hummock of ashes, his legs spurting blood. The lieutenant was kneeling over him, trying to bandage the wound, as the bullets whizzed around them. "Mr. Hammond, get down!" Kappel yelled, grabbing the lieutenant by his collar and pulling him flat to the ground.

Hammond called over his shoulder to Waterhouse. "Get the rest of the men up here fast. Skirmish line—leave your packs—just bring your weapons and entrenching tools."

Waterhouse ran down the slope and ditched his pack. "Come on," he shouted, waving his carbine and entrenching tool toward the men on the foxholes behind him. "Kappel got hit, and the lieutenant wants us up there—"

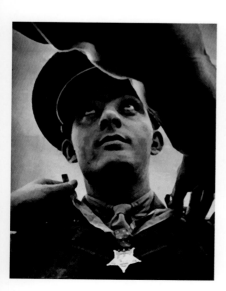

John Basilone with the medal. He is the only non-officer in US history to be awarded both the Medal of Honor and the Navy Cross, and the only Medal of Honor recipient to go back into combat and be killed in action. *Courtesy of the Sgt. John Basilone Foundation*

An early self-portrait of PFC Charles Waterhouse on Iwo Jima. *From the private collection of Jane Waterhouse and Amy Lotano*

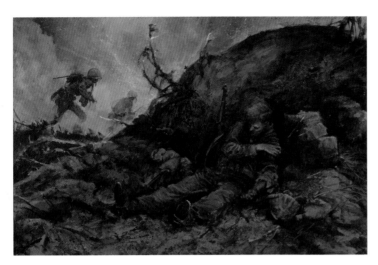

Portrait of the Artist as a Young Man by Charles Waterhouse. The last man out had grabbed Waterhouse's carbine, leaving the seriously wounded Marine with only a useless rifle jammed with ash. *From the private collection of Jane Waterhouse and Amy Lotano*

He felt something hit him in the shoulder, a wallop as hard as a baseball bat that forced him down, back into the hole. Voices started yelling, "Waterhouse has been hit!"

He'd landed in more or less a sitting position. Leaning against the side of his hole, he tried to assess the damage. There wasn't much blood, but when he looked down, he was surprised to see that his left hand was flopping around on his leg like a dying fish, twisting and twitching. The initial burst of pain had been excruciating, but now he couldn't feel a thing.

They always said if you can't feel anything, it's bad.

A corpsman in a hole a few feet away offered to come over, but the Japanese were still letting them have it, so at first Waterhouse told him no. Now he decided he probably could use a second opinion. The corpsman ran over, applied a bandage to his shoulder, put a tag on him, and gave him a parting shot of morphine.

The rest of the platoon was moving out, headed up the slope, toward the lieutenant and Kappel. As the last man passed, he called down to Waterhouse, "Hey, Charlie, gimme your carbine." He swapped out his M1 rifle for the wounded Marine's carbine, then disappeared into the smoke.

PFC Waterhouse was alone but not unobserved. Every once in a while, a bullet would hit his hole. The enemy knew where he was, and they wanted him to know that they knew. Under the circumstances, he figured it would be smart to put a round in the chamber of the rifle.

Using his one good hand—his right—he managed to raise the rifle enough to try to open the bolt. It was jammed to the hilt with ashes. On this blasted island, ashes were everywhere: in your mouth, in your hair, in your ears, in your boots. A Marine needed to continually clean his weapon, because a buildup of ashes there could be fatal.

Wouldn't you know—the bastard who'd taken his carbine wasn't just a son of a bitch, he was a slob, to boot!

Waterhouse kicked the rifle and tried the bolt again. It still wouldn't budge. He'd been the only one in his platoon to qualify as an expert marksman. The government gave him an extra five bucks in his pay for this skill—and goddamn it, he wanted to earn it. He wanted to fire off a goddamn clip at goddamn Suribachi: *To whom*

it may concern: Best wishes, from PFC Charlie Waterhouse. But the gun was as useless as his arm. The only option was to get out of the open and find some cover.

He waited for a lull in the action and left the hole, crouching low, dragging the rifle behind him, dodging both enemy and friendly fire, as he slowly worked his way down the steep terraces that cascaded into the dark void of the beach.

The beach was a mess. Waterhouse staggered past overturned trucks and destroyed equipment that lit up like a macabre amusement park with each exploding mortar. About thirty yards from the shore was a makeshift aid station manned by a couple of doctors, but there was no room for any more wounded, and they told him to find a spot somewhere close to crap out.

He hunkered down in a pile of debris and ashes, wiggling on his rump like a crab to scoop out a shallow depression in the black sand. It would do, but the chances that he'd be able to survive a mortar attack, or a barrage of artillery, were slim to none. A cloud bank had rolled in, dark and ominous, as though to cast the final die. Waterhouse felt the first cold spit of rain. Taunting words echoed through his head, his "smart uncle" telling his parents that their boy was too soft to ever be a Marine. He turned his grimy face up to the sky.

Three days into the battle, the ships were crammed with the wounded, literally bulging at the seams. The Higgins boat that picked up this latest batch of casualties had chugged and bobbed across the entire range of beachhead, from Green to Blue, getting nothing but rejection slips.

They'd stacked the litters wall to wall. PFC Waterhouse squatted up against the bulkhead in a sloshing pool of bilge water tinged red with blood. It took awhile, but eventually the 4th Marine Division command ship gave the okay to bring them onboard. Because Waterhouse was ambulatory, and the information on his tag said he had on a battle dressing and had been given a shot of morphine, there was no rush for him to be checked out by a doctor. The good news was his left hand was no longer jitterbugging around; on the flip side, he seemed to be paralyzed from the shoulder to his fingertips.

The physician who finally examined him told his assistant to make up a cast. "Sir, my arm's not broken," Waterhouse protested. The doctor just repeated, "Make up the cast," and began puncturing him with needles.

What the doctor knew that the young PFC didn't was that the bullet in his shoulder had severed the nerves. They put him in a cast that kept his hand up, frozen in half-assed gesture of hello, with his fingers curled over the plaster.

By the next afternoon, Waterhouse could feel his little finger, even move it a bit. One of the replacements in his company had been shot in the shoulder on Guam. He'd described how the feeling had come back, finger by finger, until he was totally recovered. Surely, Charlie thought, the same thing would happen to him.

That night, some of the officers came down into the hole. They said that things were going very bad onshore. They'd lost a lot of people, and they needed more Marines on the beach, so if anybody felt well enough to go back . . .

Moans and groans, all around. But for all of the moaning and groaning, some of the sacks began to empty.

Elated by the sensation in his one little finger, PFC Charlie Waterhouse followed the straggling line of volunteers, topside. He was going back. They'd be landing on the 4th Division beaches, but

with any luck he could make his way to the Green Beach, where his platoon was still filling in the holes around Suribachi. Imagine how surprised they'd be to see him—and the first thing he was going to do was to get his carbine back.

Half a dozen men were already up on deck, waiting for the boats to arrive. Charlie Waterhouse started to fall in behind them, then he looked down and it hit him: they weren't going to raise a wooden pallet, the way the ship crew had when he was taken aboard. He'd have to climb down on the nets. He wouldn't be able to do it in a cast. He wasn't going back.

And there, for the first time, he started to cry.

On February 23, PFC Waterhouse was once again up on deck, looking longingly at the stretch of Blue Beach, the 4th Marine Division landing zone. The ship was anchored so close to shore, he could see puffs of smoke and flashes of intermittent fire on the northern cliffs where the demolition teams were combing through the rocky terraces, blowing up caves. The dull roar of their explosives carried across the water.

Moving clumsily, his arm still locked in its unwieldy cast, Waterhouse slowly made his way forward, toward the bow. Off in the distance, Mt. Suribachi stood strangely silent, but still ominous. He caught a flutter of movement—a small speck of color silhouetted against the leaden sky. The flag.[13]

At the base of Suribachi, members of his unit were mopping up and destroying emplacements. He stood there for a long while, memorizing the scene in his head—the yellow-ocher sky, the ashen mountain, the gray tide rolling in on the black sand.

Someday he would draw it. His left hand might be numb, but lucky for him, the right one—his drawing hand—still worked. On March 1, as his buddies in the 28th Regiment were assaulting Hill 362, Waterhouse and a group of other seriously injured Marines were transferred to another ship for evacuation to Guam.

On March 7—her thirty-second birthday—Lena Riggi Basilone received a telegram from Gen. Alexander A. Vandegrift, commandant of the Marine Corps. Vandegrift, who'd been Basilone's commanding general at Guadalcanal, informed her that her husband, John, had been killed in action. The couple was married for just a little over five months, but when Lena died in 1999, at the age of eighty-nine, she was still wearing the wedding ring he put on her finger. She never remarried.[14]

Manila John was a tough act to follow.

What Were the Chances?

At the height of the epic struggle for Iwo Jima, a Marine was killed or wounded in action every twenty seconds. In total, 22,000 Americans were injured.[15] The tally for Killed in Action on the Records of War website currently stands at 6,035, and it's still considered a growing list.[16] To finger scroll through the names, without stopping, it takes close to four minutes.

The fighting remained brutal to the last. Of the nearly 22,000 Japanese soldiers on the island, only 216 were taken prisoner.[17] The men who survived did not get any medals. No matter how valiantly, and how fiercely, they fought, those who retired to their homeland were reviled and shunned, because they had not chosen death before dishonor.

PFC Charles Waterhouse was one of the lucky ones—luckier than he ever imagined that day on the top deck, when he broke down and cried at the realization that he wouldn't be going back to his buddies. As it turned out, not only had the gunshot he suffered

severed the radial medial nerves in his shoulder, it had also nicked the artery. At the time of his evacuation, it was badly hemorrhaging and ready to blow.

During the three days Waterhouse spent on the island, eight Marines would be awarded the Medal of Honor, four of them posthumously.

The stories of two who lived were inextricably linked by chance.

THE CAPTAIN AND THE STOWAWAY[18]

The young Marine stood ramrod straight, chin up, eyes level, but the two officers had been around long enough not to be fooled: under his salty swagger, they knew the kid was sweating. Capt. Robert "Bobby" Dunlap had already made up his mind, and he thought Lt. Col. Daniel Pollock, in whose quarters they were gathered, would concur. Still, he figured it couldn't hurt to put the fear of God—and the brig—into this brazen private first class for a bit longer. He certainly had no fear of the Japanese.

Lt. Col. Pollock turned a steely gaze onto the culprit. The young Marine mastered an urge to blink. Pollock's face softened. "Well, young fella," he said with a sigh, "you're causing me a lot of administrative trouble, but I sure wish I had a whole boatload of men that wanted to fight as bad as you do."

Reining in a smile, the Marine nodded.

Capt. Robert H. Dunlap, USMC. *Official Marine Corps photograph*

PFC Jacklyn "Jack" Lucas, USMC. *Official Marine Corps photograph*

Capt. Dunlap said, "Where do I assign him, sir?"

"My cousin is in the 1/26th," the Marine offered, eagerly. "I'd like to be assigned to his outfit." It wasn't the wisest thing for the young man to speak out of turn like this, but then PFC Jack Lucas was neither wise nor fully a man. AWOL from his assignment as a trash truck driver with a rear-area supply unit back in Hawaii, he'd stowed away illegally aboard the USS *Deuel*—sleeping in a stack of Higgins boats, scrounging scraps of mess hall chow, waiting out twenty-nine of the thirty days it would take to be officially listed a deserter before turning himself in.

In the silence that followed, Capt. Dunlap held his breath, hoping the kid hadn't pushed too far. He could use another rifleman in his company. "Put him in there," Pollock said gruffly, waving them away.

"Thank you, sir." Lucas snapped a smart salute.

Before the scrappy stowaway could say anything else, Dunlap ushered him out of the lieutenant colonel's quarters and up onto the deck. They walked together to the bow of the ship. Lucas later recalled that a Marine photographer, who'd been wandering about taking shots on a transport ship, asked them to pose for a picture.[19] Jack flashed a big smile for the camera.

And why not? Things had worked out exactly the way he wanted them to. Lt. Col. Pollock would fix it so he wasn't classified as a deserter. He wouldn't be stuck hauling trash while everyone else went off to war. He was going to fight the Japanese and make them pay for what they did at Pearl Harbor.

Although the snapshot has been lost in time, it would have captured the striking physical differences between the photographer's subjects. At 5 foot 6 and all of 148 pounds, twenty-four-year-old Bobby Dunlap—"the biggest little man on campus" according to his college yearbook—was as lean as a greyhound and just as fast.[20] Although Jack Lucas stood only a couple of inches taller, with his 18-inch biceps and well-muscled 185-pound frame, he was the epitome of a well-oiled fighting machine—and the devil-may-care glint in his eyes seemed to suggest to any taker that they didn't know the half of it.

Which was true. Because unbeknown to Capt. Dunlap, Lt. Col. Pollock, and pretty much the entire US Marine Corps, PFC Jacklyn "Jack" Lucas was only sixteen years old.

For all their outward differences, like the ebb and the flow of the Pacific Ocean that surrounded them, an undertow of destiny had drawn these two men together. Both were sons of farmers. Bobby Dunlap's father, a World War I veteran who'd set track records back in his high school days, ran a dairy farm on the same land that his forebears had once homesteaded. Louis Lucas—who Jack always said was the only person he'd ever listened to—was a tobacco farmer before his premature death from cancer when his son was only ten.

Both Marines were competitive. In high school, Bobby played football and basketball and ran track, and he went on to earn four varsity letters in three sports in college. Despite his size, Dunlap was so fast on the gridiron that the Philadelphia Eagles invited him to try out for their team. He enlisted in the Marines instead.

Packed off to military school at age twelve, Jack Lucas rose to become a star athlete, cadet captain, and captain of the football team. But where Bobby Dunlap excelled in the classroom, acting in theater productions and serving as treasurer of the student body, Jack made a practice of bucking the rules at every turn; where fellow classmates remembered Dunlap as "the little man with the big heart," Lucas was a self-described "mean kid" and perennial troublemaker.[21]

In 1942, just as Bobby Dunlap was graduating from college and preparing to join the Reserves, thirteen-year-old Jack Lucas swaggered into a US Marine recruiting center and tried to enlist. The recruiter laughed and sent him packing. The following year, as a grizzled and pumped-up fourteen-year-old, Lucas tried again, claiming he was seventeen and had the permission papers from his mother to prove it. He later said she signed the papers to get him out of town. This time it worked.

While Dunlap was breezing through parachute training, shattering obstacle course records all over the Marine Corps, earning his wings and commissions, Jack Lucas was on an up-and-down course of his own. He excelled in boot camp, quickly qualifying as a heavy machine gun crewman and sharpshooter. When his commanding officer finally discovered that the newly promoted PFC Lucas was underage—although not *quite* as underage as he actually was—he was assigned to duty as a garbage truck driver for the 6th Base Depot in Hawaii, about as far away from the action as a Marine could get. Not one to buckle under authority, Lucas managed to stay constantly in trouble, brawling and boozing and spending time in the brig for being in possession of a stolen truck stocked with beer.

Meanwhile, then 1Lt. Bobby Dunlap was seeing plenty of action with the Paramarines during the assault on Valla Lavella and Bougainville. Dunlap said later that his greatest fear at that time wasn't being killed, but whether he would be capable of killing. "I wasn't sure I could shoot anyone," he admitted.[22] But when the moment came, and it was kill or be killed, the young lieutenant chose to survive, earning commendations and a promotion to captain. Following the breakup of the Paramarines, now Capt. Bobby Dunlap joined the 5th Marine Division, assuming command of Company C, 1st Battalion, 26th Marines.

Of the two Marines standing on the bow of the USS *Deuel* that January day, only the officer had proven his worthiness to earn a place on this ship. But they both possessed the will to fight for their country, and there could be no doubt that they were both heading toward the same destination. Capt. Dunlap knew what that destination was. PFC Lucas, along with the other Marines onboard, would find out soon enough—although when they first heard the name, it wouldn't mean much to most of them: Iwo Jima.

The US desperately needed the island as a landing base for B-29 bombers and fighter escorts on the way to Japan. Expectations were that they'd be able to take the island in three days—after all, for months they'd been raining down bombs on it from the air and blasting its shore with big guns from the sea, softening up the resistance, wearing the enemy down.[23] Little did they know.

Neither did they know that the stowaway, the captain, and the lieutenant colonel would each play a pivotal role in the coming battle. One would lose half the men in his battalion yet manage to gain control of the last high hill during the campaign; two would be recognized with the Medal of Honor for their actions.

D-day
February 19, 1945

The initial resistance came from the island itself. As soon as the heavy equipment rolled onto shore it sank, hopelessly mired, into sucking gravel pits of volcanic sand. The Japanese waited until the stalled equipment and waves of Marines hit critical mass, then they sent up signal flares; suddenly every rock, cave, cliff, and underground bunker on the island sprang to life as forges of high ordnance fire.

As part of the third wave, Dunlap's Company C, 1st Battalion, 26th Marines, was set to go at 1100. Jack Lucas and his cousin had been assigned to the same Higgins boat. They didn't speak and wouldn't see each other again during the battle, although Lucas would later find out that they'd fought within spitting distance of each other. Hours went by. Word came that the beaches were closed so bulldozers could mop up the wreckage. It wasn't until 1500 that the Higgins boats carrying Dunlap's men dropped their ramps off the shores of the island.

PFC Lucas lumbered forward, stepping into water up to his neck. He flapped around helplessly, like all the other well-oiled fighting machines stranded on the Red Beach, trying to get traction. At their last stop in Saipan, a Marine with appendicitis had been let off the ship, and Lucas had been given his rifle and gear. Judging by the length of the trousers, the guy must have been a giant because

he'd had to roll them up. Now that they were wet, they twisted around his feet like Tootsie Roll wrappers. Jack drew out his bowie knife and cut off the legs of his uniform below the knees.

It was only after making this sartorial alteration that Lucas fully absorbed the scene around him. Dead Marines bobbing like overturned buoys in the surf. Other Marines, alive one moment and shattered into tiny bits the next, disintegrated by the force of exploding mortars. This was real—all too real for a boy who only five days before had celebrated his seventeenth birthday. But hell if he was going to get shot the minute he landed! Jack Lucas wanted to wreak some havoc on the enemy first.

Capt. Bobby Dunlap was already onshore, navigating through the chaos and carnage. He later recalled, "I thought, 'If I'm going to get men killed, I'm not going to do it here on the beach; I want them accomplishing something,'" so he rallied his company and led them forward.[24] Inspired by Dunlap's leadership, other units started to get up from the sand and follow.

The captain pushed his men 200 feet inland, fighting for every inch as they cut across the narrow isthmus of the island. Lucas's group had just made it up a steep grade when word filtered back that one of the heavy-weapons crewmen had been killed. A sergeant ordered Lucas and another Marine back to the beach to bring up a water-cooled machine gun, so they dodged bullets all the way down to Red 1 and hauled the heavy sucker up, coughing through the sulfuric fumes and smoke, dodging whizzing bullets, and cursing the black ash that pulled them two steps back for every step they took forward.

By the end of that first day, the 1st Battalion had lost all of its officers with the exception of Capt. Bobby Dunlap and two lieutenants. At twilight the Marines were told to hunker down and prepare for the night ahead. Lucas, his Browning Automatic Rifleman (BAR man), and the other two riflemen in his fire team found a crater. The men started scooping out the black sand, working feverishly to bank the sides before they collapsed in an ashen heap. It was expected that the Japanese would launch a banzai charge at dawn, so the Marines took turns keeping watch in one-hour shifts, shivering as the night temperature dropped to 40 degrees under a sky ablaze with exploding Japanese spigot mortar rounds that whistled over their heads and rocked the volcanic core of the island with thunder.

D-day + 1
February 20, 1945

The banzai attack never came. Gen. Tadamichi Kuribayashi had adopted a new strategy; each Japanese soldier was pledged to kill ten Marines before he died.[25] And on this, the second day of the battle for Iwo Jima, every Japanese soldier on the island was out to make good on that promise.

At first light, Capt. Dunlap started moving his division from the beach area to Motoyama Airfield No. 1 on the Motoyama Plateau, toward the southern end of the island. Resistance grew fiercer the closer they got to the airfield, with every mound and formation of rocks spewing fire on the advancing Marines. Many of the enemy fortifications were made of reinforced concrete, about 15 feet square and covered with sand, with narrow embrasures just large enough for a man with a deadly weapon to see out.

Dunlap brought his machine guns forward and told them to focus their sights on these small openings. Working in tandem with flame-throwing tanks, the Marine gunners were able to pick off one

fortification after another. Dunlap later estimated that in the first hour and a half, Company C had killed over 300 of the enemy. With these pockets of resistance neutralized, the captain pushed his men forward until they were in advance of adjacent USMC units and slightly past the actual airfield.

About 400 yards ahead was an open area of hills studded with Japanese pillboxes, caves, and bunkers. Dunlap knew he'd have to punch his way through this fortified defense belt in order to stop the enemy artillery and machine guns from slaughtering the approaching Marines, but he needed someone to get close enough to identify their exact positions. Just then, a Japanese soldier—unaware that Marines were in the area, watching—stood up and began sauntering inland, dragging his rifle behind.

"Don't shoot!" Dunlap hissed. He had a plan—so bold, so dangerous that he would never ask one of his men to carry it out. Getting to his feet, the young captain began to walk forward slowly, head down, dragging his Johnson rifle, doing his best to achieve a semblance of nonchalance while his heart hammered in his chest and a single thought ran on a loop in his head: *please, let them think I'm just one of their comrades.* Dunlap continued to put one foot in front of another until he'd advanced 200 yards toward the enemy—close enough to hear some chattering in one pillbox, and almost too close to an artillery battery jammed with about thirty Japanese and enough ordnance to blow his entire company to kingdom come—before he was spotted.[26]

It took Bobby Dunlap—the man who had crushed USMC obstacle course records during his Paramarine training—an hour and a half of zigzagging and outrunning bullets and grenades to get back to his lines. Immediately he picked up the radio and called in fire on the enemy position, only to be told *no can do*—the situation wasn't going to improve any time soon. The captain was ordered to pull his men back 500 yards. Dunlap put down the radio and gave the order.

Company C, 1st Battalion, 26th Marines, fell back 500 yards. All of them except Bobby Dunlap.

Jack Lucas's fire team dropped back as ordered. Dunlap was off to their right, but his attempts to direct fire on the enemy had been thus far ineffective, and the Marines had been told to cease-fire until the captain redirected the offensive. They found a couple of 20-foot-long trenches, running parallel about 4 feet away from each other, and decided it might be as good a place as any to hunker down. One of the other riflemen, a PFC from Wisconsin named Malvin Hagevik, led them into the rear trench, where they lined up with Hagevik at one end; Lucas and the BAR man, PFC Allan Crowson of Arkansas, in the middle; and the team leader, Cpl. Riley Gilbert, from Texas, on their right.[27]

From their position they could see a US tank preparing to shoot flames into an enemy pillbox. As much as Lucas hated the Japanese, he had to admit that death by flaming napalm was an awful way to go. Little did he and his fellow Marines realize that, having anticipated the attack, the enemy soldiers had fled from their pillbox through an underground tunnel that opened up in the trench ahead of them. When Gilbert jumped into it to reconnoiter, he landed on one of the fleeing soldiers, scrambling out as his team opened fire.

The trenches were in such proximity, the Marines had to shoot from the hip, not the shoulder. During the fierce fight, Jack managed to kill two of the enemy, but then his rifle jammed. As he was struggling

to unjam it, cursing the ash that had gotten in the barrel, Lucas glanced down and noticed what his comrades had not. Two Japanese grenades had landed in their trench. With only four seconds of fuse, there was no way to know for sure how long they'd been there.

Lucas shouted, "Grenade!" Pushing his BAR man out of the way, he dropped to his knees and used his rifle butt to ram the first grenade into the ash before diving on top of it. With his other hand he grabbed the second grenade and pulled it underneath his body, trying to burrow it into the sand as far as he could.

The explosion was terrific. The force of it shot Lucas from a prostrate position into the air and spun his body around like a propeller until gravity took over and landed him on his back in the trench. Over the ringing of his ears, he could just make out the *rat-tat-tat* of his rifle team as they finished off the enemy.

The pain, when it came, was excruciating. His body had been riddled, from head to thigh, with shrapnel: doctors would later count over 250 entrance wounds. One of his arms was twisted—severed?—under him. His eyeball had been blown out. Slivers of wood from his rifle stock had burrowed into his torso. One lung had been punctured and he was choking on his own blood, but, miraculously, the six grenades Lucas kept strung across his chest had deflected the chunks of metal from his heart. Still, the young Marine was such a mangled heap that his companions left him for dead and moved on.

Lucas forced himself to stay conscious enough to keep his airways clear, but he knew he was slowly suffocating. Entombed in the ashen trench, he prayed, "God, please save me." Out of the corner of his one good eye, he saw movement. A Marine was passing by. Too weak to speak, Lucas wiggled his fingers.

"Corpsman!" shouted the Marine.

A corpsman made his way to the trench, hefting a carbine and 50 pounds of medical equipment. Within seconds he started administering morphine, treating Lucas's wounds and popping his eyeball back into its socket. When an enemy soldier stood up to lob a grenade, the corpsman shot him, saving the life of the seventeen-year-old Marine, twice. Lucas later learned that the corpsman was killed on Iwo.

Eventually a group of litter-bearers carried Lucas back to the beach, depositing his borrowed gear and shattered rifle onto the sand next to him, along with something else: an intact Japanese grenade that he'd been gripping in his hand.

It hadn't gone off.

But if Jack Lucas was counting miracles, he couldn't stop there. If his rifle hadn't jammed, causing him to look down, all of the members of his team would be dead. And if he hadn't been able to jam the live grenade into the sand, it surely would have killed him. The ash that he'd been cursing since he stepped onto shore had turned out to be a blessing that day.

D-day + 1, D-day + 2
February 20–21, 1945

While Jack Lucas was lying in an abandoned Japanese trench, praying for God to save him, Capt. Bobby Dunlap was huddled in a shell hole about 200 yards forward of the front lines, manning a one-man observation post from which he was using a voice-activated radio to rain artillery fire down on the Japanese.

There was no dearth of targets—the enemy had dug into every cliff, cave, and cranny on this northern part of the island. Once Dunlap's skillful direction of fire started getting results, runners

arrived with more telephones. Eventually, a small crew of radiomen were sent to work alongside the captain. Now he was really in business.

Time after time the enemy knocked out his phone lines, but the captain and his small team remained at their post. Throughout the long day and night of D-day + 1 and into D-day + 2, Dunlap never stopped—chain-smoking cigarettes, gobbling squares of chocolate D-bar to keep up his energy, risking his life by standing on the shelf of the crater in order to effectively direct fire on cave after cave. By that point, Dunlap was orchestrating two battalions of artillery, naval gunfire from the USS *New York*, and sixteen bomber planes.[28] After over thirty-six hours of constant pounding on the enemy defenses, return fire began to diminish. It was only then that Capt. Dunlap agreed to leave his shell hole and fall back with the reserve.

Despite his grievous wounds, PFC Lucas lingered off the shores of Iwo Jima until a destroyer could be found to escort his hospital ship—one among a convoy carrying thousands of grievously wounded men, including my father—to Guam. Over the next few months Lucas would undergo twenty-one surgeries. Over 200 pieces of metal were too close to vital organs to remove and would stay in his body for the rest of the life.

The three Marines whose lives Lucas had saved continued to fight in Dunlap's company, although all three would eventually join the ranks of the Iwo Jima wounded. Allan Crowson—the BAR man Jack pushed away from the grenade—spent eighteen months in the hospital, recovering from his injuries.

On the evening of February 26, after a few days of respite, Capt. Dunlap's Company C Marines were ordered forward. Once again, the captain moved out beyond the lines, on a mission to ferret out the enemy positions. Spotting a group of Japanese soldiers manning machine guns, Dunlap paused to shoot them before taking off over the hill. As fast as Bobby Dunlap was, the bullet from an enemy rifleman was faster: it caught him in the left hip and knocked him down.

Seeing their captain lying helplessly out in the open, a team of litter-bearers volunteered to brave the intense fire in order to save him. "The proudest moment I ever had was when they carried me off Iwo Jima on a stretcher," Dunlap later said. "Over 100 men got out of their foxholes and saluted me by presenting arms while shells were falling all around. I bawled like a baby."[29]

On October 5, 1945, in a ceremony at the White House, President Harry Truman placed the Medal of Honor around the neck of seventeen-year-old PFC Jack Lucas. He was the youngest recipient in any service or conflict to be recognized with the nation's highest honor since the Civil War.

It would take Capt. Dunlap another two and a half months to receive his medal from the president. The Japanese bullet that had felled him left the hero in a body cast, paralyzed from the waist down. He eventually regained the use of his legs, but his days of racing against the wind like a greyhound were over.

The captain and the stowaway would continue to live divergent lives. Dunlap married his college sweetheart and retired from the Corps as a major in 1946. For a few years he went back to the family farm, but the injuries he'd suffered were too severe for such physical work. He turned down an offer of $20,000—a great deal of money in those days—from Paramount Pictures, which wanted to make a movie about his story. Dunlap told them they could never capture the awful brutality of Iwo Jima, and he wanted no part of a glamorized Hollywood rendition.[30]

Instead of fame and fortune, Bobby Dunlap opted for a job as a high school math teacher. He coached the school's football, basketball, and track teams, as well as Little League and a swim team at the YMCA, and still found time to serve as a deacon in his church and a member of the rotary club. Mr. Dunlap became an inspiration to the hundreds of students he taught and coached over his nineteen-year career. Most of them never knew he had fought in the war. He never spoke of it.

True to form, Jack Lucas continued to take an up-and-down path, with the downs becoming ever more frequent and dramatic. Lucas couldn't seem to settle down in a civilian job. In 1961 he joined the US Army as a paratrooper to conquer his fear of heights, but he drank too much and brawled with officers, so the Army packed him off with an honorable discharge just to be rid of him. On the home front, Lucas blew through two marriages—his second wife embezzled money from the meat company he'd started, and actually tried to have him killed—ultimately getting into hot water with the IRS. Forced to move into a mobile home with no utilities, Lucas nearly lost his Medal of Honor when the place burned down, but he was able to retrieve it from the ashes, with only the ribbon singed.

For Dunlap the medal was a reminder of his Marines. "I'm proud of it," he said. "But I am prouder yet of the men who were with me," adding, "I can still see their faces."[31] Although Lucas freely admitted that being recognized with the nation's highest honor didn't cause him to "grow wings and become an angel," the medal became for him a kind of anchor in his stormy life. "I have never brought shame to the Medal of Honor and pray I never do," he wrote. "I must not, for it represents too much."[32]

On February 19, 1995—the fiftieth anniversary of the battle for Iwo Jima—Lucas and his extended, if somewhat checkered, family attended a commemorative ceremony at the Iwo Jima Memorial on the edge of Arlington National Cemetery, across the Potomac from Washington, DC. It was a grand affair, but the highlight for Jack Lucas was having the honor of walking down the carpeted runway alongside Captain—because, although he was a now major, for Jack he would always be "the captain"—Robert Dunlap, in the towering shadow of the 80-foot bronze statue of the Marines raising the flag on Iwo Jima.

The event seemed to mark a turning point in Jack's life. A few years later he met the kind, patient woman who would become his third wife; with her, he achieved the kind of peace that had always eluded him. The stowaway and the captain never met again. Dunlap suffered two strokes and was in poor health. On the Marine Corps birthday in November 1999, he was too ill to attend the ball, so a contingent of Marines brought the ball to him, conducting a color guard ceremony in the Dunlap home and sharing birthday cake with the ailing hero and his wife. Bobby Dunlap passed away a year later at the age of seventy-nine.

In the time remaining to him, Jack Lucas and his wife traveled around the country, attending events where he was often the guest speaker. The stowaway who had thrown himself on two grenades to save his fellow Marines died of leukemia in 2008, surrounded by his wife and family. At the age of eighty, Jack Lucas had finally come of age.

BASIC TRAINING

Instead of rejoining his regiment on Iwo, PFC Waterhouse was transferred to another ship and taken to Guam, where hospital attendants promptly cut off his cast and put him into a more elaborate contraption. This new cast wrapped around his chest and ribs, encasing his left arm in a sleeve of plaster from shoulder to wrist and buttressing it with a metal rod that kept it raised up in the air, with the elbow bent. "My hand was out," he later recounted, "with the fingers extended into little leather cups that attached with rubber bands to a big metal ring. It looked like I was playing a banjo."

Soon after arriving on the island, he was ordered to report back to the aid station on the airfield with his gear. They told him he'd be flying to Hawaii for further treatment. "You realize if the Japanese manage to shoot down the aircraft over the Pacific," the corpsman said candidly, " you'll drown in that big cast you're wearing." As a preventive measure, he said they'd decided it would be better to remove the rod and support around his chest.

The pain of lowering his arm brought Waterhouse to his knees. After helping him to his feet, the doc handed over a pair of snips. "If you go down," he advised, "use these to cut off your cast and help the others remove theirs." Then he held up some wire cutters. "Take these too. One of the men has his jaw wired. If he gets air sick, it could be kind of fatal."

It was long and cold flight, and Waterhouse was grateful to be physically able to periodically escape his cramped sleeping area on the bottom stretcher and walk forward to the cockpit to stretch his legs and—this was wartime, 1945—have a smoke. On one of these breaks, he saw that they were passing over some of the bomb-cratered Japanese strongholds in the Marshalls. He'd left the snips and wire cutters back in his gear and was relieved when the pilot commented that, even if the enemy still had any antiaircraft guns down there, they were flying out of range.

A line of ambulances waited on Hickam Airfield on Oahu, ready to take the wounded to #10 Aiea Heights Naval Hospital. PFC Waterhouse refused to be carried in on a litter and walked into the ward lugging his own gear.

The following day at his physical assessment, Waterhouse emphasized to the examining physician that he didn't want to be sent home because he was going back to Iwo Jima. The doctor raised an eyebrow. "You sure you didn't take a shot to the head?"

He told the patient to sit down, and put a stethoscope to his chest, his wry smile turning to a frown. "How long have you been walking around, private?"

"Ever since it happened," Waterhouse replied.

"Lie down," the doctor ordered. "*Now.*"

Within ten minutes, Waterhouse was on an operating table while a team of naval surgeons worked feverishly to try to patch up the seeping artery in his arm that was about to explode. The emergency surgery saved his life, but the triage surgeons couldn't repair the extensive damage to the nerves in his arm. He was just one among many thousands of wounded Marines in need of long-term, specialized medical care. That couldn't happen here. The hospitals in Pearl Harbor were at full capacity and bracing to receive another influx of new casualties, so Waterhouse was notified that as soon as he had recovered enough to travel, he would be sent stateside for further treatment.

He had plenty of company on the journey back to the mainland, young men like himself—carried on litters, hobbling on crutches, wearing body casts and slings, bandaged, stitched, and scarred, and some barely conscious—boys in their late teens and early twenties who'd been maimed and injured on remote Pacific islands that just a few years before they wouldn't have even been able to spell the names of, who were being shipped from Hawaii to military hospitals all across the nation. Marines with what their buddies back in the thick of fighting called *million-dollar wounds*—the kind that hurt like hell but didn't kill you and were just bad enough to get you sent home.

A lot of these injured men would've gladly given that million bucks back if it meant being able to rejoin their platoons. As Waterhouse boarded the hospital train in Oakland, California, he told himself that this was only a temporary situation. He'd get some R&R and see his folks, the doctors would patch up the nerves in his arm, and he'd be back in business.

He didn't know that every mile that the train traveled east was taking him farther away from his life as a fighting Marine, and closer to his destiny.

Waterhouse would be reporting to St. Albans Naval Hospital in Long Island the following week, but he had a three-day pass in his pocket, so as soon as they pulled into New York, he hopped aboard the next train to Perth Amboy. He hadn't told his parents he was coming home. So much had happened since the last time he'd seen them—he'd been promoted from PFC to corporal and was the recipient of a Purple Heart. Charlie stood on the stoop of his parents' small home at 511 New Brunswick Avenue that day, feeling every inch a man. But when his mother opened the door, she didn't take notice of the chevron on his uniform, or the ribbon on his chest, or even the big cast on his arm; she saw only that—by the grace of God—her beloved son had been returned to her.

It was the day before Mother's Day, and this was the best present Bertha Waterhouse would ever get.

The following night, Charlie was set up on a blind date. A couple of his best buddies had just come back from the Navy. One of them already had a steady girl, so he asked two of his cousins to come along to round out the group. The cousins—the Andersen sisters—turned out to be knockouts. The older one, Jane, was a gorgeous, blue-eyed blonde, but it was her younger sister, Barbara, who quickened Charlie's pulse and made him question whether he was dreaming.

Her pug nose and bright smile brought him back to one afternoon, a lifetime ago. It was 1943. Private Charlie Waterhouse was on a pass from basic training, having spent the previous days on a grueling seventy-two-hour combat exercise. He hadn't slept and was nearly dead on his feet, but he couldn't resist going back to his alma mater, Perth Amboy High School, to show off in his new uniform.

As the proud new Marine sauntered down the halls, peering into classrooms to see if any of the kids looked familiar, his eye was immediately drawn toward a pretty brunette. On an impulse he

waved at her, and she rewarded him with a big smile. And now here she was, that same pretty girl. Could this be real or was it fate?

It was both.

Barbara, too, remembered that earlier meeting. Her teacher had seen her making eyes at the young Marine in the hallway. "Miss Andersen," the woman said sternly. "If you want to flirt, go to the back of the room." Caught in the act and totally flustered, Barbara thought she'd been ordered to the back of the room, so she got up and took a seat in the last row, causing the teacher to say indignantly, "And the next step will be down to the front office, young lady!"

It was a common-enough scenario in 1946—the chance meeting between the handsome serviceman on leave and the pretty high school twirler—but theirs would prove to be an uncommon love story; and while chance continued to play a big part in Charlie Waterhouse's life, he knew that something far more powerful had brought Barbara "Bobbie" Andersen into it. She would be his soulmate, his beloved, and his partner—the person who at every critical juncture and turning point in his career would say, *Yes, you can do it, Charlie. Go ahead; I believe in you.*

Cpl. Charlie Waterhouse with his girl, Bobbie Andersen. Theirs would be a lifelong love match. *Waterhouse family photograph*

All the patients at St. Albans were either recuperating from an operation or waiting to have one. Here Charlie Waterhouse underwent further surgery to repair the severed radial nerve in his arm. For four and a half hours, the surgeons at St. Albans labored to align the intricate signaling cable of nerves in his arm, with the hopes of restoring dexterity to his elbow and wrist and reviving sensation to his thumb and fingers.

The patient was kept awake the whole time so he could tell the surgeons what he was feeling. They would poke and prod, then ask, "Does this hurt? What about now? Does it feel cold? Is it warm and tingly? Can you clench your fist? Can you move your finger?"

Following the operation, Waterhouse had to report to sick bay at least twice a day for treatments. The doctors stuck pins into him to see what hurt, and drew maps on his arm to track his progress.

Gradually, some of the feeling in his arm began to return, although three of his fingers remained paralyzed, with the nails on his left hand petrified like rock to his skin and still embedded with the ashes of Iwo Jima. The doctors predicted that he'd recover the function of his arm from the shoulder down; below the wrist, they said nothing could be expected.

After months of being in a cast, calcium deposits had formed in his joints, welding Waterhouse's elbow into a 90-degree angle. In order to remedy this, daily rehabilitation sessions were instituted, involving two very large corpsmen and physical therapy akin to something out of a medieval torture chamber. This is how Waterhouse described it: "They had me sit with my bent elbow on the edge of a table. One of the corpsmen would hold me down, while the other leaned on my arm with all of his weight, in an attempt to break up the deposits." He added, "And, believe me, I would come right out of the chair!"

From St. Albans, Waterhouse was sent to a naval "recuperating hospital" called Sea Gate, which had been set up in the old Half Moon Hotel on Coney Island. The hotel had an infamous history. In 1941, a heavily guarded FBI informant who had testified against members of the organized crime syndicate Murder, Inc., either fell or was pushed to his death from the window of room 623. The corner room in Ward 3 that Waterhouse shared with three bunkmates was on that same floor, with a nice view of the boardwalk and the Atlantic Ocean.

Sea Gate was a kind of military medical limbo for patients well enough not to require constant care but not considered fit enough to be discharged or returned to active duty. It was a highly regimented existence—up at 0530 to swab the decks and make their racks, fall out for roll call and inspection, orders for the day, and chow.

In between physical therapy and doctor appointments, the men were free to do to anything other than go back to their bunks. Waterhouse spent most of his time in the large room off the library, where a large stash of artist supplies were stocked for use by interested patients, and he could draw and paint to his heart's content.

After noon inspection on Saturday until Monday morning, the men had liberty. For Charlie, this became a different kind of drill, involving a mad dash from the hospital to the trolley car, a high-stakes race from the trolley to the subway station, and the subway to Grand Central, and a quick run over to the crosstown that would take him to Penn Station, so he could hop the Jersey shore train to Perth Amboy, where he would catch the #4 or #6 bus to Raritan Township to make it in time for his date with Bobbie Andersen. They'd take in a late movie, stop for ice cream, then take the #4 back to her parents' house, where they'd sit in the parlor, hold hands, and kiss until it was time for Waterhouse to do the dash in reverse.

During the winter months, the long waits between trolleys and trains in the cold and snow took a toll on his wounded arm, which would stiffen, turning white and then blue, from shoulder to the fingertips, due to lack of circulation. He carried a hand warmer the size of a cigarette case and packed with wadding soaked in lighter fluid that lit with a wick, tucking it next to the dead hand curled up in his pocket. "The arm was blue," Waterhouse said, "but I had my love to keep everything else warm."

Between rehabilitation sessions, Waterhouse passed the time by doing what he loved to do most: drawing Marines. A Red Cross volunteer named June Stechman who taught art classes at the hospital

noticed the young corporal's talent. She gave him a set of paints and encouraged him to copy some of the works of the Old Masters. His first and only attempt—a large canvas of the Virgin Mary holding the baby Jesus, inspired by Murillo's *Madonna and Child*—impressed Stechman so much that she arranged to have it displayed in a Brooklyn department store over the Christmas holidays.

Charlie later gave the painting to his parents, who presented it to St. Peter's Episcopal Church in Perth Amboy in gratitude for their only son's safe return and recovery. The painting still hangs in the church today, and while my father always rolled his eyes when he saw it, and cringed at the primitive lines and clumsy brushwork, it has provided a familiar—and much-loved—backdrop for generations of family weddings, baptisms, and funerals.

Feeling that such a budding talent shouldn't be confined to just the Sea Gate arts-and-crafts room, Mrs. Stechman appealed to the hospital commandant to get permission for Waterhouse to take some art school classes. On the strength of his portfolio of drawings and paintings, Waterhouse was admitted as a special student to the prestigious National Academy of Design.

Twice a week, he traveled from Coney Island into Manhattan to join a group of artists in the crowded basement of the academy, on East 86th Street, where—after vying for a spot to sit, stand, or lean—he would spend several hours, sketching an assorted grouping of cracked and broken plaster cast sculptures. There were no instructors, but the young corporal was driven, working through lunch and even smoke breaks; critiquing his own efforts; trying to figure out what worked, what didn't, and why; and comparing his techniques with those around him.

The spring of 1946 brought big changes. With the war over, and the lessening need for hospital facilities, the Navy made plans to close down Sea Gate and return the hotel to its original owners. The doctors concluded that everything possible had been done for Waterhouse. He would continue to get weekly shock treatments at the Veterans Administration, but although the painful jolts made the fingers of his dead hand twitch and jump, their only lasting effect was a series of ugly red welts, so eventually this course of therapy would be abandoned.

In mid-May, Waterhouse and the other Sea Gate patients were shipped to Bainbridge, Maryland, where over a dizzying seventy-two-hour period, they were inspected, examined, reoriented into civilian life, barraged with information about medical benefits and the newly enacted GI Bill, and entertained with a motivational speech on the virtues of continued service—a pitch that ended with a poker-faced colonel ordering them to raise their right hands. The colonel then paused and, with deadpan expression, asked, "Now, are there any questions before I administer the oath for reenlistment?"

Several of the men had already signed up for tours of duty in China or Japan, but the Marines had no use for a corporal with a bum arm, so Charlie collected his discharge papers and took the next train back to New Jersey. A few weeks later he was giving his own pitch to the editor at King Comics. When the man passed on his idea for a Medal of Honor strip, Waterhouse whipped out some storyboards he'd developed for a comic that chronicled the battle of Iwo Jima.

"Christopher Columbus!" the editor exclaimed. "We just got done with four years of fighting! People don't want to relive the war." Then he took a second look at the samples. "You're not bad, kid, but you could use some training," he said. "Ever consider going to art school?"

Had he ever considered . . . ?

His kindly Red Cross mentor, June Stechman, had nudged him onto the threshold. Thanks to the GI Bill, the door was suddenly open. The comics editor gave him the final push.

Charlie Waterhouse was ready for a new kind of basic training.

The Journey of a Thousand Hands, 1947–1950

Students from the Newark School of Fine and Industrial Arts attend a picnic at the home of illustrator Harvey Dunn in 1949. Charlie Waterhouse is seated behind the woman in the dark jacket at the left. *Family photograph*

Art School

If those words conjure up an image of creative types in smocks and berets suffering for their art, think again. In 1947, the students enrolled at the Newark School of Fine and Industrial Arts were a different breed. Like Charlie Waterhouse, many of them had served in the war. They'd fought through jungles, parachuted onto beaches, and driven in armored tanks across Europe to get to this place. And they knew they were the lucky ones. Under the new GI Bill, they became eligible to attend a year of school for every year of completed service at a remuneration of eighty or ninety dollars a month, depending on their marital status. In their eyes, this tuition fee was not payback, but a privilege to be earned—an opportunity for a second chance.

This was especially true for Waterhouse, who had escaped the jaws of death on Iwo Jima when so many hadn't. He walked into art school that first day, determined to do whatever it took to acquire the skills he'd need to become a cartoonist. Little did he know that he was about to come under the tutelage of two extraordinary men who would challenge him to dig deeper, and dream bigger, than he'd ever thought possible.

William James Aylward was a student of the great Howard Pyle. Like many of his fellow pupils—an illustrious group that included the likes of N. C. Wyeth, Frank Schoonover, and Maxfield Parrish—Aylward carried on the Brandywine tradition in his work. He also

brought to the drawing board an extensive knowledge and love of all things nautical, which sparkled in his jewel-toned watercolors for the Jules Verne classic *20,000 Leagues under the Sea* and infused his illustrations on the pages of Jack London's *Sea-Wolf* with the salty air of adventure.[1] Over a career spanning more than fifty years, William J. Aylward had risen to the top ranks of American marine painters of the twentieth century—where, incidentally, he continues to remain to this day.

Steven R. Kidd—affectionately known to his pupils as Joe—left Chicago at the age of seventeen to seek his fame and fortune in New York. Like many young artists, he began by churning out spreads for the pulp magazines, taking on any job that came his way. On a cold December day in 1931, at the raging height of the Great Depression, Kidd walked brazenly into the art department of the *New York Daily News* and asked for an art assignment. They gave him one, and he never really left, building a huge fan base among their readership and achieving near rock star status for classic illustrations such as *The Twelve Days of Christmas* and *Casey at the Bat*.[2]

Interestingly enough, the creative DNA of Howard Pyle pumped through Kidd's veins as well. He'd studied with another famous Pyle pupil, Harvey Dunn, at the Art Students League and had fully embraced Pyle's teachings. Just as exciting to Charlie Waterhouse was the fact that these two teachers were made of the same stuff as his early heroes, Thomason and Dickson. Aylward had served as one of eight combat artists assigned to the American Expeditionary Forces in France during World War I, and Joe Kidd had been a World War II combat artist in the Pacific.

In order to understand the training Charles Waterhouse received at the Newark School of Fine and Industrial Arts, and the lifelong impact that William Aylward and Joe Kidd had on his work, it is first necessary to understand Howard Pyle—the man whom N. C. Wyeth called "the master,"[3] and the artist whose work Vincent Van Gogh said "struck me dumb with admiration."[4]

Howard Pyle (1853–1911) is regarded as the father of American illustration and the founder of the Brandywine style of American painting. The author and illustrator of a host of perennial classics, including *The Merry Adventures of Robin Hood*, *Men of Iron*, and four volumes of Arthurian Legends, Pyle's historical paintings—in particular, his depictions of pirates—exemplify the aesthetic approach known as romantic realism.

Romantic realism—a seeming contradiction in terms—is realistic art with *something done to it*. In the same way that William Shakespeare shuffled the letters of Elizabethan English into a glorious language that never before, or since, has been spoken by man, Howard Pyle imagined a world for his buccaneers and pirates—a world so bold and colorful, yet so implicitly right and true, it's become part of our collective American imagination.[5]

William J. Aylward (1875–1956)

A pupil of the great Howard Pyle, William J. Aylward carried on the Master's tradition as a combat artist in World War I and, later, renowned marine painter. Brandywine authority Henry Pitz called him "a brilliant watercolorist whose limpid, dashing technique concealed the accurate student behind the brush."[6] Mr. Aylward took a keen interest in his student Charlie Waterhouse, and they kept up a regular correspondence until Aylward's death in 1956. His influence is apparent in the seafaring paintings created by Waterhouse during his years as USMC artist in residence.

Howard Pyle and Students outside School at Chadds Ford, June 1902. The giant of a man standing in the top row, second from the left, is master illustrator Howard Pyle. Waterhouse's teacher and friend William J. Aylward is seated on the ground directly below Pyle. *Courtesy of the Delaware Art Museum*

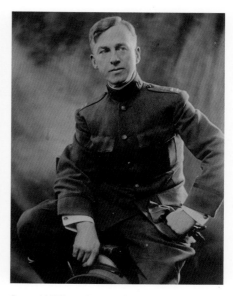

Capt. William James Aylward, Army combat artist, 1918. *Courtesy of National Archives*

Troops Waiting to Advance at Hatton Chattel, St. Mihiel Drive by Capt. William James Aylward, 1918. *Courtesy of National Archives, image no. 57041*

Mending the Nets, oil on canvas by William J. Aylward. Aylward was best known for his paintings of seascapes and ships. ©2019 National Museum of American Illustration, Newport, RI. Photo courtesy of American Illustrators Gallery, New York, NY

Steven R. Kidd (1911–1987)

Renowned *Daily News* illustrator Steven R. Kidd, known to his friends and students as Joe, was the man whom Charles Waterhouse called "a great artist, great teacher and great friend."

"To understand Joe Kidd as an artist, one had to know the person," wrote Waterhouse. "He was full of an intense enthusiasm for illustration. Within five minutes of our first meeting, we were talking about his mentor and teacher, Harvey Dunn. A student of Howard Pyle['s], Dunn taught the same principles and also communicated Pyle's commitment to illustration as an important form of art."[7]

Steven R. Kidd—affectionately known as Joe—demonstrates his technique at the Waterhouse annual Christmas party in 1982. *Waterhouse family photograph*

In this original pen-and-ink illustration, Steven R. Kidd adds a sexy overlay to the iconography of pirates popularized by Howard Pyle. *From the private collection of Jane Waterhouse*

Seoul Street Scene by Steven R. Kidd. Waterhouse's teacher Joe Kidd was a war artist in Korea. His work is in the private collection of the Smithsonian and has hung in the White House. *Courtesy of Dinah Kidd Hillgartner*

The Brandywine Legacy

"If a recital of indisputable facts had been the only mission of the historians, there would have been no Gibbon, no Parkman, Green, Michelet, or Toynbee. The facts without interpretation are inert. At the heart of all great history is imaginative reconstruction.

"The pictorial artist reconstructs in just such a way. His mind stores up all the authentic material he can find and then projects itself into that material. The artist acts out the characteristics of his pictures, trying to think their thoughts, imagining the feel of unaccustomed garments on his body, moving through rooms of another age, adapting himself to strange furniture. He tries to live the life of another milieu and because imaginative projection is his birthright, he may often make a better job of it than the footnote-haunted scholar."

—Henry C. Pitz[8]

These paintings are a visual testament to the influence of master to pupil, and teacher to student, over three generations of artists.

An Attack on a Galleon by Howard Pyle, December 1905. More than any other artist since, Pyle iconized the lore of life as a pirate. *Courtesy of the Delaware Art Museum*

Jeremiah Snyder, by Charles Waterhouse. The influence of Brandywine artists such as N. C. Wyeth, Frank Schoonover, and William J. Aylward is apparent in Waterhouse's treatment of the water, the texture of the canoe and trees, and the drama of the scene. *From the private collection of Jane Waterhouse*

Under Full Sail, oil on canvas by William J. Aylward. Aylward's father built and owned Great Lakes ships, instilling a lifelong love of the sea in his son. ©2019 National Museum of American Illustration, Newport, RI. Photo courtesy of American Illustrators Gallery, New York, NY

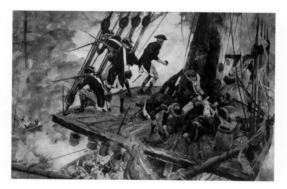

Fighting Top by Maj. Charles Waterhouse. Golden-age illustrators such as Frank Brangwyn, N. C. Wyeth, Harvey Dunn, and William J. Aylward were well known for creating dramatic scenes in the rigging of ships. With this painting from the Marines in Revolution series, Waterhouse pays homage to his illustrious forebears. *Art Collection, National Museum of the Marine Corps*

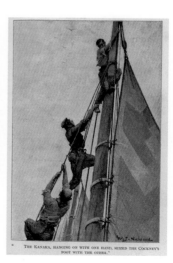

THE KANAKA, HANGING ON WITH ONE HAND, SEIZED THE COCKNEY'S FOOT WITH THE OTHER.

"The Kanaka, hanging on with one hand, seized the Cockney's foot with the other," an illustration by William J. Aylward for *The Sea-Wolf* by Jack London (New York: Macmillan, 1904).

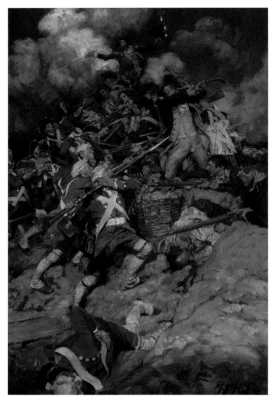

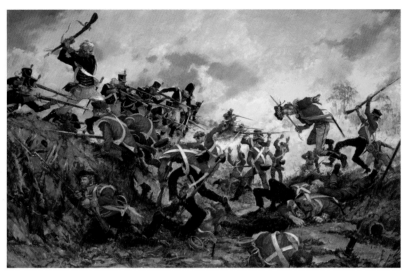

Repulse of the Highlanders, New Orleans by Maj. Charles Waterhouse. The counterpoint of elevated and prone figures, angles of swords and rifles, and color of the uniforms, earth, and sky add both focus and movement to this composition. *Art Collection, National Museum of the Marine Corps*

They Scrambled up the Parapet and Went over the Top Pell-Mell, upon the British by Howard Pyle, 1899. Pyle was a Quaker whose understanding of battle came only from his ability to create a vivid picture in his head and transfer it brilliantly to canvas. *Courtesy of the Delaware Art Museum*

"Sir Lancelot climbs to catch the lady's falcon" by Howard Pyle. Pyle uses his pen and ink to create a woodcut effect. Original illustration from *The Story of the Champions of the Round Table*, written and illustrated by Howard Pyle (New York: Charles Scribner's Sons, 1922).

Original pen and ink by Steven R. Kidd. The lineage from master Pyle to Kidd is, quite literally, black and white. *From the private collection of Amy and Gary Lotano*

King Herod, original pen-and-ink illustration by Charles Waterhouse. The decorative influence of Pyle and the bold lines of Kidd are carried into Waterhouse's art. *From the private collection of Amy and Gary Lotano*

Howard Pyle believed that what made a work of art great was its ability to tell the truth, simply and directly. The root of the word "illustrate," he would often tell students, was to make clear. He considered illustration to be far more than a commercial profession. It was a calling, a noble calling that embraced and covered the *whole* of art: landscape, portraiture, character, architecture, poetry, pathos, humor, beauty, design, color, and form. In Pyle's estimation, only the best talents should be recruited as illustrators—the ones who had the strongest imaginative powers, and the gift of being able to immerse themselves in the situations they needed to convey. "My final aim in teaching," he wrote, "will not be essentially the production of an illustrator of books, but rather the production of painters of pictures. For I believe that the painters of true American Art are yet to be produced."[9]

Forty years after his death, W. J. Aylward and Steven Kidd were carrying on Pyle's legacy, but while both remained committed to producing painters of pictures, their techniques—at the easel and in the classroom—were diametrically different. "We took a painting class with Mr. Aylward in the morning," Waterhouse said. "Each of us would bring a work in progress to be critiqued. You'd put your painting on the easel at the front of the room, and he would look at it, thoughtfully. And he'd tilt his head and frown, just a bit, and say, 'I feel that you haven't quite . . .' Then he'd zero in on the problem—a shadow in the wrong place, a clumsy gesture—and pick up a brush and make one or two strokes on the canvas. And he would quietly ask, 'Do you see where I'm going with this?'

"After Mr. Aylward's, we'd go to Joe Kidd's Illustration class. Again, the same picture went up on the easel. And Joe would look at it and he'd say, 'This is crap. Nothing about it works'—then his eyes would narrow and he'd point to the spot where Aylward had made his brushstrokes—'except for that part right there. Now *that's* first rate.'"

It was Joe Kidd who would become Charlie Waterhouse's mentor, chief source of inspiration, and toughest critic. In Waterhouse's book *Marines and Others*, he wrote of Kidd, "His brutal, devastating truths would leave you gasping, but determined to show him next time."

While Mr. Aylward continued to gently nudge Waterhouse toward painting, Kidd put him through a kind of illustration boot camp, chastising him for "drawing with his hand," while drumming the pen-and-ink artist's creed into his head:

Black against black
Gray against gray
White against white
Black against gray
Gray against white
Black against white where it counts[10]

Any illustrator worth his salt, Joe maintained, should be able to create dozens of compositional variations on the same theme, using these values to dramatically convey mood, movement, and time of day.

Kidd invited his special students to weekend marathon painting sessions at his home studio in the Hudson River valley of New York, where the tangy odors of pigment, fixative, and turpentine were laced with the smell of coffee and overflowing ashtrays. By evening, a thick, gray curtain of cigarette smoke hung in the air. Joe would assign a subject for his students to paint, then turn on a metronome, his voice rising intermittently above their mutters, and labored

breathing, to lecture or to share a story about some legendary artist.

Waterhouse wrote: "I would return from these sessions wide-eyed, unable to sleep, staggering up the street in the wee hours before dawn with a bundle of pictures under my arm, under the disapproving eyes of neighbors who thought I was returning from an all-night binge." He added, "And I was—returning intoxicated, with pictures and images racing through my mind."[11]

Kidd was a hard taskmaster, and not every student appreciated his style. But Charlie thrived on it, soaking in every word, striving to improve his technique and strengthen his weaknesses. Halfway through art school, he had married his beloved, Bobbie Andersen. It was no longer just about him. He had a wife—and perhaps one day he'd have a family—to support.

The metronome of his *life* was ticking, so when Joe Kidd criticized the way he drew hands and gave him a file folder of illustrations that showed the way it *should* be done, he stepped up to the challenge. In the space of a week, Waterhouse filled several sketchbooks, drawing over 1,000 hands—male, female; young, old; from every kind of angle; showing a range of movement and gesture—which he presented to Kidd, like a cat bestowing a large, juicy mouse upon his master.

Joe smiled, lit up another cigarette, and said, "Good. Now shut up and paint."

The Prudential Bulletin, cover art by Charles Waterhouse. *From the private collection of Jane Waterhouse and Amy Lotano*

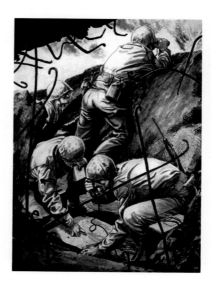

Artillery Spotter, Prudential illustration by Charles Waterhouse. Even as a staff artist for Prudential, Waterhouse managed to draw a few Marines. *From the private collection of Jane Waterhouse and Amy Lotano*

Prudential illustrations by Charles Waterhouse. The "black against white where it counts" mantra of Joe Kidd can be clearly seen in these early illustrations.

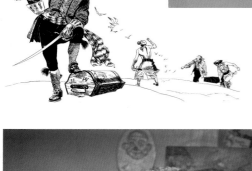

Throughout his career, and his life, wife Bobbie was a constant source of encouragement for Charlie Waterhouse. *Family photograph*

The combination of tough love and hard work proved effective, because immediately upon graduating from NSFIA, Charles Waterhouse was hired as a staff illustrator for the Prudential Insurance Company. The art director, Henry Gasser, a highly respected watercolorist in his own right, appreciated good talent and kept his stable of artists busy. It was a good place for a young illustrator to cut his teeth.

But while Waterhouse sat at his drawing board, churning out pen-and-ink spots for Prudential publications, his mind continually drifted to his buddies in the Marines. Many of them were only just now coming home, after staying on for the long cleanup of Iwo Jima or being shipped to Japan. Those who had signed on for another tour of duty were heading to Korea. Waterhouse felt like he should

be with them, but he knew he'd never pass the physical. A hand that turned stiff and blue in cold weather would prove a dangerous hindrance over in the Frozen Chosin; still, the artist spent some sleepless nights, worrying about his brothers in the Corps—and he might've had a few more such nights, had he known then how dire the situation was.

As November 1950 drew to a close, three members of Waterhouse's old platoon met at Hagaru-ri.

Only two would live to tell of it.

Capt. Carl Sitter, USMC
Battle of Hagaru-ri, Chosin Reservoir, Korea, November 29–30, 1950

Around the same time that Hector Cafferata and the men of Fox Company were fighting off an enemy onslaught on Fox Hill above Toktong Pass, on another frozen slope in the Chosin Reservoir, Maj. Reginald Myers and a ragtag unit of Marines and soldiers found themselves on East Hill, caught between an icy rock and a cold, hard place. Orographically speaking, there was not much to distinguish this hill from the other rugged, snow-pocked peaks ringing this valley, but the fact that it offered a direct line of fire onto the Marine base in the village of Hagaru-ri made it a valuable piece of real estate—real estate currently owned by the 4,000 Chinese soldiers who were entrenched on its summit.

For twenty-four hours, Maj. Myers and a small band of 250 men had battled their way upward, clinging to the icy ledges of East Hill with frostbit fingers, digging into the bloodstained snow, and inching doggedly toward the crest, while the enemy pushed back each hard-won advance. At the end of the day, their ranks had dwindled to fewer than eighty. Myers knew his men were too exhausted to survive a full-on counterattack, but he decided to hold his ground in the hopes that reinforcements might be coming.

They were, but to get to Myers would take perseverance, resourcefulness, and guts. Fortunately, the task force assembled by Col. Lewis "Chesty" Puller had all three. It was a mixed bunch made up of 250 British Royal Marine commandos, led by Lt. Col. Donald Drysdale, and 270 Marines from G Company, 3rd Battalion, under the leadership of Capt. Carl L. Sitter. They had been given the task of beating a path into Hagaru-ri and reporting to Lt. Col. Tom Ridge, commanding 3rd Battalion, 1st Marines, responsible for the defense of Hagaru-ri. Upon the force's arrival, Ridge would order the unit to reclaim East Hill from the Chinese.[12]

Carl Sitter had grown up in Pueblo, Colorado—a city that has produced more Medal of Honor recipients than any other in America. The son of a tough-minded steel mill worker, and grandson of a God-fearing Presbyterian minister, Sitter's mettle and faith had been steel-tested in the Pacific during World War II. Wounded in action on Eniwetok, the twenty-two-year-old first lieutenant was back in the thick of things six months later, leading a rifle platoon of Marines into battle on Guam.

On Guam, in the face of fierce enemy fire, Sitter moved from position to position to encourage his men, until a bullet caught him square in the chest. He'd taken a shot to the heart, yet, incredibly, the .45-caliber pistol holstered below his left shoulder had saved him, shattering into a shield of cold-hammered steel and taking the brunt of the bullet's impact. Sitter believed that God had spared his life for a reason, so despite the piercing pain, he rose to his feet and continued

to fight, refusing to be evacuated with the rest of the wounded until his mission had been accomplished.[13]

Sitter was twenty-eight now, and a captain. The hell he'd faced so bravely in the jungles of the Pacific had frozen over into this cold and bitter conflict in the northeast of the Korean peninsula, but some things had stayed the same: he was still a Marine, still faithful, and still wore a .45 strapped to his chest.

It was eleven miles to Hagaru-ri, and the Chinese army was determined to wring as much blood as possible out of every step. Fourteen Marines fell during the first hour. By noon, the task force had advanced only two miles. Drysdale and Sitter decided that their best bet would be to load their men into trucks, put it in high gear, and hard-pedal it through the gauntlet of enemy emplacements until they crashed the Chinese line.

The method worked to a point, but it remained slow going. Each time the enemy surged forward to stop them, Sitter's Marines would pile out of the trucks and charge the attackers. Then they'd jump back on the trucks and ride to the next engagement, all while under heavy mortar fire.

Along the way, a burst of machine gun fire riddled Sitter's jeep, killing his driver, but the steel-willed captain would not be deterred. He urged his men to fight on until they reached Hagaru-ri. It took them twelve hours to cover eleven miles, and of the 270 Marines who started the journey, only 160 made it the whole way.[14]

But Drysdale had fared worse: when the British commander arrived an hour later, half of his commando unit was gone.

Capt. Carl Sitter, Battle of Hagaru-Ri, 23–30 November 1950 by Col. Charles Waterhouse. *Art Collection, National Museum of the Marine Corps*

Sitter let his men sleep. They'd accomplished the first part of their mission, but he knew the crucible still lay ahead. On an icy ridge out in the darkness, Maj. Myers's remnant force was trying to hold on, fighting for their very survival. The Marines needed a clear path to Hagaru-ri. "George" Company had to take East Hill; there was no other choice.

At dawn, Sitter roused his exhausted Marines and outlined the plan. The 1st and 2nd Platoons would lead the assault, attacking both sides of the hill. Moving in waves, the assault teams began a slow, two-pronged advance. They faced heavy resistance from the enemy, and from the icy hill itself. It was so slippery that nearly every step forward ended in a slide back. With the attack stalled, Sitter was forced to bring in his reserve to fight against the Chinese right flank.[15]

By the time these units linked up with the last vestiges of Myers's group, it was nearly noon. Sitter realized that a charge to the summit now would be suicidal. Better, he decided, to cement their lines and prepare to cut the enemy down when they ran down the hill to attack, as he knew they would.

Sitter ordered his men into an L-shaped defense formation and told them to dig in. Meanwhile, he called in Corsairs to fly over the crest and pummel the enemy encampment. By 1700, the Marines commanded two-thirds of the hill, but as daylight faded and temperatures dropped, the peak seemed farther away than ever—unapproachable, and ominously silent.

Like everything else in this miserable place, time appeared to be frozen. One hour . . . two hours . . . three hours passed. At 2000 the shrieking call of bugles shattered the silence. All at once, green flares lit up the sky, illuminating a molten flow of enemy attackers pouring down from the summit, screaming "Marine, you die!"

The Marines responded with mortars and machine gun fire, and yet still the Chinese kept coming. Anticipating that their store of ammunition would soon run out, Sitter called for artillery support. A mortar shell exploded nearby, ripping shrapnel through Sitter's chest and cutting his face to ribbons, but, once more the trusty holstered .45 had protected his heart. Not long after, a Chinese soldier pitched a grenade at Sitter, wounding him a second time. Despite these injuries, the steely captain continued to fight, leading his men in hand-to-hand combat when the enemy surged through a break in the defenses, and repelling repeated attacks throughout the long, cold night.

At daybreak the Chinese pulled back. George Company had held the line and retained their ground, but Capt. Sitter knew the enemy would be back. He called down below and told them he needed anybody they could send—cooks, bakers, clerks, mechanics, engineers, air controllers—if they had a pulse and were strong enough to shoulder a weapon, he wanted them in foxholes.

That second night the Chinese didn't even wait for the cover of darkness, starting down the hill at dusk in a seemingly endless column of four men across. Sitter's Marines were exhausted, their machine guns so frozen they had to be kicked before they would fire. The motley group of reinforcements was gripped in fear. One of them asked, "Captain, what do we do?"

"You'd better fight," Sitter replied, through gritted teeth, "or we're never going to get out of here."[16]

Throughout that long night, while grenades exploded and bullets whizzed overhead, Capt. Sitter coolly moved from foxhole to foxhole, and gun position to gun position, checking on each man and coordinating the efforts of the entire combat team. Despite being

wounded for a third time, he vehemently refused to be evacuated. All of his other officers had been killed or seriously injured; it was his duty, he said, to stay with his Marines.

Sitter stayed for another five brutally cold, brutally bloody days until, on the morning of December 5, elements of the 5th Marines came to relieve what was left of his company. He was asked later if he'd been afraid on East Hill. "We're all afraid of something," Sitter said. "The major thing I was afraid of is that I wouldn't be able to inspire my men to continue to fight."[17]

That would prove to be a groundless fear. Only sixty of his men came through it alive, but their stalwart captain made sure that they didn't leave a soul behind.

It is commonly agreed that there were no victors in the Korean War.

That the United States did not emerge as the clear loser is attributable, primarily, to the brave efforts of the United States Marines Corps. On November 1, 1950, in response to the buildup of United Nations forces in North Korea, 300,000 soldiers from the People's Republic of China surged across the border, annihilating an entire South Korean division and inflicting upon the US Army the most ignominious defeat in its history.

In a matter of weeks, the Chinese had surrounded two Marine regiments and blocked the supply route in a dozen places. But despite being outmanned and woefully unequipped to fight in subzero temperatures, the Leathernecks proved time and again that they were a different breed of fighters than the People's Army had ever encountered. The question was, How long could these few and proud hold out against a Red tide that just kept on coming?

US Army Corps commander Maj. Gen. Edward Almond urged Marine Corps Maj. Gen. Oliver Smith to abandon his dead, leave behind his equipment, and begin immediate airlift evacuations. Smith's response was swift and decisive. "We'll fight our way out as Marines," he said, "bringing all our men, weapons, equipment, and gear with us."[18]

And so they did.

By December 9, the leathernecks of 5th Regiment that relieved Sitter and Myers had dislodged the last of the enemy from East Hill, clearing the way for American forces to begin the move out of Hagaru-ri. In all, 10,000 troops, and over a thousand pieces of heavy equipment, would pour through the town on the journey south. No dead were left behind. For the Marines who fought in the hills and in the passes, and on the frozen plains of the Chosin Reservoir, what might've been a rout seemed more like a bittersweet victory march. "We're not retreating," insisted Maj. Gen. Smith. "We're simply attacking in another direction."[19]

Despite his many wounds, Capt. Carl Sitter survived the long trek south. The following autumn, the recently promoted major stood—humbly, head bowed—as President Harry Truman placed the Medal of Honor around his neck. Sitter said that it took his breath away, knowing that he'd been recognized with the nation's highest honor, and he shared it with the courageous Marines, living and dead, who'd fought under and alongside him at Hagaru-ri. "The blue and stars on the medal," he said, "belong to them."[20]

Carl Sitter continued to serve, giving a full thirty years of his life to the Marine Corps before retiring as a colonel in 1970. After leaving active duty, he began a second career with the Virginia Department of Social Services. In an interview for the documentary series *Beyond the Medal of Honor*, he was asked to describe the nature of courage. "When you live your life for your fellow man, and your fellow Marine," Sitter said, "that's one of the most courageous thing you can do."[21]

By then, Carl Sitter had exchanged his holstered .45-caliber pistol for a prayer book. At age seventy-five, he returned to college, studying for the ministry at the Union Theological Seminary and Presbyterian School of Christian Education in Richmond. He passed away a month before graduating.

It had been his intention to minister to the elderly and homebound.[22]

Eternal Band of Brothers, Frozen Chosin by Col. Charles Waterhouse. Commissioned by the Chosin Few Association to mark the dedication of the missile cruiser USS *Chosin* (CG-65). Waterhouse's painting depicts the US military winding its way down Funchilin Pass. *Art Collection, National Museum of the Marine Corps*

A Genuine Charles Waterhouse

While Marines such as Carl Sitter and Hector Cafferata were risking their lives in Korea, Charles Waterhouse was drawing pictures for the purposes of promoting and selling life insurance. Since Charlie graduated from art school, his teacher, William Aylward, had kept up a lively correspondence. My father saved all of his letters. The nearly translucent, watermarked paper has been ironed into crisp creases through repetitive folding, and the ink is faded, but Mr. Aylward's beautiful penmanship still leaps off the page.

By this time, Aylward was well into his seventies and caring for his invalid wife; still, he continued to regularly post his former pupil books and small care packages—one even containing a proof signed by the master himself ("I'm sending you one of Mr. Pyle's good things"[23])—and to jot down tips of the trade that he thought might be helpful, which he put on separate sheets, under the header "Shop Talk by W.J.A."

But the kindly artist's support also took more practical form. In a note dated November 12,1951, Mr. Aylward passed along the name of the art director at Boy Scouts of America. "He is particularly interested in your pen-and-inks," he wrote, adding this solicitous advice: "The best time to see him is 10 am or 2 pm on any day but Saturday. It would be a good idea to call first for an appointment."[24]

Another letter, dated the following year and sent to the attention of Mr. Charles Waterhouse, Advertising Department, Prudential Insurance Co., is particularly poignant. It reads:

Dear Charlie:

I always regret my brutal criticism of your oil black-and-white that you showed me the last time I saw you.

Frankly I do not consider it a genuine "Charles Waterhouse."
. . .

While the picture was dull and heavy, there was unquestionably merit there—for after almost three months have past since you showed it to me, I can visualize it as clearly as tho' it were only yesterday—So you must have said something at that.

Hoping to see you soon and with best wishes to you always.

Your sincere friend,

W. J. Aylward[25]

Three years later, on August 20,1955—a day after my sister, Amy, was born—my father walked into Prudential and asked to see his boss, Henry Gasser. By then, Charlie Waterhouse was the art department's rising star, with five years of experience under his belt. "Mr. Gasser thought I was going to ask for a raise," he recounted. "But instead I said, 'I quit.' And the cigar literally fell out of his mouth."

It was a huge risk. He had a wife and two kids. But if he didn't do it now, he knew that years down the road he'd end up behind Henry Gasser's desk, blowing smoke and wondering if . . .

It was time to take a chance.

Time to see if he had it in him to be the genuine Charles Waterhouse.

The curtain was lowering on his first life. Act 2 was about to begin.

★ CHAPTER 5 ★

ON THE SPOT
1955–1966

By the 1950s, the golden age of American illustration, sparked by Howard Pyle and carried on through the talents of many others, had begun to lose its luster. Although its bright star, Norman Rockwell, would continue to produce covers for the *Saturday Evening Post* into the 1960s, the heyday of illustrated magazines, advertising, and newspapers was all but over. In order to earn a living as a freelance illustrator in the age of photography, an artist had to work harder and faster and be more versatile than the other guy.

That suited Charlie Waterhouse just fine. The week after quitting his staff position at Prudential he delivered three drawings to three different publications. Then he went home and waited for the art departments to call.

For eighteen days the phone didn't ring.

Every morning he would take a 9-by-12-inch gesso panel, squeeze out a batch of paints, and start a picture. He'd work all day, creating and solving problems of color, value, and composition. He described this exercise in handwritten notes we found later in his personal files. "Some subjects danced along. Others were fought all day long, every inch of the way," he wrote. "Sometime after dinner, before the kids went to sleep, the panel would reach the final stage of completion that I was capable of at this stage of my development, and I would select a subject for the next day's effort." Continuing in this way, Waterhouse produced eighteen paintings "of varying degrees of competence and success" in eighteen days.

Then the phone started to ring, and it never stopped.

By the time I was in the first grade, I knew how to spell *illustrator* and *Iwo Jima*.

I'd already realized that my father was different from other dads. He didn't fix things around the house, shovel snow, or do yard work. My mother performed those tasks. Instead of driving off to work each morning (he didn't know how to drive, either: my mom was the only one with a license), my dad went up into the attic of our house and drew pictures all day.

The door that led to his studio was always open, so that my dad could listen to the radio mounted on the wall in the parlor while he worked. In keeping with the nostalgic whimsy so prevalent in the 1950s, our radio looked like an early-model wooden telephone, with a crank handle for changing the stations and a Bakelite receiver that, when lifted or replaced in its cradle, turned it on and off. Out of its monospeaker emanated the soundtrack of my childhood: William B. Williams in his Make Believe Ballroom playing a smooth, jazzy chorus of Nat King Cole, Lena Horne, Peggy Lee, and Sinatra, accompanied by my father's whistling—or if the picture wasn't going so well, an improvised bridge of swear words, counterpointed by my mother's inevitable reproval (*"CHAR-lie"*) from wherever in the house she happened to be.

A thick cloud of blue-gray smoke spangled with swirling dust motes filled the stairwell leading to the studio, and the sooty aroma of India ink, stale cigarettes, and drying pigment wafting down on the waves of whistled melody was irresistible to a curious toddler. I can remember pulling myself up those fourteen steps on my hands

and knees with the determination of a mountain climber—sliding down them on my bottom was a lot easier.

If I was very good, and very quiet, my father would give me a sheet of paper and some crayons and let me sit on the gray linoleum floor, under the slanting tent of his drawing board, so I could make my own pictures. When my sister came along, that changed. Amy was three years younger, as active and outgoing as I was self-contentedly sedentary; to her, the studio wasn't a temple of art, but an Aladdin's cave waiting to be explored.

Her busy little hands itched to take hold of the plaster skull that our father kept on his taboret—poor Yorick, with a marble jauntily set into one of his empty eye sockets. Instead of coloring on scraps of paper, she used crayons to draw loopy circles across the pages of several of Daddy's art books—a hangable offense in the Waterhouse household, from which she was saved by virtue of the fact that she was only three and had the most disarmingly radiant baby-toothed smile.

From Amy I learned that fingers could be swished in the bowls of warm, paint-swirled water that stood next to our father's brushes, and that the artifacts that he used as props for his illustrations—many of which were weapons—worked well as toys. Our particular favorite was an authentic-looking toy handgun that we discovered, once our fingers were long enough to reach the trigger, shot wooden yellow bullets that stung like wasp bites.

Despite its many attractions, our parents impressed upon us that the studio was not a playroom but a special place to be entered, by invitation only, on those rare occasions when Daddy didn't have a deadline. After we went to bed, our father often returned to his drawing board to finish an assignment, chain-smoking Winstons and popping Necco wafers while he labored through the night. At dawn, with his good hand cramped up and ink-stained, and his cigarettes all gone, he'd wait for a light to come on in the house across

Charles Waterhouse working in his attic studio in Edison, New Jersey, ca. 1958. *Family photograph*

the street, so he could bum a cigarette from a neighbor who worked the 5 a.m. shift, before going back to complete his picture.

The body of work my father produced over this period of time is staggering.

After his death, my sister undertook the massive task of organizing and archiving his illustrations. Just about every day I would get a four-word text from her (*I've found another one*) or a JPEG of an image with this question: *Do you think this could be his?* And it almost always was. Because not only was our dad a prolific illustrator, he was a bit of a stylistic chameleon.

Illustrators, like actors, are frequently typecast. Refusing to be limited or labeled, Waterhouse established a reputation as an artist who could work in a wide range of media and seamlessly cross subject categories. The covers and spreads he created for men's magazine such as *Saga*, *Climax*, and *Argosy* in the 1950s and early 1960s, are peopled with a sprawling cast of tough guys, gangsters, and busty women. At the same time, he was churning out hundreds of spots for trade and textbooks with such kid-friendly titles as *Cup and Saucer Chemistry*, *Enoch and the Brave Un*, *That Dog Spike!*, and *When Wagon Trains Rolled to Santa Fe*, as well as doing first-rate illustrations for historical publications, and reissued classics by Robert Louis Stevenson, Joseph Conrad, and P. G. Wodehouse.

The referral his teacher, Mr. Aylward, gave him to the art editor of Boy Scouts of America resulted in a long association with that organization. Throughout the 1960s, Waterhouse's illustrations appeared regularly in the *Boy Scout Quarterly*, and he did the cover and inside art for the 1964 edition of the *Boy Scout Handbook*. His work was regularly seen in magazines such as *Outdoor Life* and *Reader's Digest*, in feature stories for the Associated Press, and in corporate communications and national advertising.

Illustration for *Saga* magazine by Charles Waterhouse. Sexy girls and violence were the hallmarks of the men's magazines and pulps of the 1950s and 1960s. *From the private collection of Jane Waterhouse and Amy Lotano*

On the flip side of the work Waterhouse did for magazines such as *Saga* and *Argosy* were family-oriented illustrations such as these covers for Equitable Insurance and the Boy Scouts of America, and the textbooks he illustrated for Grosset and Dunlap. Daughter Jane was the model for the little girl with the white headband on the far left. *From the private collection of Jane Waterhouse and Amy Lotano*

Treasure Island by Robert Louis Stevenson, illustration by Charles Waterhouse, 1961. *From the private collection of Jane Waterhouse*

The Black Arrow by Robert Louis Stevenson, illustration by Charles Waterhouse, 1961. *From the private collection of Jane Waterhouse*

Waterhouse surveys his work in his attic studio, c. 1959.
Waterhouse family photograph

When one considers the sheer volume of output, it seems impossible that Charlie Waterhouse found time to do anything other than draw and paint; indeed, the small notebook he kept to record each assignment, its corresponding fee, and its date of final payment is a poignant reminder of the pressure he must have been under to provide for his family, given the uncertain, check-is-in-the-mail nature of a freelance art career.

But the illustration years were also the years of my childhood, and I can attest that while my dad was working around the clock to meet deadlines, he was also teaching a weekly class in Advanced Illustration at his alma mater, the Newark School of Fine and Industrial Art, and being regularly "volunteered" by his wife and daughters into painting backdrops for church pageants and school plays.

We spent our summers inside a series of finned and finicky used cars—each the size of a small tank—traveling thousands of miles toward points west, stopping at every art museum and historical point of interest encountered along the way. On two of these Westward Ho trips, we were accompanied by both sets of grandparents and our miniature poodle, Pepi. My mom drove, while my father pored over Rand McNally road maps, searching out the most-scenic routes—which, to him, meant avoiding all major highways and, if possible, following the broken-red-line roads that, in map-speak, signified two lanes or less, questionable paving, and a high potential for detours—while I sat in the back seat, writing in my journal and cooking up fictional plots in my head that revolved around a plucky female protagonist who, through a series of intrigues, discovers the family she's been living with has adopted her.

When we were at home, the door of our small Cape Cod on Dartmouth Street was always open to "the artists"—an eclectic group of my father's old Newark School of Fine and Industrial Art classmates and his favorite students, who came to spend time up in the studio with my dad while he was noodling on his pictures. They'd bring with them their work-in-progress oil paintings, watercolors, maquettes, and sketches; clippings and used bookshop treasures; and conversation and company. In the space of a few hours, they'd fill the ashtrays . . . leave a few more coffee rings on our furniture . . . and eat up the cold-cut sandwiches and baked goods my mother always had on hand.

What especially impressed me was that they'd ask questions about what I was reading, and thinking, and doing, as if I were a person of interest and not just a little kid. The discussion that ensued was always a learning experience. A mention of my favorite novel, *Little Women*, inspired a torrent of free-flowing associations on their part that would sweep me out of my Louisa May Alcott comfort zone into the transcendentalist realm of her father, Bronson, veer fleetingly toward Ralph Waldo Emerson, before circling back to Louisa May and possible feminist ties with Mary Wollstonecraft Shelley. My father's friends seemed incapable of the sort of social discourse that I'd later identify as small talk. It amazed me how they could pick up the thread of a conversation initiated months or even a year before, but I came to learn that that was just what artists did: they paid attention.

There was a certain zany Kaufman and Hart aspect to our life on Dartmouth Street. My sister and I grew up thinking it was perfectly normal to have a dad who would get off the New York bus on a hot summer day and dive into the above ground pool in our backyard, dressed in his sports jacket, shoes, shirt, and trousers. Or that keeping a nervy cat leashed to a clothesline made good sense. Or that asking someone to pose in an awkward position, wearing a silly costume and brandishing a lethal weapon while our father made sketches, was no big deal.

The man from the electric company who came to check our meter once found my father standing stoically, wrapped up in a wool blanket, with his trousers rolled to his knees, posing as a Seneca Indian, while my mother took shots of him with our Polaroid camera. My grandmother posed in our driveway for a feature story in *Saga*

Mary Andersen, aged seventy-eight, poses in our driveway for a story about a gun-toting grandma in *Saga* magazine. *Waterhouse family photograph*

Waterhouse added a coat and glasses to the final illustration but kept the hat. *From the private collection of Jane Waterhouse*

Sometimes the artist is his own best model. *Waterhouse family photographs*

magazine, in a flat-brimmed flowered hat, elaborately buckled dress, and button pearl earrings, carrying a pocketbook in one hand and a SIG Sauer pistol in the other.

I remember sitting on the steps that led into the basement, quietly watching while the teenage boy who lived next door and the pretty girl from across the street pretended to pour cement over an imaginary body in our utility sink, while my father drew sketches for a grisly illustration in a true-crime magazine that would spark in me a lifelong fascination with murder mysteries, and a lingering fear of our basement.

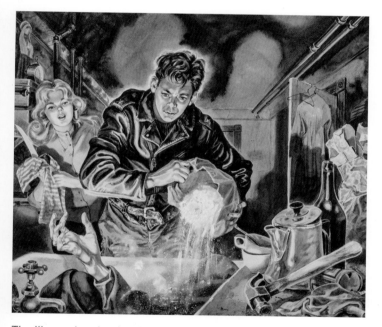

The illustration that inspired my career as a mystery writer—note the hand protruding out of our basement sink. *From the private collection of Jane Waterhouse*

With the phone ringing off the hook and an endless string of deadlines to meet, it would seem Charlie Waterhouse's professional life couldn't get any fuller. He'd been asked to join two of New York's most prestigious art organizations—the Society of Illustrators, whose past members included Howard Pyle, Maxfield Parrish, Frederic Remington, Rockwell Kent, the Wyeths, and Norman Rockwell, and the Salmagundi Club, whose roster contained such illustrious names as William Merritt Chase, Louis Comfort Tiffany, Childe Hassam, and Winston Churchill. Not only did this reflect well on his standing

as an illustrator, being a club member gave him the opportunity to participate in sketch trips sponsored by the various branches of the armed forces. During the 1960s, Waterhouse served as an official artist for the Army in Alaska, for Marine Corps training maneuvers in Quantico, and onboard several Navy aircraft carriers. But he was just getting warmed up.

I'd heard my parents talking in low voices. The Marines were looking for a combat artist to cover the action in that war-torn place over in South Asia that we saw every night on the evening news.

Vietnam.

My father had his sights set on going to Vietnam.

Capt. Donald Cook, USMC
Vietnam, December 31, 1964 – December 8, 1967[1]

In the Vietnamese language, *Binh Gia* means Peaceful House, which is exactly what thousands of refugees fleeing from the North in the early 1960s hoped to find upon settling in the Phuoc Tuy Province of South Vietnam. Being predominantly Catholic, and universally anti-Communist, they had promptly built a church in the center of their town, then dug a moatlike ditch around the entire village, filling it with sharpened punji stakes, coils of barbed wire, and minefields. Such measures seemed to protect them pretty well until the night of December 28, 1964, when a group of Vietcong guerrillas slipped through their defenses, killing the Rangers at the gate, shooting the crucifix off the church door, and setting up a command post in the nave.[2]

Army Rangers from the Republic of Vietnam responded immediately to the situation, some arriving on foot, others airlifted into position by US helicopters, only to be fought off by guerrillas wearing uniforms that they'd stripped from the Rangers they'd slaughtered. During the confusion of battle, two American soldiers attached to the 33rd Ranger Battalion were captured.

Oddly enough, the five waves of Vietnamese Marines from the elite Killer Shark 4th Battalion that choppered into Binh Gia the following morning met no resistance. The Vietcong had returned to the jungle to resupply. Villagers slowly emerged from their hiding places, and together with the Marines they began to bury the dead from both sides.

A tall, smiling Marine advisor named Capt. Donald Cook, who had come to observe the Killer Sharks in action, began handing out hard candies, teasing smiles from the children.[3] Just then, the church bells started to ring, rising above their peals of laughter; at that moment, Cook—a devout Catholic and father of four—probably felt just a little closer to home.

It was his second trip to Nam. The year before, at precisely the same time that President Diem was overthrown and assassinated, Cook had carried classified documents to the commanding officer of a USMC helicopter squadron in Da Nang. This particular trip was more of a fact-finding tour, an opportunity to observe operations, gather on-the-ground intelligence, and build relationships with the Vietnamese Marines. In a birthday card to his wife written shortly before Christmas, Cook urged her not to worry, saying, "It is really quite an opportunity and it appears that it will be an experience to remember."[4]

These were still the early days in a conflict that, even years later, no one wanted to call a war. As 1964 drew to a close, there were fewer than 24,000 Americans in country, mostly serving as support units for supply, maintenance, aviation, and transportation. But military higher-ups, and intelligence officers such as Capt. Cook, knew that was about to change. As an advisor, it was his job to get up to speed as quickly as possible and help prepare for the escalation.

The Marine advisor had been in country for only eighteen days, but he'd made the most of every moment—hitching chopper rides along the Mekong delta, participating in search-and-clear operations, and experiencing the heat of enemy artillery fire. So in the late afternoon of December 30, when a US Army gunship making a strike on an enemy encampment in an old rubber plantation ended up being shot down in flames, the Marine advisor naturally wanted to take part in the search and recovery at the crash site.

On New Year's Eve, Donald Cook, along with a young Army first lieutenant named Philip Brady and about 120 seasoned fighters from the Killer Shark Marines, headed deep into the shadowy recesses of the abandoned plantation, with the intention of retrieving the bodies of the four Americans and twelve Vietnamese soldiers who'd perished on the gunship. It was a dangerous and noble mission, and it was doomed from the start.

The Vietcong ambushed them at the crash site. In the fierce hand-to-hand combat that followed, the Killer Sharks were completely eviscerated. Twenty-nine of its thirty-five officers were counted among the dead. According to an eyewitness, Capt. Cook was wounded in the thigh while attempting to rally his Vietnamese allies. Unable to walk and certain he was about to be killed or captured, Cook ripped the Marine Corps emblem off his utility jacket, slipped his dog tags and a rosary off his neck, removed his wedding band and the wallet containing a picture of his four children, and buried them in the blood-red soil of the rubber plantation.[5]

For a very long time after that, no one could say for sure whether Donald Cook was alive or dead. Then, gradually, reports began to surface: inspiring tales of a hard-nosed, tough-minded Marine prisoner of war whom the Vietcong just couldn't break.

Donald Cook was a Brooklyn-born, Jesuit-educated Irish Catholic who played a mean game of football, excelled in the classroom, and almost never missed Mass. While attending St. Michael's College in Vermont, he encountered two of the great loves of his life: his future wife, Laurette, and the United States Marine Corps. He'd stay loyal to each—and faithful to his beliefs—to his dying breath.

After college, Donald and Laurette married, and Cook hit the Marine Corps fast track running as hard as he could, successfully qualifying as an officer and an expert in communications, studying Chinese, and graduating number one in his Army Intelligence class. He then traveled with his growing family to Hawaii, where he commanded the first interrogator-translator team manned by Marines who were Chinese linguists.

During this time the young captain developed a strong interest in the Code of Conduct, especially as it pertained to the experience of American POWs during the Korean War. He soon became an expert in the subject, mastering the interrogation techniques used by Chinese Communists. In classes that he taught to Marine aviators, Cook would often role-play, demonstrating how interrogators used mind games to get information from their prisoners. The less you said, he told his students, the better your chances for survival.

As Vietnam started to heat up, Cook's assignments took him farther into the Far East. He served as a liaison officer on Taiwan before being assigned to the Third Marine Division headquarters at Okinawa, where, in addition to his duties as a communications officer, he developed a training plan for semitropical environments and spent his off-hours listening to Vietnamese-language records.

In short, the wounded American whom the Vietcong had captured was a highly trained intelligence officer, with an encyclopedia of classified information in his head. In the words of 1Lt. Philip Brady, who survived the crash site ambush, Capt. Donald Cook was "a potential bullion mine of information for the communists."[6]

But Donald Cook knew it all came down to what *he* knew and *they* didn't.

They didn't know his branch of the service, because he'd removed his insignia and wasn't wearing the tiger-striped uniform of the Vietnamese Marines. They didn't know he had top-secret security clearance and access to sensitive war plans. They didn't know he could understand basic Vietnamese.

On the other hand, he knew full well that the Vietcong had a deep-seated hatred of American advisors because they fostered close relationships with the Vietnamese freedom fighters. He knew the enemy would use any information they had about his family against him, and that anything he put in writing would be used against the United States. He knew a prisoner-of-war camp was an extension of the battlefield, and that his captors would do everything they could to undermine authority, break down the chain of command, and destroy morale. Above all else, Donald Cook knew the Code of Conduct.

He knew the Code really well.

The process of determining whether someone is eligible for a Medal of Honor—like the road to sainthood—involves a series of strictly enforced and highly regulated qualifications that put the candidate under intense scrutiny every step of the way. While the criteria vary slightly depending on the branch of the service, *all* Medal of Honor recommendations must include statements from at least two eyewitnesses who can provide incontrovertible evidence on the person's actions.

It would take thirteen years for Donald Cook to be awarded a Medal of Honor, mainly because verifiable information of his heroics could be obtained only as the men held with him in the POW camps either escaped or were released.

For nearly three years, the Vietcong held Capt. Donald G. Cook in a series of primitive jungle POW camps that made the Hanoi Hilton look like the Ritz. During most of that time he was locked in leg irons and kept in a bamboo cage the size of a Maytag refrigerator, forced to subsist on half rations of rice infested with rat feces and weevils—punishment for his stubborn refusal to divulge any information beyond his name, rank, birth date, and serial number.

The Vietcong weren't his only enemy. In order to survive, Cook had to wage a daily war against killer mosquitoes and poisonous adders, long soaking monsoons and mind-numbing heat, and slow starvation

and the weakening of his body. Despite all this, throughout his captivity, Donald Cook actively assumed leadership over ten fellow prisoners, looking out for their welfare, caring for their health, and uplifting their morale, while never veering from the Code of Conduct.

Seven of them survived.

Their testimony about Cook paints a portrait of a remarkable Marine, who was equal parts tough sonofabitch and saint.

Fellow prisoners described how, after a failed escape attempt, Capt. Cook was brought back to the camp at gunpoint, beaten, and forced to his knees. When one of the Vietcong guerrillas came up behind him with his gun drawn, announcing in perfect English: "I shall now kill you. I have the authority to do so," Cook coolly responded, "You can't kill me. Only God can decide when I die."[7]

On another occasion, the commander of the prison camp—outraged because Cook could not be intimidated into writing an antiwar propaganda statement—put a cocked pistol to his head. Calmly, Cook began reciting the nomenclature from *The Guidebook for Marines*: "The automatic pistol, caliber .45 M1911A1, is a recoil operated, magazine fed, self-loading hand weapon . . ."[8]

It was the prison commander who ended up blinking first.

Sgt. George "Smitty" Smith, an Army medic imprisoned with Cook at a camp near the Cambodian border, later said this about the hard-nosed Marine: "I believe he would have stopped shitting if he had thought 'Charlie' was using it for fertilizer."[9]

Cook made it clear to the Vietcong that he was the senior officer and legal spokesman for the junior Americans, knowing full well that by taking on this role he'd be subjected to even-harsher treatment. He encouraged his fellow POWs to stay physically fit and to continually resist the enemy. "Don't say jack shit," he advised them, "because the more you talk, the more vulnerable you become."[10]

But Cook's leadership went far beyond simply maintaining discipline and morale. On his own initiative, he assumed the responsibility of caring for the sick and downhearted, sharing his food with weaker prisoners, carrying their packs on marches, and nursing them through life-threatening illnesses. Whenever meager quantities of medicine were distributed, he gave his own portions to his men in need. In May 1966, when one of their small group succumbed to pneumonia, Cook stripped and washed his body, praying aloud and placing a homemade cross made of sticks and string in his friend's hands before the Vietcong took his corpse away.

By then, Cook was already suffering the debilitating effects of malaria, beriberi, scurvy, hepatitis, and chronic amoebic dysentery, and yet, according to the others, he never complained and he remained abjectly uncooperative, refusing to put pen to paper even to request medical treatment. Isolated from the other prisoners, Donald Cook made his presence known by bellowing *The Marines' Hymn* in a strong Irish tenor that would ring through the camp.[11]

Douglas Ramsey, a US Foreign Service officer with the US State Department, who would earn the distinction of being the longest-held Vietnam POW, recalled a time when the prisoners were made to march over highly treacherous terrain to a new camp, 150 miles away. Cook had contracted a severe case of malaria. He'd developed diarrhea and night blindness and couldn't keep down a morsel of food; yet, although barely able to stay on his feet, he refused to let anyone else take his pack. "How Cook managed to make it through the fourteen-day march, I will never know,"[12] Ramsey said, adding that the obstinate Marine was staggering so much that he probably clocked in twice as many miles as the rest of them.

A good deal of testimony about Donald Cook comes from Army PFC Charles Crafts, a young draftee from North Jay, Maine, who'd been in country for only three weeks when he was captured. Crafts was imprisoned with Cook for nearly two years. While he estimated that the Marine captain was kept in isolation during at least half that time, the young private would later say that Don Cook's "awe-inspiring presence always felt near."[13]

To keep up morale, Crafts said Cook would tell a good (and not always clean) joke every day, never repeating the same one twice. He prayed, too, daily reciting St. Joseph's Prayer for men in battle. At Christmas, he molded a nativity set out of clay. At Easter he explained all fourteen of the Stations of the Cross. And yet, Crafts said, as confident as Cook was in his faith, the captain never tried to impose his views on the others, other than reminding them that the Vietcong had captured their bodies, not their spirits.[14]

But, sometimes, it was their bodies that got the best of them.

Once, while they were again being marched to another camp, Crafts came down with malarial fever. When he told Cook that he couldn't go a step farther, the Marine said firmly, "Yes, Charlie, you must. If the Apostle Paul walked to Rome, you and I can walk to Hanoi, if necessary."[15] And, so, Charlie Crafts kept walking. It wouldn't be the last time that Donald Cook saved his life.

Cook realized that even the strongest of wills would eventually wear down, given years of constant disease and privation. He didn't expect his fellow prisoners to adopt his religious beliefs, nor would he expect a young draftee like Charlie Crafts to adhere strictly to the Code. Donald Cook felt he couldn't consciably deny young men who were facing almost certain death a chance for freedom by ordering them not to sign an antiwar statement.

And so it came to be that, acting as their legal advisors, Cook brokered a release for Charlie Crafts and an Army sergeant named Sammie Womack from Farmville, Virginia, who'd been held prisoner for only four months (Womack would later say that he would have gladly followed the Marine captain into hell "armed only with a water pistol").[16] By parsing each word, Cook ensured that the men's written statements contained just enough to satisfy the Communist Front, but not one syllable more.

Despite all these efforts, Charlie Crafts almost didn't make it, collapsing into a malarial coma before his papers were approved. Again, it was Capt. Donald Cook who saved him, cleaning out the private's airway and carefully nursing him back to health.

On February 16, 1967, Crafts and Womack were set free. At the last moment, Crafts asked the Vietcong to release Capt. Cook instead of himself. Cook refused the offer, citing Article Three of the Code, which states: "I will accept neither parole nor special favors from the enemy."[17]

He did, however, accept a favor from his friend Charlie Crafts. In the lining of his eyeglass case, Charlie smuggled out a letter that Cook wrote to his wife. Knowing that the Vietcong would try to exploit his feelings for his family, he'd refused to sign the Red Cross card that would allow him to get packages from home. This letter was the first time that Laurette would be hearing from him since his capture, and Cook was very aware it might well be the last.

He began by telling her that it was *she* who had borne the worst part of this experience, and that—God willing—he'd make it up to her someday. Cook said that because of her love, and the love of his children, he considered himself the luckiest of men. At the end of the letter he wrote: "Life to me is so simple. There is life, death and

eternity. If we can't save our souls, what good is anything else? I must follow my conscience and my honor and I know you understand no matter what the outcome is."[18]

Douglas Ramsey, the Foreign Service officer who remained a prisoner of war until 1973, bore witness to the last leg of Cook's journey toward eternity. He said that the Marine captain had experienced a relapse of malaria just as the monsoon season was arriving, bringing with it gale-force winds and some of the heaviest rainfalls on record. Food supplies, which were always scarce in the jungle, fell to near-starvation levels. Cook's strong, athletic physique dwindled into a skeletal frame of less than 120 pounds; yet, still, he exuded an air of indomitable confidence. According to Ramsey, "His remarkable composure and peaceful presence seemed to shed a spiritual light in the cage around him."[19]

Even the Vietcong had grudging respect for the tough Marine. When Doug Ramsey fell ill with malaria, they allowed him to move into Cook's cage. For weeks Ramsey hovered near death, while Cook cooled his fevered brow with wet cloths, held his convulsing arms and legs, washed his clothes, and spoon-fed him. "He knew when to pat you on the back," Ramsey said. "And he knew when to kick ass."[20]

Before Ramsey had time to fully recover, Cook's health took a turn for the worse. He'd contracted a deadly form of malaria. The Marine was already in a weakened state, his spleen swollen from chronic disease. He started throwing up live worms. Seeing how serious his condition was, the Vietcong started giving him extra food and medicine for the parasites. Ramsey tried his best to care for him, but Cook just shrugged him away. His gas tank, he said, was almost empty.

No, Ramsey assured him, you're destined to live.

Donald Cook never spoke of dying again. He knew full well that after monsoon season ended, the Vietcong would move camp again, and he attempted to prepare for the ordeal, exercising as best as he could to regain some strength in his wobbly legs. When his food and medicine came back up, Cook would eat his own vomit to survive. His greatest struggle, Cook confided to Ramsey, was putting God and country before the love of family. That was the hardest part, he said, the thing he wrestled with everyday.

The rains stopped, and the Vietcong told the prisoners to pack up their gear. They would be heading northeast to a remote province in the Central Highlands. It was rugged terrain, a challenge for even those in tiptop shape. In their weakened state, Ramsey knew they were beat before they started.

But Cook persevered.

Ramsey watched as—in an act of sheer will—the skeletal Marine pulled himself up the face of a cliff, clawing his way to the top. "Come on, Doug," he called over his shoulder, "If I can make it, you can too."[21] But Ramsey's legs couldn't hold him, and eventually he collapsed to the ground with chest pains.

A decision was made to divide up the group. Ramsey would remain behind with two of the guards until he was well enough to travel. Around noon on November 27, 1967, Cook and Ramsey said their final goodbyes. In a twist of fate, one of Ramsey's guards had met up with a pretty nurse and seemed to be in no rush to leave their temporary camp. The flirtation, which lasted eighteen days, gave Ramsey time enough to recoup his strength, probably saving his life.

When they finally arrived at the new camp, Cook's guards were there, but the captain was nowhere to be seen. In response to Ramsey's questions, the Vietcong replied that Cook had "gone to a camp rather far from here."[22]

Doug Ramsey had lost a friend and his primary source of inspiration. In his testimony to the Medal of Honor review board, he said that the Marine Corps had lost a future commandant.[23]

Donald G. Cook was the first of forty-eight Marines to be taken prisoner in Vietnam, and the only Marine advisor ever captured. He is the first Marine, officer or enlisted, in USMC history to have earned a Medal of Honor for his actions as a POW.

In 1972, the Vietcong released a list of prisoners who died in captivity. The date of Cook's death was given as December 8, 1967; cause of death, malaria. He was thirty-three years old. It's likely that he died in what is now the Bu Gia Map Nature Preserve, but his body has never been recovered.

For years the Marine Corps kept Donald Cook on the rolls, promoting him to colonel so Laurette could collect his pay to raise their four young children. In 1980, he was declared officially dead and awarded the Medal of Honor.

His headstone, filigreed in gold leaf that designates it as belonging to a Medal Honor recipient, lies in Section Ml of Arlington National Cemetery. But his spirit—that uncompromising, indomitable spirit that the Vietcong could never capture—remains in the highlands of Vietnam, where, somewhere on the wind, a strong tenor voice still sings *The Marine Hymn.*

Donald Cook, then a lieutenant: a tough Marine, with a strong moral code and piercing blue eyes that convey both strength and compassion. *Marine Corps photograph*

In Waterhouse's painting of Capt. Donald Cook as a POW, there is that same piercing gaze, but the face is sculpted by suffering. The likeness—and the emotional truth and veracity of this portrait—is haunting. It is as if the artist had channeled the power of Cook's personality. *Art Collection, National Museum of the Marine Corps*

ARMED WITH A SKETCHBOOK
Vietnam: 1967, 1969, and 1971

At the same time that Capt. Cook was working to get his fellow prisoners out of Vietnam, my father was doing everything he could to get there. He was the first civilian the Marines looked at when they were interviewing artists to cover the combat action, and they offered him a real sweetheart of a deal. For the privilege of spending thirty days in a war zone, they would pay for his air transportation and give him a per diem of $9.50—with the understanding that $4.50 would be deducted daily for his food;[24] in exchange, he would be expected to present them with a finished painting or sketch for the Navy and Marine Corps permanent collection.

Oh—and they wanted him to leave immediately.

Except for that last part, my dad thought it sounded great. For over twelve years, he'd been working without the safety net of a regular weekly paycheck, and in order to keep food on the table for his wife and daughters while he was off drawing Marines, he'd have to finish the assignments waiting on his drawing board. With a heavy heart, he passed on that trip, but three months later, when the opportunity arose again, he jumped at the chance.

The year 1967 marked a tipping point in the Vietnam conflict. Although it would be another year before the "most trusted man in America," Walter Cronkite, officially pronounced the war as unwinnable, the grim daily death toll had already become a familiar backdrop to family dinners all across the country. According to polls, nearly half of the electorate disapproved of US involvement. I was fifteen and a sophomore in high school—myopically focused on myself, politically naive, easily swayed by emotion—and when we debated the issue in my social studies class, I found myself vacillating between the compelling arguments presented by the "Dove" side and the knowledge that, at that very moment, my dad was wrapped up in a blanket at home, shivering with fever, suffering the side effects from the malaria shots he'd gotten in preparation for flying to South Asia.

Throughout every step of his career, my father sought my mother's approval before making a move, so agreeing to this monthlong tour of Vietnam would have been a joint decision. To my sister and me, they presented a cheerful united front, underplaying the inherent dangers and doing everything to preserve our sense of normalcy and security. And yet my mom knew my father better than anyone, so she must have realized that he wouldn't be content to draw pictures while sitting safely on the sidelines.

I used to wonder what they said privately in the days before he left, whether they talked about practical things—insurance policies, outstanding bills, and how we'd survive if something happened to him over there—but now I'm guessing that, by tacit agreement, they left those things unsaid. Since surviving Iwo Jima, my father fully believed, with an aggressive optimism, that only nice things would happen to him in his life, and since my mother fully believed in my father, instead of thinking in what-ifs, she was always the first to say, *Sure, Charlie, go for it.*

In February 1967, only a week after Crafts and Womack were released from their jungle hell, combat artist Charles Waterhouse disembarked from a jet in Bien Hoa, South Vietnam. He'd left his New Jersey home in a raging snowstorm, arriving in an alien place of torporific heat where the air was thick with the buzz of incoming mosquitoes and the bang of outgoing artillery. Stopping only long enough in Saigon to get a plague shot, he set off to find the action.

Waterhouse was forty-three years old—nearly twice the average age of the Marines and Navy airmen he encountered—but not so old a dog that he wasn't able to pick up a few new tricks. In short order, he learned to hitchhike, and to run fast enough to jump on and off any number of moving vehicles. For the thirty days that he spent in country, Waterhouse rode on just about anything that would take him: jeeps, trucks, and tanks; fixed-wing planes, helicopters, and Seawolfs; Coast Guard cutters and Higgins boats; and missile cruisers and destroyers.

He flew B-52 missions with SAC over Laos and North Vietnam. He hopped aboard an MSB for a twelve-hour mine sweep patrol down Long Tau River to the South China Sea. He was hoisted up in slings by hovering choppers in the Gulf of Tonkin and launched by catapult from the decks of carriers. In wildly pitching seas, he hung over the rails of a fan deck and was seasick. On an overcrowded medivac flight, he sat on a narrow bench *outside* the chopper, clinging onto a safety belt with his legs dangling free, as it skimmed the treetops and rivers, heading to a hospital in the Iron Triangle. With bleeding hands, and only six usable fingers, he dug his first foxhole since 1945, slept in it for three nights, and was charged a dollar per day for his quarters. He spent a fair amount of time hunkered down in bunkers, waiting in the fetid heat and semidarkness until the last burst of shellfire finally stopped.

He was in his element.

Self-Portrait, in Our Foxhole at the DMZ

The combat artist hunkers down. After digging this foxhole, the government deducted a dollar from Waterhouse's $9.50 per diem for every night he stayed in it. Sketch from *Vietnam Sketches: From the Air, Land and Sea* by Charles Waterhouse (Rutland, VT: Charles E. Tuttle, 1970).

NACAL combat artist Charles Waterhouse, armed with only a sketch kit. *Waterhouse family photograph*

Like any Marine, Waterhouse lived out of a field pack and wore fatigues and jungle boots, but instead of a weapon he carried a map case packed with an array of sketchbooks, a paint set, a cheap plastic camera, and dozes of rolls of film. Unlike the average soldier, sailor, or Marine, who lived and fought in a designated area of the war zone, he could go wherever the winds blew him, from the Mekong delta to the DMZ.

In a Vietnamese hospital run by two American doctors in Rach Gia, not far from the Cambodian border, Waterhouse was asked to bring his sketchbook into the operating room. The Americans were being evacuated soon, and the doctors wanted to leave illustrated step-by-step instructions to help their Vietnamese counterparts perform the cleft palate surgery that was needed by so many of the children in the villages. After observing the procedure and making sketches, Waterhouse sat on the floor of the hospital and drew pictures of the young patients in the ward. "They had never seen an artist before," he wrote. "They hung all over me, and, for a little while I made them happy."

Everywhere he went he drew pictures, using quick, fluid lines and sometimes shaky-handed scribbles, to depict everyday scenes of people who were doing their best to fight—or simply live through—a brutal war.

My father came back from his first tour of Vietnam twenty-two pounds lighter, with thirty rolls of undeveloped film, a sea bag stuffed with goodies from the PX in Japan—a set of Noritake china for my mother, two elaborately dressed samurai and geisha figures, embroidered kimonos, and a pair of state-of-the-art (circa 1967) reel-to-reel tape decks for my sister and me—and over 473 sketches that he'd made, working fast, often under fire, to faithfully capture the people, places,

Vietnamese women waiting at a checkpoint in Dung Lai. *From the private collection of Jane Waterhouse and Amy Lotano*

Vietnamese boy. A simmering, wary distrust seems to linger in the air between artist and subject. *From the private collection of Jane Waterhouse and Amy Lotano*

The handwritten note at the bottom of this sketch by Waterhouse reads: "Dummy stick restaurant: I never had nerve enough to try the food." *From the private collection of Jane Waterhouse and Amy Lotano*

Cyclo Sacktime in one of the back alleys of Saigon near airfield. The artist added, "The only time you can relax in one of these." *From the private collection of Jane Waterhouse and Amy Lotano*

Dear Ma, We Got Mortared Last Night. In *Delta to DMZ,* Waterhouse noted, "This original sketch was drawn in the Rung Sat zone of the Delta. They were mortared just before I arrived and just after I left." *Navy Art Collection*

Color study from a sketch made in I Corps. *Navy Art Collection*

Ticket Home. Sketch. The litter-bearers carry the casualty; the corpsman holds the plasma bottle. *Navy Art Collection*

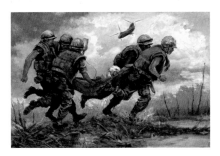

Ticket Home. Painting. Sometimes Waterhouse would turn his on-the-spot sketches into finished pieces. *Art Collection, National Museum of the Marine Corps*

and events, refining them late at night in his bunker, sometimes even in the head. These sketches would become the raw material for scores of fully rendered pen-and-ink illustrations and dozens of oil paintings, which were gifted by the artist to the Navy and Marine collection.[25]

Even by the standards of the day, what remained from his per diem (in total, after food and foxhole deductions, Waterhouse earned $147 for his monthlong tour of duty as a combat artist) wouldn't stretch too far, so he quickly jumped back into freelance work to make up for lost time. According to his records, during the two-year period between his first and second combat tours, my father created over 165 illustrations, 150 spot drawings, at least twenty-five full-color paintings, and eighteen book jackets.[26] By 1969, American troop levels in Vietnam were at their peak, and the death toll had officially exceeded that of the Korean War. Richard Nixon had campaigned his way into the White House by advocating "peace with honor," but the beginning of the end of this war would turn out to be protracted, bitterly fought, and bloody—and once again the Navy and Marines were looking for an artist to visually chronicle it. The opportunity to witness history unfolding was like a clarion call to my father.

Since his last trip to Vietnam, my gawky adolescent sister had blossomed into a slender, long-legged teenager. I was a junior in high school, and while I sometimes argued against the war at the dinner table, the extent of my pacifism was wearing a black armband that an actor had tied on my arm during an amateur production of *Hair*. I thought it looked cool, and the actor was cute, so I kept it on for about a week. The thought of my father once again putting on his jungle utilities scared me less this time around, maybe because the Vietnam I'd seen in my dad's artwork and heard about in his funny, self-deprecating stories seemed so far removed from the place where all the violence and atrocities were being committed—the Vietnam that we heard about on television every night.

I didn't realize how real the danger was until after his death, when my sister and I found a sheaf of notes, written not in my father's neat, distinctive printing, but in a wobbly cursive we barely recognized. These notes had been jotted down in real time over the course of a night patrol through the hilly roads outside Da Nang. The narrative is hard to follow, with stop-and-start phrases that turn and twist across the page.

On a separate sheet of paper, obviously written several hours later, my father tried to describe the events of this particular evening again, but while the second account provides more detail, it lacks the urgency of the scribbles made in situ, when the outcome and the artist's survival still hung in the balance. This transcription combines elements of both:

I'm huddled in the rear seat of a Jeep driven by two armed MPs, hunkered down next to some ammo boxes and gear. It's long after curfew and we're bumping along the rut-packed road. A cool breeze propels tendrils of scudding clouds over and beyond the full moon, alternately revealing and concealing the heavy tropical vegetation. Our mission is to zip back and forth along the road to spot any VC activity. We have just been fired at as we raced down the bumpy surface of a mountain road in a pass, 7,000 feet up in the hills to the north of Danang. The silent, helmeted figures of the MPs in the front seat are holding the stanchion of an M60 machine gun. I'm clutching my sketch kit. This is supposed to be my last day in country before flying out to the fleet in the Gulf of Tonkin. My sweat-

dampened clothing feels clammy and chilly. I feel an overpowering surge of homesickness for my wife and daughters, and my comfortable studio. What the hell am I doing here?

Every two or three minutes we have to swerve over to the side of the road to one of the innumerable streamlets of water splashing down from the rocks above, while one of the MPs dashes out to scoop up a helmet full of water to pour into the steaming radiator of our Jeep—a bit like the Keystone Kops, like all war. In motion you are a hard target, but on these halts the sitting-duck feeling sets in.

Just down the road, a more violent explosion shatters the air. *Oh-oh, this time it's for real.* They are set to hit the convoy hard. At the moment of impact we had just rounded another horseshoe curve on two wheels and were protected by the solid-rock mountainside. As we screech to a stop and turn back, I wait for the chatter of small arms and more grenades— it could have been a rocket this time. I'd like to wipe the sweat out of my eyes but don't want the fragment dust from the grenades to get in them. We are due to overheat again, and I dread the few moments to dash over to a spurting stream, fill a helmet, and splash it into the steaming radiator. While the MPs perform this job, I scan the rocks and brush above us for any movement, leaning on the grips of the M60 machine gun, which is frozen in position, sweat-soaked in silence. I can fire this thing if I need to, but there's a locked nut on the mount and I can't find the tire wrench that was used to lock the gun in position. I kick the metal boxes of machine gun ammo out of the way and feel for it with my free hand amid the assorted gear. I fumble in back of, and in between, the seats in front of me. Kick it several times.

At the next stop for water we get a rock and try to loosen the nut. This results in a few bruised fingers, much rock dust and fragments, and no visible change in the mobility of the gun—we can't see any targets anyway and must keep moving. Leaning on it doesn't help either. There seems to be a lot of swearing going on, and I find I am doing most of it—and the portion of it that isn't directed at myself is dedicated to the GI who locked this gun in place.

At last we pull over as the wrecker roars down the road accompanied by another MP jeep, which stops to let us borrow their tire iron and finally get the stubborn locking nut loose. Now the gun can be moved in any direction and we have reinforcements. We still can't see any target and have drawn no more fire, but a free-swinging M60 improves my morale.[27]

My father served his last tour of duty as a Vietnam combat artist during the summer months of 1971. He was pushing fifty by then, and my mother felt he was also pushing his luck, but he promised her that he wouldn't play Marine this time: except for a few advisors who'd stayed behind to train the South Vietnamese, the Marines had all been pulled out. That seemed to reassure my mom. She didn't realize that with the Marines had gone the last shreds of order and security. On this last trip, my dad would be ambushed by a group of lawless "Honda cowboys," narrowly escape a Vietcong staging area by careening in a speeding Jeep down a 12-foot embankment, and spend several sweltering hours hunkering down in a bunker with rockets bursting overhead.

No matter how many tight situations Charles Waterhouse encountered as a combat artist, they paled in comparison with the day-to-day dangers faced by the American Marines, Navy personnel, and soldiers who served in the Vietnam War. Those who were lucky

enough to survive came back forever changed, only to find that instead of being lauded for their service, they were more often regarded as unwelcome reminders of an unpopular war.

Fifty-seven Marines and fifteen Navy hospital corpsmen were awarded the Medal of Honor for their actions in Vietnam. Their citations read like a litany of personal sacrifice—they died smothering grenades, using their bodies as shields, rescuing fallen comrades, providing medical service to the fallen, holding back enemy forces so that their platoon mates could escape, and exemplifying honor and courage as prisoners of war. One Marine, Capt. Jay R. Vargas, requested that his mother's name be engraved on the medal and added to the rolls.

We're not quite sure how many sketches my father made during the 1969 and 1971 trips. In 1967, he came back with 473, so one could probably assume, over his three tours, the tally must be close to a thousand, but it's a bit like estimating how many of the enemy that Hector Cafferata shot that night on Fox Hill—the actual number would be so high, no one would believe it.

I have a master of fine arts degree in theater, so maybe it should come as no surprise that, in reflecting back at the pivotal moments of my father's life, I get the sense of Unseen Hand working behind the curtain, clearing the decks and putting all the pieces in place for the next scene. In dramatic terminology this is known as an *entre'acte*—a transition that takes the action from one point to the next by providing the missing links needed to forward the plot.

The year 1971 was one of those times.

To begin with, my sister, Amy, fell in love. On a class trip to the Franklin Institute in Philadelphia, as she was climbing through a 12-foot-high model of the human heart, she locked eyes with a boy named Gary Lotano. Although they were both sophomores, their paths hadn't crossed before: she was on the college track and—to hear him tell it—he was on the fast track to a lot of trouble. A sepia-tone picture strip taken that day shows them crammed into a photo booth with several other classmates. In the next frame, it's just Amy and Gary. He's looking at my sister. Her face is tilted ever so slightly in his direction. The electricity in the air around them is so tangible, there's a sense that the kids in the first frame have spontaneously combusted from the heat.

Some parents might not be overly thrilled to learn that their daughter has fallen head over heels with the class bad boy, but from the moment Gary Lotano first swung into our house with a pair of crutches and a phony leg cast (he thought that would help make this first meeting memorable), he pretty much had us all at hello. Despite his mischievous streak, it was clear that this young man was hardworking, faith filled, family oriented, fiercely loyal, and funny—qualities that my parents deeply valued; what's more, he possessed a self-assured confidence that was rare in someone his age.

Surprised to discover that Amy's artist father was working in a cramped, poorly lit attic, Gary promptly offered to build an addition onto the back of our home that could serve as a large, bright, functional studio space. It didn't faze my dad that the architect and constructor of his future studio was a sixteen-year-old kid who'd never built anything outside wood shop class. He recognized in Gary the same drive and determination that had helped him chase his own dreams.

My father's unconditional belief in his future son-in-law would be repaid, time and again. When he needed a place to work, Gary built him a studio. When he needed a place to exhibit his paintings and create more of them, Gary built him a museum. And when my parents needed a place where they could comfortably live out their days, Gary built a wing onto my sister's dream house.

The new studio was completed in the early fall of 1971. Gary had proved that he could be a fine builder, and he won the admiration and enduring love of the entire Waterhouse family. He didn't realize then that in the process, he'd built a post of the Marine Corps that, very shortly, would see a lot of action.

Before leaving for his final trip to Vietnam, my father had delivered a full-color painting depicting George Washington's historic march to Trenton for a Rutgers University Press publication titled *New Jersey: The Crossroads of Freedom*. Working in oil on canvas, he created a dramatic composition that was a reflection of his Brandywine heritage, and, at the same time, a "genuine Charles Waterhouse."

Around the same time that the studio was being built, a proof of *George Washington's March to Trenton* ended up on the desk of the director of Marine Corps History and Museums, retired brigadier general Edwin H. Simmons. Also on the general's desk was a manuscript for a carefully researched history on the role played by the Continental Marines in the American Revolution. The book would be the Marine Corps' special anniversary gift to the nation on the occasion of the upcoming bicentennial. It was a story that had been waiting to be told for 200 years—a story that needed to be fully illustrated in order to fully come alive.

The general tapped his index finger on Waterhouse's painting. "Get this man," he told his assistant.

Cover for *New Jersey: The Crossroads of Freedom* by Charles Waterhouse, Rutgers University Press. *From the private collection of Amy and Gary Lotano*

A call came almost immediately from Marine Corps headquarters. The Marines wanted Waterhouse to paint a series of fourteen large paintings for a book called *Marines in the Revolution*. His paintings would be exhibited in major cities around the country during the yearlong bicentennial celebrations. There was only one catch: the only way they could pay for Waterhouse's work would be by putting him on active duty.

"I'm sorry, sir," the apologetic voice on the phone said, "but we can only make you a major."[28]

My father been discharged from the USMC in 1946 as a corporal. A quarter of a century later, they wanted to bring him back as a *major*. He would often joke that in the annals of military history, the only other corporals to get such a big promotion were Napoleon and Hitler—adding proudly, *and they weren't Marines*.

The most amazing thing of all was, this time around he wouldn't have to dig foxholes or carry a weapon.

All he had to do was paint. Paint his heart and soul out.

ARTIST IN RESIDENCE
1973–1991

"Prayer to God for these blessings and for continued favor and help to prove worthy of these gifts—a measure of talent sufficient. . . . As everything must at times the euphoric feelings are balanced by periods of depressions as knowledge of shortcomings and difficult pictures and production problems build up as tensions and deadlines approach."

—Excerpt from Waterhouse's journal, 1973

On January 9, 1973, the newly minted Maj. Charles Waterhouse accepted a nine-month active-duty commission to produce a series of paintings for *Marines in the Revolution*. The book, commemorating the founding of the Continental Marines on November 10, 1775, would be published to coincide with the American bicentennial. Not only would the artist be wrestling the mother of all deadlines—fourteen major works in less than a year—the assignment came with a rigorous set of strictures.

The paintings were to be of museum quality—monumental in scale and in style reminiscent of the historic realism exhibited in the Paris Salon and Royal Academy. Each panel had to possess the power and appeal of a stand-alone, while cohesively working together as a group when displayed as a series. From a purely technical perspective, all of the compositions had to function as two-page spreads in the book *Marines and the Revolution*; specifically, that meant each picture must be oriented horizontally and designed as though an imaginary seam line ran down its center. Because they would also appear on magazine covers and publications during the bicentennial, the upper-right quadrant of the paintings should be composed with a magazine's masthead in mind.

All of the paintings had to pass the muster of "the Committee"—a panel of historical experts, researchers, writers, and designers that would check to ensure that uniforms were accurately rendered down to the last buckle and button, and that every musket, brig, barge, and frigate was authentic. The time of day, year, and weather conditions, as well as the environmental features, topography, flora,

and fauna of the locations had to be factually verified. Portrayals of historic figures were to be based on existing portraits, or contemporaneous accounts that described the person's physical attributes and bearing. In addition, museum director Brig. Gen. Edwin Simmons instructed the artist that each of his paintings must be able to tell fifty discernible stories.

For the last twenty-three years, Charlie Waterhouse had been meeting the demands of the toughest art directors in the business. He did not hesitate. He just got to work.

In faded ink, on a tattered old file folder, my father wrote, "Art is putting life into space." The presence of quotation marks suggests that this was something he'd heard from Joe Kidd or Bill Aylward or read about in the teachings of Howard Pyle or Harvey Dunn. It might have even come from one of the Old Masters. It doesn't matter who first said it; they all lived it. And now it was his turn.

For the next nine months, his job was to fill a 4-by-5-foot Masonite panel with as much life as it could hold, and then repeat the process thirteen times. Pyle would always tell his students, "Throw your heart into the picture and then jump in after it."[1] But before he could do that, Waterhouse had to dive headfirst into the early history of the Marine Corps. Charles R. Smith's text for *Marines in the Revolution* provided him with the big-picture story; for the finer details, he devoured thousands of pages of research material and liberally drew upon primary sources from the National Archives, including military records, maps, naval and maritime documents, and the private journals and letters of Revolutionary War Marines.

Instead of just taking notes, Waterhouse made sketches—hundreds of quick drawings of figures standing, sitting, crouching, fighting, rowing, running, or firing weapons. Some of these were little more than loose squiggles made with a felt-tip pen. Others were finely drawn in pencil, then overlaid in ink. For the artist, it was all part of the casting process, to determine which of these characters might have what it takes to play a part in the picture that was starting to take form in his head.

Working in much the same manner that classically trained artists such as Leonardo da Vinci and Michelangelo have used since the Renaissance, Waterhouse created a "cartoon" on tracing paper, cutting out figures from his sketches like paper dolls, moving them around, arranging them in groups, and filling in the extra players until he was satisfied with the overall composition. This cartoon became his master sketch. Only when it was approved by the higher-ups at the Marine Corps museum could he begin painting.

The first step of the painting process was to apply several coats of gesso to the Masonite panel. Next, the board was given a wash of

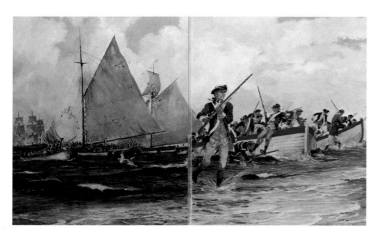

The paintings for *Marines in the Revolution* had to function as double-page spreads in publications. *Art Collection, National Museum of the Marine Corps*

color that evoked the mood and established the tonal values of the piece. Then, as Pyle taught and others had done before him, Waterhouse proceeded to throw his whole heart into the empty space that needed to be filled with life, and jump in after it with both feet. While he had the full support of the staff at the museum and the author's text to guide him, when it came to filling up those empty spaces with life, he was on his own.

And yet he wasn't. Because, in a way, they were all in that studio with him—his early combat artist heroes, Thomason and Dickson, Delacroix, Gericault, and the great military artists of the past, as well as the kindly Red Cross volunteer who first encouraged him to pick up a paintbrush, and his mentors, teachers, and Brandywine predecessors—the entire unbroken chain of picture makers to which he was linked.

On the tough days, they whispered in his ear. "*The characters in your pictures have had a past and will have a future,*" Howard Pyle reminded him. "*Think of that! You have caught a moment in some lives, but there have been moments before and some will come after—feel as if you could tell their past history and their future.*"[2]

The translucent sails of Mr. Aylward's earnest letters unfurled in his memory, piloting him forward. *Always remember your light source . . . It requires imagination to make a thing appear to exist which really only exists in the artist's mind . . . Be a genuine Charles Waterhouse.*[3]

And wherever he turned, Joe Kidd was there, blowing smoke at him. "You know the history; now do something with it! Make a picture, for crying out loud!" Or, when the doubts set in and the difficulties and deadlines seemed insurmountable—"Shut up and paint, Charlie. Just shut up and paint."[4]

Waterhouse worked up to sixteen hours a day, seven days a week, filling those blank panels with 273 fully realized characters, each having a unique past, present and future: more than a hundred background figures, thirty sailing vessels, seventy muskets and rifles, nine cannons, and six dogs. He also created seventy line illustrations that appeared as chapter headings and illustrations in the published book.

As their special bicentennial gift to the nation, the United States Marine Corps presented the National Park Service with a long-term loan of the fourteen *Marines in the Revolution* paintings for display at New Hall Military Museum in the historical Independence Hall district of Philadelphia, where thousands of Americans, and tourists from all over the world, could see them.

Maj. Waterhouse and wife, Barbara (*fourth from left*), attend an exhibition of *Marines in the Revolution* at the Society of Illustrators in New York City, in 1975. *Waterhouse family photograph*

The artist and his proud daughter Jane. *Waterhouse family photograph*

In the words of museum director Brig. Gen Edwin Simmons: "Waterhouse's art took the Marine Corps community by storm."[5] Then Secretary of the Navy J. William Middendorf, a connoisseur of the old Dutch Masters, was thrilled with Waterhouse's classical approach.[6] To average Marines, Waterhouse unofficially became "their Rockwell." But it wasn't just the military community that was talking. Renowned author and historian William Manchester said that Waterhouse's paintings were "masterpieces,"[7] and American illustration authority Walt Reed proclaimed that he was "following in the footsteps of Howard Pyle, Harvey Dunn, and N. C. Wyeth."[8]

The Marines decided they wanted Waterhouse as their artist in residence, and for the next eighteen years they kept him painting their history, promoting him through the ranks—from major to lieutenant colonel and eventually to colonel, even obtaining special congressional legislation in order to retain him after he turned sixty-five, so that he could complete a full twenty years of service. By then

Maj. Waterhouse in the studio built by his son-in-law Gary Lotano.

the artist had completed over 160 paintings for the USMC collection, depicting every campaign in the history of the Corps from its inception through Operation Iraqi Freedom. Examples of his work could be seen in major museums, galleries, and exhibitions around the country; on battleships and missile cruisers; on television shows; in private collections; and even orbiting the earth on a T-shirt worn by a crew member of the space shuttle.

In a letter to former commandant Gen. Wallace M. Greene, Waterhouse wrote: "I look upon my assignment as Artist in Residence US Marine Corps, not as a job, rather a Mission."[9] Part of that mission, in his mind, was to visually memorialize the legendary figures of the Corps, and those whose courageous actions had led to them receiving the Medal of Honor. During his artist-in-residence years, Waterhouse would paint many of these men, including the first and "the fightingest."[10]

THE FIRST: CPL. JOHN F. MACKIE, USMC
The Battle of Drewry's Bluff, May 15, 1862

The sleepless king in Shakespeare's *Henry IV, Part II*, paces his chamber, anguishing over the outcome of the civil war tearing his kingdom apart. "O God!" Henry rails, "That one might read the book of fate." But, thinking it through, he relents, saying that were it possible to foresee the perils and struggles ahead of us, even the happiest of men would likely "shut the book, and sit him down and die."

Abraham Lincoln suffered through many such sleepless nights. In the early hours of May 15, 1862, the care-ridden president was pacing the floors of the White House, waiting to hear word on the outcome of a naval battle that he believed (and most historians concur) could put an end to the Civil War.

A small Union navy flotilla made up of a two wooden hull ships and three ironclads—the *Galena*, the *Naugatuck*, and the famous USS *Monitor*—was heading down the James River in Virginia, on its way to attack the rebel stronghold of Fort Darling on Drewry's Bluff, which guarded the estuary that led to the Confederate capital. After securing the fort, Lincoln had given the fleet orders "to proceed to Richmond and shell that city into surrender"[11]—fully expecting that Gen. George B. McClellan and his 100,000-man army would by then be in position to launch a simultaneous land assault on the seat of Jefferson Davis's government.

Had Lincoln been able to foresee the coming events, it would surely have driven him to despair. Because, instead of quickly marching down the Virginia peninsula, Gen. McClellan (aptly nicknamed the Virginia Creeper) was mired in an unnecessary siege at Yorktown; meanwhile, a large rebel force had gathered at Fort Darling in a last-ditch stand to defend the capital. At that moment, Confederate marines and snipers were manning the guns on Drewry's Bluff, just waiting for the Union navy to round the sharp bend that led to the river's mouth, and into the jaws of the enemy.

Henry IV was right: if Lincoln had known that the failed opportunities of this day would result in the Civil War dragging on for three more bloody years, it might have been beyond his bearing.

The Battle of Drewry's Bluff has the grim distinction of being the only time in Marine Corps history that US Marines fought former Marines in direct combat. For the Union side, it would prove to be a rout. With up to fourteen big guns in place on the fortified ramparts, and more than 200 Marines in rifle pits on both sides of the river, all

the Confederates had to do was wait until their vessels emerged into the basin below the bluff, and then pick them off like sitting ducks.[12]

They hit the *Naugatuck* first, blasting its deck into smithereens and forcing the ironclad to skulk ignominiously out of range. In short order, the two wooden hull ships were torched like kindling. The mighty *Monitor*, unable sufficiently to elevate its guns to return fire to the shore, floundered around impotently. Of the ironclads, only the *Galena* remained, but it lacked the *Monitor*'s thick iron sheathing, and the merciless rebel fire pierced its armor plating as if it were paper.[13]

Undeterred, a young corporal of the Marine guard named John Mackie repeatedly stuck his neck out of the battered gunports to take aim at his brothers in gray onshore. Then disaster struck—a 10-inch enemy round tore into the *Galena*'s armor belt, smashing one of the Parrot guns and annihilating its gunnery crew. The ship's assistant surgeon described the scene as a "perfect slaughterhouse."[14]

With the commander injured and the guns unmanned, all appeared to be lost. Then a voice rang out above the chaos. "Come on, boys!" Cpl. Mackie shouted. "Here's a chance for the Marines!"[15]

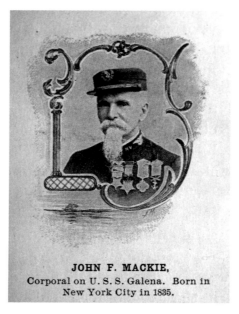

JOHN F. MACKIE, Corporal on U. S. S. Galena. Born in New York City in 1835.

Sgt. John Freeman Mackie in later life, proudly wearing his medals. *Official Marine Corps photograph*

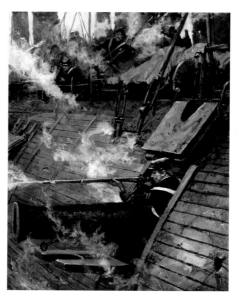

Cpl. John Mackie, USMC, by Col. Charles Waterhouse. The first Marine Medal of Honor recipient takes aim and goes down in history. *Art Collection, National Museum of the Marine Corps*

The Marines on the *Galena* fought fiercely for over four hours until their last round of ammunition was gone and the commander was forced to steer the ship out of range. When President Lincoln boarded the ship to inspect the damage, he told the assembled crew, "I cannot understand how any of you escaped alive."[16]

For his actions, Cpl. John Mackie became the first Marine to earn the Medal of Honor. As Commodore Percival Drayton was hanging the ribbon around his neck, he said, "Sergeant, I would give a stripe off my sleeves to get one of those in the manner as you got that."[17]

Grainy photographs of John Mackie taken after the war show a dignified old man with a bristly white goatee and mustache posing in a beribboned Union uniform and oak-leafed cap. In his painting, Waterhouse captures Mackie as a young corporal, rising out of the shell-pocked gunport, caught in the very instant of firing.

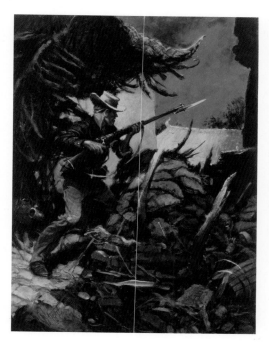

Pvt. Daniel Joseph Daly, USMC, The Battle of Peking, China, 14 August 1900 by Col. Charles Waterhouse. Daly received his first Medal of Honor for his actions during the Boxer Rebellion. *Art Collection, National Museum of the Marine Corps*

THE FIGHTINGEST: SGT. DAN DALY, USMC
Boxer Rebellion, Banana Wars, and Belleau Wood, 1900–1918

He was a Marine's Marine—a character worthy of those blood, guts, and glory tales that Charlie Waterhouse couldn't get enough of as a kid. The Chinese who encountered him during the Boxer Rebellion called him *Quon Fay*, which means "Very bad devil."[18] To the Germans in Belleau Wood, he was a *Teufel Hund*, or devil dog.[19] Maj. Gen. Smedley Butler—himself a legend of the Corps—said he was "the fightingest Marine I ever knew."[20]

He had a face that only a mother could love; yet, if ever there were a poster child for one of Col. Waterhouse's paintings, it was Dan Daly. Standing tall at 5 foot 6, and weighing less than 135 pounds soaking wet, Daly had been an amateur pugilist in his hometown of Glen Cove, New York, before enlisting in the Marine Corps in 1899—a tad too late to help Teddy Roosevelt ride roughshod through the Spanish-American War. After boot camp, Daly was shipped to Peking, China, as part of a small contingent of Marines charged with protecting the US embassy during an epic fifty-five-day siege by the fiercely anti-Western Boxer insurgents.

In order to buy time for his fellow Marines to consolidate their defensives, Pvt. Daly volunteered to assume a post on the dangerously exposed ramparts of the Tartar Wall, acting as a one-man point of resistance between the American line and the Chinese onslaught.

Armed with only a bolt-action rifle and a bayonet, Daly spent the night alone on the wall, fighting off continuous bull-rush assaults by roving bands of attackers. Legend has it that when reinforcements arrived at dawn, the area in the front of the Tartar Wall was littered with the corpses of 200 Boxers.[21] While this may be a slight overstatement, it's closer to the truth than the tersely worded citation for Daly's first Medal of Honor:

In the presence of the enemy during the battle of Peking, China, August 14, 1900, Daly distinguished himself by meritorious conduct.

More would be written on his next one.

Fifteen years later, Sgt. Dan Daly found himself in the middle of another insurgency during the Banana Wars in Haiti. Daly was leading a reconnaissance patrol of mounted Marines through the jungles, in a search for the rebel strongholds that were threatening to undermine the American-backed Haitian government. Just as

they were about to cross a river, a band of 400 Caco outlaws ambushed them. The Marines splashed and struggled through the water, with bullets whizzing over their heads. All of them made it to the opposite shore, but they'd lost twelve horses, and the mule carrying the only machine gun, in the process.

The sergeant brought his men to higher ground, pulling them into a tight perimeter so they'd be ready for the next attack. They were greatly outnumbered and Daly knew that in order to survive, they'd need that machine gun. He waited for cover of night, then slipped outside the Marine lines and headed back to the water, silently knifing the bandits he found lying in wait along the way. The jungle at night was dark as pitch, the river like a sea of black ink; Daly dove

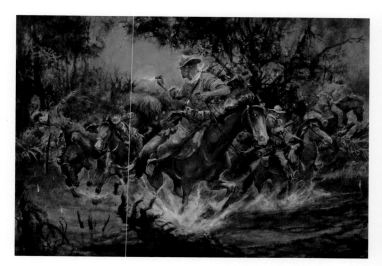

Gy. Sgt. Daniel Joseph Daly, USMC, Fort Liberté, Haiti, 24 October 1915 by Col. Charles Waterhouse. Although Waterhouse prided himself on painting real people—not perfectly starched heroic types—it's interesting that in these two Medal of Honor paintings of Daly, he's depicted in profile, looking back over his shoulder. In both pictures, Daly is shown in a position of towering strength that belies his small, wiry frame. *Art Collection, National Museum of the Marine Corps*

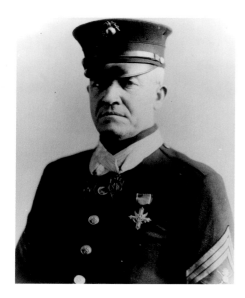

Sgt. Maj. Daniel Joseph Daily, USMC. A face that only a mother could love, but a great Marine. *Official Marine Corps photograph*

Americans owned two-thirds of the woods and had managed to crush what some had deemed as an unstoppable storm trooper offensive. Daly is credited with capturing thirteen Germans over the course of that single day's fighting.

On June 26, 1918, the commander of the 4th Marine Brigade sent a message to his division commander: "Woods now US Marine Corps entirely."[24]

Belleau Wood gained a new name in French official papers: Bois de la Brigade de Marine, in honor of men such as Dan Daly.

For his actions at the Battle of Belleau Wood, Daly was recommended for his third Medal of Honor. Someone in the chain of command couldn't accept the idea of anyone having three such medals, so instead he was awarded the Distinguished Service Cross, and later the Navy Cross, along with France's Medaille Militaire. It was all the same to Daly. He didn't do it for the medals, which he called "a lot of foolishness."[25] He did it because he loved being a Marine.

COMING FULL CIRCLE
Special Exhibits Gallery, USMC
Washington, DC, February 19, 1991

Forty-six years to the day after landing as a nineteen-year-old Marine PFC in the first-wave assault on Iwo Jima, Col. Charles Waterhouse retired from active duty in a formal ceremony held in Washington, DC, attended by family, friends, and members of the museum staff. He stood on the dais—beaming and resplendent in his dress blues—as the then commandant, Gen. Alfred M. Gray, presented him with a Legion of Merit, signed by the president of the United States, and the Marine Corps Historical Foundation's Distinguished Service Award. Once the formalities were over, the guests were invited to continue the celebration at the opening of a retrospective of Waterhouse's work in the Special Exhibits Gallery of the museum.

A white-gloved Marine, who looked like he'd stepped out of a recruitment poster, offered me his arm, and we exchanged pleasantries as he officially escorted me into the event. And, suddenly, whatever I was saying to him went out of my head.

I'd attended dozens of my father's exhibitions before. I'd had a ringside seat to his artist in residency, watching every painting grow from a set of squiggles on a piece of paper into a finished work on his easel. I was there when each of the major Marine Corps series made its debut. But until I saw them all together like this, I'd never fully appreciated the scope and magnitude of what my dad had accomplished over the nearly two decades of his active service. The museum had billed this exhibit as the largest collection of his work ever assembled.

For me, it was like a family reunion.

Everywhere I looked, I saw faces I recognized. The effete fellow in the powdered wig and cerulean blue coat, looking so out of place in the line of first recruits, staring out from the picture as if to say, *What have I gotten myself into?* The Continental Marine raising the flag at New Providence who looks like the old actor Wallace Beery. The Shawnee shooting a scowl over his shoulder as his fellow braves edge their canoe up a Marine gunboat on the Ohio River. The poor fallen horse in the lower-right corner of the Lancer charge at San Pascal, whose one terrified eye, in the throes of death, reflects the horrors of battle.

in, with only his hands and the intermittent light from enemy fire to guide him through the murky depths. After several tries, he finally located the dead mule floating near the opposite bank.

The bullheaded, 130-odd-pound sergeant detached the machine gun and ammunition and strapped them to his back; he then proceeded to lug this 200-pound load back through the enemy-infiltrated jungle to his men. By dawn, the machine gun had been assembled and emplaced, and the Marines were ready to turn the tables on the Cacos.[22]

For his actions in Haiti, Dan Daly would earn a second Medal of Honor. But he wasn't done yet.

When the US entered the First World War, Dan Daly couldn't stay away. In June 1918, the Marines were engaged in a battle of epic proportions in a square mile of shattered trees and boulders called Belleau Wood, where over and over again, the crusty forty-four-year-old sergeant would risk his life. At one point, while leading a counterattack with rifles and bayonets, he urged his men forward with this now-famous line: "Come on, you sons of bitches; do you want to live forever?"[23]

For over a thousand Marines, hope of eternal life on this earth would end in the ensuing hand-to-hand battle, but by nightfall, the

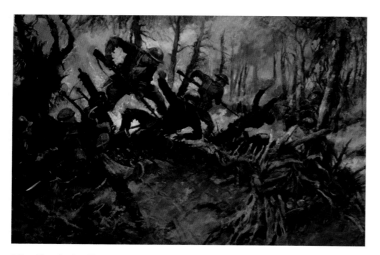

The Battle for Belleau Wood by Col. Charles Waterhouse. It was here that Daly was said to have spurred on his men with the famous line "Come on, you sons of bitches, do you want to live forever?" *Art Collection, National Museum of the Marine Corps*

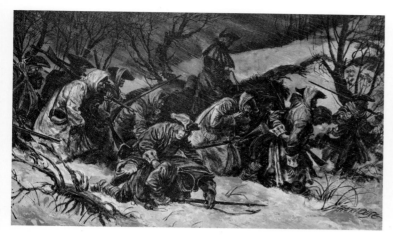

Washington's March to Trenton, duotone illustration by Charles Waterhouse for a 1969 Bell Telephone publication *Tel-news. From the private collection of Amy and Gary Lotano*

Marines with Washington at Princeton by Maj. Charles Waterhouse, *Marines in the Revolution* series. *Art Collection, National Museum of the Marine Corps*

1969 illustration for Bell Telephone publication *Tel-news*, by Charles Waterhouse. *From the private collection of Amy and Gary Lotano*

Lancers at La Mesa by Lt. Col. Charles Waterhouse, Marines in the "Conquest of California" series. *Art Collection, National Museum of the Marine Corps*

Hatfields and the McCoys, 1965 illustration by Charles Waterhouse. Early on, Waterhouse exhibits his skill at populating a crowd scene with interesting characters. *From the private collection of Amy and Gary Lotano*

John Brown's Raid at Harper's Ferry by Col Charles Waterhouse, 1980. Waterhouse takes his skill to the next level with a monumental painting that features over 100 fully realized figures, including accurate portraits of Jeb Stuart, Robert E. Lee, USMC Lt. Israel Green, and John Brown. *Art Collection, National Museum of the Marine Corps*

Among them, I saw people I actually *knew*. The pretty little flower girl lifting the hem of her gown to curtsy at Commandant Archibald Henderson on the occasion of his 1838 wedding was my niece Noelle. My brother-in-law Gary was everywhere—charging up hills, loading ammunition, and firing muskets.

Some of these paintings had lived in my father's studio for months. Others I could only recollect seeing once or twice before they moved into the Marines Corps' collection, but that was partly because, over the years, my sister and I had moved on too. I was in college when my dad accepted his first commission, and Amy and Gary were still in high school. Now they were married with two children, and I was a single working mother with a three-year-old son. Another generation was counting the dogs in our father's pictures, scouring every painted inch to find the *CW*s and *Waterhouse*s that he hid so cunningly in the folds of a jacket or the stump of a tree, in lush foliage, on trampled snow and spuming waves. They had never known Grandpa Kernel before he was Col. Charles Waterhouse, USMC artist in residence. But I had.

Walking through the retrospective exhibit that night, it hit me what a quantum leap my father had made, from illustrator to artist in residence. A leap—not just stylistically, but substantially—that becomes even more apparent when one compares the work he'd been doing only a short time before, with the paintings he created for the Marine Corps.

At one point during that evening, I remember Amy and I both looked at each other and uttered the same word: *amazing*. Neither of us could imagine a more-fitting finale.

But that's not how my father saw it. Because, for him, retirement simply meant he'd have more time to paint Marines, and now that headquarters wasn't assigning him a specific subject to paint, he had free-range access to every period in Marine Corps history.

We didn't know it then, but the 160 paintings in this retrospective would represent less than a third of his legacy to the Corps.

THE MUSEUM PIECE

At age seventy-four, Charles Waterhouse was working at much the same pace that he had before his retirement, although he allowed himself the luxury of a midday nap between his marathon sessions at the easel. One hot July afternoon in 1998 while he was taking his daily snooze, a sudden stabbing pain in the ball of his thumb jolted him awake; when it went away as soon as it started, he fell back into a drowsy sleep.

Then it happened again.

This time, it felt like a dental pick prodding the exposed nerve of a tooth. He lifted his left hand and was amazed to see the thumb jerking wildly, the same way it had just after he'd been shot. He called out, "Bobbie, come in here quick—"

My mother rushed into the room. "What's the matter?" she asked anxiously. "Is something happening?"

"Yes," my father replied, in a voice choked with emotion. "Look at this."

He crossed the fingers of his left hand—the pointer with the middle, the ring with the pinkie—uncrossing and crossing them again, smiling with childlike delight at his own dexterity. It was something he hadn't been able to do since 1945. Then he reached over and touched my mother's face. "I feel it," he said, pinching her cheek. "I feel it."

"There are only two ways to live your life," said Albert Einstein. "One is as though nothing is a miracle. The other is as though everything is a miracle."

Did the restoration of movement and feeling to Waterhouse's fingers fifty-four years after they were rendered lifeless qualify as a medical miracle? I suppose that depends on how you live and look at *your* life. For my father, there could be no doubt. In a letter to his grandchildren shortly after it happened, he wrote:

It is a minor miracle—a major miracle—whatever. I never, ever prayed to God to help me, except when I was aboard ship off of Iwo Jima to help me get better so I could go back. I have had so many blessings—I am the most blessed man on earth—I have a marvelous wife, two marvelous daughters, Jane and Amy, a wonderful son-in-law, the most wonderful granddaughter you ever saw. A fantastic grandson named Matt, and another fantastic one named Baylen. I have been truly blessed. I have many, many friends. I have done everything I ever wanted to do. I have become a successful illustrator in all the magazines, and the greatest thing, of course, is that I was Artist-in-Residence for the United States Marine Corps, and I think God intended that that's why I was spared at Iwo Jima, and brought home that I could do something nice for the Marines, and that this is what I was intended to do. I still pray to God; I always do, and thank him for the marvelous life that I've had, but I never asked for this blessing, and I kind of think I was doing all right without it. But for some reason or another, He must've just decided that, *Why not? We'll let him have it.*

Not long after he got the feeling back, my father and I went to see *Saving Private Ryan*, which had just been released. At the end, as the dying captain played by Tom Hanks whispers his final words to the young private, my dad—who was notoriously hard of hearing—nudged me, asking in a loud voice, "What did he say?"

I spoke directly into his ear. "He said, 'Earn this.'"

My father drew in a breath and sank back against his seat, nodding at the screen. Tears were coursing down his cheeks.

Most survivors of war struggle with the same existential question: Have I done enough to earn the gifts for which others had paid the ultimate price? Charlie Waterhouse kept an ongoing tally, seeking to recompense his vast personal debt by doing "something nice for the Marines." He saw this latest blessing as part of that plan. Something had been given to him, so he needed to give something back.

To build up strength in his hand, he began playing with a small ball of clay. Over time the clay balls grew larger and larger. Eventually, recognizable shapes emerged from these small, malleable lumps—a head . . . an arm . . . a torso. Wire and wooden armatures were for support and structure. Heads and limbs attached to torsos, figures were shaped, naked bodies were clothed and textured. And—*surprise, surprise*—they all turned out to be Marines.

In true Waterhouse fashion, he threw himself into this new passion, trailing the moist, earthy smell of clay along with him wherever he went. That summer, while I was driving my parents to a Company C Marine reunion in the Adirondacks, he completed the anatomical frame of a 20-inch-high figure, griping that there really wasn't enough room for him to work properly. I suggested that perhaps the "*front seat sculpting*" feature had escaped the minds of the people who'd

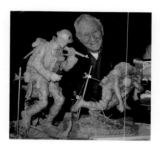

Waterhouse with clay figures on armatures. He started at the age of seventy-seven when the feeling in his left hand came back, fifty-six years after being wounded on Iwo Jima. *Waterhouse family photograph*

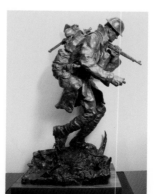

The Doughboy, bronze by Charles Waterhouse. The first casting, which includes a piece of barbed wire from the Battle of Belleau Wood, is owned by daughter Jane. *Waterhouse Museum photo*

engineered my mother's Chevy. By the return trip, the figure had become a Revolutionary War sentry standing watch in the snow, authentically dressed in the ragged uniform and scarf-wrapped hat of a Continental Marine.

Waterhouse would ultimately complete five major bronzes, keeping his hand—both his hands—in every step of the process, from clay to wax, to casting and final patina.

THE COLONEL CHARLES WATERHOUSE HISTORICAL MUSEUM
1999–2008

It was like a replay of one of the classic old movies that my father loved so much. "Hey, kids, let's put on a show!" cries Mickey Rooney in *Babes in Arms*. Judy Garland chimes in, "We can use my dad's barn!" Only this time it was my practical-minded brother-in-law, Gary, who came up with the spur-of-the-moment idea. A commercial building he'd recently bought in downtown Toms River had a vacant space on the top floor that he thought would be perfect for exhibiting the colonel's ever-growing body of work.

Immediately my sister's mind went into high gear. We shouldn't call it a gallery, Amy said, because the artwork wasn't for sale. This would be more of a museum—the Col. Charles Waterhouse Historical Museum—a place where active-duty members of the armed forces, veterans and their families, art lovers, history buffs, teachers, students, and the community at large could experience, free of charge, our country's history as visualized through the eyes of a renowned military artist and lifelong New Jersey native. The paintings and sculptures the colonel had created since his retirement would be supplemented with temporary loans from private collectors and national and state institutions—even some major works owned by the Marine Corps—and displayed on a rotating basis.

My father was over the moon.

From the beginning, the Waterhouse Museum was a labor of love. Gary took on the renovation process, knocking down walls, replacing the heating and electrical systems, and clearing out clutter from the long-defunct business that once occupied the space. Meanwhile, Amy began multitasking her way into the book of Guinness World Records, simultaneously performing the jobs of museum curator, office manager, PR coordinator, grant writer, interior decorator, and custodian, all while trying to keep a step ahead of a daunting learning curve.

We'd lived our entire lives surrounded by art and history. Since we were kids, both my sister and I have been avid museumgoers, but there was no boot camp to train and prepare her to run one. In short order, Amy found herself in the trenches, filing for 501(c)3 nonprofit status; framing, hanging, and lighting paintings; making arrangements for artwork to be shipped from around the country; creating signage and brochures; forming an advisory board; and compiling mailing lists and writing press releases. It took eight months of hard work to get from the germ of an idea to the day of the official opening, but throughout the process my father never lost faith: if we could build it, he was sure they would come.

And they did.

Over the next eight years a steady stream of visitors flocked to the museum: young Marines, about to be deployed or recently returned from the Persian Gulf; old Marines, including Vietnam vets and the last vestiges of the Greatest Generation, along with their wives, kids, and grandchildren; elementary, middle school, high school, and college students with their teachers and professors; the privately schooled, the religiously schooled, and the home-schooled; civil service organizations, historical societies, and art groups; senior citizens and Boy Scouts; colleagues from the USMC Heritage Center, artists, and friends; regimental color guards, new recruits, drill sergeants and their detachments, four-star generals, and living heroes of the Corps—even commandant Gen. Michael W. Hagee. With them came strangers, ordinary people who'd heard about the place or were just passing by. No matter who they were or what their reasons were for coming, the colonel's wife, Bobbie, would be on hand to greet them, making them feel as though they were *exactly* whom she most wanted to see walking through the door.

It wasn't the Met.

For one thing, it was located above a pizza parlor, reachable only by climbing up a steep staircase of twenty-one steps. For another, it was devoted to the work of a single artist. Museums that focus on the artwork of one individual are rare but not unheard of; what made the Waterhouse Museum unique is that visitors were given free access to Waterhouse's paintings but also to Waterhouse himself. Instead of having to rely on secondhand information from a docent, or listening to an audio guide, one could learn about a work, what it depicted, and how it had been created, directly from the artist—a man whose enthusiasm for his subjects was contagious, and whose breadth of knowledge and depth of experience enabled him to customize his commentary to fit the age, background, and special interests of just about any audience.

And then there were the paintings.

Looking at a Waterhouse painting is not a spectator sport. It grabs you by the neck and pulls you headlong into the time and place that the artist has creatively imagined. Years before, Gen. Simmons told the artist that every panel in the Marines in the Revolution series needed to tell fifty discernible stories. Waterhouse embraced that directive and had been running with it ever since. But at the museum we witnessed an amazing phenomenon occurring: for every one of the fifty stories a painting told, it seemed to evoke fifty more from the Marines, sailors, and soldiers who looked at it.

For them, a dark, tangled jungle lit up by mortar fire was a Rorschach test. The sweat-streaked face of a Marine became a mirror—the angle of a weapon the key to a tamped-down yet still-raw memory that unleashed tongues, brought lumps to their throats, and filled eyes with tears. This was more than just an exhibition of war paintings. It was a place where those who had served our country could share their stories with family and friends—a place where they could gather and connect with each other, honor and be honored, remember and heal.

It was, as my sister said, "an unusual place run by unusual people." And, like the Hotel California, some would check in and never leave. Gunner Ed Sere, a Marine vet and retired New York firefighter, wandered in with one of his neighbors. He was new to the area, still reeling from the pain of burying so many of his buddies after 9/11, but seeing the paintings stirred something deep inside him. He left his number with my sister and told her to call if there was anything he could do. She did and there was. Ed would become the executive director of the museum, a partner in arms both for my father and Amy, and a cherished member of the family.

They were all there, waiting.

The Waterhouse Museum in Toms River, New Jersey, was a special place where visitors could stop by to see the paintings and talk with the artist, who was always on hand, and often at work. *Waterhouse family photograph*

Curator Ed Sere (*third from right, in background*) watches as the artist chats with guests of honor Gen. Michael Hagee and his wife, Silke, who visited the Waterhouse Museum while the general was serving as the thirty-third commandant of the Marine Corps. *Waterhouse family photograph*

Col. Charles Waterhouse, with museum director and daughter Amy Lotano Waterhouse at the museum. *Waterhouse family photograph*

Members of the Sgt. John Basilone Detachment pay a visit to the Waterhouse Museum in 2004. *Waterhouse family photograph*

The next "Greatest Generation" of Marines was always welcome at the Waterhouse Museum and always left with signed prints, compliments of the artist. *Waterhouse family photograph*

John Basilone, who groused to the brass that he felt like a museum piece,[1] had turned into one. But in a different kind of museum—one that celebrated who he really was—not the gussied-up poster Marine with the fancy medal around his neck, but the machine gun–blazing warrior "one-man army" who'd once kept a force of over 3,000 Japanese soldiers from retaking the airstrip on Guadalcanal. True to his wishes, Manila John was back with his men: his fellow Marines and blood brothers—the ones he'd led, fought with, and died for—the Marines who'd come before and those who came after. Men such as Dan Daly, Smedley Butler, Hector Cafferata, Mitchell Paige, Pappy Boyington, Ray Davis, and John Ripley, standing shoulder to shoulder with everyday Grunts, POGs, BARs, and Leathernecks whose names might not ring a bell, but whose powerful stories were written across their faces.

Peppered among them were fallen comrades cut down on the field of battle. The Killed in Action always seemed a living part of the pictures somehow, and one particular picture would come to symbolize them. On the wall at the entrance to the museum, a full-scale photo print of Waterhouse's painting *The Assault on Penobscot* was prominently displayed.

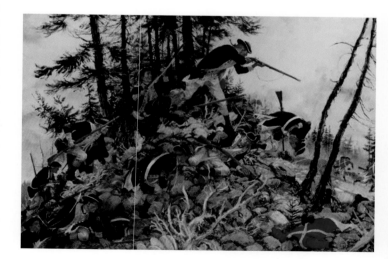

The Assault on Penobscot, 28 July 1779 by Maj. Charles Waterhouse, Marines in the Revolution series. The original painting was destroyed on 9/11, when Flight 77 crashed into the Pentagon. *Art Collection, National Museum of the Marine Corps*

The original was destroyed on 9/11 when terrorists caused Flight 77 to crash into the Pentagon; fortunately, Peter Murphy, counsel for the commandant of the Marine Corps, in whose office the painting hung, safely evacuated in the black smoke prior to the collapse of the side of the building.

Of the painting, only ashes remained.

There's a relational theory commonly known as six degrees of separation, which says that each of us is a maximum of six steps away, by way of introduction, from any other person. Maybe there's something to the theory, or maybe it was just time and chance, but walking through the museum you could sense the connective web between these Marines—across the wars, over the decades, and through the centuries. A selection of Waterhouse's first Medal of Honor paintings were hung within steps of each other in a large rear gallery, and three of them were stunners.

Propped up on an oversized display easel, the hard-nosed private Hector Cafferata stood bootless in the snow, firing with perfect aim at what he wanted to hit. On the adjacent wall—blazing a trail of glory across the wars—was the Fighting Sergeant of Guadalcanal, John Basilone. Just a few steps away, another Guadalcanal legend, Mitchell Paige, appeared to thunder off the canvas, wielding a machine gun like a rifle, with belts of ammo strapped around his neck. Basilone and Paige earned their Medals of Honor within twenty-four hours and a few miles of each other, defending the same airstrip. It seemed fitting that here at the museum, they should be together: two tough Marines, locked and loaded, eternally at the ready.

Over the years, my father developed a warm friendship with Mitchell Paige. Early on November 15, 2003, his wife, Marilyn, called my parents to tell them that Mitch had succumbed to congestive heart failure. Later, when Dad was opening up the museum, he hit the electrical switch, taking pleasure as he usually did to see the lights flicker on over all of the paintings, he saw that one light—the light above Mitch Paige—had gone off.

In his memoir, *A Marine Named Mitch*, Paige described being so stricken with malaria during an enemy air attack on Guadalcanal that he could only lie supine on the jungle floor, helplessly looking up at the Japanese bombers overhead. One of his men, Wilson B. Faust, refused to get into his foxhole, choosing to remain by Paige's side as the explosions came closer and closer. A bomb fell a few yards to their right, ripping a steaming crater into the ground and pelting them with debris and mud. Sure that the next would be a direct hit, Paige asked Faust to recite with him the 121st Psalm—*I lift my eyes to the hills; from where is my help to come?*[2]

The memory of that was fresh in his mind on the night of October 24, 1942, as he and his platoon lugged their machine guns and packs through the driving rain, across a nightmare terrain of spiny ridges, muddy slopes, boggy jungle, and kunai grass, tall enough to shelter a standing attacker—*The Lord shall preserve you from all evil*—in an attempt to draw a final defensive line in "the nearest thing to an indefensible position."[3]

I like to think that before Mitchell Paige slipped into the rugged terrain, which leads from this world to the next, that his old platoon mates were by his side, faithfully whispering words of encouragement and comfort. *The Lord shall watch over your going out and your coming in, from this time forth for evermore.* Because, to paraphrase a few lines of poetry beloved by members of the Corps—when Mitch

Paige got to heaven, to Saint Peter he could tell, *Another Marine reporting, Sir* (from the poem "The Marine," author unknown).

He'd surely served his time in hell.

PLSGT. MITCHELL PAIGE, USMC
The Battle for Guadalcanal, October 26, 1942

It was the first major US ground defensive of the war. Guadalcanal, a.k.a. Starvation Island, had nothing going for it unless you liked malaria-carrying mosquitoes, but it did have an airstrip within spitting distance of Australia, New Zealand, and other key Pacific bases, so the Marines were under orders to keep it, *at all costs*, out of the hands of Japanese. The night before, Sgt. John Basilone had done his part to stave the enemy away from Henderson Field, but once darkness fell on October 26, it was Platoon Sgt. Mitchell Paige's turn. He and his men—and their machine guns—were the only things standing between an assaulting force of 2,500 Japanese soldiers and Fox Company. And Fox Company was the only thing standing between the enemy and the airfield, so it was up to Paige's platoon to hold the line.

Paige had his men string barbed wire in front of their positions and hang blackened ration cans on it, which contained empty cartridges that would rattle if someone knocked into them.[4] They sat in a drizzling rain, silently waiting. And waiting. Around 0200, tiny colored lights began to appear in the jungle, flickering on and off like fireflies. Assembly signals. Paige pulled the pin on a grenade. His men followed suit.

Suddenly, the ration cans started rattling. Grenades sailed through the air, exploding as the first wave of the assault swarmed toward them. Arching red tracer bullets outlined the dark shapes crawling across the ground.

Over the enemy's shrieks, a Japanese soldier cried, "Blood for the emperor!"

In an impromptu tribute to President Roosevelt's wife, one of Paige's men shouted back: "Blood for Eleanor! Blood for Eleanor!"[5]

Years later, Paige said, "When they hit our line, it was so fast and so fierce that it took me fifteen years to tell anybody what had happened—it was something you couldn't describe; I couldn't describe it."[6] All he knew at the time was that most of his men were dead, and that the few who weren't were being hit hard.

In an attempt to hold the line and keep the remainder of his platoon alive, Paige ran from machine gun to machine gun for hours, mowing down everything that moved, trying to give the Japanese the impression that a slew of Marines were still there, ready for their next attack. When, at one point, some of the enemy managed to overrun his position, Paige swiveled the machine guns around on them and started firing behind him, toward the Fox Company line. The Marines there assumed that Paige's men had been killed and that the Japanese were using their guns.[7]

It was a scenario that could easily have happened. Shortly afterward, a soldier with a Nambu machine gun got close enough to have Paige dead to rights. Unable to pull back the bolt handle, Paige leaned back, falling on his knee with the butt up against his neck, feeling a sudden warmth from his chin to his Adam's apple. The soldier fired all thirty rounds at him, and thirty times he fell back on his knee, feeling that same warmth, until the round was over and Paige pulled back the bolt, bobbed up with his gun, and *BAM*—in one burst, the enemy soldier was gone.[8]

He found three more belts of ammunition and quickly fired them off into the trees and along the ridge, spraying bullets like water from a hose. His was the only automatic weapon firing from a forward position, and all the firepower of the Japanese army was aimed at him, so he kept at it until all his rounds were gone. Three of his men voluntarily crossed the kill zone to resupply him; one of them had already been wounded and another was hit along the way.

By then it was growing lighter. Paige looked around. Nothing was moving. Dead bodies were everywhere. He knew that as soon as dawn broke, the Japanese would see how little resistance was left, and send up another wave. From the crest line, he watched as a ragtag force of twenty-four Marines—bandsmen, wiremen, runners, cooks, and even mess boys, led by Maj. Odell M. Conoley—mounted a counterattack to regain control of the Fox Company spur. Inspired by what he would later call "that beautiful charge,"[9] Paige shouted back to his remaining men. "Tell everybody over there to fix bayonets! I'm going over the hill!"[10]

He unclamped one of the piping-hot .30-caliber guns from its tripod, threw his two remaining belts of ammo around his neck, and started down the slope, heading into the thick of the Japanese force as bullets rained down around him.

An enemy officer with about twelve men jumped out of the tall grass and he mowed them down, both grass and men. It was a kill-or-be-killed situation, and he continued to surge forward, unaware of the heavy weight of the machine gun, unaware that its water jacket was so hot it had blistered him from the tips of his fingers to his shoulder, unaware of anything until he heard the sound of a rebel yell behind him as his remaining men came careening down the hill with their bayonets drawn, whooping and hollering loud enough that you would think they were a thousand, and not just six beat-up Marines willing to follow their sergeant into hell.

Paige's job that night had been to keep the Japanese from overrunning their position and getting to Henderson Field. He'd done it. The next day, Lt. Col. Lewis B. "Chesty" Puller dropped by to visit. He told Paige that the regimental commander was recommending him for the Medal of Honor and that he was also recommending one of his sergeants—a Marine named Basilone—for his actions protecting the airstrip on October 24.

"Johnny Basilone?" Paige asked.

Paige had first met Basilone in New River, North Carolina, soon after Basilone joined Puller's 1st Battalion, 7th Marines. Manila John had been in the Philippines at the same time as Paige, but they had not met. When they ran into each other just before being shipped out to the Pacific, Mitch had asked Basilone when he was being promoted to platoon sergeant. "Soon, I hope," he'd replied with a grin. Paige took the opportunity to tell Chesty Puller that he hoped this would secure Johnny Basilone his promotion.[11]

As for his Medal of Honor, Paige would always say that it belonged to the thirty-three men who took a stand against 2,500 Japanese soldiers one night, long ago, on Guadalcanal.[12]

A little over five years after the light went out above Mitchell Paige's picture, we turned off the lights at the museum for the last time. Amy and museum director Ed Sere, who had envisioned moving the paintings to an even-larger facility, took the closing as a personal failure. Despite all her efforts, to this day my sister feels a sense of failure—but then, she too is her father's daughter.

Amy and Ed were in the front line. Where I sat, in the back pew, enabled me to take a more ecclesiastic view. There is a time for everything, and a season for every activity under the sun. Time had run out for this special place run by special people, which drew so many special people and affected them in ways that we could have never imagined. And, for the Waterhouse family, a light was about to go out that would change everything.

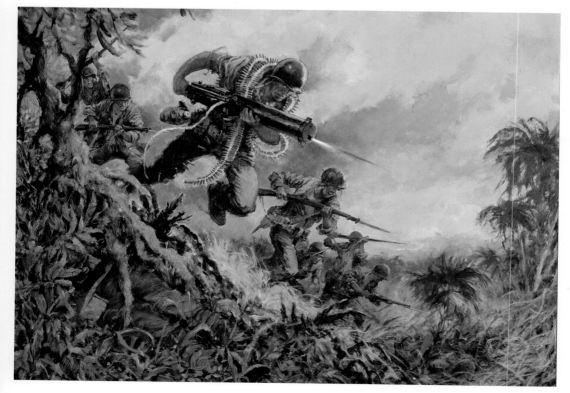

PltSgt. Mitchell Paige, USMC, Solomon Islands, 26 October 1942 by Col. Charles Waterhouse. The artist enjoyed a warm friendship with Mitch Paige until the Medal of Honor recipient passed away in 2003. *Art Collection, National Museum of the Marine Corps*

TWO WAVES

In August 2009, my mother was diagnosed with stomach cancer. She died three days after Christmas. The amount of pain, and grief, and love contained within the space of those two sentences could fill several volumes. But not this one: this is my father's Medal of Honor story—a story that he fought to complete, against all odds. I remember driving him home from the hospital after the doctor broke the awful news. We didn't speak much, both caught up in our thoughts, trying not to break down in front of each other. I pulled into the driveway of the home where my parents had moved after my dad's retirement. It was late, and the house looked dark and vacant as if its very foundations had already settled on the fact that its season had ended. I leaned over to hug my father, watching as he got out of the passenger seat and walked in front of the car, toward the garage, leaning heavily on his cane. He turned around to give a final wave, as he always did, and at that moment, in the halo of the headlights, instead of my chipper, chin-up dad, I saw a lost and broken man.

They'd been married for sixty-one years.

In a letter to his closest friends after her death, he wrote, "Our meeting and life together was the greatest thing that ever happened to me. Without her, I would be nothing. We still laughed and interrupted each other, and we still held hands and kissed till the end."

One of the photographs of our parents that Amy and I treasure was taken by a dear friend at an annual art festival held at Powers' Crossroads, outside Atlanta. My father had set his easel up in a muddy clearing between the trees for a painting demonstration. In the picture, he's wearing a baseball cap with MARINES embossed across the lid and is leaning forward with a look of fierce concentration on his face, applying a considered brushstroke to the work-in-progress painting. It had just begun to rain, and my mother stands behind him, smiling at the camera, holding a red umbrella over his head.

Four years later, when our parents' ashes were interred in Arlington, we were asked if we wanted to inscribe something on the granite below my mother's name. Beloved wife? Caring mother? We didn't have to think twice. Her tombstone reads *She held the umbrella*.

But she was gone, and without her sheltering, steadfast, all-encompassing support, our father's world collapsed. For the first time in our lives, he

Line drawing of Bobbie Waterhouse, lovingly inscribed "My Barbara."
Waterhouse Family Collection

"She held the umbrella."
Bobbie and Charlie Waterhouse, Powers Crossing, Georgia.
Photograph by Claire Albrecht

completely stopped drawing and painting. Any mention of the Medal of Honor series was met with only a shrug and a sad smile.

In the letter to his friends he'd said it all: Without her, I would be nothing.

Not "I *would have* been nothing"—he was struggling with the painful present tense, questioning whether there could even be a Colonel Charles Waterhouse without a Barbara.

My sister and I watched and waited, looking for signs that Dad was coming around, but not wanting to rush him. Although he continued to avoid his easel, we were relieved when he began focusing his attention on an article for *Illustrator* magazine he'd been asked to write about the pulp artist Herbert Morton Stoops. We worked on it together. He noodled on the computer, creating layouts. I read what he'd written and finessed his copy. Gradually, outside the windows of the room where he now lived, and where my mom had died—the same windows that, in December, had been frosted with snowflakes that she said looked like Christmas trees etched in the glass—seasons changed. Birds came back to plash in the birdbath and nibble at the popcorn my father would leave outside whenever we went to the movies. The Stoops article was published.

Late that spring, after one of our movie nights, we were having dinner at a local restaurant when my father said to me, in a tentative, almost apologetic voice, "I think I might go back to painting."

"That's great, Dad," I told him. "I'm sure Mom would be happy."

"She is." He nodded, his eyes glistening with tears. "I talked it over with her. She thinks I should try to finish the Medal of Honor series."

"Well, you'd better get to work then," I said.

And that was that. There was no ramp-up, no slow-and-steady easing back in. From that point on, it would be full speed ahead. For all of us.

While the hiatus after my mother's passing seemed to have only enhanced his skills at the easel, it had diminished his health. For years our father struggled with congestive heart failure, high blood pressure, and age-related diabetes. To the amazement of his nephrologist, he'd managed to keep his severely failing kidneys functioning just enough to stay off dialysis by being stingy with his fluid intake—an act of supreme willpower for a lifelong teetotaler who'd been used

to drinking gallons of water and a couple of quarts of milk each day. Maintaining the delicate ecosystem of his failing body involved an arsenal of pills, and a complex balancing act that involved frequent meals, wrapped legs, fluctuating sugar levels, and epic enteric episodes—all of which my dad took in cheerful stride. He had a mission to fulfill, and if that's what needed to be done in order to accomplish it, so be it.

At his age, most people turned their thoughts to end-of-life issues, but my father wasn't one of them. He had only one concern: Who would get his USMC artwork? That summer, he sat down with Gary, Amy, and me to discuss the matter. He told us that he wanted the USMC paintings to go to his Marine Corps family. An implicit question hung in the air. The paintings belonged equally to Amy and me—that's what our mom had wanted, and up until now it had always been the intention. Were we okay with his decision?

We were, without a doubt. And we set out to make it happen before he died.

At the end of August we met with the commandant to discuss the colonel's bequest. Over the next few months, Amy and I snapped to like a pair of brigadier generals, carrying out operations on two fronts. Our first initiative was to facilitate the gift to the National Museum of the Marine Corps. We organized it, with military precision, so that the paintings were deployed in two waves. The first wave would consist of about 200 works created by the colonel since his retirement—half of which were Medal of Honor paintings—plus over a hundred small portraits of the Medal of Honor recipients, a grouping that we referred to as "the Heads." The second wave of Medal of Honor canvases would be shipped at a later date.

It was a huge undertaking. Paintings that had been wrapped and stored ever since the museum closed its doors had to be unwrapped, cataloged and numbered, photographed, and put into order. Several of the masterworks were so large they required both of us to move them. We turned the upstairs of Amy and Gary's home into a staging

Col. Waterhouse with the Medal of Honor "heads." He sculpted the original clay figure of the sentry, seen here in bronze, in the front seat of a car as we drove to a Company C reunion.
Waterhouse family photograph

area. Vietnam artwork went into the playroom. World War I occupied the green felt bed of the pool table. World War II had infiltrated the entire central hallway, with specific campaigns propped in piles against the walls.

Meanwhile, downstairs on the home front in our father's studio, the situation had quickly intensified. While painting the Medal of Honor series was primarily the colonel's battle, we were constantly getting drawn into it. On any given day he'd need more paint, another shipment of frames, new ink cartridges—simple requests that weren't always so simple to satisfy. As crazy as it seems, we once spent weeks wracking our brains, trying to figure out how to stretch several odd-sized canvases onto standard-sized stretchers. We visited art supply stores, bought special glue, and tried all sorts of zany remedies, including hand-stitching strips of canvas onto the pictures and asking Dad to fill in the blanks. The short-term solution was making our own stretchers; after that, we strongly encouraged him to paint to standard size.

In addition to religiously working at the drawing board and easel, the colonel also spent several hours a day in front of his ancient, and dangerously overloaded, McIntosh computer, researching future subjects and designing layouts for a Medal of Honor book that would include a full-color painting showing each recipient in action, a portrait, and the corresponding citation. Computer crashes were frequent, noisy, and often tragic. Still, he'd find time to one-finger-type me an all-caps email with an update on MOH whenever my freelance writing deadlines prevented me from coming down to see him.

11/12/10

Subject: WORK … WORK … WORK … WORK … WORK

HI JANE … I HEAR FROM AMY … THAT YOU ARE … GOING MAD … MAD … MAD WITH THE WORK LOAD … WISH I HAD THE ANSWER … BUT I COULD NEVER FIGGER IT OUT EITHER … I GOT UP AROUND ONE LAST NIGHT AND TRIED READING … THEN WORKING … NEXT THING … IT WAS ABOUT THREE …

MADE A GOOD DESIGN … SO FAR I HAVE MADE ABOUT SIX OR SEVEN NEW DESIGNS … I STILL DREAD TO THINK OF JUST HOW MANY I HAVE YET TO MAKE … LET ALONE FINISH … BUT I DO KNOW THAT I AM CUTTIN THEM DOWN … BIT BY BIT … ONE AT A TIME … CANT IMAGINE IT'S MID-NOVEMBER … SCARES HELL OUTTA ME … JUST HAVE TO … NOT THINK ABOUT IT … SOMEHOW WE WILL BOTH MANAGE TO GET THROUGH IT … KNOW MOM IS SMILING … GONNA NAP A BIT … THEN BACK TO WORKKKKKKKKKKKKKKKKKK …
 LOVE, DAD

Once again, Amy was in the front line, taking care of his day-to-day needs. I did whatever I could to support her, at the same time stepping into my mother's shoes—knowing I could never fill them—acting as his creative sounding board, willing ear, cheerleader, devil's advocate, and emotional support. It was a role that came easily to me. At least two or three times a week I'd drive down to take him out to dinner or the movies, parking in the circular drive in front of his bedroom

studio. On my way to the door, I'd peer into the window to see if my dad was at his easel, or in front of the computer, or snoozing in his recliner with his USMC cap pulled down over his eyes.

Even when he was tuckered out, he'd rally and, after a hello kiss, quickly get down to the first order of business: introducing me to his newest Medal of Honor recipients and reacquainting me with others, telling me about the snags he'd hit, and pointing out specific things he was pleased with—a feature, or a gesture, or the sense of movement he'd been hoping to achieve that seemed to be coming together. The art discussion always came first—and he'd listen to any comments I had about the overall composition, color, mood, visual impact—but after that he'd start to talk about the men themselves, who they were and what they did, his voice aerated with amazement, sounding like an awestruck kid's.

Sometimes I prompted him. I'd pick up one of the canvases and say, "Tell me about him, Dad."

And he'd nod with approval. "Yeah, he's a good one," he'd say, the color pumping back into his wan cheeks, his eyes sparkling. "Funny thing about him—"

Then he'd share some personal anecdote or a tidbit of information that brought the recipient to life in a way that no official citation ever could.

When I asked about one of the Vietnam recipients, a ruggedly handsome man in an aviator's helmet and jumpsuit who was carrying the limp body of a wounded Marine, my father let out a rueful chuckle. "That's Clausen. Ray Clausen."

He said, years before, he was invited to a parade for surviving Medal of Honor Marines. Clausen had marched in it. Along the way, a few raucous people on the parade route started throwing cans of beer; Clausen would catch them, pop them open, and gulp them down before tossing the cans back into the crowd.

That my father disapproved of this behavior was no surprise; I knew he'd be offended by such a lack of decorum in someone who represented the Marine Corps and wore the nation's highest medal. But to my astonishment, my dad gave the man in the picture an apologetic shrug and said softly, "I found out later on what he did in Vietnam."

Fighting back tears, he looked down at the canvas. "And I'll tell you," said my teetotaler father, choking up with emotion, "if I ever saw that Marine again, I'd buy him a beer."

During a helicopter rescue in Vietnam, PFC Clausen ran through a minefield in the face of heavy enemy fire and successfully carried eleven wounded Marines, and one dead body, across hazardous, mine-laden terrain to the waiting chopper.

Clausen passed away at the age of fifty-eight, seven years before the colonel depicted his exploits on canvas. I think my dad saw the painting as his own private toast to the man—a way of saying, "Hey, Ray, this Bud's for you."

What kept my father going after my mother's death was his determination to pictorially memorialize the Medal of Honor recipients. What kept him up at night was the numbers game—the ongoing tally of what he'd done against what he'd yet to accomplish—and the growing anxiety that he wouldn't stay alive long enough to complete this final legacy. It became almost an obsession, and he left evidence of it everywhere: scraps of paper, envelopes and dinner napkins, on the title page and in the margins of sourcebooks—*81 Marines WWII*, he'd write in big letters, along with a campaign-by-campaign countdown: 5 *Kwajalein* . . . 4 *Guam*. . . 3 *Samoa*. . . 2 *Tinian*. . .

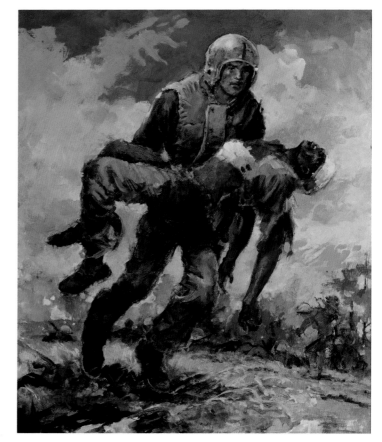

PFC Raymond M. Clausen Jr., USMC, Republic of Vietnam, 31 January 1970 by Col. Charles Waterhouse. *Art Collection, National Museum of the Marine Corps*
[For more about PFC Raymond Clausen, see pages 252–253.]

To his dismay, he came to realize that not all websites on the internet are created equally, and that discrepancies existed among the various lists of Medal of Honor recipients. One night when I came to take him out to dinner, I discovered him slumped at the computer with his head in his hands. He looked up at me and said miserably, "I found three more corpsmen." He didn't begrudge these men their medals. He just felt he was running out of time.

I tried to channel my mother's voice of reason. "No one has ever attempted to do what you're doing, and odds are no one ever will again," I told him. "It doesn't matter if you miss a few, Dad. You can't expect to paint every single recipient."

But my father saw it differently. I remembered him telling me about one of the gatherings he'd attended in honor of the recipients. The master of ceremonies at the event read off each name so that the recipient could stand and be acknowledged. After he announced Richard E. Bush, Okinawa, the emcee glanced at the list and saw that the next recipient was also Bush for Okinawa. Assuming that the same name had inadvertently been typed twice, the man skipped it and went on to the next.

The omission didn't escape my father, who knew that two men by the name of Bush had received their medals on Okinawa: Marine Cpl. Richard Earl Bush and Hospital Apprentice First Class Robert Eugene Bush, US Navy—who had promised his mother as he was leaving for training as a naval corpsman that he was going into the service to help people, not to kill them.

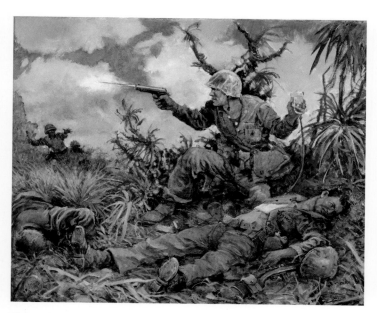

HA1c Robert Eugene Bush, USN, Okinawa Jima, Ryukyu Islands, 2 May 1945 by Col. Charles Waterhouse. *Art Collection, National Museum of the Marine Corps*
[For more about Navy Corpsman Robert E. Bush, see pages 216–217.]

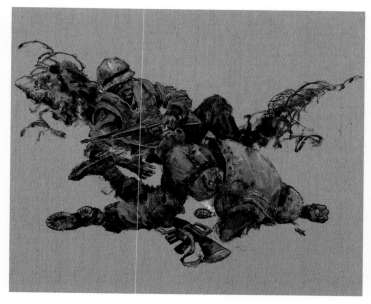

PFC James Anderson Jr., USMC Cam Lo, Vietnam, 28 February 1967 by Col. Charles Waterhouse. Anderson was the first African American to be awarded the Medal of Honor in Vietnam. *Art Collection, National Museum of the Marine Corps*
[For more about PFC James Anderson Jr., see page 300–301.]

It had bothered my father that night when Bob Bush's name wasn't announced. It seemed wrong to him that such a brave man should not be recognized—although, it should be noted, the former corpsman received his share of recognition. Harry Truman said that of all the Medal of Honor recipients he had decorated, Corpsman Bush was his personal favorite, and Tom Brokaw featured Bush's story in his superb book *The Greatest Generation*. Still, that night, and to his dying breath, my dad was driven by the conviction that none of these brave men should ever be omitted or left behind.

Nowhere is that conviction more evident than in the canvases that my sister and I referred to as the Grenade Paintings.

In World War II, twenty-seven Medals of Honor were awarded to Marines who threw themselves on grenades to save their comrades. Twenty-one Marines were recognized for shielding others from grenade explosions in Korea; during the Vietnam War that number rose to twenty-three. Added together, that meant over seventy of the Medal

of Honor pictures would essentially be telling the same story.

But, somehow, in Col. Waterhouse's series, they don't. He approached each composition from a different angle, leveraging all of his skill to make it visually distinctive. He never saw these men as one of many. He saw them as individuals with a past and a future that—in the vast majority of cases—had tragically been cut short. He felt he owed it to them, and to their families, to create a painting that was as unique as they were, and although he didn't live long enough to complete every last one of them, these canvases are a testament to them all.

On February 24, 2011, Amy and I were on the second floor of her home in Toms River, doing one last roll call of the 263 paintings that my father was gifting to the Marine Corps. The special air-conditioned moving van that would take them to the National Museum would be arriving any moment.

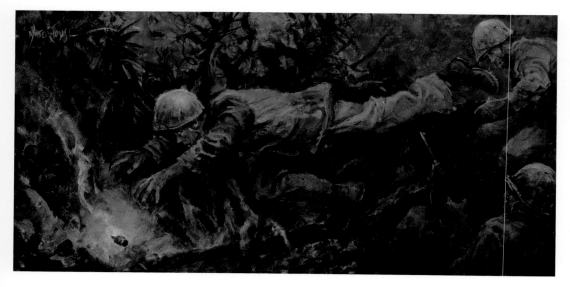

PFC James LaBelle, USMC, Iwo Jima, 8 March 1945 by Col. Charles Waterhouse. *Art Collection, National Museum of the Marine Corps*
[For more about PFC James LaBelle, see page 206.]

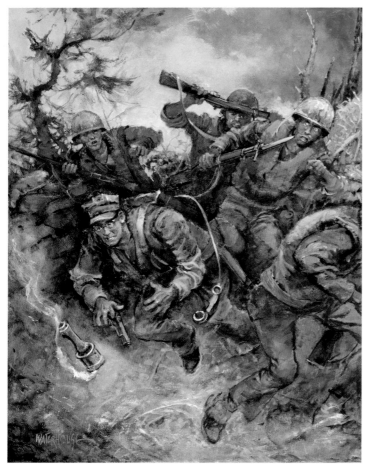

PFC Robert E. Simanek, USMC, Korea, 17 August 1952 by Col. Charles Waterhouse. *Art Collection, National Museum of the Marine Corps*
[For more about PFC Robert Simanek, see pages 268–269.]

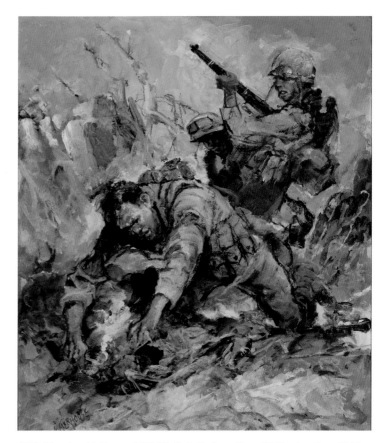

PFC Charles H. Roan, USMC, Peleliu Landing, 18 September 1944 by Col. Charles Waterhouse. *Art Collection, National Museum of the Marine Corps*
[For more about PFC Charles Roan, see page 178.]

2/27/11

I WAS JUST GOING TO WRITE A QUICK EMAIL . . . WHEN YOURS CAME IN . . . I MISS YOU . . . WORKIN HARD TO GET SOME OF THE SECOND WAVE ON ITS WAY . . . SLICK VARNISHED SOME OF THE CANVAS LAYINS . . . AN THEY DONT LOOK BAD . . . MAYBE THEY WONT NEED AS MUCH WORK AS I FEARED . . . LAID IN AN OLD REJECTED CANVAS IDEA . . . AND MADE IT WORK . . . GOT TWO FINISHED DRAWINGS FOR ED TO TRANSFER . . . SO THINGS ARE STILL MOVING . . . HAVE TO SPEND A DAY LOOKIN THRU FILES FOR SOME VITAL SKETCHES FOR THE TWO PLANNED BIG CANVASES . . . AND THEN IT'S JUST A MATTER OF PAINT . . . PAINT . . . PAINT . . . AND ALMOST TIME TO GIVE THE BOOK SERIOUS ATTENTION . . . WITH MUCH LOVE . . . DAD

During the long process of photographing and documenting the canvases, we had both come to the same realization: we couldn't part with all of the Marine Corps artwork. We told Dad that we wanted to keep a few special ones for the family, with the understanding that we'd make them available to the Marines at any time, and that the majority of what we kept would eventually end up in the USMC collection. He agreed: he knew that our mom was smiling.

At the last minute, my sister and I put a few more beauties into the family pile. When we heard the van pull up, we just looked at each other. "Well, sis," Amy said, "here goes the first wave." We'd worked for months to make this moment happen.

That day our father was carefree and happy. By the next morning his full attention was on the second wave.

THE LAST MAN

We were sitting in my sister's kitchen with a senior staff member from the Marine Corps Scholarship Foundation who had driven up from Washington, DC, to discuss setting up an endowed scholarship in the colonel's name that would enable children of wounded Marines or Navy corpsmen to pursue an education in the arts. Although it was still August, the burnished gold light pouring through the windows, and the frenetic acrobatics of the squirrels in the trees outside, foreshadowed summer's waning. Looking across the table, I saw that my father was waning too.

It had been what he liked to call a "productive" morning. He was thrilled to hear about the scholarship and had enthusiastically given our guest a preview of the second wave of his Medal of Honor series, lifting the unbaked canvases that were layered like sheets of phyllo dough on his easel, unrolling the half-done paintings stacked like proofing loaves on the bookshelves, and sifting through the finished ones that he'd piled against the walls. But now that lunch was over, and the visit seemed to be winding down, I could tell that Dad was anxious to shuffle back to his spacious bedroom studio, to the Marines who were waiting for him there: the men with whom he'd been living, day and night—the ones he knew so well, and the others who were just featureless specters penciled on canvas, whose stories he had yet to tell.

But just then our guest threw out a curve ball. He had a favor to ask, he said, on behalf of the foundation's CEO, Margaret Davis, a person whom Dad admired and respected. The Marines' latest Medal of Honor recipient, Dakota Meyer, was going to announce an initiative to raise $1 million in scholarship funds at a gala reception held by MCSF at the Library of Congress on September 13. Given the colonel's longtime support of the foundation, and his commitment to depicting the Medal of Honor awardees, would he be willing to create a canvas showing Sgt. Meyer's courageous actions in Afghanistan that the commandant could unveil at this event?

All eyes were on my father. He had a long-suffering expression on his face that I recognized—the same look he'd get whenever Amy or I tried to rope him into an extracurricular project that threatened to pull him away from his true work. It used to be that we could easily overcome that look with humor or cajoling. But that was back when his energy seemed boundless, and he could measure these pesky interruptions in moments bartered from a given day, not minutes subtracted once and for all from his life. He'd always been generous with his talents, but with his eighty-seventh birthday looming and his health failing fast, he'd turned miserly with his remaining resources. I knew what he was thinking before he said a word: *Haven't I enough on my plate already, trying to paint Medal of Honor recipients from the Banana Wars through Vietnam? The Afghanistan War is a bridge too far. I don't have time. I'm running out of time—*

He frowned. "That's less than a month away."

"You could finish ten paintings in that time," I countered.

"It wouldn't have to be a huge canvas," Amy said.

"And it would be a great way to bookend the series," I suggested.

"From Mackie to Meyer—I like that." Amy seamlessly picked up the thread. "Chronologically, he could be the last man in the series."

"I saw an interview with him on *60 Minutes*, Dad," I said. "He's got an amazing story."

He shot another stricken look at us, his traitor daughters. "They've all got amazing stories," he replied.

We knew it was as far out on that limb that we'd get him to go. Although he hadn't received a definitive answer from the colonel, the man from the Scholarship Foundation had witnessed enough of our tag-team approach to know that Amy and I would do our best to convince him. After he'd gone, I followed my father back into his room and fired up the computer. It took only seconds to locate the *60 Minutes* interview on YouTube. "Take a seat, Dad," I said.

I stood behind him and hit PLAY.

CPL. DAKOTA MEYER, USMC
Ganjgal, Afghanistan, September 8, 2009[1]

It didn't hurt that he was a good-looking kid—a big Kentucky farm boy with a fringe of blond, bowl-cut hair and an All-American smile somewhat tempered by the abiding sadness in his eyes. But I knew it would take more than a striking physical appearance to spark my father's interest. To him, they were all beautiful, all bursting with vitality and heartbreakingly young, these men who'd been awarded the Medal of Honor. What had this particular baby-faced Marine done to put him at the head of the queue when so many others who came before were still waiting to be painted?

As it turned out, he'd done something remarkable—a feat of such bold and daring initiative that it amazed the seasoned helicopter pilots who first arrived at the scene and witnessed it. They both agreed that they'd never before seen the like.

For Cpl. Dakota Meyer, however, it was a cut-and-dried situation. Four of his fellow Marines—his brothers—were getting lit up in the kill zone and needed help. They'd left the patrol rally point on foot in the early hours of September 8, as part of a convoy that included soldiers from the Afghan National Army and Border Police, heading to the remote hamlet of Ganjgal to meet with village elders who had agreed to renounce the Taliban. As they were approaching the winding slope that led to the village, a large force of heavily armed insurgents surrounded them, firing from all directions. Trapped and under duress, 1Lt. Michael Johnson had radioed their coordinates back to the rally point, requesting immediate artillery and air support. The officers in charge promptly denied Johnson's request, encouraging him to try to tough it out.

The youngest and lowest-ranking Marine, Cpl. Dakota Meyer—a sniper who served as a turret gunner—asked the officers for permission to take a truck from the rally point into the kill zone but was refused. Over the next forty-five minutes, the persistent young Marine made the same request three more times. Time after time, permission was denied.

After serving two tours of duty in the region, Cpl. Meyer had become as leery of bureaucracy as he was of the enemy. Maybe he was just tired of always having to fight his way out of red tape, or maybe he was just following the advice of another southern country

boy, Davy Crockett: *Be always sure you're right, then go ahead—* whatever the reason, when the third cry for help came in over the radio and Gy. Sgt. Edwin Johnson was heard shouting that if support didn't arrive soon, they were all going to die, the twenty-one-year-old corporal looked over at his staff sergeant, Juan Rodriguez-Chavez, and said, "That's it. We're going in."

If what Meyer did was insubordination, blame it on the Marines. Because *No Marine Left Behind* isn't just some boot camp mantra, it's a deeply held principle for which Leathernecks throughout history have been willing to die. The two men got into a gun truck and drove it down the steeply terraced terrain directly into the kill zone, with Rodriguez-Chavez at the wheel and Meyer in the highly exposed gunner's position, manning the vehicle-mounted Mark [Mk.] 19 grenade-launcher machine gun.

They might as well have painted a target on their heads and piped out a recording of "The Star-Spangled Banner."

The whole valley turned on the truck, letting loose a steady stream of fire power that kept Meyer pivoting from left to right, and right to left, in an attempt to answer each report. Enemy attackers surged toward their vehicle, only to be killed by Meyer's deadly aim with the Mk. 19 and his M240 machine gun. By then the Mk. 19 had jammed, so they double-backed to the rally point, swapping to another vehicle with a turret-mounted .50-caliber machine gun.

Again they headed into the kill zone, encountering a team of trapped Afghan soldiers and US personnel. With pinpoint accuracy, Meyer held the enemy at bay long enough for the stranded troops to escape the ambush area. Even after being wounded in the arm by RPG and mortar shrapnel, the determined corporal refused to stop. Their mission wasn't complete, he told Rodriguez-Chavez. They'd yet to locate 1Lt. Johnson and the other Marines. "If you didn't die trying," Meyer would later say, "you didn't try hard enough."[2]

Commandeering a third gun truck, Rodriguez-Chavez and Meyer made two more trips into the zone, linking up with Army captain William Swenson, 1Lt. Ademola Fabayo, and a small Afghan contingent. Nearly two hours after the initial request for air support was made, the distant thunder of approaching helicopters could finally be heard overhead, but even with the covering fires from Meyer's and Fabayo's guns, the ground fighting proved too intense for the pilots to safely land. The only good news was that one of them had spotted the low stone wall where Johnson and his men had taken refuge, and dropped a smoke grenade to mark the position.

A plume of purple smoke rose from the top of the hill. As soon as Meyer saw it, he jumped off the truck and took off running, with impacting rounds tearing up the ground around him. Miraculously, he reached the short wall without being hit and ducked down, finding Gy. Sgt. Edwin Johnson. Johnson had been shot and stripped of his weapons and most of his gear, as had 1Lt. Michael Johnson, Gy. Sgt. Aaron Kenefick, and Hospital Corpsman James Layton. "You feel like nothing but being a failure," Meyer later reflected.[3]

It had taken over six hours to find his comrades, and he wasn't going back without them. In the face of enemy fire, the Marine lugged Johnson's body out of the trench and carried it back to the Humvee. With the help of Swenson and one of the Afghan Border Patrol officers, he made multiple trips back and forth, bringing out the dead, both American and Afghan, and ensuring that no Marine was left behind.

At the end of the *60 Minutes* interview, news correspondent David Martin asked Meyer if he realized how extraordinary his actions were that day. The young Marine shrugged and leveled his abidingly sad eyes at the camera. "It would've been extraordinary," he replied flatly, "if I'd brought 'em out alive."[4]

After seeing the video, my father just nodded. I left him alone. He started sketching almost immediately.

A little over three weeks later, Gary, Amy, and I drove it down to Washington. Dad wasn't up to making the trip, so Amy made a short speech on his behalf under the glistening dome of the Library of Congress, telling the newly promoted sergeant and Medal of Honor awardee that he would hold a special place in the artist's legacy and history. "While there will always be heroic Marines who will be awarded the Medal of Honor," Amy said, turning to Meyer,

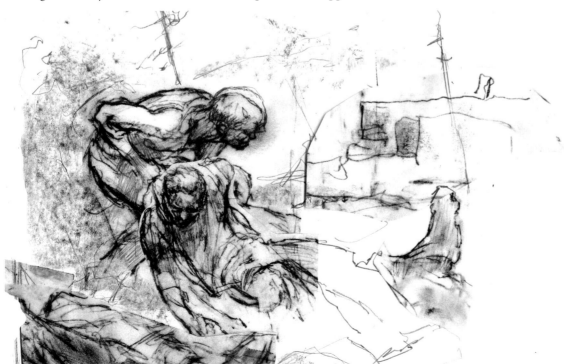

Waterhouse's preliminary sketch for the Dakota Meyer painting. *From the private collection of Jane Waterhouse and Amy Lotano*

"From a chronological perspective—*yours* will be the last painting in the Col. Charles Waterhouse Medal of Honor series."[5]

At that point, Commandant Jim Amos unveiled the painting. Meyer was amazed and visibly moved. "It was a six-hour battle, but Col. Waterhouse chose the exact, right moment to paint," he said later. He was even more thrilled to learn that the picture, along with Waterhouse's portrait of him, was being made into a commemorative print, which would be sold to raise money for the Marine Corps Scholarship Foundation's fiftieth-anniversary fund drive.

The next day, we described every detail of the event to Dad. He was happy to hear that everyone was pleased with Meyer's painting, but happier still to have his daughters back home so we could put our entire focus on launching the second wave of Medal of Honor paintings.

By the time the second van from the National Museum of the Marine Corps pulled into the drive at the end of that August, our father had completed another eighty-one MOH canvases. Added to his previous gift of 263 paintings, this would constitute one of the most significant donations ever made to the USMC's art collection.[6]

Sgt. Dakota Meyer unveils Waterhouse's Medal of Honor painting, *In the Zone*, at a gala event for Marine Corps Scholarship Foundation in the Library of Congress. *Official Marine Corps photograph*

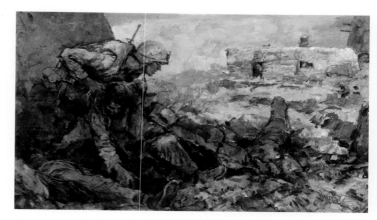

Cpl. Dakota Meyer, USMC, Gangal, Afghanistan, 8 September 2009 by Col. Charles Waterhouse. *Courtesy of the Marine Corps Scholarship Foundation*

THE FINAL BATTLE

My father's studio bedroom was bright and spacious. Its windows overlooked a parklike setting of mature trees, a pebbled courtyard rimmed by shaggy-barked elms, and a birdbath that he could see from his easel. The Medal of Honor recipients had completely infiltrated it, overrunning the flat surface and covering all the walls, but he'd reserved a prominent space next to his bed for a man who was not recognized with the Medal of Honor—an oversight that many Marines hoped, with all of their hearts, would someday be rectified. His name is Colonel John Walter Ripley.

My father knew him. Years before, he'd illustrated a marvelous book written by John Grider Miller called *The Bridge at Dong Ha*. Inspired by what Ripley did in Dong Ha, Col. Waterhouse created one of his most memorable paintings, *Ripley at the Bridge*. It hung beside the artist's bed during the last four years of his life, a silent witness to his own final battle.

That it should be Ripley seemed fitting. Through sheer perseverance, that one Marine had pulled off an eleventh-hour miracle—something my dad was attempting to do by finishing his Medal of Honor series. Yet, a heartrending irony pervades Ripley's story: he carried out his mission and won the battle while knowing the inevitable fact that the war was still lost. In his foreword to *The Bridge at Dong Ha*, retired Navy vice admiral James B. Stockdale wrote: "It's easy to give your all when victory appears to be around the corner. The real hero is the man whose sacrifices for his brothers-in-arms come from a sense of sheer duty, even though he knows his efforts are probably doomed to failure."

COL. JOHN RIPLEY, USMC
The Bridge at Dong Ha, Easter Sunday 1972[1]

The end of the line.

That more or less summed up the town of Dong Ha, in the spring of 1972. Located on the Cua Viet River along Highway 1, the war-torn country's only north–south artery—Dong Ha was a wayside stop for those traveling north or south, the last outpost of the Republic of Vietnam before it petered into the Demilitarized Zone, which by then was anything but, and the Communist-held north.

Strategically, that made it very important.

On Easter Sunday, after days of heavy shelling, 30,000 North Vietnamese soldiers, spearheaded by at least 200 tanks, were preparing to attack the South as part of a three-pronged initiative that would secure their military dominance. Once they crossed the DMZ, only one thing stood between them and control of the vital Highway 1 artery: the bridge at Dong Ha. When they were over that bridge, they could begin dealing with their southern countrymen in their own brutal way.

Protection of the Dong Ha area fell to a battalion of 700 battle-hardened Vietnamese Marines led by Maj. Le Ba Binh, with the support of USMC co-van (an abbreviation of the Vietnamese *Covan My*, which translates as "American advisor") Capt. John Walter Ripley. Ripley, a native Virginian who'd been a Marine officer for ten years, was—by his own choice—one of the last American Marines remaining in Vietnam. Ripley's credentials were impressive. After graduating from the US Naval Academy, he had trained extensively at the US Army's Airborne and Ranger schools, with the frogmen of the US Navy underwater demolition teams, and with a USMC reconnaissance company, where he'd honed his skills in demolitions and mountain climbing—skill sets that would come in handy over the course of the ordeal he was about to face.

That Easter Sunday, Ripley received a radio communication from Brigade warning of the imminent enemy assault and ordering him to fall back on Dong Ha and protect the bridge site. Ripley and the Vietnamese Marines established their position, setting up two rifle companies along the river. From the other side of the bridge they could already hear the inexorable grind of heavy machinery. The tanks were on their way.

Binh's Marines were tough, but they had never shot at tanks before. The major had called in a Vietnamese tank battalion for support, but Ripley knew that forty medium tanks with 90 mm guns would be no match for hundreds of Soviet T-54s. The next radio message from Brigade confirmed his worst fears: the firebases in the South were getting hit hard—no backup would be coming. Ripley and his Vietnamese Marines were the only game in town. If he couldn't stop the Communist tank column from coming across the bridge, then he'd have to blow it up.

Ripley took a long, hard look at the bridge. Erected in 1967 by Seabees from a US Navy construction battalion, it had been built to last. Its massive framework was girded by heavy longitudinal stringers constructed of steel I beams and supported by five immense, steel-reinforced concrete piers, as wide as the two-lane bridge, that rose 20 to 30 feet out of the water. The only resources Ripley had at hand to bring down this massive concrete-and-steel bridge were several of boxes of TNT, some satchel charges, a pack of soggy matches, and his own determination and know-how. It would have to be enough.

Loaded up with satchels packed with TNT, a K bar to cut fuse, his weapon, and some water, Ripley slipped through the razor-wire fence under the abutment and went out under the bridge, hand over hand, wresting the charges between the stringers while the North Vietnamese on the opposite shore fired at him; then he lifted himself up, turned himself over, and crab-walked back across the bridge's underside to get more charges. He did this six times, dangling from the support girders, dodging bullets, lugging his heavy load—bleeding, nearly passing out from the excruciating pain, while muttering his favorite prayer: *Please God, don't let me screw this up.*

Laying the charges was just the first step. There was still the matter of lighting them. Ripley's plan A was to strike some of the soggy matches in his pocket and hope they'd catch. His plan B was to pull the pin on one of the grenades he was carrying, jump 20 feet into the water, and swim like hell to get as far away as he could before it exploded. Luckily, the matches worked.

By now, his arms felt like they'd been pulled out of his sockets. The bridge was crucifying him, but if it didn't go down it would all be for naught. He knew he had to set a backup fuse, so he went back

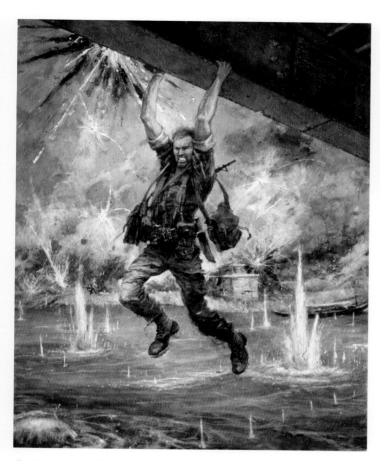

Ripley at the Bridge by Col. Charles Waterhouse, USMC (Ret.).
From the private collection of Jane Waterhouse and Amy Lotano

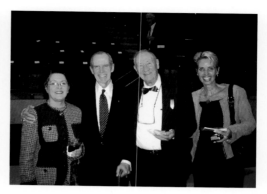

Left to right:
Moline Ripley,
Col. John Ripley,
Col. Charles
Waterhouse, and
daughter Amy
Waterhouse
Lotano.
*Waterhouse
family
photograph*

out with a coil of communication wire used for field telephones, weaving it over the bridge's infrastructure like a spiderweb and spooling it out as he worked his way back toward his men. From across the river, Ripley heard the sound of tanks starting up. The North Vietnamese were ready to roll, and the bridge was still standing. He felt a sense of futility more devastating than any physical pain; in spite of all his efforts, he'd failed.

And then the bridge blew up, exploding great chunks of steel and concrete into the air and the water. Single-handedly, Capt. John Ripley had stopped the North Vietnamese army and put a kink into the works of the Easter Offensive. It was a fleeting victory.

Within a month, NVA forces would fight their way across bridges to the west. But it would take three years for the Communists to reassemble all the pieces and mount another large-scale assault; in the meantime, American bombing was able to resume in the North, paving the way for the release of prisoners of war being held in Hanoi.

For his actions, Ripley would be awarded the Navy Cross.

Before his death, Col. Ripley and his son came to the Waterhouse Museum for the unveiling of the colonel's painting. Afterward, he shared his story with an audience of invited guests. It was a speech that he'd given many times before, but Ripley admitted, on that particular occasion, instead of just telling it, he felt as though he were reliving it.

In a voice choked with emotion, he described standing in front of the ragged remnants of his Vietnamese Marine battalion when they assembled for their first morning muster. Of the 700 men who'd covered him when he was out on the bridge that Easter Sunday, there were only fifty-two survivors.

More often now, when I visited my father, I'd find him in his chair, wrapped up in a fleece jacket and blanket with his Marine cap pulled over his nose. No matter how ill he was, the drill would be the same: first, he'd point me to a patch of cheek, unevenly mowed by yesterday's razor, upon which I was expected to plant a kiss; then he'd watch as I went around the room, reviewing his Medal of Honor works in progress. There was always something new to see—a vignette that he'd finished in the middle of the night, a painting waiting to be framed, some sketches ready to be transferred to canvas. These were the milestones we measured from visit to visit, and week to week.

We didn't talk about the other ones.

Over the four years that he'd devoted to this series, I'd watched him go from using a cane, to a walker, then to a wheelchair, and from a recliner to a motorized lounger that with the press of a button took him from a prone to a standing position. From the chair it was only five steps to his easel, but even that was becoming a struggle.

His painting had changed as well. When he began the series, his canvases tended to be as sprawling and epic as the feats of the men he was depicting. Time didn't factor into it then; he was still thinking big, in wraparound covers and double-page spreads. But as the series progressed, the pictures grew smaller. His style became looser and more painterly—the brushstrokes bolder, the color choices more unexpected. He began to play with perspective and negative space. An abstract quality crept into his backgrounds, and the knife-edged intensity of his compositions made them seem more edgy and violent. I wondered how he could sleep at night.

But sleep was the last thing on his mind. By then he was working so fast that he often neglected to write down the names of recipients he was painting. He could tell us exactly what each man had done, and recount the where, when, and how of the picture, but as to the *who*...? He'd gesture vaguely toward a mountain of books and a tsunami of paper. It was over there somewhere that he'd jotted it down, and sooner or later he'd find it. Amy and I numbered these canvases, filing the nameless recipients under *Missing MOH USMC*—USMC, in this case, standing for *U Should Match Citation* with the scene depicted on canvas.

Outwardly, my father maintained a cheerful demeanor but his frustration betrayed him. There was so much to do. Someone had to take high-res photographs of the finished canvases. When was Ed coming to help with the pages? Why wasn't his printer working? Did I know how to insert copy into an Adobe InDesign layout? Before, when he talked about the book and the paintings, he sounded ebullient and hopeful. Now he spoke of them as though they were hard, heavy things, weighing him down, like the crushing load that Ripley carried on the bridge. All alone.

THE EVOLUTION OF A MARINE CORPS ARTIST

Waterhouse's technique changed over the course of painting the Medal of Honor series, the vigor and precision of his earlier works giving way to fluid brushstrokes, strong color choices, and a bold execution of environmental elements.

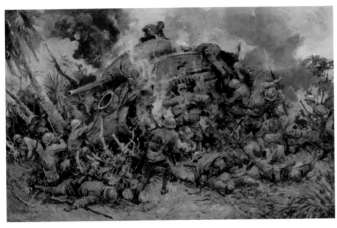

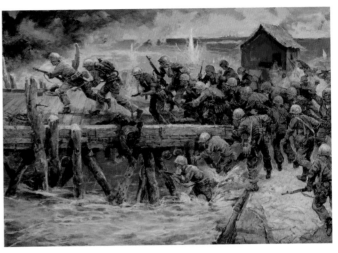

Gy. Sgt. Robert H. McCard, USMC, Saipan, 16 June 1944 by Col. Charles Waterhouse. *Art Collection, National Museum of the Marine Corps*

1stLt. William D. Hawkins, USMC, Tarawa, 20–21 November 1943 by Col. Charles Waterhouse. *Art Collection, National Museum of the Marine Corps*

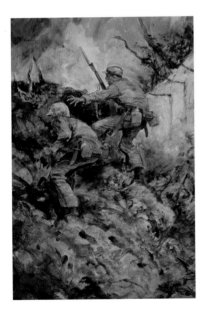

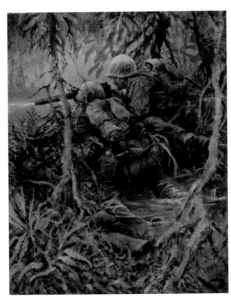

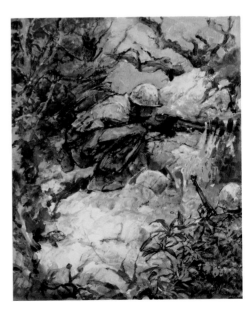

PFC Donald Ruhl, USMC, Iwo Jima, 19–21 February 1945 by Col. Charles Waterhouse. *Art Collection, National Museum of the Marine Corps*

PFC Henry Gurke, USMC, Bougainville, 9 November 1943 by Col. Charles Waterhouse. *Art Collection, National Museum of the Marine Corps*

Cpl. Lewis Bausell, USMC, Peleliu, 15 September 1944 by Col. Charles Waterhouse. *Art Collection, National Museum of the Marine Corps*

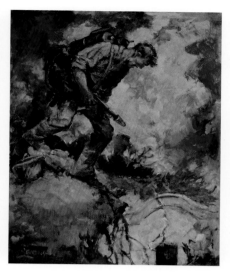

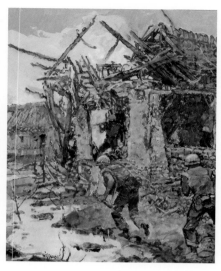

2ndLt. John P. Bobo, USMC, Vietnam, 30 March 1967 by Col. Charles Waterhouse. *Art Collection, National Museum of the Marine Corps*

PFC Albert E. Schwab, USMC, Okinawa, 7 May 1945 by Col. Charles Waterhouse. *Art Collection, National Museum of the Marine Corps*

Maj. Jay R. Vargas, USMC, Vietnam, 2 May 1968 by Col. Charles Waterhouse. *Art Collection, National Museum of the Marine Corps*

The first day that my father could no longer make the five steps to his easel he saw as a temporary setback. The second day he regarded it as a challenge to be overcome. As the days mounted he became increasingly withdrawn, cocooned in his own frustration. His nose started to bleed, violently. When it stopped, he told me happily, *Got that licked*—as if it was one less impediment to keep him from painting. The next day he began bleeding from the mouth.

We called my father's doctor and described what was happening. He basically told us that if Dad went to the hospital, the only thing they'd do was just stick a bunch of tubes in him, schedule some tests, and slowly rob him of his dignity. We decided to tough it out. Amy and Gary took on the yeoman's share. I came down each afternoon and stayed until bedtime. We hired an overnight caregiver. The vigil had started.

For us, at least.

He can no longer sleep at night. He spends his days thrashing restlessly in his chair—he doesn't want to go to bed. He tells me: *I keep painting the picture, over and over. I can't seem to get it done. I just keep painting and painting.*

Which picture, Dad? I ask.

His eyes, which have in recent days turned cloudy, snap to sudden attention. *You know*, he says. *You know the one.*

One afternoon, Ed Sere comes to visit, carrying a thick manila envelope filled with layouts. Dad is too weak to look at them, so Ed places them on the chair in front of his drawing board. They stay there, like a reproach—a thorn in my father's side that God has decided not to remove. Ed and I talk about plans for the book, keeping our conversation upbeat and positive. It's clear that Dad suspects we're humoring him. He turns his head. In that instant, I see that same steely look of determination he had when he set out to show his smart uncle that he could be an artist . . . that he could be a Marine. He's visualizing the walk to his easel—first the left foot, then

the right foot, then the left again—like Ripley, egging himself along on the bridge. Reach. Grab. Pick it up. Reach. Grab.

By November 10—the Marine Corps birthday—everything is a struggle. We wonder how much longer he can go on this way. When our mother was dying, we told her how much she was loved, and let me know that it was okay for her to go. Amy suggested that maybe Dad was waiting for us to give him permission.

I leaned over and gave his sunken cheek a kiss. "Happy birthday, Dad," I said. "I think Mom is waiting for you to take her to the Marine ball."

His eyes flickered open. He looked at me as if I'd gone nuts: Mom was dead and he still had a book to write, paintings to finish.

He didn't want our permission. He was going to die trying.

At 4:41 a.m. on November 16, our father, Col. Charles Waterhouse, passed away. Neither of his daughters was with him. For weeks, we'd scarcely been away from his side, but time and chance are fickle, and in the end they turned against us. On his night in Gethsemane, we fell asleep. The thought that in his last moments our father was alone continues to bring us to our knees.

But writing this book has made me believe that he wasn't.

I think—I know—they were there with him. The always faithful, his Medal of Honor Marines and corpsmen: whispering psalms, singing the Marine Hymn, telling him they'd see him in the funnies. Supporting, shielding, and buffering him from fear during his hand-over-hand struggle to make it across the bridge, to Barbara.

For a long time after he died, Amy and I avoided looking at the Medal of Honor canvases that our father had been working on during the last month of his life. When we finally did, we were bowled over by what we saw. Death is an inherent part of all the Medal of Honor paintings. It's always there—sometimes right in your face, sometimes lurking, ominously, in the shadows. But in his final paintings, death is omnipresent.

None of them are finished. Some of the figures appear to float in an eerie negative white space, while others seem mired in a sea of thick impasto. A couple of the paintings are crudely executed, as if, in the end, he'd come full circle, shedding all his years of training, and was drawing now more from will than skill. They are painfully raw, viscerally fearsome. At the bottom of one, he wrote KOREA in a spidery hand that I barely recognize.

But I've had my chance.

Now it's time for them to tell their own stories. Time to let the Medal of Honor paintings of Col. Charles Waterhouse speak for themselves.

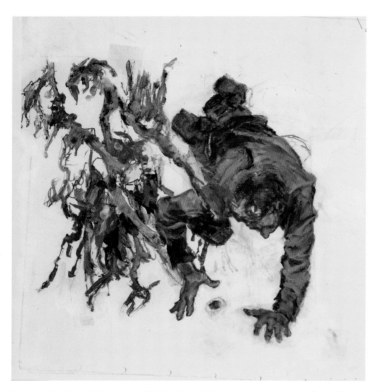 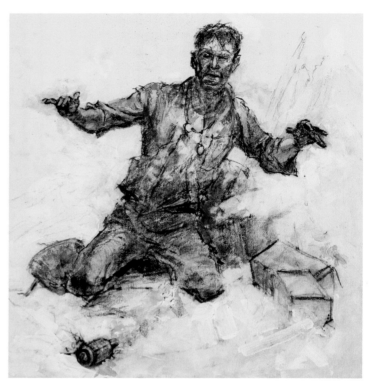

Two unfinished "grenade" Medal of Honor canvases by Col. Charles Waterhouse. *From the private collection of Jane Waterhouse and Amy Lotano*

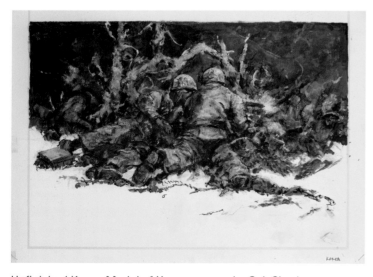

Unfinished Korea Medal of Honor canvas by Col. Charles Waterhouse. *From the private collection of Jane Waterhouse and Amy Lotano*

In shaky handwriting, the dying artist wrote "Korea" on the bottom of this unfinished Medal of Honor canvas. *From the private collection of Jane Waterhouse and Amy Lotano*

PART TWO

VALOR ON CANVAS
The Medal of Honor Paintings of
Colonel Charles Waterhouse, USMC (Ret.)

Honor is purchased by the deeds we do.

—Christopher Marlowe

FIRST RECIPIENTS:
Civil War
Spanish-American War
Boxer Rebellion
Banana Wars

Cpl. John F. Mackie, USMC[1]
Battle of Drewry's Bluff, May 15, 1862

Medal of Honor Citation
Onboard the USS *Galena* in the attack on Fort Darling at Drewry's Bluff, James River, on May 15, 1862. As enemy shellfire raked the deck of his ship, Corporal Mackie fearlessly maintained his musket fire against the rifle pits along the shore and, when ordered to fill vacancies at guns caused by men wounded and killed in action, manned the weapon with skill and courage.

To learn more about John Mackie, see chapter 6, "The First."

SGT. JOHN HENRY QUICK, USMC[2]
Battle of Cuzco Well, Cuba, June 14, 1898

Marine Corps chronicler and artist Capt. John W. Thomason wrote tales about the original leathernecks—men far more comfortable in the Marine Corps than they ever were at home. When Thomason said that the ideal Marine of the "Old Breed" had "drilled shoulders, and bone-deep sunburn and an intolerant scorn of nearly everything on earth," he was probably picturing Sgt. John Henry Quick.

Born on June 20, 1870, in Charles Town, West Virginia, John Quick enlisted in the Marines on August 10, 1892, which made him a six-year veteran by the time the Spanish-American War broke out.

On June 14, 1898, Companies C and D of Lt. Col. Robert W. Huntington's Battalion of Marines, along with about fifty Cubans, advanced through the hills at Guantánamo Bay, Cuba, to seize Cuzco Well, the main water supply for the Spanish garrison. The USS *Dolphin* was offshore, standing by to furnish naval gunfire support if needed. When the assault companies came under heavy long-range rifle fire, Capt. George F. Elliott—who, in 1903, would become the tenth commandant, USMC—signaled to the *Dolphin* to shell the Spanish position, but the message was misinterpreted, and the vessel began dropping shells on a small detachment of Marines on their way to join the fight.

At that point, Sgt. Quick stepped up and announced to his captain that he was a signalman. He commandeered a flag from the Cubans, secured it to a long stick, and strode up to the top of the hill, visible not only to the *Dolphin* but to Spanish artillerymen, who trained their long rifles at the lone Marine, subjecting him to furious fire.

Turning his back to the enemy, Quick began to wave his flag, using the old Myer "wigwag" signal system—a dot-dash code, in which words had to be spelled out very slowly, letter by letter—telling the *Dolphin* to cease-fire. Newspaper correspondent Stephen Crane,

already famous as the author of *The Red Badge of Courage*, happened to be with the Marines at Cuzco Well. He later reported, "I saw Quick betray only one sign of emotion during his heroic action. As he swung his clumsy flag to and fro, an end of it once caught on a cactus pillar, and he looked sharply over his shoulder to see what had it. He gave the flag an impatient jerk. He looked annoyed."

After Sgt. Quick finished his message and had received a reply from the ship, he picked up his rifle and resumed his place on the firing line. The *Dolphin* shifted its fire. By early afternoon, the demoralized Spanish force began their retreat. Having lost the only freshwater source in the vicinity, they were forced to withdraw a distance of twelve miles, leaving control of the entrance to Guantánamo Bay in the hands of the Marines and the US Navy.

For his actions at Cuzco Well, Sgt. John Quick received a Medal of Honor and the praise of his superior officers. In 1930, Lt. Gen. John A. Lejeune wrote, "Perhaps of all the Marines I ever knew, Quick approached more nearly the perfect type of noncommissioned officer. A calm, forceful, intelligent, loyal and courageous man he was. I never knew him to raise his voice, lose his temper, use profane language, and yet he exacted and obtained prompt and explicit obedience from, all persons subject to his orders."

On November 20, 1918, after continuing to serve in the Philippine-American War, the Battle of Vera Cruz, and World War I, then Sgt. Maj. Quick retired due to ill health. But being a Marine was all Quick knew, and he requested to come back on active duty, serving from July to September 1920 until it became clear that—physically at least—his days as a "perfect type of noncommissioned officer" were over. He died in St. Louis on September 9, 1922, at the age of fifty-two.

Sgt. Alexander Foley, USMC[3]
Tianjin, China, July 13, 1900

Alexander Foley was born to a family of Irish immigrants on February 19, 1866, in Heckscherville, Pennsylvania. His father was a coal miner, and the Foleys soon moved to Lost Creek, one of many anthracite-coal-mining patch towns that sprung up in Schuylkill County, Pennsylvania, in the late nineteenth century. From an early age, Alex worked as a breaker boy, and then a miner, for the local colliers. At the age of twenty-two, he decided he didn't want to spend the rest of his life underground, in the dark. In 1883, seeking fresh air, a change of scenery, and adventure, the young man headed to Philadelphia and signed up for a five-year hitch with the Marines. The experience must have agreed with Foley because, in 1883, after serving out his first tour of duty with a character rating of "excellent," he reenlisted.

Although being a Marine would prove as dangerous as being a miner, on this next tour of duty, in addition to fresh air and adventure, Pvt. Foley saw his first combat, serving on Cuba during the Spanish-American War and during the Philippine Insurrection, where, for his courage in a fierce fight at Luzon, Foley was promoted to sergeant.

On July 13, 1900, while serving with the 1st Regiment (Marines) during the Boxer Rebellion in Tianjin (then called Tientsin), China, Sgt. Foley, along with three other Marines, came to the rescue of a badly wounded Army major from the 9th Infantry, risking their lives to carry him to a field hospital about 3 miles away. For his bravery that day, Foley was recognized with the Medal of Honor.

On August 1, 1902, Foley was promoted to gunnery sergeant. He reenlisted in December 1903, and again in December 1908, serving several years of sea duty and being promoted to first sergeant before being transferred to garrison duty at Culebra, Puerto Rico. Foley returned to Lost Creek to visit his family at the end of 1908, looking by one account "the picture of health," but on January 14, 1910, he suffered a massive heart attack while on duty. He was buried with full military honors on the Municipal Cemetery, Culebra, Puerto Rico. First Sgt. Alexander Foley was forty-three years old.

Sgt. Clarence Sutton, USMC[4]
Tianjin, China, July 13, 1900

Clarence Sutton was born on February 18, 1871, in Urbanna, Virginia. The oldest of four children, Clarence's father worked as a merchant, and the family was comfortably well off enough to send their fourteen-year-old firstborn to the prestigious Virginia Military Institute in Lexington. Known as "the West Point of the South," VMI boasts that seven of its alumni are recipients of the Medal of Honor. But from the moment Clarence Sutton arrived in August 1885, he struggled to keep up with the academically demanding regimen. Cadet Sutton was forced to repeat his first year, and although he is listed as a member of the Class of 1890, he resigned from the school before graduating.

In June 1899, Sutton joined the Marines. He served in the Philippines, and by the time of the action in Tianjin, China, he had reached the rank of sergeant. Along with Alexander Foley and two fellow Marines, he helped to save the life of an Army officer at Tianjin.

In the recommendation for the Medal of Honor, Regan stated, "It was with the greatest difficulty and persistence in their noble work that they got me off the field. They placed me on an improvised litter made of two flannel shirts and two rifles . . . I was a heavy man, and with the greatest of care over the roughest kind of ground, under fire, they carried me to a Marine Hospital in the city, a distance, I judge of about three miles."

In addition to the Medal of Honor, Foley is mentioned in dispatches by Company F commander Capt B. H. Fuller as "showing great coolness and bravery" taking messages under fire on July 13.

At the end of the Boxer Rebellion, Sutton and Foley were sent to the Marine garrison at Cavite, in the Philippine Islands, where, on May 11, 1902, in the presence of their units, their citations were read out loud and they were bestowed with the Medal of Honor.

In 1909, then First Sgt. Sutton resigned from the Corps due to illness. On October 9, 1916—four years after Foley died at the age of forty-four—forty-five-year-old Clarence Sutton passed away. He is buried in Arlington National Cemetery.

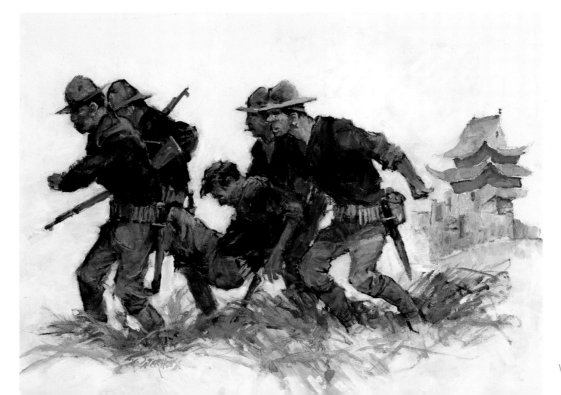

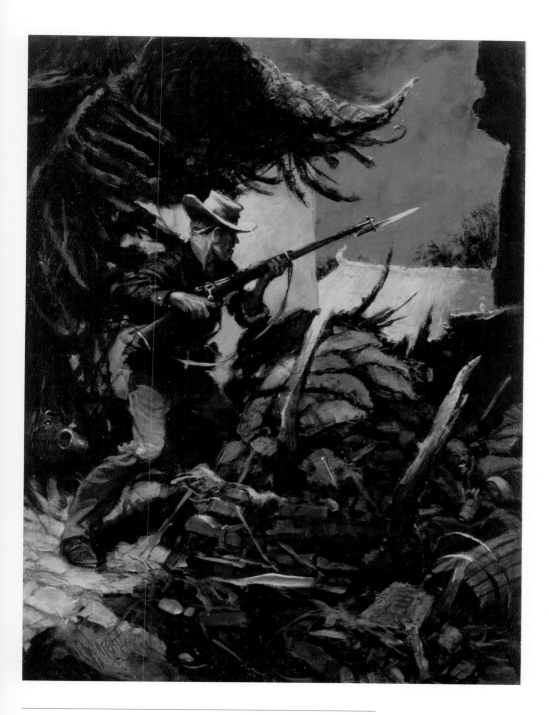

PVT. DANIEL J. DALY, USMC[5]
Boxer Rebellion, August 14, 1900

Medal of Honor Citation

The President of the United States of America, in the name of Congress, takes pleasure in presenting the Medal of Honor (First Award) to Pvt. Daniel Joseph Daly (MCSN: 73086), United States Marine Corps, for extraordinary heroism while serving with the Captain Newt Hall's Marine Detachment, 1st Regiment (Marines), in action in the presence of the enemy during the battle of Peking, China, August 14, 1900, Daly distinguished himself by meritorious conduct.

To learn more about Dan Daly, see chapter 6, "The Fightingest."

CAPT. HIRAM "MIKE" BEARSS, USMC[6]
Samar, Philippine Islands, September 11, 1901

He was born Hiram Eddings Bearss on April 13, 1875, in Peru, Indiana—although those unlucky enough to call him Hiram, a name he vehemently disliked, were in for a fight; but then, fighting came naturally to "Mike" Bearss, not because he was mean, but because he was always bucking the confines of something: classrooms, authority, boredom, injustice. Although bright, Mike bounced through a number of prep schools and universities, attending Notre Dame, Purdue, and DePauw before landing with his brother at Norwich University, a military school in Vermont, where Cadet Bearss became the captain of the brand-new football team, engaged in hijinks, and did a fair amount of drinking.

His influential family managed to secure an appointment to the US Naval Academy for their wayward son, but by 1898, Mike Bearss had had enough of academic life. A local congressman's help was solicited. He encouraged the young man to accept a commission as a temporary second lieutenant in the Marine Corps. Mike Bearss wasn't really sure what being a Marine entailed, but after being told it was "as close to committing suicide as you'll ever get," he wanted in.

And this time the restless rebel stuck. On May 26, 1898, Bearss received his commission as a second lieutenant. Four months later, 1Lt. Bearss was aboard the USS *Solace*, headed to the Philippine Islands. The US had been ceded the Philippines after the Spanish-American War, sparking an insurrection by a fierce guerrilla faction bent on overthrowing the American-backed government. Upon arriving, Bearss was assigned to stations at Cavite and then Olongapo, where he was promoted to captain on July 23, 1900. Later transferred to Subic, Bearss helped track down and capture a notorious outlaw, leading his party of Marines through rice fields, jungles, and barrios until they'd captured their prey and turned him over to the Army to stand trial. It was around this time that Bearss's relish for the forced march earned him the nickname "Hiking Hiram."

On November 17, 1901, then Capt. Bearss was on Samar, routing Moro insurrectionists who were making a last stand on the fortified 200-foot cliffs along the Sohoton River. The Moro camps were reachable only by bamboo ladders or by treacherous back trails, and to protect their lairs the Moros had packed tons of rocks in cages, ready to dump over anyone hardheaded enough to come after them. "Hiking Hiram" Bearss was known for his hard head.

Joining forces with Capt. David D. Porter, Bearss and Porter marshaled their respective columns up a trail to higher ground. Spotting two enemy camps on the cliffs on the other side of the river, the Marines opened fire, killing about thirty Moro guerrillas and scattering the rest. Then they hopped into dugout canoes, crossed the river, and started climbing up the bamboo cliffs, with Bearss and Porter in the lead, surprising the enemy encamped at the top, who fled into the jungle. The Marines destroyed the Moro camp and blew up a hostile powder magazine. In 1934, both Capt. Bearss and Capt. Porter received the Medal of Honor from President Franklin D. Roosevelt for their actions at Samar.

Bearss spent over twenty years with the Marines, serving in every conflict from the Spanish-American War to World War I and achieving the rank of brigadier general. Bearss maintained that the secret to handling Marines was "to feed them, see that no other officer bothered them, and never ask a man to go where the commander himself would not go."

In the short years of peace following World War I, Bearss's larger-than-life, overbearing, and hard-drinking behavior often rubbed subordinates the wrong way. Charges were eventually filed against him for being drunk on duty, and using profanity to berate his officers in front of enlisted men. Bearss accepted a medical discharge from active duty in 1919. Two years later, Mike Bearss was killed in an automobile accident.

MAJ. ALBERTUS W. CATLIN, USMC[7]
Vera Cruz, April 22, 1914

"Remember the Maine!" screamed the yellow-press headlines on February 15, 1898, after the battleship USS *Maine* mysteriously exploded and sank in the harbor of Havana, Cuba. Out of its crew of 355, more than 260 officers, sailors, and Marines would perish in that disaster. Among the surviving officers was the commander of the Marine detachment, then 1Lt. Albertus Catlin—a tough, cigar-chomping Marine who, time and again, would be an eyewitness and participant to history as it unfolded.

Albertus Catlin was born three years after the end of the American Civil War, on December 1, 1868, in Gowanda, New York. He entered the US Naval Academy in May 1886. Three years after the first football game was played at Rutgers University, Catlin was captaining the Annapolis football team, where he played left halfback. Upon graduating with the Class of 1890, Catlin served his required two years of sea duty as a midshipman aboard the USS *Charleston*.

Believing that the Marine Corps offered more opportunity for an up-and-comer like him, on July 1, 1892, Catlin applied to the Marines and was commissioned a second lieutenant. Six years later, in May 1898—only months after emerging from the wreckage of the *Maine*—while serving aboard the USS *St. Louis* during the blockade of the harbor at Santiago de Cuba, Catlin led a group of sailors and Marines in a daring underwater attempt to cut the undersea telegraph cable linking Cuba to Jamaica.

Over the next twenty years, Albertus Catlin would be assigned to Marine barracks around the US and serve overseas duty in the Philippines, the territory of Hawaii, the Dominican Republic, and Guantánamo Bay. For his actions on April 22, 1914, at Vera Cruz, while serving aboard the USS *Wyoming*, then Maj. Catlin would receive the Medal of Honor for "distinguished conduct in battle" and "courage and skill" in leading the Marines of the 3rd Marine Regiment—newly formed from shipboard detachments—in the successful capture of several critical installations in that city.

By October 1917, Maj. Catlin was in France, serving as the commanding officer of 6th Marine Regiment, 4th Brigade, 2nd Division, American Expeditionary Forces. Once again, Catlin was at the front lines of battle, and history, fighting with the 6th Regiment during the Battle of Belleau Wood, where on June 6, 1918, he was wounded in the chest by a German sniper and evacuated to a hospital. Upon returning stateside, Catlin was appointed brigadier general. He went on to serve at the Marine Barracks in Quantico and command the 1st Brigade of Marines in Haiti, but for the rest of his life Catlin suffered the aftereffects of the wound he'd received at Belleau Wood. In December 1919, he retired from the Marine Corps. Brig. Gen. Catlin died on May 13, 1933, at the age of sixty-four and is buried in Arlington National Cemetery.

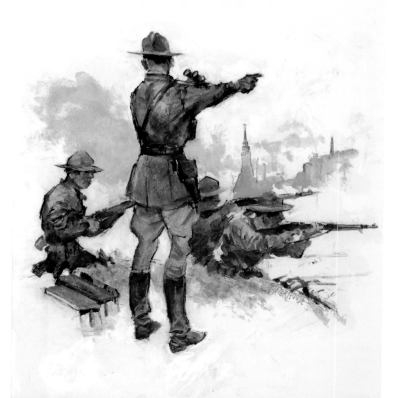

Gy. Sgt. Daniel J. Daly, USMC[8]
Fort Liberté, Haiti, October 22, 1915

Medal of Honor Citation
The President of the United States of America, in the name of Congress, takes pleasure in presenting the Medal of Honor (Second Award) to Gunnery Sgt. Daniel Joseph Daly (MCSN: 73086), United States Marine Corps, for extraordinary heroism in action while serving with the 15th Company of Marines (Mounted), 2nd Marine Regiment, on October 22, 1915. Gunnery Sgt. Daly was one of the company to leave Fort Liberte, Haiti, for a six-day reconnaissance. After dark on the evening of October 24, while crossing the river in a deep ravine, the detachment was suddenly fired upon from three sides by about 400 Cacos concealed in bushes about 100 yards from the fort. The Marine detachment fought its way forward to a good position, which it maintained during the night, although subjected to a continuous fire from the Cacos. At daybreak the Marines, in three squads, advanced in three different directions, surprising and scattering the Cacos in all directions. Gunnery Sgt. Daly fought with exceptional gallantry against heavy odds throughout this action.

To learn more about Dan Daly, see chapter 6, "The Fightingest."

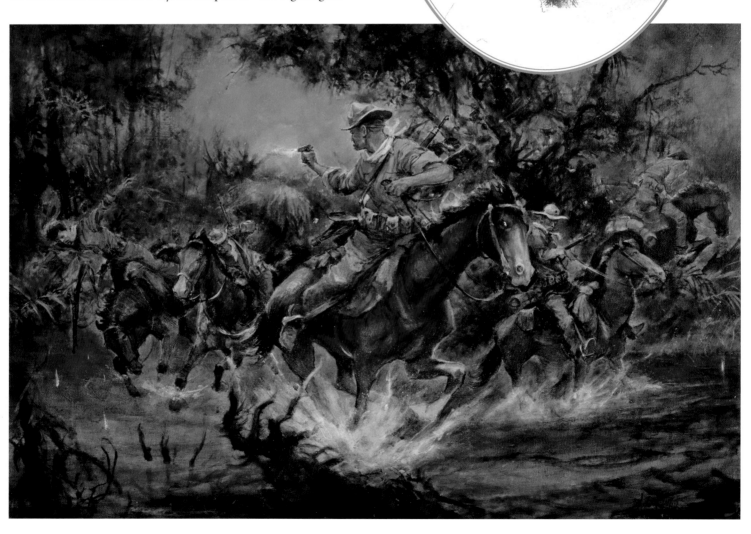

CAPT. WILLIAM P. UPSHUR, USMC[9]
Fort Liberté, Haiti, October 24, 1915

A biography of noted physician, surgeon, and educator John Nottingham Upshur, which appeared in a 1908 compendium called *Men of Mark in Virginia: Ideals of American Life*, stated Upshur's belief that "every young man should be taught to have singleness of purpose and a laudable ambition to succeed"—qualities that his father, George Upshur, a prominent physician and surgeon at the Naval Hospital in Portsmouth, Virginia, had instilled in him, and he had passed on to his own son, William.

Born on October 28, 1881, in Richmond, Virginia, William Peterkin Upshur understood at an early age the values for which his family stood. Just the name "Upshur" conveyed a sense of upright certainty, and it was taken for granted that William would follow the footsteps of his grandfather and father into the distinguished Virginia Military Academy. Instead of pursuing a profession in medicine, however, William went on to study law at the University of Virginia before entering the Marine Corps in 1904 as a second lieutenant.

During his illustrious thirty-nine-year career, Upshur would be stationed at nearly every Marine barracks in the US and overseas, serving during his early years in Cuba, Panama, and the Philippines; in Peking, China; during the Boxer Rebellion; and in Haiti during the Banana Wars.

On October 24, 1915, then Capt. Upshur was on a six-day reconnaissance patrol in the deeply forested jungles of Haiti, with three squads of mounted Marines from 15th Company, 2nd Regiment. They'd been searching for Caco bandits ever since they left Fort Liberté, and now, as the last rays of the sun gave way to darkness and they were heading across a river not far from the rebel stronghold of Fort Dipitie, a large force of about 400 Caco bandits found them.

Greatly outnumbered, and disadvantaged by their position in a deep ravine by the riverbank, the Marines were surrounded on three sides by the Cacos, who were firing down from their hiding places in the bushes above. Upshur's detachment fought its way to a good position, keeping the enemy guerrillas at bay through the night. At first light, Capt. Upshur led a surprise attack against the bandits, marshaling his three squads in a three-prong assault against the enemy that caught the Cacos off-guard and sent them scrambling. Upshur and his Marines then aided in the capture of Fort Dipitie.

For these actions William Upshur was awarded the Medal of Honor.

Upshur continued to serve with the Marines before, during, and after World War I, rising to the rank of major general and carrying out each assigned duty with "singleness of purpose" and an "ambition to succeed." His last station was that of commanding general, Department of the Pacific, with headquarters in San Francisco, California. On August 18, 1943, while on an inspection tour of his command, Maj. Gen. Upshur perished in an airplane crash near Sitka, Alaska. He was sixty-one years old.

A collection of Upshur's letters from 1898 to 1928, which he wrote diligently to his parents every other day—except during the years 1912, 1913, and 1923—is part of the archival material in the Wilson Library at the University of North Carolina at Chapel Hill. The letters contain vivid descriptions of his educational and military experiences; unfortunately, since William Upshur and his wife, Elizabeth, had no children, he was not able to pass the long-held core beliefs of the Upshur family onto the next generation.

It had all the elements of a classic adventure story: a large band of Caco guerrillas, led by a charismatic zealot named Charlemagne Péralte was on the run and hiding in a secret camp, plotting his next move, and a small fighting force with a bold plan to capture the supreme bandit in chief. Fittingly enough, the final chapters were played out in a remote mountain outpost, on Halloween night, ending in a deadly All Soul's Day reckoning.

On October 31, 1919, after learning that Péralte and over a thousand of his followers were camped in the vicinity of Capois, preparing to capture and pillage Fort Rivière, USMC Sgt. Herman Hanneken, a captain in the Gendarmerie d'Haiti, along with Marine Cpl. William Button, a first lieutenant in the Gendarmerie, and about twenty gendarmerie set off to put an end to Péralte's lawless reign.

Heavily disguised and under the cover of darkness, they hiked through the mountains, stealthily moving past Caco guard posts until they reached the heart of Péralte's camp.

In the surprise attack that followed, Sgt. Hanneken opened fire on Péralte, killing him and about nine of his bodyguards; meanwhile, Cpl., Button turned his Browning Automatic Rifle on Péralte's followers.

The fight between Hanneken's small force and the bandits continued through the night, but without the guidance of their inspiring leader, the Cacos resistance soon lost its steam, and by morning, over 1,200 of Péralte's followers had been killed, captured, or dispersed.

CPL. WILLIAM ROBERT BUTTON, USMC[10]
Fort Liberté, Haiti, October 31–November 1, 1915

William Robert Button was born on December 3, 1895, in St. Louis, Missouri, where fellow Medal of Honor recipient Herman Hanneken had been born just two years earlier. Button enlisted in the Marine Corps in April 1917 and was shipped to Haiti soon after, as part of a Marine contingent sent to quash the Caco rebels seeking to overthrow the pro-US Haitian government.

Along with Sgt. Herman H. Hanneken, Button is credited with helping to track down and kill the leader of the Cacos, Haitian nationalist Charlemagne Péralte, during the night action of October 31 – November 1, 1919. For this action, he was recommended to receive the nation's military highest honor.

On July 1, 1920, Maj. Gen. Commandant John A. Lejeune, USMC, presented the Medal of Honor to Sgt. Button in a ceremony in Washington, DC. After receiving his medal, Button took a short leave to visit his family in St. Louis before returning to Haiti.

On April 15, 1921, twenty-five-year-old Sgt. William Button died of pernicious malaria at the Department Hospital, Cap-Haitian, Haiti.

At the request of his father, Button's remains were returned to St. Louis for burial. On Sunday, May 29, 1921, Sgt. William Button was interred in Valhalla Cemetery, with a complement of Marines from St. Louis acting as honor guard and pallbearers. During his brief career, Button had maintained character markings of excellent and was well liked by his comrades. His fellow Marines in the Gendarmerie d'Haiti contributed funds for a bronze memorial tablet to be erected at Sgt. Button's burial place, with the remainder of the money going toward flowers to be placed on his grave each Memorial Day.

2Lt. Herman H. Hanneken, USMC[11]
Grande Rivière, Haiti, October 31 – November 1, 1915

Herman Henry Hanneken was born on June 23, 1893, in St. Louis, Missouri, where he attended the Henrick Preparatory School. In July 1914, Hanneken enlisted in the Marine Corps as a private, serving in the enlisted ranks for the next five years and advancing to the rank of sergeant. While on duty in Haiti as part of the Haitian Constabulary working with the Gendarmerie in 1919, Hanneken led a daring nighttime raid, October 31 – November 1, on the camp of the supreme leader of the Cacos bandits, Charlemagne Péralte, killing the notorious insurrectionist, an act for which both he and Cpl. William Button would be awarded the Medal of Honor. Shortly afterward, Hanneken was appointed a second lieutenant. Over the next few years, he would become the Marines' "supreme" bandit hunter, receiving a Navy Cross in Haiti for shooting and killing Péralte's successor, Osiris Joseph, and capturing another notorious bandit—and a second Navy Cross—during the Nicaraguan campaign in 1928.

Known by his men as "Hard-Hearted," or sometimes "Hot-Headed," Hanneken continued to serve in the Corps until 1948, commanding 2nd Battalion, 7th Marines, at Guadalcanal and taking part in the campaign at Cape Gloucester and commanding the 7th Marines on Peleliu, adding to his decorations along the way. He retired from the Corps at the rank of brigadier general. Brig. Gen. Hanneken died in 1986 at the age of ninety-three, having outlived his fellow St. Louisan Medal of Honor recipient William Button by sixty-five years.

In July 1915, the Marines of the 5th Company were sent to Haiti to suppress a takeover by Caco rebels opposed to the US intervention in Haiti. After months of campaigning by Marines and their Haitian allies through the dense jungles of the island, only one rebel stronghold remained: Fort Rivière. Built atop a 4,000-foot mountain and manned by 300 fierce Caco bandits, the fortification was considered impregnable. When advised that the fort would be difficult to capture, even with a strong battery, Butler replied, "Give me a hundred picked volunteers, and I'll have the colors flying tomorrow."

In the clinch, it would be just two volunteers—a crusty career sergeant and a young Jewish private—who, along with Butler, would lead the attack that eventually took down the "impregnable" fortress.

On November 17, after leaving a small group of Marines on the ridge outside the fort with a machine gun, Maj. Smedley Butler would lead about eighteen Marines crawled through the grass toward the fort. When they found a drainage tunnel that led to the inner courtyard, Sgt. Iams said to Butler, "Oh, hell, I'm going through," and went headfirst through the narrow hole. Gross and Butler followed. By the time they emerged through the other side, Iams was already firing his M1903 Springfield as fast as he could work the bolt, shooting two of the Caco guards and clubbing or stabbing several others. By then, Gross and Butler had joined the fierce hand-to hand combat, and more Marines had poured through the drainage tunnel to enter the fray; meanwhile the Marines on the ridge dispatched or captured the rebels attempting to flee. It was all over in a matter of fifteen minutes, at the end of which time, about fifty Cacos had been killed and the rebel stronghold was in the hands of the Marines.

MAJ. SMEDLEY D. BUTLER, USMC[12]
Vera Cruz, April 22, 1914
Fort Rivière, Haiti, November 17, 1915

Smedley D. Butler was born on July 30, 1881, in West Chester, Pennsylvania. The Butlers were a distinguished Quaker family of lawyers, judges, and congressmen. Smedley attended the West Chester Friends Graded High School, followed by the Haverford School, where he brushed shoulders with the offspring of the Philadelphian upper crust and rose to the top, becoming the captain of the school's baseball team and quarterback of the football team. Against the wishes of his father, he left Haverford thirty-eight days before his seventeenth birthday to enlist in the Marines, hoping to fight in the Spanish-American War. After lying about his age, Butler was commissioned a second lieutenant, setting the tone for a thirty-four-year career as one of the most daring, most highly decorated, and most charismatic and controversial figures in United States Marines history.

Known variably as "Old Gimlet Eye," "the Fighting Quaker," and "Old Duckboard," Butler wholeheartedly believed that no job was impossible for Marines, and made believers out of the Marines who served with him in the Philippines and China, in Central America and the Caribbean during the Banana Wars, and in France during World War I. Butler rose to major general, the highest authorized rank at that time, becoming one of only two Marines—Sgt. Dan Daly is the other—to be recognized twice with the Medal of Honor: Butler's first medal was for distinguished conduct in battle at Vera Cruz on April 22, 1914; his second, for leading an attack on Fort Rivière, Haiti, on November 17, 1915.

In his later years, Smedley Butler became an outspoken critic against war profiteering and the kind of military adventurism that had been so much a part of his early, legendary campaigns as a Marine. He died of cancer in 1940, at the age of fifty-eight.

SGT. LINDSEY R. IAMS, USMC[13]
Fort Rivière, Haiti, November 17, 1915

Ross Lindsey Iams was born in Graysville, Pennsylvania, on April 5, 1879. At the age of twenty-two, Iams traveled to Pittsburgh and enlisted in the Marine Corps. Details about Iams's first twenty-one years on Earth, and his first fourteen years as a Marine, are few and far between, but some combination of his early experiences and innate abilities and character had molded Ross Iams into the bold, tough, scrappy "old sergeant" described by Franklin Delano Roosevelt in a 1917 memo to the assistant secretary of the Navy, recommending that he, along with Maj. Smedley Butler and Pvt. Samuel Gross, receive Medals of Honor for their actions at Fort Rivière, Haiti, in November 1915.

After various appointments as a Marine gunner, first and second lieutenant, and captain, Iams was permanently commissioned a captain in June 1920. According to his service record, Iams spent eleven months at the French Front during World War I; in addition to Haiti, he had assignments in Mexico, China, and Nicaragua—all campaigns in which Maj. Smedley Butler played a pivotal role, but whether Iams continued to serve under "Old Gimlet Eye" (a man two years his junior) is not clear.

Ten years after retiring in 1932, Iams returned to active duty as a major in January 1942 for a brief period during World War II. Although Maj. Ross Iams died in 1952, his name is familiar to young recruits, who must complete a fifty-four-hour training exercise called the Crucible before they can call themselves Marines. As a preface to the body-sparring event, they are read Iams's Medal of Honor citation and reminded that there may come a time when it's necessary to engage in hand-to-hand combat, as Sgt. Iams did, during the attack against a large band of Caco bandits holding the mountain fortress at Fort Rivière, Haiti, on that day long ago.

PVT. SAMUEL GROSS, USMC[14]
Fort Rivière, Haiti, November 17, 1915

Samuel Gross, whose real name was Samuel Margulies, was born in Philadelphia, Pennsylvania, on May 9, 1891. The three Marines whose lives would be linked by their actions during the attack on Fort Rivière all hailed from Pennsylvania. Butler attended secondary school not far from where Gross grew up, but the two moved in different worlds. Butler came from a privileged Quaker family that traced its roots in this country back to the 1600s, while Gross was the son of Jewish immigrants.

On June 2, 1913, Samuel enlisted in the Marine Corps, under the name of Gross, in Norfolk, Virginia. When or why he came to Norfolk rather than enlisting in Philadelphia is a mystery. Two years later, while serving with a detachment of Marines aboard the USS *Connecticut* that had been sent to put down a rebellion in Haiti, twenty-four-year-old Pvt. Gross found himself with Butler and Iams, storming the Caco stronghold at Fort Rivière and engaging in the hand-to-hand combat mentioned in their citations; in some accounts, Gross is credited with saving Maj. Butler's life.

On June 2, 1917, then Cpl. Gross ended his first enlistment, leaving active duty only to enlist again in March 1918

as a private, most probably looking for action in World War I, but his health got in the way. He went to the Philadelphia Naval Hospital in June 1918, transferred to the Naval Hospital in Washington, DC, in July 1918, and was carried on the rolls of Marine Barracks, Washington, DC, until September 10, 1918, when Pvt. Gross was medically discharged from the Marines. He died in 1934 at the young age of forty-three and is buried at Har Nebo Cemetery in Philadelphia.

To date, Samuel Gross is the only Jewish Marine to receive the Medal of Honor.

In 1982, Jewish War Veterans of the US from Drizin Weiss Post #215 in Philadelphia went in search of Samuel Gross's grave, only to find it unmarked. They placed an American flag on the empty space and initiated proceedings to have the Veterans Administration erect a suitable headstone. In 1983, a new headstone was dedicated, with the six-point Star of David above Gross's name, and the five-point star of the Medal of Honor below it. Kaddesh was read for the forgotten hero. Attending the ceremony was Samuel's niece, Barbara Margulies.

1ST SGT. ROSWELL WINANS, USMC[15]
Dominican Republic, July 3, 1916

Roswell Winans was born on December 9, 1887, in Brookville, Indiana. After graduating from high school, Winans spent two years working in Alaska, at a time when the territory was still very much the Last Frontier. In 1908, Winans joined the Army, serving as an enlisted man until discharged. He joined the Marine Corps in October 1912. During his next forty years as a Marine, Winans saw action in Mexico, Nicaragua, Haiti, and the Dominican Republic, and in some of the fiercest fighting of World War I, eventually achieving the rank of brigadier general.

For his heroic actions at Belleau Wood, Winans received a Silver Star with Oak Leaf Cluster (in lieu of a second Silver Star), the Purple Heart, and the French Croix de Guerre with palm. But it was for his actions in an engagement against a large rebel force at Guayacanas, in the Dominican Republic, that then 1st Sgt. Roswell Winans would receive the Medal of Honor.

On July 3, 1916, the Marines of the 2nd Brigade were fighting their way through the thick brush, trying to break through a rebel stronghold. Marine Cpl. Joseph A. Glowin had placed his machine gun—actually a Benet-Mercie automatic rifle, already out of date and subject to frequent jams—behind a large log in the road and had started to open fire on the enemy trenches when he was struck twice by enemy bullets and had to be dragged from behind the gun to a position of cover.

Enter 1st Sgt. Winans, center stage. Winans came forward with a Model 1895 Colt-Browning "Potato Digger" machine gun

and began firing at the enemy, coolly remaining in the open to repair his gun when it jammed, while rebel bullets whizzed all around him. Although the words of Winans's citation help paint a picture of the action, Winans later described the scene in an interview that appeared in the March 17, 1917 edition of the *Recruiters' Bulletin*. His words could be those of any Marine—from the Banana Wars to the present day—who finds himself in the face of fire:

A call went up for a hospital apprentice as Cpl. (George) Frazee had been shot in the head. He had been working hard getting his gun pointed on the enemy and had just succeeded. "You are right on them now, give them hell!" were the last words he said.

I don't know how the other men felt, but I expected to be shot at any moment and just wanted to do as much damage to the enemy before cashing in. Several members of our platoon did cool and creditable work in changing cartridge extractors and repairing jams under fire. We faced the enemy as much as possible while repairing our guns, as we had a horror of being shot in the back.

Brig. Gen. Roswell Winans died on April 7, 1968, at the age of eighty, after a lifetime of bravely facing the enemy and never turning his back.

1Lt. Christian F. Schilt, USMC[16]
Quilali, Nicaragua, January 6–8, 1928

Christian Frank Schilt—one of the early pioneers of Marine aviation—was born in Olney, Richland County, Illinois, on March 19, 1895, seven years before the Wright Brothers first took to the air at Kittyhawk. After attending Rose Polytechnic Institute in Terre Haute, Indiana, Schilt enlisted in the Marine Corps in June 1917, serving as an enlisted man in the Azores with the 1st Marine Aeronautical Company, a seaplane squadron that flew antisubmarine patrols, and was the first complete organized air unit of any service to go overseas in World War I.

Inspired by that assignment, Schilt entered flight training at the Marine Flying Field in Miami, entering as a corporal and emerging in June 1919 as an aviator and a second lieutenant.

2Lt. Schilt's first tour of expeditionary duty was with Squadron D, Marine Air Forces, 2nd Provisional Brigade, in Santa Domingo. After completing the Marine Officers Training School course at Quantico, Schilt was sent overseas again, taking to the skies with Squadron E, 1st Provisional Brigade, at Port-au-Prince, Haiti, then being transferred to the 2nd Brigade, where he was tasked to make an aerial survey and map of the coastline of the Dominican Republic.

Over the next five years, Schilt remained in Quantico, leaving briefly to serve at the Naval Air Station in Pensacola and take a course in aerial photography at Chanute Field, back in his home state of Illinois. In November 1926, Schilt took second place in the Schneider International Seaplane Race at Norfolk, flying his Curtiss racer at a whopping speed of more than 230 mph over seven laps of a triangular 50-kilometer course. He was honing his skills and adding to his knowledge of aircraft capabilities; he would show himself to be a master of both during his next assignment.

The following November, now 1Lt. Schilt was ordered to Managua, Nicaragua, joining Observation Squadron 7-M in support of Marines sent to protect American interests during the Nicaraguan civil war. On January 6, 1928, Schilt volunteered to fly into the besieged town of Quilali, Nicaragua, to deliver aid to two Marine patrols that had been ambushed and cut off by rebel bandits. From January 6 to 8, Schilt made a total of ten flights under "almost impossible conditions," landing his biplane on a makeshift airstrip that the Marines had cleared and burned out on the rough, rolling main street of the village, all while under heavy fire. But landing his aircraft was only part of the challenge. Schilt's biplane had no brakes, so in order to make it stop, the Marines on the ground had to hop on its wings and drag their feet until it came to a halt. In repeated feats of sheer skill and will, Schilt was able to evacuate eighteen casualties, carry in a replacement commander, and deliver much-needed supplies to the desperate Marines.

During his long and distinguished career, Gen. Schilt served in World War II as the Marine aviation commander on Guadalcanal, and the commanding general of the 1st Marine Aircraft Wing in the Korean War. Before his retirement as a four-star general in 1957, Schilt was the director of aviation at Headquarters, US Marine Corps.

Sadly, in the years before Schilt's death, Alzheimer's disease erased these soaring achievements from his memory. Christian Schilt passed away in 1987 at the age of ninety-one.

Lt. Cmdr. Alexander G. Lyle, USN Dental Corps[1]
French Front, April 23, 1918

Alexander Gordon Lyle was born on November 12, 1889, in Gloucester, Massachusetts. He graduated from the Baltimore (Maryland) College of Dentistry in 1912. On April 21, 1915, Lyle accepted a commission in the Navy as an assistant dental surgeon and was assigned to Newport Naval Station in Rhode Island, where he remained until June 1917, when he joined the 5th Marine Regiment, serving as part of the American Expeditionary Forces in France.

By April 1918, the 5th Marines were southeast of Verdun, being schooled in the grim realities of trench warfare: rats and cooties, filth and infectious disease, wire raids and poison gas attacks. On April 23, during a barrage of heavy shelling, Marine Cpl. Thomas Regan, a teamster in Supply Company, 5th Regiment, was hit by shrapnel in an artillery barrage and began hemorrhaging from his femoral artery.

Acting quickly, Dental Surgeon Lt. Lyle administered lifesaving aid, stopping the bleeding and saving Regan's life. For this act of courage under fire, and because the Marines were part of the American Expeditionary Forces, the Army recognized Lyle with a Medal of Honor, and he received a Silver Star from the Navy. In July 1918, Lyle would be awarded a second Silver Star for his actions during the Battle of Soissons.

After the war, Lyle continued to serve. In July 1930, he was back again with the Marines, assigned to the 4th Marine Regiment in Shanghai, participating with that unit in operations in the Yangtze River valley. At the onset of World War II, Lyle was transferred to Quonset Point Naval Station in Rhode Island, serving there from 1941 to 1943. In March 1943, he was promoted to dental surgeon with the rank of rear admiral, becoming the first dental officer in any of the armed services to attain the status of flag officer. Lyle went on to become the inspector of dental activities for the Navy Bureau of Medicine and Surgery, a position that he held until 1946.

During his long, illustrious career, Lyle initiated many breakthrough practices and services, including mobile dental units to care for Navy personnel while on shore duty, and the development of a postgraduate program for dental officers and technicians.

Lyle retired from the Navy on August 1, 1948, having been promoted to the rank of vice admiral. He died on July 15, 1955, at the age of sixty-five and is buried in Arlington National Cemetery.

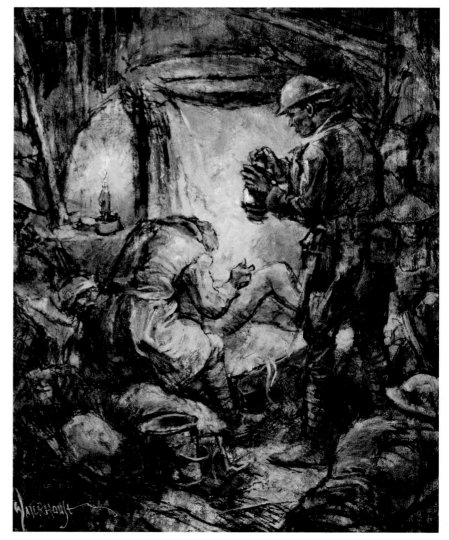

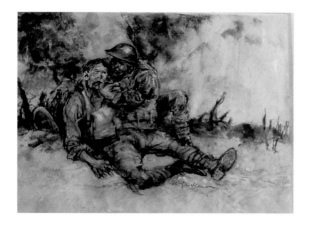

Lt. jg Weedon Osborne, USN Dental Corps[2]

Battle of Belleau Wood, June 6, 1918

Weedon Osborne was born on November 13, 1892, in Chicago, Illinois. In 1915, Osborne graduated from Northwestern University Dental School. After practicing dentistry for two years, in May 1917—just weeks after the US entered the First World War—Osborne was appointed a US Navy dental surgeon as a lieutenant, junior grade, and assigned as a dental surgeon with the 6th Marine Regiment, 4th Brigade, 2nd Division. This assignment would guarantee that dental surgeon Lt. Osborne would be in the thick of the fighting during one of the Marines' most iconic battles, where they demonstrated their "death-defying boldness" and "tenacious endurance" on an international stage. The French later said that the Marines' performance at the Battle of Belleau Wood was akin to a transfusion of blood into a dying man. That analogy was apt: a river of US Marine blood would flow into the depths of that dark forest before the woods were declared "now US Marine Corps entirely."

On June 1, Osborne arrived on the western front with the 2nd Battalion, 6th Marine Regiment, just as the Germans were taking the village of Bouresches, east of Belleau Wood, and the French were falling back. Faced with the possibility of withdrawal, a Marine captain famously said, "Retreat, Hell! We just got here!"

The Marines managed to blunt the German advance but not their resistance. On June 6, the Marines of the 6th Regiment attacked, charging into the fire of enemy machine guns with First Sergeant Dan Daly's (73rd Company, 6th Regiment) battle cry ringing in their ears: "Come on, you sons of bitches, do you want to live forever?" Many of them didn't live to see the dawn. Enemy guns cut down over 1,000 Marines that day, and Lt. Osborne was one among the Navy medical personnel who worked tirelessly to retrieve the wounded and rush them to safety. While Osborne was helping carry Capt. Donald Duncan, commanding 96th Company, to a place of cover, an enemy round struck, killing both men, among others.

For his acts of courage, the twenty-five-year-old dental surgeon was awarded a posthumous Medal of Honor, which was presented to his sister, Elizabeth; in December 1919, Elizabeth also christened the naval destroyer *Osborne* (DD-295).

Lt. Weedon Osborne is buried at the Aisne-Marne American Cemetery, Belleau, in Aisne, France. A street in the village of Bouresche is named for him.

Osborne's extremely rare "Tiffany Cross" version of the Medal of Honor was at some point lost to his family. In 2002, the FBI received word that, in violation of federal law, someone was selling it. The medal was seized and later delivered to the National Museum of the US Navy.

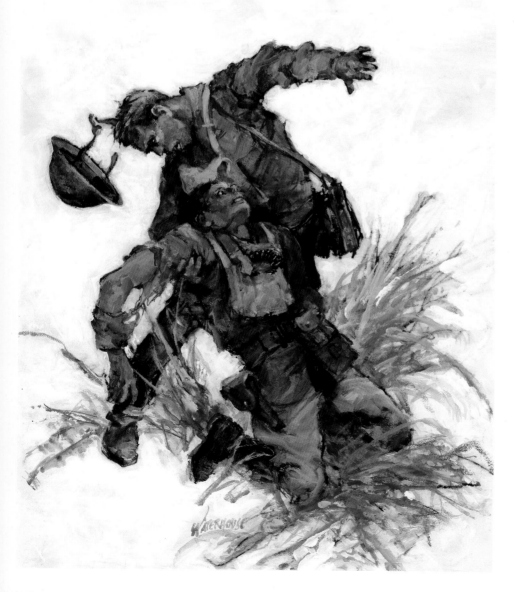

GY. SGT. ERNEST A. JANSON (A.K.A. CHARLES HOFFMAN), USM3[2]
Château-Thierry, France, June 6, 1918

There are many reasons why some people enlist under different names than the ones they were given at birth. They could be hiding that they were underage or escaping from a troubled family life. Charles F. Hoffman, born Ernest A. Janson, had a different reason for changing his name. He was absent without leave—a criminal offense—from the US Army, having bolted after serving ten years, before he enlisted in the Marines on June 14, 1910.

Born in New York City on August 17, 1878, at age thirty-nine, Gy. Sgt. Charles Hoffman was one of the oldest and most experienced Marines fighting with 49th Company, 1st Battalion, 5th Regiment, 4th Brigade, 2nd Division, American Expeditionary Forces, at the Battle of Belleau Wood.

In the predawn hours of June 6, 1918, the silence was pierced by the shrill blasts of whistles, and the shouts of tough Marines such as 1st Sgt. Daniel "Pop" Hunter, 67th Company, and Gy. Sgt. Charles Hoffman, 49th Company, urging their men forward into the open fields. Hoffman's company, commanded by Capt. George Hamilton, had a clear objective: they were to take the right side of the enemy-owned ridge known as Hill 142, which jutted from north to south to the west in front of Belleau Wood. Bracketed by deep ravines, Hill 142 was covered by brush and patches of trees and the highest ground on the battlefield, making it a valuable piece of real estate for both sides. Companies from two German battalions, including numerous Maxim machine guns, were positioned on either side of the ridge. Luckily for the Marines, the enemy hadn't had time to dig in.

The Germans hadn't counted on the sheer determination of these Marine Devil Dogs, or the fearless acts of courage that would be carried out by individual Marines on that day. Although their ranks were thinner, Hoffman's company managed to reach Hill 142, but before the gunnery sergeant could consolidate his line, the Germans launched several counterattacks. As Hoffman was organizing a position on the northern slope of the hill, he spotted a dozen enemy soldiers, armed with five light machine guns, crawling toward his group. Sounding the alarm, Hoffman charged the Germans, bayoneting the two leaders and forcing the others to flee. For this one action, the Marine with two names would receive two Medals of Honor: one awarded by the Navy, and one, ironically, awarded by the Army, from which he was AWOL.

In November 1918, Gy. Sgt. Hoffman returned to the States and was admitted to the Naval Hospital in New York for continued treatment of the wounds he had suffered in France.

By 1921, he had dropped his alias and was living under his real name, Ernest A. Janson.

That same year, Janson was selected to represent the Marine Corps as a pallbearer at the November 11 interment of the World War I "Unknown Soldier." Janson continued to serve in the Marine Corps, assigned as a recruiter in New York City, and, at the age of forty-eight, to the Marine Barracks at Quantico. He retired in the fall of 1926, at the rank of sergeant major, and returned to New York. Janson died in May 1930, after a brief illness. He is buried at Evergreen Cemetery in Brooklyn, New York. On his headstone there are two names: Ernest August Janson is on top, and the bottom line reads "AKA, Charles E. Hoffman."

LT. ORLANDO PETTY, USN MEDICAL CORPS[4]
Battle of Belleau Wood, June 6, 1918

Orlando Petty was one of twins born on February 20, 1874, in Cadiz, Ohio. In 1900, Orlando graduated from Franklin College, New Athens, Ohio, where he was a member of Alpha Kappa Kappa fraternity. In 1904, he received his MD from Jefferson Medical College in Philadelphia, serving his internship at St. Timothy's Hospital, practicing as an associate surgeon before joining the US Naval Reserve Force in 1916 as a lieutenant, junior grade, in the Medical Corps.

On June 11, 1918, while serving with the 2nd Battalion, 5th Regiment, 4th Brigade, 2nd Marine Division, during the Battle of Belleau Wood, Lt. Petty's dressing station in the front lines at Lucy-le-Bocage came under heavy German artillery shelling, including poison-gas shellfire. Remaining calm and focused, Petty continued to attend to and evacuate the wounded. When an exploding shell hit the station, knocking Petty to the ground, he discarded the shredded mask he'd been wearing and carried on with his work until the building had been hit so many times it collapsed in flames around him. Petty managed to escape from the wreckage, carrying a wounded Marine officer on his back. Although severely gassed and sent to the hospital, after just a few days Lt. Petty insisted on being released so he could return to duty in the front lines, caring for his Marines.

After the war, Dr. Petty went back to Philadelphia. From 1923 until shortly before his death, Petty taught at the University of Pennsylvania Medical School, becoming one of the nation's leading authorities on diabetes and authoring a groundbreaking medical book, *Diabetes and Its Treatment by Insulin and Diet*. Petty also served as a personal physician to President Herbert Hoover and Philadelphia mayor Harry A. Mackey. He later became Philadelphia's director of public health and the head of its Bureau of Communicable Diseases

On June 2, 1932, fifty-seven-year-old Orlando Petty killed himself with a German Luger pistol that he'd brought back from the war. Family members told detectives investigating his death that Petty had been despondent over an undisclosed medical condition, which had left him in failing health.

Dr. Orlando Petty and Dr. Joel T. Boone are the only Navy Medical Corps officers to be recognized with the Medal of Honor for their actions during World War I.

GY. SGT. FRED W. STOCKHAM, USMC[5]
Battle of Belleau Wood, June 13–14, 1918

Fred Stockham was born on March 16, 1881, in Detroit, Michigan. After his mother died, his father traveled to New Jersey and left the little boy in the care of a foster mother; other than the Marine Corps, this woman and her daughter would be the only family that Fred would ever know.

Stockham took his first post as a Marine on July 16, 1903. Over the next fifteen years he would be honorably discharged and reenlist three times. From 1903 to 1907, Pvt. Stockham served two tours of duty in the Philippines and one in China.

He continued to serve in civilian life, working as a fireman in Belleville, New Jersey, where his foster mother was living, and in St. Louis, where his foster sister moved after her marriage. While living in St. Louis, Stockham joined the Minnetonka Tribe of Red Men and the Independent Order of Odd Fellows, but these fraternal organizations never quite matched the camaraderie he'd felt in the Marines.

By 1912, he was back at the recruiters. The now Sgt. Stockham was sent to South America, where he saw combat during an engagement at León, Nicaragua. On May 30, 1916, he was honorably discharged in Mare Island, California, but somewhere along the 3,000-mile trip back East, Fred Stockham had second thoughts. He reenlisted a week later in New York City.

In 1918, Marines were headed *Over There,* to the trenches of the French Front. Thirty-seven-year-old Gy. Sgt. Stockham volunteered for the front lines. Serving with the 96th Company, 2nd Battalion, 6th Regiment (Marines), 4th Brigade, 2nd Division, American Expeditionary Forces, he saw combat against the enemy in the Toulon Sector at Aisne, as the German spring offensive continued in force and the outcome of World War I hung in the balance. The real trial was still to come.

On June 13, 1918, Gy. Sgt. Fred Stockham was in the dark forest of Belleau Wood, where deadly mustard gas and bullets rained down on US Marines. During an intense enemy bombardment of high explosives and gas shells that lasted several hours and left most of Stockham's company killed or wounded, the gunnery sergeant noticed that shrapnel had shredded the gas mask of a wounded comrade. Without hesitating, Stockham put his own mask on the young man's face, knowing that the act would cost him his life. Gy. Sgt. Stockham then continued to direct and assist in the evacuation of the wounded until he collapsed from the horrific effects of the gas, dying in agony several days later.

His company commander, then 2Lt. Clifton Cates, wrote a citation recommending Stockham for the Medal of Honor, but the paperwork was lost, and the brave gunnery sergeant was soon forgotten. Stockham's body was shipped back from France in 1920 and buried in Hollywood Cemetery, Union, New Jersey, in an unmarked grave beside the resting place of his foster mother.

In the 1930s, his former company commander, now Lt. Col. Cates—who, in 1948, would become the nineteenth commandant of the Marine Corps—realized that Stockham had never been recognized with a Medal of Honor. He wrote another citation, with testimony from men who had served with the gunnery sergeant—including the Marine whose life Stockham had saved—saying that "No man has ever displayed greater heroism or courage and showed more utter contempt of personal danger."

A Medal of Honor headstone was dedicated in September 1980, with great fanfare and many dignitaries present; then, marking the centennial of the Battle of Belleau Wood in June 1918, a large monument was added, dedicated by the Belleville Historical Society, which now stands over Fred Stockham's grave. The former foster child was also adopted by the city of St. Louis, where his sister had lived and where his Medal of Honor is on display at the Soldiers Memorial Military Museum.

Gy. Sgt. Matej Kocak, USMC[6]
Soissons, France, July 18, 1918

Thirteen immigrants received the Medal of Honor during World War I. Matej Kocak is one of them. Born on December 3, 1882, to a peasant family in what was then Egbell (now Gbely, Slovakia) in the Hungarian sector of the Austro-Hungarian Empire, Kocak was just one of the thousands of young men who, in the early years of the twentieth century, sailed across the sea, hoping to forge new opportunities, and new lives, in the United States of America. Many were immediately drawn to the glow of the steel mills in southwestern Pennsylvania, but not Kocak. On October 16, 1907, the tall, strapping Slovak enlisted in the Marines, beginning his eleven-year career in the Corps at Marine Barracks, League Island, Pennsylvania. In December 1911, a few months after his first tour of duty ended, Kojak reenlisted in New York City and was assigned to Marine Barracks, Navy Yard, New York.

From April to November 1914, Pvt. Kocak served with the Marines at Vera Cruz, Mexico. After his enlistment ended in December 1915, he reenlisted again. In 1916, Kocak saw his first action, participating in skirmishes against the *gavilleros* rebels at Las Canitas, Dominican Republic. Upon being promoted to corporal in January 1917, Kocak returned stateside to join the 12th Company, 5th Marine Regiment, at Quantico, Virginia.

By year's end, Cpl. Kocak was with the Marines at St. Nazaire, France. On January 23, 1918, he joined the 66th Company, 1st Battalion, 5th Marine Regiment, 2nd Division, American Expeditionary Forces. On June 1, Kocak was promoted to sergeant in time to take part in the iconic battle against the Germans in Belleau Wood, and at Soissons, which would be the largest American offensive to date in World War I.

At Soissons, two Marines—Sgt. Louis Cukela and Sgt. Matej Kocak—received Medals of Honor for separate acts of astonishing bravery during the first twenty minutes of the assault. Both were immigrants and became best friends.

Sgt. Kocak crawled into the enemy lines and single-handedly eliminated the German infantrymen guarding the flank of an enemy machine gun, using his bayonet and the butt end of his rifle to neutralize them before taking on the hostile machine gun pit. The German gunners turned their machine gun on Kocak, but they only succeeded in knocking off his helmet. Jumping into the pit, Kocak killed three of the Germans. Six more jumped into the fray. Outnumbered, Kocak swung his bayoneted rifle around, keeping them at bay. They were closing in around the gutsy sergeant when members of his platoon arrived, whereupon the Marines were able to take the six Germans prisoner.

Of the battle at Soissons, the commanding general of 2nd Division, Army Maj. Gen. James G. Harbord, would say, "The story of your achievements will be told in millions of Allied homes tonight." But thirty-five-year-old Matej Kocak would not live long enough to bask in the glory, nor would he ever know that for his actions, he would be awarded both the Army and Navy Medals of Honor. Sgt. Kocak was killed on October 4, 1918, in the Argonne Forest, during the attack at Blanc Mont Ridge, just a little over a month before the Armistice was signed. He is buried at the Meuse-Argonne American Cemetery and Memorial in Romagne, France.

Sgt. Louis Cukela, USMC[7]
Soissons, France, July 18, 1918

In the 1930s, while attending a Solution School class at the Army's Infantry School at Fort Benning, Georgia, Marine Capt. Louis Cukela (pronounced coo-KAY-la) was called upon to present his solution to a complex military situation that had just been presented.

"I attack," Cukela responded.

The instructor huffily explained that a close examination of all the variables showed that the best course of action would be to withdraw to more defensible terrain.

"I am Cukela," the captain said in his characteristically blunt, broken English. "I attack." He tapped the Medal of Honor ribbon on his uniform. "How you think I get this?"

The story of how Louis Cukela came to "get" two Medals of Honor (one Army, one Navy) for the same action in World War I is as extraordinary and colorful as the man himself. Born on May 1, 1888, to a Catholic family living among Serbs, Slovaks, and Bosnians in the volatile area of Spalato (now Split, then part of the Austria-Hun-garian Empire), Croatia, Cukela witnessed the tensions that would soon erupt in war.

In 1913, he immigrated to America, serving for two years as a cavalry trooper in the US Army. This early equestrian experience engendered in Cukela a lifelong dislike of horses. If sawing on the reins and shouting "Stop horse!" wasn't enough to control his steed, Cukela was known to slam his fist down on the creature's head and yell, "I am Cukela. You are horse. When I tell you stop, you stop."

On January 31, 1917, Louis Cukela enlisted in the Marine Corps. From that point on, the Croatian former cavalryman would refer to himself simply as an "American Marine."

On the early morning of July 18, 1918, Cukela was an acting gunnery sergeant with the 66th Company, 1st Battalion, 5th Regiment (Marines), 4th Brigade, 2nd Division, American Expeditionary Forces, in the Fôret de Retz (Retz Forest) near Soissons, France. Battle-worn, dirty, with their bellies and canteens long empty, the 5th Marines had been pinned into place by very effective enemy machine gun and artillery. Sgt. Cukela knew that before an advance was possible, the German machine guns would have to be silenced.

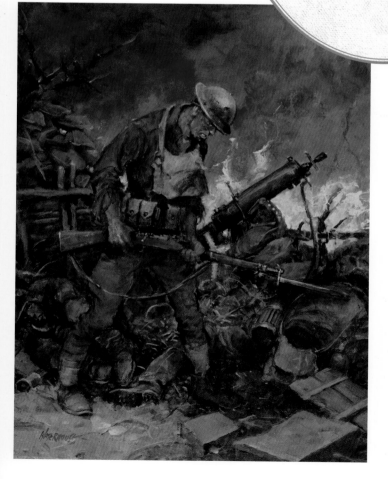

Disregarding the warnings of his comrades, Cukela crawled out from the flank, inching toward the German lines in the face of torrential fire until he was behind the first enemy position. Rushing the machine gun emplacement, the lone sergeant took on the entire crew, slashing some with his bayonet and driving off the others. In a final coup de grâce, he bombed out the remaining portion of the strongpoint by using the Germans' own hand grenades. With a display of "magnificent dash and power," Cukela then went on to capture two machine guns and four enemy soldiers. Because of fearless actions such as his, Gen. John J. Pershing later said, "The tide of war was definitely turned in favor of the Allies."

Cukela was retired on June 1, 1940, but returned to active duty on July 1, 1940, as a major. During the war years, he served at Marine Barracks Norfolk, followed by Marine Barracks Philadelphia, where he went on terminal leave on April 1, 1946, and was placed on the inactive retired list in May, finishing his nearly thirty-two years of military service as a major, becoming one of the "Giants of the Corps," and richly adding to its lexicon of memorable quotes. During the Battle of Belleau Wood, he famously said, "Next time I send damn fool, I go myself." Cukela died in 1956 at the age of sixty-eight. The penultimate "American Marine" was one of only seven Marines during World War I to receive America's highest military honor, and one of only two Marines to be awarded two Medals of Honor—one Army, one Navy—for the same action.

LT. JOEL T. BOONE, USN MEDICAL CORPS[8]
Vierzy, France, July 19, 1918

Joel Thompson Boone was born to Quaker parents on August 2, 1889, in St. Clair, Pennsylvania. While attending Mercersburg Academy in 1909, Boone met Helen Elizabeth Koch, who would later become his wife. Theirs would be a lifelong love. Inspired by his uncle—a country general-practice physician and homeopath—Boone decided to become a doctor. In 1913, he received his MD degree from the Hahnemann Medical College in Philadelphia. By that time, he and Helen were engaged. Upon learning that doctors in the Navy received regular paychecks, Dr. Boone jumped at the chance to sign on, knowing that such security would allow him and Helen to set a wedding date.

In April 1914, Boone was appointed lieutenant (junior grade) in the Medical Corps, US Naval Reserve. He and Helen were married two months later. Over the next several months, Boone trained and served at various posts, including the Naval Hospital at Portsmouth, New Hampshire; the Naval Medical School at Washington, DC; and the Naval Training Station at Norfolk, Virginia.

In May 1915, Lt. Boone transferred to the regular Navy. That same year, he saw his first combat with Marine forces in Haiti. During the campaign to put down the Caco insurrection, Boone contracted a potentially fatal form of malaria that became so severe that in June 1916, he was ultimately evacuated aboard the USS *Solace*.

In April 1917, Lt. Boone was serving aboard the USS *Wyoming* when the news came that the US had entered World War I. In August, Boone was transferred to the 6th Regiment of Marines at Quantico, Virginia, arriving with that unit in France in early October, where he served as battalion and regimental surgeon, 6th Regiment, and then as assistant division surgeon of the US Army's 2nd Division, American Expeditionary Forces.

On July 19, 1918, during the critical Aisne-Marne offensive, Surgeon Boone was with the 6th Regiment (Marines) in an area not far from Vierzy, "near the cemetery, and on the road south from that town." The 6th Regiment had been moved from its initial reserve to the front, with an objective to secure the Soissons-Chateau-Thierry Road, but German artillery, supported by ample air observation and an arsenal of destructive firepower, was determined not to let that happen. With insufficient artillery support to cover them, the Marines advanced across the level ground, in full view of the enemy, and were cut down in massive numbers.

Lt. Boone left the relative safety of a ravine, dashing through an open field with his medical kit. Under the most-dangerous conditions imaginable, with enemy fire raining all around and a noxious "mist of gas" wrapping him like a shroud, Boone calmly applied dressings and administered first aid to wounded Marines. The need was so great that he soon ran out of dressings.

Boone made his way through a "heavy barrage of large-caliber shell, both high explosive and gas," to retrieve more dressings, returning to the field with a sidecar loaded up with supplies, which he administered to suffering Marines. He made a second trip that same day, loading his sidecar and bringing additional lifesaving dressings and medicine to the wounded in the field.

For these actions, Lt. Joel Boone was recognized with a Medal of Honor. Boone would continue to make history, serving two terms as assistant physician to the White House under Presidents Warren G. Harding and Calvin Coolidge, and a third term as physician to the White House under President Herbert Hoover.

In April 1945, Boone was promoted to commodore, serving as the medical officer of the 3rd Fleet under Adm. William Halsey. On September 2, he represented the Navy Medical Department on the deck of the USS *Missouri* at the Japanese surrender. He was later tasked with providing care during the evacuation of prisoners of war at Japan's Omori POW camp in Tokyo.

In March 1950, then RAdm. Boone became the inspector general of the Medical Department. He went to Korea that same year, earning the distinction of having served in three major wars. Among Boone's many accomplishments are the development of helicopter decks aboard hospital ships during the Korean War, and the first medical and safety survey of US coal mines.

By December 1950, Boone's health had begun to fail. He retired from the Navy and was promoted to vice admiral. He is the most highly decorated medical officer in Navy history. VAdm. Boone died on April 2, 1974, in Washington, DC, and was laid to rest at Arlington National Cemetery. His wife, Helen, passed away two years later and is buried beside him.

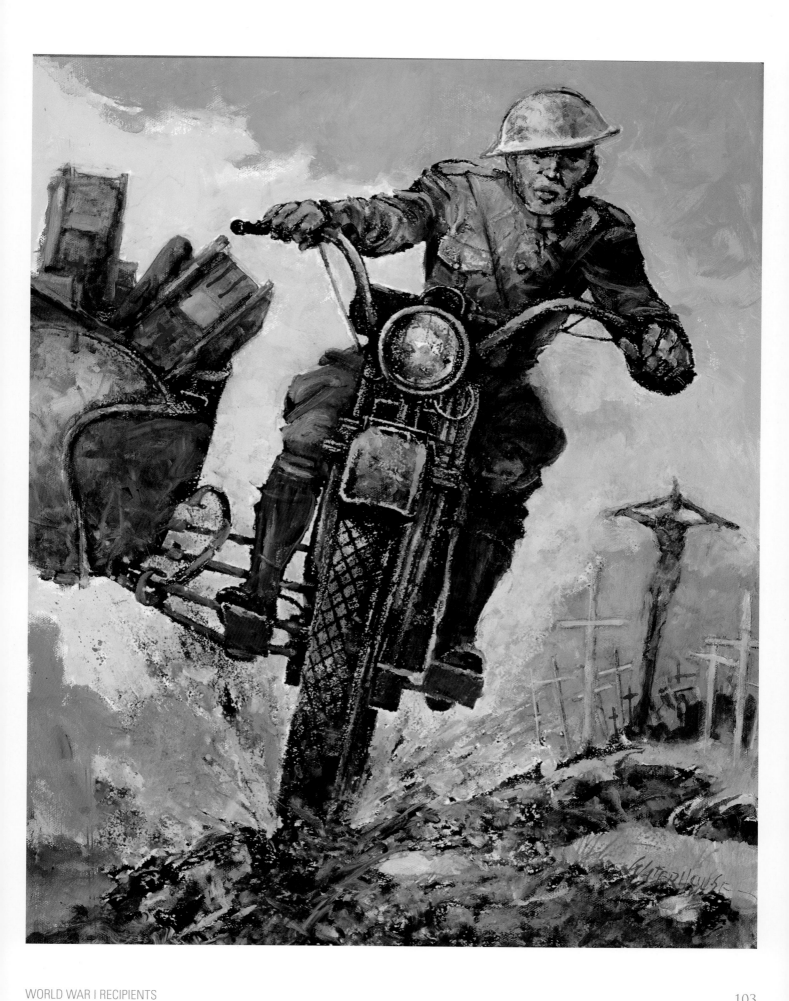

PhM1c John H. Balch, USN[9]
Vierzy, France, July 19, 1918

John Henry Balch was born on January 6, 1896, in Edgarton, Kansas. In May 1917, with the sounds of the war in Europe growing ever louder, Balch interrupted his studies at Kansas State University in Lawrence to travel to Kansas City, where he volunteered for a Navy's officers program. After training to become a pharmacist's mate (the equivalent of a hospital corpsman), Balch was assigned to the 3rd Battalion, 6th Regiment, 2nd Marine Division, American Expeditionary Forces, and headed to the western front in France.

In the blood-soaked forest of Belleau Wood, where Balch was wounded on June 8, his coolness in the face of fire was battle-tested. For his heroic service in evacuating the wounded, Balch later received the Army's Distinguished Service Cross and the Croix de Guerre.

During the Battle at Soissons, on July 19, 1918, the unflappable pharmacist's mate was back among the exhausted and battered Marines of 3rd Battalion, 6th Regiment. The battle would be fierce and brutal. Balch was assigned to an aid station near Vierzy, but he didn't stay there. Over a period of sixteen hours, he continually ventured out into the front lines, fearlessly exposing himself to enemy fire in order to treat the wounded and carry the fallen Marines back to safety.

On October 5, at the Battle of Somme-Py (Blanc Mont), PhM1c Balch displayed his fortitude again, advancing through heavy fire, ahead of the Marines, to set up a battle-dressing station. His Medal of Honor recognizes his exceptional bravery at both Vierzy and Somme-Py.

John Balch was honorably discharged on August 19, 1919. A month later he was presented with the Medal of Honor in a ceremony at the YMCA in Chicago, Illinois. In the years after the war, John Balch was said to have opened a men's clothing store in Chicago. He returned to the Navy during World War II, serving as a lieutenant in Australia and the Philippines. Balch retired from the Naval Reserve in 1950 at the rank of commander. Appropriately, the MCB Quantico, Virginia, medical clinic is named the John Henry Balch Health Clinic.

John Balch, one of the most highly decorated servicemen in US Navy history, passed away in 1980, at the age of eighty-four.

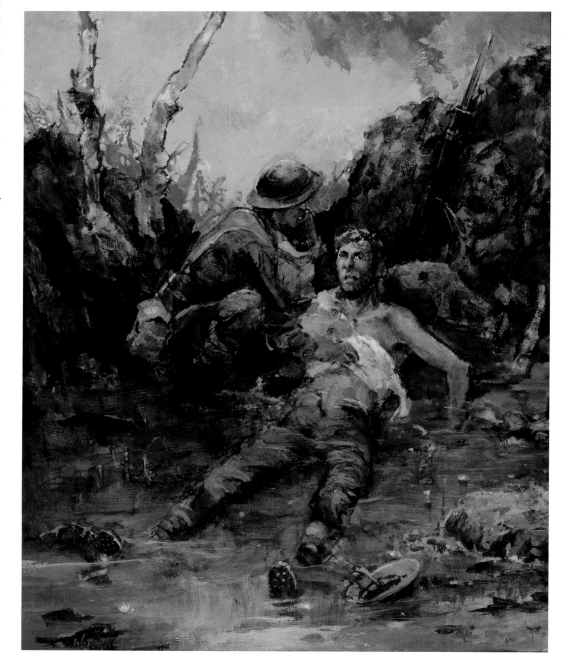

HA1c David E. Hayden, USN[10]
Thiaucourt, France, September 15, 1918

David Ephraim Hayden was born on October 2, 1897, in Florence, Texas. According to the 1900 and 1910 censuses, through most of their childhood, David and his older brother, Elbert, lived with their grandparents. In 1917, two events occurred that would change David's life: his brother, Elbert, died from a traumatic brain injury after being kicked in the head by a horse; shortly afterward, David Hayden went to Houston and signed up with the US Navy. It is quite possible that his brother's death was one of the reasons he chose to train as a hospital apprentice.

By December 21, 1917, Hospital Apprentice First Class David Hayden was headed to the French front with the 2nd Battalion, 6th Regiment Marines, 4th Brigade, 2nd Division, American Expeditionary Forces.

On September 15, 1918, while with his unit at Thiaucourt, France, HA1c Hayden risked his life to save the life of Marine Cpl. Carlos D. Creed, 96th Company, 2nd Battalion, 6th Regiment, who'd been severely wounded by enemy machine gun fire while crossing an open field and was lying, bleeding and exposed, in an area of intense fire. Hayden packed up his medical kit and made a run for the fallen Marine, dressing his critical wounds in the field while under fire in the open field, then picking him up and carrying him through a hailstorm of German artillery fire.

For his actions in World War I, Hayden would receive the Medal of Honor, the Silver Star Medal from the Army, World War I Victory Medal, the Italian Croce di Guerra, and the Portuguese Cruz de Guerra. Before leaving the service, Hayden achieved the rank of pharmacist's mate third class.

David Hayden spent the next thirty-four years of his life as a US marshal, stationed at various posts in California. During that time, he received two awards for superior service. After World War I, he participated in the burial ceremony of the first Unknown Soldier; he was given that same honor in 1958 at the burial of the Unknown in World War II. Hayden died in 1974 at the age of seventy-six.

CPL. JOHN H. PRUITT, USMC[11]
Blanc Mont Ridge, France, October 3, 1918

On October 4, 1896, John Henry Pruitt came into this world at Pruitt Hollow, Boston Township, near the small settlement of Fallsville, Newton County, Arkansas. On October 4, 1918, Cpl. John H. Pruitt was killed on a smoke-veiled hill in France where the flashes from shells and artillery—in the words of Capt. John Thomason—"came redly through the clouds." On October 4, 1921, after lying for three years under French soil, Pruitt's body arrived back in the US to be taken to its final resting place at Arlington National Cemetery.

The oldest of four children, John Henry moved with his family from Arkansas to Jerome, Arizona, after his youngest brother was born. Located in the upper reaches of Cleopatra Hill, between Prescott and Flagstaff, Jerome was literally built on copper, growing from a cluster of prospector tents into a gunslinging, Wild West mining town. It's not known what drew the Pruitts to Jerome, but once there, John attended the local schools and by 1913 had found work as a salesman at the general store on Main Street. At some point, John Pruitt moved to Phoenix. His name appears on a memorial at the Phoenix campus of Arizona State University, honoring active-duty fallen alumni.

By April 1917, continuing his education was the furthest thing from John Pruitt's mind. The US had just entered the world war, and on May 3, Pruitt decided to do his part by enlisting in the Marines. He had only seventeen months to live, but in those seventeen months, John Henry Pruitt would give 100 percent of himself to his comrades and country.

In July, after qualifying as a marksman, Pruitt joined 78th (E) Company, 6th Regiment, which would become part of 2nd Battalion, 4th Brigade, 2nd Division, sailing with his unit in January 1918 for France.

From June 1 to 14, Pvt. John Pruitt fought against the enemy around Château-Thierry, participating in the legendary battles at Bouresches and Belleau Wood. On June 14, he was gassed in action and evacuated to a field hospital, rejoining his unit in August.

On August 4, Pruitt was promoted to corporal. From September 12 to 15, Cpl. Pruitt was engaged in operations against the Germans at Bois de Montagne, St. Mihiel sector, where he aided in the capture of an enemy machine gun near Thiaucourt, receiving a Silver Star citation from Gen. John J. Pershing for "distinguished and exceptional gallantry."

On the morning of October 3, during the battle of Blanc Mont Ridge, with the front line of his regiment being cut down in swaths by German machine gun fire, Cpl. Pruitt set off, alone, in search of the enemy nest. He silenced the gun, and later that day he went out on a second one-man mission into hostile territory, capturing another machine gun, killing two of the enemy, and returning with forty Germans whom he'd found hiding in a dugout.

That same day, Pruitt was hit by shellfire, and the following fateful day, October 4—the date John Henry Pruitt came into the world and the date he would leave it—the young Marine died of his wounds.

Cpl. Pruitt is one of only nineteen recipients who received two Medals of Honor, one from the Army and one from the Navy, for the same action.

In December 1919, the Navy named a destroyer in Pruitt's honor. In 1941, the USS *Pruitt* was undergoing overhaul at Pearl Harbor when the Japanese attacked. Declared shipshape in January 1942, the *Pruitt* sailed for offshore duty, earning a total of three battle stars during World War II.

The last of the "four-stack" destroyers, it was decommissioned in 1945 and sold for scrap, making these words, written at the time of its launching, even more haunting: "Wherever the destroyer *Pruitt* pokes its nose will come recollections of a boy who fought and died; of a boy who covered his name with glory that will last long after the destroyer *Pruitt* has been antiquated and sent to its base for salvaging."

PVT. JOHN J. KELLY, USMC[12]
Blanc Mont Ridge, France, October 3, 1918

Were it not for the World War I–era uniform that Pvt. John J. Kelly is wearing in his official photograph, he might be mistaken for a Boy Scout, rather than a mean fighting machine described by his fellow Marines as "a ball of fury, a tiger" and "not anybody you'd like to fool with," on or off the battlefield.

He was born on June 24, 1898, in Chicago, Illinois. Not much is known about Kelly's early years. He ran away and joined a circus at age sixteen, returned to Chicago, and enlisted in the Marine Corps on May 15, 1917, just a month after the US declared war on Germany; it's almost as if his first nineteen years were just practice for the life he'd lead as a Marine in "the war to end all wars."

By January 1918, Private Kelly was attached to the 78th Company, 2nd Battalion, 6th Regiment, 4th Brigade, 2nd Marine Division, headed to France. From this point on, Kelly's datebook gets crowded. At the end of May 1918, he was with his unit as it deployed on very short notice to help the French blunt a major German offensive at Château-Thierry, one of the first major actions of elements of the American Expeditionary Forces under Gen. John J. "Black Jack" Pershing. Kelly fought through the vicious battles at Belleau Wood, earning a Silver Star, and was headed with his unit to the next big battle at Soissons until he got in trouble and headed to Paris instead. In September, Kelly participated in the AEF-led attack at the St. Mihiel salient, where he added three Silver Stars to his credentials as a war fighter.

In October, Kelly was at Blanc Mont Ridge; by this time, the angry young man had stoked up a roaring fire of hatred for the Germans, and he was ready to level it at them. Kelly had boasted he would be the first to capture a German machine gun. At the start of the battle, Pvt. Kelly ran like a *fénnid*—one of the fierce mythological warriors that his Irish mam might have told him about—dashing through no-man's land and through an Allied artillery barrage, 100 yards ahead of the front lines, and straight toward an enemy machine gun nest. He lobbed a grenade into the nest, killing one German, then he took out his sidearm and shot another. When Kelly finally returned to his line—again, through a friendly artillery barrage—he brought with him eight German soldiers, held at gunpoint.

For his actions at Blanc Mont Ridge, Pvt. John Kelly was awarded two Medals of Honor, one from the Army and one from the Navy. Kelly went on to fight in the Meuse-Argonne Offensive and remain in Germany as part of the occupation forces. During World War I, Kelly also earned two Purple Hearts—one for shrapnel wounds in his thigh, and another for surviving a gas barrage in June 1918, during which he inhaled toxins. Kelly would suffer from the effects of these injuries for the rest of his life.

Peacetime didn't prove easy for John Kelly. He battled the bottle, drifting between Florida and Chicago, taking jobs as a house painter when he could get them and stirring up trouble wherever he could. According to his

grandniece, Kelly was a passionate Irish nationalist and once faced a court martial for refusing to accept an award from the British government. But when it came to talking about his actions at Blanc Mont Ridge, Kelly's characteristic brashness faded. "The guys that are dead are greater heroes than I am," he told the *Chicago Tribune* in 1938.

In 1957, when John Kelly died of cirrhosis at the age of fifty-nine, he was the last surviving of nineteen two-time Medal of Honor recipients. He'd be pleased to know that history has shown that of the thirty-three countries listed as birthplaces of his fellow recipients, Ireland—with well over 250 medals—can claim the most.

On October 8, 1918, while participating in an air raid conducted by the Royal Air Force's No. 218 Squadron, 2Lt. Talbot's DH.4 was attacked by nine Luftstreitkräfte enemy scouts. In the ensuing dogfight, Talbot skillfully fended off the hostile force while Gy. Sgt. Robinson manned the machine guns, shooting one of the enemy planes down in flames.

On October 14, while en route to an air strike on an enemy ammunition depot near Pittham, Belgium, Talbot and Robinson experienced engine trouble and became separated from their formation. Out of the blue came a dozen enemy Fokker and Pfalz fighter planes, gunning to take them down. While Talbot skillfully piloted the DH.4 through a hailstorm of hostile fire, Robinson let loose with his machine guns, firing off at a cyclic rate of 500–600 rounds per minute, managing to shoot down one of the enemy aircraft before a German round

caught him in his elbow, leaving it dangling from his arm by a single tendon. During the fierce exchange, Robinson's machine gun jammed. It might have been the end for both of them, but in a masterful display of teamwork and tenacity, Talbot maneuvered the DH.4 through enemy fire, gaining enough time for his wounded gunnery sergeant to clear the jam with one hand and return to the fight. Robinson continued to return fire on the Germans until he was wounded in so many areas of his body that he collapsed. With steely resolve, Talbot attacked the nearest enemy scout, shooting the plane down. By now his gunner was unconscious and his motor was failing, so Talbot dove to escape the enemy force, skimming the German trenches below at an altitude of 50 feet and managing to land his DH.4 on the closest Belgian airfield, where he was able to find lifesaving help for his comrade before returning to his aerodrome at La Fresne.

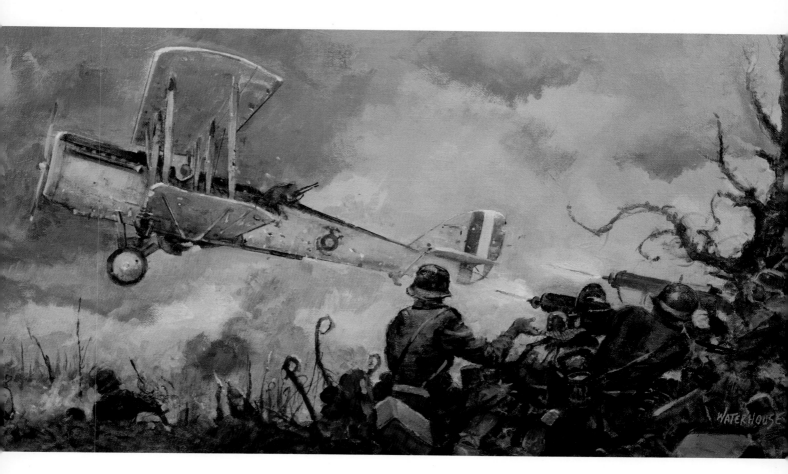

GY. SGT. ROBERT GUY ROBINSON, USMC[13]
1st Marine Aviation Force, France, October 8–14, 1918

Robert Guy Robinson was born on April 30, 1894, in Wayne, Michigan. Robinson was working as a mechanic in Chicago when the US entered the World War I in April 1917. A month later, the twenty-one-year-old mechanic enlisted in the Marines as a private. The 5-foot-5, 142-pound recruit completed his training at Parris Island, South Carolina, and was sent for additional training at Wilbur Wright Flying Field, near Dayton, Ohio.

On July 18, 1918, now Cpl. Robert Robinson sailed aboard the USS *DeKalb* with the newly created 1st Marine Aviation Force, headed to France. As an element of the Navy's Northern Bombing Group, the Marine aviators of 1st Marine Aviation Force would be tasked with flying bombing, supply, and observation missions along the Belgian coast.

Robinson was paired with pilot, 2Lt. Ralph Talbot; like an aerial version of Astaire and Rogers, they operated as a seamless team: Talbot flying the de Havilland DH.4 two-seat biplane (known as the "Liberty Plane" because of its new American engine, or, more ominously, the "Flaming Coffin" because of a defect in its original British design), while Robinson manned the ring-mounted machine guns from the rear seat. As observer, Robinson's role was to be an extra pair of eyes for Talbot; in combat situations, however, it was his skill with a machine gun and as a bombardier that really mattered.

On October 8, Robinson's deadly aim helped fend off an attack by nine German scout planes and shoot one enemy aircraft down in flames. On October 14, after becoming separated from their formation during an air strike against a German ammunition depot near Pittham, Belgium, their DH.4 came under attack by a dozen enemy Pfalz fighter planes. Robinson managed to shoot down one German plane before being riddled by bullet wounds to his chest, leg, abdomen, and left arm, which was almost completely severed at the elbow and left hanging by a single tendon. Talbot masterfully wove his DH.4 through the enemy force, landing the plane at a Belgian airfield in time for surgeons to be able to save his gunnery sergeant's life. For these two actions, Talbot and Robinson became the first Marine Corps aviators to be awarded the Medal of Honor for bravery in aerial combat.

In June 1919, after a lengthy period of hospitalization in both France and Washington, DC, Gy. Sgt. Robinson— promoted on November 1, 1918—was honorably discharged from the Marine Corps. He was later appointed a second lieutenant in the Marine Corps Reserve, where he served until his retirement in 1923. In September 1936, Robinson was promoted to first lieutenant. He eventually moved to a small cabin outside St. Ignace, Michigan, becoming something of a recluse. In October 1974, Robinson was found lying dead in his garden. He was seventy-eight. No one in the St. Ignace area had known that the grizzled old man living in the isolated cabin was one of the early legends of Marine Corps aviation and had been awarded the Medal of Honor for heroism during World War I. Robinson was buried with full military honors in Arlington National Cemetery.

2LT. RALPH TALBOT, USMC[14]
1st Marine Aviation Force, France, October 8–14, 1918

For a daredevil, sitting in the cockpit of a DH.4 biplane, suspended in midair between a pair of spindly porch-trellised wings, is an adrenaline rush. For a poet, such as 2Lt. Ralph Talbot, it's something else. In this fragment from one of his unfinished poems, Talbot describes taking off in his fighter plane at twilight:

Against the west my wings are bars

Between the sunset and the stars

Below ten thousand feet in space

The earth's old patchwork pock marked face . . .

Ralph Talbot—poet, patriot, and Marine Corps pilot—was born on January 6, 1897, in Weymouth, Massachusetts. At Weymouth High School, Ralph was the captain of the debate team and a standout athlete on the football, baseball, and track teams. He organized the school's first cross-country team and edited its first real yearbook. Ralph's dream was to go to Yale to pursue his passion for writing, but when his father died during his senior year, that seemed unlikely to happen. In a twist of fate, soon after graduation, one of his friends passed away from meningitis and the boy's wealthy family generously arranged for Ralph to take their son's place at Mercerville Academy in Pennsylvania, a prestigious college preparatory school for young men with Ivy League aspirations. Ralph worked hard to repay their kindness, becoming a shining star on the debating and cross-country teams, while excelling in academics and winning the school's Karux Prize for excellence in theme writing.

In the fall of 1916, Talbot enrolled in Yale. During his freshman year, Ralph participated in three sports and built a reputation as a promising essayist and poet. When America entered the war, many of the members of his class were abandoning the halls of academia to serve in Europe. Ralph had heard some of his cross-country teammates talking about the air corps. The idea captured his imagination, as is clear from this 1918 poem:

Pilot of strength and ease and grace

Craft of wondrous symmetry. (*Jones*)

On October 15, 1917, after studying at the Du Pont Aviation School in Delaware, Talbot enlisted in the Navy and started a course of flight training, becoming naval aviator No. 456. He'd set the goal and attained it; now it was time to raise the bar: Talbot wanted to get into the action overseas. Hearing that the Marine Corps was struggling to recruit aviators, and thinking that might work in his favor, Talbot made the switch from the Navy to the Marine Corps Reserve, where he earned a commission as second lieutenant.

By August 1918, 2Lt. Talbot was in France with Squadron C, 1st Marine Aviation Force.

One of his first missions was dropping tins of "bully beef" to a detachment of French troops cut off from their supply base. Although Talbot laughed off these supply runs as "aerial grocery business," they were not without danger, necessitating that the pilot drop to under 500 feet before releasing the cargo of cans, exposing his aircraft to ground fire from enemy machine guns and rifles.

In the two aerial-combat missions that would earn him—and his gunnery sergeant, Robert Robinson—the Medal of Honor, Talbot exhibited both his skill as a fighter pilot and his coolness under pressure. But the war had changed Ralph Talbot. He was no longer the idealistic young man who saw being a pilot as a way to fly above . . .

. . . The mire,

The sordidness of life, small vanities . . .

What he flew above now were scenes of carnage—fields moldering with wasted lives, the earth's face pocked with mortar craters, scorched shards where once were trees.

In his final poem, "The Circus," Ralph Talbot sounds cynical and weary:

I have put my best years in my work,

Have I.

I have performed at all hours.

I have remained

On high. . . .

Cheers!

Cheers for the "Superman"

The Nation's Aviator! . . .

We are the star performers—Buffoons!

Who swing from bar to bar with ease,

For Honors!

Beneath the Big Top—on the Big Trapeze.

(Le Fresne, October 1918)

On October 26, just a week after boldly maneuvering through twelve German scout planes, shooting down one of them with his front guns, then flying like a bat out of hell to save the life of his wounded comrade, 2Lt. Ralph Talbot was killed after volunteering to test an engine on a recently repaired aircraft. During the test run, the engine failed; the gunner managed to catapult from his seat, but Ralph Talbot was trapped in the burning wreckage. He was just twenty-one years old.

WORLD WAR II RECIPIENTS

1LT. GEORGE H. CANNON, USMC[1]
Midway Islands, December 7, 1941

George Ham Cannon was born on November 5, 1915, in Webster Groves, Missouri. His family later moved to Detroit, Michigan, where George graduated from Southwestern High School. He then attended the Culver Military Academy in Indiana before entering the University of Michigan in Ann Arbor as a member of the Reserve Officers Training Corps program. During his senior year at Michigan, Cannon was commissioned as a second lieutenant in the US Army Engineer Reserve. After earning his degree in mechanical engineering, Cannon resigned his Army commission to become a second lieutenant in the Marine Corps.

Cannon spent the next few years continuing his training, and on assignments at Quantico and the Marine Corps Base in San Diego. By July 1941, the newly promoted first lieutenant was sailing to Pearl Harbor with Battery H, 6th Defense Battalion, Fleet Marine Force, edging ever closer to the day that would go down in infamy—and the place where Cannon would enter the annals of Marine Corps history.

On September 7, 1Lt. Cannon reported for duty as commander of Battery H on Sand Island, Midway Atoll. One of the farthest outposts of the US fleet defensive and communications, Midway was a rich target for a Japanese Empire intent on dominating the Pacific.

The Marines of the 6th Defense Battalion waited and trained as diplomatic talks between the US and Japan hit an impasse and gradually broke down. On Sunday, December 7, while the Marines on Midway were going about their daily routines, Japanese bombs started dropping on Pearl Harbor. When intelligence began filtering in from Army and Navy sources, many on Midway

assumed that this was just a realistic battle exercise; as the day drew on, however, it became clear that the attack was all too real. The Marines went on high alert, scrambling to their guns.

Hours later, under the cover of darkness, on a night so clear that in the words of the commander of the 6th Defense Battalion, Lt. Col. Harold Shannon, "the sand looked like snow and the breakers on the reef clearly outlined the island," the Japanese destroyers *Sazanami* and *Ushio* circled silently around Midway, skulking off Sand Island.

Manning the Battery H command post with his team, 1Lt. Cannon was well placed to relay tactical information to the batteries on the beach, which would be vital in order for them to provide accurate fire during an attack. His position in the powerhouse, at the southern tip of Sand Island, was not only tactically critical; it placed Cannon in the direct line of attack. One of the Japanese destroyers took aim, firing off a 5-inch shell that hit the command post, spraying shrapnel and erupting it into flames. Cannon's pelvis was crushed in the blast, and he was bleeding internally. In a show of superhuman strength, he managed to stay conscious and composed enough to regain control of the battery and maintain communications until reinforcements arrived, refusing to leave his position until his command post was operational and all his wounded Marines had been evacuated. 1Lt. George Cannon died soon after, at the age of twenty-six. He was the first Marine to receive the Medal of Honor in World War II.

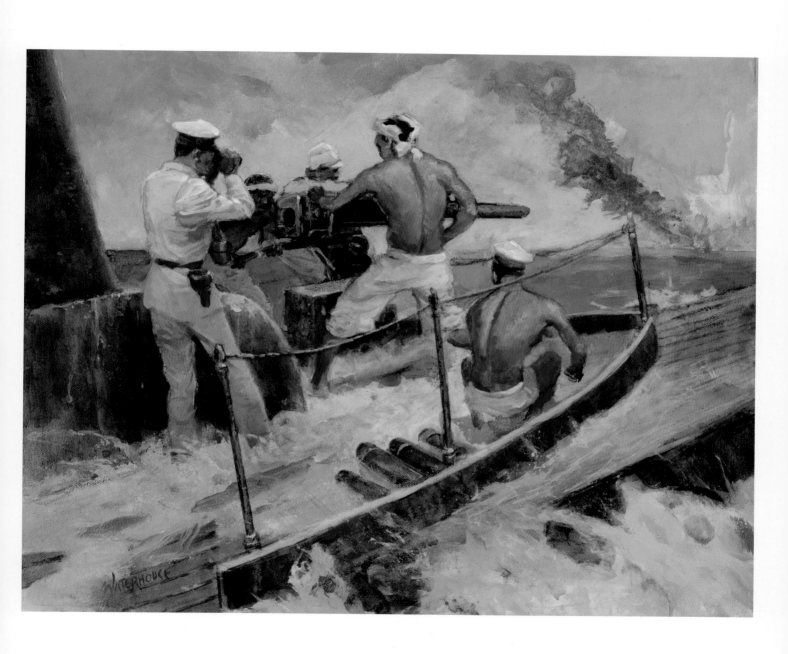

Capt. Henry Talmage Elrod, USMC[2]
Wake Island, December 8–23, 1941

Henry "Hank" Talmage Elrod was born to a farming family in the tiny town of Rebecca in Turner County, Georgia, on September 27, 1905, three years after the Wright Brothers took their first flight. In an era when less than 10 percent of students graduated from high school, Hank Elrod proved exceptional, continuing his studies at the University of Georgia and Yale. When his father passed away in his senior year at Yale in 1927, Hank dropped out of school and enlisted as a private in the Marine Corps in order to provide for his family. He entered officer school and quickly worked his way up the ranks, ultimately undergoing flight training and earning his wings in 1935.

On December 4, 1941—three short days before the attack on Pearl Harbor—the by then Capt. Elrod flew to Wake Island with Marine Fighting Squadron 211. From that day on, Hank Elrod was thrust under the microscope of history.

While the charred remains of the US Fleet were still smoking in Hawaii, the 500 Marine defenders of the island, and twelve fighter pilots of VMF-211, were soon face to face with a vastly superior enemy, intent on seizing Wake and controlling its airfield. On December 9 and 12, Capt. Henry "Hammerin' Hank" Elrod downed two Japanese aircraft, knocking out a pair of enemy Zeros and scoring the first air-to-air "kills" that Marines achieved in World War II. Elrod also conducted a series of low-altitude bombings and strafing runs on enemy ships, becoming the first pilot ever to sink a warship with small-caliber bombs delivered from his fighter aircraft.

But despite the heroics of Hammerin' Hank and his squadron, the Japanese were relentless, coming back in repeated attacks until all of the Marine aircraft on Wake had been destroyed. By December 23, Capt. Elrod was one of the last officers on the island. Without a plane to fly, and with 2,500 Japanese troops on their way, Capt. Elrod leveraged the experience of his fourteen-year career as a Marine, taking command of a defensive flank made up of surviving crew members, pilots, and artillerymen and directing them to dig trenches, set up firing positions, and hold their ground. When the enemy hit the beach, Hammerin' Hank urged his Marines on, repositioning them to meet the assault on all sides. Having given away his rifle and pistol to a fellow Marine, Elrod stood defiantly, raining fire with a captured Japanese machine gun, until an enemy bullet struck him in the chest, killing him. The large Japanese force seized the island, capturing or killing its remaining defenders and holding Wake Island until the end of the war.

Capt. Henry Elrod became the first Marine aviator to be recognized with a Medal of Honor in World War II.

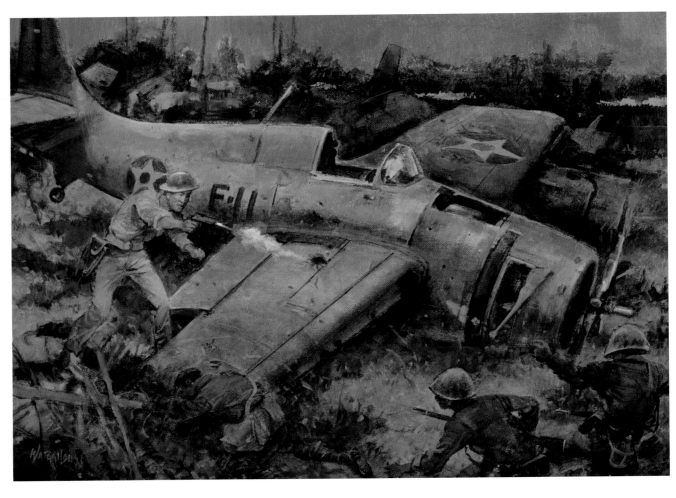

CAPT. RICHARD E. FLEMING, USMC[3]
Battle of Midway, June 4–5, 1942

Richard Eugene Fleming was born in Saint Paul, Minnesota, on November 2, 1917, just a few months before soldiers and Marines began arriving in France to fight in World War I. It would take years for the boy to understand the meaning of the words "courage" and "sacrifice," but in the next World War, Richard Fleming would put those words into action.

A career in the military seemed to be a given. While attending Saint Thomas Military School in St. Paul, Fleming was chosen as top student officer of his class. After graduating from the University of Minnesota in 1939, he enlisted in the Marine Corps Reserve. In 1939, Fleming applied for flight training, finishing at the top of his class a year later. The young aviator was quickly promoted up the ranks from first lieutenant to captain, serving at the Naval Air Base at San Diego before being sent to Midway Island just ten days before the Japanese attack on Pearl Harbor.

Fleming was assigned to Marine Scout Bombing Squadron (VMSB) 241 (a.k.a. "the Sons of Satan"). The squadron was equipped with sixteen Douglas SBD-2 Dauntless and eleven ancient Vought SB2U-3 Vindicator dive-bombers. All were at the ready.

By June 3, the Japanese fleet had already been observed approaching Midway. Their objective was clear: to take control of the island and secure its airfield.

On June 4, squadron commander Maj. Lofton Henderson, with Capt. Fleming on his wing, led an attack against Japanese aircraft carriers. When Henderson's plane was shot down, Fleming took over the lead, diving to perilously low altitudes before releasing his bomb. It was a technique he would use again.

Despite the fact that his Dauntless was riddled by 179 hits from Japanese fighter guns and antiaircraft batteries, Fleming was able to fly through total darkness, in hazardous weather, to safely land his plane at Midway.

On the morning of June 5, after less than four hours of sleep, Capt. Fleming, now piloting an SB2U-3, took to the skies again, directing the second division of Marine Bombing Squad 241 in a coordinated glide-bombing attack on the *Mogami* and *Mikuma*, a pair of heavy Japanese cruisers that had been damaged in the night in a collision off Midway caused by an American submarine, USS *Tambor*. Although accounts vary, survivors on both sides agree that early in the engagement, Fleming pressed his Vindicator to an altitude of about 500 feet, put his aircraft into approach glide,

and made a screaming dive at the Japanese cruiser *Mikuma*, Shot through with flames from Japanese antiaircraft fire, and unable to pull out of his dive, Fleming managed to keep his plane on course until he could release his bomb, scoring—depending on the source—a direct hit or near miss before crashing into the after-turret of the enemy cruiser. Both Fleming and his gunner perished that day. The crash caused an explosion in the *Mikuma*'s engine room, and it sank the next day.

The Japanese commander of the *Mogami*, who witnessed the attack, later said, "I saw a dive-bomber dive into the last turret and start fires. He was very brave," but no evidence has ever been substantiated that Fleming deliberately flew his plane into the enemy cruiser.

Twenty-four-year-old Capt. Richard Fleming was the second aviator to be recognized with a Medal of Honor in World War II.

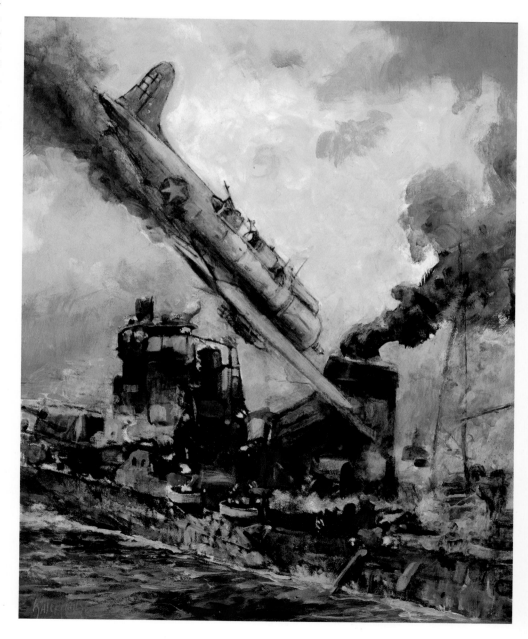

On June 27, 2005, a devoted husband, father, and grandfather named Robert Galer died of a stroke at the age of ninety-one. That Robert Galer was a retired Marine brigadier general, a World War II flying ace, a Medal of Honor recipient, and one of the most highly decorated aviators in Marine Corps history—not to mention an NCAA hall of famer—would have surprised many of those who knew him, because Bob Galer wasn't a man who spoke much about his accomplishments, on the court or in the Corps.

Robert Galer was born on October 24, 1913, in Seattle, Washington. He attended the University of Washington, earning money in the school bookstore while leading the Huskies basketball team into a division championship. Known by his fellow players as "Goose," Galer was the top offensive threat for a fast-paced team that local sportswriters dubbed "the Greyhounds." During his time at UW, Galer earned All-America honors as a forward—one of only sixteen UW Huskies to do so—and inductions into both the Husky and the NCAA halls of fame.

In 1935, after graduating with a BS degree in commercial engineering, Galer began the required training for the Naval Aviation Cadet program at the Naval Reserve Aviation Base in Seattle. He made the cut. By February 18, 1936, Galer was a cadet in the student naval aviation program on the rolls of the Marine Barracks at the Naval Air Station in Pensacola, Florida. He was commissioned a second lieutenant in the Marines on July 1, 1936, and designated a naval aviator in April 1937: Bob "Goose" Galer, the former quick-footed basketball forward, was on the fast track toward becoming one of the best Marine fighter pilots of World War II.

On December 7, 1941, Galer was serving as a captain with Marine Fighting Squadron 211 in Oahu when the Japanese attacked Pearl Harbor. By the following May, Galer had been given command of Marine Fighting Squadron 224. History was now setting the pace for Goose Galer, and he definitely was ready. On August 30, 1942, Galer and his squadron were headed to Guadalcanal, where they became part of the Cactus Air Force.

From August to September 1942, now Maj. Galer repeatedly led his squadron in daring and aggressive raids against Japanese aerial forces in the area of the Solomon Islands. Over a period of twenty-nine days, Galer shot down eleven enemy bomber and fighter aircraft, receiving a Medal of Honor for his actions; under his leadership, his squadron would destroy a total of twenty-seven Japanese planes.

Galer continued to serve after his heroic actions in the Solomons, adding to his well-earned collection of medals in Korea, where, as commanding officer of Marine Aircraft Group 12, he led a "maximum effort strike of Marine attack aircraft against a heavily defended industrial area in the North Korean capital city of Pyongyang." In addition to the Medal of Honor, over his distinguished career Galer would be awarded the Navy Cross, the Legion of Merit with Combat "V," the Distinguished Flying Cross with one gold star, a Purple Heart, an Air Medal with ten gold stars, and a rare British Distinguished Flying Cross. And yet he seldom spoke about his glory days as an athlete or an aviator. To Robert Galer, whether he was shooting hoops or shooting down enemy planes—it was all just part of his job.

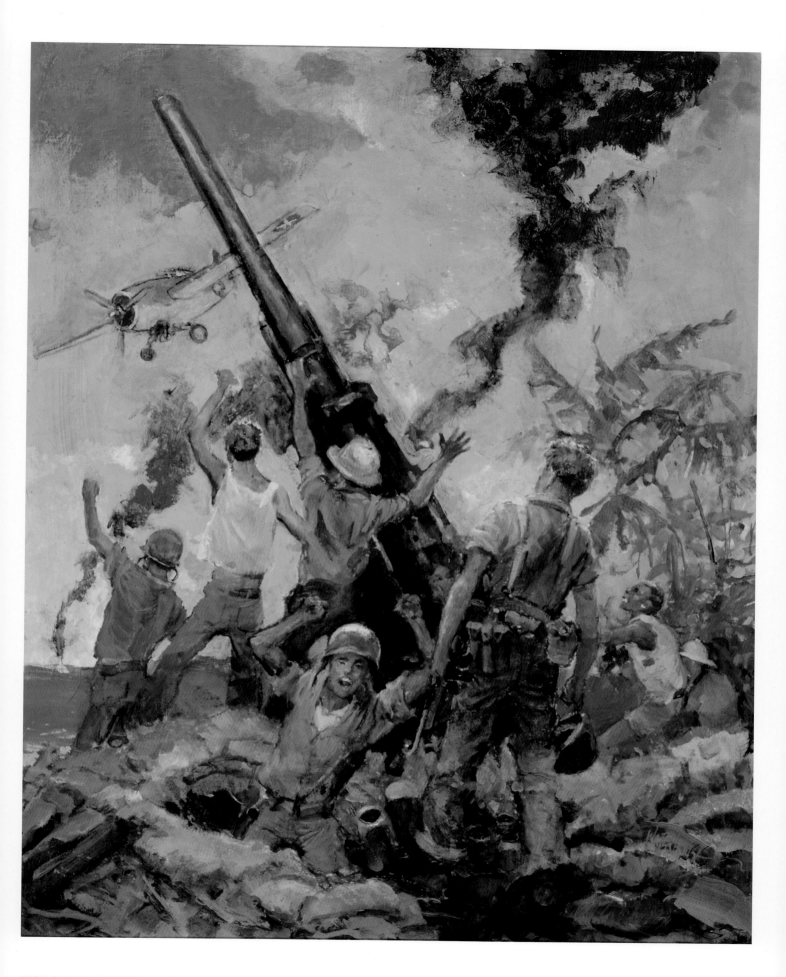

MAJ. JOHN L. SMITH, USMC[5]
Solomon Islands, August–September 1942

John Lucian Smith was born on December 26, 1914, in Lexington, Oklahoma, coming of age in the Great Depression and weathering the punishing storms of the Dust Bowl by the time he was fifteen. Those who survived those years had a tendency to build a protective wall around themselves, keeping feelings and fears deep within. This ability to maintain a calm exterior in the face of challenge helped make John Smith an exceptional fighter pilot. It may also be why many of his fellow aviators regarded their poker-faced leader as cold and unemotional. Joe Foss, who would go on to become a Marine flying ace, recalled his first meeting with Smith on Guadalcanal in 1942. "I said to John, 'Are you old veterans going to show us around?'" Foss recounted. "And this guy was really a dead-puss. He very rarely smiled, and he just says, 'Tomorrow you will be a veteran.'"

What Foss and the other aviators didn't realize was that as the aerial war in and around the Solomons progressed, "dead-puss" Smith anguished about the toll it was taking on his squadron, writing home to his wife, "I am proud to get it (the Navy Cross), except that they think that it is good payment for seeing young pilots who are sharing my tent go down in flames day after day."

But Smith was an Okie, bred to rise above whatever was coming at him; and what was coming at him, and at the other pilots of the Cactus Air Force, was a highly disciplined, numerically superior Japanese force, determined to take them down. Under Maj. Smith's leadership, Marine Fighting Squadron 223 would destroy a total of eighty-three enemy aircraft, racking up nineteen air victories in just fifty-four days. Between August 21 and September 15, 1942, Smith personally shot down sixteen Japanese planes, earning him the nation's highest honor.

In 1943, as executive officer with Marine Aircraft Group 32, then Lt. Col. Smith would continue to lead his fighter pilots in combat over the Philippine Islands area. After the war, he settled into family life, teaching his kids how to play competitive sports and keep a poker face during card games. Smith worked in the civilian aerospace industry until 1972, when he was abruptly laid off from his position with North American Aviation. Shortly afterward, the Marine Corps flying ace and Medal of Honor recipient committed suicide. Suffering from depression and what was then called "battle fatigue"— now known as post trumatic stress disorder—John Lucian Smith could no longer contain the inner storms and anxieties that he'd valiantly fought to keep inside, and at bay. He was fifty-seven years old.

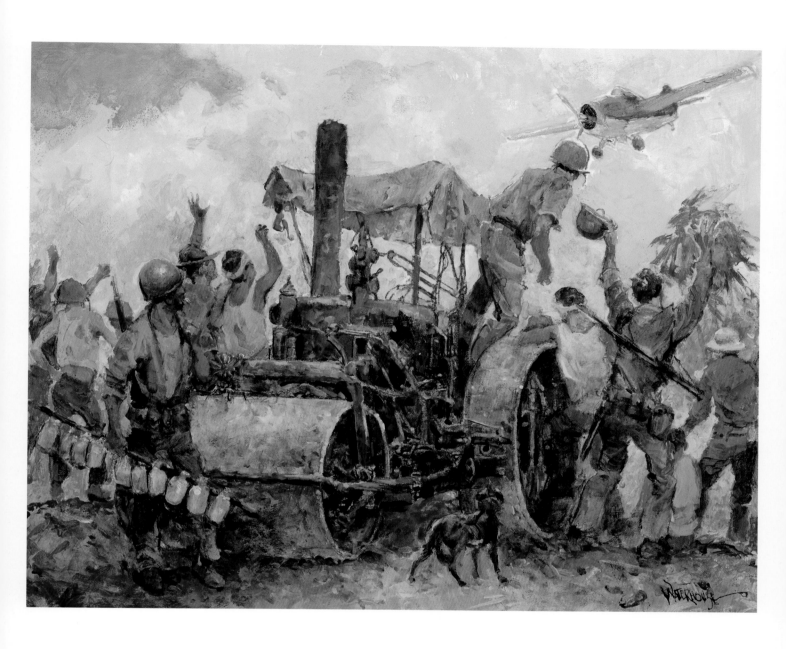

MAJ. GEN. ALEXANDER VANDEGRIFT, USMC[6]

Alexander Archer Vandegrift was born on March 13, 1887, in Charlottesville, Virginia. He might have followed in the footsteps of his father, a prominent architect and contractor, but from an early age, "Archie"—as he was called—was fascinated by the military, an interest that was kindled by reading historical novels and listening to family tales of his fighting Dutch ancestors. After graduating from Charlottesville High School and attending three years at the University of Virginia, Archie Vandegrift left school to do what he'd always wanted to do: become a leader in the Marine Corps.

The first step was to pass a competitive, weeklong examination, which he did in 1908. The following year, Vandegrift earned a second lieutenant commission. In 1919, while still at the Marine Officers School (the Basic School today), the young second lieutenant wrote an article titled *Aviation, the Cavalry of the Future*. His visionary thinking was somewhat undermined by a series of disciplinary infractions that resulted in a rating of "Not Good" at his first evaluation.

From that low point, the trajectory of Vandegrift's career veered ever upward, paralleling—and often helping to shape—the history of the United States Marine Corps.

During the Banana Wars, 2Lt. Vandegrift served in Cuba and Nicaragua; in 1914, he was at Vera Cruz as a newly promoted first lieutenant. Two years later, Capt. Vandegrift was in Port-au-Prince, Haiti, helping to quell a Caco insurrection. By 1927, Maj. Vandegrift was at 3rd Brigade (Marine) headquarters at Tientsin, China. Following duty at Quantico and his promotion to lieutenant colonel, he was back in China as commanding officer of the Marine detachment at the American Legation at Pieping.

But his service was only beginning.

In November 1941, shortly before the US entered World War II, now Brig. Gen. Vandegrift became the assistant division commander of the 1st Marine Division at Camp Lejeune. In March 1942, he was promoted to major general and assumed command of the division. The curtain was about to rise on the first large-scale offensive against the Japanese in the Solomon Islands. What happened at Guadalcanal, and its environs, would affect the course of all future operations in the Pacific theater and, quite possibly, determine the outcome of the war. From August 7 to December 9, 1942, Maj. Gen. Vandegrift orchestrated land, sea, and air forces of the Army, Navy, and Marine Corps with resourcefulness and prescient leadership, succeeding against the odds—against the terrain and the weather, against disease and starvation, and against a fanatical and numerically superior enemy.

For his efforts, Vandegrift would be recognized with a Medal of Honor. He continued to lead during World War II, assuming command of I Marine Amphibious Corps in July 1943 to plan and lead the initial attack at Bougainville.

On January 1, 1944, Lt. Gen. Alexander Vandegrift was sworn in as the eighteenth commandant of the United States Marines. A little over a year later, he was appointed general, becoming the first active-duty officer to receive a four-star rank. Gen. Vandegrift is one of only four commandants to have received a Medal of Honor.

SGT. CLYDE A. THOMASON, USMCR[7]
Makin Island, August 17–18, 1942

They were called Carlson's Raiders, a "suicide commando outfit" filled with the most gung ho of gung-ho Marines, under the command of Lt. Col. Evans Carlson, a man so tough he ate bullets for breakfast—which to a certain brand of Marine sounded better than a mess kit of warmed up K rations. To become a Carlson's Raider, you had to be willing to kiss K rations goodbye and prove you could forage and hunt for your food. Of the 1,000 Marines who volunteered to join, only 800 survived the grueling training. Another 200 would be shaved off the cream of the crop before the 2nd Raider Battalion was shipped out for duty in the Pacific.

It might seem unlikely that one of the Marines who'd made the cut was a twenty-six-year-old former insurance agent from Atlanta, Georgia, named Clyde Thomason; in fact, Lt. Col. Carlson thought so highly of this too-old, long, lanky southerner that he'd signed a height waiver (at 6 foot 4, Thomason was too tall to even be considered for the Raiders) and recommended that he be promoted up the ranks to sergeant. Sgt. Clyde Thomason wrote back to his pals at the office, "I hope I haven't bitten off more than I can chew."

And yet, all through his life, Clyde Thomason had pushed his own boundaries. In 1932, after graduating high school, he jumped in an old jalopy with some of his buddies and took a yearlong road trip across the US. In December 1934, Thomason enlisted in the Marine Corps, serving aboard ship during the Sino-Japanese War. That experience cured his wanderlust for a while. He settled into civilian life, taking a nine-to-five job as a fire claims adjuster, but following the Japanese attack on Pearl Harbor, Thomason reenlisted in the Marines. Assigned, at first, to a guard company in San Diego, PFC Thomason was chafing at the bit, writing home that he wanted to be "where the action was happening."

He would find plenty of action in the company of the like-minded warriors of 2nd Marine Raider Battalion.

On August 17, 1942, Carlson's Raiders launched a commando-style raid on Japanese-held Butaritari Island in the Makin Atoll, Gilbert Islands. Landing with the advance element of the assault, Sgt. Thomason was at the lead of a small patrol sent to scout out the island. All seemed quiet— too quiet. Coming upon a small wooden hut, Thomason immediately rushed forward, kicking through the door, surprising the Japanese sniper inside, and shooting him down before he could even level his rife.

The element of surprise wouldn't always work in Carlson's Raiders' favor during their next encounters with the

enemy. From August 17 to 18, they fought, toe to toe, with Japanese soldiers who had the reputation of being the best jungle fighters in the world. But months of physical and mental preparation paid off for Carlson's Raiders. In one "four-minute inferno" of a battle, the Raiders took down at least thirty of Japan's finest. It was then that hostile snipers hidden in the palm trees began exacting a toll on the Marines with Nambu light machine guns.

The Raiders who were with him that day say that Thomason remained out in front, oblivious to enemy fire, pointing out targets to the Marines and calling out better cover whenever he saw a Raider exposed, until a Japanese sniper with a deadly aim zeroed in on the tall, fearless sergeant, cutting him dow.

The savage battle continued throughout the day. Although Carlson's Raiders prevailed, they departed the island under such heavy fire they were unable to carry away their dead. The bravery of Carlson's Raiders on Makin was soon eclipsed by what was happening on the island of Guadalcanal—a larger battle that would determine the course of the war in the Pacific.

Sgt. Clyde Thomason was the only Marine to receive the Medal of Honor for the daring raid at Butaritari, and the first enlisted Marine to receive the Medal of Honor in World War II. His body, along with the bodies of the other 2nd Battalion Raiders who fell during those two bloody days, would lie on that small, desolate island for fifty-seven years.

In 1998, efforts were renewed to bring the slain Marines home. In 1999, bodies were found, buried in a mass grave with some World War II weapons and hand explosives; nineteen were identified as Marines lost in the August 1942 raid.

On August 17, 2001, thirteen 2nd Battalion Marines who lost their lives on Makin—including Sgt. Clyde Thomason—were buried with full honors at Arlington National Cemetery. The other six were returned to family members. Attending the ceremony in Arlington was Clyde's eighty-year-old half brother, Hugh Thomason, of Bowling Green, Kentucky, who had served during World War II and Korea. After the playing of "Taps" and a twenty-one-gun salute, Hugh Thomason remarked, "I had to sort of think of other things; otherwise I may not have been in a good emotional state to receive the flag." He added, "It was very satisfying to bring the return of the remains to a close."

After a short lifetime of "rambling fever" and wanting to be "where the action was happening," Clyde Thomason had found his way home.

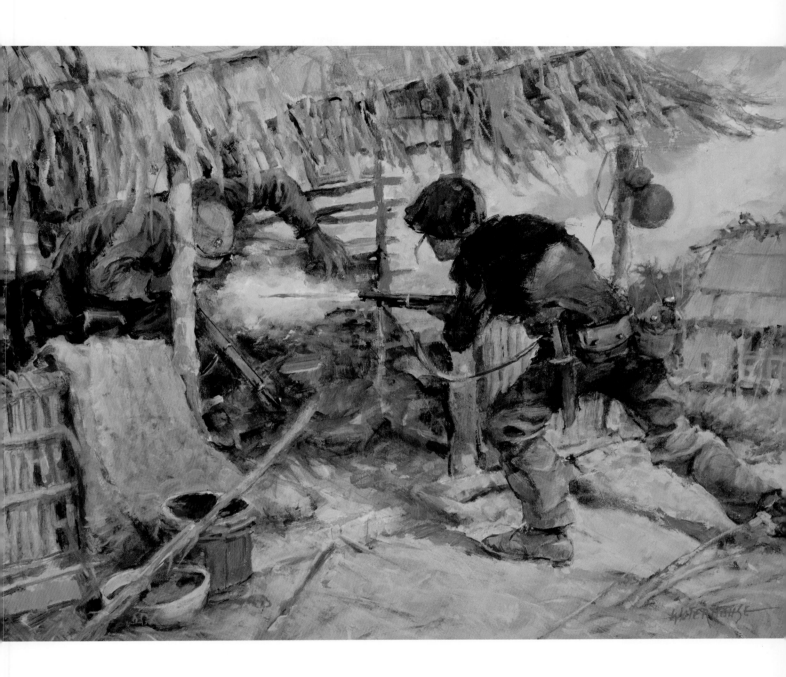

Kenneth Dillon Bailey was born on October 21, 1910, in Pawnee, Oklahoma. The family later moved to Danville, Illinois. At Danville High School, Kenneth was diligent in the classroom, a standout player on the football and swimming teams and involved in many activities, serving on the staff of the yearbook and as a member of the booster club, the Boy's Athletic Association, and student council. Somehow he also found the time to box with a group of students who called themselves "the Rough and Tumble Club," and to sing with the glee club.

Kenneth went on to attend the University of Illinois, where he played varsity football and served in the ROTC program and the Illinois National Guard. After graduating with a degree in agriculture in 1935, Bailey entered the Marine Corps as a second lieutenant and quickly worked his way up the ranks. By the time of the Japanese attack on Pearl Harbor on December 7, 1941, he was a captain. Tall, blue eyed, well built—the veritable poster image of a fighting Marine—Bailey was itching to bring the war to the Japanese. In August 1942, now Maj. Bailey did just that, as a company commander in the elite Marine Raiders on Tulagi. During that campaign, Bailey was credited with throwing dynamite into a cave, killing the thirty-six enemy soldiers inside, and personally attacking a hostile machine gun nest. He received a battle wound and a Silver Star for his actions.

Bailey's leadership in the South Pacific was just beginning. Stories about his daring exploits while serving as commanding officer of Company C, 1st Raider Battalion, on Guadalcanal would become the stuff of Marine Corps legend.

On September 12–13, 1942, during the battle for Henderson Field, Bailey's company was positioned as battalion reserve between the main line and the coveted airport, when the Japanese penetrated a gap in the main line. Not only was the fearless major able to repulse the threat, while consolidating his own position, he drew upon every weapon at his command to effectively cover the forced withdrawal of the main line.

As Bailey was out in front, leading his Raiders, two enemy bullets pierced his helmet. According to USMC lore, the major engaged in face-to-face combat with the Japanese soldier who fired the shots, killing him on the spot. Despite his head wounds, Bailey stayed in the fight, ordering his men to hold their ground and continuing to battle alongside them for the next ten hours, until his vastly outnumbered company had defeated the superior enemy force.

On September 27, despite having been wounded again, Bailey insisted on returning to combat. He was killed that day by an enemy machine gunner. One of his Marines later said, "It was a great thrill to see him in the early dawn of our fiercest battle, still leading and urging his men forward to victory. When he lost his life, he was again leading his men forward—the only direction he knew."

Maj. Kenneth Bailey was thirty-one years old.

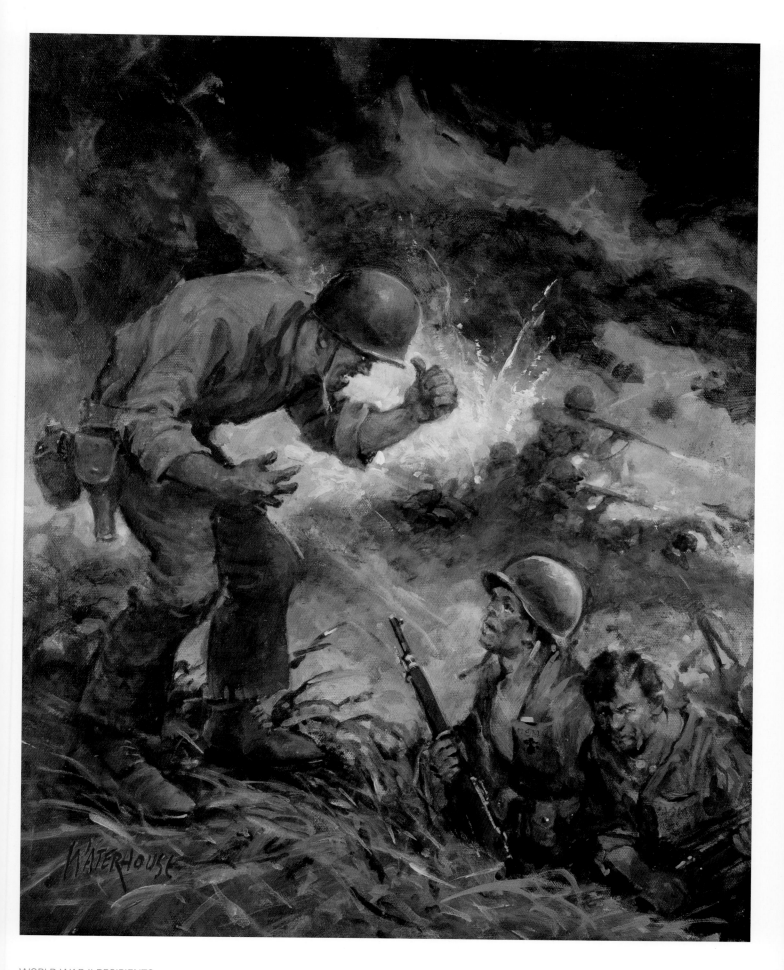

COL. MERRITT A. EDSON, USMC[9]
Guadalcanal, September 13–14, 1942

Merritt "Mike" Edson was born on April 25, 1897, in Rutland, Vermont, growing up downstate in Chester, where he graduated from the local high school. After two years at the University of Vermont, Edson left college to serve with the 1st Infantry Regiment, Vermont National Guard, patrolling the Mexican border. Although his first service was with the Army, Edson was commissioned a second lieutenant in the Marines Corps in 1917, serving in France and Germany in World War I. His name would go down in the annals of Marine Corps history, forever linked to a bloody ridge on Guadalcanal and an epic fight that marked a turning point in the Marines' struggle to hold "the Canal."

It was a fight that Edson saw coming.

In his memoir, *Goodbye, Darkness*, author William Manchester paints the scene of a meeting between Edson and Maj. Gen. Alexander Vandegrift, commanding general of the 1st Marine Division in charge of operations in the Solomons. Huddling with his superior over an aerial map, Edson pointed to a coral ridge south of Henderson Field—a Japanese airfield they desperately wanted to recapture. This, he predicted, would be where the Japanese would make their next attack. In a quiet, raspy voice, Col. Edson asked for permission to defend the ridge with his 1st Marine Raiders and three understrength companies of the 1st Parachute Battalion, with some engineers and Pioneers attached.

From the night of September 13, 1942, all through the following day and night, "Red Mike"—his nickname on Guadalcanal, which went back to Edson's fighting days on Nicaragua when he'd sported a red beard—led approximately 800 Marines in a historic twenty-four-hour stand against the repeated assaults of more than 3,000 Japanese soldiers on a rugged, kunai-covered hogback ridge paralleling the Lunga River south of the airfield. After holding off the first ferocious onslaughts, Edson told his exhausted Marines, "You men have done a great job so far, but I have one more thing to ask of you. We have to hold out one more night."

His Marines held. And through the long hours of brutal fighting—often in hand-to-hand combat against the enemy with bayonets, rifles, pistols, grenades, and knives—Red Mike never left their sides, fearlessly exposing himself to fire and encouraging, cajoling, and inspiring his men to hold their ground—to die in their holes if they had to, until the last of the Japanese forces were pushed off the ridge. The Marines' fight for Guadalcanal continued for the next four months, but after that night on Edson's Ridge, the enemy was forced to go on the defensive, and the airfield would remain in American hands.

By then, Edson went on to serve as chief of staff of the 2nd Marine Division, where he was instrumental in preparing for the invasion of Tarawa, earning promotion to brigadier general in 1943. Following his retirement from the Marine Corps at the rank of major general, Edson served as the first commissioner of the Vermont State Police.

Arguably, his longest-lasting contributions to the Corps were to come in the congressional "unification" hearings of 1946–47, and his testimony in 1951 and 1953, which helped ensure the survival of the Marine Corps.

In 1955, Edson's family found his body slumped in a car in their garage. Although a formal autopsy was never done, according to the medical report, Edson's blood contained a large quantity of carbon monoxide. His family never believed it was a suicide. In the months prior to his death, Edson had been serving on a Defense Advisory Committee, dealing with issues concerning prisoners of war. Although known for his taciturn nature and fierce resolve, Merritt Edson was a sensitive soul who cared deeply about his men. When one of his runners was killed on Guadalcanal, witnesses said he "cried like a baby." It's possible that his work on behalf of POWs, added to the unresolved grief for all those lost young Marines he had rallied and cajoled into battle, had overwhelmed him. But for the men who served beside him on Edson's Ridge, Edson would live on forever as the indomitable Iron Mike.

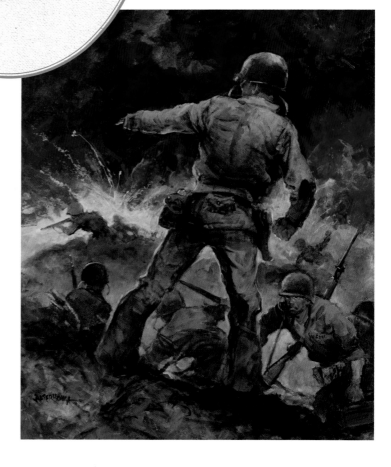

Capt. Joseph J. Foss, USMC[10]
Guadalcanal, October 9 – November 19, 1942

Jacob "Joe" Foss was born in a farmhouse near Sioux Falls, South Dakota, on April 17, 1915. Maybe it was natural, living under the vast South Dakotan skies, with not so much as a flicker of electricity anywhere around to distract him, but Joe's attention was always focused upward. At age twelve, he went all the way to Renner to see Charles Lindbergh, who was on tour with his monoplane, the *Spirit of St. Louis*. Four years later, Joe and his dad paid the princely sum of $1.50 apiece to take their first airplane ride. He never forgot it. Even after his father was killed in an accident, and Foss had to take over the running of the family farm—battling through dust storms and the Depression—he managed to steal off to watch a Marine Corps aerial team perform aerobatics in open cockpits. For Joe, the deal was sealed: he wanted to fly.

Over the next few years, while his brother stayed home to mind the farm, Foss worked his way through school and then college. Armed with a pilot license and his college degree, he hitchhiked to Minneapolis to enlist in the Marine Reserves. At age twenty-six, Foss was designated a naval aviator and commissioned as a second lieutenant, only to be told that he was too old to be a fighter pilot. Assigned to a photographic reconnaissance squadron, Foss's repeated requests for transfer finally paid off in October 1942, when he, now a captain, was sent to serve as executive officer of Marine Fighting Squadron 121—part of the Cactus Air Force—on Guadalcanal.

From October 9 to November 19, 1942, Capt. Foss personally shot down twenty-three Japanese aircraft, leaving many others in flames. On January 15, 1943, he added three more enemy aircraft to the tally, chalking up a record of aerial-combat achievement unsurpassed in the war. During three sustained months of combat, his squadron—dubbed "Foss's Flying Circus"—would shoot down seventy-two Japanese aircraft, twenty-six of which were credited to their daring captain, landing the former South Dakotan farm boy in a tie with his hero, America's first "ace of aces," World War I pilot Eddie Rickenbacker.

In 1943, Joe Foss received the Medal of Honor from President Franklin Delano Roosevelt. Foss was called back to active duty during the Korean War, eventually reaching the rank of brigadier general. Ever looking upward, he went on to have a successful career in politics, serving as governor of South Dakota and the first commissioner of the newly created American Football League.

In 2002, at the age of eighty-six, Foss made headlines again when his pacemaker set off the metal detector at the Phoenix Sky Harbor International Airport; in the subsequent search by airport security, his star-shaped Medal of Honor was discovered and confiscated. It was eventually returned, but the incident sparked a national furor. "I wasn't upset for me," Foss said. "I was upset for the Medal of Honor, that they just didn't know what it was. It represents all the guys who lost their lives—the guys who never came back."

Joe Foss suffered a stroke several months later. He died on New Year's Day 2003.

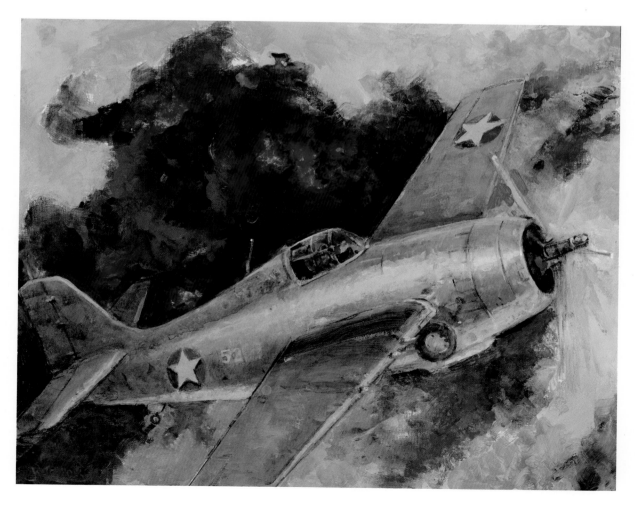

SGT. JOHN BASILONE, USMC[11]
Guadalcanal, October 24–25, 1942

Medal of Honor Citation

For extraordinary heroism and conspicuous gallantry in action against enemy Japanese forces, above and beyond the call of duty, while serving with the 1st Battalion, 7th Marines, 1st Marine Division, in the Lunga Area, Guadalcanal, Solomon Islands, on 24 and 25 October 1942. While the enemy was hammering at the Marines' defensive positions, Sgt. BASILONE, in charge of two sections of heavy machine guns, fought valiantly to check the savage and determined assault. In a fierce frontal attack with the Japanese blasting his guns with grenades and mortar fire, one of Sgt. BASILONE'S sections, with its gun crews, was put out of action, leaving only two men able to carry on. Moving an extra gun into position, he placed it in action, then, under continual fire, repaired another and personally manned it, gallantly holding his line until replacements arrived. A little later, with ammunition critically low and the supply lines cut off, Sgt. BASILONE, at great risk of his life and in the face of continued enemy attack, battled his way through hostile lines with urgently needed shells for his gunners, thereby contributing in large measure to the virtual annihilation of a Japanese regiment. His great personal valor and courageous initiative were in keeping with the highest traditions of the US Naval Service.

To read more about John Basilone, see chapter 2, "The Battle for Henderson Field."

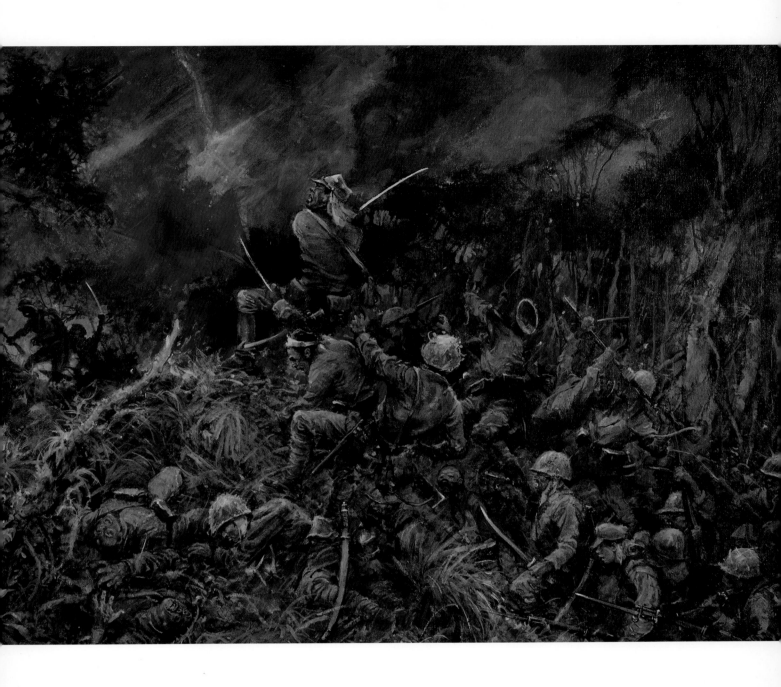

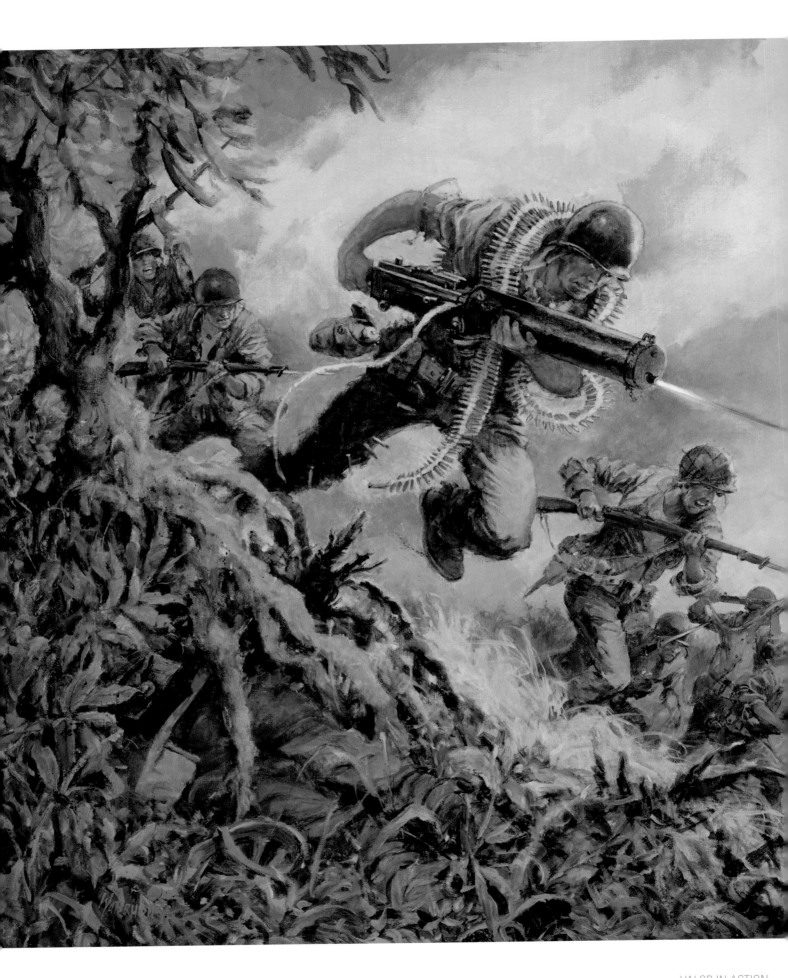

PLSGT. MITCHELL PAIGE, USMC[12]
Guadalcanal, October 26, 1942

Medal of Honor Citation

For extraordinary heroism and conspicuous gallantry in action above and beyond the call of duty while serving with the 2nd Battalion, 7th Marines, 1st Marine Division, in combat against enemy Japanese forces in the Solomon Islands Area on October 26, 1942. When the enemy broke through the line directly in front of his position, Platoon Sergeant Paige, commanding a machine gun section with fearless determination, continued to direct the fire of his gunners until all his men were either killed or wounded. Alone, against the deadly hail of Japanese shells, he manned his gun, and when it was destroyed, took over another, moving from gun to gun, never ceasing his withering fire against the advancing hordes until reinforcements finally arrived. Then, forming a new line, he dauntlessly and aggressively led a bayonet charge, driving the enemy back and preventing a break through in our lines. His great personal valor and unyielding devotion to duty were in keeping with the highest traditions of the United States Naval Service.

To learn more about Mitch Paige, read his story in chapter 7.

CPL. ANTHONY CASAMENTO, USMC[13]

Guadalcanal, November 1, 1942

Anthony Casamento was born on November 16, 1920, in Manhattan, New York, and grew up in West Islip, on the South Shore of Long Island. In 1940, twenty-year-old Casamento took the train into Manhattan and enlisted in the Marine Corps. After completing his recruit training at Parris Island, he was promoted to private first class and assigned to Company D, 1st Battalion, 5th Marines, 1st Marine Division.

Six months after the Japanese attack on Pearl Harbor, the 1st Marines were headed for the first major offensive of the Pacific War: the battle for Guadalcanal.

On November 1, 1942, while serving as leader of a machine gun section, now Cpl. Casamento's section came under heavy enemy fire along a ridge near the Matanikau River. Over the course of the brutal fighting, all the members of his unit were either killed or incapacitated.

With effective personnel gone, Cpl. Casamento took it upon himself to set up, load, and man his unit's machine gun. Despite being wounded, the corporal provided supporting fire, tenaciously holding the enemy forces at bay. At the same time, he managed to single-handedly destroy a Japanese machine gun emplacement, rain deadly fire on an enemy emplacement, and hold his critical position until the main defending force could arrive. During this heroic one-man stand, Cpl. Casamento was wounded fourteen times, leaving him permanently disabled for the rest of his life.

Because all the witnesses to his actions had died in combat, the brave Marine received no decoration until 1965, when he was belatedly awarded a Navy Cross. Casamento refused it, saying his commanding officer had believed his actions that day on Guadalcanal merited a Medal of Honor.

In 1979, the disabled veteran maintained a fifty-one-day vigil, sitting in his wheelchair outside the White House, day after day, seeking the recognition that had been denied to him for over thirty-five years. In 1980, President Jimmy Carter presented Anthony Casamento with the Medal of Honor. The proud recipient passed away seven years later, at the age of sixty-six.

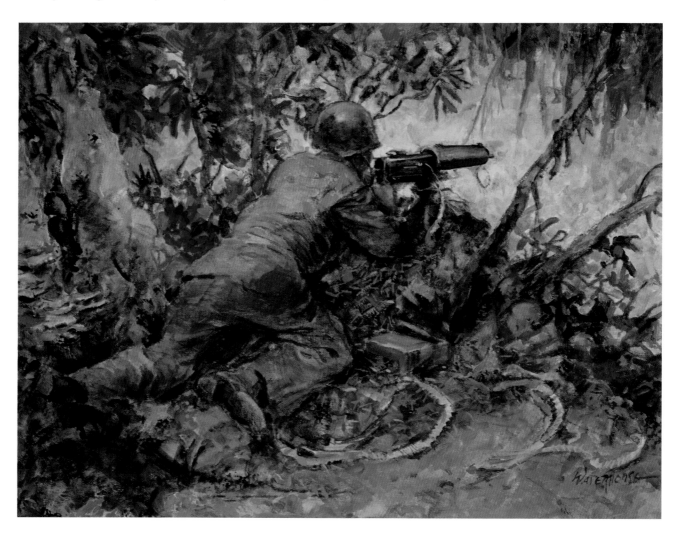

LT. COL. HAROLD L. BAUER, USMC[14]
Guadalcanal, November 14, 1942

Fellow athletes at the Naval Academy called him "Indian Joe" because of his lean, sinewy appearance. For the fighter pilots serving under him, he was "Coach," a revered mentor who was always willing to give encouragement and advice.

His name was Harold Bauer, and he was born on November 20, 1908, in Woodruff, Kansas, to Volga German immigrants who moved their family to North Platte, Nebraska. In high school Bauer played football and baseball and ran track, while excelling in academics. He entered the Naval Academy at Annapolis in 1926 and was appointed a Marine second lieutenant upon graduation.

After a stint as a marksmanship instructor and assistant coach for the Annapolis football and lacrosse teams, Bauer was assigned to the Naval Air Station in Pensacola, Florida, where he earned his wings and was promoted to captain. He served with several squadrons before heading to the South Pacific after the attack on Pearl Harbor.

On September 28, 1942, as commander of Marine Fighting Squadron 212, Lt. Col. Bauer piloted a fighter plane against an enemy force that outnumbered his more than two to one, boldly engaging them and destroying a Japanese bomber. On October 3, Bauer shot four enemy planes down in flames, leaving a fifth smoking badly.

On October 16, after successfully leading twenty-six planes in a 600-mile overwater flight, Bauer sighted a squadron of enemy planes attacking the USS *McFarland*. Although low on fuel, Bauer took on the entire squadron himself, fighting so brilliantly that four of the Japanese planes were destroyed before he was forced to return for fuel.

Less than a month later, Bauer was shot down off the coast of Guadalcanal after destroying two enemy aircraft. He was spotted in the water, wearing his flotation device and apparently uninjured, and had motioned his wingmen to return to base. A later search yielded no trace of him.

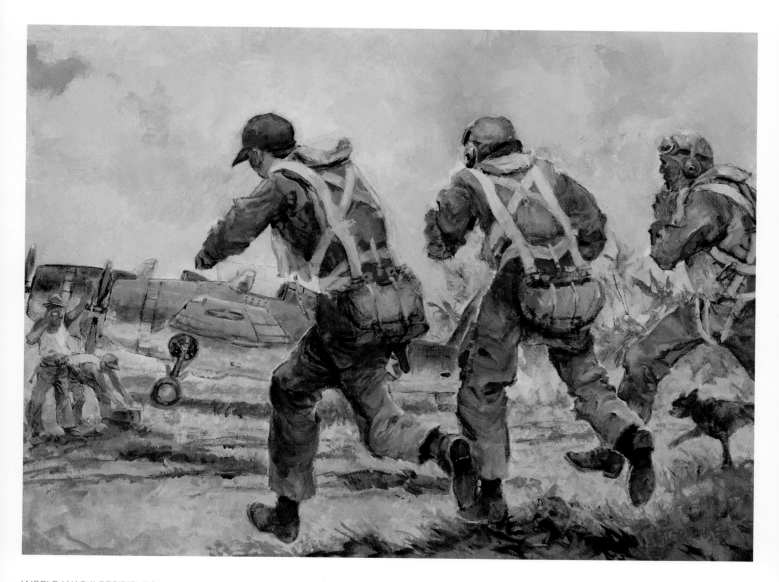

1Lt. Jefferson DeBlanc, USMC[15]
Solomon Islands, January 31, 1943

Jefferson DeBlanc was born on February 15, 1921, in Lockport, Louisiana. As a child, he remembered playing cowboys and Indians with his friends. Then one day an airplane landed in a nearby cow pasture. When the children ran over to get a closer look, the pilot lifted Jefferson into the cockpit. It was a magical, life-changing moment. From that day on, whenever the little boy played cowboys and Indians with his pals, he wore an Eddie Rickenbacker flight suit and Sam Browne belt and goggles.

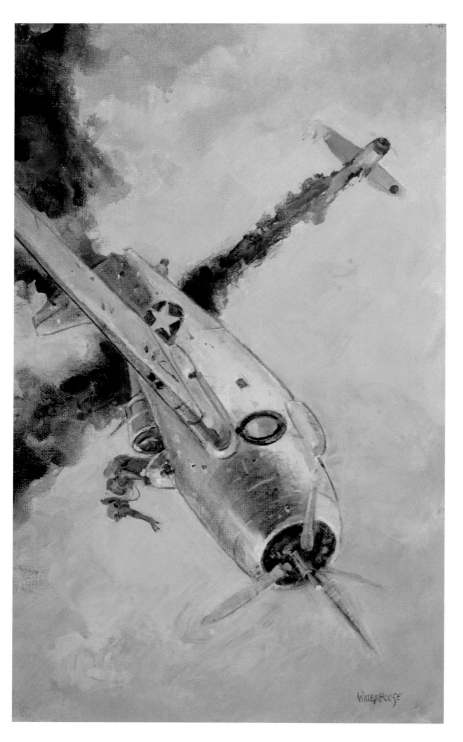

This early fascination with planes followed DeBlanc into Southwestern Louisiana Institute (now the University of Louisiana at Lafayette), where he studied and excelled in his pilot training. In 1941, DeBlanc enlisted in the US Naval Reserve. After further training, he was appointed as an aviation cadet. Upon being discharged from the Naval Reserve, DeBlanc was commissioned a second lieutenant in the Marine Corps Reserve, receiving further instruction with the Advance Carrier Training Group.

In October 1942, DeBlanc was assigned to Marine Fighting Squadron 112 and headed to the South Pacific to take part in the battle for Guadalcanal. Jefferson DeBlanc would be one of approximately 24,500 Cajun Americans to serve in World War II.

From the get-go, he proved to be an exceptionally talented fighter pilot, shooting down two Betty bombers on his very first day of duty. Quickly promoted to first lieutenant, within a matter of weeks DeBlanc joined the ranks of the elite Marine Fighting Aces.

On January 31, 1943, while leading a six-plane section assigned to protect dive-bombers and torpedo planes attacking Japanese ships in an area off the Solomons, 1Lt. DeBlanc and his group became embroiled in a fierce air battle against the Japanese. Having already flown beyond their range, the Wildcats were "using gas like mad." Low on fuel, two of the pilots headed back. DeBlanc stayed. "I figured, if I run out of gas, I run out of gas," he told the *Times-Picayune* of New Orleans in a 1999 interview. "I figured I could survive a bailout. You've got to live with your conscience. And my conscience told me to go ahead."

But it wasn't DeBlanc's conscience; it was his skill and courage that enabled him to take down five enemy planes in the span of the next few minutes, before his cockpit was hit so hard the shrapnel blew his watch off his wrist. Out of fuel and badly wounded, DeBlanc bailed out over the enemy-held waters around Kolombangara Island. Supported only by his life jacket, the injured pilot swam through shark-infested water for six hours, until he reached the beach. For three days DeBlanc subsisted on coconuts, until he was captured by a group of indigenous people who eventually bartered him to another tribe for a sack of rice. These natives put DeBlanc in a canoe and paddled him to a coast watcher—one of the unsung heroes of the Pacific war who, in the era before radar, used clandestine radios to relay valuable information to the air bases. DeBlanc was flown back and treated in a hospital.

During his two tours of duty as a fighter pilot in the Pacific at Guadalcanal and Okinawa, 1Lt. DeBlanc is credited with shooting down nine enemy aircraft. He served in the USMCR until 1972, all the while teaching and completing graduate and doctoral degrees in math, physics, and education. Jefferson DeBlanc died in 2007 at the age of eighty-six.

1Lt. James E. Swett, USMC[16]
Solomon Islands, April 7, 1943

James Swett was born on June 15, 1920, in Seattle, Washington, and grew up in San Mateo, California. While attending college, he earned a private pilot's license, racking up 450 hours of flying. In 1941, Swett joined the Navy Reserves. Finishing at the top of his flight training class, he was given a choice of a commission in the USN or the USMC. Swett chose the Marines.

After becoming carrier-qualified and receiving his wings, 1Lt. Swett was shipped to the South Pacific and assigned to VMF-221, as part of the Marine Aircraft Group 12, 1st Marine Aircraft Wing.

On April 7, 1943, after two uneventful patrols off Guadalcanal, Swett's four-plane division landed but he received word that 150 enemy planes were headed for the US fleet at Tulagi. He scrambled his division, taking to the air in his F4F Wildcat fighter, and flew directly into the face of a large formation of Japanese Aichi D3A dive-bombers. "The sky was black with 'em," Swett recounted.

He pursued three of the dive-bombers, shooting down two while taking heavy fire. Despite having his left wing holed by friendly fire, Swett managed to shoot down the third bomber and bring down four more. He was attacking a fifth when he ran out of ammunition. The Japanese had shattered his windshield and shot off his oil cooler. Knowing he'd never get back to base, Swett decided to ditch his Wildcat in Tulagi Harbor. He struggled out of the bullet-ridden cockpit just before the plane sank.

He floated until he was found by a Coast Guard patrol. "Are you an American?" they called. "Damn right I am," Swett replied.

On his very first combat mission, Swett became an ace and a Medal of Honor recipient. He went on to fly 103 missions and was credited with downing more than 15.5 Japanese planes. "War is a terrible thing," he later said, "but freedom is not free and sometimes you have to fight for it."

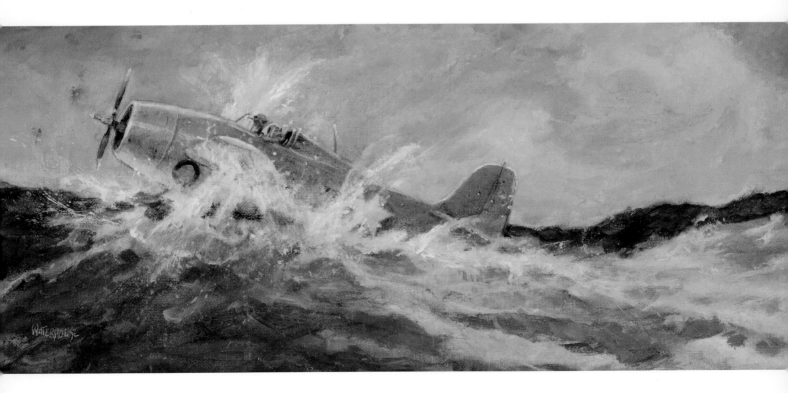

1Lt. Kenneth A. Walsh, USMC[17]
Solomon Islands, August 15, 1943

Kenneth Walsh was born on November 24, 1916, in Brooklyn, New York. After graduating from Dickinson High School in Jersey City, New Jersey, where he had been an outstanding athlete, the seventeen-year-old enlisted in the Marine Corps, serving as an aircraft mechanic and radioman before being accepted for naval flight training and transferred to Pensacola, Florida. In April 1937, Walsh earned his wings as a private. He spent the next four years on scout and observation flying assignments, serving with Marine Aircraft Group 12, 1st Marine Aircraft Wing, Fleet Marine Force in San Francisco, while working his way up the ranks. At the time of the Japanese attack on Pearl Harbor, Walsh was on the East Coast as a second lieutenant with Marine Fighting Squadron 121. By 1943, he was a first lieutenant assigned to Marine Fighting Squadron 124, and one of the Corps' most experienced Vought F4U Corsair pilots.

His experience would come in handy on Guadalcanal, where his unit was immediately committed to combat, flying an escort mission on the very same day it arrived on the island. 1Lt. Walsh established a reputation among his fellow airmen of being a tough, aggressive, and highly skilled fighter pilot.

On April 1, 1943, Walsh scored his first kill—a Japanese Zero—on a patrol over the Russell Islands. That same month, Walsh was the leader of an eight-plane division launched from New Georgia Island to provide support for naval and ground forces around Vella Lavella, 180 miles from Guadalcanal. Encountering thirty Japanese fighter planes and dive-bombers, Walsh's squadron took them on and, although outgunned, successfully managed to avert an attack on US ships and beachheads.

In May, Walsh scored three more kills; by August, when his squadron moved over to the newly captured airbase at Munda, he had upped his tally to ten.

On August 15, Walsh repeatedly dove his Corsair into an enemy formation that outnumbered his division 6 to 1, shooting down two enemy aircraft before a Japanese Zero hit his starboard wing tank. Somehow, he made it back to the base at Munda in one piece, but his plane ended up on the scrap pile.

On August 30, during a vital escort mission, Walsh developed engine problems and was forced to return to Munda. After securing another Corsair, Walsh set off on his own, hoping to catch back up with his squadron. On the way, he spied a large force of fifty Japanese Zeros. Without a moment's hesitation, Walsh attacked, engaging in a fierce, lone battle against the enemy and destroying four Japanese Zeros before his Corsair was so riddled with cannon fire that his only option was to make a dead-stick landing off Vella Lavella island, where he was later rescued. It was his third water landing in six months.

During World War II, Walsh would shoot down a total of twenty-one enemy aircraft, seventeen of which were Zeros.

After his Medal of Honor action, Walsh continued to serve in the Marines, flying combat missions in Korea, and on assignments in the US and the Pacific, until he retired after twenty-eight years of continuous service in 1962 as a lieutenant colonel. Kenneth Walsh died in 1998 at the age of eighty-one.

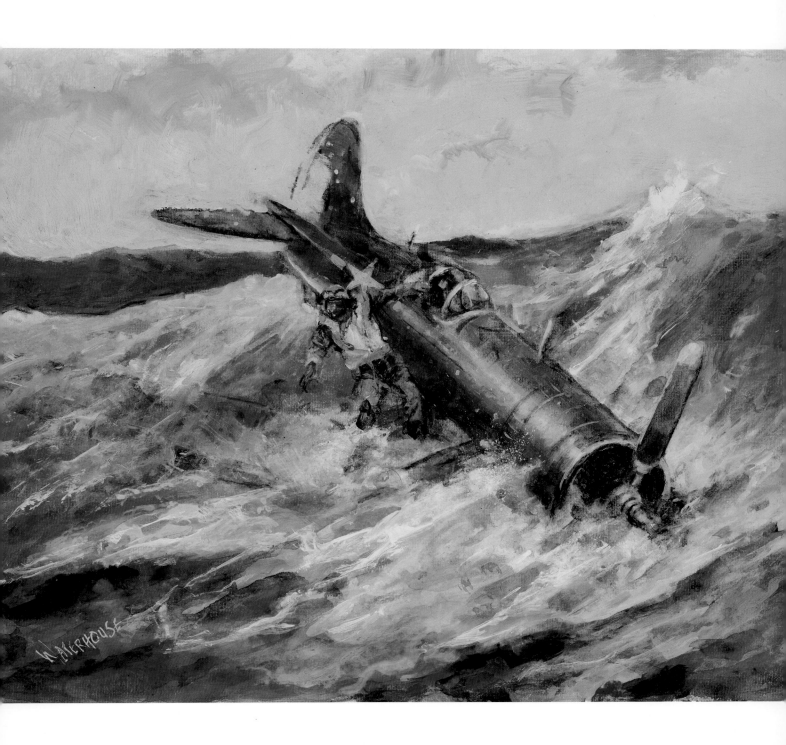

1Lt. Robert M. Hanson, USMCR[18]
Bougainville, November 1, 1943

Robert "Rob" Hanson was born on February 4, 1920, in Lucknow, India, where his parents were then serving as Methodist missionaries. Growing up, Rob's playmates were Hindu children. The Hindu religion includes both teachings that condemn violence, and those that consider violence in war as a moral duty. The Hindu children Hanson knew had been taught that the use of force in self-defense was just, but they couldn't have dreamed that their young friend—the son of a devout missionary family—was destined to become "Butcher Bob," a Marine Corps flying ace responsible for shooting down twenty-five Japanese planes over the Pacific.

Hanson's journey into the record books would be filled with adventure. He attended a missionary-run primary school in the western Indian Himalayas, heading back to the States to go to junior high school before returning to India to become light-heavyweight and heavyweight wrestling champion of the United Provinces of Agra and Oudh. History was already nipping at Hanson's heels. In 1938, while en route to the US to attend college, Rob decided to bicycle his way through Europe, ending up in Vienna during the Nazi *Anschluss*—the annexation of Austria by Nazi Germany. He was studying at Hamline University in St. Paul, Minnesota, when the Japanese attacked Pearl Harbor and the die was cast: Rob Hanson decided to become a fighter pilot. By February 19, 1943, Hanson had earned his wings and a commission as second lieutenant in the Marines.

Arriving in the South Pacific in June 1943 as a newly promoted first lieutenant and fighter pilot with Marine Fighting Squadron (VMF) 215—known in those days as "the Fighting Corsairs"—Hanson quickly established a reputation as a daring aviator with a complete disregard for his own safety.

Both of these qualities were evident on November 1, 1943, when, as a Corsair pilot for Marine Fighting Squadron 215 in the air battle over Bougainville, Hanson single-handedly attacked six Japanese Kates with such ferocity that three went up in flames and several others were forced to jettison their bombs before reaching Torokina. Shot down by a rear gunner in one of the Kates, Hanson set his Corsair down in the water, paddling for six hours in his life raft and, by some accounts, crooning a Cole Porter song until a US destroyer came by and rescued him. In a single day, Hanson had earned ace status and ditched his plane in the ocean.

Hanson returned to his squadron, continuing to wreak havoc on the Japanese, shooting down twenty enemy aircraft in a period of seventeen days. By then his signature blend of nonchalance and ferocity had earned him the nickname "Butcher Bob."

On February 3, 1944—the day before his twenty-fourth birthday—after bringing his total of destroyed enemy planes up to twenty-five, Hanson volunteered to fly an escort mission over Rabaul, New Britain. He never returned. Hanson was subsequently declared killed in action. The sports field at the school he attended in the Indian Himalayas is still called Hanson Field.

These lines from an ancient Hindu hymn seem to be a fitting eulogy for Medal of Honor recipient and Marine ace 1Lt. Robert Hanson:

May your weapons be strong to drive away the attackers,

May your arms be powerful enough to check the foes,

Let your army be glorious, not the evil-doer.

(*Rig Veda*, 1-39:2)

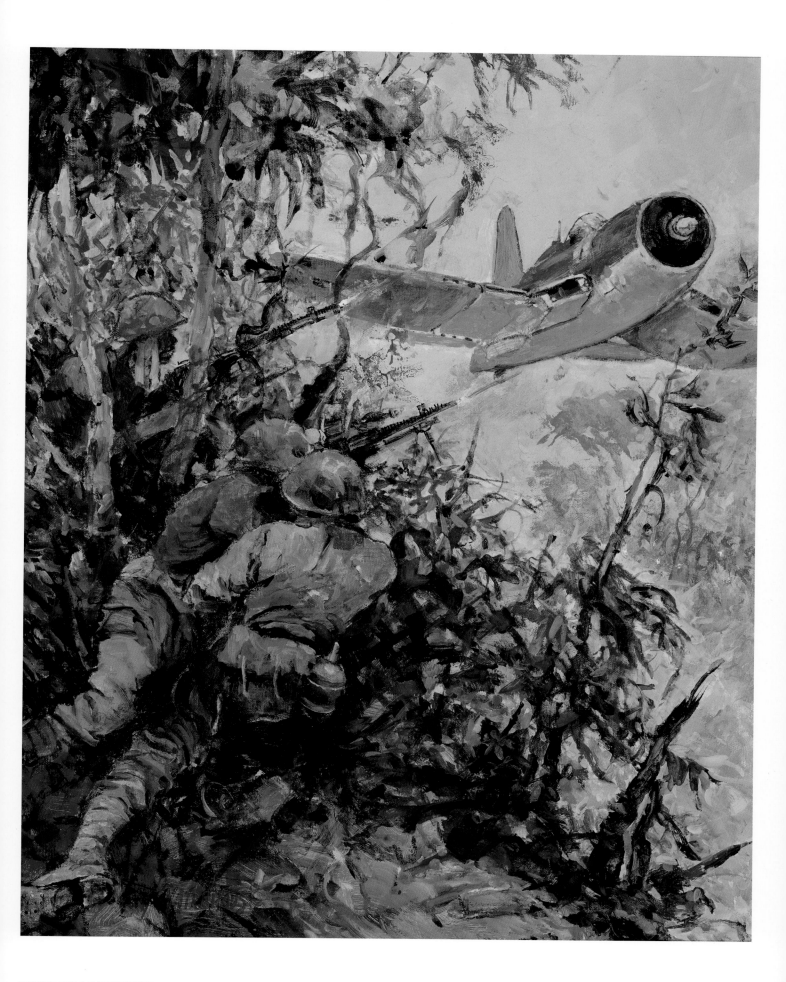

SGT. ROBERT A. OWENS, USMC[19]
Bougainville, November 1, 1943

Robert Allen Owens was born on September 13, 1920, in Greenville, South Carolina. The Owens family soon moved to Spartanburg, which Robert would always consider his hometown. To help out with finances, the young man dropped out of high school after his sophomore year, finding work at one of many textile mills then operating in the Spartanburg area. In early 1942, Owens quit his job as a textile worker and joined the Marines, motivated, like many young men who enlisted at that time, by the attack on Pearl Harbor.

By June of 1943 Owens was serving with Company A, 1st Battalion, 3rd Marines. Part of the new 3rd Marine Division, the motto of the 3rd Marines was *Fortuna Fortes Juvat*—Fortune Follows the Brave—and, as fortune would have it, his new division was headed for an overseas assignment at Tutuila, American Samoa, with later stops in New Zealand and Guadalcanal to train for their first combat mission.

Along the way, Owen demonstrated he had the makings of a leader and was promoted up the ranks to sergeant. At 6 foot 3 and 223 pounds, Sgt. Owens was the image of a Marine fighting machine, but no amount of training and commitment could have prepared him for what he and his fellow Marines were about to face.

On November 1, 1943, the 3rd Marine Division was the spearhead of the I Marine Amphibious Corps during the landing at Cape Torokina on the island of Bougainville. The Japanese defenders were waiting behind a camouflaged 75 mm regimental gun, positioned in such a way that no landing craft could approach the beach without passing within 150 yards of its muzzle: in short, the enemy gunners couldn't miss. The gun had already destroyed four landing craft and damaged ten more. Making matters worse, it was strategically situated so that it could be attacked only from the front, with its gun crew safely out of the range of Marine rifle fire and grenades.

It seemed clear to Sgt. Owens that the success of the entire Bougainville operation depended on neutralizing that gun. In order to do that, someone would have to charge it from the front. He figured that someone might as well be him. Calling on four volunteers to cover him, Owens placed them where they could keep adjacent enemy bunkers under fire, then he took off at a run, charging the vast smoking mouth of the still rapidly firing cannon. Entering through the fire port, Owens drove the hostile gun crew out of the rear door, where they were mowed down by Marine riflemen. In the pursuit, Sgt. Owens tragically was shot and killed. For the Marines of the 3rd Division, Owens's heroic efforts had come in the nick of time. At the moment he burst through the fire port, there was a round in the chamber of the Japanese cannon and the breech was almost closed. Another 150 pounds of high explosives stood at the ready, nearby.

Commanding general of the 3rd Marine Division, Maj. Gen. Allen H. Turnage, would later say of Owens's actions, "Among the many brave acts on the beachhead of Bougainville, no other single act saved the lives of more of his comrades or served to contribute so much to the success of the landings."

Sgt. Robert Owens was twenty-three years old.

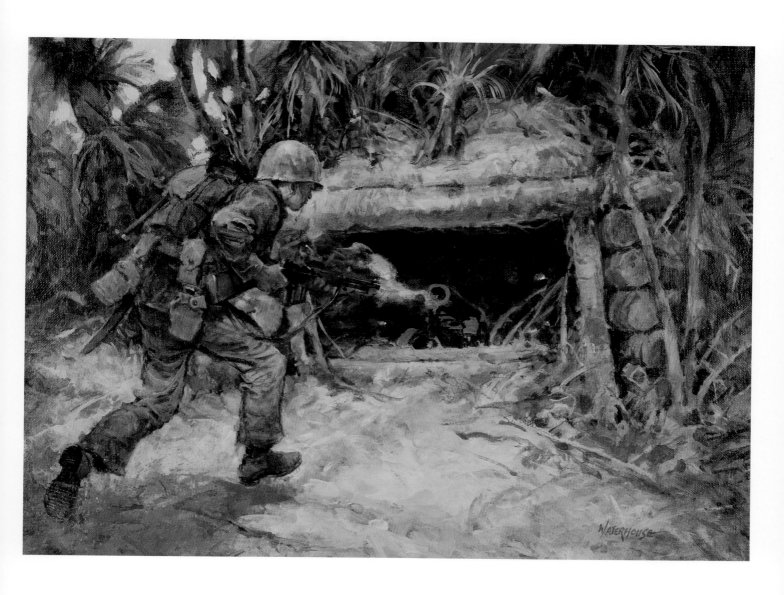

SGT. HERBERT J. THOMAS, USMC[20]
Bougainville, November 7, 1943

Herbert Joseph Thomas Jr. was born on February 8, 1918, in Columbus, Ohio. When Herbert was seven years old, the Thomas family moved to South Charleston, West Virginia. At South Charleston High School and Greenbrier Military Academy, Thomas was a star on the gridiron, playing halfback and earning a scholarship to play at Virginia Polytechnic Institute (now Virginia Tech), where he led his team in pass receptions and scoring and all Virginian college players in scoring. In his senior year at VPI, Thomas was chosen as a member of the Virginia All-State football squad and the All-Southern team, receiving an honorable mention for All-American. He would go on to be named to the Virginia Tech Sports Hall of Fame.

Despite his outstanding record both on the playing field and in the classroom, Thomas left college in the spring of 1941, just two months shy of graduating, to serve his country. He initially joined the Army Air Corps as an aviation cadet but was discharged after four months of service for "flying deficiency." In March 1942, Herbert Thomas enlisted in the Marines.

By November 7, 1942, the former football star had achieved the rank of sergeant and was serving in the Pacific with Company B, 1st Battalion, 3rd Marines, 3rd Marine Division, during the battle at Koromokina River on Bougainville, participating with Marine infantry in an assault against two entrenched, and skillfully camouflaged, Japanese emplacements that were raining fire against the left flank of the Marines.

Sgt. Thomas led his squad through dense jungle undergrowth and, in the face of tremendous hostile fire, advanced toward the center of the enemy's position, wiping out the first two Japanese machine gun crews in one fell swoop. Upon discovering a third enemy emplacement, Thomas positioned his men in tactical locations around it, pulled the pin on a grenade, and threw it, but the athletic precision of his aim was thwarted by the jungle growth: the grenade bounced off a thick overhead vine and landed among his men. Herbert Thomas, who only a few years before had sprinted to fame as a football player, now sprinted to save the lives of his fellow Marines, diving on the grenade and covering the explosion with his body. He died instantly at the age of twenty-five.

Sgt. Thomas was awarded the Medal of Honor posthumously on August 1, 1944. The following March, his sister, Audrey Irene Thomas, christened a Navy destroyer, the USS *Herbert J. Thomas*. The Herbert J. Thomas Memorial Hospital (now part of the Thomas Health System) in South Charleston, West Virginia, is named in his honor, as is Thomas Hall, a dormitory on the upper quad of Virginia Tech.

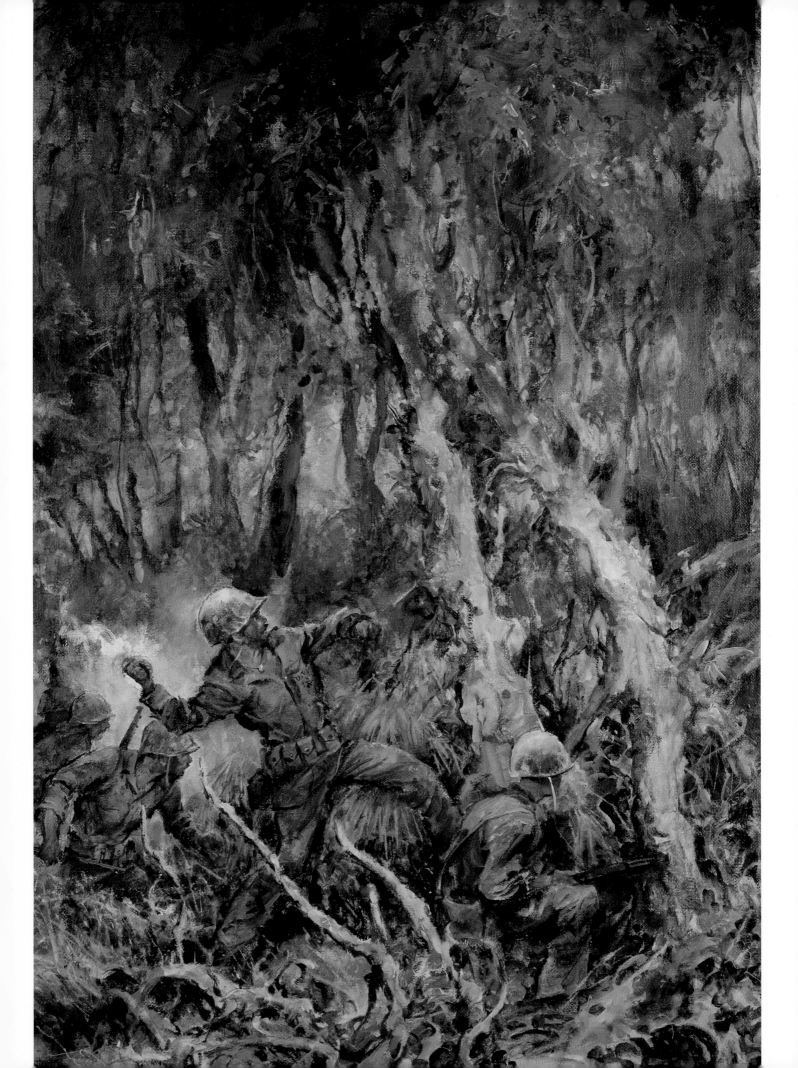

PFC HENRY GURKE, USMC[21]
Bougainville, November 9, 1943

Henry Gurke was born on November 6, 1922, in Neche, North Dakota. Henry's father, a German-speaking carpenter from western Ukraine, and his Ukrainian mother had immigrated by way of Winnipeg, Manitoba, settling in the northeastern corner of North Dakota, just a mile from the Canadian border. One of five children, Henry was baptized in the Lutheran Church, attending the local schools, where his classmates remembered the boy as a good athlete and a star on the basketball court. After graduating from high school, Henry joined the Civilian Conservation Corps (CCC), stationed in Larimore, 100 miles away from home. The camaraderie of working with others his age and living in the boisterous, rowdy barracks appealed to Henry, but he'd tired of planting trees and dismantling old telephone lines: he wanted to do something meaningful, so after his first hitch in the CCC, he enlisted in the Marines in April 1942.

Upon completing his training, Private Gurke was attached to the 2nd Separate Pack Howitzer Battalion of the 22nd Marines, sailing with them to various locations in the Pacific before being transferred to Company D, 3rd Marine Raider Battalion.

Standing 6 foot 1, fit, and muscular, Gurke proved to be a natural fit for the Raiders and was soon promoted to private first class. After a year and a half of bouncing from island to island, assignment to assignment, and unit to unit, in November 1943, PFC Gurke finally met the enemy face to face, with Company M, 3rd Marine Raider Battalion, 2nd Raider Regiment (Provisional), of the I Marine Amphibious Corps on Bougainville.

On November 6, Gurke celebrated his twenty-first birthday, slogging through the hellacious jungles of that island. In the words of 3rd Marine Division commander Maj. Gen. Allen H. Turnage, "Never had men in the Marine Corps had to fight and maintain themselves over such difficult terrain as was encountered on Bougainville."

As dawn was breaking on November 9, PFC Gurke was holed up in a soggy foxhole with a BAR man, providing fierce defensive fire against the main Japanese vanguard in the fight to retain control of a vital roadblock. Intent on taking out the two-man position, the enemy began barraging the Marines with grenades. With the shower of grenades growing ever more intense, Gurke knew their luck couldn't possibly hold out. He also knew his companion was manning an automatic weapon with more fire power than his and could therefore provide the most resistance, so when a hostile missile dropped into their hole, PFC Gurke thrust his comrade aside and threw himself over it to smother the explosion. The Marine whose life Gurke saved continued to defend the position and survived the Pacific Campaign.

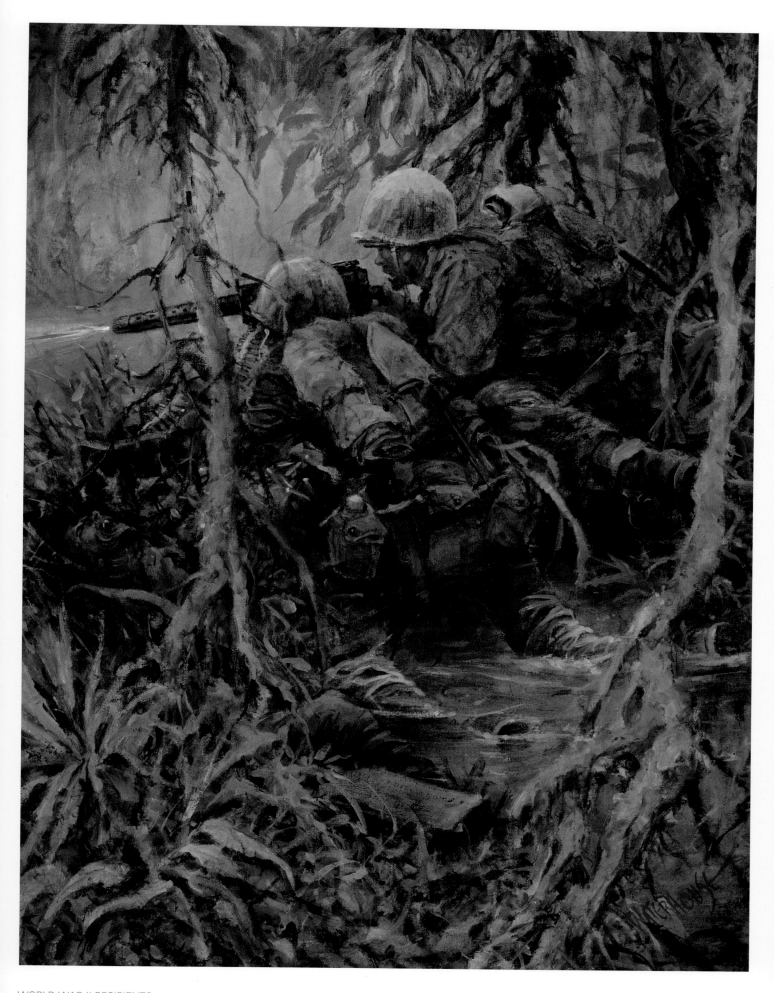

SSGT. WILLIAM J. BORDELON, USMC[22]
Tarawa, November 20, 1943

Born on Christmas Day 1920, he served as an altar boy and was the top-ranking cadet in his high school's Junior Reserve Officers Training Corps program, so it was no surprise that after the Japanese attack on Pearl Harbor, William Bordelon was among the first in line to sign up to fight for his country. He tried the Navy first but was turned down because he'd been born with webbed toes. The Marine Corps accepted the eager young man and trained him as a combat engineer.

Bordelon had his first bitter taste of combat on Guadalcanal. Eight months later, as a newly promoted staff sergeant in the Assault Engineer Platoon, 18th Marines, 2nd Marine Division, the twenty-two-year-old Texan took part in the initial assault on a small atoll in the Gilbert Islands called Tarawa.

The Japanese defenders were waiting for the Marines as they hit the beach on November 20, 1943. SSgt. Bordelon was one of only four men in his LVT to survive the landing. Under ferocious fire from the Japanese *rikusentai*, he and his comrades climbed out of the vehicle and fought their way through barbed wire, taking cover behind a 4-foot seawall.

Most of their equipment had been lost, but Bordelon managed to secure enough dynamite to make demolition charges. Defiantly, he stood, facing the enemy machine gunner, lobbing one charge after another until he'd eliminated two hostile pillboxes. As he was hurling a charge at a third, Bordelon was hit by machine gun fire. He insisted on remaining in action, using his rifle to provide cover for Marines scaling the seawall.

When one of his demolition buddies was wounded, Bordelon went to his aid, but another bullet caught him as he was attempting the rescue. Refusing medical assistance, Bordelon improvised another demolition charge and launched a single-handed assault on a fourth Japanese pillbox.

William James Bordelon—altar boy, top cadet, heroic Marine—perished in a final burst of enemy fire. The young San Antonian was the first Texan to receive a Medal of Honor in World War II, and the only enlisted man to earn the medal during the brutal battle for Tarawa.

"He died a real fighting man," Bordelon's company commander later wrote. "And he was killed doing a job he would ask no one else to do."

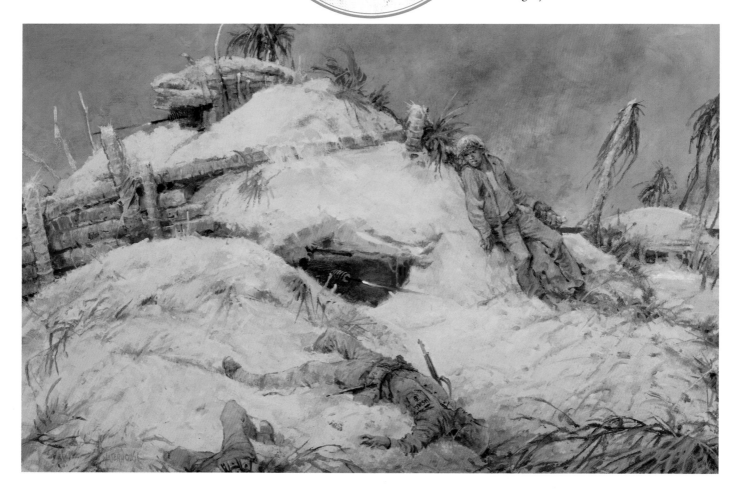

1Lt. William Hawkins, USMC[23]
Tarawa, November 20–21, 1943

William Deane Hawkins was born on April 19, 1914, at Fort Scott, Kansas. In 1919, the Hawkins family moved to El Paso, Texas. Shortly afterward, the rambunctious five-year-old William was running around and accidentally bumped into a neighbor who was carrying a pot of boiling water. It spilled over him, burning over one-third of his body, causing severe muscle damage that prevented him from straightening his arm and leg. Doctors recommended surgery to cut his muscles, but William's mother refused, knowing that the operation would leave her son crippled; instead, she embarked on a regime of constant massage. Over time, William's muscles healed and he was able to walk, but the scars would remain with him all his life.

Rather than consider himself flawed, William approached every challenge—including the death of his father when he was eight—as a fighter. Blessed with a quick mind and indomitable spirit, he skipped the fifth grade, graduating from El Paso High School at the age of sixteen. By the time he was a student at the Texas College of Mines, the little boy who was never expected to walk was a collegiate athlete. He never forgot the loving care he'd received during his convalescence, spending his summers working as a bellhop, ranch hand, and railroad handyman to help care for his widowed mother.

Although he was originally against the war, Hawkins decided to enlist after the Japanese attack on Pearl Harbor. Turned down by the Army Air Forces and Navy Air Corps on the basis of his "disfigurement," on January 5, 1942, Hawkins joined the Marines, who accepted the 5-foot-10, 145-pound recruit, "burns and all."

After recruit training, Hawkins attended scout-sniper school and was sent to Guadalcanal, where he so distinguished himself that on November 17, 1942, he received a battlefield commission and was given his own sniper platoon to command. His men, who called their leader "Hawk," adored him.

On November 20, 1943, while commanding a scout-sniper platoon in Headquarters and Service Company, 2nd Marines, 2nd Marine Division (Rein), in the assault on Betio Island, Tarawa Atoll, 1Lt. Hawkins and his platoon were the first to meet the enemy, face to face. With a fierce yell, Hawk and his Marines swarmed up the Betio pier and onto the landing, engaging the Japanese *rikusentai* (naval landing force) in fierce hand-to-hand combat. The battle for Tarawa had begun. Although twice wounded in the shoulder during that fearless charge, Hawkins told the corpsman not to tie his bandages too tight, explaining, "I'll have trouble shooting."

Joining with the forces fighting desperately to gain a beachhead, Hawkins spent the rest of that day and night leading his platoon in grenade and demolition attacks on enemy pillboxes and installations. When the gunner of an amphibious vehicle was killed in a burst from an enemy machine gun, Hawk manned his weapon, cleaning out six Japanese machine gun nests. "I'll never forget the picture of him, riding around with a million bullets a minute whistling by his ears," one of the officers in his outfit said later. "I never saw such a man in my life."

As dawn broke on November 21, Hawkins and his Marines returned to the dangerous mission of clearing the beachhead of Japanese resistance. Hawk personally initiated an assault on five enemy machine gun emplacements, alternately crawling, or dashing, forward—firing point-blank into the slits of each pillbox before tossing in his grenades. Despite being seriously wounded in the chest, Hawkins refused medical treatment, managing to destroy an additional three pillboxes before a Japanese sniper bullet hit him in the shoulder, severing his artery.

He fell within fifty yards of where SSgt. William Bordelon, who would also be awarded the Medal of Honor, had died the day before.

Unabashedly weeping, Hawkins's men carried their beloved leader to an aid station. "Boys," he said to them before he died, "I sure hate to leave you like this."

Hawkins's actions inspired his Marines to rise from their foxholes, en masse, and charge the Japanese, eventually cutting Betio in two and driving the enemy back. Col. David Shoup would later say, "It's not often that you can credit a first lieutenant with winning a battle, but Hawkins came as near to it as any man could."

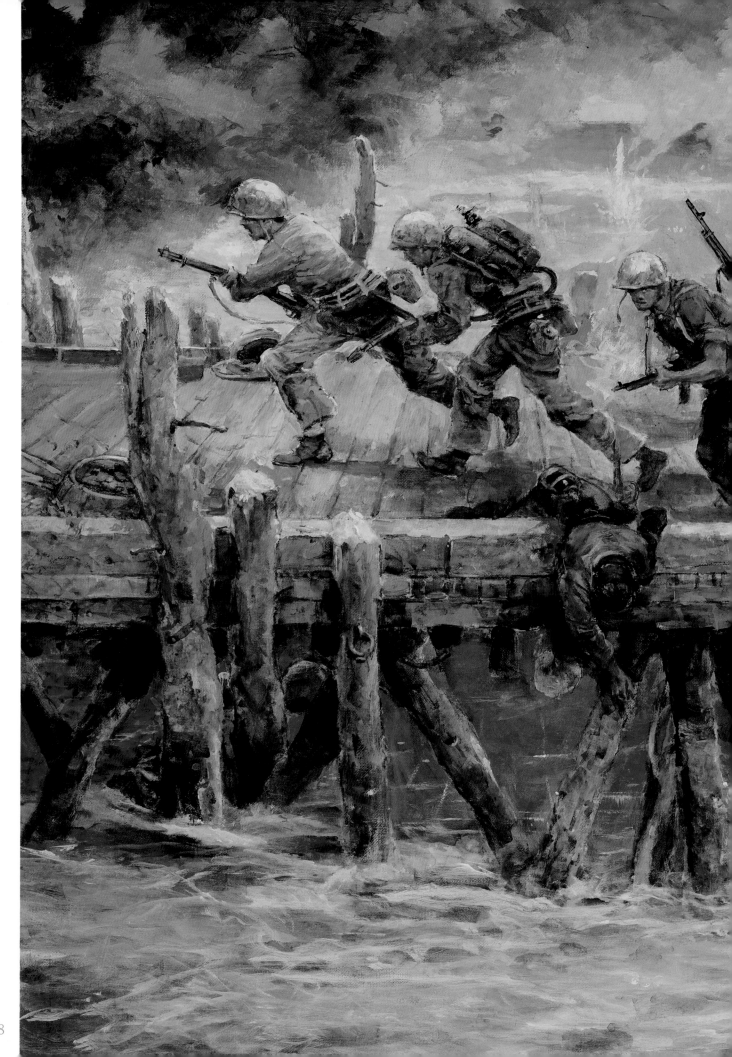

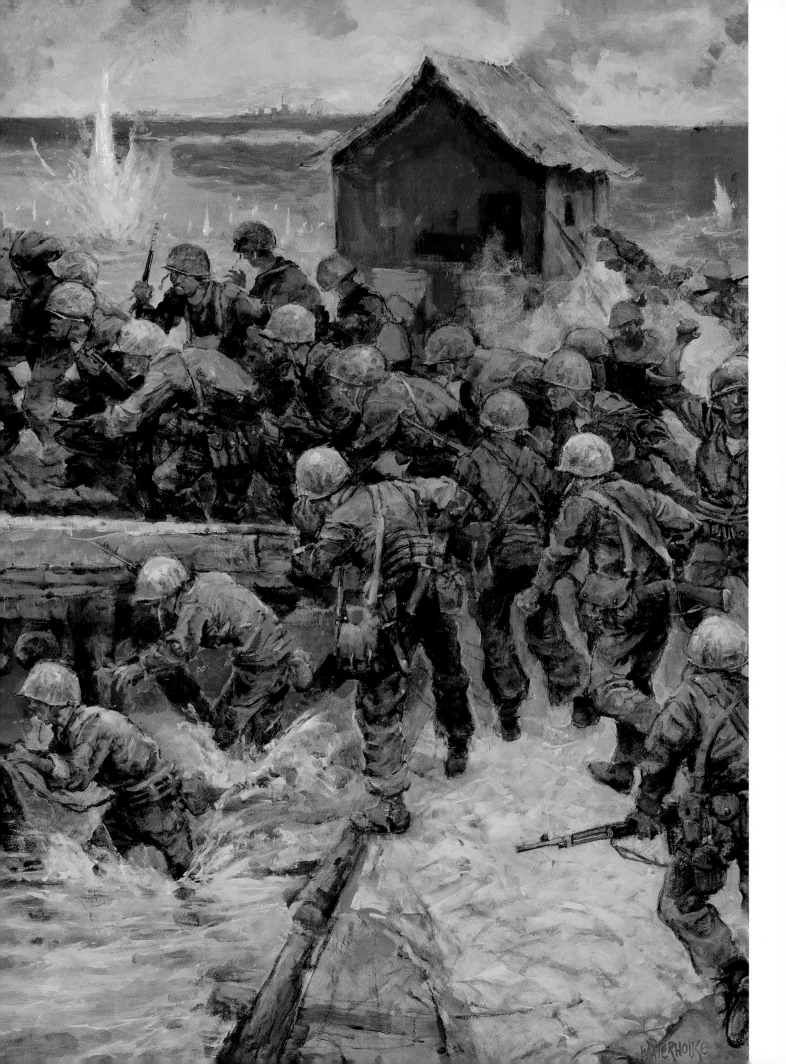

1LT. ALEXANDER BONNYMAN JR., USMC[24]

Tarawa, November 20–22, 1943

By all rights, 1Lt. Alexander "Sandy" Bonnyman Jr. wasn't supposed to be in the thick of the fight; not—like the three others who received Medals of Honor at Tarawa—because of a physical deformity or twist of fate, but because he held, in his privileged hand, a full suite of exemptions: he was thirty-three years old, married with three children, and the owner of a copper mine considered essential to the war effort. What's more, his assignment as executive officer of the 2nd Battalion, 8th Marines' Shore Party, should have relegated Bonnyman to a support role at the rear of the line. But from the beginning, it was clear that Tarawa was no ordinary battle, and Sandy Bonnyman was no ordinary Marine.

Born on May 2, 1910, in Atlanta, Georgia, Sandy Bonnyman grew up in Knoxville, where his father was the president of the Blue Diamond Coal Company. Bonnyman Sr. hoped that his son would follow the straight line of his footsteps into a corner office at the coal company, but from an early age, the boy was hell-bent on following his own path. In an effort to rein in his willful spirits, his father sent him to a Catholic boarding school in Lakewood, New Jersey, where—if not saving grace—Sandy found football. Pigskin ball tucked under his arm, Bonnyman carried the family tradition into the ivy-covered halls of Princeton, playing first string for the Tiger football team in his sophomore year before being kicked out—possibly for punching the dean.

Devastatingly handsome, with piercing blue eyes and chiseled features, Bonnyman might have done well in Hollywood; instead he headed to the mountains of Virginia, working in mines and construction sites and acquiring hands-on experience in demolition, surveying, and engineering. In 1939, convinced that war was on the horizon and the demand for copper would soar, Bonnyman secured a lease on a copper mine. It was and it did.

In 1942, at age thirty-two, Bonnyman enlisted in the Marines. Told that he was too old to go directly to officers' training school, he earned his commission the hard way, on the battlefield in February 1943 at Guadalcanal.

By the time 1Lt. Bonnyman landed with the 2nd Battalion, 8th Marines' Shore Party, on November 20 1943, at Tarawa Atoll, any illusions that war was just another grand adventure had faded in the face of grim reality. And it was about to get grimmer. With the assault waves pinned down by punishing enemy fire and unable to reach Betio Island, Bonnyman, on his own initiative, gathered a group of men and led them across the fire-swept Betio Pier to the beach. There he organized a team of flamethrowers and demolition charges to carry out the destruction of several enemy installations that were preventing the advance.

On the second day, November 21, Japanese soldiers in a large cement blockhouse were inflicting a vast amount of pain on the Marines. The large, sand-covered redoubt was impervious to air attack and offshore naval shelling and seemed to be invincible, but Bonnyman had devised a plan to take it down. He organized a group of a dozen flamethrowers and demolition experts and advanced his small team to the mouth of the blockhouse, killing as many Japanese defenders as they could before they were forced to return for more grenades and ammunition.

The following morning, November 22, Bonnyman and his small force renewed their attack, tossing grenades into every gunport they could find, pouring diesel fuel down the air shafts of the blockhouse, and flushing out and killing more than 100 of the enemy. With a cigar clamped between his teeth, Bonnyman scrambled to the highest point of the bunker. As he called out for more explosives, he was hit by enemy fire.

For his bravery that day, 1Lt. Bonnyman was recognized with a posthumous Medal of Honor. The location of his body, like the bodies of hundreds of Marines who fought on Tarawa, remained unknown until a nongovernmental group called History Flight set out on a mission to recover their bones. In 2015, Bonnyman's grandson, Clay Bonnyman Evans—who chronicled the journey in his book *The Bones of My Grandfather*—knelt beside Bonnyman's well-preserved skeletal remains. A seventy-two-year-old mystery was solved and a hero was finally brought home.

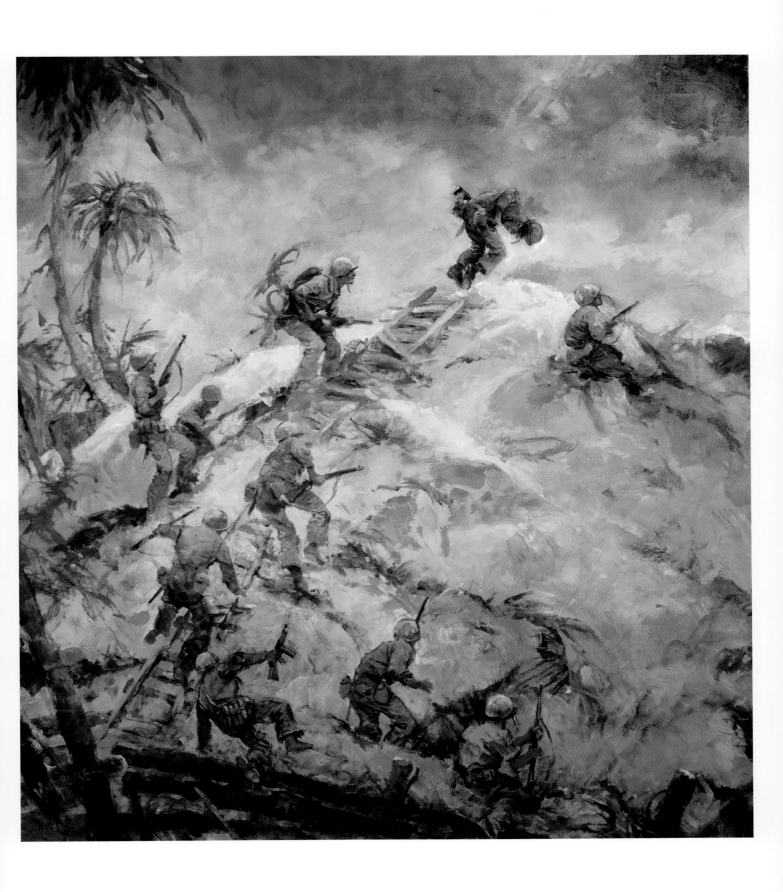

COL. DAVID M. SHOUP, USMC[25]
Tarawa, November 20–22, 1943

"If you are qualified," Col. David Shoup wrote in the journal he kept on Tarawa, "fate has a way of getting you to the right place at the right time—tho' sometimes it appears to be a long, long wait." For Shoup, the journey from self-professed "Indiana plowboy" to commanding officer of all Marine Corps troops in action against the Japanese on Betio Island, Tarawa Atoll, may have seemed long and winding, but, in hindsight, the signs, stars, and shifting tides were all leading him to where he needed to be.

David Shoup was born on December 30, 1904, on a farm in Battle Ground, Indiana, just a stone's throw from the site of Gen. William Henry Harrison's 1811 victory at Tippecanoe. As a boy, and all through his life, Shoup sought to emulate bold, patriotic leaders like Harrison, while holding true to the small-town progressive ideals that made him a natural opponent against big business and the unnecessary use of force.

An excellent student, at age twelve David was enrolled in Covington High School, where he maintained high grades in an advanced curriculum that included French, English, physics, and history, and was elected class president in his senior year. After graduating in 1921, Shoup left the homestead to attend DePauw University on a full-tuition scholarship. At DePauw, Shoup majored in mathematics and was a member of the track-and-field and rifle teams, as well as being a football player and a competitive wrestler. In 1925, he won the Indiana and Kentucky Amateur Athletic Union marathon. But when a bout of pneumonia, resulting in a hospital stay during his junior year, incurred a tide of mounting bills, Shoup was forced to take a year off from school. After a stint as a schoolteacher, he opted to enroll in the Reserve Officers Training Corps (ROTC) to complete his degree at DePauw.

In 1926, Shoup resigned his Army Reserve commission to become a Marine officer, slowly climbing his way up the ranks while serving on a number of assignments in the US, China, and Iceland.

He was an observer at Guadalcanal with 1st Marine Division and an observer with the Army in New Georgia, receiving a Purple Heart. It was for his brilliant mind and organizational skills that then Lt. Col. Shoup was assigned the task of planning the invasion of Tarawa Atoll. But the tide turned again when the commander of the reinforced 2nd Marines took ill during the initial rehearsals of the assault: suddenly, Shoup—after being promoted to colonel on November 9, 1943—found that he was in command of the entire force ashore on Betio Island. Fate had gotten him to the right place at the right time.

And yet, on November 20, 1943, the tide—not metaphorical, but all too physical—nearly turned against him for good, when the expected high tide that was needed to buoy the assault waves never came, leaving the Marine amphibious assault crafts floundering offshore, in target range of deadly Japanese 75 mm artillery cannons.

Col. Shoup and elements of his tactical command team headed to the Betio shores at 0800. His LVT made three attempts to land. With the LVT disabled, and his leg riddled with shell fragments, Shoup jumped into the water, making it to the shelter of the long pier and establishing a command post, where for the next two and a half days, the stubborn, bullnecked, former midwestern plowboy tirelessly directed eight landing teams in some of the most brutal combat of the war, earning the nickname "the rock of Tarawa."

Despite his painful wound, Shoup remained on his feet the whole time, relinquishing command to receive medical care only when most of Tarawa Atoll was in American hands. One of four Marines awarded the Medal of Honor for their actions on Tarawa, thirty-eight-year-old Col. David Shoup was the only recipient to survive the battle and receive this honor in person.

On January 1, 1960, Lt. Gen. Shoup assumed his post as the twenty-second commandant of the Marine Corps and was promoted to four-star rank, becoming the third of only four CMCs to have earned the Medal of Honor.

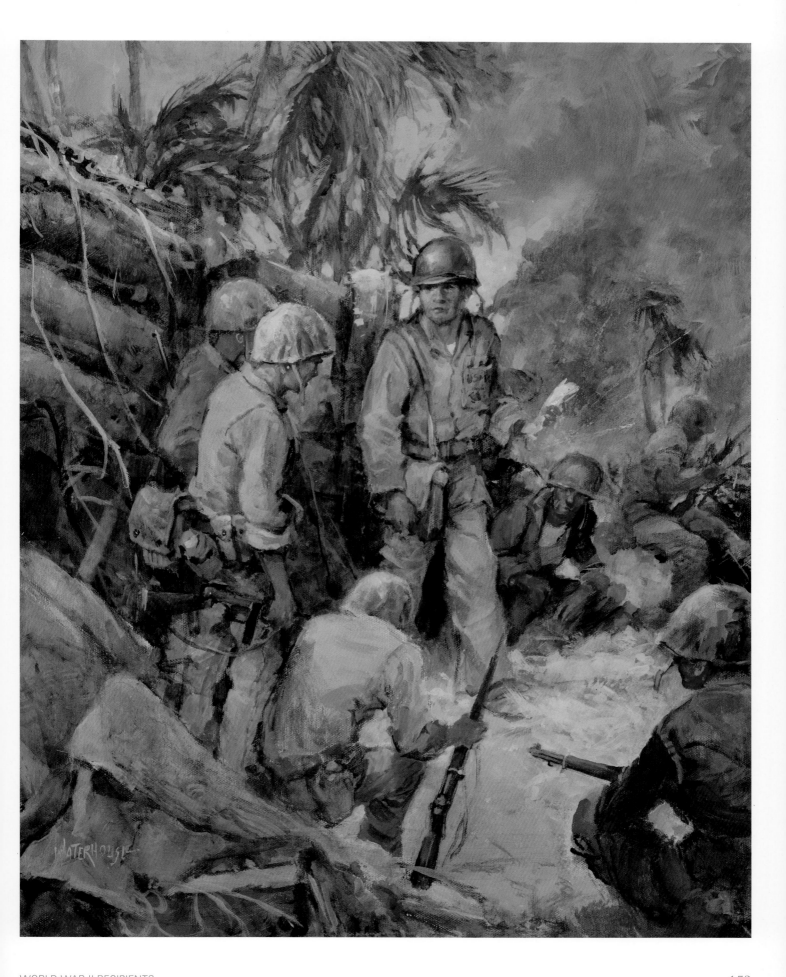

PFC RICHARD B. ANDERSON, USMC[26]
Roi-Namur, February 1, 1944

Richard Anderson was born on June 26, 1921, in Tacoma, Washington. He grew up in Agnew, just east of Port Angeles. After attending Sequim High School, Richard wandered south to California where he was briefly employed in a shipyard in Richmond before enlisting in the Marines on July 6, 1942.

Anderson's recruit training and his subsequent first assignment were in San Diego, at the Marine Corps Recruit Depot and the Marine Corp Barracks, Naval Receiving Station. In April 1943, he was promoted to private first class, ultimately joining Company E, 2nd Battalion, 23rd Marines, in the newly formed 4th Marine Division as a mortarman.

Standing at 5 foot 6, candid photographs of Anderson in his Marine uniform show a good-looking young man, with dark, curly hair, a dimpled smile, and perfect teeth. In one snapshot, taken while on leave shortly before his unit's departure for the Marshall Islands in January 1944, he sits with a pretty blonde on his lap, each flashing happy smiles at the camera. Was she Anderson's sweetheart? Was it on this leave that the young PFC had the words "Death Before Dishonor" tattooed on his arm? Did he know that Medal of Honor Sgt. John Basilone, the fighting hero of Guadalcanal, had that same tattoo? As fate would have it, these questions remain unanswered. PFC Richard Anderson, so young and vibrant in these last photos, would be killed on a faraway island in less than a month.

On February 1, the 23rd Marines were part of the invasion force against the Japanese on Roi Island. Spotting as a forward observer for his mortar unit, PFC Anderson was hunting for snipers in the area of Roi airfield when he noticed a shell hole occupied by three other Marines. Thinking it would provide the perfect vantage point from which to attack enemy emplacements, he joined them. Soon afterward, Anderson zeroed in on a hostile position. As he was preparing to throw a grenade at an enemy position, it slipped through his hands and rolled toward his companions. Reacting immediately, the twenty-two-year-old Marine hurled his body on the grenade, absorbing impact of the explosion and saving his fellow Marines. *Death Before Dishonor.*

In 2008, the Port Angeles Federal Building was named the Richard B. Anderson Building. At the renaming ceremony, a letter written by Harry Pearce—one of the three men whose lives Richard had saved—was read. In it, Pearce wrote, "He gave me a chance to live."

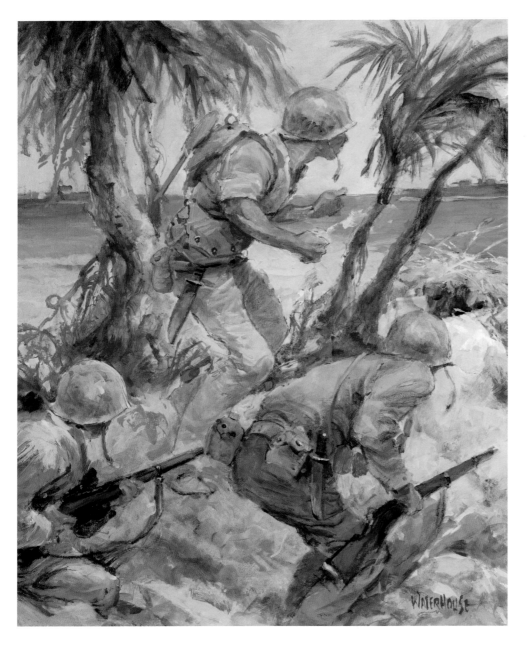

1Lt. John "Jack" Power, USMC[27]
Roi-Namur, February 1, 1944

John "Jack" Power was born on November 20, 1918, in Worcester, Massachusetts. As the fourth of five children in a devout Irish Catholic family, the Powers lived in the shadow of the Cathedral of St. Paul, and much of their lives revolved around the church. Young Jack attended the St. Paul's and Sisters of Mercy School, where he earned the nickname "Sunshine" because of his cheerful smile and sunny disposition. At Classical High School, and while attending the College of the Holy Cross, Jack Power was an avid athlete, playing basketball, football, tennis, and golf. His math teacher later described him as "a good and determined student."

After graduating from Holy Cross, Power enlisted in the Marine Corps Reserve in July 1942 and was quickly assigned to Officers' Candidate School and commissioned a second lieutenant in October 1942. Promoted to first lieutenant by mid-January of the following year, 1Lt. Power was soon sailing with Company K, 3rd Battalion, 24th Marines, as part of the newly formed 4th Marine Division, on their way to the Marshall Islands. During the long voyage, Power often quipped, "Let the other guy have the glory." In the heat of battle, he said it was his intention to turn the platoon over to his sergeant. His Marines just laughed: they knew that wasn't going to happen—no one was closer to his men than 1Lt. Power.

On February 1, the 24th Marines took part in the assault at Roi-Namur. After the capture of Roi, the surviving Japanese defenders fled to nearby Namur. The Marines went after them. In landing on Namur, Power's company encountered the heaviest resistance of the invasion. All thoughts of letting "the other guy have the glory" fell away as 1Lt. Power stepped boldly into the lead, setting a demolition charge on a Japanese pillbox. During his charge on the enemy emplacement, Power was severely wounded in the stomach, but he refused to be evacuated. After an emergency dressing was applied, Power sprang back into action. Clutching his bleeding midsection with his left hand, he continued to fire his weapon with his right, advancing on the entrance of a hostile pillbox that had been torn open by his men. Charging the opening, Power emptied his carbine into it. As he was attempting to reload, one of the surviving Japanese soldiers inside fired off shots, hitting the lieutenant in his stomach and head, killing him.

On October 18, 1947, Jack Power finally came home to Worcester, to the tolling of the cathedral bells and a twenty-one-gun salute. He was laid to raid in St. John's Cemetery. The Power family donated Jack's posthumous Medal of Honor to Holy Cross College.

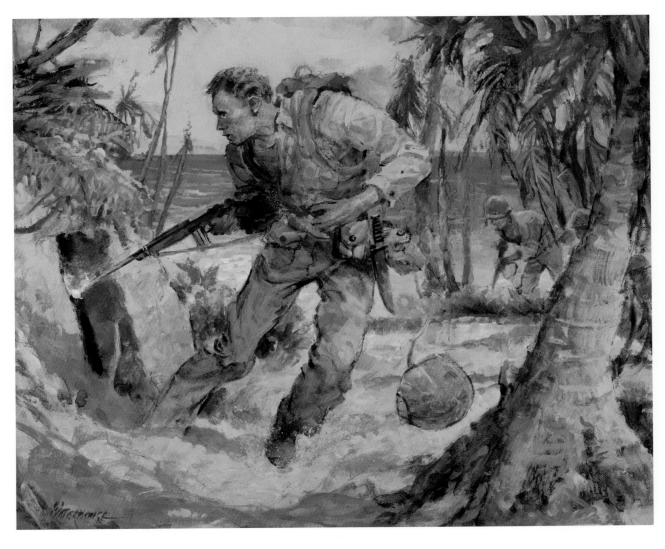

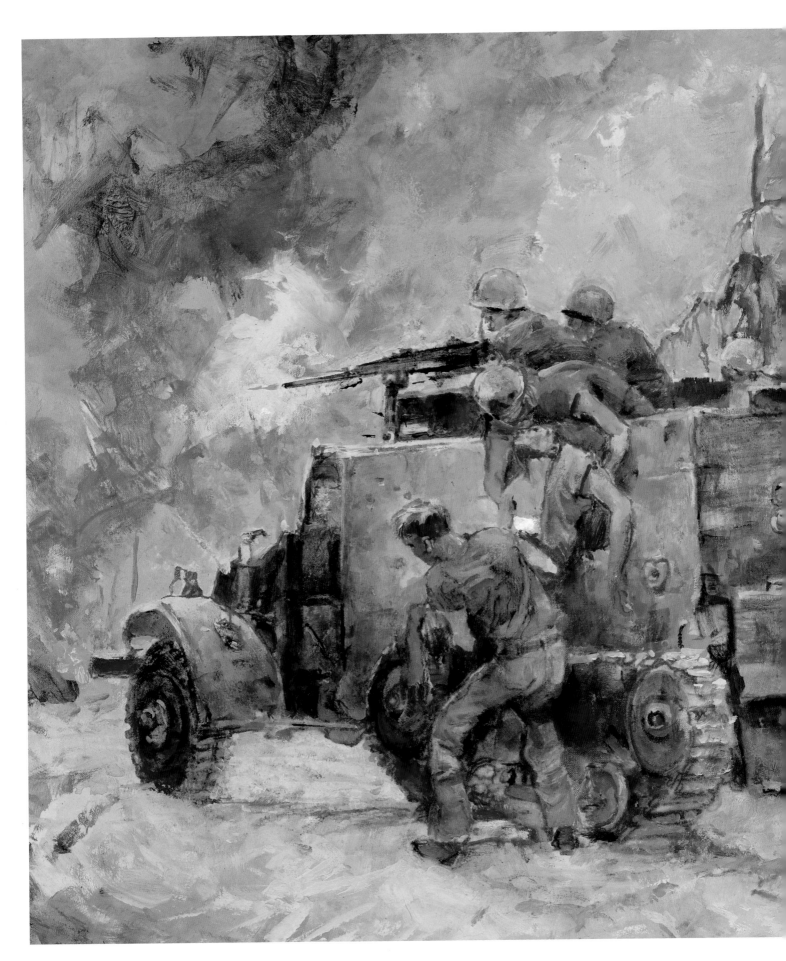

156

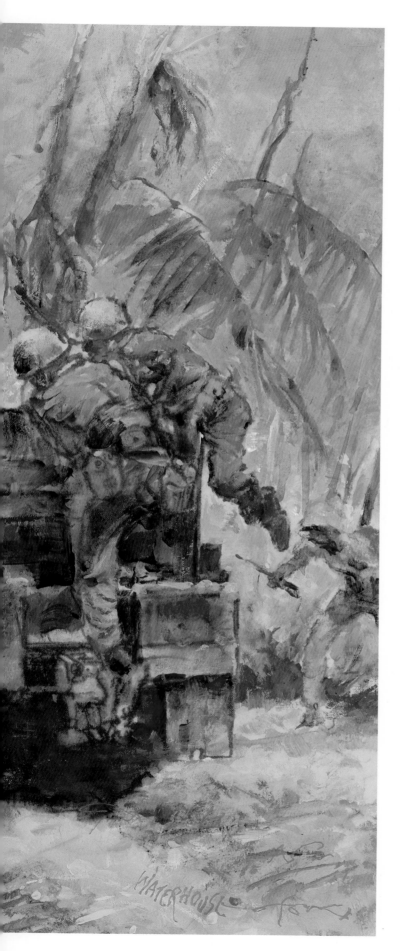

LT. COL. AQUILLA DYESS, USMC[28]
Roi-Namur, February 1–2, 1944

Aquilla "Jimmie" Dyess was born on January 11, 1909, in Andersonville, Georgia. He is one of only nine known Eagle Scouts to receive the Medal of Honor, and, to date, the only American to receive both the nation's highest military decoration *and* the Carnegie Medal for civilian heroism, which Dyess was awarded for saving the lives of two swimmers off the coast of Charleston, South Carolina, in 1928.

Dyess was in the Army ROTC at Clemson Agricultural College and, after graduating with a BS in architecture, served in the Army Infantry Reserve. In civilian life he worked as a general contractor and was the assistant director of a summer camp for boys.

In 1935, Dyess was commissioned as a first lieutenant in the Marine Corps Fleet Reserve. While attached to the 19th Battalion reserve in Augusta, Georgia, he was awarded two bronze shooting medals as a member of the Marine Corps Reserve Shooting Team, which won the Hilton Cup in the National Matches in 1937 and 1938.

When the men in his unit were mobilized to take part in World War II, Jimmie Dyess quickly worked his way up the ranks, serving as commanding officer of the 1st Battalion, 24th Marines (Rein), 4th Marine Division, in action against the enemy Japanese forces on Namur Island.

During two days of heavy fighting in early February 1933, Lt. Col. Dyess came to the aid of a team of Marine snipers that had inadvertently pushed through Japanese lines and had been pinned down. He personally braved heavy enemy fire to make the rescue.

The next day Dyess was back in the field, leading his men and encouraging them to push forward. As he was standing on the parapet of an antitank trench, directing the infantry in an attack against the last Japanese position in the northern part of the island, Dyess was killed by a burst of enemy machine gun fire on February 2. He was thirty-five years old.

PVT. RICHARD K. SORENSON, USMCR[29]
Roi-Namur, February 1–2, 1944

Richard Sorenson was born on August 28, 1924, in Anoka, Minnesota. His father, a US Navy World War I veteran, worked as a machinist for Buick, and the family lived for a few years in Flint, Michigan, before returning to Richard's hometown in time for him to attend Anoka High School. After hearing the news on the radio that the Japanese had attacked Pearl Harbor, Richard skipped school the following morning to take the trolley to Minneapolis and enlist in the Navy, but his parents refused to sign the consent papers for their seventeen-year-old son.

Richard turned eighteen the following August, waiting for the Anoka Tornadoes football season to end, before making a second foray into Minneapolis, this time to enlist in the Marines. He was sent to San Diego for basic training—a trip that marked the young man's first time away from home and his first time on a train. A few months later, Pvt. Sorenson was assigned to Company M, 3rd Battalion, 24th Marines, 4th Marine Division, where he continued his training before sailing for Kwajalein Atoll in the Marshall Islands.

On February 1, 1944, Pvt. Sorenson landed with his assault battalion on Namur Island. The unit fought their way into the interior of the island, where they encountered a large Japanese blockhouse. Unaware that it contained an arsenal of torpedo warheads and aerial bombs, the Marines threw a satchel charge at the emplacement, triggering an explosion that covered the island with debris and resulted in many casualties. The commander ordered the battalion to pull back, but Sorenson's company didn't get the word. By nightfall, a group of about thirty Marines had dug in around the shattered blockhouse, setting up a perimeter around its footings.

The Japanese attacked at dawn. "We were completely surrounded," Sorenson recalled in an interview for the video series Medal of Honor Book. "It felt like General Custer." Down to just one light machine gun, after an hour of fighting, things only got worse when one of the five Marines in Sorenson's hole yelled, "Grenade!" Without hesitating, Pvt. Sorenson jumped on the missile, covering it with his body before it exploded. Miraculously, the twenty-year-old Marine was not killed instantly, and thanks to a corpsman who tied off his gushing artery, his life was saved.

Over the next nine months Sorenson underwent six surgeries. When he was presented with his Medal of Honor in July 1944 at the Seattle Naval Hospital, all of the doctors and nurses who had treated him were in attendance to show their support for the brave young private who jumped on a grenade to save the lives of his comrades and had lived to tell the tale.

"Somebody had to do it," Sorenson later said. "It just happened to be me."

Sorenson passed away at the age of seventy-nine in 2004.

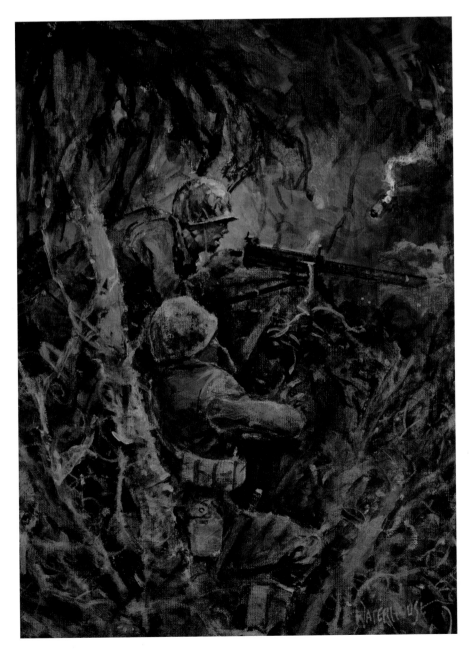

CPL. ANTHONY P. DAMATO, USMC[30]
Eniwetok, February 19–20, 1944

To understand who Anthony Damato was only through the words of his citation would be to see him as just one of many brave young men who received Medals of Honor for falling on grenades to save the lives of fellow Marines during World War II. Information about Damato's early life provides few clues as to the genesis of his heroism. He was born in the tiny mining community of Shenandoah, Pennsylvania, on March 28, 1922. He attended Cooper High School and worked as a truck driver before enlisting in the Marines in January 1942.

His official biography states that Pvt. Damato "went to Derry, Northern Ireland, in May of that year." It's the first clue that offers a glimpse into the exciting—and often daring—path that led Anthony Damato to Eniwetok Atoll, where his short life would precipitously end. The reference suggests that Damato was one of about 500 Marines of the 1st Provisional Marine Battalion that landed in Northern Ireland in May 1942, on a top-secret mission to protect a naval operations base and other critical installations that were vital to the Allies' success in winning the Battle of the Atlantic against the Nazis. These "Irish Marines," who billeted in Quonset huts on the grounds of the Beech estate in Derry, formed long and lasting relationships with the local people, in some cases courting and marrying Derry girls. Many of them carved their initials into the trunk of an ancient oak, known to this day as "the Marine Memory Tree." It's very possible that Anthony Damato made his mark there. He would definitely make it elsewhere.

In October 1942, Damato volunteered for special duty with a select invasion party that took part in the North African landings, where he received a promotion to corporal and a commendation for "especially meritorious conduct in action" on November 8, while assisting in the efforts to seize hostile vessels and capture the port at Arzew, Algeria.

By the time Cpl. Damato landed with an assault company of the 2nd Battalion, 22nd Marines, V Amphibious Corps, on Engebi Island, Eniwetok Atoll, in the Marshalls, he had participated in the Battle for the Atlantic and the invasion of French North Africa.

This low-lying coral island would be the last stop on an honorable tour of service for the twenty-one-year-old Marine.

In the dark hours of February 19–20, 1944, Cpl. Damato was sharing a foxhole with two other Marines when a Japanese grenade landed in their midst. Without hesitating, Damato threw himself over the deadly missile, sacrificing his life for his comrades.

On April 9, 1945, the entire community of Shenandoah turned out to pay homage to their hometown hero as his mother was presented his posthumous Medal of Honor in a ceremony held at Cooper High School, where Damato had been a student only a few years before.

After the war, Cpl. Damato's remains were reinterred in the National Cemetery of the Pacific in Honolulu, Hawaii. Across another sea, an oak tree still stands, bearing the initials of the "Irish Marines" like Anthony Damato who helped the Allies prevail in the Battle of the Atlantic.

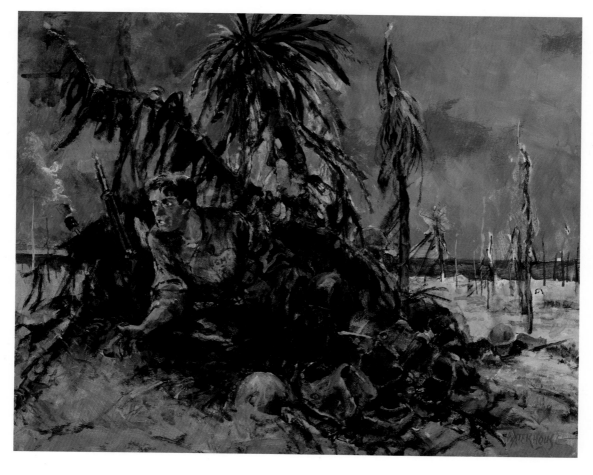

SGT. ROBERT H. MCCARD, USMC[31]
Saipan, June 16, 1944

Robert Howard McCard was born on November 25, 1918, in Syracuse, New York. During high school, Robert took a business course and was a standout football and baseball player. In December 1939, McCard enlisted in the Marines, later serving a year at sea aboard the USS *Tuscaloosa*, where he and his gun crew won a $5 prize for coming in second place in a 5-inch antiaircraft gun competition.

From July 1940 to January 1943, McCard worked his way up the ranks, before being assigned as platoon sergeant to Company A, 4th Tank Battalion, 4th Marine Division.

On January 31, 1944, McCard was in the Pacific, landing with the 4th Marine Division at Roi-Namur on Kwajalein Atoll in the Marshall Islands. Over the next few months they would see combat at Ennugaret, Ennumennett, and Namur Islands.

On June 15, nearly 71,000 men of the 2nd and 4th Marine Divisions—McCard and his Company A, 4th Tank Battalion, among them—stormed the beaches of Saipan.

By the following day, June 16, McCard, acting both as the platoon and gunnery sergeant of Company A, was part of a four-tank spearhead ordered to attack up the road and over the ridge leading to the Aslito Airfield. The tank that McCard was commanding was in the lead. As the Sherman clambered up the front of the slope and rounded the nose of the ridge, it rolled into the jaws of four Japanese type 88 field guns. They opened fire, shooting McCard's tank point-blank, taking off a track and putting it out of commission. Realizing it was a no-win situation, the other tanks in the column were ordered to withdraw.

Cut off, and with no immediate outside help in sight, McCard told his crew to bail out and make a run for it. Making no effort to follow, McCard stood alone in the open turret, manning the weapons, lobbing fragmentation and smoke grenades, and providing cover for his Marines to get clear. He was later found slumped in the turret, with the bodies of sixteen dead Japanese soldiers littered around his bullet-ridden tank.

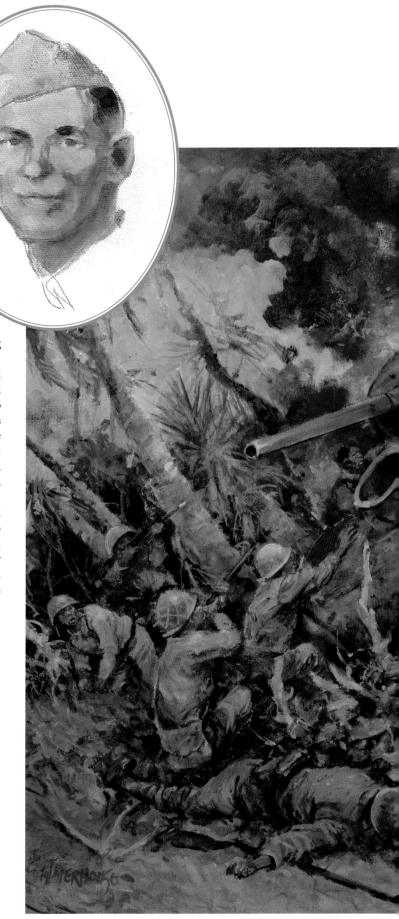

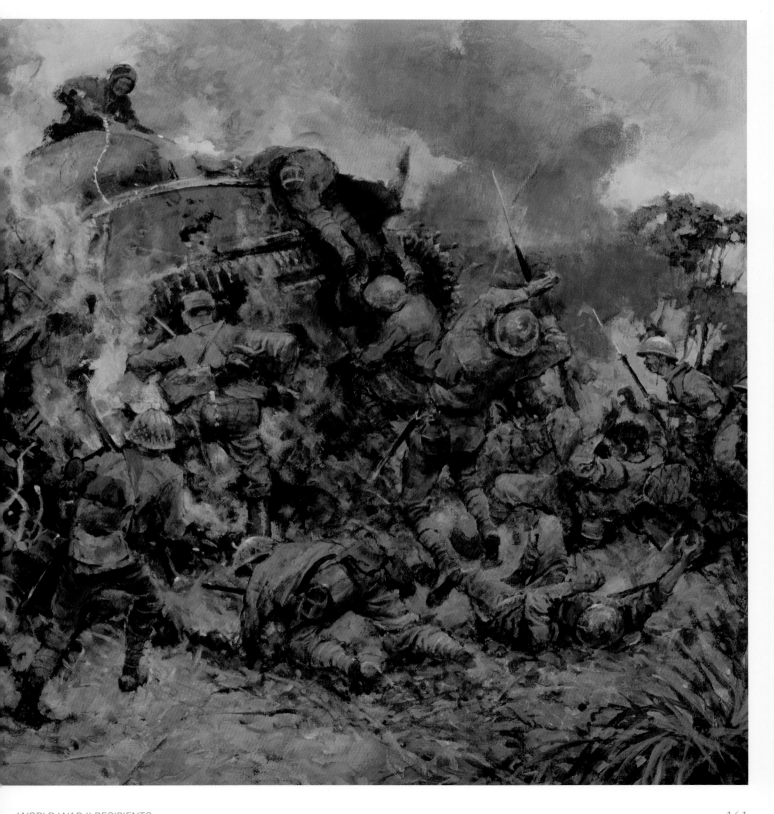

PFC HOWARD EPPERSON, USMC[32]

Saipan, June 25, 1944

Harold Epperson was born on July 14, 1923, in Akron, Ohio, and grew up in the working-class steel town of Massillon, an area where the local culture revolved—and continues to revolve—around football. At Massillon Washington High School, Harold played for the Tigers football team, a breeding ground for future professional players. A fellow Marine would later describe Epperson as "a real go-getter" with "that football kind of attitude." But a pro ball career wasn't in the cards for him, so upon graduating, Epperson took a job with Goodyear Aircraft before deciding, with a war going on, that a go-getter like him should be serving his country.

He enlisted in the Marine Corps Reserve in December 1942. As a member of the 1st Battalion, 6th Marines, 2nd Marine Division, Epperson would share in the Presidential Unit Citation awarded his organization for its service during at Tarawa. He had survived one brutal battle, but there was another yet to come.

On the night of June 25, 1944, PFC Epperson and two of his fellow Company C Marines were on Saipan, taking turns behind their Browning light machine gun, waiting for the rugged hills in this open area north of Mount Tipo Pale to come to life with the inevitable sounds of enemy movement in the eerie darkness. Epperson—or "Egghead," as his buddies affectionately called him—took the first watch. The attack began around 0200.

Fully awake, and all too aware of the moonlit glint of bayonets heading toward them, the other Marines sprang into action while Epperson, behind the gun, maintained a steady stream of fire. He held off most of the assailants, but a few had gotten close enough to start hurling grenades. When he saw a sputtering hostile missile land in their trench, Epperson pushed away from the gun and went for it, shielding his companions from the explosion. The blast tore off most of his left arm and shoulder. Still alive, Epperson managed to hoist himself behind the machine gun, raining fire on the ground to his front until, overcome by blood loss, he slumped to the ground. The two other Marines continued the fight; eventually, a corpsman came by to relieve Epperson's pain with a shot of morphine, but there was nothing more he could do. The twenty-year-old hero died soon afterward.

On July 4, 1945, Epperson's posthumous Medal of Honor was presented to his mother at a ceremony in Tiger Stadium back in Massillon, attended by 8,500 townspeople, his fellow football players and classmates, and the Massillon Washington High School band.

"He was a boy who became a Marine," his brother, Chuck Epperson, would later say. "Why did he do it? He was a Marine . . . he did it because his country needed and demanded the best he could give it.

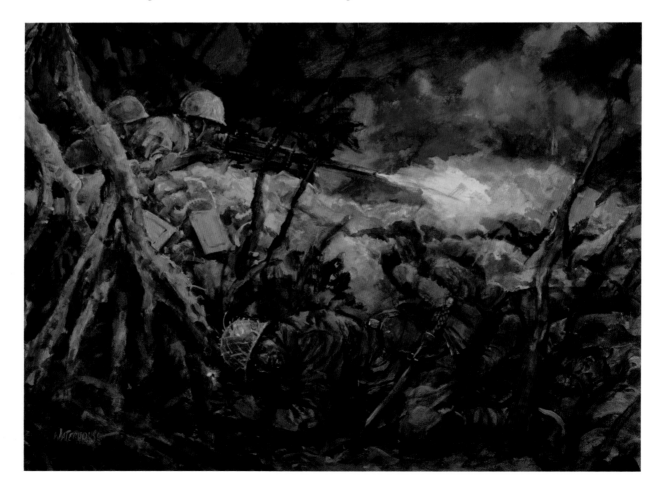

PFC HAROLD AGERHOLM, USMC[33]
Saipan, July 7, 1944

Harold Agerholm was born on January 29, 1925, in Racine, Wisconsin. Growing up in Racine's close-knit Rubberville neighborhood, within spitting distance of the Ajax Rubber Company, Harold was always looking out for others. During the Depression, he would hop aboard the trains chugging through Rubberville, throwing off enough coal for family and friends to cook and heat their homes. He was constantly bringing stray pets and baby turtles back home. But Harold could be tough too: if word got out that one of the younger Agerholms had skipped class, he would drag the culprit back to school, by force if necessary. After his father was killed in an accident, Harold—the middle child and eldest son—assumed the brunt of responsibility for his widowed mother, brothers, and sisters.

In July 1942, after months of working as a multigraph operator at a local manufacturing company, the seventeen-year-old announced that he wanted to enlist in the Marines. "He begged so hard to go, I finally gave my consent," Mrs. Agerholm later said.

In November 1943, a year and a half after completing his training and being promoted to private first class, PFC Agerholm was with Headquarters and Service Battery, 4th Battalion, 10th Marines, 2nd Marine Division, taking part in the battle for Tarawa. At the end of that bloody campaign, he went to Hawaii with the 2nd Marine Division to train for the next invasion.

Agerholm landed on Saipan on June 15, 1944, as an artilleryman with the 4th Battalion, 10th Marines. The battle raged on for three long, hard weeks.

On July 7, the Japanese launched a fierce counterattack. That day, countless Marines would owe their lives to a nineteen-year-old midwesterner who was always looking out for others. When an adjacent battalion was overrun, PFC Agerholm obtained permission to drive an ambulance jeep out to search for survivors. For over three hours, Agerholm drove through fire, dodging marauding enemy soldiers, jumping out to pick up casualties, and piling as many wounded men as he could into his jeep. It's estimated that he evacuated forty-five wounded Marines before he was shot and killed by a Japanese sniper.

At the request of Harold's grief-stricken mother, the admiral commanding the 9th Naval District presented her son's Medal of Honor in a private ceremony at her home. "He read the paper to me and handed me the star," Mrs. Agerholm said in an interview with the local newspaper. "It was very nice."

In 1947, PFC Harold Agerholm's remains were removed from the 2nd Marine Division Cemetery on Saipan and reinterred in Mound Cemetery, back in his hometown.

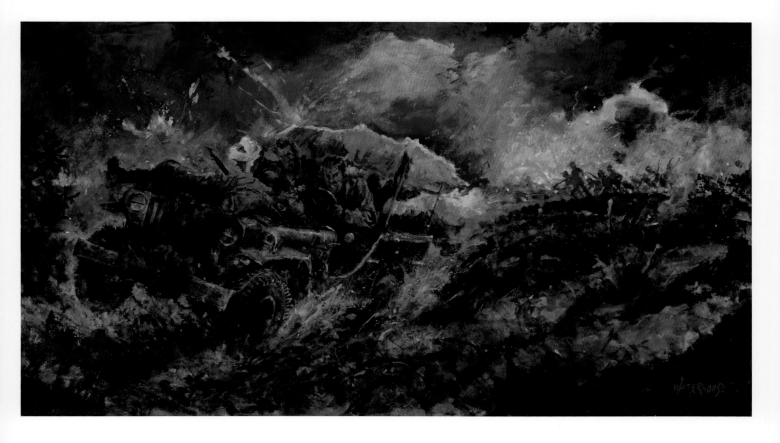

SGT. GRANT F. TIMMERMAN, USMC[34]
Saipan, July 8, 1944

Grant Timmerman was born on February 19, 1919, in Americus, Kansas. His Marine Corps photograph shows an earnest, bespectacled man who looks far more like a young Ivy League professor than a tank commander, and indeed, even in the small Kansan town in which he grew up, this saxophone-playing young man who had learned to speak French and Russian must have been a bit of an anomaly. After graduating from high school, Grant took a pre-engineering course at a state teacher's college before moving to California, where he found work as a welder. A few months later, in October 1937, the multilingual welder enlisted in the Marines.

By the time the Japanese attacked Pearl Harbor, PFC Timmerman had already completed a four-year enlistment serving as a motor transport driver with the 4th Marines, Motor Transport Company, in China and an assignment at the Naval Prison at Mare Island. After reenlisting at his old rank of PFC in February 1942, Timmerman was quickly promoted to corporal and then sergeant. On this go-round,

Timmerman sought out a more combat-forward role, which he found serving as a tank crewman with Company B, 2nd Tank Battalion, 2nd Marine Division, in November 1943, during the battle at Tarawa.

By June 1944, Sgt. Timmerman was with the 2nd Tank Battalion attacking Saipan as a commander of "Bonita"—a Sherman tank named for one of his old girlfriends. To the young crewmen serving under him, the twenty-five-year-old sergeant was an "old China hand," who wouldn't let a few shrapnel wounds keep him from being in the thick of the fight.

On July 8, Sgt. Timmerman was out in front with the Bonita, spraying a steady stream of fire from his turret-mounted antiaircraft machine gun, helping to clear the way for an advance of infantry against the enemy. When heavy resistance from Japanese pillboxes and trenches halted the tank's progress, the sergeant ordered his crew to stop and prepare the 75 mm main gun and warned the accompanying infantry to hit the deck. As he was fearlessly standing in the open turret, Timmerman saw a Japanese soldier rush his tank and lob a grenade toward the tank's open hatch. He moved his body to block the hatch, taking the full force of the missile with his chest, shielding his crew below and was killed instantly in the explosion

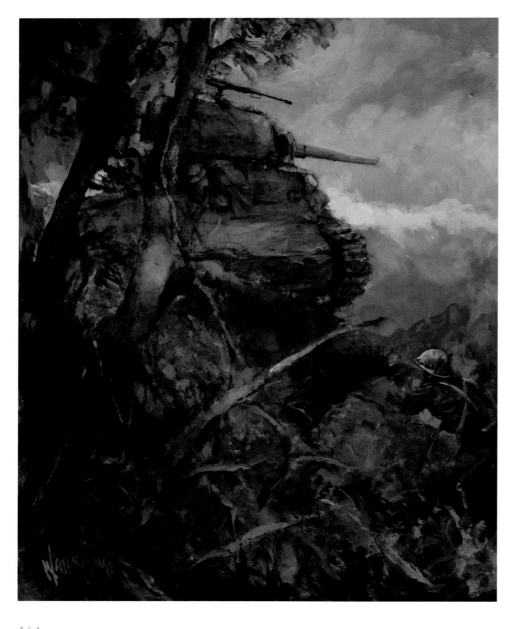

PFC LUTHER SKAGGS JR., USMC[35]
Guam, July 21–22, 1944

Luther Skaggs Jr. was born on March 3, 1923, in Henderson, Kentucky. Located on the Ohio River in the northwestern corner of the state, Henderson was once the world's leading producer of dark tobacco, but by the time Luther was born, the tobacco trade had dried up, and corn and coal were being raised from its red clay soil.

Luther's family went way back to the early Kentucky pioneers—displaced Irishmen turned frontiersmen who came through the Cumberland Gap around the time of the American Revolution, leaving whispers of their name on the land—a hunters' trail called Skaggs Trace, a meandering trickle of water called Skaggs Creek—before heading west into Ohio or deep into Kentucky.

If hardship and catastrophe can prepare a man for the horrors of war, then Luther Skaggs Jr. was ahead of the curve. By the time he was fourteen, he'd experienced the Great Depression, the Dust Bowl, and record-breaking ice storms and floods. He'd faced personal challenges as well. His parents' divorce may have been one of the reasons why there is no record of Skaggs attending or completing high school. Still, folks with long memories in that area recalled him as "a mighty nice, quiet kid" with soft blue eyes that sparked like flint when there was a fight brewing. He might be small in stature, but Luther Skaggs was tough as an old boot.

Luther joined the Marines after the attack on Pearl Harbor. Upon completing his recruit training, he was promoted to private first class and shipped for overseas duty as a mortarman with Company K, 3rd Battalion, 3rd Marines, 3rd Marine Division, landing with them on July 21, 1944, in the assault on Guam.

Skaggs's section leader and seven of his buddies were cut down by Japanese mortar fire right on the beach. PFC Skaggs took command of the 81 mm mortar section, leading his team across 200 yards of open beach to an elevated position that would allow them to provide covering mortar fire for the landing forces.

Throughout that day and into night, Skaggs pounded the enemy relentlessly with fire. The Japanese retaliated, charging Skaggs's position, getting close enough to throw a grenade into his foxhole. The explosion shattered his lower left leg. He calmly improvised a tourniquet, refusing to call a corpsman because he didn't want to pull focus or manpower away from the task at hand. For the next eight hours, Skaggs remained propped upright in his foxhole, directing fire and warding off the enemy with his rifle and hand grenades. Under the leadership of the tough little private first class, his section was able to repel the constant enemy incursions and keep their mortar tube hot.

The following morning, Skaggs crawled from the cliff, on his own volition, and made his way to the rear, where he continued to fight until the beachhead was secure. Doctors were eventually forced to amputate the twenty-one-year-old hero's leg. Eleven months later, Skaggs stood at rigid attention on his crutches as President Truman placed the Medal of Honor around his neck. For the next thirty years, Skaggs continued to lead, serving as the president of the Washington, DC, chapter of 3rd Marine Division Association, two-term president of the Medal of Honor Society, national commandant of the Purple Heart Association, and special assistant to the chairman of the President's Committee on Employment of the Handicapped. He died in 1976 at the age of fifty-three.

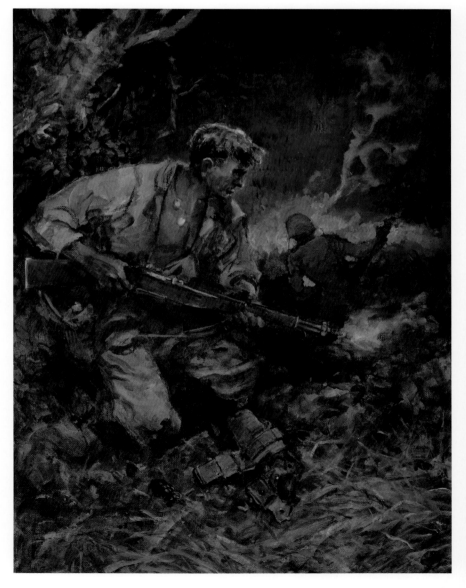

PFC Leonard Mason, USMC[36]
Guam, July 22, 1944

Middlesboro, Kentucky, has several claims to fame: it's the only city in the US built entirely inside a meteorite crater, home to the oldest continually played golf course in the country, and the birthplace of ragtime music. It's also the birthplace of Leonard Foster Mason—native son and its only Medal of Honor recipient—who was born in Middlesboro on February 22, 1920. By the time he reached boyhood, Leonard's hometown had become known for its gambling establishments, brothels, and saloons, earning it the nickname "Little Las Vegas." Under the rule and thumb of the infamous Ball brothers, shoot-outs on the main streets of Middlesboro were a daily occurrence, and it was considered one of the deadliest, wildest places around, which may be why, when Leonard was a teenager, the Mason family moved to Lima, Ohio.

In Lima, Leonard graduated from high school and worked for an automotive body shop. He married, had a son, and showed all signs of settling down in the town—which just happened to be the birthplace of a young man about his same age named William Metzger Jr., who would go on to receive a Medal of Honor for his actions while serving with the Army in Germany. A local historian has posited that Mason and Metzger may have been inspired to join the service after seeing *Sergeant York*, a movie about a World War I Medal of Honor hero, starring Gary Cooper, that was playing in Lima in 1941.

Whatever his motives, Leonard Mason enlisted in the Marine Corps in April 1943.

By the next year he was promoted to private first class and assigned as an automatic rifleman with 2nd Battalion, 3rd Marines, 3rd Marine Division, headed to Guam in the Marianas Islands.

On July 22, 1944, while clearing hostile positions holding up the advance of his platoon through a narrow gully, Mason's platoon came under fire from two Japanese machine guns, not more than fifteen yards from their position. Alone, and acting on his own initiative, PFC Mason climbed out of the gully and made his way around to the rear of the enemy emplacement. A target for hostile riflemen firing from above, Mason was soon wounded in the arm and shoulder but continued to press on. Even after he'd been grievously—and, as it turned out, mortally—wounded in a sudden burst from an enemy machine gun, the heroic private first class continued his mission, destroying the enemy position, killing five Japanese soldiers, and wounding another before rejoining his platoon and consenting to be evacuated.

In 2013, the city of Middlesboro—by then a completely revitalized town—named a portion of its main street Leonard F. Mason Medal of Honor Memorial Highway.

In 2017, friends, family, and veterans gathered in Lima to unveil a permanent marker in Mason's memory. At the ceremony, his son expressed his appreciation to the town. "He was buried at sea, and we never had a place we could go to," Larry Mason said.

VALOR IN ACTION

Capt. Louis H. Wilson Jr., USMC[37]
Guam, July 25–26, 1944

In the history of the Corps, only four men who rose to commandant, USMC, have been Medal of Honor recipients. Louis H. Wilson Jr. is last of that elite group. Born on February 11, 1920, in Brandon, Mississippi, Wilson was already demonstrating his skills as a leader on the football and track fields as a student at Millsaps College in Jackson, Mississippi. Graduating in the Class of 1941, he joined the Marine Corps Reserve, receiving a commission as a second lieutenant. After completing officers' basic training, 2Lt. Wilson was assigned to the 9th Marine Regiment, serving with them throughout the winter and spring of 1943 as they island-hopped through the Pacific, making stops at Guadalcanal, Efate, and Bougainville, edging closer and closer to Japan and to the island of Guam.

The largest of the Marianas Islands, the 32-mile-long island of Guam had been in US possession since it was ceded from Spain after the Spanish-American War in 1898, until the Japanese seized it in December 1941. It was time for the US to take it back. As commanding officer of Company F, 2nd Battalion, 9th Marines, 3rd Marine Division, now Capt. Louis Wilson would be instrumental in making that possible.

On July 25–26, 1944, Wilson's rifle company was on Guam, tasked with taking a portion of Fonte Hill. In the midafternoon of July 25, Capt. Wilson gave the order to attack, leading his men across 300 yards of rugged, open terrain, through heavy Japanese machine gun and artillery fire, pushing forward until they'd captured the objective. Seeing that the other assault teams hadn't fared so well, Wilson assumed command, organizing their units, directing fire, and rallying his troops to hold their position over a five-hour period of continuous enemy onslaughts. Wounded on three separate occasions, the stalwart captain refused medical attention until he'd set up night defenses. While receiving medical attention in the rear, the Japanese launched a series of vicious counterattacks and Wilson returned to his men, repeatedly exposing himself to enemy fire, racing from unit to unit, dashing 50 yards in front of the lines to rescue a wounded Marine, and repelling wave after wave of enemy assaults that often degenerated into hand-to-hand combat.

By the morning of July 26, the Japanese efforts were defeated. Wilson had held his ground, and in doing so, his Marines had annihilated over 350 enemy soldiers.

For Wilson, it was the beginning of a long, illustrious career that would include service in Korea, just after the war's end, and the Vietnam War. In 1975, Gen. Louis Wilson Jr. became the twenty-sixth commandant of the United States Marine Corps, reorganizing and refitting the post-Vietnam Corps into a modernized fighting unit the way he reorganized and refitted the Marines under pressure and heavy fire on the island of Guam.

The Marines of the 2nd Marine Division and 4th Marine Division were exhausted after a month of brutal fighting on Saipan, but before that battle was over, aerial bombing had already begun over the area of the Pacific where they were headed next: a 50-square-mile island ringed by a protective barrier of escarpments called Tinian.

Because of its size, location, and adaptability to airfields, it was essential that Tinian be taken. This time, however, the Marines wouldn't be landing on the beach—the island had just one—which was mined and heavily defended by the Japanese. While the depleted 2nd Marine Division staged a diversionary beach landing, the 4th Marine Division landed at several strategic points on the northwest shore, slipping through breaks in the cliffs that had been discerned by underwater reconnaissance.

The invasion of Tinian on July 24, 1944—the result of outstanding intelligence and hard-knock experience garnered at bloody places all through the Pacific—was considered a brilliant success, and although Japanese colonel Keishi Ogata would launch a fierce and aggressive counterattack that first night, by dawn's early light on July 25, the field was strewn with the bodies of 2,000 of Ogata's elite fighting force.

That's not to say that the remaining days of the campaign would be easy.

Two Marines would be recognized with posthumous Medals of Honor for their actions on Tinian. One was a private, one a private first class. Both hailed from the state of Illinois. Both threw themselves on grenades to save the lives of fellow Marines. Both were twenty-three years old when they were killed. Here are their stories . . .

PVT. JOSEPH OZBOURN, USMCR[38]
Tinian Island, July 30, 1944

Joseph William Ozbourn was born on October 24, 1919, in Herrin, Illinois. He attended grammar school in the town of Buckner. It's not known how far he went in his education. By the time the Great Depression hit, Joseph was ten years old. He lived in an area rich in coal deposits; somebody had to mine it, and while it was a dangerous, bone-achingly difficult way to earn a living, men and boys had to do what they could do to put food on the table. Ozbourn became a trip rider in the mines for the Old Ben Coal Corporation in Western, Illinois. Working as a coal miner—one of the war-essential occupations—meant that Joseph Ozbourn was not subject to the draft; still, on October 30, 1943, he volunteered to enlist in the Marine Corps.

Less than a year later, Pvt. Ozbourn was serving as a Browning Automatic Rifleman (BAR man) with the 1st Battalion, 23rd Marines, 4th Marine Division, on Tinian.

On July 30, 1944, Ozbourn's platoon had been assigned "mop-up duty," clearing the last of the Japanese holdouts from the pillboxes and dugouts along a treeline. Ozbourn was moving forward to lob an armed grenade into one of these, when a sudden blast in the entryway knocked him backward, severely wounding him and the four other Marines around him. Unable to toss the grenade into the hostile position, and with no place to throw it without endangering his companions, Ozbourn fell on the missile, shielding his comrades from the blast.

On December 22, 1945, Pvt. Ozbourn's widow christened the USS *Ozbourn* (DD-846), a Gearing-class USN destroyer.

Originally buried at Tinian, Pvt. Ozbourn's remains were later reinterred at the National Memorial Cemetery of the Pacific in Honolulu, Hawaii.

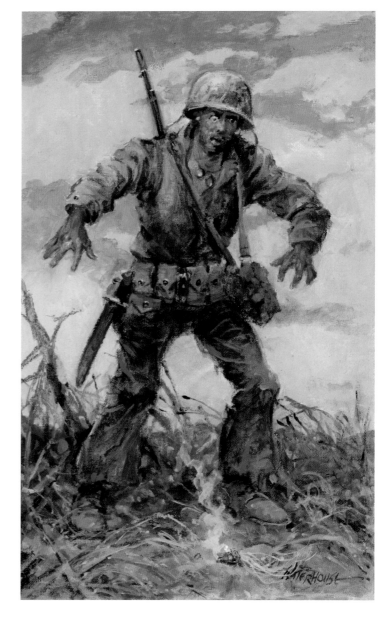

PFC Robert L. Wilson, USMC[39]
Tinian Island, August 3, 1944

Robert Lee Wilson was born on May 21, 1920, in Centralia, Illinois. One in a farming family of eight children, Robert was the son his father considered his right-hand man. "He was one of the best workers I ever saw," Mr. Wilson later said, adding, "None of my boys believed in waiting for the draft. They volunteered."

After volunteering for the Marine Corps on September 9, 1941, Wilson applied himself to his training and service with the same work ethic and initiative he'd shown back on the farm.

During the two years he spent in the Marines, Wilson fought in nearly every major engagement in the Pacific.

For his actions in August 1942, while serving as a member of the 1st Marine Division (Reinforced) in the Solomons, Wilson received a Presidential Unit Citation signed by the secretary of the Navy, Frank Cox.

PFC Wilson would be recognized with a second Presidential Unit Citation, signed by Secretary of the Navy James Forrestal, for "outstanding performance of duty in combat during the seizure and occupation" of Tarawa on November 20–24, 1943. Wilson also received a Purple Heart with one gold star, awarded to Marines who have been previously wounded and already have a Purple Heart.

By the time PFC Wilson landed on Tinian with Company D, 2nd Pioneer Battalion, 18th Marines, 2nd Marine Division, the Illinois farm boy was a battle-tested Marine.

On August 4, 1944—three days after the island was declared secured—Wilson's platoon was advancing through underbrush in an isolated part of the island when they were ambushed by a group of Japanese holdouts. Ready for the fight, PFC Wilson daringly advanced toward the enemy, while the squad's automatic riflemen closed ranks around him. Suddenly, a Japanese grenade landed in their midst. Wilson shouted out a warning and dove on the missile, saving the lives of his fellow Marines.

Wilson's posthumous Medal of Honor was presented to his mother at a ceremony held on July 26, 1945, at the American Legion cottage in his hometown of Centralia.

In 1948, PFC Wilson's remains, initially buried in the military cemetery on Tinian, were reinterred in Centralia's Hillcrest Cemetery, not far from his family's farm.

PFC FRANK P. WITEK, USMCR[40]
Guam, August 3, 1944

In his play *Twelfth Night*, William Shakespeare wrote: "Some men are born great, some achieve greatness, and some have greatness thrust upon 'em." This is the story of an ordinary person who achieved greatness by seizing his time and chance.

Frank Witek was born on December 10, 1921, in Derby, Connecticut, into a working-class family of Polish ancestry. His parents moved their brood of six children to Chicago, Illinois, when Frank was nine. By all accounts, Frank was a polite, average student who, after finishing Crane Technical High School, settled down in a typical, nine-to-five job, where he was working when the Japanese attacked Pearl Harbor. A month later, Witek enlisted in the Marine Corps Reserves. Along with his enlistment papers, he provided several character references, describing him as a boy of high moral character who never caused any trouble and was respectful to his elders. In a quote more likely to have caught the eye of the Marine recruiter, one person wrote that Frank Witek was "one who would succeed at anything he attempted."

Witek succeeded enough in his training to pass with a mark of "satisfactory." By January 1943, Pvt. Witek was with the 3rd Marine Division in New Zealand, preparing for the assault on Bougainville. This was the last time his family would hear from him. Over the next few months, Witek fought with the 3rd Marine Division in the mountains and jungles of Bougainville, with only a brief rest on Guadalcanal, before heading to the next campaign.

On July 21, 1944, now PFC Frank Witek landed as a BAR man with Company B, 1st Battalion, 9th Marines, 3rd Marine Division, in the invasion of Guam.

At Bougainville, Witek had already proven himself to be a good Marine. On August 3, during the Battle of Finegayan on Guam, his moment of greatness came and he would rise to it, courageously.

During a critical stage of the battle, PFC Witek boldly advanced with his Browning Automatic Rifle, forward of the tanks that were spearheading the attack, and headed into the Japanese lines, intent on silencing a hostile machine gun that was halting his platoon. Fully aware that the odds were stacked against him, Witek continued to move in on the enemy gun, alternately firing his rifle and lobbing grenades, until he was within yards of the hostile position. Although hit by machine gun fire from another section of the enemy's line, Witek succeeded in wiping out the Japanese machine gun nest, rendering it permanently out of commission. When Witek's body was later recovered, it was discovered that of the 240 rounds of ammunition he'd been carrying, only eight cartridges remained. The person who wrote that character reference had been right: Frank Witek was "one who would succeed at anything he attempted."

Maj. Harold Connecticutt C. Boehm, of the 1st Battalion, 9th Marines, who witnessed the events, later wrote, "It is essentially due to PFC Witek's action that his platoon was able to continue its attack and subsequently seize its objective. I would not hesitate to say that his single act contributed materially to the capture of the Finegayan road junction with so few casualties."

When the moment was thrust upon him, BAR man Frank Witek seized his rifle and achieved greatness in the eyes of a grateful nation.

Lewis Bausell was born on April 17, 1924, in Pulaski, Virginia. The Bausell family soon moved to Washington, DC. After graduating from McKinley High School, he was employed as bookbinder with a Washington printer. On December 15, 1941, a week after the attack on Pearl Harbor, he enlisted in the Marine Corps.

Upon completing his initial training, Bausell joined the 1st Battalion, 5th Marine Regiment, 1st Marine Division, in New River, North Carolina. He was promoted to private first class, before sailing to the Pacific in May 1942, to train for landing in the Solomon Islands.

Bausell spent the next two years with the 5th Marines, preparing for, and participating in, several critical campaigns. As part of the landing force on Guadalcanal, his unit continued to fight on that island for four months, managing to make it to Cape Gloucester just days after the original invasion, where they battled their way through swamps, kunai grass, and thick mangrove forests until the airfields had been captured and consolidated. After a brief stop on Pavuvu Island for some rest and relaxation, the Marines of the 1st Division headed to their next campaign on the tiny coral island of Peleliu. Predictions were that it would be a swift, two-day crush to victory. Predictions were wrong.

On September 15, 1944, now Cpl. Bausell's squad in Company C was assigned to clean out one of the many enemy caves that honeycombed the coral ridges of Peleliu Island. Having zeroed in on one, a Marine lieutenant and a team of flamethrowers stood at one end, while on the other end, Cpl. Bausell led the charge, firing his rifle into the mouth of the cave. When a Japanese soldier rushed forward to hurl a grenade at the Marines, Bausell threw himself on the deadly weapon, blunting the explosion with his body and saving the lives of his men.

Evacuated to a hospital ship, Bausell died three days later and was buried at sea.

Secretary of the Navy James Forrestal presented Cpl. Bausell's posthumous Medal of Honor to his parents on June 11, 1945.

During the ceremony, Lewis's mother, Mysa Bausell, made an impassioned plea, asking that her only surviving son, Charles—a naval boatswain's mate, first class, who had been serving in the Pacific for four years, with only one thirty-day furlough—be brought home. Forrestal assured the weeping woman that the Navy was "looking into" the possibility. Whether or not Forrestal arranged the young man's release from duty, Charles William Bausell did survive the war in the Pacific.

Lewis Bausell is the only Marine from the nation's capital to have received the Medal of Honor in World War II.

MAJ. GREGORY "PAPPY" BOYINGTON, USMCR[42]

Solomon Islands, September 12, 1944 – January 3, 1945

Gregory Boyington was born on December 4, 1912, in Coeur d'Alene, Idaho, the product of an unhappy marriage marred by alcohol abuse and domestic violence. When Greg was two, his parents divorced and he moved with his mother to Spokane, Washington. A few years later, mother and son were back in Idaho with a new father figure and a stepbrother in tow. Although there is no evidence of a marriage or adoption, the little boy was now called Gregory Hollenbeck—a name he would grow up believing was his until, many years later, he had to produce a birth certificate to enlist as an aviation cadet. His mother's latest relationship proved to be as turbulent as her earlier one, and young Greg swore to himself that he'd never have anything to do with liquor. It was a pledge he wouldn't be able to keep.

When he was six, a famous aerial pilot landed his biplane in the meadow next to his elementary school. On that day Greg would learn two things: first, he wanted to be a pilot, and second, with his innate charm and intelligence, he could talk his way into anything. He managed to finagle $5 from his stepfather, coax his mother's permission, and convince the pilot to take him barnstorming. The rest, as they say, was history.

By 1942—after working his way toward an aeronautical-engineering degree, nabbing a job at Boeing Aircraft, wangling his way into an aviation program eligible only to bachelors (despite have a wife and three kids), and ending a stint with the American Volunteer Group, the "Flying Tigers," under questionable circumstances—Greg was able to talk his way back into the Marine Corps, securing himself a major's commission and, for a short time, second in command with Marine Fighting Squadron 121 on Guadalcanal.

Boyington backed up his talk with action. A year later he was given the task of molding twenty-seven inexperienced—and often undisciplined—replacement pilots into a cohesive, combat-ready team. The fledgling fighters of the new unit, VMF-214, called themselves the Black Sheep Squadron and dubbed their thirty-one-year-old commander "Pappy." Between September 12, 1943, and January 3, 1944, Maj. Boyington led his squadron in a series of hazardous flights over heavy defended hostile territory, with devastating results to the Japanese. Nine of the pilots in the Black Sheep Squadron would become aces.

At the end of 1943, Pappy Boyington was just one plane short of attaining the Marine record of twenty-six "kills." Three days into the new year, he took that record, shooting down a total of twenty-eight enemy planes—including two with the AVG—before his Corsair was shot down. He survived the downing but was picked up by an enemy submarine. It was one situation from which Boyington couldn't talk himself out of. He spent the next twenty months in a POW camp, enduring beatings, torture, and starvation, wryly commenting later that due to the enforced sobriety, his health improved during his imprisonment.

After the atomic bombings and Japanese capitulation, Boyington was liberated and welcomed home as a hero. Over the next decades, he went through a string of marriages and battled alcoholism His autobiography, *Baa Baa Black Sheep*, became a hit TV series, but the portrayal of his pilots as a band of misfits and drunks cost him the friendship of many of his squadron mates. At age sixty-one, Boyington fell in love with a strong, grounded woman who agreed to marry him under the condition he remain sober. He did, and together they spent many happy years, playing golf and traveling, until lung cancer—a foe that even Pappy Boyington couldn't beat—claimed his life in 1988, at the age of seventy-five.

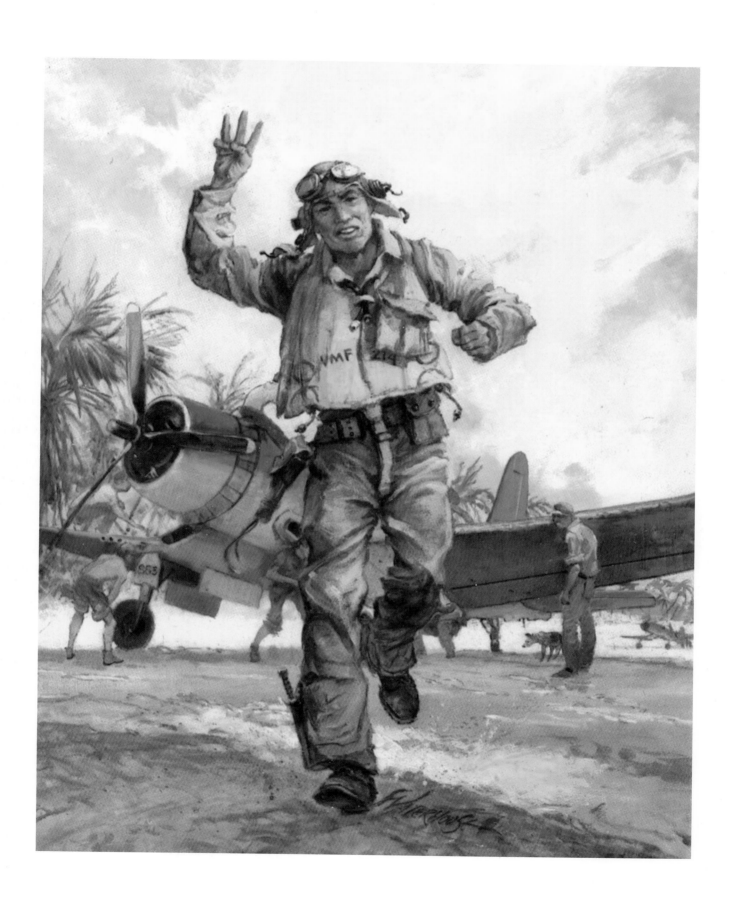

1LT. CARLTON R. ROUH, USMC[43]
Peleliu, September 15, 1944

Carlton Rouh was born on May 11, 1919, in Lindenwold, New Jersey. He enlisted in the Marines as a private in January 1942, a month after the attack on Pearl Harbor. While serving with the 1st Battalion, 5th Marines, 1st Marine Division, on Guadalcanal, Pvt. Rouh personally carried wounded Marines out from under fire until being wounded himself. His leadership and initiative earned him a Silver Star. While at rest in Australia, Rouh received a commission as a second lieutenant.

After successfully leading a machine gun platoon during the New Britain campaign, Rouh was promoted to first lieutenant.

On September 15, 1944, after landing with his unit on Peleliu Island, 1Lt. Rouh was moving his mortar platoon toward the top of a small coral ridge, so they could dig in for the long night. Spotting a Japanese cave that had earlier been blasted open by a Marine flamethrowing squad, the first lieutenant decided to inspect it to ensure it was empty.

Two dead Japanese soldiers were sprawled at the entrance. With his carbine at the ready, Rouh stepped into the darkness: no sound, no movement. He edged his way along the wall, making out the shape of supplies, but he could see no signs of life. Just then a shot rang out. The bullet hit Rouh on his left side. He staggered back through the cave to his platoon. Several Japanese soldiers followed him. One launched a grenade that was already sputtering. With no time to throw it back, Rouh pushed two of his comrades to the ground, dropped his carbine, and made a dive for the deadly missile. He was down on his elbows and one knee when it exploded. The impact had caught him in the abdomen and chest, but none of his men were hurt in the blast. Still conscious, Rouh was aware enough to know that the Marines had come out on top during the ensuing firefight.

His body pocked by shrapnel, with one steel fragment lodged next to his heart, Rouh was evacuated and, miraculously, lived, becoming one of four World War II Marines who threw themselves on an exploding grenade to save their comrades and lived to tell the tale.

Carlton Rouh retired from the USMC at the rank of captain. A lifelong resident of Lindenwold, New Jersey, Rouh served one term as mayor of the town in 1956. He passed away in 1977 at the age of fifty-eight.

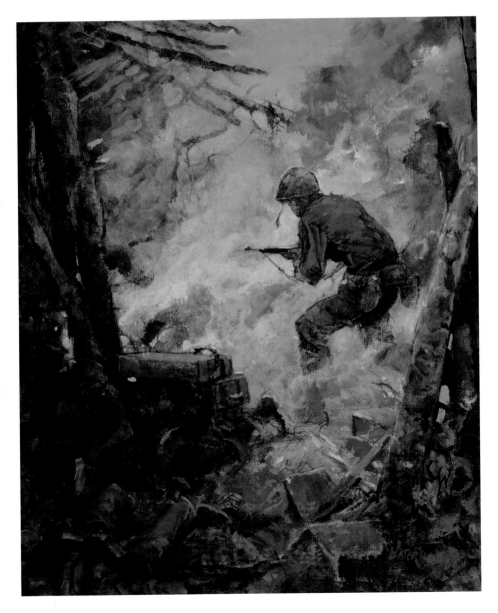

PFC Arthur J. Jackson, USMC[44]
Peleliu, September 18, 1944

Arthur "Art" Jackson was born on October 18, 1924, in Cleveland, Ohio. He grew up in Canton, home of the Canton McKinley Bulldogs—even as a boy Jackson was all about football. At the age of fifteen, Art moved with his parents to Portland, Oregon, where he played varsity football at Grant High School. After graduating, Jackson spent a few months working for a naval construction company in Alaska before heading back to Portland: the eighteen-year-old was considering joining the Marines. Looking the young man up and down, the recruiter asked if he liked football. Jackson said yes, he loved it; as a matter of fact, he'd played for his high school football team. "You'll like the Marines then," the recruiter told him. "You'll have a chance to do all sorts of physical activities."

Jackson enlisted in January 1943.

On September 18, 1944, while serving with 3rd Squad, 2nd Platoon, Company I, 3rd Battalion, 7th Marines, 1st Marine Division, on Peleliu, PFC Jackson showed exactly what "sorts of physical activities" he was capable of performing.

With his platoon pinned down by heavy fire, Jackson peeled off his pack and leggings, loaded himself up with grenades and ammo, and sprinted across 100 yards, through kunai grass and heavy enemy fire, toward the Japanese pillbox that was firing 7.7 mm heavy machine guns and other automatic weapons at the Marines. Firing his Browning Automatic Rifle into the bunker's opening, Jackson hurled a phosphorus grenade, smoking out some of its inhabitants, then finished the job off with a well-aimed charge of explosives, brought to him by a fellow Marine, that literally blew the lid off the emplacement. Jackson's "bomb pass" took the lives of thirty-five hostiles, but it was just the first quarter. He headed off to the next enemy position.

That day, PFC Jackson—the "one-man Marine Corps" of Peleliu—would take out a total of twelve Japanese pillboxes. When he finally returned to his platoon, his fellow Marines hoisted him up on their shoulders. "I felt like a ball player who scored the winning run," Jackson later said in his interview for the Medal of Honor Book video series. "They said I was the most gung-ho SOB that they ever knew," adding wistfully, "I had a lucky day."

Sadly, in 1961, the gung-ho Marine's luck would run out. With tensions building in Cuba in the aftermath of the Bay of Pigs, then Capt. Jackson, stationed at the base at Guantánamo, killed a Cuban worker in a restricted area who he believed to be a spy. Although it was a case of self-defense, Jackson panicked and, along with several of his fellow Marines, buried the man's body, which was later discovered, ending his long and distinguished service with the USMC.

Jackson later worked as a mail carrier, and with the Veterans Administration in California, before moving to Boise, Idaho, in 1973. Beloved by his community, the former "one-man Marine Corps" of Peleliu passed away in 2017 at the age of ninety-two.

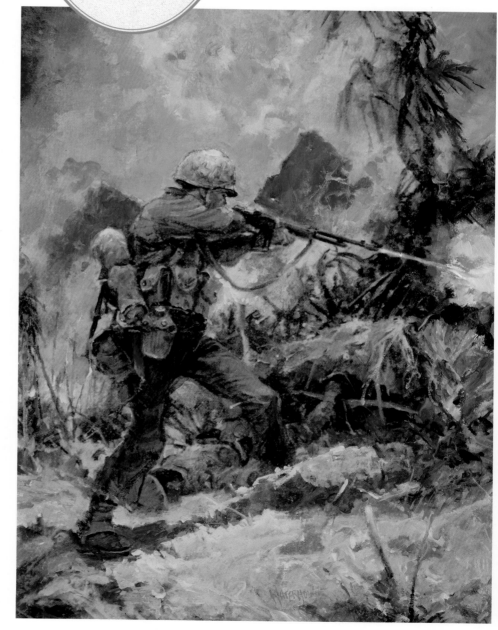

If you were driving across the Texas Panhandle in 1938 or 1939, and you stopped off at a service station in the small town of Claude, chances are that the kid with the dark curly hair and friendly smile who ran up to clean your windshield and fill your tank was Charlie Roan. Described by those who knew him as an ordinary "small-town American boy," Charlie attended the local high school and the local Methodist church, pumped gas after his classes, and played ball with his friends in his spare time.

Like many typical small-town American boys his age, this affable, helpful young man would soon be in a faraway place that he'd never heard of, fighting for his country. But when his moment came, PFC Charles Roan would prove to be anything but ordinary.

Charles Howard Roan was born on August 16, 1923. At the age of seventeen, Charlie enlisted in the Marine Corps Reserve. By the time of the Marine landing at Pelieu on September 15, 1944, PFC Roan already had fifteen months of overseas duty and quite a bit of combat under his belt, serving as a rifleman with Company F, 2nd Battalion, 7th Marines, 1st Marine Division, during the battles for New Guinea and Gloucester.

On September 18, 1944, during a rapid advance along an exposed ridge on Peleliu, Roan's squad leader ordered his Marines to withdraw, having discovered that a portion of their unit had been cut off from the company and was under enemy attack.

PFC Roan, along with four of his fellow Marines, ducked for cover into a depression in the rocky crags of the ridge, only to learn that their position was far from safe. Japanese soldiers in a cave above them started lobbing grenades, engaging the Marines in a frenetic back-and-forth volley. During the exchange, PFC Roan was wounded by a hostile grenade that had landed nearby; when a second grenade landed in the midst of his comrades, Roan flung himself over it, absorbing the impact of the explosion with his body and saving the lives of the other Marines. He was twenty-one years old.

On July 21, 1945, Roan's posthumous Medal of Honor was presented to his mother in a simple ceremony on the lawn of the Armstrong County Courthouse in Claude, Texas.

On National Medal of Honor Day, March 25, 2019, the Panhandle Plains Historical Museum brought PFC Charles Roan's Medal of Honor to the Ussery-Roan Texas State Veterans Home—a long-term nursing facility in Amarillo that serves Texas veterans and their spouses and Gold Star parents—for a special event to celebrate the life and sacrifice of local hero and small-town American boy Charles Roan.

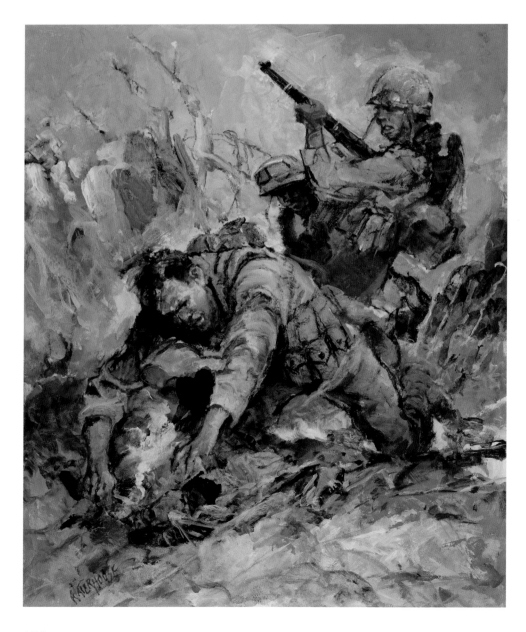

Capt. Everett Pope, USMC[46]
Peleliu, September 20, 1944

Everett Pope was born on July 16, 1919, in Milton, Massachusetts, growing up in nearby Quincy. An Ivy Leaguer to the bone, Pope set his sights on Bowdoin College, where he became captain of the state-champion tennis team and a member of the Phi Beta Kappa honor society, graduating magna cum laude with a bachelor of science degree in French. Four days after receiving his degree, Pope enlisted in the Marine Corps Reserves.

He was commissioned a second lieutenant on November 1, 1941. By June 1942, as the leader of a machine gun platoon with the 1st Battalion, 1st Marines, 1st Marine Division, the Phi Beta Kappa whiz kid was headed to Guadalcanal. During that bloody campaign, Pope would learn the hard facts of jungle warfare. By the end of his next campaign, now a captain commanding Company D, 1st Battalion, 1st Marines, on Cape Gloucester, Pope would be an expert in the jungle. While on mopping-up operations, he led a fourteen-man patrol through dense jungle trails on a 12-mile trek that resulted in twenty enemy dead and seven captured.

In mid-September 1944, Capt. Pope was serving as commanding officer of Company C, 1st Battalion, 1st Marines, 1st Marine Division, on Peleliu, five square miles of hell embedded with intricate enemy caves, where the heat cranked up to temperatures that soared above 115 degrees. Landing on the island on September 15 with 235 men, four days later Capt. Pope's unit had dwindled to ninety. Most of his riflemen were gone, and he was using support personnel to fill in the ranks.

On September 20, Pope was ordered to assault Hill 100, a barren coral slope protruding from the face of what had been aptly dubbed Suicide Ridge. In the face of incredible odds, the captain led his men to the top, only to find that instead of a summit, they had reached a plateau—an easy target for mortar and artillery fire from an invisible enemy dug into the taller peaks.

Pope's Marines fought bravely to hold their ground. By dark, they were nearly out of ammunition, with only one light machine gun and a limited supply of grenades and their rifle bayonets to defend themselves.

At dawn's early light, with a large force of Japanese preparing a fresh assault, Pope was ordered to withdraw. It would take the Marines another ten days to capture Hill 100, and about the same amount of time for the men in Pope's unit to bury their dead. "I was not a hero," Pope later said, "but I was among heroes."

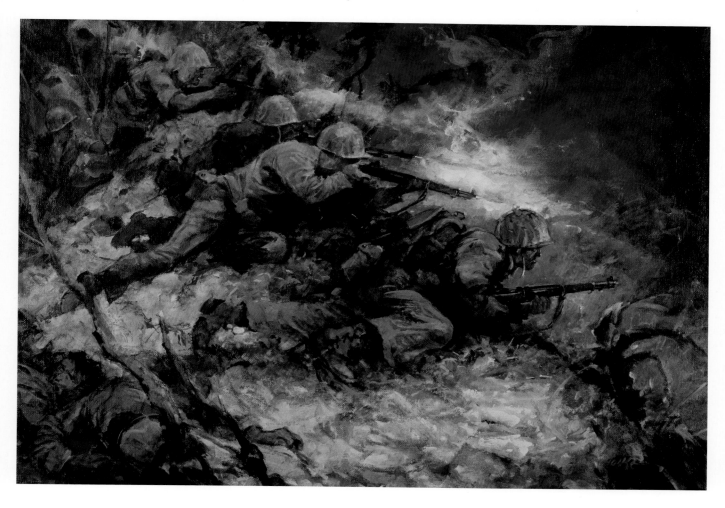

PFC JOHN DRURY NEW, USMC[47]
Peleliu, September 25, 1944

Sometimes, other than in the words of a citation, so little is known about the life of a Medal of Honor recipient that the person's story comes alive only by reading through the lines and adding up the numbers. Such is the case with PFC John Drury New.

PFC New is one of thirty-three recipients whose home state is Alabama. New was born in Mobile on August 12, 1924, growing up and attending school there.

PFC New is one of twenty-five Marines in World War II who threw his body on an exploding grenade in order to save the lives of his comrades. Only four of these brave men lived.

New's official Marine Corps bio contains 277 words, a little more than fourteen words for each of his nineteen years. Even his official photograph is enigmatic. While most Marines stare directly into the camera, Private New glances away, his face in three-quarter profile.

And yet, the bare statistics of his short life are telling.

Enlisting in the Marines on December 8, 1941, John D. New was the first Mobile man to enlist after Pearl Harbor.

As a rifleman with Company F, 2nd Battalion, 7th Marines, 1st Marine Division, Private New participated in three of the most critical campaigns in the Pacific theater. In 1942, he fought in the battle for Guadalcanal, sharing in the Presidential Unit Citation awarded the division for their heroic actions on that island. In 1943, he took part in the seizure and occupation of Cape Gloucester and the defense of the area around its airfield. He was promoted to private first class in April 1944. He landed with the 1st Marine Division on Peleliu on September 15, 1944, and was killed nine days later, on September 25, after diving on a Japanese grenade that had landed in his company's observation post and saving the lives of two of his comrades.

And that adds up to one brave young Marine.

New's posthumous Medal of Honor was presented to his father. After the war, the hero's remains were reinterred in the Mobile National Cemetery, in his hometown.

Col. Waterhouse's painting shows PFC New facing forward, in the moment before the grenade explodes.

PFC Richard E. Kraus, USMCR[48]

Peleliu, October 3, 1944

Richard Edward Kraus was born on November 24, 1925, in Chicago, Illinois. When Richard was seven years old, he moved with his parents and sister to Minneapolis, Minnesota. Although facts about Richard Kraus's life are few and far between, it's evident that he was always willing to take the initiative and volunteer. First forward seemed to be the watchwords of his short life. While still attending Edison High School, seventeen-year-old Kraus attempted to join the Marines but was told he had to wait for his eighteenth birthday. He enlisted on December 23, 1943.

After completing his training, Kraus was promoted to private first class and assigned as an amphibious tractor driver with the 8th Amphibious Tractor Battalion, III Amphibious Corps, Fleet Marine Force. In July 1944, Kraus's unit was shipped out for service in the South Pacific, where the eighteen-year-old Marine would spend the last three months of his life. Arriving on Pavuvu Island on August 20, the Marines of the 1st Division began preparing for the invasion of Peleliu.

No amount of preparation could ready them for the physical and psychological toll that this most inhospitable of southern Pacific islands would exact upon them. The coral rocks, lack of water, scorching temperatures, and punishing humidity would be enough to sap the starch out of any old salt. Richard Kraus—just barely out of boyhood—had never seen combat, but then no Marine had seen combat the like of what they were about to experience. The September 15 D-day landing on Peleliu, and the intense weeks of fighting that followed, was a shock to the system for all of them.

On October 3, word filtered down to the men in Kraus's unit that a wounded man needed to be evacuated from the front lines. PFC Kraus—always first and forward—was one of four who volunteered for the task. The effort it would have taken for the battle-exhausted, sweating, and dehydrated Marines to lug a stretcher over the rough terrain, in high heat and under heavy fire, cannot be overestimated. Upon returning to the rear with the casualty, they were approached by two men who, from a distance, might have been Marines. Using proper caution, one of the members of Kraus's group asked for the password. There was no response: these were Japanese soldiers, and they were now close enough to throw a hand grenade, which landed among the stretcher-bearers. First and forward, PFC Kraus dove for the grenade, using his body to shield his comrades from the blast. His mother was presented with his posthumous Medal of Honor on August 2, 1945. Initially buried on Peleliu, in 1948, Kraus's remains were reinterred in Fort Snelling National Cemetery, Minneapolis, Minnesota, at the request of his parents.

PFC Wesley Phelps, USMCR[49]
Peleliu, October 4, 1944

Wesley "Wes" Phelps born on June 12, 1923, in Neafus, Kentucky, a tiny speck of a town at the crossroads to someplace else. Wes's parents were young when they married—his mother would have been considered underage in most states—and they had six children in quick succession, raising them on a 70-acre farm. Wes was their last. The boy attended Ohio County schools, walking 3 miles each way. In his spare time, he helped out on the farm and tinkered around with one-tube radio sets.

Although only 5 foot 1, Wes Phelps was smart and ambitious, and he wanted more than a life on the farm could offer. After high school, he took courses in basic electricity and radio repair. Thirsty for more knowledge, he attended a specialized school to learn about field radio and aircraft radio receiver repair.

Before he could put this expertise to use in civilian life, Wes was called to active duty with the Marines, assigned to a signal battalion where he had an opportunity to leverage his technical expertise. By August 1943, Pvt. Phelps was an expert both in radios and the use of the Browning .30-caliber heavy machine gun.

As a member of Company M, 3rd Battalion, 7th Marines, 1st Division, Phelps survived four months of combat in "the Green Inferno" of Cape Gloucester, New Britain. For the young Marine, there would be no more time for tinkering with radio sets. After undergoing additional amphibious training, Phelps was promoted to private first class and reassigned to Company K.

The 1st Division was headed to an island called Peleliu, where the rocky coral terrain offered no quarter from Japanese assailants who attacked in the darkness, and scorching daytime temperatures could soar to 115. By day's end of October 4, 1944, PFC Phelps had been slugging it out with the entrenched enemy on the coral ridges around "Bloody Nose Ridge"—the Marines' nickname for Umurbrogol Mountain—for two weeks. The combat-seasoned Marine had dug in on the ridge crest with his foxhole companion, in a forward defensive machine gun position, prepared for another sleepless night and the attack that was sure to come. When it did, it was ferocious. The two Marines fought off the initial onslaught, but a Japanese grenade managed to sail past them, landing in their hole. Shouting out a warning, Phelps rolled on top of the missile, using his body to shield his buddy from the explosion and sacrificing his life for his fellow Marine. Wes Phelps was twenty-one years old.

COL. JUSTICE CHAMBERS, USMC[50]
Iwo Jima, February 19–22, 1945

Justice Chambers was born on February 2, 1908, in Huntington, West Virginia. As a youngster, Joe was active in the Boy Scouts, and a good-enough football player to make the team at Marshall College. From Marshall, he went on to George Washington University before earning his law degree at National University in Washington, DC, while simultaneously holding down a job in the US Department of Agriculture.

Chambers had enlisted in the Navy Reserves in 1928, but one seasick week on a naval destroyer was enough to convince him he'd signed up for the wrong service. Told that his next-best option was the Marines, he reportedly replied, "What are Marines?" He soon found out and was to destined become a textbook example of the best of the breed.

By the time Chambers was called to active duty in 1940, he was a major, revered among the men he trained. They called him "Jumping Joe," for his bounding smile and boundless energy. Two years later, Jumping Joe was in the South Pacific, where he received the Silver Star on Tulagi for evacuating the wounded—with both of his arms in splits—while directing the night defense of an aid station. He went on to participate in the invasions of Roi-Namur, Saipan, and Tinian, where he earned a second Purple Heart. Inspired by their leader, his Marines dubbed themselves "Chambers Raiders."

By then, Chambers was a lieutenant colonel, 6 foot 2, battle-seasoned, and as "tough as a fifty-cent steak." He was definitely the right man to command the 3rd Assault Battalion, 25th Landing Team, 25th Marines, 4th Marine Division, in the assault on Iwo Jima on February 19–22, 1945.

Everything was against him. His sector, beneath high ground, was being raked mercilessly by enemy fire. The battalion had lost more than half its officers and half its enlisted men. Chambers set up his command post in a crater. Most colonels would have stayed there, but not Jumping Joe. He led his remaining men up the terraced quarries. While directing the Marines' first rocket barrage, Jumping Joe stood to warn one of his men to keep down and was hit by enemy machine gun fire on February 22. He thought he was a goner. Then one of his Chambers Raiders kicked his foot. "Get up, you lazy bastard," the Marine said. "You were hurt worse on Tulagi."

But, in fact, Chambers' wounds were so serious that he was evacuated and medically retired at the rank of colonel. He later became a staff advisor for the Senate Armed Services Committee. In 1962, President John F. Kennedy appointed Chambers to the post of deputy director of the Office of Emergency Planning, where he served with distinction for many years. He died in 1982 at the age of seventy-four.

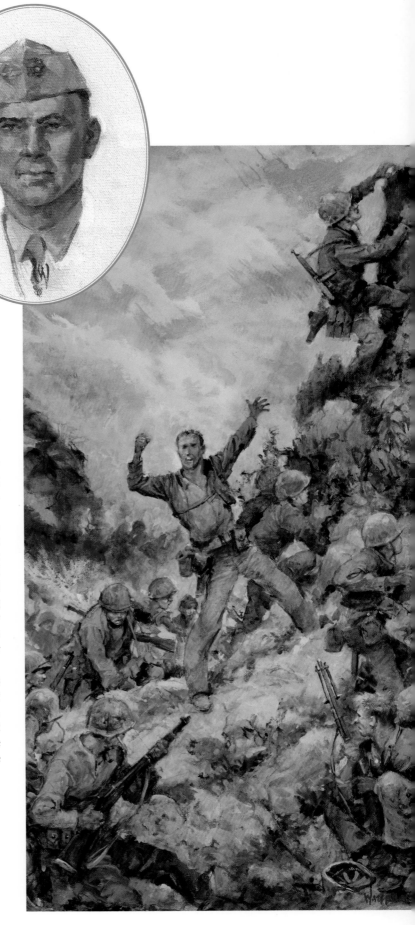

SGT. DARRELL S. COLE, USMC[51]

Iwo Jima, February 19, 1945

Darrell Cole was born in Flat River, Missouri, on July 20, 1920. When his father was injured in a mining accident, Darrell worked nights as a janitor in order to stay in high school, yet he still played in the band, sang in the chorus, ran track, and served as yearbook editor and in student government.

Cole enlisted in the Marines in August 1941, raring to fight for his country, but to his dismay, he was assigned as field musician.

After filling in for a downed gunner on Guadalcanal and earning a Bronze Star on Saipan for taking over his squad for their fallen leader, Cole was sure he'd be able to trade his bugle for a rifle, but his pleas for a combat role fell on tone-deaf ears.

In 1945, Cole's requests were finally granted, and on February 19 the newly promoted sergeant landed in the third-wave assault with Company B, 1st Battalion, 23rd Marines, 4th Marine Division, on Iwo Jima. Cole led his machine gun section up the first of several fortressed terraces embedded with Japanese pillboxes and infantry trenches.

After setting up a machine gun, he grabbed some hand grenades and threw them into the pillboxes, knocking out the enemy positions. Down to one machine gun, Cole turned it on a pillbox that was halting the advance. Their return fire wounded Cole's gun crew and knocked out the weapon.

Armed only with a grenade and a .38-caliber revolver, Cole ran through fire and threw the grenade into the pillbox but was unable to silence its guns. On his third try, Cole's aim was true. As he stood at the entrance of the pillbox, a wounded Japanese soldier dropped a grenade at his feet, killing him instantly.

On October 20, 2000, the USS *Cole* was damaged in a terrorist attack in Yemen that killed seventeen of its sailors. The ship was repaired and returned to duty, living up to its motto and namesake: "the Determined Warrior."

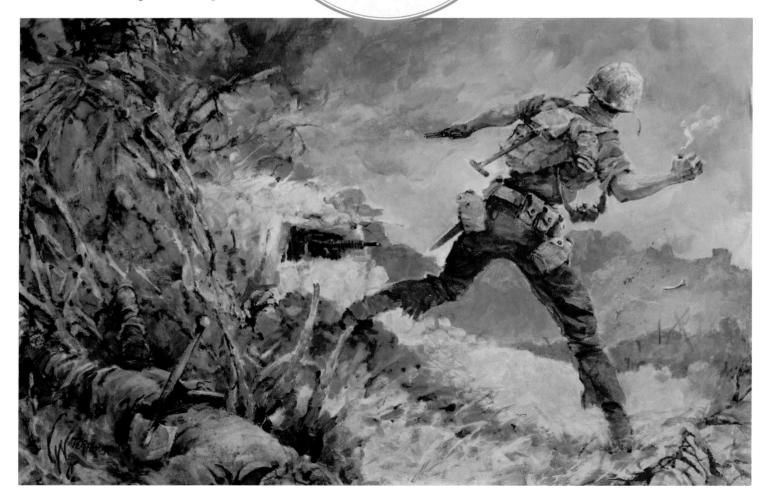

CPL. TONY STEIN, USMC[52]
Iwo Jima, February 19, 1945

Anthony Stein was born on September 30, 1921, in Dayton, Ohio. The son of immigrants, Tony was a handsome kid, with dark, curly hair and gray eyes and a streak of fearlessness that made him a natural leader in his tough hometown. After dropping out of school in the ninth grade, Tony took a series of odd jobs before finding work as a tool-and-die maker.

In 1940, Stein jumped into the Mad River to save the life of a drowning boy; two years later he was boxing in Dayton's Golden Glove championship, at a fighting weight of 128.

Because his occupation was on the war-effort-essential list, Stein was prevented from enlisting until 1942. Chomping at the bit, he volunteered for the Paramarines, seeing combat at the end of the Guadalcanal campaign and serving in Vella Lavella and Bougainville, where he shot five snipers in a day.

Stein returned home, no longer a 128-pound lightweight but a well-muscled Marine. He married a hometown girl but was restless for the next campaign.

On February 19, 1945, as part of Company A, 1st Battalion, 28th Marines, 5th Marine Division, Cpl. Stein came ashore in the fourth wave of the assault on Iwo Jima. He was packing a surprise for the enemy: a fast-firing .30-caliber machine gun, dubbed "the Stinger," that had been salvaged from a wrecked aircraft and modified for use by one man.

Stein pushed fearlessly ahead, storming a series of hostile pillboxes and destroying them with his Stinger. He made eight trips back to the beach to retrieve more ammo, bringing a wounded Marine with him each time. In a matter of hours, Stein knocked out nine other enemy strongholds and is credited with killing at least twenty Japanese. Despite being hit in the shoulder by mortar fragments, Stein insisted on staying with his platoon, covering their withdrawal with his Stinger that night before seeking aid.

Placed on a hospital ship, Stein was soon restless again. On March 1, he rejoined his buddies as they were about to tackle one of the most infamous positions on Iwo Jima: Hill 362A. Cpl. Tony Stein became one of the many casualties during that assault.

Stein's twenty-four-year-old widow accepted his posthumous Medal of Honor.

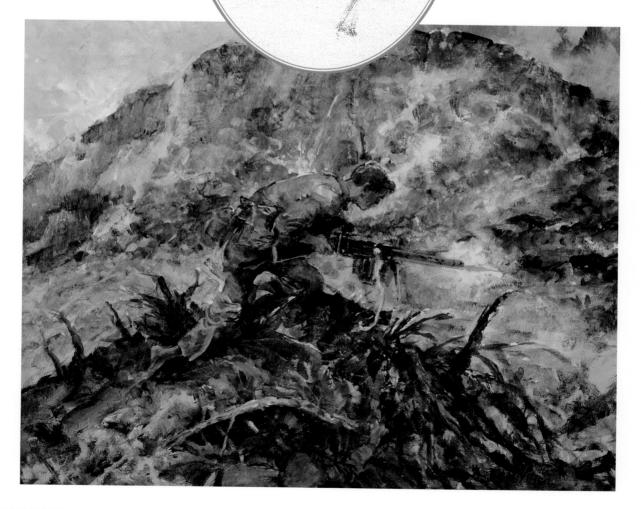

PFC JACKLYN "JACK" LUCAS, USMC[53]

Iwo Jima, February 20, 1945

Medal of Honor Citation

For conspicuous gallantry and intrepidity at the risk of his life above and beyond the call of duty while serving with the First Battalion, Twenty-Sixth Marines, Fifth Marine Division, during action against enemy Japanese forces on Iwo Jima, Volcano Islands, 20 February 1945. While creeping through a treacherous, twisting ravine which ran in close proximity to a fluid and uncertain front line on D-plus+1 Day, Private First Class Lucas and three other men were suddenly ambushed by a hostile patrol which savagely attacked with rifle fire and grenades. Quick to act when the lives of the small group were endangered by two grenades which landed directly in front of them, Private First Class Lucas unhesitatingly hurled himself over his comrades upon one grenade and pulled the other one under him, absorbing the whole blasting force of the explosions in his own body in order to shield his companions from the concussion and murderous flying fragments. By his inspiring action and valiant spirit of self-sacrifice, he not only protected his comrades from certain injury or possible death but also enabled them to rout the Japanese patrol and continue the advance. His exceptionally courageous initiative and loyalty reflect the highest credit upon Private First Class Lucas and the United States Naval Service.

To read more about Jack Lucas, see chapter 3, "The Captain and the Stowaway."

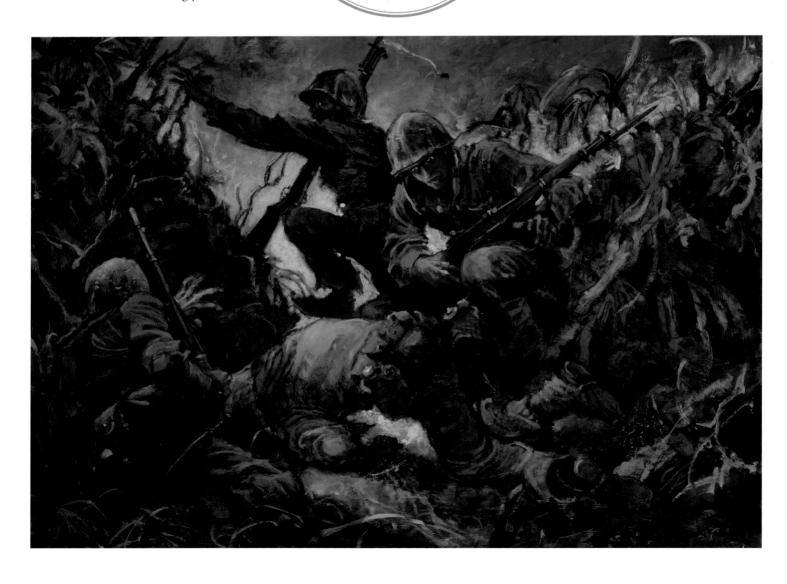

Capt. Robert H. Dunlap, USMC[54]

Iwo Jima, February 20–21, 1945

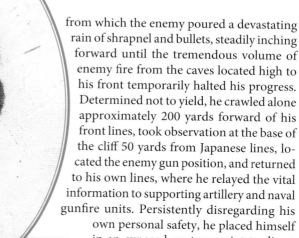

Medal of Honor Citation

For conspicuous gallantry and intrepidity at the risk of his life above and beyond the call of duty as Commanding Officer of Company C, First Battalion, Twenty-Sixth Marines, Fifth Marine Division, in action against enemy Japanese forces during the seizure of Iwo Jima in the Volcano Islands, on 20 and 21 February 1945. Defying uninterrupted blasts of Japanese artillery, mortar, rifle, and machine gun fire, Captain Dunlap led his troops in a determined advance from low ground uphill toward the steep cliffs, from which the enemy poured a devastating rain of shrapnel and bullets, steadily inching forward until the tremendous volume of enemy fire from the caves located high to his front temporarily halted his progress. Determined not to yield, he crawled alone approximately 200 yards forward of his front lines, took observation at the base of the cliff 50 yards from Japanese lines, located the enemy gun position, and returned to his own lines, where he relayed the vital information to supporting artillery and naval gunfire units. Persistently disregarding his own personal safety, he placed himself in an exposed vantage point to direct more accurately the supporting fire and, working without respite for two days and two nights under constant enemy fire, skillfully directed a smashing bombardment against the almost impregnable Japanese positions despite numerous obstacles and heavy Marine casualties. A brilliant leader, Captain Dunlap inspired his men to heroic efforts during this critical phase of the battle and by his cool decision, indomitable fighting spirit, and daring tactics in the face of fanatic opposition greatly accelerated the final decisive defeat of Japanese countermeasures in his sector and materially furthered the continued advance of his company. His great personal valor and gallant spirit of self-sacrifice throughout the bitter hostilities reflect the highest credit upon Captain Dunlap and the United States Naval Service.

To read more about Robert Dunlap, see chapter 3, "The Captain and the Stowaway."

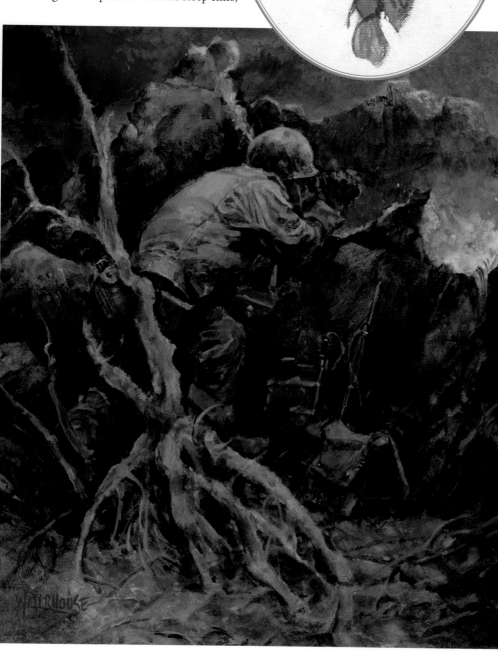

Ross Franklin Gray was born on August 1, 1920, in Marvel Valley, Alabama. One of eight children in a family of "hardworking, good people" R. F., as he was called, was a quiet, soft-spoken boy who enjoyed hunting and fishing. In his junior year, he left high school to work for his father as a carpenter. Deeply religious, R. F. served as a lay preacher and deacon in the Methodist Church and didn't smoke, drink, or cuss.

That didn't change when, in July 1942, he enlisted in the Marine Corps Reserve, where his nickname became "the Preacher." Although devout, R. F. never pushed his beliefs on others and was well liked by the men in his unit.

In 1944, PFC Gray left for overseas duty, taking part in the Roi-Namur campaign and the landings at Saipan and Tinian. When his best buddy was killed on Saipan, something shifted inside him. Up until then, Gray had been serving as a company carpenter. After the loss of his friend, the Preacher decided it was time to put down his hammer and move into the line of fire. After Tinian, Gray trained to become an expert in the laying, reconnaissance, and removal of minefields—knowledge that would come in handy where he was headed.

On February 19, 1945, Sgt. Gray landed in the first wave at Blue Beach 1 with Company A, 1st Battalion, 25th Marines, 4th Marine Division. After two days of brutal fighting, the battalion was attempting to advance toward Airfield No. 1, but Japanese general Tadamichi Kuribayashi's main defense line—a network of entrenched emplacements connected by communication trenches and fronted by land mines—had stopped them in their tracks.

Due to casualties, Gray found himself a platoon sergeant of Company A. With his men taking a beating, he pulled the platoon back. He'd spotted the low brow of an enemy pillbox 30 yards away. He knew he had to neutralize it, but first he had to deal with the minefield surrounding it. Creeping forward under fire, Gray drew upon his expertise to probe for mines and clear a path to within throwing distance of the emplacement.

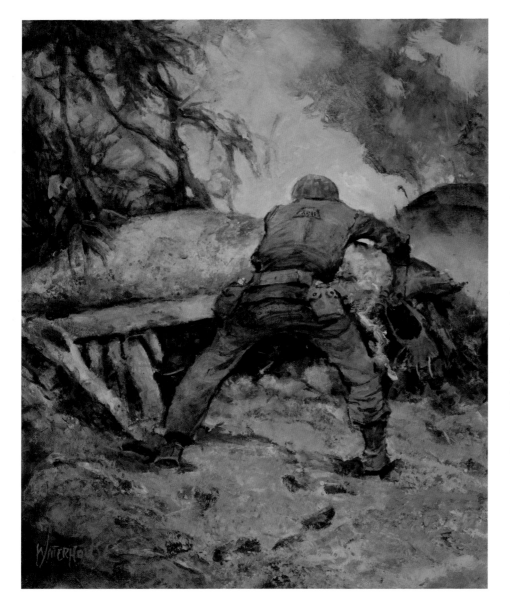

He then picked his way back through the minefield and announced to his platoon that he was going to take out the pillbox. After commandeering twelve satchel charges and some volunteers to provide cover, the Preacher picked up a 20-pound satchel charge and said, "Pray for me." Alone, and without a rifle, he headed into the kill zone, advancing through the cleared path in the minefield, until he was close enough to arm the satchel charge and throw it at the enemy position. The explosion collapsed its entrance but didn't silence its guns. Gray returned for another satchel charge and tried again. This time it worked. In all, the Preacher traveled back and forth through the minefield six times, blowing up enemy positions and returning for more charges until he'd broken the Japanese defensive line.

On February 27, Gray was hit by a Japanese shell and mortally wounded. As litter-bearers were carrying him out, he signaled for them to stop. Unable to speak due to his injuries, he withdrew a small book from his pocket, pointed to the names of all the men in his platoon, and indicated where they were located; then, with the last of his strength, the Preacher raised himself up on the stretcher and lifted his hand—a final benediction to his fellow Marines.

Among his personal effects was a Bible.

Gray had underlined a passage from 2 Timothy:

> I have fought the good fight.
> I have finished my course.
> I have kept my faith.

PFC DONALD J. RUHL, USMC[56]
Iwo Jima, February 21, 1945

Donald Jack "D. J." Ruhl was born on July 2, 1923, in Columbus, Montana. Throughout high school, the blue-eyed, brown-haired youth worked as a farmhand, earning fifteen dollars a week plus room and board. Realizing that his dreams of playing Major League baseball weren't likely to pan out, Ruhl took a job as a lab assistant in an oil refinery, contenting himself with playing for the company team. For a time.

In 1942, D. J. Ruhl enlisted in the Marines, qualifying as a sharp shooter and a combat swimmer and competitively boxing in recruit matches. Thirsty for action, the young Montanan volunteered for parachute training, where he earned his wings and was promoted to private first class. After an additional six months of training in New Caledonia, he saw his first combat at Bougainville. When the parachute battalions were disbanded, PFC Ruhl was assigned as a rifleman to 3rd Platoon, Company E, 2nd Battalion, 28th Marines, 5th Marine Division.

His new platoon was a mixed bag of salts and newbies, and yet, to a man, they agreed that the farmer from Montana was an obnoxious showboater—a rebel who ignored orders if he thought he knew better, and who liked to flaunt his independence by wearing a baseball cap instead of a helmet. In hindsight, they came to understand that Ruhl was an insecure young farm boy, desperate to do something that would make the folks at home proud, and gain him acceptance in the eyes of his fellow Marines.

And from the moment he landed on Iwo Jima on February 19, 1945, PFC Ruhl set out to do just that, by wedging himself into the front lines at every opportunity. He requested to act as a runner. He participated in an assault on a blockhouse and bayoneted a Japanese soldier trying to escape. He ran through mortar fire to rescue a wounded Marine and rashly disobeyed orders by carrying him back to the aid station. He volunteered to spend the night in an abandoned Japanese aircraft gun emplacement to prevent hostiles from taking hold of the valuable weapon. Had the enemy returned, it would have meant certain death, but at least, he told his commander, he'd be able to warn the platoon.

Ruhl made it through that night. The next day, during a frontal assault on enemy fortifications at the base of Suribachi, he and his platoon guide, Sgt. Hank Hansen, ran forward, advancing toward a Japanese bunker. After calling for more grenades, they climbed up to the top and peered over the side. Below them was an elaborate trench system, swarming with Japanese soldiers. The two Marines opened fire. Suddenly a Japanese grenade landed between them. Calling out a warning—"Watch out, Hansen!"—PFC Ruhl instantly dove on the grenade. The explosion blasted him into the air, killing him.

Twenty-one-year-old D. J. Ruhl, who'd wanted so desperately to do something that would make the folks back in Montana and his fellow Marines proud, saved the life of his comrade that day. Sgt. Hansen was killed in action a week later, after participating in the first flag raising atop Mount Suribachi.

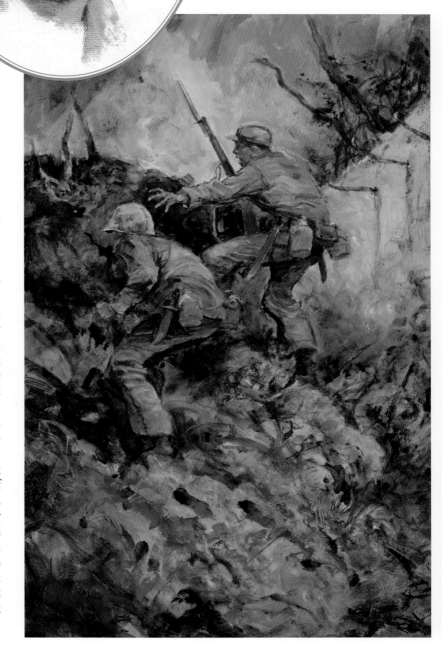

CAPT. JOSEPH J. McCARTHY, USMCR[57]
Iwo Jima, February 21, 1945

Joseph J. McCarthy was born on August 10, 1911, in Chicago, Illinois. The youngest of six children, Joe was always big for his age, which worked to his advantage in Chicago's rough-and-tumble South Side. During high school he was an outstanding swimmer, an all-state football player, and the player responsible for the winning home run that cinched the city's baseball championship for his team.

In 1938, McCarthy joined the fire department, while serving weekends in the Marine Reserve—he'd wanted to join the regulars but was turned down for having bad molars.

By 1940, with the war looming, the Marines had bigger things to worry about than McCarthy's teeth, so they sent the twenty-eight-year-old sergeant to serve as the chief of the fire department at the Marine base in San Diego. After Pearl Harbor, he completed Officers

Training School, coming out as a lieutenant assigned to the 4th Marine Division.

Whether they called him "Big Mac" or just Joe, his fellow Marines soon learned that the 6-foot-4, 240-pound Irishman didn't suffer fools gladly, play politics, or play fast and loose with the truth. Promoted to captain, he was given command of Company G, 2nd Battalion, 24th Marines.

In 1944, McCarthy took part in the Roi-Namur and Saipan-Tinian campaigns. On July 4, during the brutal battle for Saipan, he left his position and dashed through raging fire to carry two wounded comrades to safety—an action for which he was awarded the Silver Star.

On February 19, McCarthy landed with his company in the 24th Marines on Yellow Beach 2, Iwo Jima. By the next day, his company

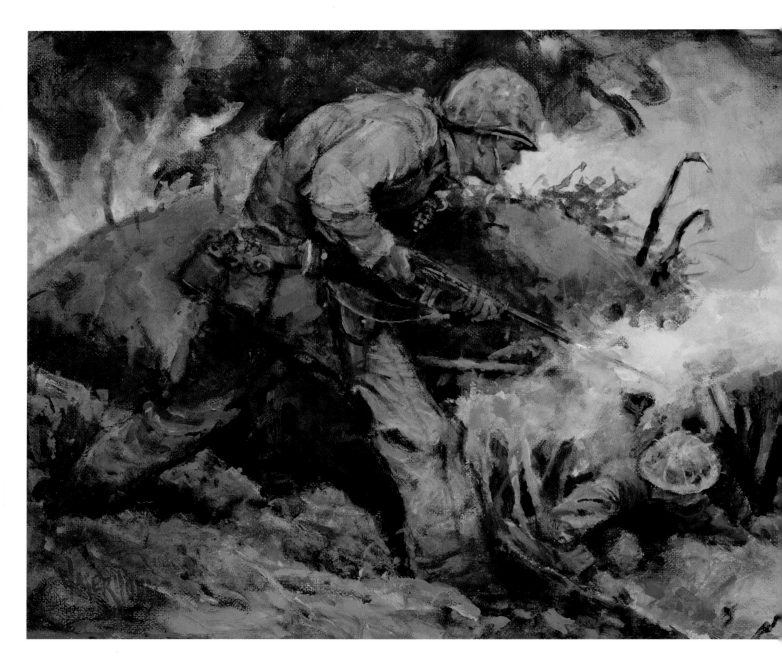

was caught on the receiving end of deadly fire from an all-but-invisible enemy that had dug into the ashen bowels and rocks of the island. In the face of mounting casualties and negligible yardage gains, McCarthy decided to take action.

He handpicked a rifle squad, and a demolitions and flamethrower team, to accompany him across seventy-five yards of fire-swept ground to charge a heavily fortified pillbox that was halting their advance. Hurling hand grenades into the emplacement, McCarthy dispatched the soldiers attempting to escape, before demolishing a second enemy position. When a Japanese soldier took aim at one of his Marines, McCarthy jumped him, shooting the aggressor with his own weapon.

McCarthy's fearless assault contributed to breaking the enemy's defense belt around the airfield. He did it, he later said, because "it had to be done, and you can't just tell the boys what to do—you have to show them."

McCarthy was critically wounded on March 7, but when a priest attempted to administer the last rites, Mac flatly told him he wasn't going to die.

In 1949, Joe McCarthy drove from Maine to North Carolina, visiting the families of the twenty-six Marines in his company who had been killed on Iwo Jima. He told each family that their man had been every bit as brave as he was, just not as lucky.

McCarthy served in the USMCR until 1971 and continued his career with the Chicago Fire Department, where he was credited with setting up the city's fire and rescue operation and revitalizing the ambulance service. In a 1992 interview, McCarthy said, "I would hope and pray there never be another Medal of Honor issued. I hope and pray there's never any more wars."

He died in 1996 at the age of eighty-four.

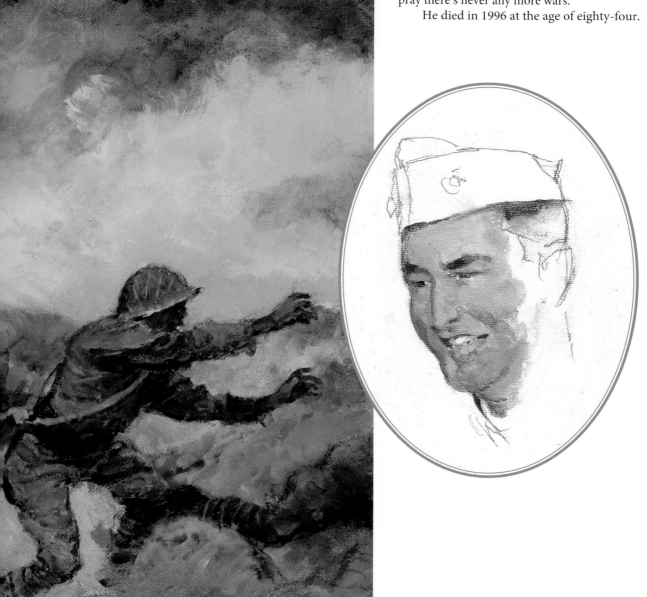

CPL. HERSHEL "WOODY" WILLIAMS, USMC[58]
Iwo Jima, February 23, 1945

It weighed about seventy-two pounds. It sprayed a tongue of flame that could lick up anything within 100 feet and turn it to toast. It was the perfect weapon to battle against an enemy that attacked and then disappeared into the sulfuric smoke like ghosts—the only weapon with the physical and psychological power to rout a determined, fanatical foe out from the network of caves, fortified emplacements, and miles of subterranean tunnels buried deep within the volcanic ash of Iwo Jima. The weapon that the fierce Japanese defenders of the island feared and despised most was the flamethrower. And that meant that Marine flamethrower operators were prime targets for enemy fire. A Marine with an M2 flamethrower strapped to his back might as well be wearing a target with a flashing neon arrow pointing to the pack of combustible tanks that said "Shoot me HERE."

On February 23, 1945, five Marines and a corpsman gained an unforgettable place in US history as they raised the American flag (the second that day) on Mount Suribachi. The Marines of 1st Battalion, 21st Marines, 3rd Marine Division, looked south, momentarily heartened by the sight of the stars and stripes, but that moment of hope was soon dampened by the hopelessness of the situation they were facing. Pinned down under enemy machine gun fire, and with their casualties mounting, the Marine advance had been stalled by fierce resistance coming from reinforced-concrete Japanese pillboxes peeking slyly out of the black sand that were impervious to US bombs and artillery. It was a job for the special-weapons unit, but HQ Company was down to their last flamethrower: a 5-foot-6 corporal from West Virginia named Hershel Williams who, at 135 pounds, would have to strap on a flame tank backpack half his weight and somehow crawl, crab, or elbow his way across more than 100 yards of sucking sulfuric sand while the enemy focused the full force of firepower on his every move. The odds of him making it were slim to none, but Capt. Donald Beck—who'd earned a Silver Star on Guam and now found himself in command of HQ Company—could see no other way out of the Marines' current predicament. He asked Williams if he thought he could do something with his flamethrower.

The twenty-one-year-old corporal said, "I'll try."

Born on October 2, 1923, and raised on a dairy farm in Quiet Dell, West Virginia, Hershel "Woody" Williams had never had the luxury of letting age, size, or personal inclinations get in the way of carrying out his responsibilities. By the time most kids were jumping around the sports field, he was jumping off the running board of his father's pickup truck to deliver milk and pick up the refills—and those were the good times, because his father died when Woody was only nine, and by then, the Great Depression was making the family's daily life even harder. "You could work all day for ten cents," Williams later recalled, so it was no wonder when he learned that he could earn twenty dollars a month working with the Civilian Conservation Corps, he dropped out of high school and headed off to Morgantown to build walls and then build and mend fences for the CCC in Montana.

In December 1941, after the Japanese attacked Pearl Harbor, Woody Williams tried for the first time to enlist in the Marine Corps, only to be told by the Marine recruiter that at 5 foot 6, he was too short. By 1943, with the war raging, the Marines had relaxed the height requirements, and Woody Williams finally made the grade.

Williams served in the South Pacific in New Caledonia, Guadalcanal, and during the Battle of Guam. It all led to this one moment, on February 23, on Iwo Jima, when Woody Williams was asked if he could do something with his flamethrower that could help the 21st Marines advance.

Once Williams strapped on his flamethrower pack, the clock started ticking. From the moment he stepped forward on the field of battle, the average flamethrower had four minutes to live. But for the next four hours, covered by only four riflemen (two of whom wouldn't survive), Cpl. Woody Williams would shatter the averages, time after time, destroying a total of seven Japanese pillboxes, all while under terrific enemy small-arms fire. He repeatedly returned to his own lines to prepare demolition charges and obtain serviced flamethrowers, only to go out again to wipe out one position after another. At one point, a wisp of smoke alerted Williams to the air vent of a Japanese bunker; he approached it close enough to put the nozzle of his flamethrower through the hole, exterminating the occupants. On another occasion, he stopped a charge of three Japanese soldiers by incinerating them in a burst of flame from his weapon. Williams's relentless rampage against the entrenched enemy would earn him the Medal of Honor.

Woody later maintained that his mind shut off after he'd destroyed the third pillbox, and he didn't remember anything after that. But the aftereffects of combat stress remained with him long after the war, until one Sunday in 1961, when he reluctantly agreed to go to church with his family. The sermon that morning was about sacrifice and, for Woody Williams, it struck a deep chord. "I'd had men who gave their lives to protect me," he said. The idea of service was familiar to Williams—in addition to his active-duty service with the Marines, he spent thirty-three years with the Veterans Administration—now, with his newfound faith, he was able to give back in even-deeper ways. After retiring from the VA, Woody ran a veterans' home, taught Sunday school, and served as chaplain of the Congressional Medal of Honor Society. In 2010, he began focusing his efforts on Gold Star families, establishing the Woody Wilson Medal of Honor Foundation, a nonprofit organization that provides scholarships to Gold Star children and facilitates the establishment of Gold Star family monuments.

The last living World War II Medal of Honor recipient, Woody Williams is a reminder that no matter one's age or size, greatness often starts with two small words: "I'll try."

Gy. Sgt. William Gary Walsh, USMC[59]
Iwo Jima, February 27, 1945

Records state that William Gary Walsh was born on April 7, 1922, in Roxbury, Massachusetts. In fact, his name at birth was William Gary, and he was born in Maine to an unwed mother who placed her infant in the care of his grandmother. When the old woman became too ill to care for the boy, a capable widow named Mary Walsh took little Billy in, adopting him as a son and raising him with her three other children.

"Red," as the neighborhood kids in Roxbury dubbed the ginger-haired youth, was a good athlete who enjoyed playing baseball and attended the local schools. He was working for a trucking company and playing catcher for the Dorgan Athletic Club baseball team in his spare time when the Japanese bombed Pearl Harbor. That same night, eighteen-year-old Red Walsh camped out with the other baseball players from the club so they could be there when the Marine recruiter unlocked the door the following morning.

After recruit training, Walsh volunteered for the elite Marine Raiders, serving with the 3rd Raider Battalion at Bougainville until they were disbanded. Walsh then returned to the States to attend noncommissioned officers school, coming out as a platoon sergeant assigned to Company G, 3rd Battalion, 27th Marines, in the newly formed 5th Marine Division.

In the predawn hours of February 27, 1945, on Iwo Jima, now Gy. Sgt. Walsh and his company were on the move, stumbling in the darkness across rocky terrain, picking their way through a boneyard of 3rd Division Marines who had fallen, and attempting to break through the Japanese defenses north of Airfield No. 2. Walsh's company and two others had been given the task of securing the low ridge that guarded the approach to Hill 362A—the gateway to the airfield.

The assault was scheduled for 0800. They watched as US air, naval, and ground artillery rained fire down on the hills, in an effort to soften the enemy's defenses. When the last planes cleared, Gunny Walsh shouted to his men, "Let's move!"

Japanese resistance was swift and terrible. Marines who made it to the slope were cut down from all directions. Walsh gathered up a group of men, pressing forward until heavy fire forced them to go to ground in a trench beneath the ridge. "We can't stay here!" Walsh shouted. "Let's hit the sons-a-bitches again!"

He led his surviving Marines through a hail of fire, making it to a hole just fifteen feet from the top of the ridge. Some of his men were wounded and Walsh refused to leave them. From their higher vantage point, the Japanese started to pelt grenades. The second they rolled in, the former baseball player pitched them back. A corporal witnessing the scene from below later called it the most incredible display of courage he'd ever seen.

When an enemy grenade landed among Walsh's huddled men, the brave gunny jumped on the missile, attempting to roll it away from his squad before it exploded. It went off, killing Walsh and several of his men.

During the Korean War, Red's older brother, Cormac, joined the US Army as a chaplain, where he received four Silver Stars and a Presidential Citation for giving aid to wounded soldiers while under heavy fire. The widow Walsh had raised two amazing sons.

Waterhouse's unfinished painting of Walsh was done just weeks before his death.

PFC DOUGLAS T. JACOBSON, USMC[60]
Iwo Jima, February 28, 1945

Douglas Jacobson was born on November 25, 1925, in Rochester, New York, growing up in nearby Port Washington, where he worked in his father's carpentry business and spent his summers as a lifeguard and swimming instructor on the beaches of Long Island. "Jake," as he was called, played blocking back on the high school football team. He never had a penchant for academics, so no one was surprised when Jacobson dropped out of school to enlist in the service. Despite his athletic background, the Army and Navy rejected him as being "too fat." The USMC recruiter, however, was confident was confident the Marines could get this pudgy boot into fighting form.

And they did. Pvt. Jacobson dropped the weight but barely squeaked by in qualifying with a rifle. Luckily, he succeeded with the BAR and bazooka and was soon earning commendations with the 4th Marine Division while fighting on Tinian and Saipan.

The young combat veteran went on to serve with the 3rd Battalion, 23rd Marines, on Iwo Jima. Five long, hard days after coming ashore, Jacobson's unit came up against the second-highest point on the island after Suribachi: Hill 382.

The Japanese were embedded in every rocky crevice and cranny, and the Marines were paying a high cost in casualties. As they pushed forward, Jacobson saw a bazooka man gunned down by enemy fire. He picked up the dead man's rocket launcher, advanced to within bazooka range of a Japanese 20 mm antiaircraft gun, and released a rocket, smashing the gun and its crew to smithereens, before doing the same to an enemy machine gun position.

Carrying the two-man bazooka alone into the kill zone, Jacobson then launched a one-man assault against the enemy. During a period of less than an hour, he knocked out sixteen hostile positions and killed an estimated seventy-five enemy soldiers, blasting a gap in the Japanese defenses and allowing the Marines to get through. "I don't know how I did it," Jacobson said later. "I had one thing in mind: getting my ass off that hill."

For his heroism, the one-time pudgy recruit would receive the Medal of Honor and be named "the outstanding living Marine enlisted man of World War II."

Jacobson reenlisted in the USMC two more times and was commissioned a second lieutenant in March 1954, serving a total of twenty years and retiring as a major. In 1967, during his last month of active service, he took a general equivalency test and earned his high school diploma. Jake Jacobson died of congestive heart failure in August 2000 at age seventy-four.

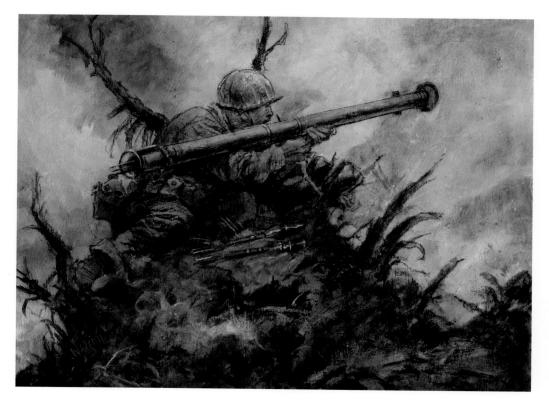

PVT. WILSON. D. WATSON, USMC[61]
Iwo Jima, February 27, 1945

Wilson "Doug" Watson was born on February 16, 1922, in Tuscumbia, Alabama. As the fourth of twelve children, Doug started working in the local sawmill at the age of eleven. In 1938, the family moved to a tenant farm in Tyronza. Doug left school in the seventh grade to work alongside his father and brother in the cotton fields.

Watson enlisted in the Marine Corps Reserve in 1942 and was deployed overseas the following year, seeing action at Guadalcanal, Bougainville, and Guam as an automatic rifleman with Company G, 2nd Battalion, 9th Marines, 3rd Marine Division. At 5 foot 8 and 140 pounds, Watson might not have been the most physically intimidating Marine in his platoon, but he was regarded as an outstanding BAR man.

Pvt. Watson's battalion, which had been held in reserve, came ashore the embattled island of Iwo Jima on February 24, 1945, to fill a gap for V Amphibious Corps, which had suffered enormous casualties.

On February 26, Watson's squad was halted by intense fire coming from enemy fortifications in the high rocky ridges north of Airfield No. 2. As they struggled forward, Watson scoured the terrain until he located the source of trouble: a camouflaged Japanese pillbox with a slotted opening just large enough to house a deadly machine gun. He took off like a shot, half crawling, half running, toward its flank.

Stepping forward with his BAR, Watson let loose a series of short bursts that kept the machine gunners down long enough for him to pull the pin on a grenade, shove it into the slot and neutralize the resistance. Later in the day he repeated this feat, taking down a second pillbox.

By the next day, Watson's platoon had made it to within 20 yards of the top of the ridge when enemy fire sent them running for cover. But Watson wasn't about to quit. Grabbing his BAR and firing from the hip, he advanced up the hill. On the reverse slope of the bluff, Japanese soldiers were gathering, ready to push the Marines back. Watson raised his weapon and started shooting—inserting clip after clip into his weapon, often standing upright in the open to get a better aim. By the time reinforcements arrived, the private was down to two rounds of ammunition. He fought on for another half hour until he was hit in the shoulder by mortar fragments and ordered to withdraw to the aid station.

Watson rejoined his platoon a few days later. On March 2, during a Japanese assault on his position, he was shot in the neck and evacuated from the island. In all, Watson was estimated to have killed ninety Japanese soldiers, enabling the Marines to advance and earning him the nickname "One-Man Regiment of Iwo Jima." He is credited with giving actor John Wayne his signature "shoot from the hip" style in films.

Civilian life wouldn't be easy for the Medal of Honor recipient, who spent time in and out of the Army, retiring as a staff sergeant, and battled a drinking problem, before returning to Arkansas, where he served for a time as the local game warden. Watson died in 1994 at the age of seventy-two. His grave marker bears an engraving of the Medal of Honor but no mention of the Marines or Iwo Jima.

PhM1c John H. Willis, USN[62]
Iwo Jima, February 28, 1945

John Harlan Willis was born on June 10, 1921, in Columbia, Tennessee. One of twelve children, tensions in the Willis family went beyond the stresses of providing for a large brood during the Great Depression. John's relationship with his father was troubled, and in his junior year of high school he moved in with his much-loved grandfather.

Big and muscular, with curly hair and a baby face, Willis might have made a good athlete if he'd had the time, but instead he chose to concentrate on his studies while working at the local grocery store each morning and again after classes. Academically, he was an excellent student. John had big plans for his life: he wanted to become a doctor and marry his high school sweetheart.

With no money for college, Willis figured his best bet would be to join the Navy and train as a corpsman. He was so good at the job that his superiors in the naval hospital where he was serving did everything they could to prevent him from being assigned to a combat division. But Willis wouldn't take no for an answer.

John and his high school sweetheart, Winfrey, married in 1944, shortly before he was shipped to Iwo Jima in February 1945 with the 3rd Battalion, 27th Marines, 5th Marines. As the senior corpsman for Company H, PhM1c Willis worked tirelessly, under the most-dangerous conditions imaginable, to provide aid to Marines with a wide range of horrific wounds. The stakes—and the casualties—only got higher and peaked on February 28, during the assault on Hill 362A. During the battle, Willis was hit in the shoulder by shell fragments, but knowing how badly he was needed, he quickly returned to the lines of fire.

By now the fighting was at close range, with pockets of hand-to-hand combat. Willis went out to treat a Marine who had dragged himself into a shell crater after his legs had been shattered by a grenade. The corpsman ducked into the hole, finding not one but two wounded Marines. He set to work immediately. A hostile grenade arced through the air and landed among them. Willis picked it up, threw it back, and returned to caring for the men. A second grenade followed; again the corpsman scooped it up and hurled it back.

The Japanese had targeted their hole and weren't going to give up, but Willis refused to abandon his patients. According to his citation, he was able to successfully lob back a total of eight enemy grenades before the ninth exploded in his hand.

Winfrey was seven months pregnant when she received the news that her twenty-three-year-old husband had been killed. A year later she traveled to Washington, DC, with her infant son to receive Willis's posthumous Medal of Honor.

CPL. CHARLES BERRY, USMC[63]
Iwo Jima, March 3, 1945

Charles Berry was born on July 10, 1923, in the steel mill town Lorain, Ohio. Strong and muscled from working summers in the steel mills, Charlie was a fine athlete, running track and captaining the high school football team in his senior year. After graduating, he spent some time as a truck driver before enlisting in the Marines in 1941.

Described by his buddies as "One gung-ho Marine," it was no surprise when Berry volunteered for the elite Paramarines.

After being promoted to private first class and earning his jump wings, Berry sailed to New Caledonia to join the 1st Parachute Battalion, which was refitting in the aftermath of Guadalcanal. By November 1943, he was headed into combat on Bougainville. The 1st Parachute Battalion, along with a company of Marine Raiders, was sent on a daring—and nearly disastrous—raid behind Japanese lines, landing, by mistake, in the middle of an enemy-held supply dump. During the ensuing firefight, seventeen members of the raiding party were killed and ninety-seven wounded, but PFC Berry escaped without a scratch.

The Paramarines were disbanded shortly afterward, and twenty-year-old Berry—battle-tested and now a corporal—was sent to the newly formed 5th Marine Division, where he was assigned as a machine gunner for Company G, 3rd Battalion, 26th Marines.

By the time the 26th Marines landed on Iwo Jima, its volcanic beaches were already littered with the debris of wrecked equipment and the shattered bodies of the dead.

Berry and his men crawled from shell crater to shell crater—dodging mortars, artillery, and the body parts of Marines disintegrated by the blasts and scattered into the ash.

On March 3, after nearly two weeks of brutal fighting, Berry's machine gun squad was picking its way through the rocky ridges and gorges around Japanese-held Hill 362B.

With darkness falling, the corporal and his two-man crew scraped out a hole in the crevasse of a rock and settled in for the night. Knowing that Japanese infiltrators would be on the prowl, they set up watches.

Sometime after midnight, Berry was nudged awake. Shadowy figures were moving stealthily toward the scraped-out hole in the rocks: the Marines had been discovered. In the space of a drawn breath, they were engaged in a pitched back-and-forth volley of grenades. When one sparking grenade landed in the hole next to his companions, Cpl. Berry dove on it, covering the explosion with his body. He later died at the aid station.

In 2005, local veteran groups in Berry's hometown spearheaded a campaign to replace the hero's nondescript gravestone with a large marble marker. His parents are buried beside their only son. Cpl. Berry's Medal of Honor is on permanent display in the history section of the Lorain public library.

PFC WILLIAM R. CADDY, USMC[64]
Iwo Jima, March 3, 1945

William Caddy was born on August 8, 1925, in Quincy, Massachusetts. The brown-haired, blue-eyed youngster loved fishing and baseball and was an avid stamp collector. Wherever he went, his beloved part-beagle dog, Cindy, followed at his heels. William made his high school varsity baseball team, but the Caddy family, like so many others, had been hard hit by the Great Depression, so he dropped out of school after his sophomore year to help with finances, taking a job as a helper on a horse-drawn milkman's truck. Ever the good son, the young man gave the lion's share of his twenty-five dollars-a-week salary to his mother.

In 1943, Caddy was inducted into the USMC through the Selective Service. Standing 5 foot 7 and weighing in at a whopping 139 pounds, the new recruit received weapons training on the Reising submachine gun, Browning automatic rifle, M-1 carbine, bayonet, and hand grenade and qualified as a sharpshooter with his service rifle. He was promoted to private first class and assigned as a rifleman to Company I, 3rd Battalion, 26th Marines, in the newly formed 5th Marine Division.

On January 5, 1945, rifleman Caddy boarded an attack transport headed for Iwo Jima.

The 26th Marines remained in reserve during the initial landing. By

the time they hit Red Beach 1, the chaos that they'd heard and seen from a distance while aboard their ship became an up-close, nightmarish reality. Among the casualties: Caddy's commanding officer and the battalion operations officer, who were blown to pieces by a single mortar.

By March 3, a veteran Paramarine, Sgt. Ott Farris, had inherited the command and the tattered remains of Company I. As they were advancing toward Motoyama Airfield No. 3, a rain of intense enemy fire halted them in their tracks. Ott, Berry, and a couple of other Marines took shelter in a shell-gashed crater. It turned out to be a bad move.

A Japanese sniper pinned them down. With the Marines trapped and unable to move, nearby enemy soldiers began pitching grenades at them. The Marines fought back with a fierce and frenetic volley of grenades that ended abruptly when a hostile grenade landed just outside their reach. Without hesitating, PFC Caddy threw himself on the missile. The nineteen-year-old Marine died in Sgt. Farris's arms.

Ott Farris later attained the rank of sergeant major and went on to earn over thirty medals, including two Silver Stars in World War II and Korea. One of Farris's sons was given the middle name Caddy, after the brave young man who'd saved their father's life.

SGT. WILLIAM G. HARRELL, USMCR[65]
Iwo Jima, March 3, 1945

William Harrell was born on June 16, 1922, in Rio Grande City, Texas. He joined the Marines in 1942 and quickly worked his way up the ranks.

As the leader of an assault group in 1st Battalion, 28th Marines, 5th Marine Division, on Iwo Jima, Sgt. Harrell experienced twelve days of bloody combat before the night that would change his life. In the predawn hours of March 3, Harrell and another Marine were holding the perimeter around the company command post when the Japanese broke through the lines. They managed to repulse the initial attack, but when the other Marine's rifle jammed, the sergeant was left to wage a lone battle against the enemy. During the pitched fight, a grenade landed next to Harrell, blowing off his left hand and reaming his thigh with shrapnel. Although unable to use his rifle, Harrell still managed to save his companion from being run through by a saber-wielding assailant, by shooting the assailant with his .45-caliber pistol.

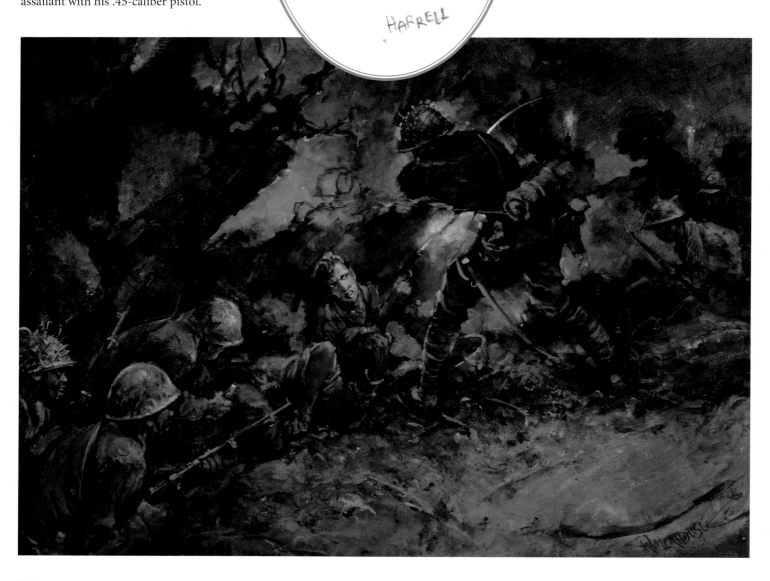

HARRELL

Ordering his wounded subordinate to withdraw, Harrell held off two enemy soldiers, shooting one and attempting to push an exploding grenade toward the other. It killed his attacker but took off Harrell's other hand. When he was finally evacuated, the bodies of twelve enemy soldiers hedged the ground around his position.

After the war, Harrell became chief of prosthetic and sensory aids at the San Antonio Veterans Administration. He married, had children, and became adept with the mechanical hooks that replaced his hands. The story should have a happy ending, but it doesn't. Tragically, in 1964, Harrell shot and killed a fellow amputee and the man's wife before turning the gun on himself. Had untreated post-traumatic stress caused him to snap? We'll never know. PTSD wasn't yet recognized as a disorder, and veterans were often left to wage a lone battle against their demons, as Harrell had that night on Iwo Jima.

HC2c George E. Wahlen, USNR[66]
Iwo Jima, March 3, 1945

George Wahlen was born in Ogden, Utah, on August 8, 1924, to a hardworking Mormon family. Weighing in at 100 pounds, George boxed, wrestled, and played halfback on the high school junior varsity football team. His life's dream was to work on airplanes, and by age seventeen he was already a mechanic and crew chief in the Army Air Corps. After quotas shut him out of the Air Corps, Wahlen considered enlisting in the Marines, His father talked him out of it, saying that the Navy would be safer. George took that advice, hoping that with his experience he'd be assigned to working on aircraft. Instead, he was sent to train as a corpsman. Fearing he'd spend the war emptying bedpans in a naval hospital, Wahlen volunteered for combat duty with the Marines.

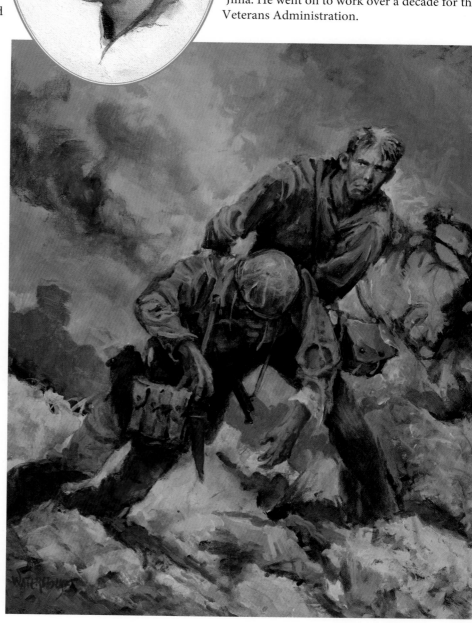

Six months short of his twenty-first birthday, as a pharmacist's mate 2nd class, Wahlen landed on Iwo Jima with Company F, 2nd Battalion, 26th Marines, 5th Marine Division, lugging a carbine, a .45 pistol, and a medical kit. Of the 240 men in his unit, only five would come through this crucible without being wounded or killed, and it would be George's job to attend to as many of the fallen as he could. Although not a practicing Mormon, George prayed continually: *Please, God, help me to not let one of my buddies down.*

God listened.

On February 26, within the span of thirty minutes, Wahlen took care of a dozen or more men, all while under heavy mortar and artillery fire. While attending a wounded Marine, an enemy grenade sent shrapnel into his eye, temporarily blinding him. As he was inching his way back to his platoon, Wahlen spotted another downed Marine. He crawled over to him just as the Japanese started pelting grenades. He'd given away his carbine and had no grenades, so he shouted to his platoon to throw him one. When they did, Wahlen crab-walked toward the enemy cave, lobbed the missile, and crawled back to treat his patient.

On March 2, as Wahlen was dragging another Marine to safety, a shell exploded behind them, knocking him flat. He had the wounded Marine apply a bandage to the wound on his back, and kept working.

By late afternoon on March 3, Wahlen was the only corpsman left on the company line. He was heading out to attend another casualty when a shell exploded in the hole where four Marines had taken cover. The explosion splintered Wahlen's ankle bone into fragments. He calmly applied a battle dressing, gave himself a shot of morphine, and crawled over to take care of the Marines. Two were dead, but he applied tourniquets to the others and waited with them until they were evacuated. Then he heard another cry for help. Unable to walk, Wahlen crawled fifty yards, trying to hold his mangled foot off the rocky ground, and attended to the wounded Marine until the stretcher bearers came. In October 1945, President Harry Truman presented his Medal of Honor.

It would take nine months and three operations for the corpsman to recover from his wounds. In 1948, George Wahlen enlisted in the Army and became a medical officer. He served in both the Korean and the Vietnam Wars, attaining the rank of major and adding two more Purple Hearts and a Bronze Star to his Medal of Honor and Purple Heart received for his actions on Iwo Jima. He went on to work over a decade for the Veterans Administration.

PHM3C JACK WILLIAMS, USNR[67]
Iwo Jima, March 3, 1945

Jack Williams was born on October 18, 1924, in the hardscrabble farming area of Harrison, Arkansas. Tall, lean, and with a ready smile, Jack was a quiet, easygoing boy who enjoyed fishing with his friends and cooling off with them in the local swimming hole, Crooked Creek. As a teen, Jack worked at the local movie theater. His high school yearbook summed him up as "Future Farmer with a twinkle in his eye, a dimple in his chin, and personality plus." But this future farmer's life was about to take a different turn.

In 1943, the draft board knocked at Jack's door. Williams opted to enlist in the Navy as a "selective volunteer" and was promptly assigned to the hospital corps. His fellow corpsmen nicknamed the slow-talking, tobacco-chewing galoot "Arkie."

On February 19, 1945, PhM3c Arkie Williams landed in the amphibious assault on Iwo Jima with the Marines of 3rd Battalion, 28th Marines, 5th Marine Division, lugging 51 pounds of medical equipment across the black sand. As the battle intensified, and Marines fought to isolate Mount Suribachi from the rest of the island, the cries for "Corpsman!" steadily increased.

On March 3, Williams and his best buddy attended a church service held in a large shell hole. That same

morning, under enemy fire, Arkie Williams helped save the lives of fourteen Marines—five others were dead before he reached them.

A little before noon, Williams went out in front of the battle lines to help a wounded Marine. Pulling him into a shallow depression, the corpsman knelt over his patient to give him a shot of morphine. Struck in the abdomen and groin by enemy rifle fire, he completed his ministrations before applying dressings to his own wounds.

Knowing that they were both goners if he didn't get help, Williams endeavored to make his way back to the rear to find stretcher-bearers, stopping to administer aid to another fallen Marine. Bleeding profusely, and in agonizing pain, Arkie Williams weakly weaved toward his platoon but was cut down by a sniper bullet, which ripped through his chest, killing him. He was twenty years old.

Jack Williams was recommended for a Medal of Honor. No officers were left to testify to his actions that day, but scores of enlisted men whom he'd treated bore witness to the bravery of the slow-talking—but fast-to-respond—corpsman from Arkansas who had saved their lives. Their statements led to Jack being awarded a posthumous Medal of Honor a year after his death.

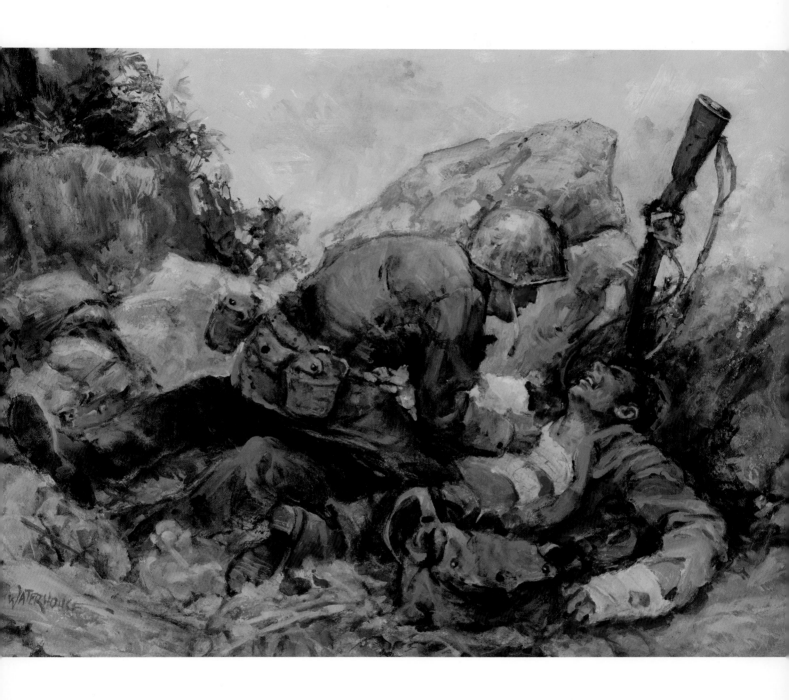

2LT. JOHN H. LEIMS, USMC[68]
Iwo Jima, March 7, 1945

John Leims was born on June 8, 1921, in Chicago, Illinois. Tall and strapping, with matinee idol looks, John earned letters in football and track at St. George High School in Evanston. He also served as the sports editor of the school newspaper and an assistant scoutmaster for the Boy Scouts. During his years at Northwestern University, he played halfback for the football team.

In 1942, Leims enlisted in the Marine Corps Reserve. He was selected for officer training and commissioned a second lieutenant in March 1944. By summer 1944, 2Lt. Leims was with the 3rd Marine Division on Guam, patrolling for Japanese holdouts. Adored by his men, Leims became known for his eager, go-get-'em attitude.

With 4th and 5th Division casualties soaring on Iwo Jima, the 3rd Division was called in from reserve. Fighting for every yard and hill, the three Marine divisions steadily pushed the Japanese northward. Casualties were so high that 2Lt. Leims inherited the command of Company B, 1st Battalion, 9th Marines.

On March 7, there was just one more ridgeline between the Marines and the northern shore; for a group of Leims's men, however, it was proving to be a ridge too far. They'd gained a grip on the bluff over the last Japanese enclaves, but from the blasts of mortar and artillery lighting up the night sky, it was clear to Leims, monitoring the action from the command post below, that they were in trouble. With communications cut off, he dispatched a runner to find out how they were faring. The runner didn't return. Acting on instinct, Leims attached his telephone to a spool of wire and set off by himself, using the darkness between flares to cross 600 yards of ashen, open ground and scale the 40-foot rocky ridge.

A nightmare of confusion and carnage awaited him. Dead and wounded Marines were everywhere; yet, through the smoke, Leims caught a glimpse of hope. From this high vantage point he could see the Pacific Ocean. The Marines had paid a high cost, but they had the enemy cornered. He knew they had to hold this hill. Leims used his phone to relay the coordinates back to command. Told that another unit was on the way, he ordered his men to withdraw. Of the seventy-five Marines who'd gone up the ridge, fewer than ten came down.

After doing a head count, Leims returned to the hill alone, in search of casualties that had been left behind. He found a seriously wounded platoon sergeant who had been cut down by a mortar shell, and a Marine had been shot in the arm and chest. By then, Leims himself was wounded, but he picked up the bleeding platoon staff sergeant and hefted him over his shoulder. He told the second Marine that he'd be back, but the Marine said, "No you won't; you'll never make it," and clamped his hands onto the second lieutenant's cartridge belt. Carrying the platoon sergeant in his arms and dragging the other Marine behind, Leims made it down the steep incline. With 600 yards of fire-swept terrain still to go, the former Northwestern halfback sprinted his precious cargo to safety.

John Leims didn't think his actions on Iwo Jima warranted a Medal of Honor. "I feel guilty," he said. "Because I know there are hundreds of men walking the street today who deserve the award just as much as I do."

1LT. JACK LUMMUS JR., USMC[69]
Iwo Jima, March 8, 1945

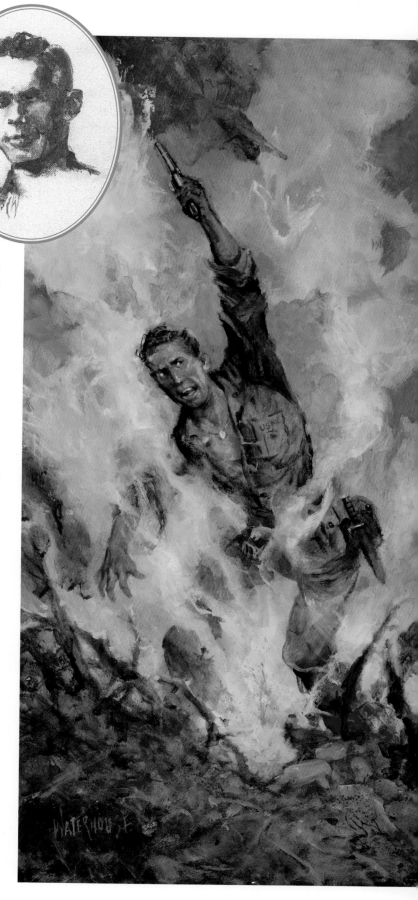

Andrew Jackson "Jack" Lummus Jr. was born on October 22, 1915, in Ennis, Texas. An exceptional athlete, Jack was offered a full scholarship at Baylor University, where he excelled on the gridiron and the baseball field.

With the nation edging closer to war, Lummus enlisted in the US Army Air Corps.

He completed his preflight training but botched his first solo flight, so when the New York Giants knocked at his door, Jack sprinted to training camp with his honorable discharge in hand and nabbed a spot on the 1941 roster. Even as a rookie, Lummus saw a lot of playing time. The Giants knew they had a rising star in the handsome Texan.

The Japanese attack on Pearl Harbor was a total game-changer. On December 21, Lummus played his final game with the Giants and enlisted in the Marines as Jack Lummus. He was quickly promoted through the ranks and selected for Officer Candidates School.

On February 19, 1Lt. Lummus landed on Iwo Jima with Company E, 2nd Battalion, 27th Marines, 5th Marine Division. After two weeks of fierce fighting, he was given command of a rifle platoon with a mission to spearhead a final assault on an enemy stronghold east of Kitano Point.

On March 8, despite being wounded by grenade shrapnel, Lummus knocked out three fortified enemy positions that were preventing his men from reaching their objective. As he was leading the advance, Lummus stepped on a land mine. The explosion blasted off those powerful legs that had carried him to victory on the playing field. Lummus continued to shout words of encouragement to his Marines until he was evacuated.

At the aid station, he reportedly told the medic, "Well, doc, the New York Giants lost a mighty good end today." He died of internal wounds shortly afterward.

Jack Lummus—two-sport athlete, pro football player, hero—was twenty-nine. He is buried in Myrtle Cemetery in Ennis, Texas.

PFC James D. LaBelle, USMCR[70]
Iwo Jima, March 8, 1945

James "Jim" LaBelle was born on November 22, 1925, in Columbia Heights, Minnesota. When he was seven, Jim's father was killed in a car accident, leaving his mother to raise eight children. In high school, Jim followed a vocational course in wood and metalwork. At 5 foot 7, and 129 pounds soaking wet, LaBelle was still a force on the baseball field and basketball court and a contender in intramural boxing. Friends remembered him as a soft-spoken, compassionate teen who kept homing pigeons and worked at a burger joint and as an apprentice acetylene welder to help his family.

By 1943, the war in the Pacific was intensifying. With his older brother labeled 4F and presumably able to take care of their widowed mother, seventeen-year-old Jim asked for permission to leave school and join the Marines. As a recruit, Jim's kindness continued. He wrote regularly to his family and tried to teach an illiterate boot to read and write. Discovering that things were rough at home, LaBelle took his mother on as a dependent, allocating her the bulk of his pay.

His correspondence stopped abruptly when, on February 19, 1945, serving with Weapons Company, 27th Marines, 5th Marine Division, PFC LaBelle landed in the third-wave assault on Iwo Jima. For the next eighteen grueling and bloody days, the young Marine would take part in a battle where "uncommon valor was a common virtue."

On March 8, LaBelle's Weapons Company was filling in a gap in the front lines. The threat of infiltrators was ever present, but it had been a long, hard day, and, exhausted, LaBelle and two fellow Marines prepared to hunker down for the night, digging a hole into the ash that collapsed in as quickly as they could shovel it out. Despite his own fatigue, Jim volunteered to take the first watch so his buddies could catch some shuteye. When a hostile grenade suddenly landed in the hole, just beyond his reach, LaBelle dove headlong onto the missile, absorbing the explosion with his body and saving the lives of his comrades.

LaBelle's posthumous Medal of Honor was presented to his mother.

In 2016—more than seventy years after he left school to serve his country—Columbia Heights High School awarded James LaBelle an honorary diploma.

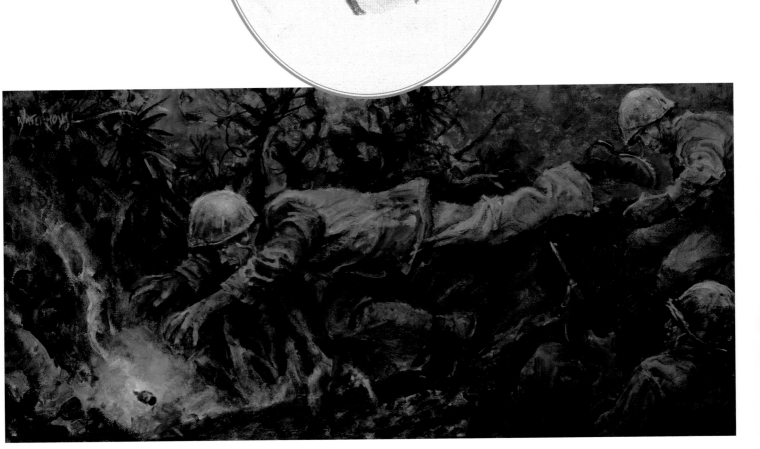

PLSGT. JOSEPH "RUDY" JULIAN, USMC[71]
Iwo Jima, March 9, 1945

Joseph Rodolph Julian was born on April 3, 1918, in Sturbridge, Massachusetts. Through his boyhood, Joseph—who preferred being called Rudy—worked with his father as an auger shop filer and later as a printworks finisher. After graduating from high school, he took a job in Old Sturbridge Village, where he honed his skills as a cabinetmaker. Tall and handsome, Rudy was popular with the ladies, but before he could marry and settle down, the war broke out.

Julian enlisted in the Marine Corps Reserve in January 1942 and was sent for basic training at Parris Island. His size, maturity, and leadership skills made him a natural drill instructor, and he was retained on Parris Island. Later assigned to the 5th Marine Division, PLSgt. Julian was one of thousands of Marines headed for an island in the Pacific called Iwo Jima.

On March 9, 1945, Julian and his platoon in Company A, 1st Battalion, 27th Marines, 5th Marine Division, were in a northwest pocket of the island known as "Death Valley." There was no air support and no naval guns, or even any mortars to help the Marines—just mouths of caves that they needed to fire at, burn, or blast before their number came up and they were added to the list of the dead.

When the barrage of mortars and artillery became too intense, PLSgt. Julian put his men into defensive position and strode alone into the Valley of Death, hurling grenades against the first pillbox he encountered. After obtaining more explosives, Julian and another Marine advanced again, taking out two more emplacements. The platoon sergeant then picked up a bazooka and finished off another pillbox before being cut down in a burst of enemy fire.

Twenty-six-year-old platoon sergeant Rudy Julian, "the one-man demolition squad of Iwo Jima," was one of twenty-seven Marines on that island to receive the Medal of Honor.

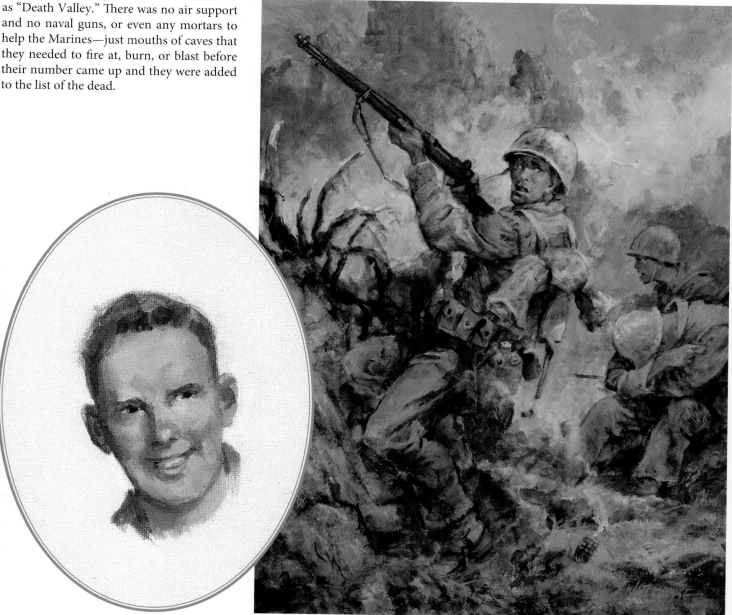

PVT. GEORGE PHILLIPS, USMC[72]
Iwo Jima, March 14, 1945

George "Junior O'Brien" Phillips was born in a small town just south of Kansas City, Missouri, on July 14, 1926. George's parents were killed in an automobile accident when he was just three, and he and his siblings went to live with their aunt and uncle, James and Lillian O'Brien, in Labadie, Missouri.

"Junior," as everyone called him, attended school at the United Methodist Church and dreamed of becoming a major-league baseball player. As a teenager he worked as a farmhand, on the railroad, and as a painter for an oil company.

In April 1944, at the age of seventeen, Phillips enlisted in the Marine Corps. On February 19, 1945, Pvt. Phillips landed with the 2nd Battalion, 28th Marines, 5th Marine Division, on the volcanic shores of Iwo Jima. Over the next three and a half weeks, he would take part in one of the most brutal and epic battles in USMC history.

On March 14, after a night of fierce hand grenade fighting with the Japanese, Phillips was standing guard while the other Marines in his foxhole were resting, when another grenade attack began. He and his companions managed to lob the missiles back until one sparking grenade landed out of reach. Yelling out a warning, eighteen-year old Pvt. Phillips threw himself over the exploding charge and was instantly killed.

Junior's sixty-year-old Uncle James, who had raised him, accepted his posthumous Medal of Honor.

In 1948, Phillips's remains were returned from the 5th Marine Division Cemetery on Iwo Jima and reinterred in Labadie's Bethel Cemetery. A memorial in honor of the young hero was dedicated in 1990. Attending the ceremony was Bob McLanahan, one of the Marines whose lives Phillips had saved. "Every morning when I first look in the mirror, I thank George Phillips for another day," McLanahan said. A photograph of Junior Phillips hung on the wall of McClanahan's home until the day Bob died.

Waterhouse never finished this painting of George Phillips. He died shortly after blocking out the composition and the colors.

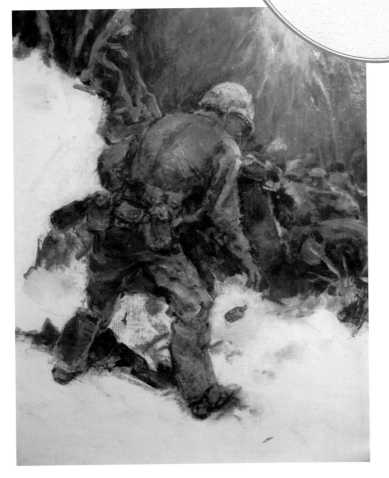

PHM1C FRANCIS J. PIERCE, USN[73]
Iwo Jima, March 15–16, 1945

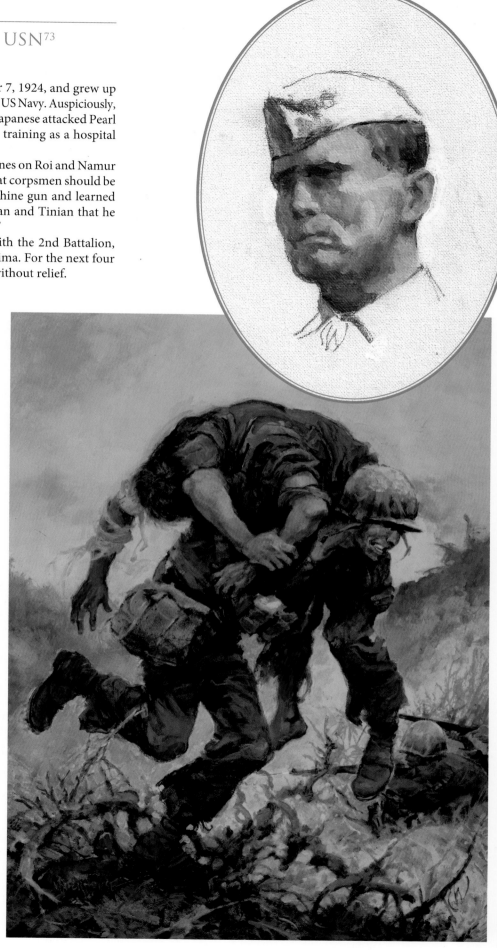

Francis Junior Pierce was born on December 7, 1924, and grew up in rural Earlville, Iowa. His dream was to join the US Navy. Auspiciously, Francis turned seventeen on the day that the Japanese attacked Pearl Harbor. A week later, he enlisted and began training as a hospital corpsman.

After his first taste of battle with the Marines on Roi and Namur Islands, Pierce decided to rethink the code that corpsmen should be unarmed. He acquired a Thompson submachine gun and learned to use it so effectively while serving on Saipan and Tinian that he was nicknamed "Angel with a Tommy Gun."

On February 19, 1945, Pierce landed with the 2nd Battalion, 24th Marines, 4th Marine Division, on Iwo Jima. For the next four weeks he worked constantly, tirelessly, and without relief.

On March 15, when heavy enemy fire took down a fellow corpsman and two stretcher-bearers who were carrying a pair of wounded Marines, Pierce carried the wounded, one by one, to a sheltered position and administered aid.

As he was attending to the last casualty, a Japanese soldier fired from a cave, wounding his patient again. Pierce used the last of his ammunition to kill the attacker, then slung the wounded Marine over his back and advanced, unarmed, through a hail of bullets, across 200 yards of open terrain.

The following morning, Pierce was seriously wounded while aiding another wounded Marine. Refusing aid, he continued to care for his patient and provide covering fire for his comrades until he was evacuated.

After the war, Pierce settled in Grand Rapids, Michigan, where he married and became a policeman, eventually serving as the head of the vice squad and an expert in bomb disposal.

In 2005, Hasbro—the makers of GI Joe—released an action figure modeled after Navy Pharmacist Mate 1st Class Francis J. Pierce.

PVT. FRANKLIN E. SIGLER, USMC[74]
Iwo Jima, March 14, 1945

Franklin Sigler was born on November 6, 1924, in Montclair, New Jersey, the second of four boys, all of whom would serve in the military. A quiet youngster who enjoyed the outdoors, "Siggy" worked part-time for his father as a plumber's assistant. After graduating from high school, Sigler enlisted in the Marines, following in the footsteps of his older brother, who'd joined the Corps at the start of the war. While he was at boot camp, Sigler received the news that his brother had been killed in a jeep accident in the South Pacific. The loss seemed only to strengthen the young recruit's resolve to serve.

On February 19, 1945, Pvt. Franklin Sigler landed with 3rd Platoon, Company F, 2nd Battalion, 26th Marines, 5th Marine Division, on the volcanic island of Iwo Jima.

By March 14, after weeks of brutal combat, the tattered remnants of Sigler's battalion were advancing toward the northern tip of the island. It was the Japanese army's last stronghold, and they were making the Marines pay for every yard. When their squad leader became one of the casualties, twenty-year-old Pvt. Sigler assumed command. He lined up the six remaining men and told them to cover him as he charged an enemy emplacement, which he destroyed, in the words of his Medal of Honor citation, with hand grenades or—according to eyewitnesses—a bazooka. Sigler then initiated a one-man assault on other enemy positions, fearlessly directing his machine gun and rocket fire into cave openings and silencing their resistance. Despite being wounded, Siggy managed to crawl back to his squad and, one by one, carry three downed Marines to safety, returning to direct fire until he was evacuated to an aid station.

For the rest of his life, Franklin Sigler walked with a limp due to the wounds he sustained on Iwo Jima. Sigler seldom spoke about the war. He married and had two daughters, but recurring "nervous disorders" made it difficult for him to hold a steady job. The term "post-traumatic stress" didn't come into use until the 1970s; veterans from the Greatest Generation tended to suffer in silence. Of his actions on Iwo, he would later say, "We were scared all of the time, but we were doing what we had to do."

Toward the end of his life, Sigler mastered his demons, serving with the Passaic County Sheriff's Office and working with a firm that built golf courses. He died in 1995 at the age of seventy.

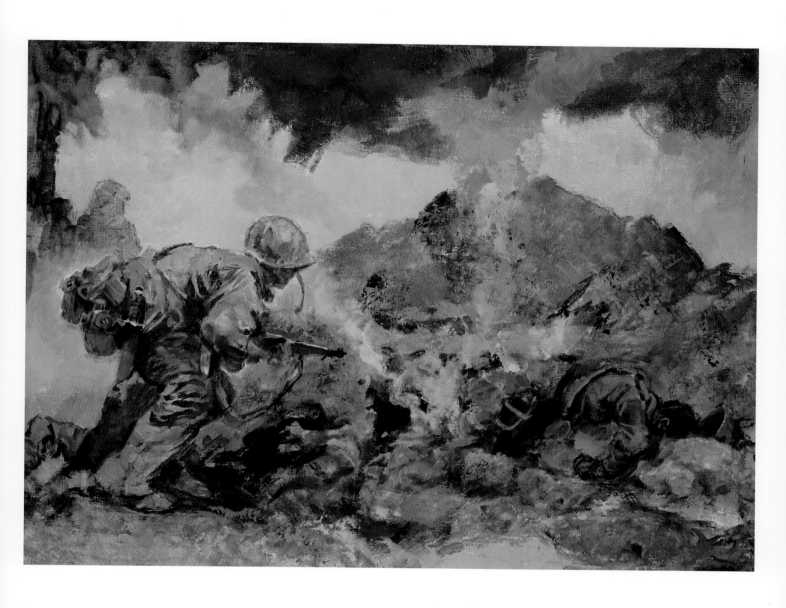

1Lt. Harry L. Martin, USMCR[75]

Iwo Jima, March 26, 1945

Harry L. Martin was born on January 4, 1911, in Bucyrus, Ohio. A small, feisty kid with rosy cheeks and an irrepressible Irish grin, Martin was an average student who never earned a varsity letter, but never quit, and always did his best to help his team win. After a few false starts, Harry worked his way through Michigan State with a BS in business, which he used to secure a position as a supervisor for a fuel tank company in Honolulu. After the attack on Pearl Harbor, Martin talked himself into the Marine Corps. It wasn't an easy sell for the thirty-year-old volunteer, but Harry persisted, and his college degree earned him a shot at officer training.

1Lt. Martin was eventually assigned as a platoon leader with Company C, 5th Pioneer Battalion—a jack-of-all-trades outfit that provided whatever was needed for amphibious landings. And on the island of Iwo Jima in February 1945, the requests for ammunition and supplies never ended. Stationed on the beaches, the Pioneers helped to build metal-latticed roadways over the shifting ash so heavy equipment could get up to Airfield No. 1. Due to heavy casualties, they also experienced brief harrowing periods on the front lines.

By March 25, the island was considered secure, and the Marines who'd survived were told to hand in their ammo in advance of being shipped out. A few old-timers kept back a few clips but most retained only their .45 pistols.

The Japanese holdouts, however, were not intending to give up without a fight. In the predawn hours of March 26, about 300 enemy survivors—armed with swords, grenades, and rifles pilfered from dead Marines—moved stealthily into the area near Airfield No. 2 and attacked, wreaking carnage and death on an unguarded bivouac area of newly arrived airmen before advancing toward the Pioneers. Awakened by the gunfire, Martin directed his men into firing positions, hastily formed a defense line, and sent his supply sergeant to the beach for ammunition. They held back the initial attack, but amid the chaos, several Marines were trapped out in front. Rather than let them fend for themselves, Harry Martin moved into no-man's land, armed only with a pistol, and went out to find them.

Despite being hit twice by enemy fire, Martin managed to locate his missing men and lead them back to the main line. By then, four Japanese attackers had taken over a nearby machine gun pit. Unable to get the gun in action, they began hurling grenades. Gripping his .45 in hand, Martin charged the machine gun pit and shot them.

With pressure continuing to build on their defensive line, the thirty-four-year-old first lieutenant then made a daring tactical decision: he charged. Martin's surviving Pioneers fell into line behind him, storming into the swarm of enemy attackers and pushing them back toward the airmen, who, having rallied from the attack, had armed and were fighting back.

Martin didn't live to taste victory—a Japanese soldier threw a grenade at him and he was killed in the explosion—but his tactical brilliance saved the lives of many Marines on that last day. Harry Martin, the guy who never gave up, was the last Marine to be recognized with a Medal of Honor for his actions on Iwo Jima.

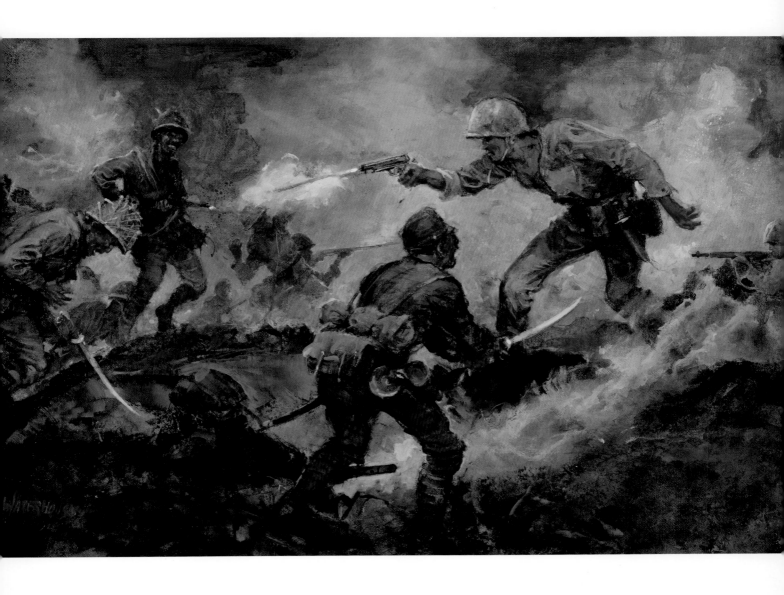

PFC HAROLD GONSALVES, USMCR[76]
Okinawa, April 15, 1945

Harold Gonsalves was born on January 28, 1926, in Alameda, California. In high school, Harold played football and baseball, ran track, swam, and sang tenor in the school glee club. He left school in his junior year, finding employment as a stock clerk with Montgomery Ward in nearby Oakland.

By the time Harold turned seventeen, the war in the Pacific was well underway. In May 1943, Gonsalves enlisted in the Marine Corps. Upon completing his training, he quickly became an active-duty cannoneer. The following March, Gonsalves was with the 22nd Marines, participating in campaigns in the Marshall Islands and during the liberation of Guam.

At the end of 1943, PFC Gonsalves was reassigned to Battery L, 4th Battalion, 15th Marines, 6th Marine Division, landing with them on April 1, 1945, and serving as acting scout sergeant with Battery L during the battle for Okinawa.

On April 15, the Marines of the 4th Battalion were taking fire from a Japanese stronghold at the top of a tall ridge on the Motobu Peninsula. Gonsalves, as part of a forward observation team responsible for directing the Marines' return fire, repeatedly braved his way through enemy bullets and mortars to report back to his team leader on target locations.

Eventually, word came down from the battalion's commanding officer: he wanted the team to advance to the front lines. Gonsalves and a few other Marines, tasked with laying down telephone lines so they could communicate with the battalion at the rear, took the lead, keeping their heads down as they made their way up the hill. Nearing the top, they found a spot to conceal themselves behind a patch of thick undergrowth while they regrouped. Suddenly, PFC Gonsalves heard the sound of something metal hitting the rocks next to them: a Japanese hand grenade. Immediately, he threw himself on top of the exploding missile. He did not survive the blast, but his Marines did, and they were able to complete their mission.

An estimated 250,000 to 500,000 Hispanic Americans served honorably in all branches of the military during World War II. Hispanic American Marines took part in every campaign in the Pacific theater, earning a total of fifteen Navy Crosses and one Medal of Honor, which was awarded posthumously to PFC Harold Gonsalves for his self-sacrifice.

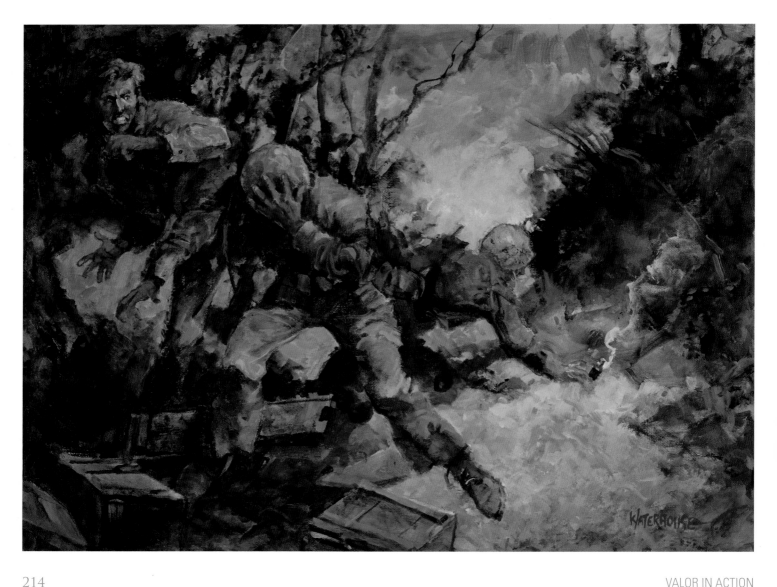

CPL. RICHARD E. BUSH, USMCR[77]

Okinawa, April 16, 1945

Richard Earl Bush was born on December 23, 1923, in Glasgow, Kentucky. His forebears were early settlers in Barren County, of which Glasgow is the county seat. The first mention of the family goes back to 1803, a time when Scottish immigrants had begun filtering into the area, drawn by its plentiful rivers, rolling hills, and meadows, making it an ideal place for agriculture.

Richard grew up on a tobacco farm, leaving high school after his first year to drive a tractor alongside his father. In September 1942, Richard and his brother enlisted in the service, Richard joining up with the Marine Corps Reserve. Worried sick about their safety, their father warned his two sons, "If either one of you comes home with a medal, I'm going to beat you to death."

Richard didn't set out to be a hero; in fact, he didn't really want to leave the family farm. "I still have splinters in my fingernails," he'd say later, "from where they came and pulled me off the porch."

And yet, leave he did, going on to serve with the highly decorated Marine Corps Raiders in the South Pacific. To get into the Raiders, Marines had to volunteer. Standards for acceptance were high. Candidates had to prove they were strong swimmers, were physically fit, and had exceptional endurance and the skills to survive. Richard Bush—the reluctant recruit who'd promised his father he'd keep his head down and fly under the radar—not only made the grade, he rose to the rank of corporal.

When the Raiders disbanded, Cpl. Bush was reassigned to the 1st Battalion, 4th Marines, 6th Marine Division. His regiment trained on Guadalcanal, participating in the battle for Guam before preparing for the 1st Battalion's next amphibious landing: Okinawa. During the long, bloody battle for that island, eleven Marines would be recognized with Medals of Honor. On April 16, 1945, Richard Bush became one of them. While leading his squad up rugged terrain in the final assault to capture 1,200-foot Mount Yaetake in northern Okinawa, the twenty-year-old corporal was seriously wounded and evacuated with other Marines to a protected cover of rocks. Although "prostrate" and "under medical treatment," when a Japanese grenade landed in their midst, Bush pulled the missile under his body, absorbing the force of the exploding charge. The explosion tore off several of his fingers and left one eye permanently blinded, but miraculously he survived. And, because of his act of selfless sacrifice, so did his comrades.

In the years following the war, Bush worked as a counselor for the Veterans Administration, earning numerous civilian awards for his efforts to aid other veterans.

Of his actions on Mount Yaetake, the humble hero later told the *Chicago Tribune*, "I wasn't out there alone that day on Okinawa. I had Marines to my right, Marines to my left, Marines behind me, and Marines overhead. I didn't earn this alone. It belongs to them too."

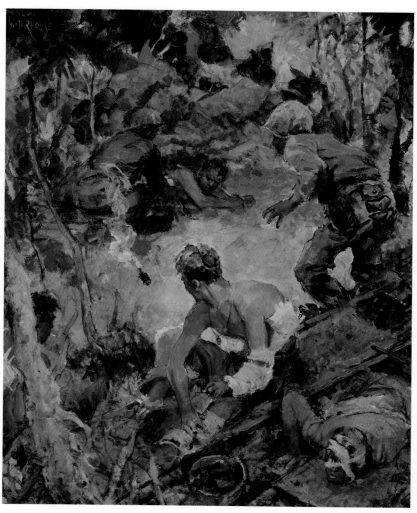

HA1c Robert E. Bush, USN[78]
Okinawa, May 2, 1945

Robert Eugene Bush was born on October 4, 1926, in Tacoma, Washington. After his parents' divorce when he was four, Robert moved with his mother to the town of Raymond, where they lived in the basement of the hospital where she worked as a nurse. In 1943, Bush left high school to join the Navy Medical Corps. He promised his mother that he was going into the service to help people, not to kill them.

Less than a year later, attached to the Marines of Company G, 2nd Battalion, 5th Marines, 1st Marine Division, HA1c Robert Bush was one of 482 corpsmen participating in the battle for Okinawa.

On May 2, 1945—thirty-two bloody days into the struggle to control the island—the rifle company under Bush's purview was waging an attack against heavily fortified Japanese positions. Marines were falling like flies, and cries for "Corpsman! Corpsman!" rose continually above the smoke of artillery fire and mortars. Dodging bullets and grenades, Bush moved from one wounded man to another, patching them up as best he could.

As his Marines pushed the assault over a hill, Bush ran to the aid of a fallen officer, who was lying in the open at the top of the ridge. He was administering plasma to the severely wounded man when the Japanese began to counterattack, with a vengeance. Within a matter of seconds, the nineteen-year-old corpsman was hit with three enemy hand grenades. The first took out his eye. He put up his arm, shielding his other eye, receiving a spray of grenade fragments in his shoulder.

Fifty years later, in his interview for the book *The Greatest Generation*, Bush told author Tom Brokaw: "I remember thinking as the Japanese were attacking, 'Well, they may nail me, but I'm going to make them pay the price.'"

With the blood plasma bottle held high in one hand, Bush drew his pistol with the other and fired at the advancing enemy until he ran out of ammunition. He then picked up a discarded carbine and, in the words of his citation, "trained his fire on the Japanese charging point-blank over the hill, accounting for [the deaths of] six of the enemy despite his own serious wounds."

Refusing medical treatment for himself until his patient was evacuated, Bush collapsed from his wounds while trying to walk to an aid station.

Following the war, Bush married his hometown sweetheart, completed high school, and scrounged up several hundred dollars to buy a friend's lumberyard in South Bend, which over the years he built into a multimillion-dollar franchise. Despite the loss of his eye, Bush managed to earn a pilot's license and often flew fellow Medal of Honor recipients on salmon-fishing trips. He remained active in veterans' causes for the rest of his life.

Robert Bush, the youngest Navy Medal of Honor recipient from World War II, died in 2009 at the age of seventy-nine.

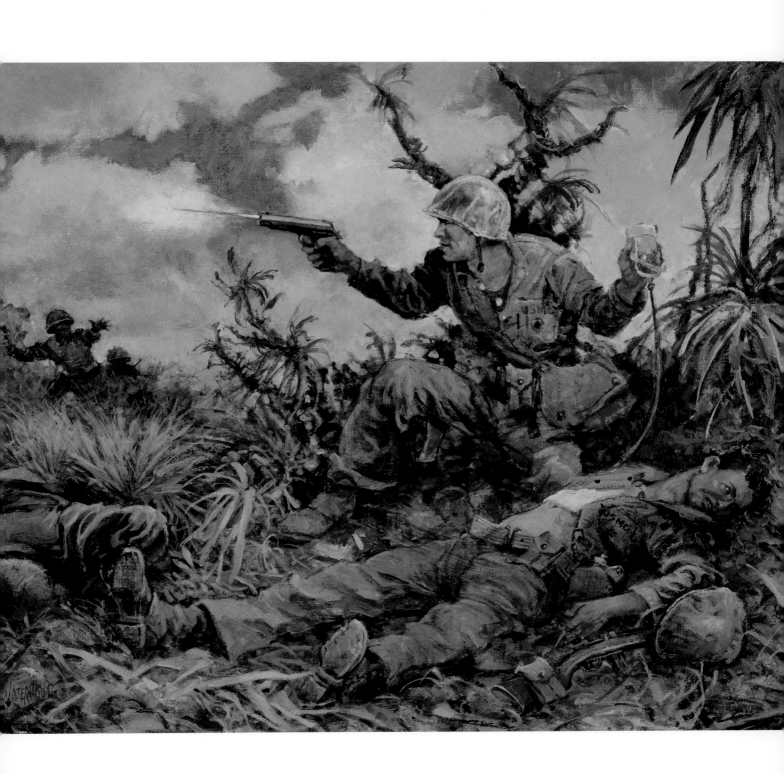

PFC WILLIAM FOSTER, USMC[79]
Okinawa, May 4, 1945

"Make them count."

Those words—whispered by the dying captain in *Saving Private Ryan*—were first uttered by a brave young Marine during the battle for Okinawa.

His name was William Adelbert Foster, and he was born on February 17, 1915, in Garfield Heights, a suburb of Cleveland, Ohio. One of six children, William attended vocational high school, with an eye toward becoming a machinist. After graduating, he found work as a planer and shaper at Star Machine and Tool Company and at Automatic Screw Machine Company, both in Cleveland, while serving in the Ohio National Guard. As the sole support of his family, William Foster was exempt from service, but he felt strongly about doing his part.

April 1 would prove to be a fateful day for the patriotic young man.

On April 1, 1944, after six years with the Guard, Foster enlisted in the Marine Corps Reserve though the Selective Service.

On April 1, 1945, PFC Foster saw his first combat, landing as a rifleman with Company K, 3rd Battalion, 1st Marines, 1st Marine Division, on Okinawa.

A month later, on May 2, Foster and another Marine were engaged in a fierce hand grenade volley with enemy infiltrators who had penetrated their company lines. When a Japanese grenade landed in their foxhole, out of reach, and with no time to lob it back, Foster dove on it, shielding his companion from the explosion. Although mortally wounded, Foster was able to hand his two remaining grenades to his fellow Marine. "Make them count," he said hoarsely.

On August 19, 1946, the then commandant of the Marine Corps, Gen. Alexander A. Vandegrift—himself a recipient of the nation's highest honor—presented Foster's parents with his posthumous Medal of Honor in a ceremony at the Cleveland City Hall. Foster's remains were returned to the US in 1949, and reinterred in Cleveland's Calvary Cemetery.

In 1990, a special Medal of Honor headstone was erected on his gravesite.

Waterhouse's painting of Foster was never finished, but there is still a raw power to it.

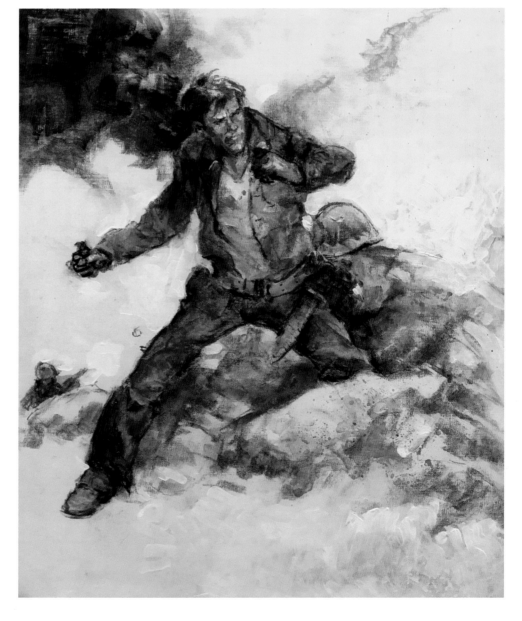

SGT. ELBERT L. KINSER, USMCR[80]
Okinawa, May 4, 1945

Elbert Kinser was born on October 21, 1922, in Greeneville, Tennessee. He worked on his father's farm prior to joining the Marine Corps.

"He was a farm boy," said the director of the Nathanael Greene Museum in downtown Greeneville, which now houses a display of Kinser's Medal of Honor and his other Marine memorabilia. "He was just a good old Greene County farm boy who left the farm and went to the South Pacific in World War II."

In December 1942, the twenty-year-old "good old farm boy" enlisted in the Marine Corps. Despite his apple-cheeked face and open smile, Kinser proved to be a tough, competent Marine. He was promoted to sergeant and saw action as a rifleman with the 1st Marines at Cape Gloucester and, later, during the Battle of Peleliu.

Landing on Okinawa on Easter Sunday, April 1, 1945, as a leader of a rifle platoon with Company I, 3rd Battalion, 1st Marines, 1st Marine Division, Sgt. Kinser led his platoon during the bloody month long campaign to push the Japanese to the far end of the island.

On May 4, Kinser and his rifle squad were advancing to take a strategically important ridge when they came under fire from a hostile position on the opposite slope. Although wounded in the leg, Kinser continued to engage the enemy in a fierce hand grenade duel. A corpsman and three litter-bearers ran to his aid, loading the wounded sergeant onto a stretcher, but before they could move to a place of safety, a hostile grenade landed in their midst. Kinser leapt from the stretcher, covering the missile with his body, giving his life so that his comrades might live.

On July 4, 1946, Kinser's posthumous Medal of Honor was presented to his parents by a future Marine commandant, Maj. Gen. Clifton B. Cates, in a ceremony at the Marine Barracks in Quantico, Virginia.

In 1949, Elbert Kinser's remains were returned to his hometown. The good old Greene County farm boy now rests in the Solomon Lutheran Cemetery in Greeneville, Tennessee.

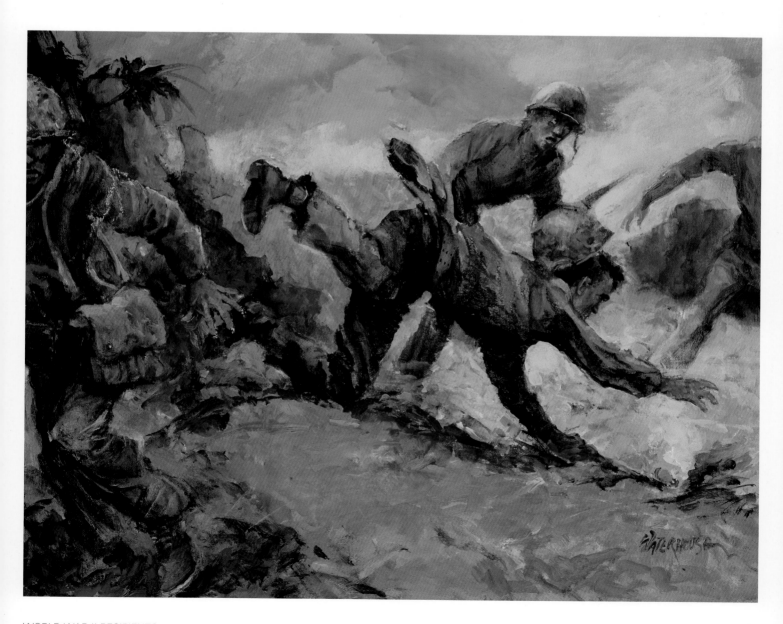

PVT. DALE HANSEN, USMC[81]
Okinawa, May 7, 1945

Dale Merlin Hansen was born on December 13, 1922, in Wisner, Nebraska. Growing up on his family's farm, Dale's closest friends were his three brothers. There was only a year separating Dale from his brother Donald, and they worked together, played together, and always had each other's backs. Dale graduated from Wisner High School in 1940. For the next four years, while the war in Europe and the South Pacific raged, Dale worked on the Hansen farm. In 1944, he received notice that the Marines had drafted him for service. Both he and brother Donald decided to enlist.

Inseparable since birth, the two brothers trained together and were assigned to the same unit. Dale exhibited skill on the Browning Automatic Rifle and earned an Expert Automatic Rifleman's badge.

On November 12, 1944, the two Private Hansens—Dale and Donald—sailed to the Pacific theater. A month later, they joined Company E, 2nd Battalion, 1st Marines, 1st Marine Division, at Pavuvu in the Russell Islands, where they underwent bazooka training and prepared for amphibious landings. On Pavuvu, the brothers saw their first combat.

Easter Sunday 1945 would be, for the Marines of the 1st Division, forever remembered as L-day, Okinawa—called such to prevent prebattle planning confusion with the D-day planning for Iwo Jima. During the initial phase of the assault, Pvt. Donald Hanson was severely injured in a land mine explosion. Although he survived, his injuries were so severe he was immediately evacuated. Dale never knew what became of his younger brother, or whether he was alive or dead. As he continued to fight along with Company E, thoughts of Donald must never have been far from his mind. But once the 1st Marines turned southward, toward the enemy fortifications at the center of the island, Hansen had no time to look back; he could only advance—often a yard at a time—in the face of ferocious fire from enemy positions dug deep into the island.

On May 7, Company E was stalled on the approach to Hill 60, a 200-foot rise studded with enemy pillboxes and mortar positions and heavily necklaced with artillery trenches. Acting on his own initiative, Pvt. Hansen crawled across an open area with his rocket launcher, firing upon and destroying, a Japanese pillbox. When his weapon was disabled, Hansen coolly grabbed a rifle and staged a one-man charge on the ridge, engaging the six Japanese soldiers who had been firing from the crest and causing hell for his platoon. He killed four of them before his rifle jammed. Thinking quickly, he used his rifle butt to light into the remaining enemy soldiers, taking them down, then he climbed down the hill to get another weapon and grenades.

Hansen remained at the lead of his company's assault on Hill 60, charging the ridge in a second one-man attack and destroying an enemy mortar position.

Four days later, on May 11, twenty-two-year-old Pvt. Dale Hansen was struck down and killed by an enemy sniper. News of Dale's death was delivered to his brother, Donald, in the California hospital where he would spend the next two years, recuperating from his wounds.

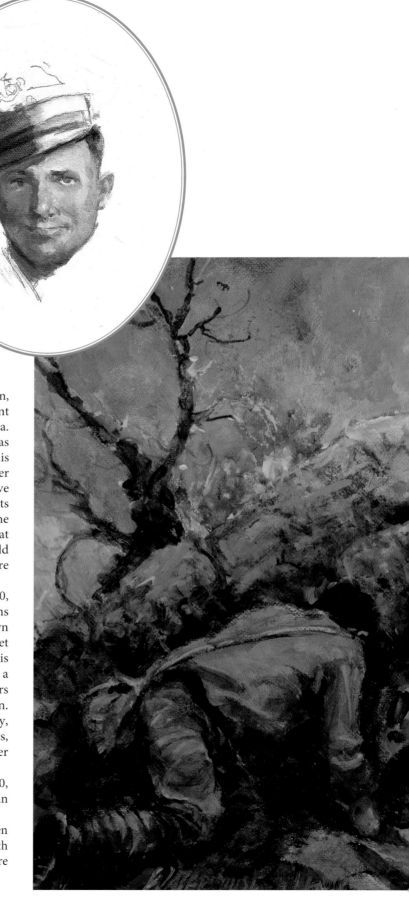

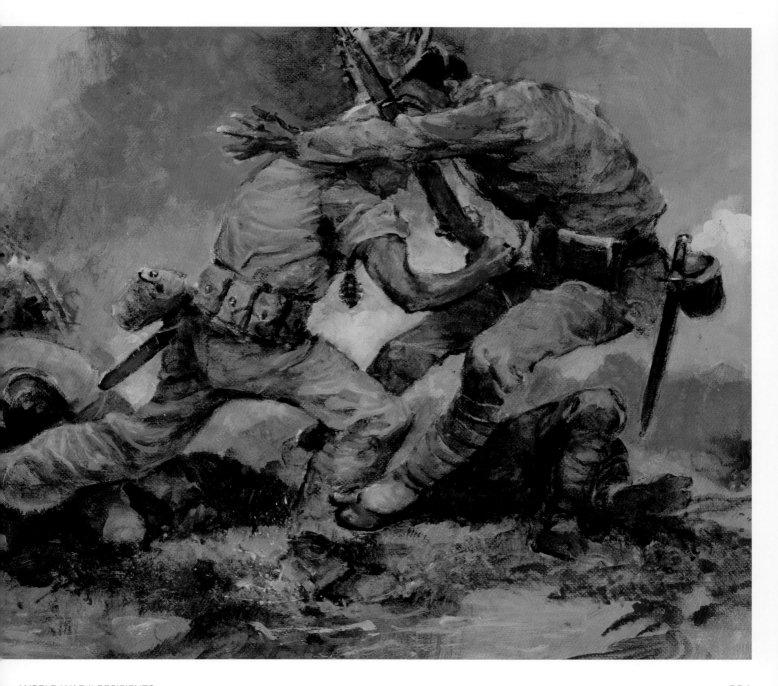

CPL. JOHN P. FARDY, USMC[82]
Okinawa, May 7, 1945

John Peter Fardy was born on August 15, 1922, in Chicago, Illinois. Newly arrived in the US from Ireland, John's parents took their heritage seriously. A good Catholic upbringing and education were imperative to them—as was the proper pronunciation of their name: FAR-day, from the Gaelic name O'Fearadaigh.

Young John was described as a "nice, quiet kid." Unlike many of his fellow Medal of Honor recipients, he didn't play sports or get involved in activities as a boy. John's C grades were just enough to secure him a spot at the lower bottom third of his class in the Christian Brothers–run high school he attended, where the motto was "*Facto Non Verba . . . Deeds Not Words.*"

After graduation, John drifted, attending a course at a secretarial college and taking classes in mechanical engineering before finding a job as a draftsman. His quiet, workaday life was interrupted, however, when, at the age of twenty-one, Fardy was drafted into the Marines.

In the space of ten months between December 1943 and October 1944, PFC John Fardy would see combat as an automatic rifleman during two bloody campaigns in the Pacific, battling his way through swamps, monsoons, and mangrove forests at Cape Gloucester and routing Japanese from the caves and coral ridges on Peleliu.

Along the way, the kid who'd always been content to stay in the background emerged as a leader. Assigned as a squad leader with Company C, 1st Battalion, 1st Marines, 1st Marine Division, the newly promoted corporal headed off to his next campaign: the assault on Okinawa.

On May 6, 1945, Cpl. Fardy's squad came under attack near the heavily defended enemy fortifications around the Asa Kawa River. They fell into defensive positions behind a drain ditch, which provided some cover from enemy artillery fire. Knowing the Marines were pinned down, the Japanese soldiers started throwing grenades. When an enemy missile landed in the ditch among his men, Cpl. Fardy jumped on it, shielding his companions from the explosion. The damage to Fardy's chest and abdomen was so severe that he succumbed to his wounds the next day.

Cpl. Fardy was the last Marine in World War II to sacrifice his life for his comrades by hurling himself on a hostile grenade. During his two years in the Marine Corps, John Fardy—who in four years of high school never won an award in the classroom or on the playing field—had exhibited the qualities of leadership and courage that would ultimately earn him the nation's highest honor. "*Facto Non Verba . . . Deeds Not Words.*"

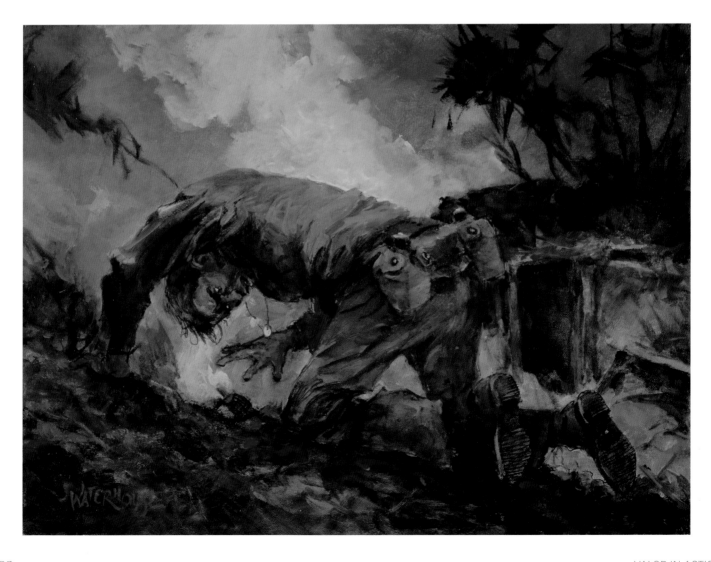

PFC ALBERT E. SCHWAB, USMCR[83]
Okinawa, May 7, 1945

Albert Schwab was born July 17, 1920, in Washington, DC. The Schwabs moved to Tulsa, Oklahoma, when Albert was a boy. Family members described him as a cheerful, athletic young man, with a zest for life and a dash of the daredevil that sometimes got him into trouble. According to local lore, Albert and his friends once created a homemade diving helmet. Albert volunteered to do a test run. He strapped the helmet on, jumped into the Arkansas River, and nearly drowned.

After graduating from Central High School in 1938, Albert spent one semester at the University of Tulsa before heading off to work in the oil fields.

Albert Schwab didn't necessarily have to go to war. He was a married man with a young family and a good job working in the oil fields—an industry important to the war effort. By 1944, the tide of World War II was turning in the Allies' favor, and although another year of hard fighting was still ahead, Schwab probably could have sat out that fighting.

But, in the spring of 1944, he chose to volunteer for the Marine Corps. His fourteen-year-old sister, JoAnn, was heartbroken. Albert had always been a hero to her, and in her eyes, he didn't need to put on a Marine uniform to prove it.

But prove it he did.

On May 7, 1945, twenty-four-year-old PFC Albert Schwab was serving as a flamethrower operator with Headquarters Company, 1st Battalion, 5th Marines, 1st Marine Division, on Okinawa, taking part in the attack on Shuri Castle. Hidden deep within the bowels of the castle was the command center of Japanese lieutenant general Mitsuru Ushijima, but an intricate line of enemy defenses laced throughout the coral ridges and cliffs surrounding Shuri were preventing the 5th Marines from making any meaningful gains.

During the heavy fighting, Company H became pinned down by enemy machine gun fire emanating from a ridge in front of them. With steep cliffs protecting both sides of the hostile emplacement, a flanking move would be futile; PFC Schwab knew the only way to neutralize the threat was to attack from the front and burn the enemy out. He picked up his 75-pound flamethrower and charged up the summit, shooting flames directly into the machine gun nest. Low on fuel, but seeing that a second machine gun had opened up fire on his unit, Schwab continued to press his attack, burning out the second enemy position before a fatal bullet to his left hip cut him down.

A year later, on May 27, 1946, RAdm. Joseph J. Clark presented Schwab's posthumous medal to his three-year-old son, Steven, during a Memorial Day ceremony at Boulder Park in Tulsa.

On October 3, 1959, a Marine camp constructed on Okinawa was named Camp Schwab.

The hero's son, Steven Albert Schwab, passed away in 2007.

In 2011, a larger-than-life-size bronze statue was unveiled at Tulsa International Airport. It shows Albert Schwab in his Marine uniform, down on one knee, hugging his little sister JoAnn goodbye before he heads off to war.

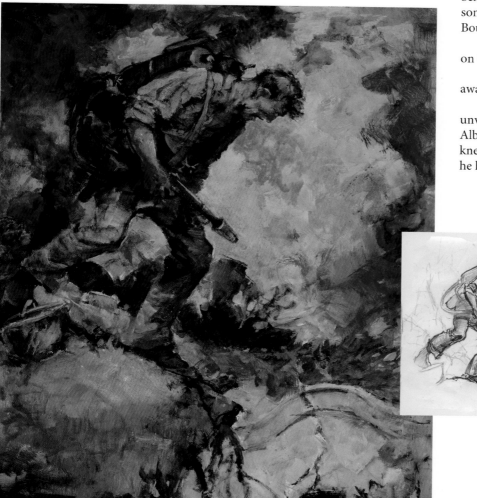

PhM2c William Halyburton Jr., USN[84]

Okinawa, May 10, 1945

On Saturday, October 11, 2003, a crowd of people gathered on the campus of New Hanover High School in Wilmington, North Carolina, for the unveiling of a masonry monument recognizing two of the school's most distinguished alumni. New Hanover is believed to be the only high school in the country with the distinction of having two Medal of Honor recipients: Army 1Lt. Charles Murray Jr., a graduate in the Class of 1938, received the medal for his actions in Alsace, France; Pharmacist Mate 2nd Class William Halyburton Jr., a USN graduate of the Class of 1943, was awarded a posthumous Medal of Honor for giving up his life to save a Marine during the battle of Okinawa.

For those who remembered Billy Halyburton, this day was long overdue. "For fifty-eight years, our community had failed in honoring Halyburton," said retired Navy captain and historian Wilbur D. Jones Jr., who was the chairman of the event.

The monument, and the later dedication of Halyburton Park in Wilmington, was the community's way of ensuring that the name of William Halyburton would live on.

Born on August 2, 1924, in Canton, North Carolina, in his youth Billy moved to the Winter Park section of Wilmington, where he lived with his aunt and uncle and regularly attended services with them at the Winter Park Presbyterian Church. Fellow classmates at New Hanover High described Halyburton as a natural leader who served on student council, acted in school plays, played varsity basketball and baseball, and impressed friends with his "low-key, deeply religious convictions."

After graduating from New Hanover, Halyburton entered seminary at Davidson College in Davidson, North Carolina. He felt called to be a minister, but for everything there is a season, and in August 1943, Billy Halyburton heeded another call: to serve his country. He enlisted in the Naval Reserve and began a rigorous course of training to become a Navy corpsman.

On Easter Day, April 1, 1945, Pharmacist Mate Second Class Halyburton landed with 2nd Battalion, 5th Marines, 1st Marine Division, on Okinawa. Serving with a rifle company, Halyburton would experience weeks of brutal fighting. By the end of the battle, overall Marine Corps casualties—ground, air, and ships' detachments—would exceed 19,500; additionally, 560 members of the Navy Medical Corps attached to the Marine units were killed or wounded. Gen. Lemuel C. Shepherd Jr., commanding the 6th Marine Division during the campaign, described the corpsman of Okinawa as "the finest, most courageous men that I know."

By May 10, the 5th Marines had been slugging through the hellish broken ground they called the Awacha Pocket for a week. Casualties were high, keeping corpsmen such as Billy Halyburton constantly on the run. When a Marine fell wounded at the far side of Wana Draw, Halyburton grabbed his medical kit and rushed off across the fire-swept terrain. Immediately upon reaching him, the corpsman began rendering first aid. When the wounded man was struck by another enemy bullet, Halyburton used his body to shield the Marine. The corpsman resolutely continued to administer medical help while being slashed by shrapnel and riddled with bullets, until he eventually succumbed from his wounds and collapsed, giving his own life so that one more wounded Marine might live.

Colonel Waterhouse lived long enough to paint all the corpsmen Medal of Honor recipients in World War II—except Billy Halyburton, the hero who for a great many years had been forgotten in his own hometown. The artist did, however, leave behind a painting of a Marine rifleman charging an Okinawan turtleback tomb. One of the island's many ancestral tombs, built in the shape of a woman's womb, these "womb tombs," were a favored place for Japanese soldiers to hide. A scene like this would have been all too familiar to PhM2c Halyburton: Marines who approached these tombs were often cut down by artillery or grenade fire, and yet they stood fast, in the face of death, with faithfulness and resolute courage, as did Billy Halyburton, who wanted nothing more than to minister and serve his fellow man.

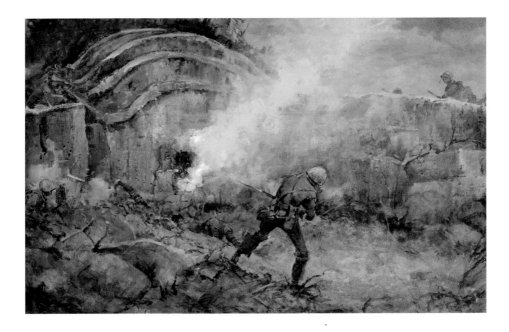

CPL. LOUIS J. HAUGE JR., USMCR[85]
Okinawa, May 14, 1945

Louis Hauge Jr. was born on December 12, 1924, in Ada, Minnesota. Although Louis was an avid athlete who participated in many sports, like many boys who grew up during Great Depression, he had to put aside playing games and start earning his keep at an early age. After completing his first year of high school, Hauge took a job in a canning factory, where he worked his way up to assistant foreman. A few years later, he moved out west in search of better opportunities, finding employment as a painter in a shipyard in Tacoma, Washington.

On August 23, 1943, Hauge was inducted into the Marine Corps Reserve. Upon completing his basic training and attending light-machine-gun school at Camp Elliott, California, Hauge shipped out with the 1st Marine Division, heading to New Caledonia and New Guinea. The following year, PFC Hauge saw his first combat action as a message runner with Headquarters Company, 1st Battalion, 1st Marines, on Peleliu, where he demonstrated bravery under fire and was given a meritorious promotion to corporal.

As American forces advanced from stage to stage across the Pacific theater, enemy resistance had become ever more fanatical, with most Japanese soldiers choosing to fight to the death rather than surrender. By the time the Marines landed on Okinawa in the spring of 1945, combat levels between the two opposing forces were reaching a fevered, bloody climax. The battle for the island would ultimately claim the lives of more than 12,000 US servicemen and about 90,000 Japanese combatants.

Yet, no matter how far back the Marines pushed, on May 14, 1945, the Japanese defenders on the southern end of the island were showing no signs of backing down. All day, the men of Company C, 1st Battalion, 1st Marines, 1st Marine Division, had been waging an assault against a strongly fortified, enemy-held hill, only to be pinned into place, on the receiving end of a barrage of enemy mortar and machine gun fire.

With the dusk gathering around them, and the Japanese still pouring enfilade fire into their ranks, Cpl. Louis Hauge, serving as the leader of one of the company's machine gun squads, spotted two of the enemy positions responsible for inflicting this heavy rain of pain on the Marines. He decided to take the initiative. After ordering his squad to provide cover fire, Hauge charged across an open area as bullets whizzed around. Despite being wounded, Cpl. Hauge launched a single-handed grenade attack against the first Japanese emplacement, destroying it before moving fearlessly toward the second hostile machine gun nest, which Hauge managed to demolish with grenades before being cut down by enemy sniper fire. He was twenty-one years old.

Many Marines bound for Vietnam will recall transiting through Camp Hauge on Okinawa. That installation was eventually closed, but in 2018, the regimental headquarters building of Combat Logistics Regiment 35 at Camp Kinser on Okinawa was renamed Hauge Hall, in a ceremony attended by members of Louis Hauge's family.

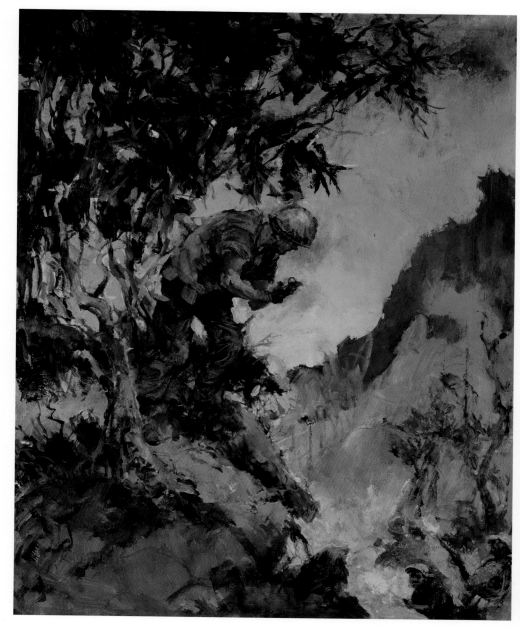

MAJ. HENRY A. COURTNEY JR., USMCR[86]
Okinawa, May 14–15, 1945

Henry Courtney Jr. was born January 6, 1916, in Duluth, Minnesota. The youngest in a family of four children, Henry received his bachelor's degree from the University of Minnesota, and his law degree from Loyola University Law School in Chicago. In 1940, Courtney joined his father's law firm and was admitted to practice law in Illinois and Minnesota. That same year, the young attorney was commissioned as a second lieutenant in the Marine Corps Reserve, having contacted a recruiter and begun the process while he was still in school.

In March 1940, 2Lt. Courtney was placed in command of the Duluth unit of the Marine Corps Reserve, which was soon mobilized and sent to San Diego for training. After serving an assignment in Iceland for ten months with Company I, 6th Marines (Rein), 1st Marine Brigade, Courtney went on to participate in the first US offensive of World War II, as the commanding officer of Company K, 3rd Battalion, 2nd Marines (Rein), in the 1st Marine Division at Guadalcanal.

After Guadalcanal, the newly promoted Maj. Courtney returned stateside; then, serving as executive officer of the 2nd Battalion, 22nd Marines, 6th Marine Division, he was headed to his next campaign: the Battle on Okinawa. On that island, the 6th Marine Division would come up against a heavily defended complex of three peaks that, before it was secured, would be bathed in American blood. The Marines called the 50-foot mound at its center Sugar Loaf Hill.

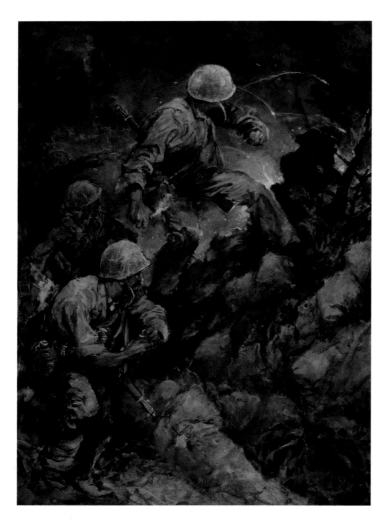

Surrounded by a barren 300-by-300-yard killing zone covered by some 2,000 Japanese soldiers with hundreds of machine guns, mortars, grenades, and satchel charges, Sugar Loaf was flanked to the right by two lower ridges: Horseshoe to the south and Half Moon to the southeast. Further compounding the attacking Marines' challenges, Japanese artillery from Shuri Heights rained down artillery fire.

The Marines repeatedly assaulted Sugar Loaf, taking heavy casualties and being driven back each time they advanced. On May 14, 1945, elements of the depleted 2nd Battalion, 22nd Marines, were ordered to take the peak at "all cost." All day the Marines tried to advance but were pushed back. Just prior to dusk, 150 Marines—spearheaded by four Sherman tanks—charged across the barren ground. Enemy tank guns and a mine quickly knocked out three of the tanks; only a small group of Marines made it through the ferocious enemy fire to the base of Sugar Loaf. They huddled together as mortars burst all around them.

In the gathering gloom, they heard the quiet, rallying voice of their twenty-eight-year-old battalion executive officer, Maj. Henry Courtney, the Minnesotan attorney who had left a promising career in his father's law practice five years before to become a Marine. Courtney addressed the Marines calmly, building his case. If we don't take the hill tonight, he told them, the Japanese will drive us back in the morning. Courtney proposed that they turn the tables on the enemy by making a banzai charge up the hill. Then he asked for volunteers.

Half of his men volunteered on the spot. Out of the darkness, another twenty-six Marines appeared with ammunition and supplies. Courtney organized the fresh troops and his volunteers into an assault team of forty-five Marines. Under the cover of night, they climbed Sugar Loaf, tossing grenades into caves and crevasses as they went, losing men to the heavy artillery and mortar fire coming from Horseshoe, Half Moon, and the Shuri Heights. By midnight, Courtney's battered assault force had made it two-thirds of the way to the top. As they paused to rest, Courtney heard voices—a large group of Japanese soldiers had emerged from a cave on the reverse slope and were assembling for an attack, from under the Marines' position. In hushed tones, the major directed his men to take all the grenades they could carry to the edge of the promontory.

The Marines charged, hurling grenades onto the enemy, blasting them off the cliff. "Keep 'em coming! There's a mess of them down there!," cried Courtney. Those were his last words. Just then, a mortar round hit the boulder where the major was standing. He was killed in the blast. Inspired by their fallen leader, the Marines kept tossing grenades, slaughtering the majority of the Japanese soldiers and driving others back into their holes. Then they hunkered down as the skies opened with a cold, drenching rain.

At dawn, when survivors of the assault staggered off Sugar Loaf, there were only twenty Marines left. One of them who went up the hill with Courtney recalled his actions that night, saying, "You always hear from the officer in charge, 'All right men, move out.' And what Henry said is 'I'm going up that hill. Who's going to follow me?'"

CPL. JAMES L. DAY, USMC[87]
Okinawa, May 14–17, 1945

James "Jim" Day was born October 5, 1925, in East St. Louis, Illinois. He enlisted in the Marines in 1943 at the age of seventeen and participated in the Battle of Guam before being promoted to corporal and assigned as a machine gun squad leader with Weapons Company, 2nd Battalion, 22nd Marines, 6th Marine Division, headed to Okinawa in the Ryukyu Islands.

From May 14 to 17, 1945, Cpl. Day and a small group of Marines maintained a courageous three-day stand in a shell crater on the northern slope of Sugar Loaf Hill, fighting off continual assaults by scores of enemy soldiers, all while under heavy artillery and mortar fire from Japanese emplacements embedded in the two surrounding peaks.

During that first night, nineteen-year-old Day repelled three more enemy attacks, enduring cold, unrelenting rain and braving bullets and mortar fire to carry four wounded comrades, one by one, to safety. He then resumed his position to continue the fight.

Only Cpl. Day and one wounded Marine survived to see the dawn. Throughout the day and night of May 16, Day fought off attack after attack. By this time, his skin had been scorched by white phosphorus from friendly fire, and his body was pierced by enemy shrapnel, and yet the corporal resolutely held his ground, hauling ammunition from a disabled vehicle back to his shell hole to maintain his one-man battle against the Japanese attackers for another forty-eight hours. When Cpl. Day was finally relieved three days later, the Marines found him on the ground, unconscious after being knocked out by an exploding artillery shell, and surrounded by the dead bodies of more than 100 enemy soldiers.

"There was really no good reason for me to fall back," Day said later. "I expected help to come at any time. It just never came, so I kept doing what I was doing."

Day remained in the Marines and rose through the ranks, commanding combat troops in Korea and Vietnam and holding commands in Japan, San Diego, and Washington and at Camp Pendleton. Almost forty years after the battle, now a major general, Day returned to Okinawa as the commander of all the Marine Corps installations on the island, providing support for the operating forces forward deployed on the island.

Because most of the Marines who saw his bravery had died during that fight on Sugar Loaf, or shortly thereafter, James L. Day would wait almost a half century to receive the Medal of Honor for his actions on Sugar Loaf. In 1995, lost papers containing the statements from eight witnesses were discovered. On January 29, 1998, President William Jefferson Clinton presented then Maj. Gen. James Day with his long overdue Medal of Honor. Nine months later, Jim Day died of a massive heart attack. He was seventy-four.

PVT. ROBERT M. McTUREOUS JR., USMC[88]

Okinawa, June 7, 1945

Robert McTureous Jr. was born on March 26, 1924, in Altoona, Florida, and grew up in nearby Umatilla. After graduating from Umatilla High School at the age of sixteen, Robert spent an action-packed year at Brewton-Parker Institute, a private Christian college in Mount Vernon, Georgia, where he majored in mathematics and played on the varsity football and baseball teams. While there, McTureous also played the trombone, performed with the Glee Club and the Double Quartet, and participated in softball, tennis, and boxing.

In 1942, McTureous returned to Altoona, with the intention of enlisting in the Marines, but was turned down twice because of a hernia. He was designated 4F (unfit for duty). Since Uncle Sam wasn't going to pay for the operation to fix his disability, the committed young man took it into his own hands. He found a better-paying job and, with some help from his brother, was able to raise enough money for the surgery. During the procedure, however, the surgeon found a second hernia. "Son," the doctor told his dispirited patient, "since you're doing this to join the service, the next operation is on me."

Declared able for duty, McTureous joined the Marines in August 1944. He excelled in his training and qualified as a sharpshooter with both the M1 Garand and the Browning Automatic Rifle.

By June 7, 1945, Private McTureous was serving with Company H, 3rd Battalion, 29th Marines, 6th Marine Division, on Okinawa. While carrying out a mission to take an important hill on Oroku Peninsula, McTureous's rifle company met with heavy Japanese resistance. Fire from the enemy was so intense that the Marines couldn't evacuate their wounded. Unable to rescue their men, and unable to take the hill, they were clearly in a lose-lose situation. Pvt. McTureous decided to take action.

Packing his pockets with grenades, and jamming more explosives into his jacket, the 5-foot-6, 138-pound ex–football player charged up the hill, launching into a fast and furious one-man assault against enemy positions that distracted the Japanese long enough for stretcher-bearers to carry out the wounded Marines below.

Out of grenades but fired up on adrenaline, McTureous returned to his company and once again armed himself to the teeth. Moments later, he was back on the hill, going from enemy cave to enemy cave, tossing grenades into every entrance and deadly explosives into every

aperture. When he was hit in the stomach by a Japanese bullet, the young private stoically crawled to a place within friendly lines before asking for aid, because he didn't want to risk the lives of those who might try to rescue him.

McTureous was evacuated to a hospital ship, the USS *Relief*, where, on the morning of June 11, he died of his wounds. The actions of this one, committed young private, who had fought so hard to get into the Marines, and fought so hard *for* the Marines on that remote Pacific island, saved the lives of many of his wounded comrades and inspired his platoon to capture the hill and complete their mission.

On May 25, 2015, a beautiful new headstone, with porcelain insets depicting Pvt. Robert McTureous, along with the seals of the 6th Marine Division, the Marine Corps, and the Medal of Honor, was unveiled during a Memorial Day ceremony in McTureous's hometown of Umatilla. A Boy Scout and a seventy-three-year-old Marine veteran had spearheaded the project to raise enough funds to erect this lasting tribute to the World War II hero. And, like McTureous, they didn't quit until their mission was accomplished.

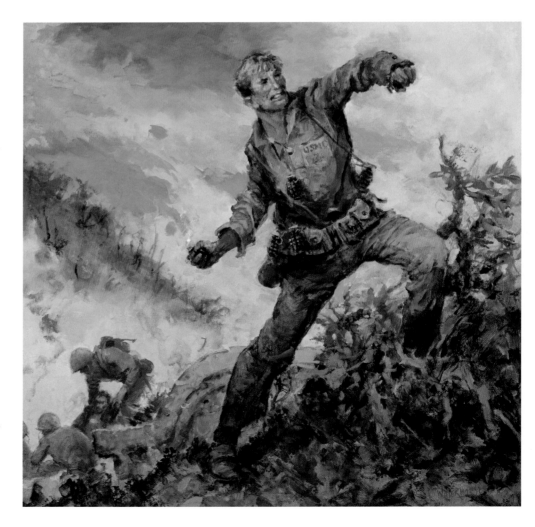

HA1C FRED F. LESTER, USN[89]
Okinawa, June 8, 1945

Fred Faulkner Lester was born on April 29, 1926, in the small village of Downers Grove, Illinois, 22 miles—and another planet away—from the hubbub of Chicago. The third son in a family of four boys and one girl, Fred's oldest brother joined the Army Air Forces, and his second oldest joined the Navy. Seventeen-year-old Fred chose to enlist in the Navy Reserve in November 1943 to train as a corpsman.

In January 1944, after completing his recruit training, Lester was promoted to seaman second class and transferred to the Naval Hospital Corps School in San Diego. He graduated in March with a rating of hospital apprentice second class and was sent for combat field training. By March 1945, Lester, now a hospital apprentice first class, was attached to the 6th Marine Division, headed for Okinawa Shima and the last great battle of World War II.

On June 8, 1945, while serving with an assault rifle platoon with the 1st Battalion, 22nd Marines, 6th Marine Division, during a fierce engagement with Japanese forces on that island, HA1c Lester spotted a wounded Marine lying in an open field beyond the front lines. Immediately, he began crawling toward the Marine, braving a torrent of fire from enemy machine guns, rifles, and grenades. Despite being wounded, Lester continued to doggedly inch forward until, finally, he reached the Marine. Ignoring his own pain, and the bullets whizzing around his head and ricocheting off the rocks, the corpsman managed to pull his comrade to safety before he was struck by another bullet. Lester had been highly trained and knew that this second wound would be fatal. He refused medical treatment, making the most of the little time he had left by instructing two Marines how to administer aid to the man he had rescued. As his life was ebbing away, nineteen-year-old Fred Lester did everything in his power to save the life of another.

In 1948, a newsletter published by the Downers Grove American Legion announced the election of Fred W. Lester—HA1c Lester's father—as their commander for 1949. The article stated that while their new commander's youngest son hadn't been old enough to participate in World War II, his three older boys served their country honorably. The eldest, a bombardier for the Army Air Forces, had been seriously injured in a midair collision during maneuvers prior to being sent to the European theater and was hospitalized for "quite some time." The second served in the Navy for the duration of the war. The third boy—named Fred after his father—who served with the Marines, had paid the supreme sacrifice, earning the Medal of Honor for his actions on Okinawa. In the accompanying photograph, Cmdr. Fred Lester stands at attention in his American Legion uniform; while his posture is proud, there is profound sadness in his eyes.

1LT. BALDOMERO LOPEZ, USMC[1]
Battle of Inchon, Korea, September 15, 1950

It's the most iconic photograph of the Korean War: two wooden ladders against a rugged seawall, jutting into an ominous sky of billowing smoke and exploding mortars. The ladder to the viewer's left hangs in the frame like an empty crucifix. On the ladder to the right, a lone Marine is caught just as he's pulling himself up over the embankment, captured forever in that one frozen moment head-and-shoulders-above, and several steps ahead of, the men standing in the landing craft below. The picture, taken on September 15, 1950, is of the Inchon landing. The Marine scaling the battlements is 1Lt. Baldomero López. And the words that the Marines of the 3rd Platoon, Company A, 1st Battalion, 5th Marines in the landing craft remember hearing as their lieutenant climbed up that ladder were: "Follow me!"

Baldomero López was born on August 23, 1925, in Tampa, Florida. "Baldy," as his family and friends called him, grew up in Ybor City, a vibrant neighborhood of Cuban, Spanish, and Italian immigrants, where his father, who had immigrated to the United States from Spain as a young man, worked in the thriving cigar industry. As a small, scrappy kid, Baldy dreamed of being a Marine, but he knew that dreaming could only take him so far, so he began to lift weights and follow the Charles Atlas program. It worked, and by the time he entered high school, López was an accomplished baseball and basketball player. His strong leadership abilities earned him the rank of regimental commander in the school's Junior Reserve Officers' Training Corps program. López enlisted in the United States Navy shortly after graduation, but was quickly tapped to attend the US Naval Academy. By his senior year at Annapolis, fellow midshipmen were predicting López's future success as a Marine officer. After years of hard work and determination, Baldy López was about to realize his dream.

On June 6, 1947, López was commissioned a second lieutenant in the Marine Corps. Over the next few years he was stationed at posts in the US and China. After the outbreak of the Korean War, López volunteered for duty as an infantry officer in Korea. He was promoted to the rank of first lieutenant on June 16, 1950. Three months later, López was off the coast of Korea with the 3rd Platoon, Company A, 1st Battalion, 5th Marines, 1st Marine Division. On September 14, 1950—the day before the Inchon landing—while he and his men waited restlessly aboard ship, López wrote a letter to his family. After asking his dad to send him some good cigars, his tone

turned serious. "Knowing that the profession of arms calls for many hardships and many risks, I feel that you all are now prepared for any eventuality," he wrote. "If you catch yourself starting to worry, just remember that no one forced me to accept my commission in the Marine Corps."

The next morning, Baldomero López boarded the LVCP that would carry him to the shores of Inchon harbor, and into the annals of Marine Corps history. Moments after he scaled the seawall, turning back to his men to yell, "Follow me," 1Lt. López entered a nightmare scene of sound and fury, as North Korean machine gunners opened fire, pinning down his Marines and trapping them in an exposed section of the seawall.

With his platoon taking heavy casualties, López again took the lead, rushing toward the enemy emplacement, a grenade at the ready. As he got within range, López pulled the pin and cocked his arm back with the grace of a skilled baseball player. It was at that moment that a spray of enemy bullets hit him, tearing through his arm and shoulder, and knocking him forward, causing him to drop the grenade. Falling to the ground in anguishing pain, López reached for the grenade, cradled it tightly to his chest, and smothered the blast with his body. He died instantly, but his selfless, split-second decision is credited with saving the lives of at least thirty men. Fernando López was twenty-five years old.

The telegram informing Mr. and Mrs. López of their son's death arrived a day after they received his final letter. On August 30, 1951, Secretary of the Navy, Dan A. Kimbell, presented López's parents with his posthumous Medal of Honor.

The Navy named an MSC Maritime Prepositioning Ship in López's honor. In 2006, when the crew of the *1st Lt. Baldomero López* sailed into his hometown of Tampa for the first time, they were met by members of the López family and a large gathering of Korean War veterans and Latino community leaders. Baldy's nephew, Mike López, born a year after his famous uncle lost his life in the Korean War, wasn't surprised by the turnout. "He was a son of an immigrant from Spain who went to the US Naval Academy and made something of himself," he said.

But to Marines, past and present, Fernando López will always be the brave lieutenant who scaled the ladder at Inchon and led his men over the rocky ramparts, crying, "Follow me!"

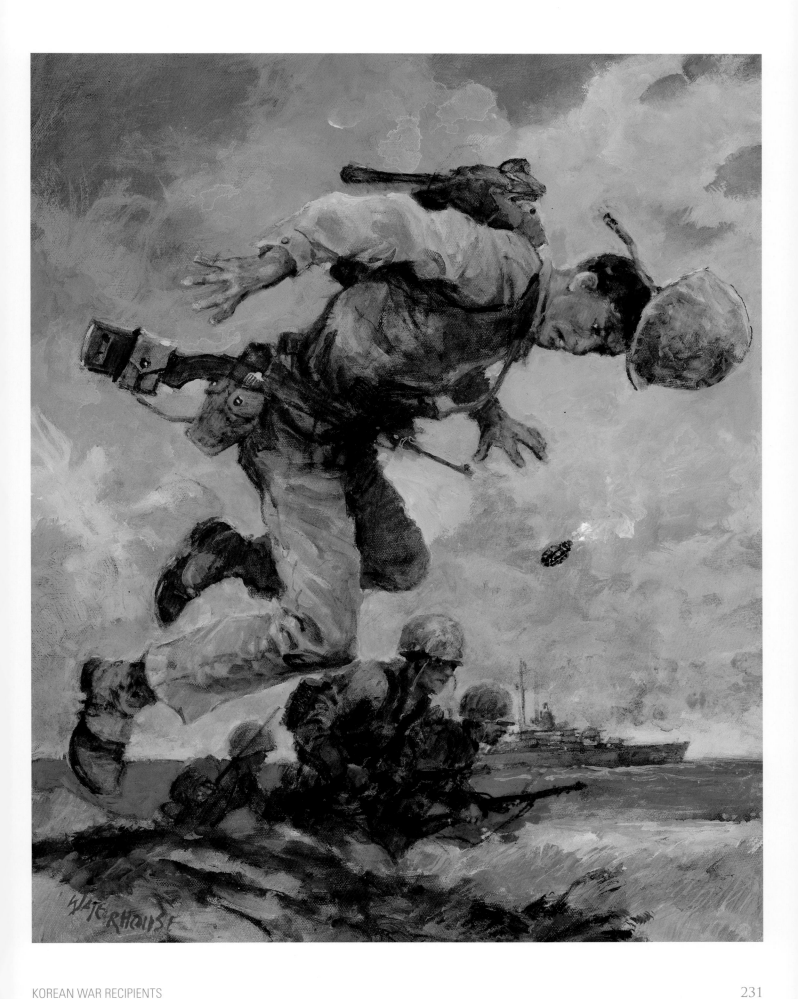

PFC WALTER C. MONEGAN JR., USMC[2]
Sosa-ri, Korea, September 17–20, 1950

They called him the Tank Killer.

Walter "Walt" Monegan Jr. was born on Christmas Day 1930, in Melrose, Massachusetts, seven miles north of Boston. At the age of sixteen, Walt dropped out of high school and enlisted in the Army, only to be discharged a year later when it was discovered he was underage. Upon learning that the Marines would accept a seventeen-year-old, he headed to Baltimore, Maryland, and enlisted. In his official Marine Corps photograph, Monegan stares coolly into the camera—chin up, oozing swagger, looking very much like another underage Marine, from an earlier war: Jack Lucas.

Monegan completed his training at Parris Island and sailed with the 3rd Marines for duty in China. By the following year, he was stationed at the Marine Barracks, Naval Air Station, in Seattle, Washington, where he met and married his wife, Elizabeth. Together they had a son, Walter Monegan III.

In July 1950, PFC Monegan was shipped to Korea with 2nd Battalion, 1st Marines, 1st Marine Division. After participating in the September Inchon Landing, his unit moved on toward Seoul.

On September 17, Monegan's company was dug in along a ridge overlooking the Seoul Highway when six North Korean tanks slammed into the Marine defensive line. Knowing that to effectively use his rocket launcher he'd have to get close, Monegan charged down the hill, taking a knee less than 150 feet from the lead tank, destroying it with one bazooka shot. Picking up his carbine, he shot the enemy crewmen as they emerged from the tank. Then he took up his bazooka again, fired off two more rounds, and blew the second vehicle to smithereens. At that point, Marine tanks were able to maneuver in and dispatch the remaining T-34s.

Three nights later, Monegan's unit was again in defensive positions when a large infantry-supported tank unit hit their lines. With five enemy tanks threatening to overrun the battalion command post, Monegan and another Marine advanced toward them, through heavy fire. Monegan hit the lead T-34 with a dead-on bazooka shot, destroying it, and quickly dispatched a second enemy tank. As he stood to engage a third, an illumination shell backlit him, and the nineteen-year-old tank killer was cut down by North Korean machine gun fire.

On February 8, 1952, Monegan's posthumous Medal of Honor was presented to his widow, Elizabeth. In her arms was their infant son, Walt III.

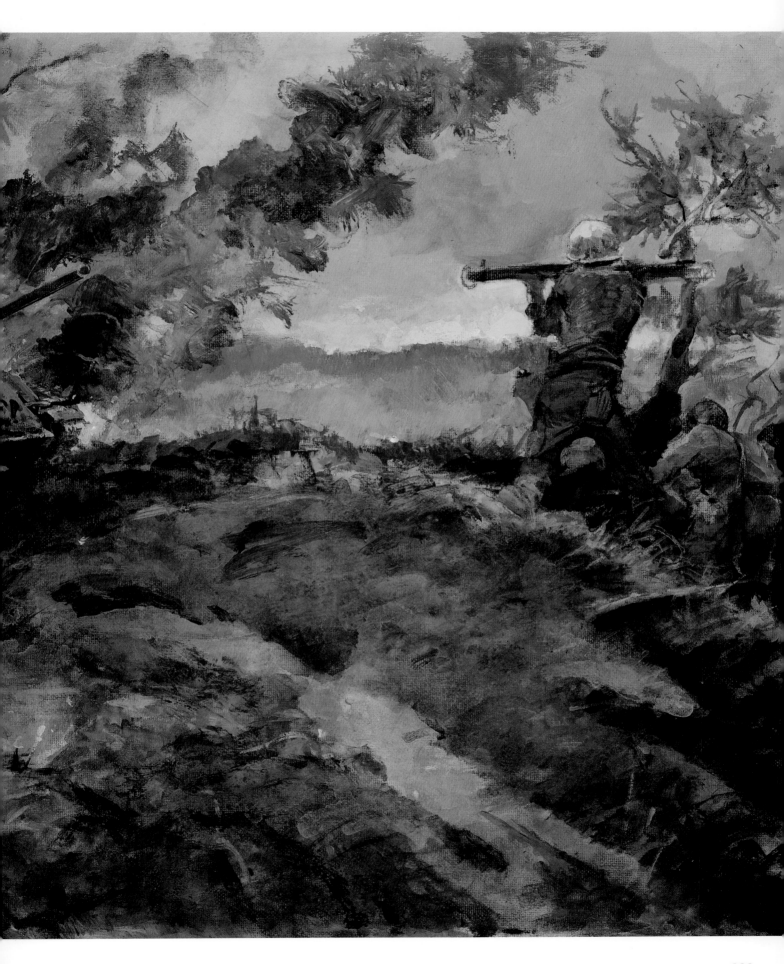

1Lt. Henry A. Commiskey Sr., USMC[3]
Yongdung P'o, Korea, September 20, 1950

In August of 1971, the cremated remains of Henry Alfred Commiskey, Sr. were scattered in the warm, silty waters of the Gulf of Mexico between Gulfport and Biloxi, Mississippi. Although he was only forty-four years old when he died, during those forty-four years Commiskey played a role in history, performing extraordinary acts of courage, above and beyond what an ordinary person would be expected to do.

The facts about Commiskey's personal life are few and far between. He was born on January 10, 1927, in Hattiesburg, Mississippi, and attended Sacred Heart Catholic School. He left school to work as a brakeman on the Illinois Central Railroad. On January 12, 1944—two days after turning seventeen—Commiskey joined the Marines. He spent twenty-one months serving in the Pacific during World War II. On February 19, 1945, Commiskey participated in the invasion of Iwo Jima. In that battle where "uncommon valor was a common virtue," he carved out a reputation as an uncommon Marine, receiving a Purple Heart and a Letter of Commendation for "high qualities of leadership and courage in the face of a stubborn and fanatical enemy."

A year later, while teaching in the tactics section at the Marine Corps Schools, Quantico, Virginia, Henry Commiskey volunteered for combat service in Korea. Serving as platoon leader in Company C, 1st Battalion, 1st Marine Regiment, 1st Marine Division (Reinforced), 2Lt. Commiskey took part in yet another iconic amphibious assault: the Inchon landing.

Five days later, on September 20, 1950, Commiskey's unit was in the neighborhood of Yeongdeungpo, on the southwestern outskirts of Seoul, with a mission of taking out the hostile forces dug in on Hill 85. Armed with only a .45-caliber pistol, 2Lt. Commiskey boldly took the lead, charging up the slope well in advance of his platoon. Without waiting for backup, Commiskey jumped into an enemy machine-gun nest, killing four of its five occupants, and engaged the fifth, a North Korean machine gunner in hand-to-hand combat, managing to hold the gunner down long enough to obtain a weapon from one of his men and finish the job. He then singlehandedly took out another hostile emplacement, leading his platoon in a complete rout of the enemy forces.

Commiskey emerged unscathed from the assault on Hill 85, but he was wounded a week later, and again on December 8, 1950. The second wound was serious enough for him to be returned to the United States for treatment. On August 1, 1951, in a ceremony on the White House lawn, President Harry S. Truman presented 1Lt. Henry A. Commiskey with the Congressional Medal of Honor, as his wife held their son Henry Jr., and daughter, Cassandra, looked on.

But Commiskey wasn't about to rest on his laurels. After training as a pilot and earning his wings in June 1953, he returned to Korea the next year with Marine Attack Squadron 212, Marine Aircraft Group 12, 1st Marine Aircraft Wing

Henry Commiskey died in August 1971, in Meridian, Mississippi. During his lifetime, he participated in two critical assaults that changed the course of history and made a courageous one-man stand for which he would receive the nation's highest honor. He'd earned wings and performed his duty, with every fiber of his being. And yet his last request was to have his ashes scattered into the waters and deep canyons of the Gulf of Mexico, as if, like Gen. George S. Patton, Commiskey believed that "all glory is fleeting" and after serving his duty, he wanted nothing more than to be a droplet in the tranquil waters off the Mississippi coast.

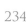

PFC EUGENE A. OBREGON, USMC[4]
Seoul, Korea, September 26, 1950

Eugene Arnold "Gene" Obregon was born on November 12, 1930, in Los Angeles, California, and raised in a largely Hispanic area of East Los Angeles, where Gene remembered by his sister, Virginia, as a popular kid who loved baseball, soccer, shadowboxing and working on cars. At Theodore Roosevelt High School, Gene was the kind of student both teachers and classmates liked. Athletic, witty, with a strong work ethic, Obregon also had a strong sense of patriotism. After graduating from high school in 1948—five months before his eighteenth birthday—he asked his father if he could join the Marines. Pedro Obregon reluctantly agreed. So on June 7, 1948, seventeen-year-old Gene enlisted in the Marines.

In August 1950, nineteen-year-old PFC Gene Obregon was in Korea, serving as a machine gun ammunition carrier with Company G, 3rd Battalion, 5th Marine Regiment, 1st Marine Division (Reinforced). By August 8, Obregon's company had already seen action along the Naktong River and participated in the Inchon landing. Over the next two months, Obregon who—except for his recruit training had never strayed farther than the neighborhoods of East L.A.—fought in the hills, rice paddies and streets of Seoul, where he distinguished himself as a dedicated, loyal and courageous member of his unit.

In his last letter home, written just two days before his death, Gene told his parents that Tony Medrano, one of his high school friends who had enlisted with him in 1948, and a favorite of the Obregon family, had been killed. "I saw him die," the anguished teenager wrote. Mr. and Mrs. Obregon were heartbroken to hear of the loss of such a fine young man. But the close-knit, loving family would have to endure much more in the days ahead.

On September 26, 1950, as PFC Obregon and the Marines of Company G were battling their way past bombed-out buildings along the barricaded streets and sniper-filled alleys of Seoul, a concealed North Korean force let loose with a deadly hail of small arms, machine gun and mortar fire. One of the first to get hit was PFC Bert Johnson. Seeing his buddy lying in the open, bleeding profusely from wounds in his head, arms and legs, Obregon shouted, "Hang on, Bert, I'm coming to get you."

Johnson yelled back, "Stay where you are!" but Obregon paid no attention. Armed only with his .45 pistol, he dashed down the middle of the street as hostile bullets whizzed through the air and enemy mortar exploded around him. He reached Johnson, and dragging him into a nearby ditch, began to bandage his friend's wounds. When a platoon-sized enemy force charged their position, Obregon grabbed Johnson's carbine and opened up fire on the onrushing troops, using his body as a shield to protect his wounded friend from the hail of hostile bullets. With the North Korean soldiers closing in, and his ammunition gone, Obregon pulled a grenade from his belt and stood to hurl it at his attackers. "That's when the machine gun got him," a platoon mate recalled. Shot twice in the face, the young hero, who had gone above and beyond to save his Marine brother, died instantly. Moments later, George Company wiped out the remaining North Korean attackers and rescued Johnson.

On August 30, 1951, Mr. and Mrs. Pedro Obregon received their son's posthumous Medal of Honor from Secretary of the Navy Daniel Kimball. Newly promoted SSgt. Bert Johnson, by then recovered from his wounds, attended the ceremony to honor the young Marine who had laid down his life so he might live. When asked what Obregon had said in the final moments of his life, Johnson replied, "He told me, 'Bert, if we're going down, we'll go down fighting like Marines.'"

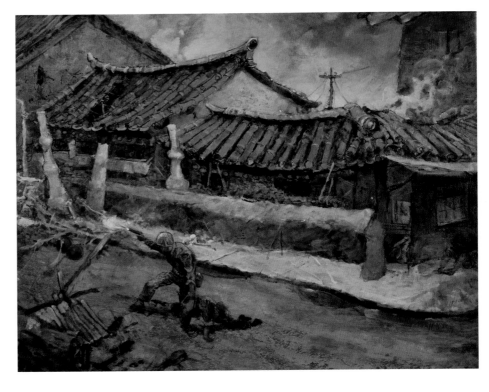

PFC STANLEY R. CHRISTIANSON, USMC[5]
Seoul, Korea, September 29, 1950

Stanley Reuben Christianson was born on January 25, 1925, in Mindoro, Wisconsin. Stanley and his eight siblings—five sisters, two brothers—grew up helping out on the family farm in Wet Coulee. After leaving school, Stanley tried farming for a while, but World War II was raging, and at age seventeen, Stanley enlisted in the Marines. While serving with the 2nd Marine Division in the Pacific, the young private took part in four major amphibious assaults: Tarawa, Saipan, Tinian, and the last major battle for Okinawa. For his actions, Christianson received a commendation for meritorious service.

Stanley went back home to Wet Coulee, but after what he'd experienced, the prospect of spending the rest of his life tilling and planting lost its appeal, so in March 1946, he reenlisted in the Marines. Over the next few years, Christianson served in a number of stations. When the conflict in Korea started, he volunteered for combat duty. In August 1950, PFC Christianson sailed to Korea as an automatic rifleman with Company E, 2nd Battalion, 1st Marine Regiment, 1st Marine Division (Reinforced), landing with his company at Inchon on September 15, 1950, and adding another amphibious assault to his already impressive World War II record.

On September 18, while his unit advancing along the road to Seoul, North Korean ambushers attacked the rear of the platoon. Reacting swiftly, Christianson stood, drawing enemy fire so he could pinpoint their positions and effectively direct the return fire of his fellow Marines. Because of his decisive action, the North Koreans cut bait and withdrew, enabling Company E to continue its advance, and earning the twenty-five-year-old private first class a Bronze Star for valor.

On September 28, 1950, Company E was at Hill 132, deploying into defensive positions in preparation for another long, hard night. Christianson and another Marine were stationed at a forward listening post covering the approach to their platoon's flank. As night's last gasp ebbed into the early hours of September 29, Christianson sensed movement in the darkness. He nudged his companion and signaled for him to run back to the platoon area and alert the command; then, without orders, Christianson continued to man his post, all alone, forward of the company line, as North Korean soldiers began filtering past him in the darkness. If he'd remained huddled and silent, they might have passed him by, but Christianson wanted to give his unit more time to prepare so he picked up his automatic rifle and opened fire.

Once the North Koreans discovered his position, they turned their weapons on the lone Marine, attacking the listening post with the full force of their automatic weapons, incendiary grenades and artillery fire. PFC Christianson bravely continued his one-man stand, keeping almost an entire enemy squad out of the fight, and buying enough time for his platoon mates to get into their fighting position. Before being swarmed and overrun, he managed to kill seven North Korean assailants, and wound several more. The twenty-five-year-old Marine was killed while manning his post after serving in Korea only fourteen days.

PFC Stanley Christianson—La Crosse County's only Congressional Medal of Honor recipient—now lies in the Wet Coulee Cemetery. A flagpole, donated and erected in 1978 by the Trane Company and the La Cross County Veterans Allied Council, stands watch over the Christianson family plot, the flag waving in the breeze over Stanley's headstone. It's a quiet place, far away from the noise of battle and the strife of war. The last burial there was that of Stanley's mother in 1974.

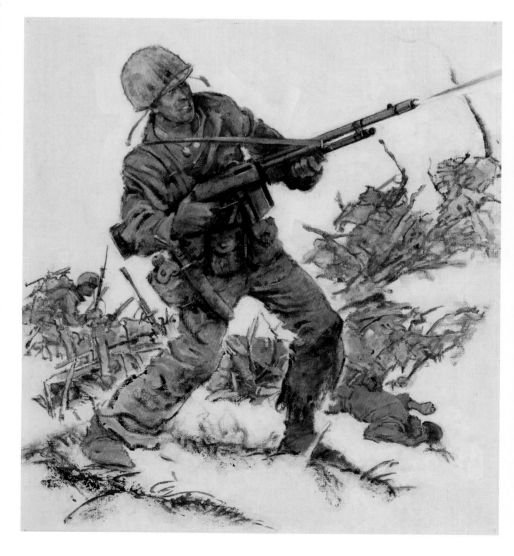

CPL. LEE H. PHILLIPS, USMC[6]
Chosin Reservoir, Korea, September 29, 1950

Lee Hugh Phillips was born on February 3, 1930, in Stockbridge, Georgia. He left school at age fifteen to work in Atlanta. On January 17, 1948, a few weeks before his eighteenth birthday, Lee enlisted in the Marine Corps Reserve. He joined the regular Marine Corps six months later. His official USMC photograph shows a self-possessed young Marine with a direct, slightly skeptical look in his eyes and the ready-steady gaze of a born leader. Phillips exhibited these qualities during his training because, in the fourteen months of his enlistment prior to being deployed to Korea, he was promoted twice.

On November 4, 1950, Cpl. Lee Phillips, serving as a squad leader with Company E, 2nd Battalion, 7th Marines, 1st Marine Division (Reinforced), was with his unit outside Sudong-ni, encountering fierce resistance from the entrenched North Korean forces holding Hill 698. The Marines' objective was clear: they needed to take the hill, wipe out the enemy emplacements and then continue the push toward the Chosin Reservoir. The North Korean defenders had other ideas, however, and after repelling five Marine assaults, still maintained a strong grip on the ridge.

Enter Lee Phillips: the young man whose steadfast gaze and calm demeanor seemed to convey that, when the chips were down, he would be someone you could count on. Cpl. Phillips gathered his squad, directed them to fix their bayonets onto their carbines and led them in a charge up Hill 698. It was an audacious move, but Phillips boldly drove the assault forward, rallying his Marines, and tenaciously moving them upward through an enemy bombardment so ferocious that only five of his men made it with him to the top. There, they came under attack by North Korean squad, intent on pushing the Marines off the hill. But the enemy had underestimated this young corporal's grit and determination.

Phillips charged directly into the hostile force, lobbing grenades and firing his rifle, inspiring his men to follow. Together, Phillips and four brave Marines managed to rout an entire North Korean squad. By now Phillips was down two fighting men, but he was far from done. One more hostile position remained, entrenched on a precipice at the crest of Hill 698 and manned by four North Korean soldiers. Lee Phillips figured it was a fair fight. Directing his remaining men to cover him, he began to climb toward the last North Korean emplacement, using one hand to pull himself up the rocky outcrops and the other to hurl grenades.

Phillips destroyed the enemy fortification, but he only had two squad members left. He barely had time to organize them in the stronghold before a squad-size enemy force counterattacked. Directing their fields of fire against an onslaught of North Korean soldiers who outnumbered them 5-to-1, Phillips and his two fellow Marines repulsed the attack. The Marines now owned Hill 698, and that portion of the road out of Sudong leading to the Chosin Reservoir was now open.

They didn't know it but the true crucible was still ahead of them. Although he survived the action on Hill 698, a few weeks later, on November 27, 1950, Cpl Phillips was killed at Yudam-ni. He was twenty years old.

At a ceremony held at the Pentagon on March 29, 1954, Secretary of the Navy Robert B. Anderson presented Phillips's posthumous Medal of Honor to his mother. Although Lee's body remains in the Chosin Reservoir, a white marble headstone with a Medal of Honor insignia dedicated in his honor stands in Marietta National Cemetery, in Marietta, Georgia. According to Marine Medal of Honor historian and author, Terrence W. Barrett, to this day Medal of Honor recipient Cpl. Lee Phillips is not counted among famous Georgians.

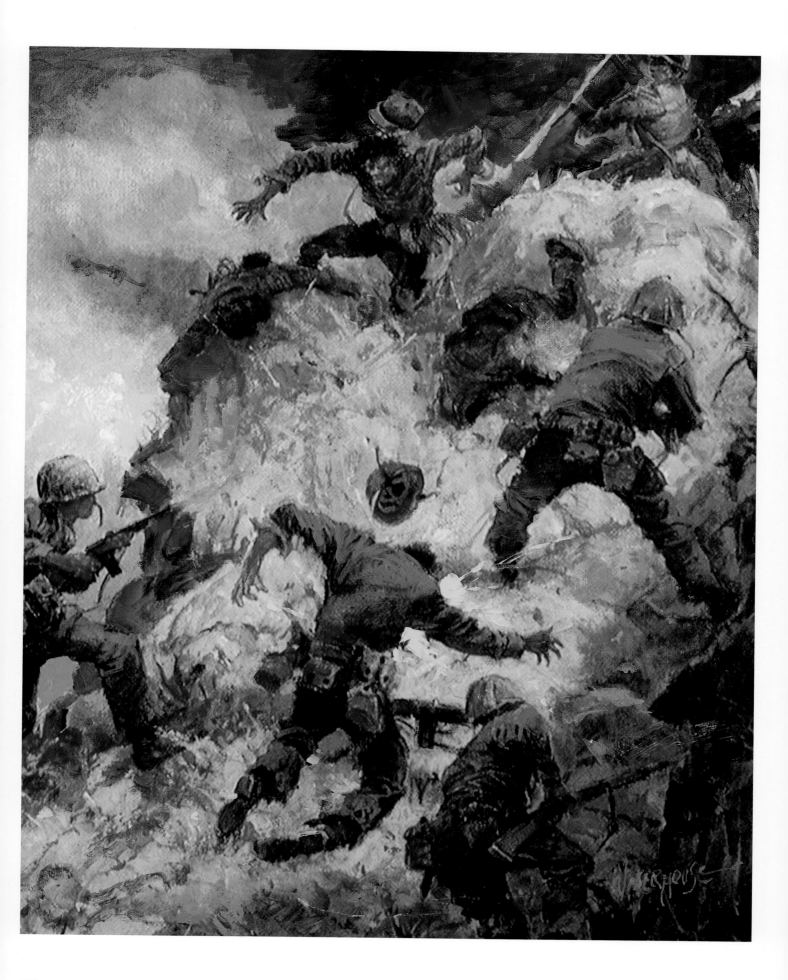

SSGT. ARCHIE VAN WINKLE, USMC[7]
Sudong, Korea, November 2, 1950

Archie Van Winkle was born in Juneau, Alaska. His father, a World War I veteran, worked in the logging business. In the late 1930s, the family moved to the deeply wooded valley of Darrington, Washington. At Darrington High School, Archie was an all-around athlete, captaining both the boxing and football teams, and also playing baseball and basketball. After getting his high school diploma, Van Winkle entered the University of Washington to study physical education. At the end of his first year, he enlisted in the Marine Corps Reserve. It was 1942, and with World War II raging, Van Winkle was soon called to active duty. For the next three years, he served as an aviation radioman-gunner and mechanic in the Solomon Islands campaign and during operations at the Philippines and Emirau, earning the Distinguished Flying Cross for valor.

After being honorably discharged in October 1945, Van Winkle continued to work toward his physical education degree, this time at Everett Junior College (later renamed Everett Community College) in Everett, Washington, where, as an offensive lineman he helped to make his team the 1947 junior college champions. Archie won the championship that year, but lost his heart to the homecoming queen, Lavonne "Bonnie" Stewart, who became his wife. In 1948, Van Winkle joined the Marine Reserves. Two years later, his Reserve unit was mobilized, putting his college degree—and married life with Bonnie—on hold.

On November 2, 1950, SSgt. Archie Van Winkle was in Korea, serving as a platoon sergeant with Company B, 1st Battalion, 7th Marines, 1st Marine Division (Reinforced) in the vicinity of Sudong when, under the cover of night, an overpowering Chinese force penetrated the center of their line, pinning down his platoon and pummeling it with a deadly barrage of automatic weapons and grenade fire.

Rallying a group of his men, Van Winkle spearheaded an attack through and against hostile frontal positions, succeeding in giving the platoon time to reorganize and gain effective field of fire. During the intense fight, the left-flank squad was isolated from the rest of the unit. Despite having received a serious elbow wound that rendered one of his arms useless, champion football player Archie Van Winkle rushed through forty yards of fierce enemy fire to reunite his troops. Even after taking a direct hit to the chest from a hostile grenade, the tough Marine refused evacuation, continuing to shout orders and encouragement to his depleted and battered platoon until he had to be carried from his position, unconscious from shock and loss of blood.

Van Winkle spent more than six months in hospitals and medical facilities recovering from his wounds. On February 6, 1952, President Harry S. Truman hung the medal around SSgt. Van Winkle's neck.

All in all, Archie Van Winkle would serve in two wars—World War II, Korea, and Vietnam— and be awarded nineteen medals. He retired as a colonel in February 1974, and moved back to Alaska where he was born. By the early 1980s, he and Bonnie were living a boat in Bar Harbor, not far from Ketchikan. Only those closest to him knew that Archie was the recipient of America's highest military decoration, the Medal of Honor. In May 1986, Van Winkle suffered a heart attack and died on his boat. His ashes were scattered into the wind and sea over the Tongass Narrows.

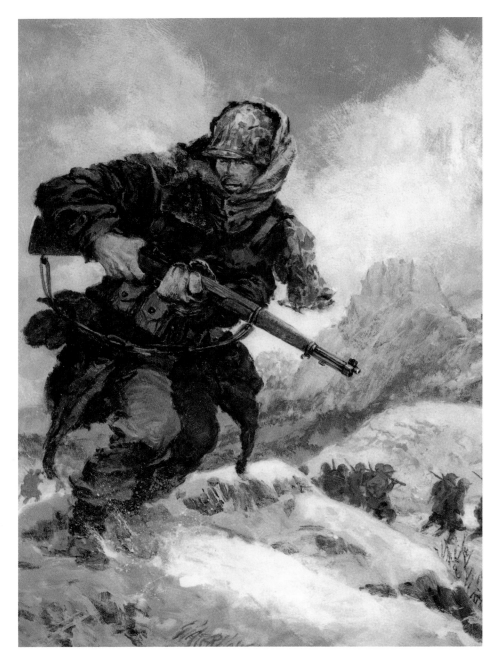

SGT. JAMES I. POYNTER, USMC[8]
Hill 532, Sudong, Korea, November 4, 1950

The youngest of nine children, James Irsley Poynter was born on December 1, 1916, in Saybrook, Illinois. At that point, the paper trail on Jim Poynter goes cold, and it might have well stayed that way were it not for the attack on Pearl Harbor, which inspired twenty-five-year-old Jim Poynter to enlist in the Marines. Poynter fought in some of the bloodiest Pacific campaigns of the Pacific during World War II, including Guadalcanal, the Solomons, Saipan, Tinian, and Okinawa.

By 1947, Jim Poynter was living in Downey, California, with second wife, Kathren. Over the next four years, the couple would have four children. In July 1950, Poynter joined the Marine Reserves. At age thirty-three, he was mature, but still in good fighting shape, with a war-full of combat experience under his belt. Men like him were needed in Korea.

Sgt. Poynter was assigned duties as a squad leader in Company A, 1st Battalion, 7th Marines, arriving in time to aid in the recapture of Seoul after the Inchon landing. For Poynter, it was like riding a bike, and he was soon leading his squad in the fight from one barricade to the next with the same kind of grit and determination that he'd shown as a young Marine in the Pacific. For his "leadership, ability and courageous aggressiveness against the enemy" at Seoul between September 24 and October 4, 1950, Sgt. Poynter was awarded a Bronze Star Medal with Combat "V."

After the retaking of Seoul, the 1st Battalion, 7th Marines were redeployed to North Korea's east coast, heading to a place called the Chosin Reservoir through the Sudong Gorge, Funchilin Pass, Hell Fire Valley, and Toktong Pass—just places on the map to them then, but soon to become hallowed ground for Marines.

On October 31—Halloween—Sgt. Poynter advised his men to get as much sleep as they could because in the morning they needed to scale the imposing ridge that stood between them and the village of Sudong-ni before pushing onto the reservoir. That ridge, known as Hill 532, would pose a bigger problem than Poynter and his company commanders could ever imagine. They didn't know that Chinese forces had infiltrated the area, and for the next five days and nights they'd fight for every yard of their advance.

On November 4, when Poynter's squad finally reached the summit, he barely had time to establish his team in defensive positions before the counterattack began. With whistles and bugle calls, the huge Chinese force charged up the hill, inflicting devastating casualties on the Marines.

Although wounded in the initial assault, Poynter maintained command of his remaining men, directing their fire and encouraging them to hold their ground. No matter how many Chinese soldiers fell, there were always more to replace them, and before long they had pierced the Marine's defensive line and surrounded their position. With his squad at risk of being overrun, Sgt. Poynter rushed forward, cutting down enemy attackers with his bayonet, and engaging them in a frenzied bout of hand-to-hand combat. Out of the corner of his eye, Poynter saw that enemy machine gun teams were preparing to set up within twenty-five yards of his position. He reacted decisively, gathering grenades from wounded Marines and heading into the open, alone. In a fearless one-man attack, Poynter managed to destroy two enemy machine gun emplacements, killing their crews. As he was rounding in on the third, Poynter was once again wounded by enemy fire, but with his dying breath he managed to pull the pin on his grenade and throw it, blowing the hostile machine gun nest and its gunners to kingdom come. Poynter's actions disorganized the advancing assault long enough for the remnant of his squad to regain the initiative and force the enemy back down Hill 532.

On September 4, 1952, in a ceremony at the Pentagon, Secretary of the Navy, Dan A. Kimball presented Poynter's posthumous Medal of Honor to his widow, Kathren, and Jim's two-year-old son, Byron Eugene.

2Lt. Robert D. Reem, USMC[9]
Chinhung-ni, Korea, November 6, 1950

Robert Dale Reem was born on October 20, 1925, in Lancaster, Pennsylvania, to a Pennsylvania Dutch family with deep roots and a long history in Lancaster County. Robert's ancestor, Tobias Ream, founded the area of Reamstown in the 1740s, and another of his early forebears settled Rheems, in the county township of West Donegal. Young Robert—known as "Reemie" by his classmates—attended Elizabethtown High School. He loved football, and in addition to playing for the school team, served as a page in the Pennsylvania House of Representatives during his senior year.

In 1943, two months after graduating, Reem enlisted in the Marines. After completing his recruit training, Reem was selected for appointment to the US Naval Academy. On June 4, 1948, the Annapolis graduate was commissioned a Marine second lieutenant. The following spring, 2Lt. Robert Reem and Donna Zimmerli, both twenty-four, were married in a ceremony at the US Naval Academy Chapel. As the handsome young couple walked out of the chapel under an arch of raised swords, they must have felt they had their whole lives ahead of them. But they would only have fourteen months.

In August 1950, 2Lt. Bob Reem was deployed to Korea. He had a job to do. There was no need to worry, he assured his wife: the Korean conflict would be settled soon. As they kissed goodbye he promised Donna he "wouldn't do anything heroic." Five months later—just weeks after his twenty-fifth birthday—Bob Reem broke that promise to his wife.

On November 6, 1950, while serving as a platoon commander with Company H, 3rd Battalion, 7th Marine Regiment, 1st Marine Division (Reinforced), in the vicinity of Chinhung-ni, 2Lt. Bob Reem led his unit through a hail of hostile machine gun, rifle and grenade fire, making three unsuccessful assaults on a "well-concealed and strongly fortified enemy position." With every attempt, their casualties mounted, but Bob Reem remained focused on achieving the objective. He regrouped his men, preparing them for the fourth and final assault. Seconds later, hostile grenade landed in the midst of Reem and his squad leaders. Reacting automatically, Reem jumped on the grenade, saving the lives of his comrades.

In what would be his last letter to his wife, Reem wrote, "I am getting mighty tired of chasing Reds up and down the hills of Korea … I'd like to come home and be with you, Donna." On hearing the news of her husband's death, Donna Reem collapsed.

In a letter of condolence Reem's company commander, 1Lt. Howard H. Harris, said that on the day Bob Reem died, he was suffering from a severe cold, but had refused to go the battalion aid station for fear he might be evacuated. "Bob's boys were dazed for many days after his death," Harris wrote, "but in tribute to his brave action they carried on with the same fighting spirit."

On February 8, 1952, Reem's widow, Donna, was presented with his posthumous Medal of Honor at a ceremony in Washington, DC.

Bob Reem had broken his promise to Donna by doing something heroic, but in the end, he fulfilled his final wish: he came home to her. Originally buried in the United Nations Cemetery near Hamhung, North Korea, Reem's body was returned to the United States for burial at Arlington National Cemetery, where so many valiant souls, who didn't set out to be heroes, ultimately come to rest.

LT. FRANK MITCHELL, USMC[10]
Hasan-ni, Korea, November 26, 1950

Frank Niclas Mitchell was born on August 18, 1921, in Indian Gap, Texas. At some point, the Mitchell family pulled up stakes and moved about 250 miles away to Roaring Springs, Texas. In high school, Frank earned high marks as a student and an athlete. He was clearly college material, but college was expensive, and opportunities for the Class of 1938, in the Texas Panhandle were limited, so a year later, at the age of eighteen, Frank Mitchell enlisted in the Marine Corps.

During World War II, Mitchell served aboard the aircraft carrier USS *Enterprise* at Wake Island, with additional service in the Marshall Islands and occupation duty in China. While attached to Fleet Marine Force Pacific, Frank was a member of its rifle and pistol team. Becoming a crack shot was a rite of passage for kids who grew up in small Texas towns, and whether it was competing on a team, or covering his Marines in battle, it was a skill that served Frank Mitchell well.

Following his World War II service, Mitchell was commissioned a second lieutenant.

He attended Colorado College under the Navy V-12 program, and spent a few semesters at Southwestern University before finishing up at Texas Tech, where he played varsity football. Around this time Frank married the former Beverly Bank and, together, they had a daughter. It seemed everything was falling into place for Frank Mitchell. But then the Korean War started, and the husband and father put devotion to country above all else and rejoined the Corps.

On November 26, 1950, while serving as the leader of a rifle platoon of Company A, 1st Battalion, 7th Marines, 1st Marine Division (Reinforced), near Hansan-ni, in the area of the Chosin Reservoir, 1Lt. Mitchell took decisive action when enemy forces opened up fire against his forward elements, inflicting numerous casualties. Seizing an automatic weapon from one of the wounded, Mitchell dashed fearlessly through a blistering barrage of small arms and machine-gun fire, training his weapon with deadly precision against his attackers and mowing the enemy down. When he finally ran out of ammunition, he started hurling grenades, while shouting words of encouragement to his men and rallying them to push the large Chinese force from their position.

In the lull that followed, Mitchell quickly set up a defensive line, which was soon counterattacked by waves of Chinese soldiers, assaulting to the front and left flank. During the onslaught, Mitchell was wounded but he continued to reorganize his platoon, leading them in fierce hand-to-hand combat and assembling a team of volunteers to search for, and evacuate, the wounded. Ignoring his own pain, Mitchell personally led a party of litter bearers through hostile lines in the lowering darkness. He then returned to his lines, where he covered the withdrawal of his wounded Marines by waging a single-handed battle against the huge Chinese force, until he was cut down in a burst of enemy fire. His body was never recovered.

SSGT. ROBERT S. KENNEMORE, USMC[11]
Yudam-ni, Korea, November 27–28, 1950

Robert Sidney Kennemore was born on June 21, 1920, in Greenville, South Carolina. A 2006 article for Gold Country Media's *The News Messenger*, written by Jim Kennemore—possibly a relative—stated, "Robert S. Kennemore was reared by several families." However checkered, Kennemore's upbringing might have been, he found a permanent home with the US Marine Corps. After enlisting in 1940, and serving in the Pacific with the 1st Division in World War II, Robert Kennemore would ever after considered himself a career Marine.

On November 27–28, 1950, SSgt. Kennemore was just north of Yudam-ni, serving as the leader of a machine gun section in Company E, 2nd Battalion, 7th Marines, 1st Marine Division (Reinforced). The situation was dire. With the company's defensive line overrun by the enemy, the platoon commander seriously wounded and casualties steadily mounting, Kennemore took the lead, reorganizing his unit and consolidating their position. And, still, the Chinese kept boring in, determined to destroy them.

In the midst of one vicious assault, enemy soldiers dragged away one of Kennemore's machine gunners, bludgeoning the Marine and stabbing him with bayonets. Heedless of his personal safety, SSgt. Kennemore scrambled across the hill to aid his comrade, but upon reaching him, he saw the machine gunner was past all help.

By now under intense fire, Kennemore crawled toward a gun pit that was occupied by three Marines. A second later, a Chinese grenade came hurtling at the position, landing next to them. Kennemore seized it and lobbed it back just in time. Before he could catch his breath, a second hostile grenade landed nearby, followed by a third. Reacting swiftly, Kennemore stepped on the first grenade and squashed it into

the snow; at the same time, he crouched down on one knee to cover the impact of the second grenade. Both missiles exploded, tearing into him. The three crewmen in the gun pit were temporarily deafened by the blast but their lives were spared. Believing no one could survive such a devastating explosion they left the sergeant for dead.

Through that long, terrible night, SSgt. Kennemore lay on the mountaintop, covered in blood and encased in ice. At some point, he awakened and felt for his legs. All that was left under the tatters of his uniform was shredded sinew and splinters of bone. Fortifying himself with a syrette of morphine, Kennemore dragged himself 100 yards across the hill, to a place where he would be more easily spotted, before he collapsed.

Hours later, when the last survivors went out onto the field to identify the fallen, a muffled cry was heard calling from a tangle of dead bodies, weakly calling "Corpsman! Corpsman!" It was SSgt. Robert Kennemore. The cruel, bone-killing cold in the Chosin Reservoir had actually staunched the blood loss from his leg wounds, slowing the damage to his internal organs; although Kennemore would lose both legs, it was this cold, and the heroic efforts of the medical corpsman who discovered his grievously wounded body and rushed him to a field hospital, that was his saving grace.

In 1953, Kennemore was summoned to the White House where President Harry S. Truman awarded him the Medal of Honor. Kennemore went on to father seven children, passing away in 1989, after a long illness, at the age of sixty-eight, following. He was never able to discover the identity of the corpsman that saved his life.

PFC WILLIAM BAUGH, USMC[12]

Hagaru-ri, Korea, November 29, 1950

William Bernard Baugh entered this world on July 7, 1930, one of eight children born to farmers Leslie and Minnie Terry Baugh of McKinney, Kentucky. At some point, the family picked up and moved stakes to Harrison, Ohio; there, William attended Butler County public schools, reaching the eighth grade before taking a job as a cobbler at the Harrison Shoe Company where he earned the princely sum of $30 a week.

Patriotism ran deep in the Baugh blood: father Leslie had served during World War I, and six of the Baugh sons proudly stepped up to do their duty when they were needed. On January 23, 1948, it was seventeen-year-old William's turn and he enlisted in the Marines. One of Baugh's fellow recruits, Jack Burkett, said, "He was one of the best-liked people in the outfit." Well-liked, perhaps—but not always the most gung-ho.

In early July 1950, the new commander of Weapons Company, 1st Battalion, 6th Marines, Camp Lejeune (later designated 3rd Battalion, 1st Marines, 1st Marine Division), then Maj. Edwin H. Simmons, met PFC Baugh for the first time when he failed to qualify with the .45-caliber pistol. Simmons described Baugh as "as Marine of no particular physical attributes," who looked younger than his years. He asked the young Marine why he was having a problem with the .45.

"Sir," William said. "It makes me nervous." That was not what his commanding officer wanted to hear, so in addition to extra instruction in the pistol, Maj. Simmons gave Baugh poor marks in conduct and proficiency.

On November 9, 1950, Baugh's anti-tank squad was part of a motorized column of vehicles traveling from Koti-ri to Hagaru-ri. As night fell, their segment of the column came under ambush by enemy soldiers, entrenched alongside the road and waiting for cover of darkness to attack. Hammered by a hail of hostile small arms and automatic-weapons, the trucks juddered to a stop. As the men in

Baugh's squad were scrambling to get clear of their vehicle, a Chinese stick grenade landed in the truck. Baugh shouted, "Grenade!" and jumped on the lethal missile, covering the explosion with his body. The twenty-year-old Marine was instantly killed.

On August 27, 1952, Baugh's posthumous Medal of Honor was presented to his parents at a ceremony held in the auditorium of the Brown General Hospital at the Veterans Center in Dayton, Ohio, where World War I veteran, Leslie Baugh, was awaiting surgery.

Originally interred in the temporary United Nations Military at Hungnam, with only a Marine blanket as a shroud, PFC William Baugh came home in July 1953, and was reinterred at Glen Haven Cemetery in Harrison, Ohio, where his mother, father and four of his seven siblings would also come to rest.

On September 22, 1984, a maritime prepositioning ship of the Military Sealift Command was named the *PFC William B. Baugh* in his honor. At the ceremony, then Assistant Commandant, Gen. John K. Davis, rephrased a question posed by 28th CMC, Gen. Paul X. Kelley, to survivors of the 1983 bombing of the Marine Barracks in Beirut. "*Lord,*" Kelley had said, "*where do we get such men as these?*" Echoing Kelley's words, Gen. Davis said, "We get them in places like Harrison, Ohio, in families like the Baughs' who imbue in their children a love for country and a love for their fellow man."

In a director's page entry written in 1984, for *Fortitudine*, the newsletter of the Marine Corps Historical Program, Edwin Simmons—then brigadier general and eminent USMC historian—made it clear that he had come to realize that extraordinary selflessness and heroism sometimes appeared in the most unlikely of packages: in ordinary Marines of no particular attributes, who sometimes felt nervous handling weapons but who, in moments of crisis, acted with extraordinary courage.

LT. COL. RAYMOND G. DAVIS, USMC[13]
Hagaru-ri, Korea, December 1–4, 1950

For four days and nights starting on November 2, 1950, in the Toktong Pass, Capt. William Barber's Fox Company Marines had been valiantly repulsing continuous assaults from a battalion-strength force of Chinese soldiers that outnumbered them 10 to 1. By December 1, the situation was desperate: if they didn't get help soon, Barber and his men were facing total annihilation. Several miles away, at regimental headquarters in Yudam-ni, the commander of the 7th Marine Regiment, Col. Homer "Blitzen Litzen" Litzenberg, sent for his first battalion commander, Lt. Col. Raymond Davis.

Born on January 13, 1915, in Fitzgerald, Georgia, Raymond G. Davis was a World War II hero who had trained and served under Marine Corps legend, Lewis B. 'Chesty' Puller. Cool under pressure and highly resourceful, Davis embodied Puller's motto, "Lead by example." If anyone could carry out a mission to save Fox Company, Col. Litzenberg believed, surely it was he.

The two men hunched over the topographical map, working out a plan. The road from Yudam-ni to the rear entrance of Toktong Pass was a straight shot of about five miles. The Chinese would expect the relief force to come in a convoy of vehicles, making them easy pickings. But what if, instead of by road, they went through the mountains, under cover of night? It would be a daring and dangerous venture: a march into enemy territory through knee-deep snow and trackless mountains. In the balance hung the wholesale slaughter of Fox Company, and loss of the only escape route to the sea for 8,000 Marines and their wounded. The men in Davis's 1st Battalion were already battle weary and frostbitten, but as Davis would later say, "I had 800 Marines out in that condition and no beef, because they were gonna rescue other Marines. There was no stopping 'em."

Traveling with just light arms, ammo and quick-energy food that could be eaten while they marched, Davis and the men of the 1st Battalion, 7th Marine Regiment, 1st Marine Division headed out in single-file, with their gear and weapons strapped down so they could move as soundlessly as possible. Tramping down drifts of snow and sliding down ramps of ice, they trekked over primitive mountain trails in pitch-black darkness, passing enemy camps and braving temperatures of thirty degrees below zero, with a wind chill that ripped through them at -70. To keep on course, Davis arranged for a howitzer in Yudam-ni to periodically lob a shell along an arc that ended at the Toktong Pass. The snaking column of determined Marines followed these intermittent trails of phosphorescent light all the way to Fox Hill, climbing and clawing their way with frozen fingers over the three treacherous ridges that separated them from their besieged comrades. On that night, Lt. Col. Davis's 1st Battalion became known as the Ridgerunners.

By the time dawn broke on December 2, the Ridgerunners had reached the hunched shoulders of Toktong-san. As they moved toward the pass, taking heavy fire from the Chinese, a sniper's bullet struck Davis in the head, ripping through the hood of his parka, grazing his forehead and knocking him backward, but he scrambled back to his feet, fighting his way forward with his men. Ultimately, Davis and his Ridgerunners reached their objective. Barber's company of 220 Marines had dwindled to a battle-worn remnant of just over eighty, but they stood proudly at attention on their makeshift splints and crutches, wearing their wrappings of blood-caked gauze like badges of honor. Lt. Chew-Een Lee, the officer Davis chose to lead his column of Ridgerunners, later said, "We never claimed that we saved Fox … but we relieved them from further attack—and we secured the pass."

On the morning of December 4, 1950, Davis and the Ridgerunners marched into base camp at Haguru, the crunch of their boots in the snow keeping time to the song that they were singing: *The Marines' Hymn*. A war correspondent reported overhearing a Navy surgeon say in an awestruck voice: "Look at those bastards, those magnificent bastards." For his leadership and courage in leading the mission to relieve Fox Company, Lt. Col. Davis received the Medal of Honor from President Harry S. Truman on November 24, 1952. Before his passing at the age of eighty-eight in 2003, he had attained the rank of four-star general.

While Col. Waterhouse left behind a portrait of Lt. Col. Ray Davis, he did not live long enough to create a canvas showing Davis and his Ridgerunners on their daring mission—although it would have been a subject ready-made for his brush. But one of Waterhouse's masterworks, "*The Eternal Band of Brothers, Chosin Reservoir*," shows the miraculous result of that daring mission. A single company of surrounded men, battling for five days and nights in arctic weather, were able to maintain a grip on a vital pass, and a brave battalion of Marines, determined to climb mountains to get to comrades in need, were instrumental in securing it—thereby enabling the passage of thousands of Marines and their wounded to 'advance from different direction' in an historic exodus to the sea. Lt. Col. Ray Davis and his Ridgerunners were part of that exodus. They are there in Waterhouse's painting. In the words of an awestruck onlooker: "Look at those bastards, those magnificent bastards."

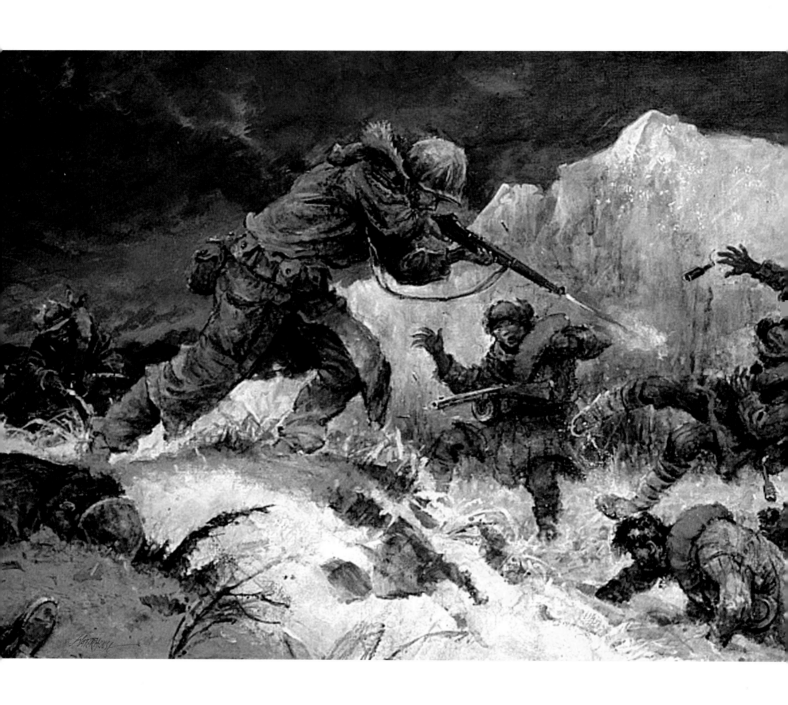

PVT. HECTOR A. CAFFERATA JR., USMCR[14]

Battle of the Chosin Reservoir, Korea, November 28, 1950

Medal of Honor Citation

For conspicuous gallantry and intrepidity at the risk of his life above and beyond the call of duty while serving as a Rifleman with Company F, Second Battalion, Seventh Marines, First Marine Division (Reinforced) in action against enemy aggressor forces in Korea on November 28, 1950. When all the other members of his fire team became casualties, creating a gap in the lines, during the initial phase of a vicious attack launched by a fanatical enemy of regimental strength against his company's hill position, Private Cafferata waged a lone battle with grenades and rifle fire as the attack gained momentum and the enemy threatened penetration through the gap and endangered the integrity of the entire defensive perimeter. Making a target of himself under the devastating fire from automatic weapons, rifles, grenades, and mortars, he maneuvered up and down the line and delivered accurate and effective fire against the onrushing force, killing fifteen, wounding many more, and forcing the others to withdraw so that reinforcements could move up and consolidate the position. Again fighting desperately against a renewed onslaught later that same morning when a hostile grenade landed in a shallow entrenchment occupied by wounded Marines, Pvt. Cafferata rushed into the gully under heavy fire, seized the deadly missile in his right hand, and hurled it free of his comrades before it detonated, severing part of one finger and seriously wounding him in the right hand and arm. Courageously ignoring the intense pain, he staunchly fought on until he was struck by a sniper's bullet and forced to submit to evacuation for medical treatment. Stouthearted and indomitable, Pvt. Cafferata, by his fortitude, great personal valor, and dauntless perseverance in the face of almost certain death, saved the lives of several of his fellow Marines and contributed essentially to the success achieved by his company in maintaining its defensive position against tremendous odds. His extraordinary heroism throughout was in keeping with the highest traditions of the United States Naval Service.

To learn more about Hector Cafferata, see chapter 1, "The Battle on Fox Hill."

Capt. William Earl Barber, USMC[15]
Battle of the Chosin Reservoir, Korea,
November 28 – December 2, 1950

The motley crew of recruits and reservists in Fox Company, 2nd Battalion, 7th Marine Regiment, 1st Marine Division (Reinforced) didn't care much for their new commander, Capt. William Barber. They'd been slugging through Korea since the Inchon landing in September, and here this dough-faced, stick-up-the-butt officer arrives in the middle of November, making them shave, and putting them through marksmanship and training drills like they were back at boot camp. What they didn't know was how hard this captain had fought to get where he was.

Born into family of subsistence farmers in Dehart, Kentucky, on November 30, 1919, Bill Barber had fought his way out of abject poverty by excelling in the classroom and on the basketball court, earning a coveted place at Morehead Teachers College. With World War II looming on the horizon, Bill Barber dropped out of college and enlisted in the Marines. He fought his way through the brutal battle for Iwo Jima where he was wounded twice, yet still managed to rescue two wounded Marines from enemy territory, earning a Silver Star for his actions.

Barber's perseverance, courage and leadership had brought him this far, but as he stood atop the Toktong Pass on November 27, 1950, watching his Company F Marine struggle up the snow-covered ridge, he wondered if it would be enough. Could this small, ragtag bunch of men defend such a vital piece of real estate from the large Chinese force intent on seizing it, and annihilating everyone who stood in their way? Did these young Marines have the guts and determination to drive a stake into this godforsaken mountain pass and do whatever it would take to claim Fox Hill as their own?

The light was already fading when the 245 men of F Company finally made it to the top. Any dreams of building a fire and sipping hot coffee were squelched by Barber's orders: they were to take their positions around the oval-shaped perimeter immediately and use their entrenching tools to chisel out foxholes in the frozen earth. As unwelcome as these orders were at the time, they would save countless lives when the attack by a regimental-sized Chinese force began, as Barber knew it would, later that night.

The Chinese came from above and came from below, and they kept coming, relentlessly, savagely, for seven hours. Through it all, Capt. Bill Barber was constantly on the move, patrolling the lines, shouting encouragement to his men, refusing to take cover as the firefight raged around him. "They haven't made the bullet yet that can kill me," he told one sergeant. His men managed to repulse the enemy but they'd taken heavy casualties. When Barber was finally able to reach his regimental commander on the radio he was told that sending reinforcements was out of the question: the entire Marine Division, from Yudam-ni to Haguru and Koto-ri, was surrounded. Barber told his commander that if they could get him airdrops of ammo and critical supplies, Fox Company could hold out another night. Then he gathered his officers and explained the situation, saying, "… we have nothing to worry about, as long as we fight like Marines."

And fight like Marines they did, for five days. On the morning of November 29, 1950, a Chinese bullet struck Capt. Barber in the groin, shattering his pelvis, but he was right—the enemy bullet did not kill him, it only made him more determined. Using a gnarled branch as a crutch, he hobbled around the tightened perimeter, rallying the small group of men who were still able to fight.

On December 2, when reinforcements finally arrived, only eighty-two of his original 220 men were able to walk off the hill on their own volition. After their epic stand was over, the corpses of approximately 1,000 enemy dead were found on Fox Hill.

For his actions in defending the Toktong Pass from November 28 to December 2, 1950, Capt. William Barber was presented the Medal of Honor by President Harry S. Truman in ceremonies at the White House. Speaking of Barber, another Medal of Honor hero of Fox Hill, Pvt. Hector Cafferata, said, "He walked the line, he kept us together."

In later years, when asked to pose for a picture holding his medal, Barber always politely refused, explaining with his soft-spoken east Kentucky drawl, that for every medal given there were probably five or six others who had merited it without ever receiving such an honor. And although he didn't say it, he didn't have to. Barber was doubtlessly thinking of the ragtag heroes on Fox Hill who had the guts and determination to drive their stake into a godforsaken mountain pass and claim it, forever as their own. William Barber died on April 19, 2002, at the age of eighty-two.

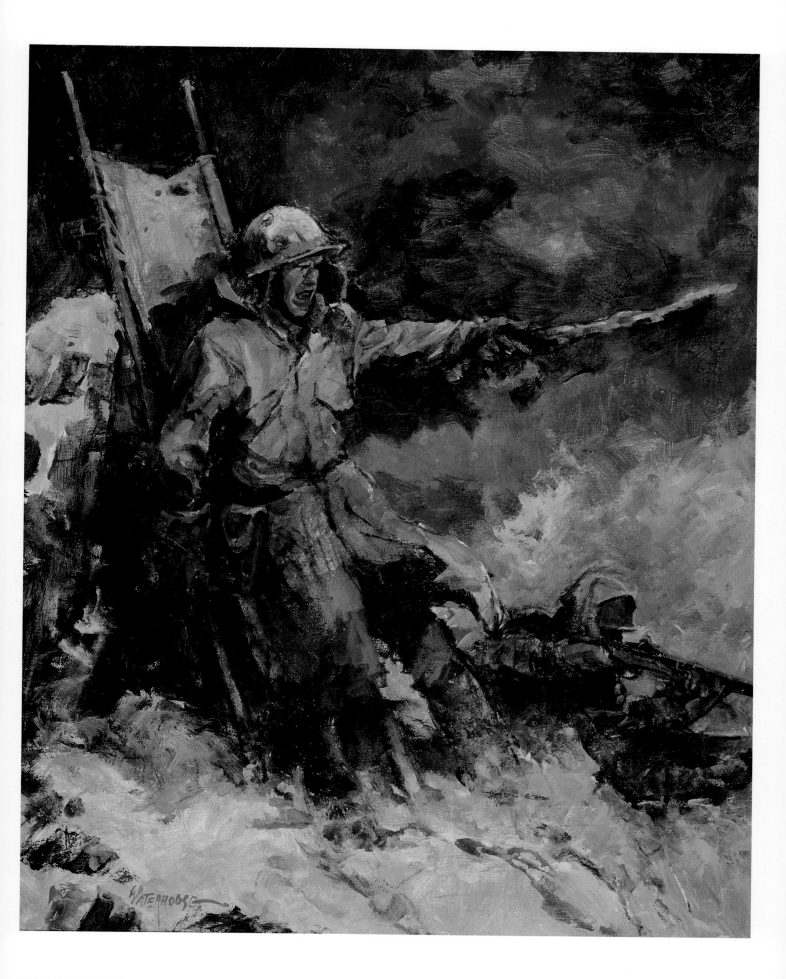

MAJ. REGINALD R. MYERS, USMC[16]
Battle of the Chosin Reservoir, Korea, November 29, 1950

Reginald Rodney Myers was born on November 26, 1919, in Boise, Idaho. He received his early schooling in Salt Lake City, Utah, and returned to his birth state for his college education, earning a Bachelor of Science degree in Mechanical Engineering from the University of Idaho, in June 1941. During his time at the university, Reginald attained the rank of cadet colonel in the Reserve Officer Training Corps.

With the clouds of World War II on the horizon, Mr. and Mrs. Myers knew that their son would want do his part, but when Reginald resigned his Army commission to accept an appointment as a second lieutenant in the Marines, they were horrified. "My mother cried, my father cried," Myers later recalled. "They said, 'you're gonna die!'" But he was resolute: Reginald Myers wanted to be a Marine. As a young officer on ship duty in the Pacific, he saw action at Guadalcanal, Tulagi, the Eastern Solomons, and Gilbert and Marianas Islands, and in June 1945, he participated with the 5th Marines, 1st Marine Division in the assault on Okinawa. In less than four years, Myers rose in ranks from second lieutenant to major.

In July 1950, Maj. Myers headed to Korea as executive officer of the 3rd Battalion, 1st Marines, 1st Marine Division (Reinforced). For his courage during the landing at Inchon in September, Myers was awarded a Bronze Star with Combat V. Four days later a Gold Star was added to that medal for Myers's daring rescue of two fellow Marines.

Maj. Gen. Oliver P. Smith, commander of the 1st Marine Division, had set up his division headquarters and initiated the building of a rough airfield in the abandoned town of Hagaru, at the southern tip of the Chosin Reservoir. Keeping the road to Hagaru-ri open was vitally important to ensure an evacuation route for the removal of troops, but in order to keep the road open it was necessary to own East Hill—a rocky ridge with a commanding position that governed the only exit.

Maj. Reginald Myers arrived in Hagaru-ri on November 26, 1950: his thirty-first birthday.

Myers was told that the Chinese had driven an Army unit of 200 soldiers off East Hill. His mission was to recapture it—a mission made more slippery than the icy ridge he would have to summit, given the fact that there was no standard fighting force in Hagaru-ri for Myers to command. "I had no Marine Rifle Company or unit of any type in my area," he said. "So as I walked toward East Hill, I formed my own combat element from support Marines, such as cooks, truck drivers, maintenance personnel and administrative personnel, recruiting Marines along the way." He ended up with about 250 men: about fifty were "hard charging Marines" from the 1st Engineer Battalion … a few were soldiers … and the rest were stragglers and service troops.

The slope of East Hill was wickedly steep, and covered with deep snow, pierced through in places by jagged rocks encased in a slippery skin of ice. To break through the top layer you needed dynamite. It

was twenty-five degrees below zero without the wind chill, and the only heat came from the hail of enemy bullets raining down from above them.

Major Myers led the way, rallying his odd lot of Marines and others as they struggled up the treacherous ascent. Only 80 of his 250 troops reached the summit with him, but they were able to hold the hill, in spite of a steady stream of enemy machine-gun fire and repeated Chinese assaults. "We called in Marine air to drop bombs and napalm. We called in artillery. We lobbed grenades into their positions. We assaulted them time and time again," Myers later recounted. "Little by little, my force dwindled due to casualties. But we were stubborn and would not leave the top of the hill."

After fourteen long hours of intense fighting, reinforcements finally arrived. The Marines from the rifle company sent to relieve Major Myers and his men were amazed to find that this motley crew of cooks, drivers and support personnel had killed more than 600 Chinese soldiers and wounded another 500. They'd held the hill and kept the road to Hagaru-ri open for Marine and Army units streaming down from the north.

Of the men who fought with him that day Myers said, "They proved that a Marine—whether a truck driver, a cook, a clerk, or whatever—was foremost a fighting combat rifleman. I was proud and honored to be with them."

For his actions on East Hill, Maj. Reginald Myers received the Medal of Honor, which was presented to him by President Harry Truman on October 29, 1951, at a ceremony at the White House. In an interview given shortly before his death in 2005, Myers was asked what the Medal symbolized. "The Medal means to me that you have to rely on everybody else," he said softly, adding, "The people who were with me deserve all the medals."

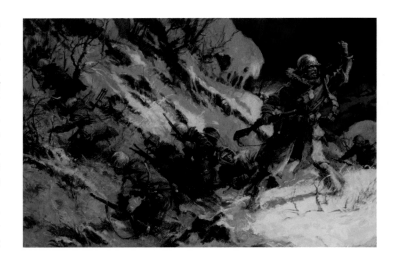

CAPT. CARL L. SITTER, USMC[17]

Hagaru-ri, November 30, 1950

Medal of Honor Citation

For conspicuous gallantry and intrepidity at the risk of his life above and beyond the call of duty as Commanding Officer of Company G, Third Battalion, First Marines, First Marine Division (Reinforced), in action against enemy aggressor forces at Hagaru-ri, Korea, on November 30, 1950. Ordered to break through enemy-infested territory to reinforce his Battalion the early morning of November 29, Capt. Sitter continuously exposed himself to enemy fire as he led his company forward and, despite twenty-five percent casualties suffered in the furious action, succeeded in driving through to his objective. Assuming the responsibility of attempting to seize and occupy a strategic area occupied by a hostile force of regiment strength deeply entrenched on a snow-covered hill commanding the entire valley southeast of the town, as well as the line of march of friendly troops withdrawing to the south, he reorganized his depleted units the following morning and boldly led them up the steep, frozen hillside under blistering fire, encouraging and redeploying his troops as casualties occurred and directing forward platoons as they continued the drive to the top of the ridge. During the night, when a vastly outnumbering enemy launched a sudden, vicious counterattack, setting the hill ablaze with mortar, machine gun, and automatic weapons fire and taking a heavy toll in troops, Captain Sitter visited each foxhole and gun position, coolly deploying and integrating reinforcing units consisting of service personnel unfamiliar with infantry tactics into a coordinated combat team and instilling in every man the will and determination to hold his position at all costs. With the enemy penetrating his lines in repeated counterattacks which often required hand-to-hand combat and, on one occasion infiltrating to the command post with hand grenades, he fought gallantly with his men in repulsing and killing the fanatic attackers in each encounter. Painfully wounded in the face, arms, and chest by bursting grenades, he staunchly refused to be evacuated and continued to fight on until a successful defense of the area was assured [sic] with a loss to the enemy of more than fifty percent dead, wounded, and captured. His valiant leadership, superb tactics, and great personal valor throughout thirty-six hours of bitter combat reflect the highest credit upon Captain Sitter, and the United States Naval Service.

To learn more about Carl Sitter, see chapter 4, "Battle of Hagaru-ri."

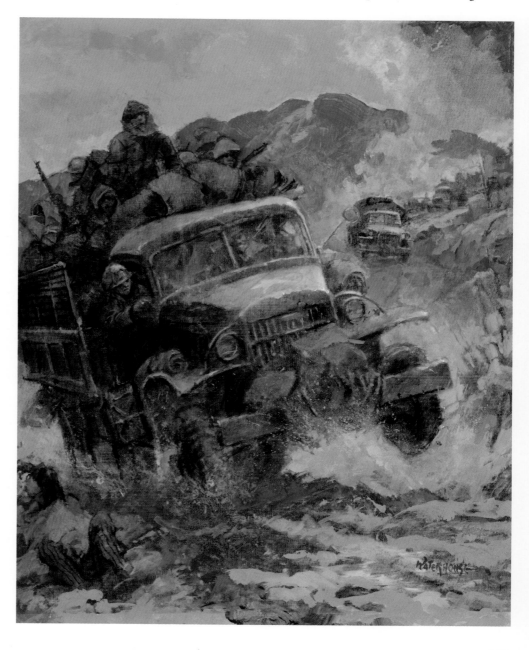

The Marine Corps History Division information on Staff Sgt. William G. Windrich paints a picture of one tough Marine: enlisted in the Corps at seventeen … fought in the epic battle for Tarawa during World War II … served as a military policeman at Camp Pendleton and China … participated in some of the bloodiest campaigns of the Korean War, including the assault at Inchon, the taking of Seoul and the Chosin Reservoir campaign—definitely one tough Marine.

And yet, there was a softer side to William "Windy" Windrich. He was born on May 14, 1921, in Chicago, Illinois, to parents Herman and Marguerite. Herman's job necessitated that he uproot his family from time to time; over the course of their childhood, Bill and his sister, Ginnie, lived in several states, moving from place to place with a big trailer hitched to the back of their car, carrying their beloved brown and white pony, Dolly. In the words of sister Ginnie, from the beginning "boy and pony were meant for each other." Bill taught himself to ride bareback and jump astride the pony at the speed of a gallop, mastering each trick no matter how many tumbles and bruises it took to do it. One snowy day, Bill made a harness out of some old leather straps, hooked up Dolly to a sled and took Ginnie for a thrilling sleigh ride that his little sister would never forget.

While attending school in Hammond, Indiana, Bill Windrich participated in a number of sports. But he was also interested in taxidermy, poetry and photography, and spent his spare time tinting his photographs and tinkering with the crystal radio he'd built.

In the early hours of December 2, 1950, all those wonderful memories— the idyllic days spent with Ginnie … the serenity of dabbing watercolor onto a photographic print … all the precious moments spent with the beloved wife and daughter he'd left at home—must have seemed, not just thousands, but millions miles away to Staff Sergeant Bill Windrich. Serving as rifle platoon sergeant with Company I, Third Battalion, Fifth Marines, First Marine Division (Reinforced), Windy and his men had been relocating from untenable position to untenable position on a snow-covered ridge called Hill 1520 near Yudam-ni, under constant enemy bombardment, holding their ground with frostbitten fingers as the temp, bracing for the next Chinese attack.

Finally, SSgt. Windy Windrich decided it was time to take action. Armed with carbine, the tough Marine sergeant led his rifle platoon in a brazen assault against an enemy-held knoll. Opposition was fierce, and in the deadly rain of automatic weapons fire, mortar and grenade, seven Marines were cut down and Windy himself was wounded when fragments of a bursting grenade tore through his helmet and burrowed into his head. Still, he battled on, training his carbine on the Chinese, and holding back hostile attackers long enough to cover the withdrawal of his fellow Marines to commanding ground.

Windrich then made his way back to his company's position where he organized a small group of volunteers, returning along with them to evacuate the wounded and dying from the hill, while staunchly refusing any offer of medical aid. He knew there was no time for that. Snapping into action, Windrich placed his remaining men on the left flank of the defensive sector in preparation for the next counterattack.

When it came, it was swift and ferocious. Wounded in the leg, Windrich refused to be evacuated, and although unable to stand, continued to fight bravely, shouting words of encouragement and directing his men's fire until he lapsed into unconsciousness from blood loss and hypothermia, and ultimately died.

On February 8, 1952, Secretary of the Navy, Daniel A. Kimball presented SSgt. William G. Windrich's posthumous Medal of Honor to his widow during ceremonies in Washington, DC. It would take another three years for Windrich's body to be identified and returned to the United States in for burial in Arlington National Cemetery.

Veterans Day, November 11, 1985, was proclaimed William G. Windrich Day by the cities of Hammond and East Chicago, Indiana. Among the attendees at the memorial ceremony in his honor were SSgt. Windrich's daughter, Alita (Bonnie) Windrich Monahan and her son—William's grandson—Mark S. Monahan, along with William's sister, Virginia "Ginnie" Windrich Swan who, on that lone ago magical day had ridden with her brother in the sleigh that he'd hitched up to their pony, Dolly, across wintry, snow-covered fields so much closer to home than the one in which he died.

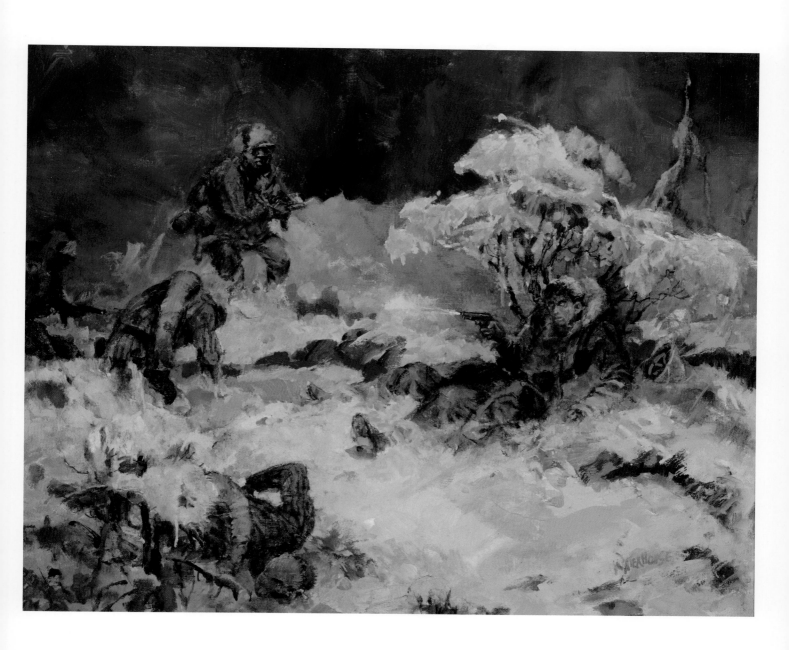

SGT. JAMES E. JOHNSON, USMC[19]
Yudam-ni, Korea, December 2, 1950

From November to December 1950, as the Marines fought their way along the mountain passes and narrow roadways of a frozen reservoir in Korea, they passed through a crucible—not of fire, but of ice—that would forge them into an eternal band of brothers. The Battle of the Chosin Reservoir is a miracle story of leadership, teamwork and unit discipline, all working together to surmount overwhelming odds. But it's also the story of ordinary individuals, driven by the will to see the light of another day.

Covering the epic "advance from another direction" was *Life* magazine photographer, and World War II Marine veteran, David Duncan. After snapping a photograph of one weary, grime-streaked, frozen warrior, Duncan was inspired to ask, "What would you like for Christmas?" The young Marine's response was quick and heartbreakingly simple. "Give me tomorrow," he said.

That Marine's name was Sgt. James Johnson, and although he didn't know it, he wouldn't see Christmas, and his number of tomorrows could be counted on one hand.

James Edmund Johnson was born on January 1, 1926, in Pocatello, Idaho. The tiny New Year's baby—born into a family that was among the early settlers of the area—would be Pocotello's only Medal of Honor recipient, and its number one hero of the Korean War.

Although only twenty-four year old, Sgt Johnson brought with him to Korea a wealth of combat experience and maturity. Inspired by his father's service with the 11th Marine Regiment in World War I, Johnson had first enlisted at the age of seventeen, fighting with the Marines at Peleliu and Okinawa during World War II. He was a married man with an infant daughter who had only been five days old when her father was deployed to Korea.

After an initial assignment to the 11th Marines—his father's World War I unit—Sgt. Johnson was assigned as a squad leader to a provisional rifle platoon in Company J, 3rd Battalion, 7th Marines. Since landing at Wonsan, Johnson had led his squad through thirty-eight days of brutal fighting.

On December 2, 1950, Sgt. Johnson was in the area of Yudam-ni, covering his platoon's withdrawal from the Chosin Reservoir, when a group of Chinese soldiers wearing the uniforms of friendly troops were spotted in the distance. Taking advantage of the Marines' momentary hesitation, the Chinese closed the distance, attacking with a force that greatly outnumbered Johnson's platoon. Johnson organized his Marines into a hasty defense, rallying them to fight off the assault. When orders came down for Johnson to move his platoon from its open location—a difficult maneuver while under fire—he directed his men to withdraw while he provided covering fire.

On his own, and in an exposed position, Sgt Johnson continued to fire his weapon at the advancing enemy until he was out of ammunition. The last time his comrades saw him, Johnson been wounded, but was still valiantly engaged in close grenade and hand-to-hand combat against the Chinese. This one lone man slowed the enemy assault long enough for an entire platoon to reposition with the larger Marine force. Jim Johnson wouldn't be given tomorrow, but he had given his band of brothers more time. His body was never found.

After the war ended, Sgt. James Johnson was declared, "presumed dead, KIA." In a ceremony at the Pentagon on March 29, 1954, Johnson's posthumous Medal was presented to his wife, Mary Jeanne, and his three-and-a-half year-old daughter, Stephanie.

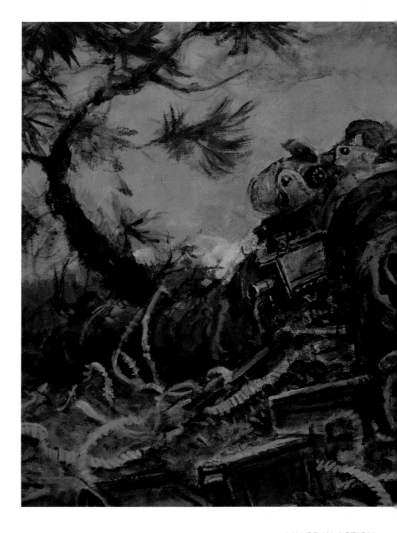

Herbert A. Littleton was born on July 1, 1930, in Mena, Arkansas. His parents called him Hal but didn't give him a middle name, just the letter A. During his childhood, the Littletons moved several times, finally settling in Sturgis, South Dakota, where Hal played scholastic basketball and football. He left high school to enlist under the Selective Service Act for a one-year term in the Marines, becoming the first young man in the Black Hills area to do so. Upon being honorably discharged in July 1949, Littleton joined the Marine Reserves and went back to earn his high school diploma. A year later, the Littletons moved to Nampa, Idaho. Hal worked as a lineman until the Korean War broke out. His father encouraged him to join the Navy, but Hal was firm: "Once a Marine, always a Marine." Before he shipped out, he popped the question to his girlfriend, Barbara Sawyer, and she said yes. The couple planned to marry when Hal returned home in the late summer of 1951.

The three photographs of Littleton wearing his Marine uniform tell a coming-of-age story. The first shows a baby-faced recruit in fatigues with a shock of curly blonde hair escaping from his pushed back cover. The second captures a confident young Marine with limpid blue eyes in dress blues, with his cover cocked at a jaunty angle. In the black-and-white photo taken before his deployment to Korea, Littleton is coverless and solemn; his mouth is set in tough-guy scowl and his eyes are dark and lusterless, as if already taking on the aspect of the bleak Korean terrain.

PFC Littleton was ultimately assigned to serve as radio operator with an artillery forward observation (FO) team of Company C, 1st Battalion, 7th Marines, 1st Marine Division (Reinforced). Along with his personal gear, Hal carried a sixty-five-pound piece of equipment strapped to his back. This radio was the lifeline of a company when things got tense.

And on April 21, 1951, things were tense, indeed. Company C had been forced to use their helmets to dig in on a barren Korean hillside at Chungchon.

That night, PFC Littleton was on watch. Around 0100 on April 22, he roused the three other members of the team, warning them of an imminent enemy assault. The senior officer, Lt. Donovan, along with Littleton and his radio, moved about twenty yards forward to observe and direct fire. In the moonlight, the antenna was all-too-visible. "Take care of that radio," Lt. Donovan barked.

As the rest of the team joined them, an enemy soldier hurled a grenade over the top of the ridge. It landed less than six feet away from the Marines. In the space of a moment, Hal Littleton slipped out of his radio harness and jumped on the grenade, which exploded immediately. The impact of the blast lifted him off the ground and tossed his body about five yards down the hill where it landed, lifeless, against a gnarled tree. Cpl. Hunters, one of the Marines whose lives Littleton had saved, later wrote: "He saved my life, he saved his radio, and he saved Charlie Company. We would have been overrun if it wasn't for that piece of equipment that Herbie shook off his back."

PFC Herbert Littleton was laid to rest at Kohler Lawn Cemetery in Nampa, Idaho. His parents never gave him a middle name, just an A, and so did Charlie Company and the US Marine Corps. On August 19, 1952, Littleton's posthumous Medal of Honor was presented to his family at a ceremony in Boise, Idaho. When the PFC Herbert A Littleton Medal of Honor Monument was re-dedicated Spearfish, South Dakota, in 2000, joining Hal's family at the emotional ceremony was Hal's fiancée, Barbara Sawyer.

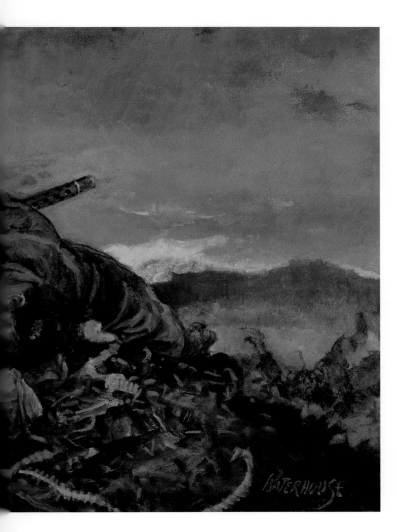

I was unsure whether my father painted this for Sgt. Johnson or PFC Littleton. Their names appear on corresponding sketches, but on the back of the canvas he simply wrote: "Land of the Morning Calm," a sobriquet for South Korea. Because I wasn't sure, I've dedicated this haunting image to both of these brave Marines.

TSGT. HAROLD E. WILSON, USMC[21]
Battle of Chosin Reservoir, Korea, April 23–24, 1951

Harold Wilson was born on December 5, 1921, in Birmingham, Alabama. Growing up, Harold worked as a delivery boy for a local grocer. After setting off with his wagon piled up with groceries, he would often stop by the park to watch—or sometimes even play—a game of baseball, delaying his return to the grocery store and earning the dubious nickname of "Speedy," which would stick with him throughout his life.

At the age of twenty-one, after a stint as a steel mill worker, Speedy Wilson enlisted in the Marine Corps Reserves. Assigned to active duty in April 1942, Wilson served twenty-seven months in the Pacific during World War II, returning stateside to stations at Parris Island and Camp Lejeune before being honorably discharged in October 1945 at the rank of sergeant.

Two years later, Wilson rejoined the Marine Reserve. In 1950, he was called back to active duty and headed to Korea as the platoon sergeant of 3rd Platoon, Company G, 3rd Battalion, 1st Marines, 1st Marine Division (Reinforced).

In the dark hours of the night of April 23–24, 1951, a large force of Communist Chinese soldiers overran the C Company outpost, pouring a deadly stream of mortar, machine gun, and artillery fire on Wilson's platoon. During the nightlong battle, TSgt. Wilson was wounded four times but steadfastly refused medical aid, moving among his men to rally them, organize defensive fire, and direct evacuation of the casualties. Unable to fire his rifle, Wilson collected weapons and ammunition from downed Marines, going from foxhole to foxhole and delivering fresh supplies, medical aid, and encouragement to his men.

By dawn, the attack had been repulsed. Dazed and suffering from concussion, Wilson stayed to personally account for each of his men before walking, unassisted, the half mile to an aid station.

Speedy Wilson went on to serve in the Vietnam War as a Chief Warrant 4 with Marine Aircraft Group 13, before being assigned as 6th Marine Corps district personnel officer in November 1968. He retired from the USMC in February 1972 and became a counselor with the Veterans Administration.

Son Harold Wilson Jr. later described his father as a modest man who seldom spoke about what he had done, saying, "He just did the job he was sent to do."

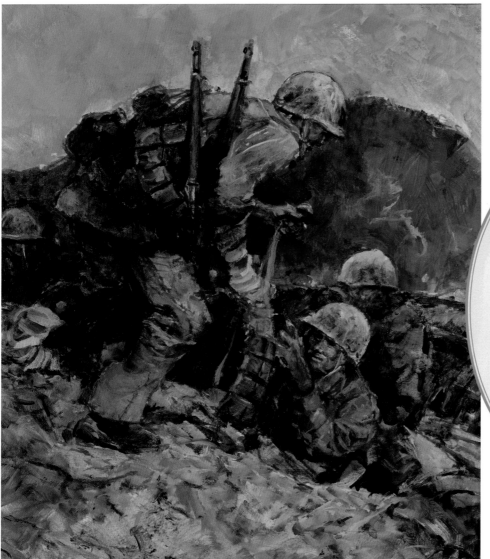

CPL. CHARLES G. ABRELL, USMC[22]
Hwachon, Korea, June 10, 1951

Standing watch outside the Vigo County Courthouse in Terre Haute, Indiana, is a life-sized bronze statue of a Marine holding a Browning Automatic Rifle, a symbol of the faithful sentry at his post: the first line of defense in protecting our freedom and liberty. The Marine depicted in this sculpture is native son, and hometown hero, Charles Abrell.

Charles was born in Terre Haute on August 12, 1931. In August 1948, just five days after his seventeenth birthday, Abrell enlisted in the Marine Corps. By September 15, 1950, Cpl. Charles Abrell was among the waves of Marines to take part in the daring, large-scale amphibious assault at Inchon, Korea. Serving as a fire team leader with Company E, 2nd Battalion, 1st Marine Regiment, 1st Marine Division (Reinforced), Cpl Abrell would spent the next nine months fighting in some of the bloodiest campaigns of the Korean War, including the battles for Seoul, Wonsan and the Chosin Reservoir.

On June 10, 1951, the combat-seasoned nineteen-year old Marine was with his unit, waging an attack against a heavily fortified enemy hill position at Hwacheon. The success of the entire mission was threatened by a relentless hail of fire coming from a Chinese bunker, entrenched on commanding ground, that had the Company E point squad pinned down, and was halting the advance and causing massive casualties.

The 1st Marine Regiment motto is "No Better Friend, No Worse Enemy," and on that day Cpl. Charles Abrell would put those words into action. Although he'd suffered shrapnel wounds from a hostile grenade early on in the attack, Abrell put the pain out of his mind, and focused on the one thing that mattered: his friends were in trouble.

In a bold one-man assault against the enemy bunker, Abrell charged through the besieged point squad, calling for his comrades to follow, and stormed through intense fire toward the enemy emplacement that was wreaking havoc on his platoon. Twice more Abrell was wounded, but he refused to give up. Time might be running out for him, but while Charlie Abrell still drew breath, there was no worse enemy the occupants of that Chinese bunker could have. When he got within range, Cpl. Abrell pulled the pin on a grenade and launched himself like a human missile into the emplacement, mortally wounding himself, but neutralizing all future danger from that enemy position, for good and for all.

Charles Abrell was two months short of his twentieth birthday when he died.

On September 4, 1952, Secretary of the Navy Dan A. Kimball presented Cpl. Abrell's posthumous Medal of Honor to his mother during a ceremony at the Pentagon. Abrell's medal is now on display at the Vigo County Historical Museum in Terre Haute, Indiana.

Although initially interred at the United Nations Military Cemetery in Tanggok, South Korea, Cpl. Charles Abrell now rests peacefully at West Lawn Cemetery in Farmersburg, Indiana, and he continues to stand watch—forever young, forever vigilant—in front of the Vigo County Courthouse. No worse enemy, no better friend.

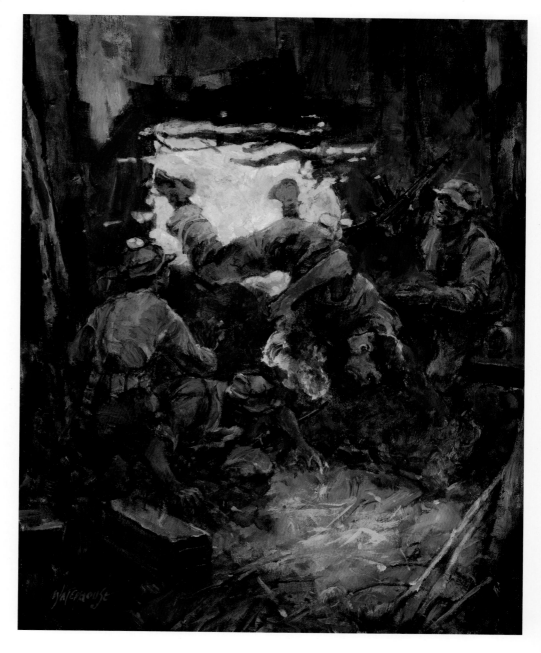

SGT. FREDERICK W. MAUSERT III, USMC[23]

Songnap-yong, Korea, September 12, 1951

There is a photograph of Frederick "Rickie" Mausert III, taken in his school days. The shadow from the baseball cap he's wearing covers his eyes. In one hand he holds a catcher's mitt, in the other a baseball. On his sweater is the varsity letter "H." It's unclear what the "H" stands for: Rickie Mausert appears to have attended a number of schools without landing anywhere long enough to establish an academic record.

He was born on May 2, 1931, in Cambridge, New York, to a mother and father who had a hard time staying put and staying married. By the time he was nine, his parents were divorced, and Rickie and his younger brother, John, were left in the separate care of others: sometimes with family members, other times, not. Rickie Mausert is remembered as an independent kid, with a bit of a swagger—doubtlessly a by-product of having to fend for himself from an early age. Girls found him charming and fun to be around. His cousin, Rye, said Rickie was "a cracker jack shot," who could hit a chicken in the head at eighty yards. He once killed an uncoiling milk snake getting ready to strike with a single shot from above and behind Rye's shoulder.

In June 1948, a month after turning seventeen, Rickie enlisted in the Marines. Like fellow Medal of Honor recipients Pappy Boyington, Jack Lucas, and Kenneth Worley (to name just a few), Mausert fed a lot of misleading biographical information to the recruiter, starting with his age and residence of record. The last time his cousin Rye saw him, Rick Mausert was looking snappy and proud in his Dress Blues. With the Marines, Mausert found the structure, stability and sense of family he'd never had. And he thrived.

By September 1951, Sgt. Mausert was in Korea as a squad leader in the 2nd Platoon of assault Company B, 1st Battalion, 7th Marines, 1st Marine Division (Reinforced). Those who served with him described Mausert as diligent, dedicated and extremely proficient with firearms. Although it was not a sergeant's weapon, Mausert liked to carry a Browning Automatic Rifle (BAR), further completing the picture of a "gung ho" Marine.

On September 12, the enemy had Company B pinned down on Hill 673 and unable to move up the slope. Marines were being picked off one after the other, falling dead or lying on the ground in exposed positions. Sgt. Mausert knew something had to be done and he knew it had to start with him.

Acting on his own initiative, Mausert charged into a minefield, and under heavy enemy fire, returned two wounded men to the Marines' line. Although he'd suffered a serious head wound during the rescue, Sgt. Mausert refused to be evacuated, insisting on leading his squad in the assault on Hill 673. During their advance, Mausert was struck in the helmet with a bullet and knocked to the ground. Dazed but determined, he sprang to his feet and, taking the forward position, threw a grenade at the enemy emplacement that had sent him sprawling, blasting it to smithereens.

Mausert's unit fought their way upward, neutralizing one enemy bunker after another, their casualties increasing the closer they got to the top of the ridge. When they finally reached the crest, Sgt. Mausert regrouped the remnants of his squad. The topmost enemy machine-gun nest was still raining down punishing fire. Again, Mausert took the initiative. In a bold one-man attack, he advanced toward the hostile gun emplacement, carbine blazing, drawing fire to himself in order to give his men time to reposition for an assault. Again he was seriously wounded, and again he refused medical aid, moving his squad forward against the Chinese emplacement, and rushing into the steely teeth of hostile machine-gun fire to hurl his grenades and obliterate another enemy position. His comrades would later recall that Sgt. Rickie Mausert was singing the *Marine Corps Hymn* as he plunged into the final machine-gun bunker and was killed in a final flurry of enemy grenades. He was twenty years old. The remainder of his squad took the crest and secured Hill 673.

After his death, a card was found among Rickie Mausert's personal belongings. On it he'd printed this quote: "A Coward Dies a Hundred Deaths, A Hero Only Once." Who knew that the "H" on the varsity sweater he wore in that photograph taken so many years before would end up standing for "Hero"?

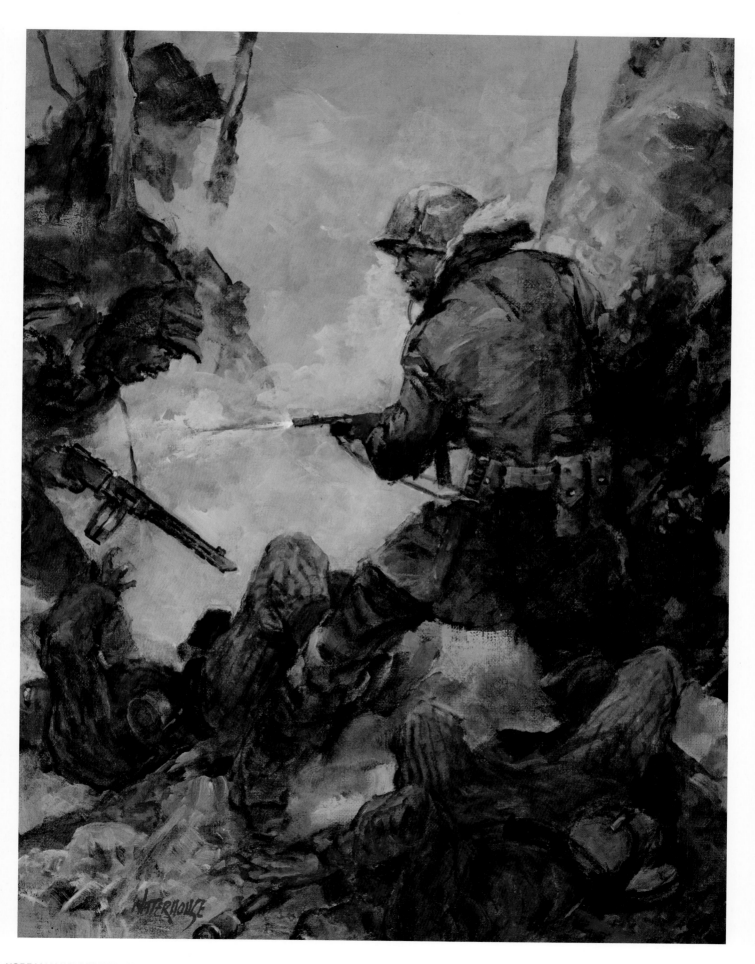

2LT. GEORGE H. RAMER, USMC[24]

Heartbreak Ridge, Korea, September 12, 1951

Born on March 27, 1927, in Meyersdale, Pennsylvania, George Henry Ramer was the only son of Maude Shannon Ramer, a matron at a local orphanage, and her husband, Harry. The Ramer family, which also included a daughter, Ethel, lived in Lewisburg, in central Pennsylvania's fertile Susquehanna River Valley, a stone's throw away from Bucknell University. Academics would play a large part in George Ramer's life. At another time he would have headed directly to Bucknell after graduating from Lewisburg High School, but like many young men in the Class of 1944, George put duty to his country first, and he enlisted in the Navy, serving in World War II until June 1946.

Upon returning to civilian life, Ramer hit the halls of academia running, enrolling at Bucknell, joining the Phi Gamma Delta fraternity and participating in the Marine Corps Reserve Platoon Leader's program. During semester breaks in 1947 and 1948, George completed summer training courses at Quantico, Virginia. His personal life was on the fast track, as well, and by August of the following year, Ramer and fiancée, Jeanne Grice, were exchanging vows at the altar of Beaver Memorial Methodist Church in Lewisburg.

In February 1950, George graduated from Bucknell with a bachelor's degree in political science and history. Having already attended his Marine Corps Reserve training, Ramer was commissioned as a second lieutenant in the Marine Corps.

With a lovely wife, his commission and a new job teaching civics, history and problems of democracy at a high school in his hometown of Lewisburg, everything that George Ramer had worked and hoped for was coming true. But George Ramer was not only a gifted teacher: he practiced what he preached. For him, civic duty and the personal cost of democracy—even when that democracy was on behalf of a nation, half a world away—weren't simply words in a textbook. They were the values by which he lived. And so it was little surprise when, in January 1951, Ramer voluntarily left the classroom and comfort of home, requesting to be called to active duty so he could serve in Korea.

On September 12, 1951, 2Lt. Ramer, serving as leader of 3rd Platoon, Company I, 3rd Battalion, 7th Marines, 1st Marine Division (Reinforced), was in the North Korean hills just past the 38th Parallel, in an area aptly known as Heartbreak Ridge. Ordered to attack and seize the enemy-infested hill, Ramer led the charge, braving a hail of hostile machine gun, mortar and small arms fire, and personally destroying an enemy bunker.

By the time they reached the summit, Ramer was down to eight Marines. They had captured the objective, but during the brutal ascent, Ramer and the majority of his remaining men had been wounded. He reorganized his small, battered group into a defensive line and waited for the KPA (Korean People's Army) counterattack.

It came swiftly and mercilessly engulfing them with the power of a human tsunami.

Wounded a second time, Ramer refused aid, ordering his men to withdraw before their position was overrun while, single-handedly, he provided covering fire, allowing for the evacuation of three fatally wounded Marines. 2Lt. George Ramer—son, husband and teacher—was mortally wounded while protecting his comrades. He was twenty-four years old.

In December 1951, Ramer's remains were returned to his hometown and reinterred in Lewisburg Cemetery. At a ceremony in Washington, DC, on January 7, 1953, Secretary of the Navy, Dan A. Kimball presented Ramer's posthumous Medal of Honor to his widow, Jeanne. She later loaned it for display at the Union County Courthouse in Lewisburg.

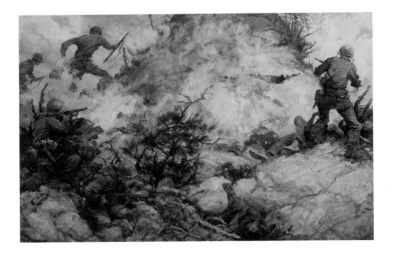

PFC Edward "Babe" Gómez, USMC[25]
The Punchbowl, Korea, September 14, 1951

Other than his service record, not much has been written about nineteen-year-old PFC Edward Gómez—known as "Babe" to his friends and family. He was born on August 10, 1932, to immigrant parents, Matiana and Modesto Gómez, living in Omaha, Nebraska. He attended Omaha High School. He enlisted in the Marine Corps Reserve at the age of seventeen. These facts shed little light on the person he was. But everything you need to know about Babe Gómez's upbringing, beliefs and values is spelled out in black and white on the pages of the final letter he wrote to his family in September 1951. In it Gómez said:

> "I'm writing this on the possibility that I may die in this next assault. You will hear about it before getting this letter and I hope you don't take it too hard … I am not sorry I died because I died fighting for my country and that's the number one thing in everyone's life, to keep his home and country from being won over by such things as communism.
>
> I am very proud to have done what little I have done … Be proud of me, Mom, because even though I'm scared now, I know what I'm doing is worth it.
>
> Tell Dad I died like a man he wanted me to be. I hope this doesn't break your heart—I love you. The kids, remind them of me once in awhile and never forget, kids, fight only for what you believe in—that's what I'm fighting for.
>
> All my undying love, Babe

Was it a premonition, or just the reality of every Marine fighting in the Battle of the Punchbowl? Either way, Babe Gómez believed that doing the right thing was the most important thing anyone could do in life.

On September 14, 1951, while serving as an ammunition bearer in Company E, 2nd Battalion, 1st Marine Regiment, 1st Marine Division (Reinforced) near Kajon-ni, PFC Gómez was advancing with his squad in support of a rifle team that was trying to clear out a heavily defended network of enemy bunkers, trenches and tunnels burrowed into the ridgeline of Hill 749, as part of the Korean People's Army (KPA) main line of resistance.

In his last letter home, Babe Gómez admitted to his mother that he was scared. But on Hill 749, the man his father wanted him to be, and the Marine that he'd worked so hard to become, merged, dispersing his fear into the swirling dust of battle. Throughout the assault, PFC Gómez fearlessly exposed himself to withering enemy fire in order to keep his machine gunners supplied with ammunition needed to drive forward and seize the KPA-held hill. While his squad deployed and prepared to meet the next counterattack, Gómez volunteered to check out an abandoned trench to see if it would be an effective position to place the machine gun. It was.

As the machine gun crew was getting ready to move their position, a hostile grenade landed between PFC Gómez and the weapon. Shouting "grenade!" Babe Gómez grabbed the activated charge and dove into the trench with the missile, covering the explosion with his body.

For his selflessness and courage that day, PFC Edward "Babe" Gómez became the 18th Marine in the Korean War to receive the Medal of Honor for heroism.

In 1952, at a combined religious and military ceremony at Our Lady of Guadalupe Church held in Omaha, Brig. Gen. Verne J. McCaul presented Gómez's posthumous Medal of Honor to his parents. Following the presentation, Babe's Medal was blessed during a special Mass conducted in his honor. The handsome young man who wanted his mother to be proud, and his father to know that he'd died like a man, fighting for the country he loved, was buried at Saint Mary Cemetery in Omaha. A white marker headstone embossed with the Medal of Honor star is a lasting testament to his bravery. Behind it waves an American flag. His parents and sister now lie next to him.

Babe Gómez represents everything that is good, and right, and true about this country. There should be more to remember about him. But Marines know what he did and Marines never forget.

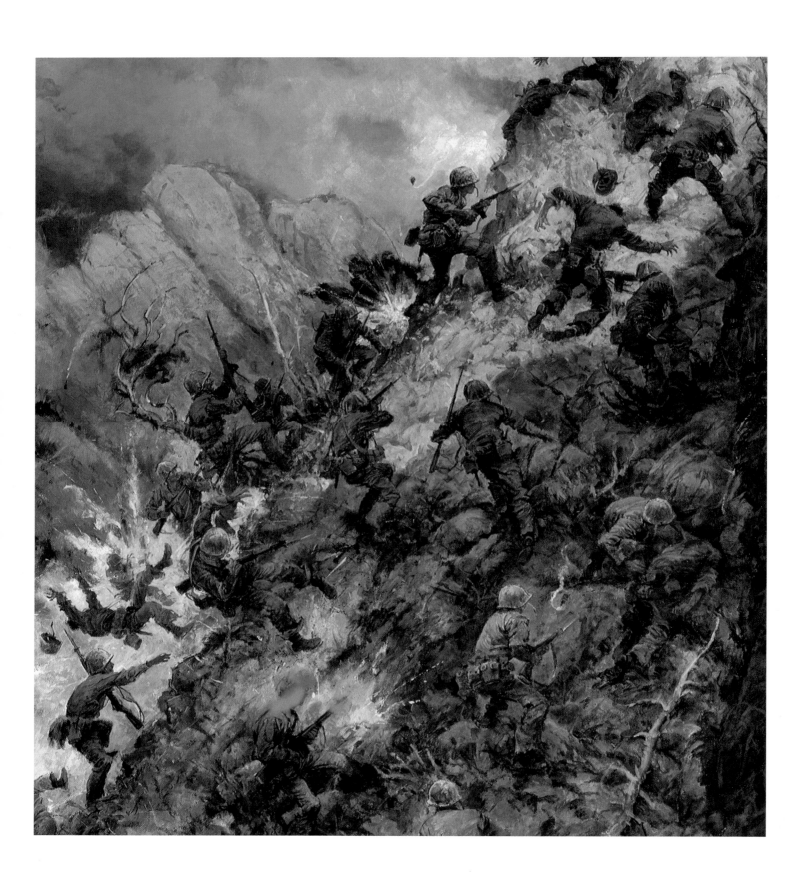

CPL. JOSEPH VITTORI, USMCR[26]
The Punchbowl, Korea, September 15–16, 1951

During World War II, a handsome Italian-American Marine named John Basilone held off a Japanese regiment of 3,000 soldiers for nearly two days with only his machine gun, pistol and machete. Nine years later, on Hill 749 in Korea, a handsome Italian-American Marine named Joseph Vittori waged a lone battle against a large enemy force, maintaining a withering fire of over 1,000 rounds from four separate machine gun positions in the space of three hours. Both heroes fought—not for glory—but out of a deep commitment to their fellow Marines. Both received the Medal of Honor. But only one of them lived long enough to wear it around his neck. The story of the one who didn't is one every American should know.

Joseph Vittori was born on August 1, 1929, in Beverly, Massachusetts. Although he was the son of Italian immigrants, everything about Joe screamed All-American. As a kid, he loved comic books, emulating the determined superheroes that fought against the forces of darkness. During his teenage years, Joe's hero worship shifted to the Marines storming beaches and battling the Japanese in the Pacific. He had a highly developed sense of duty and patriotism toward the country that had welcomed his family to its shores.

On September 26, 1950, Vittori enlisted in the Marine Corps Reserve for an indefinite tour of active duty. He was soon headed to Korea as an automatic rifleman with Company F, 2nd Battalion, 1st Marine Regiment, 1st Marine Division (Reinforced). During the South and Central Korean campaign, PFC Vittori earned two Purple Hearts and a promotion to corporal. But promotions meant nothing to him—the only thing Joe Vittori cared about was being able to fight alongside his friends.

On September 15, 1951, the Marines of the 2nd Battalion were in the Punchbowl, battling for control of a heavily fortified, enemy-owned ridge known as Hill 749. Only the day before, an ammunition bearer with Company E, PFC Edward "Babe" Gomez, had sacrificed his life on that hill, shielding his comrades from the blast of an enemy grenade. Now a forward platoon had come under such a ferocious counterattack from the Korean People's Army (KPA) forces, they'd suffered massive casualties and been forced to withdraw.

Upon hearing the news, Vittori and two volunteers from his reserve platoon pushed their way through the withdrawing troops to the front of the line, plunging into fray and overwhelming the enemy in a fierce hand-to-hand struggle, enabling the company to consolidate its position. Later, when an urgent call went up for an automatic rifleman to defend an isolated heavy machine gun position on the flank of his company's sector, Joe Vittori again stepped forward. Along with fellow F Company Marine, PFC Lyle Conaway, Vittori headed up the hill: Conaway with an M-1 semi automatic Thompson submachine gun and hand grenades, Joe with a (BAR) Browning Automatic Rifle. Seeing them, a corporal with the 2nd Platoon yelled, "You looking for another Purple Heart?"

"I got one already," Vittori replied, coolly. "But I'd like to have the Congressional Medal of Honor."

On Hill 749 that night, and into the morning of September 16, Joe Vittori showed that he was cut from the same cloth as Marine legends such as John Basilone, Mitchell Paige, Hector Cafferata, and Dan Daly. And like them, he would be, essentially, a man alone. Early in the fighting, Conaway was hit, losing the use of his right arm and the sight in one eye. Although he couldn't fire his M-1, he was able to throw grenades, but it would take more than that to keep the enemy from breaking through the gap in the battalion's lines. The Marines in the four machine gun nests were dead and Joe Vittori was the only one left to fix the situation.

Under cover of darkness, Vittori embarked on a herculean mission to hold the line, running from one machine gun emplacement to the next, maintaining a deadly field of fire on the enemy, moving from position to position, so the large KPA force wouldn't realize that, instead of the usual team of forty men at each defensive position, there was just one determined Marine, manning them all. And for hours it worked.

The ear-shattering cacophony from hostile artillery and machine guns suddenly stopped: Vittori had held the line, causing the enemy to retreat. In the eerie silence, Joe made his way back to PFC Conaway. He'd been hit. His shirt was soaked with blood, but he was more concerned about his friend. In an interview for the Netflix series, *Medal of Honor: Cpl. Joseph Vittori*, Lyle Conaway recalled that moment. "He said, 'We need help here. You're hit bad. You go first and I'll cover you.'" At that moment, Joe Vittori stood and a sniper shot him in the face, killing him instantly. The next morning the Marines counted almost 200 enemy dead in the area of Hill 749 that Vittori had defended.

Vittori's posthumous Medal of Honor was presented to his parents on September 7, 1952. For the rest of her life Joe's mother was tormented by the thought that her son had died alone. But he wasn't. Lyle Conaway was there and he'd witnessed it all. "Joe was the one who stopped them," Conaway, then eighty-eight, told the producers of the Netflix documentary. "He was the bravest man I ever …" Conaway's voice trailed off and his eyes filled with tears. No matter.

Words could never describe what his friend Joe Vittori had done.

CPL. DAVID B. CHAMPAGNE, USMC[27]
Hill 104, Korea, May 28, 1952

David Bernard Champagne was born on November 13, 1932, in Waterville, Maine. Soon afterward, parents Bernard Leo and Anna Osborne Champagne moved their family to a village called Wakefield, in the town of South Kingston, Rhode Island, where son Dave attended public schools and was remembered by his older brother as a "good, all-around kid." Their uncle was a projectionist at the local movie theater and while Dave was in high school he worked part time up in the projection booth, watching larger-than-life actors like Gary Cooper, Tyrone Power, and Humphrey Bogart stride across the big screen. Military pictures were still big box office and movie goers in Wakefield at that time would have flocked to the theater to see John Wayne in *Sands of Iwo Jima* and *Flying Leathernecks*, and Gregory Peck in *Twelve O'Clock High*.

Some biographical references suggest that Dave was an aspiring actor—he had the right kind of name and an appealing kid-next-door look—but after graduating from South Kingstown High School, instead of heading to Hollywood, eighteen-year-old Dave Champagne headed to the recruitment center in Boston, Massachusetts, to enlist in the Marines.

In November 1951, PFC Champagne celebrated his nineteenth birthday with his buddies from 1st Platoon, A Company, 1st Battalion, 7th Marines, 1st Marine Division (Reinforced) in Korea. Over the next six months he saw combat in three separate campaigns, during which time the young Marine was promoted to corporal and raised to the position of fire team leader. Although the peace negotiations continued, as far as Champagne and his fellow Marines could see, the talking wasn't doing a thing to stop the fighting and killing.

On May 28, 1952, Company A's mission was to assault a fortified Chinese position on Hill 104. Gathering his fire team together, Cpl. Champagne told them to fix bayonets. Champagne then led the charge up the steep slope into the teeth of the enemy, who were dug into the face of the hill, and raining down a barrage of small arm and machine gun fire from a series of trenches and "almost impregnable" bunkers.

Champagne and his Marines surged up the incline, overrunning the hostile positions, destroying enemy gun emplacements and engaging the Chinese in bloody hand-to-hand combat, until the Chinese troops were routed and their survivors were sent scrambling.

Cpl. Champagne knew the victory would be short-lived. He regrouped his team and positioned them in a trench, setting up a defensive line with mutually supported fields of fire so they'd be ready for the counterattack that was sure to come. And come it did.

Minutes later, the enemy mortar and artillery fire bombardment started, triggering in its wake, human waves of Chinese soldiers that surged down upon them. During the attack, an enemy bullet caught Champagne in the leg, spinning him around and knocking him to the ground. It was a serious wound, but although he was bleeding profusely, the young corporal remained intent on holding the crest of the hill. Refusing evacuation, Champagne continued to direct his fire team, firing his weapon, lobbing grenades, and hobbling fearlessly from one fighting position to the next to rally his men.

Despite their efforts to stave them off, the Chinese were closing in. And then it happened: an enemy grenade hit its mark, landing in the trench where Company A was positioned. Without hesitating, Cpl. Champagne grabbed the explosive and threw it at the assaulting enemy, but the missile went off as soon as it left his grasp. The power of its explosion blew off Champagne's hand, shredding his body with shrapnel and blasting him out of the trench. In a 1998 interview, a fellow Rhode Islander who was a member of that fire team, William A. Powers, said that Champagne, "… took the brunt of the blast. I turned him over. I held him briefly. He seemed to want to say something," but his last words were muffled by the noise of machine gun fire. Before Champagne could be dragged back into the trench, he was hit again by an enemy mortar blast and killed instantly. Twenty-year-old Cpl. David Champagne was buried in St. Francis Cemetery in his birthplace of Waterville, Maine. In July 1953, during ceremonies held at Old Mountain Baseball Field in his hometown of record, Wakefield, Rhode Island, Champagne's posthumous Medal of Honor was presented to his fifteen-year-old brother. When the Wakefield Post Office was renamed in his honor in 1998, attending the dedication was William A. Powers, the man who'd held Dave as he lay dying that day on Hill 104. Champagne's nephew and great nephew became Marines.

Champagne's painting was one of those left unfinished at the time of the artist's death.

John Doran "Jack" Kelly was born on July 8, 1928, in Youngstown, Ohio. The Kelly family later moved to a small steel mill town with the hospitable name of Homestead in Pennsylvania. Not long afterward, Jack's father died and his mother was left a widow. At Homestead High School (now Steel Valley High School) Kelly was best known for playing on the basketball team that won the 1946 state championship. He graduated in 1947, and spent four years studying at Arizona State College, leaving before earning degree to enlist in the Marines.

By early 1952, PFC Kelly was a radio operator with Company C, 1st Battalion, 7th Marines, 1st Marine Division (Reinforced) in Korea. His duties included maintaining contact with battalion headquarters and support units, and calling in friendly artillery fire upon enemy positions. He was also responsible for keeping the radio equipment—his company's lifeline, in sound working order. In the heat of action, that often meant taking cover in ditches and shell holes. Out in the open, the antennas on his radio were billboard advertisements for hostile fire from an enemy intent on disrupting and destroying the lines of communication among the Marines.

On May 28, 1952, PFC Kelly's role as a radioman was critical in enabling a platoon from Company C to provide covering fire for the lead assault platoon going up Hill 104. A nineteen-year-old corporal in Company A named David Champagne would be in the vanguard of that attack and also posthumously receive a Medal of Honor for his actions on this day.

The covering platoon was soon pinned down and outnumbered. Chinese mortar shells exploded all around them, sending up clouds of dust, debris and, horrifically, body parts. The ear-splitting volume of enemy machine gun and small arms fire made it difficult to think, let alone communicate. PFC Kelly might have remained with his radio equipment within a "relatively safe" perimeter of Marine riflemen—for that matter, he could've stayed at Arizona State—but playing it safe just wasn't in his nature.

Described by a bunker-mate as "a very dedicated Marine," Jack Kelly shrugged off his equipment, and leaving the radio with a companion, grabbed his carbine and some hand grenades and volunteered to join the assault. Moments later Kelly was charging uphill, along with 2Lt. Howard L. Siers, into a "murderous hail of machine gun fire and hand grenades." With their rifles blazing, Kelly and the lieutenant—who later received the Silver Star—went on a rampage against one enemy emplacement after another, engaging, when it was necessary, in fierce, close combat. Inspired by the two Marines, the rest of the platoon soon joined in the charge.

After destroying a Chinese position and killing two enemy soldiers, Kelly "singlehandedly assaulted a machine gun bunker," killing three more men. By this time, Lt. Siers had been severely wounded so he set about the task of reorganizing the platoon. But Jack Kelly kept going, seemingly unstoppable, launching a fearless one-man attack on an enemy machine-gun bunker. Wounded and losing strength, Kelly managed to destroy the hostile position with grenades, killing three of its occupants before being mortally wounded. The twenty-four-year-old "dedicated Marine" died moments later.

On September 9, 1953, Jack's grief-stricken sixty-four year-old mother, Emma, and his older brother, Eugene, went to Washington, DC, "at the expense of the USMC," to accept Kelly's posthumous medal from Vice President Richard Nixon at a ceremony at the 8th and I Streets Marine Barracks, where they met the families of Medal of Honor recipients 2Lt. Sherrod Skinner Jr., SSgt. William Schuck Jr., and Sgt Lewis Watkins, who were also killed in action.

Robert Ernest Simanek was born on April 26, 1930, in Detroit, Michigan, the third of four sons in a hardworking, patriotic family. Bob's two older brothers served in the Pacific during World War II, and when the Korean conflict started as he and his younger brother were coming of age, both felt it was their duty to don a uniform and do their part. Bob's uniform of choice was that of a Marine.

By May 1952, PFC Robert Simanek was in Korea with Company F, 2nd Battalion, 5th Marines, 1st Marine Division (Reinforced), serving as a BAR (Browning Automatic Rifle) man. "I really thought it was a great weapon, but it wasn't for the kind of fighting we were doing and I complained about it." Simanek later said, "So they said I could have the radio, be a radioman."

On the night of August 17, 1952, Simanek's squad was headed to Outpost Irene. "I had been to the outpost before, and no action had been there in the time I'd been on that part of the line," Simanek said, "so I took an old Readers Digest and a can of precious beer in my big back pocket, and thought I was really gonna have a relaxing situation." He added wryly, "Didn't turn out that way."

As they advanced through the western outpost area, Simanek's squad made a wrong turn and got lost. It turned out to be a felicitous accident: the large Chinese force waiting in ambush at Outpost Irene had expected them to come from a different direction, and were surprised by the Marines' approach, but they wasted no time in adjusting their fire.

With his unit already taking casualties, Simanek's first responsibility was to protect the radio, so he took

cover in trench line with 6 other Marines. Although already wounded by fragments from an exploding grenade, PFC Simanek continued to operate the radio, at the same time firing at the Chinese with his .45-caliber pistol. Then his weapon jammed. He yelled to one of his companions to toss him another one, but at that moment an enemy grenade landed in the middle of the trench. Acting instinctively, and with no regard to his personal safety, Simanek rolled over on top of the missile, absorbing the force of the explosion with his legs.

The blast didn't kill him, but when the young Marine tried to move his legs he realized he couldn't. Not only were his legs ripped to shreds and useless, shrapnel had shredded his flesh from hip and knee. He needed help, but so did a lot of his buddies, and with the enemy quickly closing in, PFC Simanek did the only thing he could do. Ignoring his pain, he picked up his radio. For the next two hours, Simanek continuously maintained radio communications with the command post, calling in a P-51 napalm drop and directing tank and artillery fire against enemy positions, while at the same time shooting at the Chinese with a borrowed pistol until the enemy retreated.

It would take PFC Robert Simanek six months to recuperate from his wounds and learn to walk again. On October 27, 1953, he received the Medal of Honor from President Eisenhower in a ceremony at the White House. "I used to talk to high school kids and tell them that this is the greatest country in the world," Simanek later said, "But I also told them no matter how much we love our country, we fought for each other. Any sacrifices were for each other."

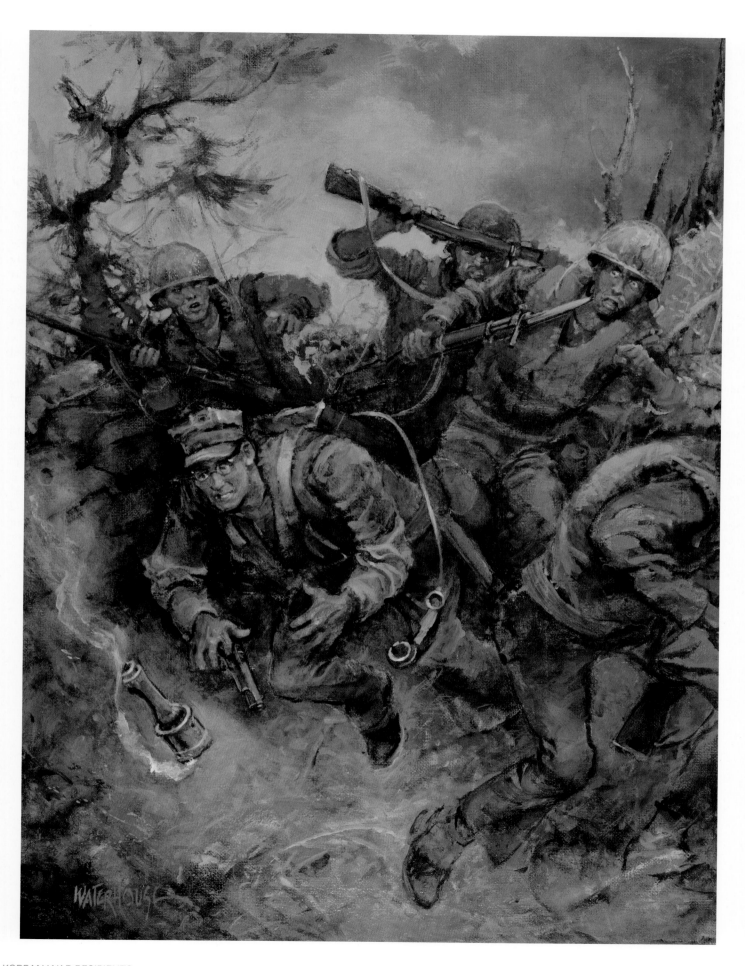

PFC Fernando Luis García Ledesma, USMC[30]
Bunker Hill Area, Korea, August 17, 1952

About 61,000 Puerto Ricans served in the Korean War. Four of them received the Medal of Honor. The first—and only Marine—was a twenty-three-year-old private first class named Fernando Luis García Ledesma. Fernando was born on October 14, 1929, in Utuado, Puerto Rico, to parents German García Y Faledo and Petra Ledesma de García. After completing his primary and secondary education in Utuado, the young man moved to San Juan where he was hired as a file clerk by the Texas Company (Texaco, Inc.). On September 19, 1951, Fernando joined the Marine Corps and headed to Parris Island, South Carolina, for recruit training. The newly promoted private first class was then transferred to Camp Pendleton, California, for combat training.

In March 1952, PFC García embarked for Korea, assigned to Company I, 3rd Battalion, 5th Marines, 1st Marine Division. A little over five months later, García would become the 38th Marine in that brutal, and all-too-often forgotten, war to earn the Medal of Honor.

On September 5, 1952, García's unit came under a pre-dawn attack at Outpost Bruce in the Bunker Hill area of western Korea. García, already wounded during the first hour of the intense assault, remained valiantly in action. As he was obtaining more grenades from the acting platoon sergeant, SSgt. Floyd V. Wiley, an enemy grenade landed nearby. "I'll get it," García shouted, throwing himself on the missile as it exploded.

SSgt. Wiley was wounded and knocked out by the blast. When he came to, he found PFC García dead. The brave young Marine's actions had saved his life. Later that morning the enemy completely overran the position, forcing I Company to pull back. PFC Fernando García's body was never recovered.

The news that their beloved son and brother would not be coming home eventually reached Fernando's parents, his two sisters, Daisy and Carmen, and brother, Hector. On October 23, 1953, at a ceremony held at the city hall in Utuado, Mr. and Mrs. García were presented with their son's posthumous Medal of Honor.

PFC García's ultimate sacrifice, in a war fought thousands of miles from his island home, is still remembered by the people of Puerto Rico. In addition to a memorial headstone at the Puerto Rico National Cemetery in Bayamón, a monument commemorating his actions stands in his hometown of Utuado. García's name is inscribed in "El Monumento de la Recordación" (Monument of Remembrance) in front of the Capitol Building in San Juan. On November 11, 2008, an oil portrait of PFC Fernando Luis García, commissioned by the government of Puerto Rico, was unveiled in the Capitol Rotunda.

There is a Marine military camp called "Camp García" at Vieques, Puerto Rico, and the United States Navy named the *García* class of ships in his honor: the lead ship in the class is called USS *Garcia*.

The name of PFC Fernando García is also inscribed in the "Wall of the Missing" at the National Memorial of the Pacific in Honolulu, Hawaii, along with the names of twenty-eight of his fellow Medal of Honor recipients whose bodies have never been recovered.

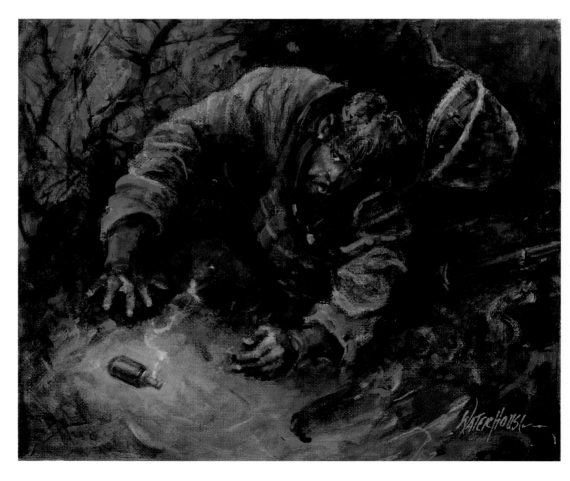

PFC ALFORD L. MCLAUGHLIN, USMC[31]
Bunker Hill Area, Korea, September 4–5, 1952

A wall in the Jonathan Bass House Museum in Leeds, Alabama, is dedicated to three native sons who earned the nation's highest military honor: 1Lt. William Lawley, a World War II Air Force pilot; SSgt. Henry "Red" Erwin, a World War II Army Air Forces airman; and PFC Alford Lee McLaughlin, a Marine machine gunner who fought in the Korean War. In a 2017 interview, the chairman of the board of the Leeds Historical Society, Frank Little, said, "To have three Medal of Honor recipients is rare for a town as small as Leeds," which is why, for Alabamans, it is known as the "City of Valor."

All three recipients were born in the 1920s, and had experienced the hardships of the Great Depression, but, in the words of former Alabama Governor, Bob Riley: "Hard times don't create heroes. It is during the hard times that the 'hero' within us is revealed."

And at a lonely outpost in the Bunker Hill area of Korea, the hero within twenty-four-year-old PFC Alford McLaughlin was revealed in ways that our nation should never forget.

The previous month, McLaughlin had been wounded in combat, receiving a Purple Heart, but by September 4, he was already back with his buddies in Company I, 3rd Battalion, 5th Marines, 1st Marine Division (Reinforced). As darkness fell, PFC McLaughlin volunteered for his second continuous tour of duty on Outpost Bruce, far in advance of the main lines, and the first point of defense against the Chinese assault that was sure to come.

Under a barrage of enemy artillery and mortar fire, McLaughlin set up plans for the defense of his platoon. Then he waited. The steady shelling—a booming overture that took place before every attack—continued for an hour. This particular bombardment was brutal, but the Marines of Company I held their positions. The next act started just after midnight. It began with the eerie blare of a bugle, followed by the shrills of whistles and taunting cries from the enemy horde, coming closer and closer. PFC McLaughlin was waiting for them with two machine guns, a carbine, and a cache of grenades.

As the first onslaught approached Outpost Bruce, McLaughlin sprang into action, unleashing an inferno of withering fire at the attackers, felling enemy soldiers like sheaves of wheat under a scorching scythe. No matter how many he mowed down, others reared up behind them, yet McLaughlin kept on fighting—like a machine, like a man possessed—all the while shouting words of encouragement to his platoon mates, inspiring them to hold their ground.

To keep his machine guns from overheating, McLaughlin alternated between them, standing up in full view of the enemy and firing from the hip until the heat from the automatic weapons had blistered his hands and scorched his skin. Despite these painful wounds, he kept at it until the guns were too hot for his raw palms to hold, and he had to switch over to using a carbine and grenades.

When dawn broke, and the remainder of the Chinese force dispersed into the gray mists of morning, dozens of corpses littered the area around McLaughlin's position. All told, PFC McLaughlin accounted for over 150 enemy dead and another fifty wounded. For his valiant defense of Outpost Bruce on September 4–5, 1952, PFC Alford McLaughlin became the thirty-third Marine to be awarded the Medal of Honor for heroism in Korea.

McLaughlin continued to fight in the third Korean winter before leaving Korea in 1953. After returning home, he married the former Kathryn West, and together they had one son. McLaughlin served as a military policeman at Camp Lejeune, North Carolina, until July 1953, when he was assigned as a mortar unit leader with the 4th Marine Corps Reserve Rifle Company at Rome, Georgia.

At a ceremony in the White House on October 27, 1953, President Dwight D. Eisenhower presented the Medal of Honor to then Cpl. Alford McLaughlin. He later returned to the 10th Marines at Camp Lejeune, retiring from the Marine Corps as a master sergeant in 1972. MSgt. Alford McLaughlin died in January 1977, as the age of forty-eight, and was buried in Mount Hebron Cemetery, in Leeds, Alabama, where his medal is on display and he is celebrated as a native son and hero.

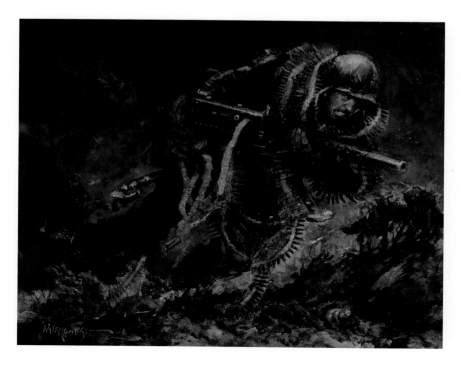

HC3C Edward C. Benfold, USN[32]
Bunker Hill Area, Korea, September 5, 1952

Edward Clyde "Ted" Benfold was born on January 15, 1931, in Staten Island, New York. When he was six, Edward and Glenys Benfold moved with their only child to Audubon, a small town in Camden County, New Jersey, an area of tree-shaded streets and comfortable homes that appealed to young families moving from crowded cities. To Teddie's father—a British citizen born in Calcutta who had immigrated to the US and become a merchant marine —it must have seemed like achieving the American dream; but with world war on the horizon, that dream would be short-lived. In June 1942, Edward was killed while serving as an officer (1st engineer) aboard the Merchant Ship USS *Castilla*, which was torpedoed and sunk by a German submarine as it was transporting troops to the European Front. His body was never recovered. For nine-year-old Teddie, all that remained of his beloved father were some photographs and a posthumous US Merchant Marine Mariners' Medal: a reminder that service to others, and duty to country, came at a personal cost.

Despite—or maybe because of—this early loss, Teddie Benfold lived life to the fullest. At Audubon High School, Ted was a color guardsman in the school band. He sang with the senior choir and was cast in the school production of *Our Town* and played the role of the town drunk in *My Sister Eileen*. On Sundays, Ted attended services, and sang in the choir, at St. Mary's Episcopal Church in Haddon Heights; in his spare time, he served in the Camden Wing of the Civil Air Patrol.

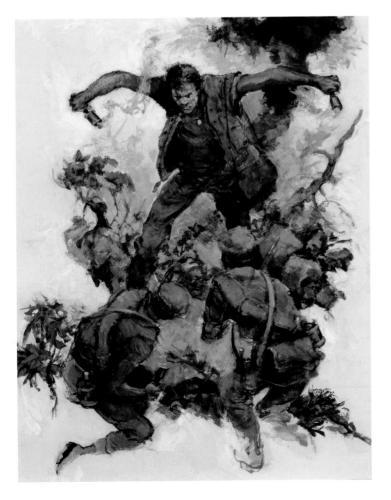

Soon after graduating high school, Benfold headed to the US Navy Recruiting Station in Philadelphia, enlisting as a hospital recruit on June 27, 1949. Over the next fourteen months, he advanced in rate to hospital corpsman third class. In January 1951, HC3c Ted Benfold married Dorothy Groff. When they exchanged vows at the altar of St. Joseph's Roman Catholic Church in Camden, NJ, either knew the span of time between 'to love and to cherish' and 'until death us do part' would be so heartbreakingly brief.

A month after the wedding Benfold was transferred to Camp Lejeune, NC, for combat field training. On May 1, 1952, HC3c Benfold participated in the A-Bomb Test on the Yucca Flat testing grounds in the Nevada desert. Fifteen days later, and thousands of miles away, Dorothy gave birth to a baby boy, Edward Joseph. While on a brief leave, Ted saw his wife for the last time, and his two-week-old son for the first and last time, before being deployed to Korea. In July 1952, he wrote Dorothy that he'd been assigned as a medic with the 1st Marine Division at Bunker Hill.

The bitter battle for ownership of the ridgeline between Hills 122 and 124 in western Korea–known by Marines as Bunker Hill—raged between August 9 and September 30, 1952 and was fought over several frontline outposts. On September 5, HC3c Benfold and the Marines of E Company, 2nd Battalion, 1st Marine Regiment were dug in at Outpost Bruce, under relentless artillery fire and mortar barrages from the Communist Chinese. As darkness fell, a battalion-strength enemy force launched an assault against the outpost. Nightmare blasts of trumpets and shrieking cries pierced the humid air, punctuated by the staccato tats of burp guns and the sudden booms of grenades. Mortar blasts lit up the sky, outlining the figure of Doc Benfold as he darted from position to position, treating the wounded and offering words of encouragement. With the assault heightening, the platoon area where Benfold was working came under attack from both the front and the rear. Moving forward to an exposed ridgeline, the corpsman noticed two Marines hunkered down in a large crater. Unable to determine their condition from his position, Benfold made his way toward theirs. As he reached them, two enemy grenades landed in the crater. At the same time, a couple of enemy soldiers began charging the position. But Corpsman Benfold wasn't about to let that happen. Picking up a grenade in each hand, he leapt out of the crater and hurled himself against the attackers, shoving the grenades against their chests as the missiles exploded, and killing them both. Twenty-one-year-old Ted Benfold was mortally wounded in the blast, but he'd saved the lives of his fellow Marines.

On July 6, 1953—at a ceremony at the Philadelphia Naval Base, attended by his widow and his mother—commandant of the 4th Naval District, RAdm. John H. Brown Jr., presented Benfold's posthumous Medal of Honor to his year-old son, Edward. Over fifty years later, at a 2009 Wreaths Across America ceremony at Beverly National Cemetery, New Jersey, son Edward told the assembled gathering that his father enlisted in the Navy because he wanted serve on a battleship as a gunner's mate, but that the recruiter had told him, "'Benfold, we need corpsmen,' so a corpsman he became." From that day on, up until the day he laid his life down for his brothers, Ted Benfold continued to step forward in service of others.

SSgt. Lewis G. Watkins, USMC[33]
First Battle of the Hook, Korea, October 7, 1952

Born on June 6, 1925, to parents Fred and Pauline Morton Watkins in Keowee, South Carolina—an old Cherokee town in the westernmost part of the state—Lewis George Watkins and his eight brothers and sisters grew up in a poor, but loving, family. Despite their hardscrabble existence, all nine of the Watkins attended school at Keowee, most of them graduating high school. Sister Betty, who was only twelve when Lewis left to serve in Korea, had vivid memories of her big brother sitting with all of them around the old wood stove, watching their mother cook the evening meal. However meager the portions might be, there was bound to be a satisfying helping of family stories passed around the Watkins dinner table, peppered with tales of war exploits and derring-do.

Military service ran in the family. Father Fred was a World War I Army veteran. During World War II, Lewis's oldest brother, Frank, was shot down over Germany while serving in the Army Air Corps. Another brother, Bobby Ray, had served in the Air Force. It was frustrating for Lewis to have to wait until he was old enough to do his part, but as soon as he turned eighteen, he dropped out of high school and enlisted in the Navy.

After serving a two-year hitch, Lewis returned to South Carolina. He earned his diploma from Greenville High School in 1949, and immediately joined the Greenville Police Department as a patrol officer. By 1950, young men were being drafted to serve in Korea. Watkins had already fulfilled his military obligation, but he resigned from the police department and volunteered to go back on active duty again, this time with the Marines. It wasn't a surprise to those who knew him. "He was a good person and would put other people, especially his family, above himself and help them first," his sister Lois said.

In the early morning darkness of October 7, 1952, while serving as a guide of a rifle platoon of Company I, 3rd Battalion, 7th Marines, 1st Marine Division (Reinforced) near Panmunjom during the First Battle of the Hook, Staff Sergeant Lewis Watkins led his platoon up a hill to retake an outpost that the enemy had overrun the night before. As they were nearing the crest, an enemy bullet hit Watkins, wounding him painfully, but he never faltered, expertly training his automatic fire on the hostile machine gun that was halting their assault. As they moved forward through a trench at the top of the hill, a grenade landed among his men. Acting immediately, SSgt. Watkins pushed aside his companions and, placing himself in a position to shield them, picked up the grenade to lob it back at the enemy. Before he could make the throw, it exploded in his hand, mortally wounding him.

In November 1952, a uniformed military officer came to the Watson home, bearing the news that SSgt. Watkins had died in action. His parents later received a letter from Marine Corps Commandant, General Lemuel C. Shepherd Jr., telling them that SSgt. Watkins had been awarded the nation's highest decoration, the Medal of Honor. The Watkins family donated Lewis's medal to the Patriot's Hall Veterans Museum in Walhalla, South Carolina. His remains were never recovered.

The postal facility in Seneca was named the SSgt. Lewis G. Watkins Post Office Building. At the renaming ceremony, district Congressman J. Gresham Barrett, asked the assembled crow. "Why would a guy risk everything he had to save somebody?" In answer to his own question, Barrett said, "You could say it was courage … his training … you could say it was a lot of different things. I say it's love. Love for his country, for his family and for his friends."

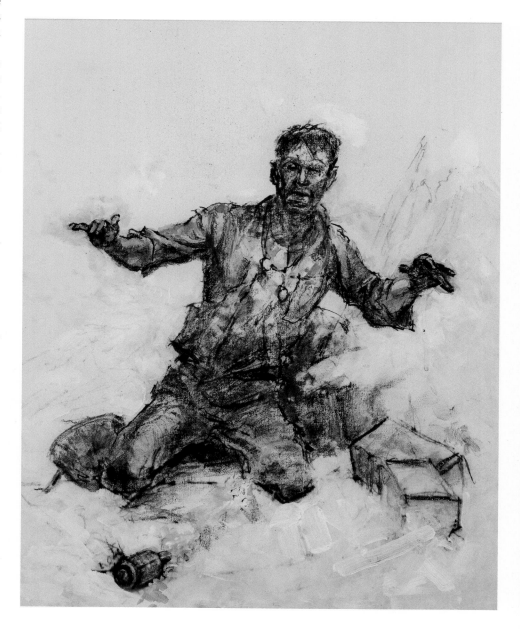

2Lt. Sherrod Skinner Jr., USMC[34]
The Hook, Korea, October 26, 1952

Chartered in 1798 to "open the way for all the people to a higher order of education" the Milton Academy in Milton, Massachusetts, is a prep school that takes seriously its motto, "Dare to be true." The students in attendance at the 2016 Veterans Day assembly were among the nation's best and brightest: a heterogeneous mix of male and female, different races, religions and countries of origin. They were also normal kids, and as the keynote speaker approached the podium, a strikingly similar thought ran through their heads: *Please, let this not be too long and boring.* They needn't have worried. The man delivering this year's address, Rod Skinner (Milton Class of 1972), had a story to share about his uncle, Marine lieutenant Sherrod Skinner Jr., would keep them pinned to their seats.

Sherrod Emerson "Rod" Skinner Jr. and his twin brother, David—the keynote speaker's father—were born October 29, 1929, in Hartford, Connecticut. After graduating from Milton Academy, the Skinner twins entered Harvard University where they participated in the Marine Corps Reserve Platoon Leaders program, serving active duty during their summer breaks until graduation. On October 9, 1951, Rod Skinner Jr. was appointed a second lieutenant in the Marine Corps Reserve. He was ordered to active duty the following day.

In 1952, at a time when the majority of his fellow Harvard grads were busy climbing the ladder of their chosen, high paying professions, Rod Sherrod dared to be true to his beliefs, serving his country in Korea as an Artillery Forward Observer of Battery F, 2nd Battalion, 11th Marines, First Marine Division (Reinforced). On the night November 26, 1952—just a few days before his twenty-third birthday—2Lt. Sherrod and his Marines were at an observation post in a critical sector of the main line of resistance called "The Hook," when their observation post came under attack by the enemy.

The Chinese attack completely severed communication lines to the Marine firing batteries. Determined to hold his position, 2Lt. Skinner organized and directed his surviving men into defensive positions, and with the only radio, continued to call down fire on the enemy until his equipment was damaged beyond repair. Undaunted, Skinner twice he left the protection of his bunker to direct machine gun fire upon the enemy and pick up fresh ammunition supplies. Both times the young lieutenant was wounded, but he refused medical aid until others in his group were attended.

With ammunition exhausted, the bunker under fierce hostile grenade attack and the outpost surrounded by Communist Chinese soldiers, Skinner realized their only hope was to take the line of passive resistance. He ordered his men to "play dead" when the hostile soldiers came into the bunker to inspect and search their bodies. The ruse succeeded. But their ordeal wasn't over. Three hours later, a suspicious Chinese soldier tossed a grenade into the bunker. In a final valiant action, 2Lt. Rod Skinner "threw himself on the deadly missile in an effort to protect the others, absorbing the full force of the explosion and sacrificing his life for his comrades."

Sherrod Skinner was the second Harvard graduate to receive the nation's highest military decoration, the first being an alumnus who had served in World War I. In closing his speech to the Milton Academy student body, Skinner's nephew said that his uncle's bravery stemmed from the school motto, "Dare to be true." "Rod was true to himself. Too many of us conduct our lives according to what we think others will think," he said. He challenged the young people in the audience to not live life "at a smug distance," but, like Rod Skinner, to have the courage to stand up for what they believe.

Waterhouse roughed out the "play dead" painting just before his death.

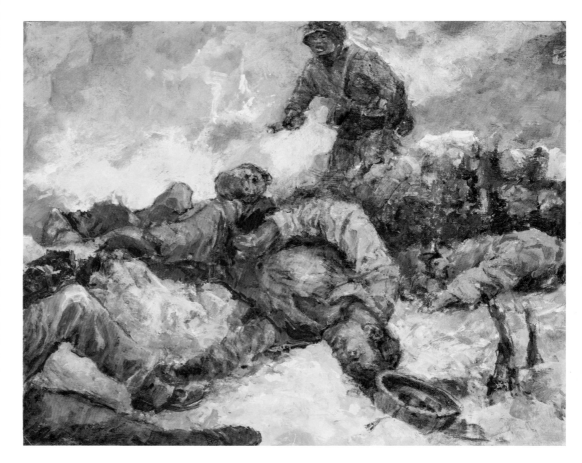

2Lt. George H. O'Brien Jr., USMC[35]
The Hook, Korea, October 27, 1952

In the predawn hours of October 27, 1952, the men of Company H, 3rd Battalion, 7th Marines, 1st Marine Division (Reinforced) slowly made their way toward a fishhook-shaped hill known as the Hook where Chinese Communist troops, backed by artillery, were wreaking havoc upon, and overrunning, Marine positions. Leading the charge that day was a twenty-six-year-old second lieutenant from Fort Worth, Texas, named George Herman O'Brien. Zigzagging down the slope toward the main trench line and shouting to his rifle platoon to follow, O'Brien wove through a hostile bombardment, pitching grenades at every enemy bunker he passed. When a burst from an enemy rifle struck him in the arm and knocked him to the ground, 2Lt. O'Brien sprang up like a Jack-in-the-Box and just kept on going. An eyewitness to his actions that day said that, at one point, five Chinese soldiers came out of nowhere and went for O'Brien. "The guy must have had tremendous reflexes, because he dropped all five," he said. "He was also wounded, but did this stop him? Hell, no! He continued to lead his platoon."

In contrast to eyewitness account is the personal testimony that George O'Brien gave to the producers of the *Medal of Honor Book* video series many years later. Speaking in a soft voice, with a pained look on his face—as if even after all this time he was still trying to make sense of it—an elderly O'Brien said, "We were taking artillery, mortars, heavy weapons fire and I was anxious to get out of that position and move toward our objective. I was losing kids while they were there and, of course, it was very upsetting."

Here his words slow, and you can see, in his mind, O'Brien is reliving the moment. "I just stopped, uh, and asked the good Lord to give me the courage and the intelligence to guide those troops," he pauses, his eyes filling with tears, before continuing, "as they should be led."

But in the heat of battle, with the objective on his mind, O'Brien supplemented prayer with action. Jumping up and calling for his boys to follow, the lieutenant launched a fearless four-hour assault against the heavily entrenched enemy, pausing only long enough to aid a wounded Marine and direct the evacuation of the wounded. During the hard-fought trek to the top, O'Brien killed at least three enemy soldiers in hand-to-hand combat. Three times he was knocked by the concussion of the grenades the Chinese threw at him, getting up each time and refusing medical evacuation. When a fresh unit finally relieved his platoon, 2Lt. O'Brien remained in place to cover the withdrawal of his men, and the removal of casualties, making sure that no one was left behind.

"We achieved our objective. We took it," George O'Brien told the *Medal of Honor Book*. Then he sighed, his eyes brimming with tears. "I lost a lot of kids …"

For this actions, 2nd Lt George O'Brien received the Medal of Honor from President Dwight D. Eisenhower at a ceremony in the White House on October 27, 1953—a year to the day that he led his Marines in the assault on the Hook.

O'Brien later said, "I repeat this on rote, that this medal's not mine, it belongs to those kids who never grew up to be grandfathers. I just hold it in trust … And I hope I wear it well—I pray." George O'Brien wore the Medal well until he passed away at the age of seventy-nine, in March 2005. He is buried at the Texas State Cemetery in Austin.

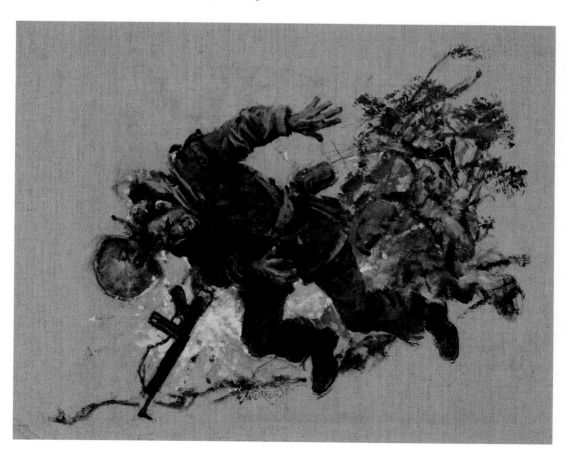

2LT. RAYMOND G. MURPHY, USMC[36]
Ungok, Korea, February 3, 1953

Raymond Gerald "Jerry" Murphy was born on January 14, 1930, in Pueblo, Colorado. An early pioneering spirit, kindled by its natural diversity and tempered with steel, may be partly why four of Pueblo's native sons have been recognized with the Medal of Honor, earning it the right to called itself "Home of Heroes."

Like many Medal of Honor recipients, Jerry Murphy was a standout athlete, playing varsity football, basketball, and baseball at Pueblo Catholic High School, while working as a swimming instructor during the summer months. He graduated from Alamosa State Teachers College with a degree in physical education in 1951, but by then the Korean War had started, so Jerry put his teaching career on hold and signed up with the Marine Reserves, enrolling in an accelerated program that enabled him to go directly from Officers Candidate School, 19th Special Basic Class, at Parris Island and on to officers training, and earning his second lieutenant bars in less than three months. Those bars would significantly diminish Murphy's chances of surviving the war: second lieutenants represented the fastest casualty rate in the USMC because they were up front, leading their men.

But as a platoon commander of Company A, 1st Battalion, 5th Marines, 1st Marine Division (Reinforced), "up front" was exactly where Jerry Murphy wanted to be.

On November 4, 1952, a night patrol that Murphy was leading came under heavy fire near Panmunjom. Of the many casualties, three of the wounded needed to be evacuated by stretcher. The gullies and arroyos in this part of Korea were similar to those in the Southwest, and Murphy knew they'd never be able to carry the wounded through them. He told his corporal he was going to take them out through the no-fire zone. The corporal said, "Mr. Murphy, we can't go down there." Murphy said flatly, "We're going down." He expected to be court-martialed but ended up with a Silver Star.

On February 3, 1953, Murphy's unit was held in reserve, waiting and watching as two platoons made an assault on a well-mined Communist stronghold called Ungok on the cliffs of a blasted-out ridge. Hours passed. Nobody came down. Sensing something was wrong, Murphy told his men, "We're going up."

On top of the ridge, they found a scene of carnage: seventeen Marines dead—many of them officers—and close to seventy-five wounded. Murphy swiftly assumed control. Despite being painfully wounded himself, he spent that day going up and down the hill, often leading assaults just to get the wounded and KIAs evacuated. Years later, in a conversation with author Larry Smith, Murphy said, "I don't recall shooting two guys with a pistol, like the citation says," adding, "One thing I remember: When it got close to the end of the day, I told somebody in my company we were going back up one more time, and I found a whole four-man machine gun crew, all of them dead. So we started lifting them up, dragging them, trying to get them off as fast as we could. Marines don't leave their dead. That was our way."

And it was Jerry Murphy's way to lead from the front. After refusing medical aid for himself and personally carrying many wounded Marines to safety, the stalwart second lieutenant remained behind with a carbine, warding off the enemy until every one of his men, and all the casualties, had preceded him to the main lines.

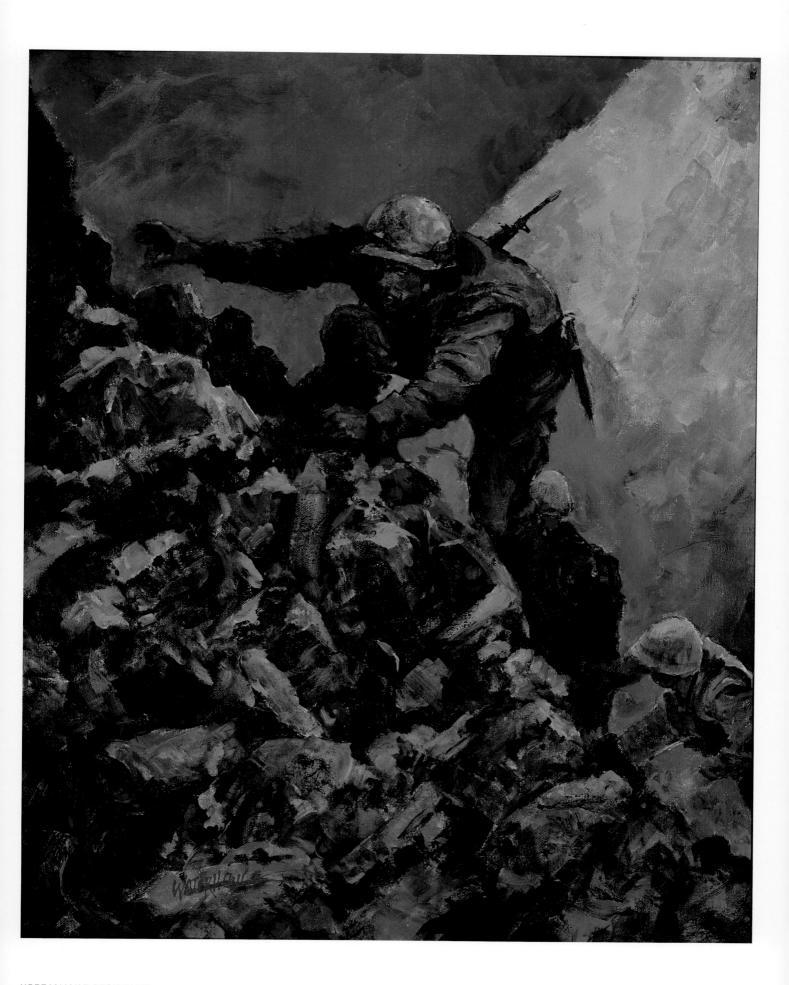

Daniel Paul Matthews and his twin brother, David, were born on New Year's Eve 1931, in Van Nuys, California.

In high school, Dan was a member of the track and football teams, but by the time he was sixteen, he was restless and ready to make his own way in the world, so he dropped out of school and took a job as a concrete-mixer operator with a Los Angeles contractor. In February 1951, Matthews enlisted in the Marine Corps. After completing his recruit training, he was promoted to private first class and assigned to Camp Pendleton where he served first with the 6th Infantry Training Battalion, and later with the 1st Battalion, 3rd Marines, 3rd Marine Division. The life of a Marine suited Daniel Matthews, and he quickly moved up the ranks from corporal to sergeant.

In March 1953, Communist Chinese forces initiated a major offensive in western Korea against three hilltop outposts north of the Main Line of Resistance (MLR) called the Nevada Cities: Carson, Reno, and Vegas. At a height of 175 meters, the tallest of these outposts, and the one that provided the best observation, was Vegas. Beginning on March 26, it would be the site of a bloody five-day battle that would cost the 1st Marine Division over 1,000 casualties.

By March 28, six attempts to recapture the vital outpost had been repulsed by the Chinese. The seventh attempt to take Vegas fell to twenty-one-year-old Sgt. Daniel Matthews, serving as squad leader of Company F, 2nd Battalion, 7th Marines, 1st Marine Division (Reinforced). As Matthews was leading his squad up the slope, they came under intense fire from a hostile machine-gun position situated at the crest of the outpost. The

Chinese gunners had them pinned down. One of Matthews's men was lying out in the open, seriously wounded, and the corpsman who'd gone to his aid was taking fire and unable to move him to safety.

Sgt. Matthews took action. Maneuvering himself to the rocks at the base of the hostile machine-gun emplacement, he jumped onto the rock, and charged the enemy position, firing his carbine in a courageous one-man attack.

Although caught by surprise, the Chinese machine-gunner was able to turn the weapon on Matthews, severely wounding him. But brave young sergeant would not be stopped. He killed two of the enemy machine gunners and chased off the third. With the machine gun silenced, his squad members were able to assist the corpsman and remove their wounded comrade from the fields of fire, but by the time they advanced up to the enemy machine gun nest that Matthews had stormed, he was already dead. As his comrades brought his bullet-riddled body down from Vegas Hill, the ceasefire and truce in Korea were only four months away.

In May 1953, Daniel's twin, David, who had enlisted in the Navy, escorted his brother's body back to the United States. Sgt. Daniel Matthews is buried at Glen Haven Cemetery in San Fernando, California.

Daniel's posthumous Medal of Honor was presented to his parents on March 29, 1954, in a ceremony at the Pentagon that was also attended by the parents of Cpl. Lee Phillips and the wife and baby daughter of Sgt. James Johnson.

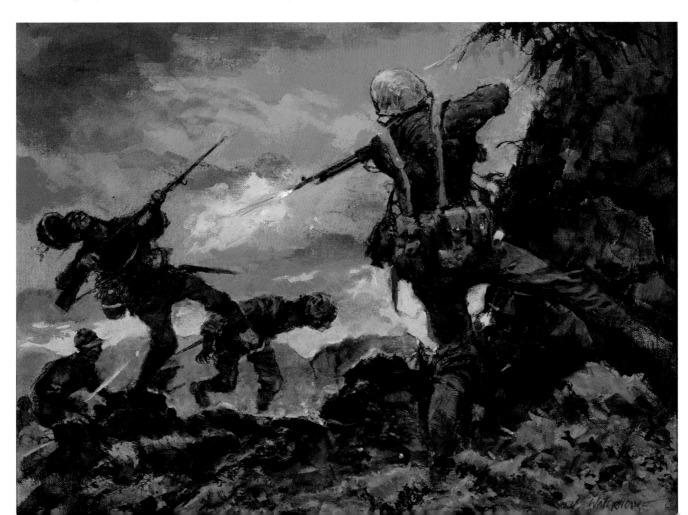

SSGT. AMBROSIO GUILLEN, USMC[38]
Songuch-on, Korea, July 25, 1953

The seventh of December, forever associated with the Japanese attack on Pearl Harbor, is an auspicious date in US history. But on December 7, 1929—a dozen years before it became the day that "would live in infamy"—a son was born to parents Pedro and Perfecto Guillen in La Junta, Colorado. They called him Ambrosio, a name that means *immortal*, after the Catholic theologian and saint, Ambrose. The Guillen family soon moved to El Paso, Texas, and along with his three siblings, Ambrosio grew up as typical All-American kids in a loving, and traditional, Mexican-American family.

After graduating from El Paso's Bowie High School, Ambrosio Guillen felt called to serve his country, and at age eighteen, he enlisted in the Marines where he soon earned a reputation as an exemplary Leatherneck. While serving as a drill instructor at the Marine Corps Recruit Depot, San Diego, California, Guillen trained two recruit honor platoons and was given a Letter of Appreciation by his Commanding general, Maj. Gen. John T. Walker, who stated that his "success in training these two platoons has demonstrated your outstanding ability as a leader."

SSgt. Guillen's leadership ability would be put to the test in combat with Company F, 2nd Battalion, 7th Marines, 1st Marine Division (Reinforced), in the Western Outposts area near Songuchon-on, Korea. On July 25, 1953—just two days before the armistice was signed—now platoon sergeant Ambrosio Guillen and his men were defending a forward outpost along the 38th Parallel, when they came under attack by an overwhelming Chinese force. With his men pinned down by hostile small arms, machine gun and mortar fire, Guillen sprang into action. Dodging explosions, lobbing grenades and continuously firing his weapon, the twenty-three-year-old platoon sergeant dashed from one fighting position to the next, directing fire, maneuvering and motivating his Marines to stand their ground, all while personally supervising the treatment and evacuation of the wounded; still, the waves of Chinese troops just kept on coming.

Judgment … Initiative … Decisiveness … Endurance … Unselfishness…Courage—these are some of the traits of leadership espoused by the Marine Corps, and on July 25, Ambrosio Guillen embodied them all. Realizing his platoon was about to be wiped out, the young platoon sergeant took the initiative, and with unflagging courage, superhuman stamina, and selfless disregard to his own personal safety, he charged forward and began engaging the enemy in fierce, hand-to-hand combat. Inspired by his example, Guillen's men surged forward with renewed zeal. By the time the bloody confrontation ended, the Chinese were in full retreat. The Marines had killed countless enemy soldiers and held their position. But the brave platoon sergeant who'd led them to victory had been critically wounded during the battle, and despite the medics' best efforts to save him, Ambrosio Guillen succumbed to his wounds.

On August 18, 1954, Secretary of the Navy Charles Thomas presented Ambrosio's posthumous Medal of Honor to Mr. and Mrs. Pedro Guillen. Attending the ceremony were their three surviving grown children, including son, Ramon, who while serving in the Army in Asia, had been given leave to escort his brother's body back home for burial at Fort Bliss National Cemetery in El Paso, Texas.

In addressing the assembled audience that day, Navy Secretary Thomas asked, "Would you and I, when our country asked the last full measure of devotion, suffer and die as nobly as this young Marine?" According to a *Washington Herald* correspondent who attended the event, Mr. Guillen, wearing Ambrosio's Good Conduct Medal on his jacket lapel, frequently wiped his eyes during the reading of the citation, and Mrs. Guillen's hands visibly shook as she accepted the Medal of Honor. After the presentation, Mr. Guillen spoke, "with great dignity in not too distinct English, for which he apologized," telling the crowd that he did "not have words to tell what was in his heart but was grateful for what his Government had done to honor his son."

In 2005, the Ambrosio Guillen Texas State Veterans Home, a facility that provides long-term care to veterans, their spouses, and Gold Star parents in El Paso, was named in honor of the brave young hero who grew up as a typical All-American kid in a traditional Mexican-American family and ended up making the ultimate sacrifice for the country he so loved, trailing clouds of glory with the intimations of his immortal name: Ambrosio.

HC3C William R. Charette, USN[39]
Panmunjom Area Korea, March 27, 1953

William Charette was born in Ludington, Michigan, on March 29, 1932. His parents died in a car accident when he was just five years old, and William and his sister were taken in and raised by an unmarried uncle. During high school, William spent the summer months aboard a ferry hauling cars across Lake Michigan, sparking dreams of a life at sea. In 1950, his bachelor uncle was called up to serve in the Korean War. A year later, nineteen-year-old William enlisted in the Navy. Inspired by his sister, who was a nurse, Charette decided to be corpsman, spending time working in a naval hospital before volunteering for combat duty. Hospital Corpsman Third Class William "Doc" Charette was assigned to Fox Company, 2nd Battalion, 7th Marines, 1st Marine Division.

On the night of March 26, 1953, Chinese soldiers in North Korea overran a critical hill outpost near Panmunjom. In their efforts to regain it, the Marines in Fox Company were taking heavy casualties. Amid the fighting, Charette became separated from his platoon. When the order came to advance, Charette's first thought was to wait for his unit, until a sergeant with a machine gun stood up and said, "OK, men, move on out, because if they don't kill you, I will." Doc Charette moved forward.

He'd never been in combat. On March 27, before he could take it all in, someone passed the word: a corpsman was needed in front of the lines. Doc Charette moved forward again.

The point man was down. As the corpsman was treating him, US air power began dropping bombs on the Chinese. Pinned down, the enemy retaliated by rolling grenades down the hill. One landed near Charette. He pushed his medical kit toward the bomb and covered his patient with his body. The explosion ripped off Charette's helmet and obliterated his medical kit, but that didn't stop him. Tearing strips of cloth from his uniform, Charette made bandages for the five wounded men next to him, taking off his tattered flak jacket to give to a Marine who was shivering from shock, and lifting another over barbed wire to carry him to safety.

Upon hearing he was to receive a Medal of Honor, Charette told his captain, "I didn't earn it."

In May 1958, this humble hero performed one more task for his country. Standing aboard the Navy cruiser *Canberra*, Charette paused before two flag-draped coffins, each containing the unidentified remains of a World War II veteran—one from the European theater and one from the Pacific theater.

One final time, Doc Charette moved forward, kneeling reverently before one. Then he rose and snapped a salute. With that, William Charette had officially chosen the coffin that would represent the remains of all the nameless lost in that war. Today it is interred in the Tomb of the Unknowns in Arlington National Cemetery.

After twenty-six years of service, William Charette retired from the Navy in 1977 as a master chief hospital corpsman. He died in March 2012, just before his eightieth birthday.

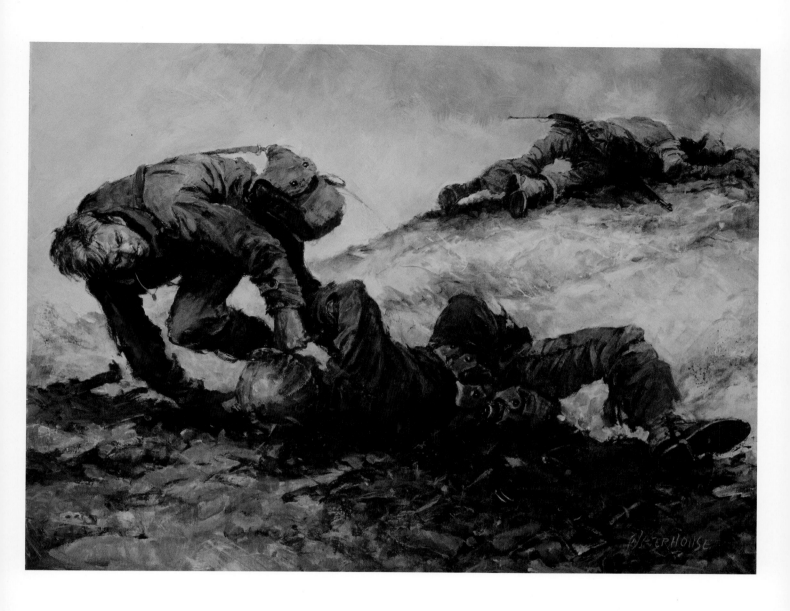

Richard DeWert was born on November 17, 1931, in Taunton, Massachusetts, to a single mother who was too busy struggling with her own demons to care for a child. From an early age, Richard was left to fend for himself, taking refuge in his imagination, where a hardscrabble yard could become a World War II battlefield, and a discarded piece of cardboard an aid station where he could carry make-believe soldiers to safety and attend to their wounds. But try as he might, the imaginative little boy couldn't fix his mother, and because she couldn't fix herself, Richard was put into foster care. He might have become a casualty of the system were it not for Joseph and Albertina Roy. As Albertina later wrote: "God sent him to us so that we could shower him with the love and affection that he never received in early childhood and he in turn returned that love and affection on us, that we also never received from a child of our own."

Having found a stable home with the Roys, Richard was able to envision a future for himself. His dream was to join the Navy and become a doctor, and on December 2, 1948, less than a month after his seventeenth birthday, he took a step toward realizing it by enlisting as a seaman recruit. After completing his training, DeWert attended the US Hospital Corps School in Great Lakes, going to serve at the US Naval Hospital in Portsmouth, Virginia.

By July 1950, HM3c DeWert was attached to Headquarters and Service Company, 1st Medical Battalion, landing with the 1st Marine Division at Inchon and participating in operations at Seoul, Wonsan, the Chosin Reservoir and the Hungnam Evacuation. But the young corpsman felt he wasn't doing enough and repeatedly requested to be transferred with the frontline Marines. On March 6, 1951, DeWert's requests were granted and he was told to report to D Company, 3rd Platoon, 2nd Battalion, 7th Marine Regiment.

Platoon Commander, 1Lt. Richard Humphreys, remembered seeing the baby-faced new corpsman arrive, carrying a large wicker basket filled with medical gear and medications. Used to seeing corpsman check in with a sea-bag loaded with personal gear, Humphreys asked, "How are you going to carry all of that?" To which DeWert replied, "It's my duty sir, I have to carry it." From that moment on, Humphreys could tell he was dealing with "a corpsman of Marines in every way."

Over the next month, DeWert proved himself over and over again, building rapport with his Marines and working tirelessly to care for the wounded.

On April 5, 1951, during the advance to gain Hill 439, a fire team from 3rd Platoon came under attack and three Marines on point position were severely wounded. As DeWert gathered his medical gear, ready to make the dash to the casualties, the platoon sergeant grabbed his arm, yelling, "Don't go out there, Doc, wait till it's clear." DeWert shook him off, saying, "You do your job, Sarge, and I'll do mine," and bolted forward into a barrage of fire.

Doc DeWert made it to the first wounded Marine, grabbing him under the armpits and dragging him toward cover. Despite being hit in the leg by enemy bullets, DeWert refused medical aid and took off toward the second Marine, dragging him to safety. Ignoring protests from his comrades, DeWert went out again. As he was crawling toward the third Marine, a hostile bullet tore through his shoulder, shattering bones; still, Doc Dewert continued to inch forward across the bullet-ridden terrain, only to find that the Marine was dead. Undaunted, DeWert began to pull his fallen comrade's body out of the line of fire. Just then, the corpsman saw that the platoon squad leader had been hit.

Hemorrhaging blood, his eyes glistening with tears of pain, DeWert mustered all of his strength and crawled 15 yards to the squad leader. As he was learning over to provide aid, HM3c DeWert was cut down in a burst of enemy machine gun fire.

When Doc DeWert was carried off the field, many of the men of Dog Company stood up and saluted. One of these Marines later said, "Seeing Richard DeWert's bravery and selfless actions was the turning point because it inspired us to move against the enemy regardless of the odds."

DeWert's Medal of Honor was presented to his mother on May 27, 1952, by Secretary of the Navy Dan A. Kimball. Sadly, despite their pleas, his birth mother had refused to let the Roys adopt Richard, although it was their plan—and his—to do so legally when he turned twenty-one. Their beloved foster son was killed at the age of nineteen, but thanks to the love of these two kind people, a lost boy was able to turn his childhood imaginings of carrying soldiers to safety into actions that soared, far above his duty, and beyond anything he could have ever dreamed.

HM John E. Kilmer, USN[41]
Bunker Hill, Korea, August 13, 1952

The bugle echoes shrill and sweet,
But not of war it sings to-day.
The road is rhythmic with the feet
Of men-at-arms who come to pray.

Those words, penned over a century ago by Joyce Kilmer (1886–1918) in his poem, *Memorial Day*, are a fitting description of the graveside memorial service that's held annually at San Jose Burial Park, San Antonio, Texas, in honor of the poet's distant cousin, Hospitalman and Medal of Honor recipient, John E. "Jackie" Kilmer.

John E. "Jackie" Kilmer was born to parents John and Lois in Highland Park, Illinois, on August 15, 1930. Not long afterward, the Kilmer family relocated to San Antonio where John Senior passed away at the age of thirty-seven, leaving Lois to raise six-year-old Jackie and his brother. Little is known about Jackie Kilmer until August 16, 1947—the day after his seventeenth birthday—when he walked into the Navy Recruiting Station in Houston to enlist as an apprentice seaman.

Upon graduating from the Naval Hospital Corps School in San Diego, California, in 1948, Kilmer was assigned to Hospital Ship USS *Repose* where he advanced in rate to hospital apprentice and finally, on September 1, 1950, to hospitalman. His official photograph shows a serious young man with a wave of thick, dark hair cresting on the high tide of his forehead and setting his dixie cup cover at a rakishly leeward angle. The smoldering dare-you-to-dare me glint in his eye is softened by a peach fuzz moustache: this is a guy who exudes attitude.

By the time the Korean War broke out, HM Kilmer was nearing the end of his four-year enlistment. When his contract expired in August, Kilmer reenlisted. On August 12, 1952, Kilmer and his unit were in western Korea, taking part in the bitter battle for Hill 122—forever known by the Marines as Bunker Hill. Between 1500 on August 12 and 0600 the following morning, artillery and aerial observers reported that

an estimated 5,000 to 10,000 rounds of enemy fire fell on 1st Marine positions, the "heaviest incoming fires received by the Division since coming into the present sector." Dug into defensive positions ahead of the main line of resistance, H Company was pinned down under heavy enemy fire and their casualties were mounting.

Kilmer stayed continuously on the move, braving intense Chinese artillery, mortar and sniper fire, dashing from position to position to administer aid and evacuate the wounded. Even when shrapnel from an exploding mortar round pierced his body, Kilmer remained selflessly focused on the Marines in his care. Refusing medical care, the young hospitalman pressed on, inching his way toward yet another casualty. As he began to treat the Marine's wounds, a heavy barrage of hostile mortar fire erupted. Without hesitating, Kilmer shielded his patient's body with his own. The Marine lived, but Jackie Kilmer was mortally wounded during the shelling. He died the following day, August 13, 1952, three days shy of his twenty-second birthday.

On June 18, 1953, Lois Kilmer accepted her son's posthumous Medal of Honor from Secretary of the Navy, Robert B. Anderson. In October 2019, Navy Secretary Richard V. Spencer announced that a future Arleigh Burke-class guided-missile destroyer, DDG-134, would be named in honor of US Navy Hospitalman John E. Kilmer.

And every year, on the anniversary of his death, Hospital Corps "A" School instructors, staff and students from the Navy Medicine Training Support Center (NMTSC) join members of several local veterans' organizations at Kilmer's grave in the small burial park outside of San Antonio, to honor a man who, in the words of his cousin, poet Joyce Kilmer—killed in action in World War I, eighteen years before Jackie was even born—

"kept the faith and fought the fight. . .
plunged for Freedom and the Right."

Col. Waterhouse died before he could paint Richard DeWert and John Kilmer, but these corpsmen sketches—scribbled as my sister drove him to a family gathering in Vermont—show that he fully intended to. At some point he'd zero in on the right composition, draw it out more fully, then transfer to canvas.

Capt. Donald G. Cook, USMC[1]

Prisoner of War, Vietnam, December 31, 1964 – December 8, 1967

Medal of Honor Citation

For conspicuous gallantry and intrepidity at the risk of his life above and beyond the call of duty while interned as a Prisoner of War by the Viet Cong in the Republic of Vietnam during the period 31 December 1964 to 8 December 1967. Despite the fact that by so doing he would bring about harsher treatment for himself, Colonel (then Captain) Cook established himself as the senior prisoner, even though in actuality he was not. Repeatedly assuming more than his share of responsibility for their health, Colonel Cook willingly and unselfishly put the interests of his comrades before that of his own well-being and, eventually, his life. Giving more needy men his medicine and drug allowance while constantly nursing them, he risked infection from contagious diseases while in a rapidly deteriorating state of health. This unselfish and exemplary conduct, coupled with his refusal to stray even the slightest from the Code of Conduct, earned him the deepest respect from not only his fellow prisoners, but his captors as well. Rather than negotiate for his own release or better treatment, he steadfastly frustrated attempts by the Viet Cong to break his indomitable spirit, and passed this same resolve on to the men whose well-being he so closely associated himself. Knowing his refusals would prevent his release prior to the end of the war, and also knowing his chances for prolonged survival would be small in the event of continued refusal, he chose nevertheless to adhere to a Code of Conduct far above that which could be expected. His personal valor and exceptional spirit of loyalty in the face of almost certain death reflected the highest credit upon Colonel Cook, the Marine Corps, and the United States Naval Service.

To learn more about Donald Cook, read his story in chapter 5.

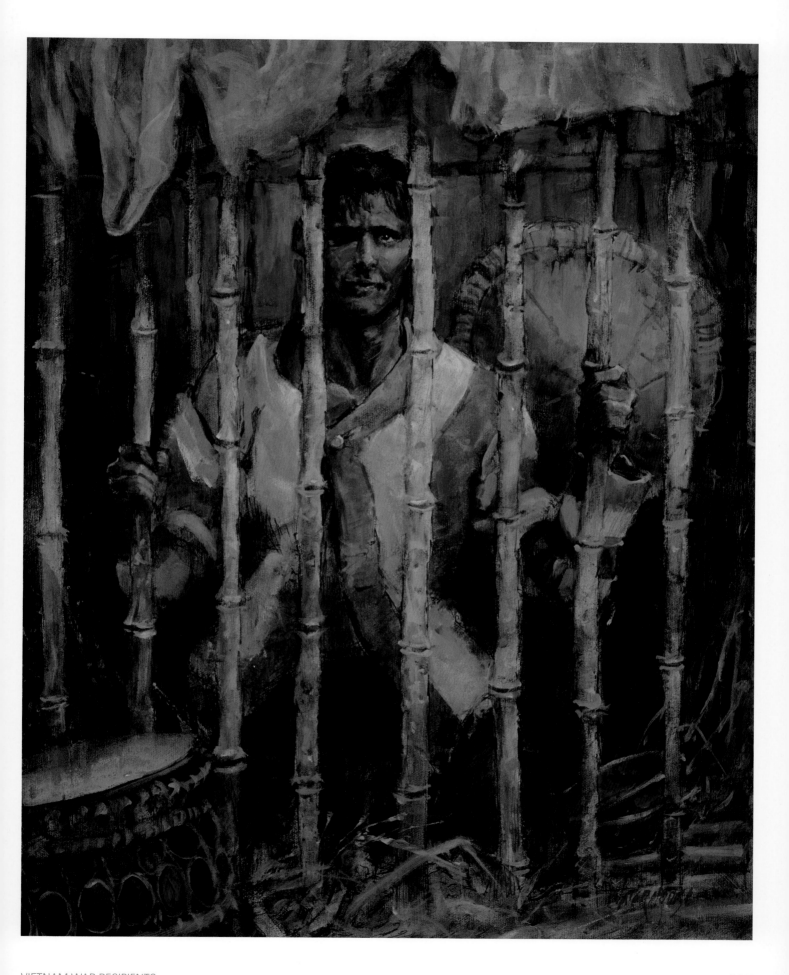

1Lt. Harvey C. Barnum Jr., USMC[2]

Quang Tin Province, Vietnam, December 18, 1965

Harvey Barnum Jr. was born on July 21, 1940, in Cheshire, Connecticut. In high school, "Barney" was president of his class, with varsity letters in football and baseball. At the end of his senior year, representatives from all the service branches came to address the boys. After the Army and Navy recruiters had spoken, a Marine gunnery sergeant strode to the podium. "You know, there's no one in this room that I even want in my Marine Corps," he said. "This is the most unorganized, undisciplined group of young men I've ever seen." And he walked off the stage.

At the break, Barnum was one of about thirty "undisciplined young men" who lined up at the gunnery sergeant's table to enlist in the USMC Platoon Leadership Class (PLC) Training Program. While attending St. Anselm College, Barney spent two summers training in Quantico. In June 1962, with a degree in economics in hand, Barnum went back to Quantico to begin the Basic School, followed by the Field Artillery Officers Orientation Course.

In 1965, then 1Lt. Barnum volunteered as a forward observer (FO) for Vietnam. Barnum had been with Company H, 2nd Battalion, 9th Marines, 3rd Marine Division (Reinforced), for about a week when, on December 18, they were ambushed during Operation Harvest Moon along a hedge-lined road near the village of Ky Phu. Amid the chaos, his company, which was attached to 2nd Battalion, 7th Marines, became separated from the rest of the battalion.

Discovering that the commander had been mortally wounded and the radio operator was dead, 1Lt. Barnum assumed command. He removed the radio from the fallen operator, strapped it on, and advanced through the heavy fire, rallying and reorganizing the badly decimated unit and leading their attack on enemy positions. Armed with a Korean War–vintage 3.5-inch rocket, Barnum went up on a knoll, fired white phosphorus on the trenches as a marker, and called in the helicopter gunships. With the enemy so close, he couldn't chance calling in artillery fire, so Barnum remained on the knoll, using his arms as an axis to direct the incoming pilots.

After organizing the clearing of a landing zone, Barnum requested and directed the landing of two helicopters for the evacuation of the dead and wounded. When the last chopper lifted off, the first lieutenant ordered the platoons to set fire to their unusable equipment. Telling them to leave their packs behind, he led his remaining men across a fire-swept 200 meters to rejoin the battalion.

Harvey "Barney" Barnum retired from the USMC as a colonel in 1989. He went on to serve as principal director, drug enforcement policy, in the office of the secretary of defense; as deputy assistant secretary of the Navy; in Reserve Affairs; and as president of the Congressional Medal of Honor Society. The Navy named an Arleigh Burke–class destroyer, DDG-124, the USS *Harvey C. Barnum Jr.* in his honor.

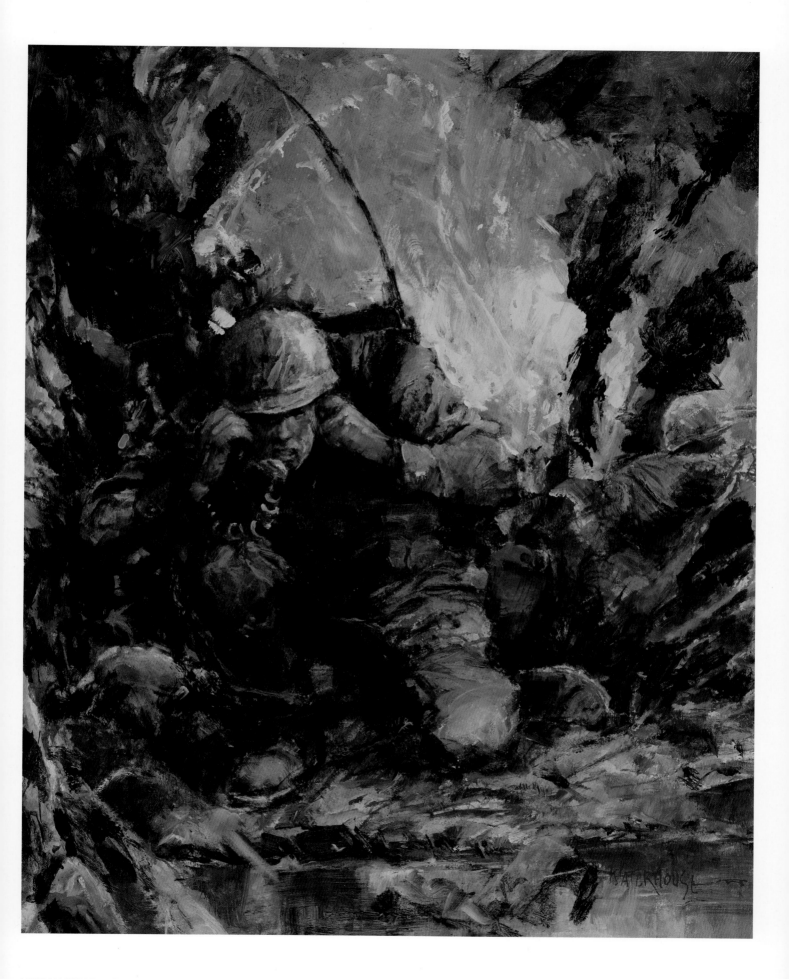

1LT. FRANK S. REASONER, USMC[3]
Da Nang, Vietnam, July 12, 1965

Frank Stanley Reasoner was born on September 16, 1937, in Spokane, Washington. By the age of nine he'd started earning his own way with a paper route. Shortly afterward, the Reasoner family moved to the old prospecting town of Kellogg, Idaho. Although Frank was on the small size—just five feet seven inches tall, fully grown—he cut a big presence as a high school athlete, excelling in football, baseball and basketball. Of all the sports, Frank liked boxing the best, and he continually worked out with weights and followed a rigorous training regimen, to ensure he was at his best in the ring.

By the time he graduated from high school in June 1955, Frank had his sights set on the Marine Corps, and, as always, when Frank Reasoner wanted something, he went all in. After successfully completing boot camp, he set a new goal: to be a Marine officer. Never mind that he didn't have a college education, and that in high school, he'd preferred shop class to his academic courses. To increase his chances, Frank attended the Naval Academy Preparatory School at Bainbridge, DC, and eventually won an appointment to the US Military Academy at West Point.

In his first year, Cadet Reasoner's steely will and competitive spirit earned him the honor of "Outstanding Plebe." Reasoner was considered too small for football, but he played baseball, wrestled and became "one of the best boxers West Point has ever seen," winning four Brigade Boxing Championships in four different weight classes. Upon graduating from West Point with a Bachelor of Science degree in 1962, Reasoner left the Army and returned to the Marines as a Second Lieutenant.

By the spring of 1965, combat units were being deployed to Vietnam, and 1Lt. Frank Reasoner—by then a married man and new father—was among them, serving as commanding officer of Company A, 3rd Reconnaissance Battalion, 4th Marines. During a training exercise at China Beach, Reasoner told to a fellow lieutenant that he didn't expect to go home alive.

As company commander, he didn't have an obligation to lead his reconnaissance teams on patrol, but taking the safe route wasn't Frank Reasoner's style. He was a man who thrived on achieving goals and carrying out missions, so on July 12, 1965, when 1st Platoon was given the mission to scout an area south of Da Nang where elements of the 9th Marine Regiment had encountered the enemy, Reasoner took the lead, accompanying the five-man advance party, and the point, deep into enemy territory, in broad daylight. As they approached the village of An My, the small team started receiving sniper fire. They pushed on through a drenching rainstorm, crossing a ditch and coming to a graveyard with low, rounded grave mounds, unaware that the Viet Cong were positioned on a nearby hill, and at that very moment a Soviet-made machine gun mounted on a tripod was aiming down at them.

Soon the heavy air was filled with the sound and fury of hostile machine gun firing from above, with additional fire from up to a hundred more Viet Cong insurgents pouring down at the Marines from an area near the enemy machine gun. Cut off from the main body of his company, and with the only available cover the circular graves, 1Lt. Reasoner ordered his men to lay down a base of fire. His goal now was to knock out the hostile automatic weapons position, and Reasoner pursued that objective relentlessly. He repeatedly exposed himself to enemy fire, killing two Viet Cong, and single-handedly destroying the enemy gun emplacement. But Reasoner's team was taking casualties and during the firefight, his radio operator was hit. The lieutenant immediately moved to the man's side, tending his wounds. When the operator was shot a second time while attempting to reach a covered spot, Reasoner again ran to his aid. He was killed by a staccato burst from an enemy machine gun. Frank Reasoner, who'd been setting and achieving lofty goals since the age of nine, died at the age twenty-seven, leaving behind a young wife and a baby son.

On January 31, 1967, Secretary of the Navy Paul H. Nitze presented the Medal of Honor to Reasoner's widow, Sally, and son Michael, in ceremonies at the Pentagon.

Said son Michael in 2001, "Although I wasn't yet two years old when he died, I can think of no better legacy for a father to leave his son than the one he left me."

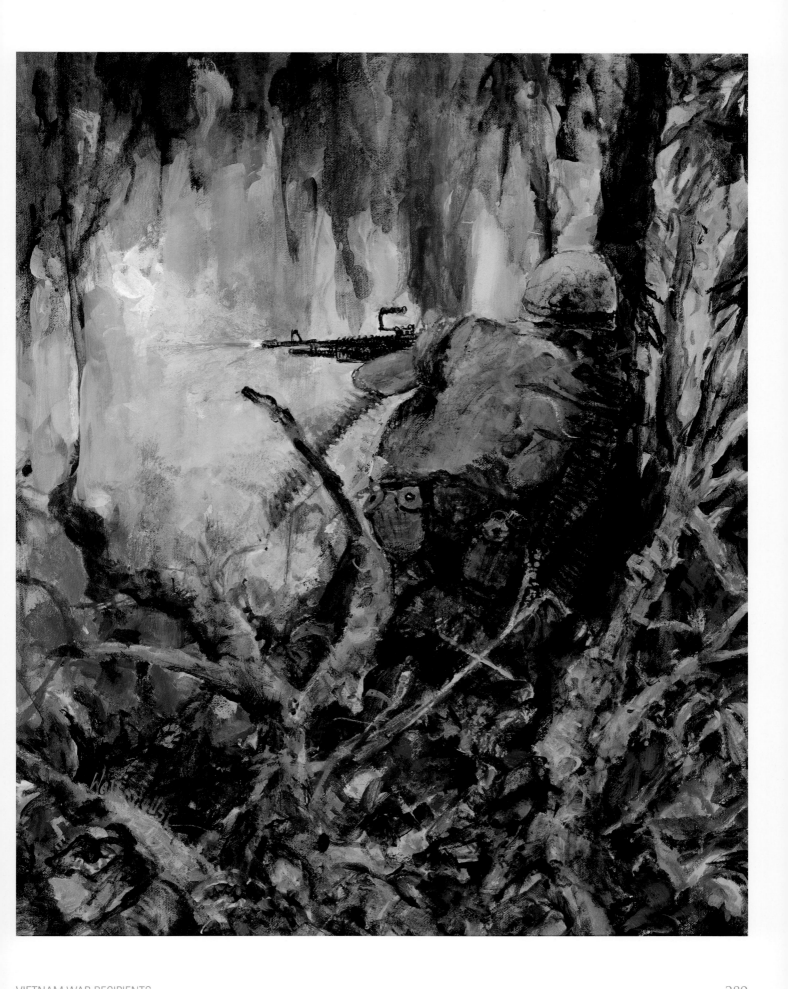

CPL. ROBERT E. O'MALLEY, USMC[4]

An Cu'ong, Vietnam, August 18, 1965

Robert Emmett O'Malley was born on June 3, 1943, in New York City. He was raised in the historically Irish neighborhood of Woodside, Queens, where he attended school and church every Sunday with another scrappy kid of Irish descent by the name of Thomas Patrick Noonan. A picture of the 1949 Kindergarten class of P.S. 76 shows Bobby and Tom, aged six: two friends, born within five months of each other, who would each receive a Medal of Honor for actions in performed in Vietnam on dates four years apart.

All four O'Malley brothers served in the military, and after graduating high school, it was Bobby's turn. He enlisted in the Marines on October 11, 1961, and was sent to Vietnam in 1965 as a squad leader in Company I, 3rd Battalion, 3rd Marines, 3rd Marine Division (Reinforced).

On August 18, 1965, while leading his squad in an area near An Cu'ong, O'Malley's unit came under intense fire from a strongly entrenched enemy force. With his men pinned down, O'Malley took the initiative, racing across an open rice paddy toward the hostile position and jumping into the enemy trench, attacking the Viet Cong occupants with his rifle and grenades and single handedly killing eight of them. He then returned to his squad, setting off with them to assist an adjacent Marine unit that had also suffered heavy casualties, where he personally assisted in the evacuation of several wounded Marines. When ordered by an officer to an evacuation point, Cpl. O'Malley assembled his battered squad and led them under fire to a helicopter. Although he'd been wounded three times, he continued to cover his unit, standing in an exposed position to pour withering fire at the enemy until the last of his men were safely on board. Only then did he allow himself to be removed from the battlefield.

Upon presenting the Medal of Honor to Robert Emmett O'Malley on December 6, 1966, President Johnson remarked, "Every time I have awarded the Medal of Honor, I wonder what it is that makes men of this quality and I wonder what a man can say in the face of such bravery."

In 1988, a Vietnam Memorial was erected in Woodside, Queens. On it are the names of twenty-seven young men from the same zip code who made the ultimate sacrifice in Vietnam.

According to then Councilman, Jimmy Van Bramer, that number is higher than from any other postal code in the nation. "It was that kind of neighborhood," said Woodside resident, Lorraine Diehl, who remembered Bob O'Malley well. "I was five years younger than him, so I looked up to Bobby like he was a superstar," she told the New York *Daily News*. "That a neighborhood guy, from your block, your parish, your school, your candy store on Laurel Hill Avenue, won the Medal of Honor was like the whole neighborhood just hit the lottery."

In later life, Bob O'Malley moved to Texas, living quietly, and privately, on a farm. For many years he remained in contact with the Noonan family, visiting his Tommy's mother every Memorial Day, to remember his neighborhood pal and fellow Medal of Honor recipient.

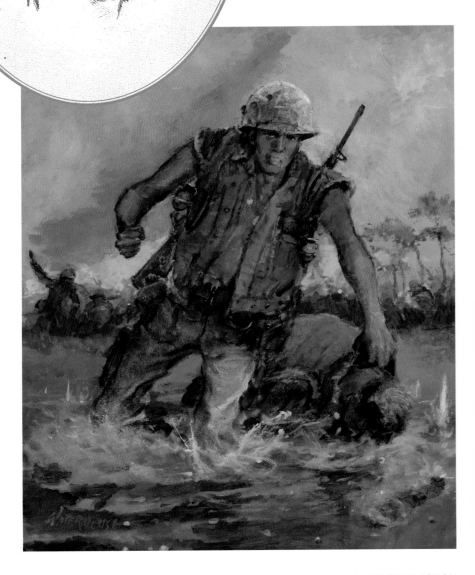

Capt. Robert Modrezejewski, USMC[5]
Operation Hastings, Vietnam, July 15–18, 1966

Robert J. Modrzejewski was born in July 3, 1934, in Milwaukee, Wisconsin. The son of Polish immigrants who came to the US at the turn of twentieth century, Robert grew up on Milwaukee's south side in a family where values like hard work, patriotism and a strong Catholic faith were the cornerstones of everyday life. At school, Robert was an average C+ student, but he excelled in sports and was the quarterback of the Pulaski High School football team. After high school, Modrezejewski attended Wisconsin State Teachers College before transferring to the University of Wisconsin in Milwaukee where he served as a member of the Platoon Leaders Class. Upon earning his Bachelor of Science degree in Education in June 1957, Modrezejewski was commissioned a second lieutenant in the Marine Corps Reserve. He was integrated into the Regular Marine Corps in May 1960.

In 1966, now Capt. Robert Modrezejewski was ordered to the Republic of Vietnam as commander of Company K, 3rd Battalion, 4th Marines, 3rd Marine Division.

On July 15, 1966, while participating in Operation Hastings—an initiative aimed to stop the North Vietnamese from infiltrating through the demilitarized zone and Laos into the South—Company K was set down in an enemy-infested jungle to establish a blocking position at the nexus of several major Vietcong trails. Although the company came under attack soon after landing, Captain Modrezejewski led his men in a successful routing of the enemy, seizing a cache of Vietcong ammunitions and supplies.

After reaching their position and setting up a perimeter, Modrezejewski's unit repelled yet another enemy attack. This marked the beginning of a ferocious battle that would continue over four days and three long nights, during which time Modrezejewski and his Marines fought back repeated enemy assaults. Modrezejewski later recalled, "They were getting stronger all the time while I was getting weaker from casualties, lack of ammunition and the fact that we were surrounded."

Although wounded in intensive close-action combat, the stalwart captain continued to rally his men, managing to crawl 200 meters under intense enemy fire to order to provide critically needed ammunition to an exposed element of his command. By the third day, Modrezejewski was down to about 100 Marines capable of fighting. Just when it seemed things couldn't get worse they did: on the night of July 18, the remnant of Company K was attacked by regimental-size force outnumbering them 500 to 1.

Capt. Modrezejewski reorganized his men, calmly moving among them to encourage and direct their fire, calling in close range air and artillery strikes until the massive North Vietnames force was repulsed. Soon afterward, news filtered down that 3rd Battalion was moving. When Modrezejewski's battalion commander told him that he wanted Company K to act as the rear guard, the beleaguered captain said wryly, 'I don't have enough Marines here to protect the Sisters of the Poor let alone the rear of the battalion." But, Modrezejewski added, "nevertheless, that was my mission," and he and his remaining men carried that mission out, despite having to fight off another large enemy onslaught just as they reached the helicopter evacuation point.

On March 12, 1968, in ceremonies at the White House, President Lyndon B. Johnson presented the Medal of Honor to two brave Marines: Capt. Robert Modrezejewski and 2Lt. John J. McGinty III. "I never looked at it as something that belonged to me," said Modrezejewski. "It was always for the wounded and those that died and the sacrifices they made … I'm the guy wearing it, for them."

HC3C ROBERT INGRAM, USN[6]
Quang Ngai Province, Vietnam, March 28, 1966

Robert Roland Ingram was born on January 20, 1945, in Clearwater, Florida. The Ingrams were a hardworking, blue-collar family of constructions workers and truck drivers, and Robert figured that, sooner or later, that would be his lot in life. But that changed in 1963, when he joined the Navy. In boot camp, Ingram developed pneumonia. He was put into the dispensary during an outbreak of spinal meningitis. "I watched the corpsmen there, the way they worked and the intensity of what they were doing," Ingram later said. "I decided at that time that I wanted whatever I was seeing that these guys were doing, and went down and changed my MOS to Hospital Corps."

By July 1965, Hospital Corpsman 3rd Class Robert Ingram was headed to Vietnam. Wanting to get as close as possible to the action, he volunteered for C Company—also known as Suicide Charlie—1st Battalion, 5th Marines. Ingram called the Marines of Charlie Company "the greatest bunch of men I ever met in my life." They called him "Doc."

On March 28, 1966, twenty-one-year-old "Doc" Ingram was with Company C, accompanying the point squad on a search-and-destroy mission against a North Vietnamese Army (NVA) outpost in Quang Ngai Province. According to his citation: "Suddenly, the village tree line exploded with an intense hail of automatic rifle fire from approximately

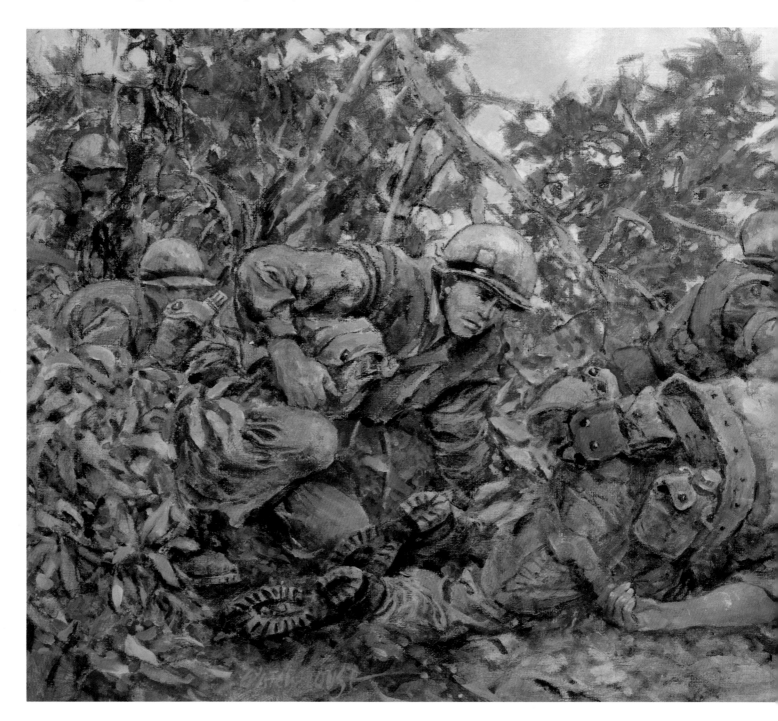

100 North Vietnamese regulars." Within moments, every member of the point squad was killed or wounded. Doc Ingram crawled across the bullet-ridden terrain toward a downed Marine. As he was administering aid, he was shot through the hand, but the cries for "Corpsman!" and "Doc!" echoing through the air cut eradicated his pain, and he continued to minister to his patients.

Wounded again in his knee, Ingram was heading toward another casualty when an enemy soldier popped out of a spider hole and shot him through the right eye. It was kill or be killed: Ingram returned the fire. "I could

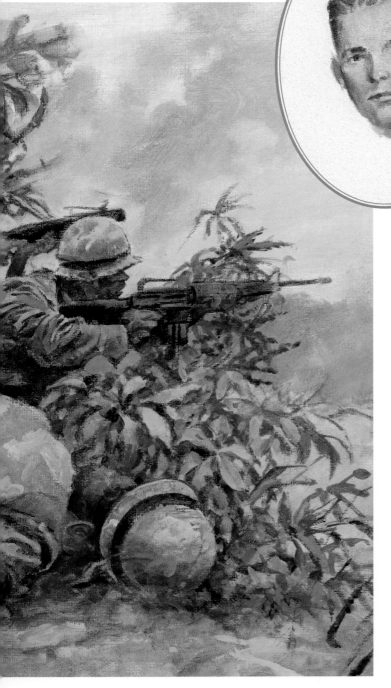

see the look of sorrow in his eyes," he later said. Although he called killing the man "the most painful thing I ever did in my life" Ingram was fired up by an even stronger emotion. "All I really wanted at that point was to go out there and take care of my men, 'cause I was gonna die anyway," Ingram said, "which is probably what kept me alive. I didn't go into shock, I went out to see what I could do."

Ingram remained on battlefield for hours, resolutely answering the Marines' anguished cries for help, administering aid, cajoling them to hang on, dragging them to safety and saving many lives. While moving one patient out of the line of fire, Doc Ingram was shot again, through his lower torso. Even then he tried to refuse evacuation.

Covered in blood and barely recognizable, after being shot four times, Ingram's his vital signs were so unreadable that the medevac helicopter crew tagged him "killed in action."

But the brave corpsman wasn't dead. He eventually recovered, went on to become a nurse, married and fathered a son and a daughter. Ingram been recommended for the Medal of Honor, but at a 1995 reunion of his Vietnam unit, his comrades realized that he'd never received the decoration. The paperwork was lost back the 1960s, but his friends from Charlie Company never forgot what he did for them and they wanted to make it right. On July 10, 1998, Robert "Doc" Ingram became the first Navy member to receive the Medal of Honor in twenty years. Appropriately enough, his award ceremony was held on the 100th anniversary of the Navy Hospital Corps.

SSGT. PETER SPENCER CONNOR, USMC[7]
Quang Ngai Province, Vietnam, February 25, 1966

Peter Spencer Connor was born on September 4, 1932, in South Orange, New Jersey. Connor's official Marine Corps photograph shows a lantern-jawed Marine with the build of a pro football linebacker, his lips tightly stretched over a hint of a smile. But there was another side to Peter Connor. He had a beautiful Irish tenor voice—so beautiful, in fact, that people who heard it never forgot. An active member of the Montclair Opera Club, Peter performed in shows and sang for local organizations throughout Essex County. He was also a vocalist in Our Lady of Sorrows Church, where his lilting voice enhanced the sacramental celebration of masses, weddings, and funerals.

Two years after graduating from high school, Connor enlisted in the Marines. He completed his training and was promoted to private first class in time to serve as a fire team leader and radioman with the 1st Marine Division in Korea during the last year of the war. Upon returning to the States, now Cpl. Connor was assigned as a squad leader and platoon guide at Camp Lejeune.

In 1955, Connor returned to civilian life in New Jersey. He married and had a daughter, while remaining a member of the Ready Reserve. Six years later, Connor enlisted back in the Marines, where, for the next four years, he served in a variety of duty stations in the States and overseas.

By August 1965, SSgt. Peter Connor was in Vietnam as the platoon sergeant of the 3rd Platoon, Company F, 2nd Battalion, 3rd Marines, 3rd Marine Division (Reinforced). At thirty-three years old, and a married father with one war under his belt, Connor was the old grunt of his unit. In a poignant post on the Virtual Vietnam Veterans Wall dated August 2, 2018, Capt. Allan James Thompson,

USMC, who knew the sergeant from those days, wrote: "Peter, I can remember us sitting on a hillside at Quantico, Virginia, SDT. I was a brand-new 2Lt. and I remember the wisdom you imparted to me that night, which I used throughout my career as a Marine. I am taking an Honor flight to DC on 9/22/18. I will see you at the Wall."

On February 25, 1966, SSgt. Peter Connor was leading his platoon on a search-and-destroy operation in Quang Ngai Province when he spotted a camouflaged enemy spider hole position. Intending to charge the hole and hurl a grenade, Connor pulled the pin and instantly realized the firing mechanism was faulty. There was no way he could cover the distance to the spider hole opening in time, and to throw the grenade in any other direction would have resulted in the death or injury of his fellow Marines. With only seconds to decide, Connor chose to hold the grenade against his own body, absorbing the explosion and sparing the lives of his comrades.

Connor died of his wounds aboard the USS *Repose*—a fitting name for a dying hero whose beautiful tenor voice, now silenced, may well have sung Stephen Foster's refrain:

> Linger in blissful repose,
> Free from all sorrowing care,
> While 'round thee melody flows,
> Wafted on pinions of air.

Connor's widow received his posthumous Medal of Honor. An award for good sportsmanship is given annually in his name at Our Lady of Sorrows High School in South Orange.

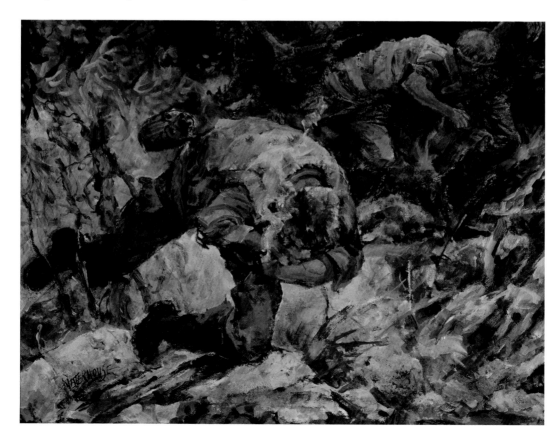

Gy. Sgt. Jimmie Earl Howard, USMC[8]
Quang Ngai Province, Vietnam, June 16, 1966

On August 21, 1967, at a ceremony in the White House, then Gy. Sgt. Jimmie E. Howard stood at attention as President Lyndon B. Johnson read the official citation recounting Howard's courageous stand at Hill 488 in Vietnam and placed the Medal of Honor around his neck. In attendance were Howard's wife and children, along with ten of the twelve surviving members from the seventeen-man platoon that had held back over 200 Viet Cong and North Vietnamese Army soldiers. With tears in his eyes, the tough Marine stepped to the microphone to give the credit to the Marines and the two Navy corpsmen who were with him that night. Then he took President Johnson by the hand and led him to the edge of the dais to personally introduce him to each of the survivors.

Who was this man Jimmie Howard? Jimmie Earl Howard was born July 27, 1929, in Burlington, Iowa. After graduating from high school he attended the University of Iowa for a year prior before enlisting in the Marines, in July 1950. As a forward observer with the 4.2-inch Mortar Company, 1st Marines, 1st Marine Division (Reinforced) in Korea, Howard earned the Silver Star Medal, the Purple Heart with Gold Star in lieu of a second Purple Heart, and the Navy Unit Commendation.

Seventeen years later, the thirty-seven-year-old father of six was in the jungles of Vietnam, serving as a staff sergeant and platoon leader with Company C, 1st Reconnaissance Battalion, 1st Marine Division. On the night of June 15–16, 1966, a battalion-sized Viet Cong force attacked Howard's unit at Hill 488. Despite suffering severe wounds from an enemy grenade, SSgt Howard distributed ammunition to his men and directed air strikes on the enemy. By dawn, after twelve hours of relentless combat, his bloodied, beleaguered platoon still held their position. When reinforcements finally reached Howard and his men, there remained only eight rounds of ammunition among the twelve survivors. "You know that movie, *The Longest Day*?" Howard later quipped. "Well, compared to our night on the hill, *The Longest Day* was just a twinkle in the eye."

Jimmie Howard always called the young men in his platoon his "Indians," and it was clear that these braves would have followed their cigar-smoking, tough talking, crusty chief anywhere. Ray Hildreth, who served him, described the colorful staff sergeant in his book, *Hill 488*: "Howard was a John Wayne type of guy. A hard slab of a man with a poker face," Hildreth wrote. "He walked into an area and you could almost hear the theme song from *The Sands Of Iwo Jima*."

Together, Howard and his men not only demonstrated courage and an iron will to survive, they became one of the most decorated unit in USMC history, receiving eighteen Purple Hearts, thirteen Silver Stars, four Navy Crosses, and one Medal of Honor—which Howard insisted was earned by all. Jimmie Howard died at his home in San Diego, California, in November 1993, at the age of sixty-four. Six years after his death, the Arleigh Burke class guided missile destroyer, USS *Howard*, was christened in his name.

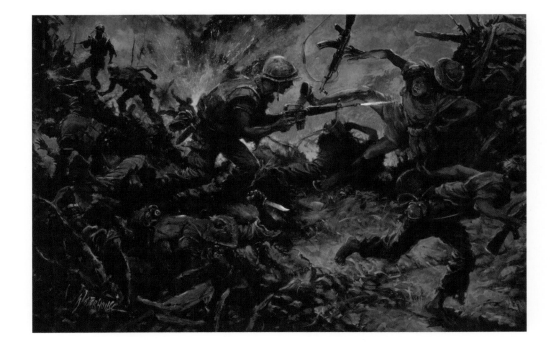

2Lt. John J. McGinty III, USMC[9]
Operation Hastings, Vietnam, July 18, 1966

John James McGinty III was born into an Irish Catholic family in Boston, Massachusetts, on January 21, 1940. John grew up in Connecticut, moving in his teenage years to Kentucky, where he went to high school before enlisting in the Marines in 1957.

After completing his training, the newly promoted private first class attended the Noncommissioned Officers Leadership School at Camp Pendleton. Transferred to the 1st Marine Division, McGinty saw duty as a rifleman and squad leader, followed by assignment as a Parris Island drill instructor and then assistant brig warden at the Naval in Norfolk before being transferred to the Far East.

In April 1966, SSgt. McGinty joined the 3rd Battalion, 4th Marines, 3rd Marine Division, serving as acting platoon leader for 1st Platoon, Company K, in the Republic of Vietnam.

On July 18, McGinty's company was providing rear security for the withdrawal of a besieged battalion that had been under assault for days by a large North Vietnamese force, when it, too, came under attack. During a series of vicious enemy onslaughts, McGinty was severely injured by shrapnel in the left eye; meanwhile, about twenty of his men became separated from the platoon.

SSgt. McGinty sprinted through gunfire and mortar shell blasts to reach them. Finding all the Marines wounded, and the medical corpsmen killed, McGinty assisted the wounded in reloading am-munition into their weapons and directed their fire at the encroaching enemy, which now surrounded them on three sides. When North Vietnamese soldiers attempted to outflank their position, McGinty shot five of the hostiles at point-blank range with his pistol. The staff sergeant then skillfully adjusted artillery, calling in air strikes to within 50 yards of his position, thereby routing the enemy and leaving an estimated 500 bodies on the battlefield.

After doctors were forced to remove his eye, McGinty retired from the Marine Corps and went to work at the Veterans Administration in San Diego.

In 1978, the pistol mentioned in McGinty's citation was stolen from a display. It was later purchased at auction by a history buff, who recognized the recipient's name and graciously returned it to its rightful owner.

In the 1980s, McGinty became a born-again Christian and stopped wearing his Medal of Honor, which he came to view as a form of idolatry because it bore an image of Minerva, the Roman goddess of wisdom and war: to McGinty, "a false god."

"He didn't have a problem with the honor," said son Michael McGinty in a 2014 interview with the *Los Angeles Times* after his father's death: "But like a lot of Medal of Honor guys, he realized the reason he was still alive is the one true God."

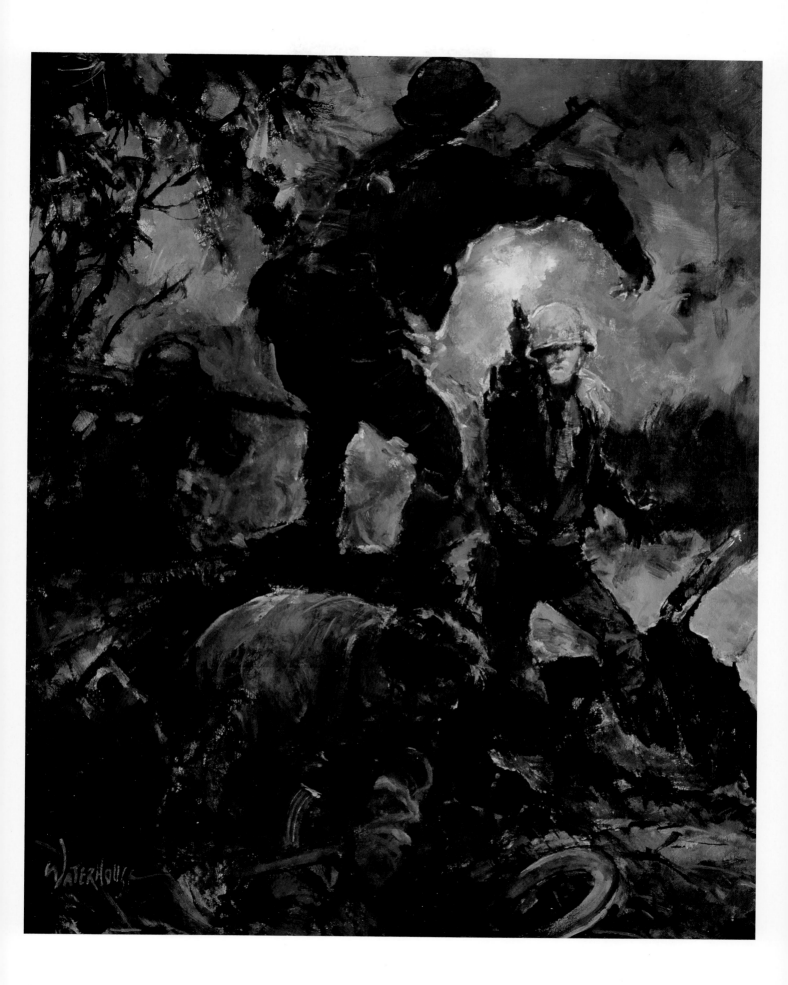

SGT. RICHARD R. PITTMAN, USMC[10]
Demilitarized Zone, Vietnam, March 28, 1966

Richard Allan Pittman was born on May 26, 1945, in Stockton, California. Although blind in his right eye, Richard's mother never called attention to his disability, so he grew up playing sports and doing all the things that active boys his age enjoyed doing. In 1961, fifteen-year-old Richard was glued to his family's black and white television set as President John F. Kennedy delivered his famous inaugural address, challenging Americans to ask what they could do for their country. The speech made a big impact on the teenaged boy, and so when Richard Pittman graduated from high school, he decided to join the service.

It was the first time in his life that his partial blindness stood in the way of something he wanted to do. The Navy and the Army turned him down, but in September 1965, Richard was accepted into the Marine Corps Reserves.

The following year, Pittman volunteered for a tour of Vietnam, passing up a coveted engineering position to become an infantryman on the front lines. On July 24. 1966, LCpl. Richard Pittman was participating in a search and destroy mission just outside the Demilitarized Zone with 1st Platoon, Company I, 3rd Battalion, 5th Marines. As his unit advanced in a column along a narrow jungle trail, a large enemy force waited in concealment, holding their attack until just the right moment, when they could sever the lead element from the rest of the company, create the most confusion and inflict the maximum amount of casualties.

From his position at the rear of the column, LCpl. Pittman could hear desperate cries for more firepower coming from fellow Marines in the lead. He quickly exchanged his rifle for a machine gun, grabbed several belts of ammunition and left the relative safety of his position to rush forward to the aid his comrades.

Dodging fire, LCpl. Pittman wielded his machine gun against dozens upon dozens of enemy soldiers. When the hostile force retreated, Pittman put down his weapon and began assisting his wounded comrades.

On May 14, 1968, then Sgt. Richard Pittman received the Medal of Honor from President Lyndon B. Johnson. He didn't realize until much later, when he first visited the Vietnam Memorial, just how many Marines had died in that jungle on July 24, 1966. Stunned by the sheer numbers, and the loss of so many lives, Pittman questioned the worth of his actions. He'd been given a medal, but what was it really worth? A few years later, a platoon sergeant that had served with him wrote a letter to the editor of *Leatherneck* magazine, crediting LCpl. Pittman with saving his life. "That made me feel a lot better," Richard said. "A lot of people wouldn't be here, a lot of families wouldn't be here. It actually makes me feel like I did some good."

In October 1988, Richard Pittman—the hopeful enlistee who'd been turned down by Navy and the Army because he was blind in one eye—retired from the Marines as a master sergeant. His mother was right: his disability never stood in the way of him doing what he wanted to do, or what needed to be done. Pittman passed away in his hometown of Stockton in October 2016, at the age of seventy-one.

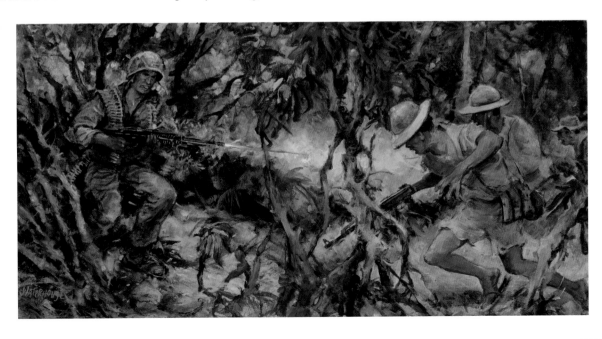

MAJ. HOWARD VINCENT LEE, USMC[11]
Cam Lo, Vietnam, August 8-9, 1966

On August 8, 1966, a helicopter carrying Captain Howard Lee and a small team of seven Marines hovered over an area near Cam Lô, looking down at the unfolding horror below, where a large force of North Vietnamese soldiers were closing in for the kill on a platoon that had been attacked while on an operation deep in enemy territory. These were Lee's Marines. And as commanding officer of Company E, 4th Marines, 3rd Marine Division, he was responsible for them. "Let us down," he said.

The pilot couldn't believe his ears. "That's crazy," he replied. "This is a hot zone."

The thirty-three-year-old captain struck a bargain with the pilot: get the helicopter as close to the hill as possible without landing, and he and two of his Marines would jump. Then Lee bowed his head and struck a bargain with God. "If it's your will, I die tonight, fine," he prayed. "But if not, then just give me the courage to do what I have to do."

Less than ten years before, praying for the courage to do or die would have been the last thing on Howard Lee's mind. Born on August 1, 1933, and bred in New York City, the only man in uniform Howard knew, as a youth, was his dad—a New York City mounted policeman. After graduating from college, Lee enlisted in the Marine Reserves thinking that he could go in, do his duty and get out fast, so he could pursue a career as "a famous accountant." But he'd shelved that plan after falling in love with the Marine Corps and its traditions. The Howard Lee that jumped off the helicopter on that day in August 1966, was one-hundred percent Marine, and a leader through and through.

The situation on the ground was dire. Hunkered down on a small hill surrounded by fields of waist high elephant grass, Lee's depleted platoon had lost its platoon commander and sergeant and was nearly surrounded. Despite having his ear "nicked" by an enemy bullet, Capt. Lee "fearlessly moved from position to position, directing and encouraging the overtaxed troops," marshaling a defense that repelled waves of North Vietnamese attacks. Immobilized when a grenade blast struck the right side of his body, temporarily blinding him in one eye, Lee shifted his focus to tactics and strategy, directing helicopters to drop much-needed ammunition throughout the night until, on the morning of August 9, he collapsed from loss of blood.

Lee floated back to consciousness to the rhythmic sound of helicopter rotors. God had given him the courage to do what he had to do. The North Vietnamese had retreated, leaving thirty-seven NVA bodies, and Lee and his Marines were finally evacuated. Lee was still recuperating from his injuries when President Lyndon Johnson awarded him the Medal of Honor in a White House ceremony on October 25, 1967.

Howard Lee never did become a famous accountant. After retiring from the Marine Corps at the rank of lieutenant colonel, he embarked on a career in horticulture and went on to become the chief landscaper for the city of Virginia Beach. Lt. Col. Lee died at his home in Virginia Beach in March 2019, at the age of eighty-five.

Although Waterhouse created Howard Lee's portrait, he didn't live long enough to put his Medal of Honor action on canvas.

PFC JAMES ANDERSON JR., USMC[12]
Cam Lo, Vietnam, February 28, 1967

James Anderson Jr. was born on January 22, 1947, at a time when the armed services were still segregated. While his place of birth is listed as Los Angeles, James grew up in Compton, where he attended the local schools. The two short decades of his life would be marked by historic change. A year after James was born, President Truman signed an executive order to desegregate the US military. The year James celebrated his tenth birthday, the first black man ran for the Compton City Council. Anderson wouldn't live long enough to see his hometown elect the first African American mayor of any metropolitan city in his home state of California, but through his final actions, he himself would change history.

After graduating from Centennial Senior High School, Anderson spent a year and a half at Los Angeles Harbor Junior College, while also trying his hand at real estate—which, in the Compton of the 1960s, was also undergoing a period of change—before deciding that his true calling was with the Marine Corps.

Anderson enlisted in February 1966, training at the Marine Corps Recruit Depot in San Diego. Upon graduating, he was promoted to private first class and transferred to Camp Pendleton.

A few months later, PFC Anderson arrived in Vietnam, where he served as a rifleman with Company F, 2nd Battalion, 3rd Marines, 3rd Marine Division, in Quang Tri Province.

On February 28, 1967—a little more than a year to the day he enlisted—Anderson's platoon came under attack while attempting to extract a besieged reconnaissance patrol in the dense jungles northwest of Cam Lộ. During the ensuing firefight, Anderson and a group of Marines—some of them wounded—had huddled up only 20 meters from the enemy position. When a hostile grenade landed in their midst, PFC Anderson reached out and grabbed it, pulled it to his chest and curled himself into a ball, protecting his fellow Marines from the explosion. He was killed by the blast.

James Anderson Jr. was the first African American Marine ever to receive a Medal of Honor. On August 21, 1968, his posthumous medal was presented to his parents. In addition to the nation's highest honor, Anderson was also recognized with the Purple Heart, the National Defense Service Medal, the Vietnam Service Medal with one bronze star, the Vietnamese Military Merit Medal, the Vietnamese Gallantry Cross with Palm, and the Republic of Vietnam Campaign Medal.

Anderson Avenue in Compton is named after the hometown hero who, in saving the lives of his brothers, forged a milestone in Marine Corps history.

In 1983, the Navy renamed a maritime pre-positioning ship the USNS *PFC James A. Anderson Jr.* (T-AK 3002) in Anderson's honor.

When Walter Singleton, the son of a veteran who had survived being held in a German POW camp, was born on December 7, 1944—the third anniversary of Pearl Harbor—the stars seemed aligned that he'd be destined to serve. Growing up in the rural community of Bartlett, Tennessee, Walter enjoyed hunting and fishing, ran track, and was a member of the Future Farmers of America.

After graduating from high school, Walter and his brother, Bobby Jo, both joined the Marine Corps. Walter excelled, ultimately serving as an instructor with Weapons Training Battalion at Parris Island, with the additional duty of training marksmanship to candidates at the US Naval Academy in Annapolis, for which he received a commendation for qualifying 100 percent of the officers-to-be.

Under service regulations, only one brother could serve in Vietnam at a time, so Walter flipped a coin with Bobby Jo. Walter considered himself lucky to win the toss. On March 24, 1967, while serving 1st Battalion, 9th Marines, in Quang Tri Province, Sgt.

Singleton's company came under intense enemy fire. Corpsmen were struggling to evacuate all the downed men from the kill zone. Seeing the dire straits his comrades were in, Singleton advanced from his relatively safe position and made several trips out into the open to rescue wounded Marines. Upon realizing that the heaviest enemy fire was coming from a hedgerow, Singleton seized a machine gun and blasted his way into the enemy stronghold.

Although mortally wounded, he continued to attack, killing eight of the enemy and driving the rest from their position, saving the lives of many Marines.

Walter Singleton, who counted himself lucky to have won the coin toss with his brother, is buried next to his parents in Memphis. Every year family members come to the Marine Corps Base at Quantico to visit the Walter K. Singleton Library, where his Medal of Honor is displayed.

PFC Douglas E. Dickey, USMC[14]

Operation Beacon Hill, Vietnam, March 26, 1967

Douglas Dickey was born on Christmas Eve 1946 in Greenville, Ohio, and grew up in a small area of Darke County called Rossburg that was too small to have its own schools. His mother described him as affectionate and unselfish, "the kind of son every mother would cherish." At Ansonia High School, Doug was a football player, the manager of the basketball team, and a member of the Darke County Honors Choir.

Only months after graduating, and just a couple of weeks shy of his nineteenth birthday, Doug, along with four of his high school buddies, enlisted in the Marine Corps Reserve. A few months later Dickey reenlisted as a regular Marine and was sent to recruit training in San Diego. He was carrying on a family tradition: both his older brother and uncle were Marines. In his official photograph, Dickey stands proudly in front of the American flag, staring hopefully into the camera with his scrubbed, choirboy face.

In October 1966, Dickey was deployed to Vietnam as a private first class. From the time he landed in country, PFC Dickey was in the thick of the action. Attached initially to Company B, 1st Battalion, 4th Marines, 3rd Marine Division, he participated in Operation Prairie, a series of strategic actions in the Quang Tri Province meant to destroy the People's Army of Vietnam south of the Demilitarized Zone.

Dickey was then transferred to Company C, 1st Battalion, 4th Marines, 3rd Marine Division, where he would serve in four major combat operations against the Viet Cong. By then, Doug Dickey was a combat-seasoned twenty-year-old who'd already been wounded twice.

On Easter Sunday, March 26, 1967, while participating in Operation Beacon Hill I, Dickey's platoon became engaged in fierce, close-range jungle combat with the Viet Cong. After a radio operator fell wounded, Dickey was sent to replace him. As he came forward to take over the radio, an enemy grenade landed among the small group of Marines. Without hesitating, Dickey threw himself on the missile, smothering the explosion with his body. Five of his comrades survived the blast because of Dickey's selfless actions.

Doug Dickey, the choirboy from rural Ohio who had been born on Christmas Eve, was killed in the jungles of Vietnam on Easter Day.

In the decades following the war, Dickey's platoon members—including the men whose lives he saved—held several reunions in Darke County to celebrate the memory of the brave young Marine.

2LT. JOHN P. BOBO, USMC[15]
Quang Tri Province, Vietnam, March 30, 1967

John Bobo was born on Valentine's Day 1943 in Niagara Falls, New York. In high school, John wasn't a high scorer in academics or sports, but his grit and determination set him apart. When the coach said he was too small to play football, John threw himself into a rigorous regime of weight training and ultimately became a standout member of the varsity track, JV basketball, intramural football, and basketball teams.

Bobo enlisted in the Marine Corps Reserve while attending Niagara University and was commissioned as a second lieutenant six months after graduating. In June 1966, 2Lt. Bobo was ordered to the Republic of Vietnam as the Weapons Platoon commander of Company I, 3rd Battalion, 9th Marine Regiment, 3rd Marine Division. There he earned the reputation of being a quiet, competent officer who cared about his men.

In 1967, Bobo and his platoon, along with Company I Marines, were engaged in operations near the Demilitarized Zone, designed to draw out the North Vietnamese army. On the evening of March 30, they were hit by a reinforced North Vietnamese company, automatic weapons, and 60 mm mortar.

The lieutenant was able to recover a 3.5-inch rocket launcher from a Marine casualty, organize a new team, and direct its fire on the enemy. During the firefight, a mortar round landed next to Bobo, severing his right leg below the knee. Refusing evacuation, Bobo made a makeshift tourniquet with his web belt and ordered his men to prop him up against a tree and put him in a firing position so he could provide covering fire while they withdrew to a more advantageous position. When Bobo's body was recovered it was riddled with bullets. The twenty-four-year-old hero had fought valiantly to the end. 2Lt. Bobo's actions enabled his men to regroup and repulse the NVA attack.

John Bobo is one of five men from Niagara Falls, to date, to receive the Medal of Honor.

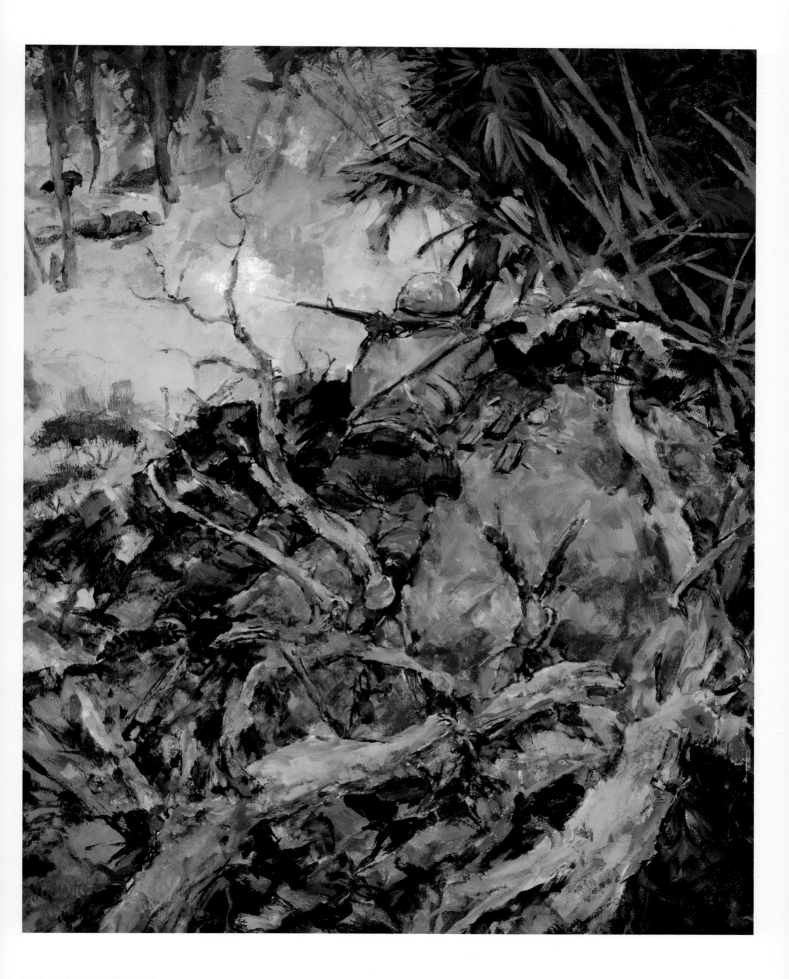

PFC GARY W. MARTINI, USMC[16]
Bingh Son, Vietnam, April 21, 1967

Gary Wayne Martini was born to parents William and Annie on September 21, 1948, in Lexington, Virginia. Gary and his sister, Imogene, moved several times with their parents before the Martinis ultimately put down roots in Portland, Oregon. During his senior year at David Douglas High School, Gary participated in several intramural sports. He joined the Marines soon after graduating, and in December 1966, was transferred to Vietnam as a rifleman in Company F, 2nd Battalion, 1st Marines.

During Operation Union, on April 21, 1967, PFC Gary Martini was with elements of Fox Company as they conducted offensive operations at Binh Son. In the course of the mission, the unit encountered an enemy force and immediately deployed to engage them. Charging across an open rice paddy, the F Company Marines advanced to within twenty meters of the enemy's trench: the enemy had them right where they wanted them and let loose with a barrage of hand grenade, small arms, automatic weapons and mortar fire, leaving fourteen Marines dead and another eighteen wounded. The remainder of the platoon was forced to take cover behind a low paddy dike.

On his own initiative, PFC Martini crawled back over the dike, ducking and dodging his way through a hail of grenades and bullets until he was fifteen meters from the enemy emplacement, in range to stand and throw a hand grenade and kill several of the enemy. Martini was crawling back across the open rice paddy to rejoin his platoon when he saw some wounded comrades lying in the open

field. He immediately raced out to help. Martini was wounded while dragging a casualty to a covered position, but that didn't stop him. He went back to help another of his platoon mates. According to his citation, "As he reached the fallen Marine, he received a mortal wound, but disregarding his own condition, he began to drag the Marine toward his platoon's position. Observing men from his unit attempting to leave the security of their position to aid him, concerned only for their safety, he called to them to remain under cover and through a final supreme effort, moved his injured comrade to where he could be pulled to safety, before he fell, succumbing to his wounds."

In October 1968, in a ceremony held in Washington, DC, Annie and William Martini were presented with their son's posthumous Medal of Honor. In attendance that day were the men whose lives Gary had fought to save, with his dying breath.

In 2000, a large Vietnam War memorial was erected in the small Willamette Valley town of Canby, Oregon. The installation, which includes a Vietnam-era helicopter mounted on red pavers in the shape of a Vietnamese *Shou* symbol, signifying "long life," took eleven years to complete. The last piece of the memorial that was finished is a bronze statue that depicts local Medal of Honor recipient, PFC Gary W. Martini, carrying the figure of missing-in-action Army soldier, Warren E. Newton—a Canby native—as a small Vietnamese child clutches his hand, looking up at him. The sculpture, created by Pennsylvania sculptor, Wayne Hyde, is entitled, "A Hero's Prayer."

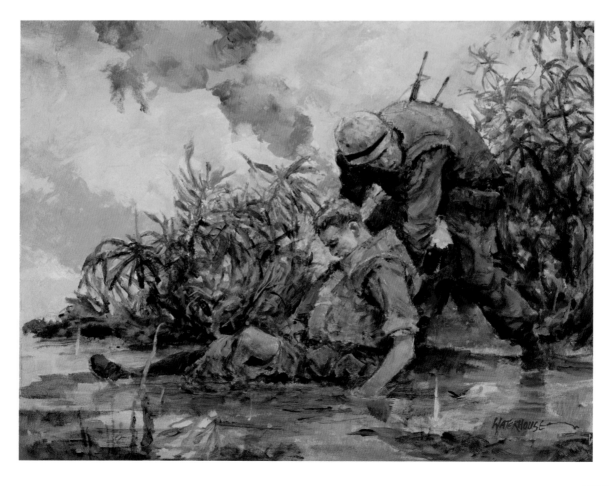

Capt. James A. Graham, USMC[17]
Quang Tin, Vietnam, June 9, 1967

Like so many places in Vietnam, the large rice paddy Quang Tri was still and tranquil one moment, and the next, charged with enemy mortar, machine gun and small arms fire that lit up the sultry June sky like a pyrotechnics show. In the years after his death, Janice Graham couldn't help but wonder why her husband ran out into that paddy, knowing the odds were he wouldn't make it back. Yet, in her heart, she knew the answer: he did it to save the lives of his fellow Marines … and also because Jim Graham never saw "any limits, but all the possibilities." This indomitable optimism had helped him to surmount the challenges of an unhappy childhood.

James Albert Graham was born on August 25, 1940, in Pittsburgh suburb of Wilkinsburg, Pennsylvania. His parents divorced when he was very young, and Jim went to live with his father in Accokeek, Maryland. It was a troubled relationship and tensions only grew as father and son worked together, operating their family-run grocery store and gas station. At age fifteen, Jim took his father's car and drove to El Paso, Texas, to join the Army. Standing six feet tall, clean-cut and well spoken, it wasn't a stretch to believe the young man was eighteen years old as he claimed. Graham taught himself to type and became a secretary to an officer. He served nearly a year of active duty before his father tracked him down and dragged him back to Accokeek.

After earning his GED, Jim returned to Pennsylvania to attend Frostburg State College, where he earned high grades, and a reputation as both a math whiz and an outstanding soccer player, while working forty hours a week to pay for his education. If that wasn't enough, Jim also became a member of the Marine Corps Reserves, met and married Janice Pritchett, and started a family.

In September 1963, Graham was discharged from the Marine Corps Reserve to accept a regular appointment in the Marine Corps as a second lieutenant. By 1966, he was a newly promoted captain in Vietnam, where he ultimately served as commanding officer of Company H, 2nd Battalion, 5th Marines, 1st Marine Division. The married father of two didn't join in when his fellow Marines drank beer, sticking with tea. Graham was known as a hard taskmaster who believed in the importance of discipline and training. He was also a devout Christian who led his men in prayer and delivered eulogies at services for those killed in battle.

So on June 2, 1967, when the leading elements of F Company came under deadly attack from enemy forces hidden behind the bamboo thicket as they were crossing that large rice paddy in Quang Tri Province, it came as no surprise to those who knew him when Capt. Jim Graham quickly organized an assault unit of ten men and boldly led them through the second platoon's position, ignoring the crossfire, and forcing the enemy to abandon the first machine-gun position, relieving some of the pressure on his second platoon and enabling the wounded to be evacuated. Still under heat from the second hostile machine gun, Capt. Graham and his small force continued to fight on until the enemy fire became so intense that Graham ordered his men to retreat for their own safety. One of Graham's Marines had been wounded too seriously to be moved, so twenty-six-year-old Jim Graham, husband and father of two, elected to stay behind with his comrade. In his last radio contact, Capt. Graham reported that he was under attack by twenty-six enemy soldiers.

In the summer of 1999, Graham's grown children—John, a Marine lieutenant colonel and Cobra helicopter pilot on active duty with Joint Forces Command in Norfolk, Virginia, and Jennifer, an Air Force Academy graduate and then lieutenant colonel stationed at Laughlin Air Force Base in Del Rio, Texas—traveled to Vietnam to visit the battlefield in Quang Tri. They found the rice paddy—still in use, still tranquil—and buried a time capsule filled with letters, photos and personal belongings on the site where their father, Medal of Honor recipient Capt. Jim Graham, had been killed.

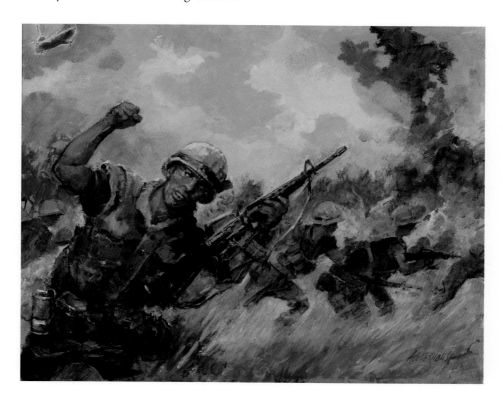

Melvin Earl Newlin was born on September 27, 1948, in the Appalachian village of Wellsville, Ohio, the fifth of eight children raised by a hard-drinking father and a mother too overwhelmed to give them her full care and attention. Melvin was the kind of kid who went out of his way to help others, whether that meant shoveling snow off the sidewalks for neighbors or helping to clean up their yards. But try as he might, he couldn't fix the inner workings of his family, and for most of his childhood, Melvin lived in foster homes, splitting his time between different schools.

Despite these personal hardships, Melvin Newlin had a burning ambition to make a name for himself in his hometown. A high school classmate recalls that Melvin always wanted to be a Marine, saying, "He had such a difficult life, but he wanted people to remember him."

In his senior year of high school, Melvin turned up, beaten and bloody, at the home of his married brother, Joe: he'd left foster care and returned to his parents, but his homecoming had been less than welcoming. Joe and his wife took the boy in, and Melvin stayed with them until he graduated from high school. On July 18, 1966, Melvin Newlin joined the Marines. His brother Richard believed that he was determined to enlist—not because he was tired of being shunted around and abused—but because he was ambitious to succeed. "He was the best of the bunch, the only one of six brothers to finish high school," Richard said. "Melvin wanted to do something with his life."

And he did. After completing his training, Newlin was promoted to private first class. In October 1966, PFC Newlin was transferred to Vietnam as a machine gunner with 1st Platoon, Company F, 2nd Battalion, 5th Marines, 1st Marine Division. By June 1967, the seasoned Marine was writing to his brother: "Joe, don't listen to all you hear on TV because people don't give all the facts. Just last month my company nearly got wiped out on Operation Union II." Melvin admitted that he'd been wounded in the arm and leg during the battle, and then added, "Please don't tell Mom, though. You know how she is about those little things." Those little things were about to get much worse.

On July 3, 1967, Company F moved to Nong Son Mountain in Quang Nam Province. The fireworks started just before midnight when the Viet Cong began a ferocious mortar and infantry assault on the outpost. PFC Melvin Newlin and four other Marines, manning a key position on the perimeter, were soon in the thick of it. With a calm belying his years, eighteen-year-old PFC Newlin continued to fire his machine gun, holding off repeated assaults by Viet Cong soldiers trying to overrun his position. His body riddled with shrapnel and his fellow Marines killed, Melvin Newlin propped himself against his machine gun and poured out a stream of deadly fire, repulsing two coordinated enemy attempts to breach his position. Time and again, he was hit by small-arms fire, but Melvin had taken hits before: if nothing else, his upbringing had made him tough. He fought on. When the enemy surged forward a third time, an exploding grenade showered Newlin with fragments, knocking him unconscious. Believing he was dead, the Viet Cong guerillas bypassed him and continued their assault on the main force. But Melvin Newlin wasn't dead.

After regaining consciousness, Melvin crawled back to his machine gun and let loose on the enemy soldiers that had bypassed him. Meanwhile, the hands of the clock had kept moving: it was the Fourth of July and it would be PFC Newlin's finest hour. In the words of his citation: "Spotting the enemy attempting to bring a captured 106 recoilless weapon to bear on other Marine positions, he shifted his fire, inflicting heavy casualties on the enemy and preventing them from firing the captured weapon. He then shifted his fire back to the primary enemy force, causing the enemy to stop their assault on the Marine bunkers and to once again attack his machine gun position. Valiantly fighting off two more enemy assaults, he firmly held his ground until mortally wounded."

On March 8, 1969, President Richard Nixon presented Melvin's Medal of Honor to his family at a ceremony in the White House. "I didn't have him back," Melvin's father said. "Medals don't mean everything, I reckon." In his last letter home, dated just before his valiant stand on Nong Son Mountain, Melvin wrote, "I guess the good Lord doesn't have my number on his list yet. But someday my number will show up, and when it does I'll go down fighting, just like all the Newlin boys."

In 2001, PFC Melvin Newlin, Medal of Honor recipient, was posthumously inducted into the Lou Holtz/Upper Ohio Valley Hall of Fame, along with fellow inductees, singer Dean Martin and basketball coach, Hank Kuzma. Melvin Newlin, who battled so much hardship before he ever battled the Viet Cong, had made a name for himself in his hometown.

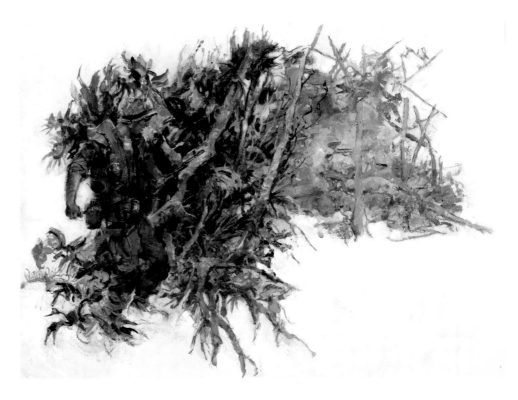

LCpl. Roy M. Wheat, USMC[19]
Quang Nam Province, Vietnam, August 11, 1967

Wheat came into the world on July 24, 1947, in Moselle, Mississippi, the first of four sons born to father, J. C., a heavy equipment operator, and mother, Stella, a seamstress. Young Roy enjoyed hunting with his dad and brothers and, like any country boy, became adept with handling guns at an early age. He also loved the camaraderie of team sports, and although he didn't make the Moselle High School football team, Roy was happy to serve as its manager. The players called him 'Doctor' because he was always first on the scene to offer aid and assistance when someone was injured.

After dropping out of school in 1965, Roy got a job bagging groceries at the Winn-Dixie Supermarket in Hattiesburg, where he proved to be such a reliable and efficient worker he was soon promoted to produce manager. But Wheat wanted more out of a life than an hourly job stocking vegetables, and in September 1966, he enlisted in the Marines.

By March 1967, PFC Roy Wheat was serving as a rifleman with Company K, 3rd Battalion, 1st Marine Division in Vietnam.

The next five months would prove eventful, and eventually fateful, for the young Marine. On April 10, PFC Wheat was grazed in the head by a fragment of shrapnel from an enemy mortar round, which hit him as he was alighting from a truck. Less than two weeks later, Roy was back with Company K on Hill 55, south of Da Nang. On July 30, shortly after being promoted to lance corporal, Wheat was wounded a second time when a Viet Cong grenade exploded nearby, embedding shrapnel into his thigh. The doctors who treated him at the hospital in Da Nang were unable to remove it, telling Roy that the scrap of metal would have to remain where it was. By August 8, the scrappy lance corporal had returned to his unit.

Three days later, on August 11, 1967, LCpl. Wheat and three of his fellow Marines were assigned the mission of providing security for a Navy construction battalion crane and crew in Quang Nam Province. After setting up security positions in a tree line adjacent to the work site, Wheat reconnoitered the area, on the lookout for Viet Cong guerrillas. As he was returning to his comrades, LCpl. Wheat unintentionally tripped a well concealed, "bouncing Betty" antipersonnel mine. It issued a menacing hissing sound, indicating that the time fuse was burning and about to go off. Shouting out a warning, Roy Wheat hurled himself on the mine, absorbing the impact of the explosion with his body. His last words to his buddies were, "I've got it."

During his year of service Roy wrote home to his family often. In 1992, his father donated the collection of his letters to the University of Southern Mississippi. In them, Roy spoke of his three great loves: love of God … love of family … and love of country. He told his parents that he yearned to return to South Mississippi after the war. He planned to purchase a piece of land adjacent to the Wheat homestead, where he could raise cattle and hogs. In Roy's last letter, dated just two days before he died, he expressed his final wishes to his family: "I want you to take good care of yourself and don't be worrying about me because I am all right. Be good and sweet and keep going to church." LCpl. Bernard Cannon, one of the Marines whose lives Roy Wheat saved that day, later wrote, "That slender Mississippi country boy had more love and compassion in him than all the rest of the company put together."

LCpl. Roy Wheat is the only Mississippian from the Vietnam War to receive the Medal of Honor.

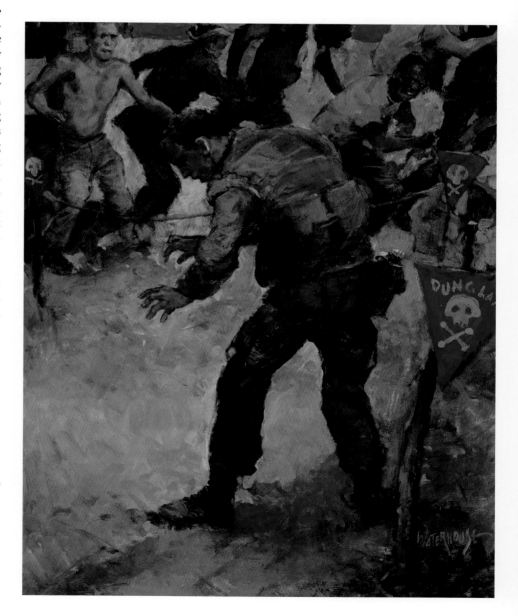

Dan Daly, Smedley Butler, Chesty Puller: these are just some of the legendary figures who embody the Marine fighting spirit, grit and determination. Maj. Stephen Wesley Pless—the first and only Marine aviator to receive the Medal of Honor in Vietnam—can be added to that list.

On August 19, 1967, an Army Boeing CH-47 *Chinook* helicopter carrying wounded men was struck by ground fire and forced down on the beach south of Chu Lai. Four of its crewmembers had jumped off board to evaluate the damage when an enemy grenade exploded near the nose of the aircraft, forcing the pilot to lift off with his precious cargo of casualties. The pilot radioed a desperate plea: "I still have four men on the ground, the VC are trying to take them prisoner or kill them; God, can somebody help them?"

Many pilots heard that frantic transmission, but only one heeded the call. Major Stephen Pless, piloting a VMO-6 Bell UH-1E *Iroquois* "Huey" helicopter, glanced over at his four-man crew. Each knew this was a suicide mission and the odds were they wouldn't be coming back, but the alternative was to leave American fighting men behind. The men nodded at their captain: they were all in.

Maj. Pless flew his helicopter to the scene and into a nightmare. Up to fifty Viet Cong soldiers were in the open, bayoneting and beating the downed Americans. Pless landed the Huey between the Viet Cong positions and the first wounded man he could see. In the words of his citation: "Maj. Pless displayed exceptional airmanship as he launched a devastating attack against the enemy force, killing or wounding many of the enemy and driving the remainder back into a treeline. His rocket and machinegun attacks were made at such low levels that the aircraft flew through debris created by explosions from its rockets. Seeing 1 of the wounded soldiers gesture for assistance, he maneuvered his helicopter into a position between the wounded men and the enemy, providing a shield which permitted his crew to retrieve the wounded. During the rescue the enemy directed intense fire at the helicopter and rushed the aircraft again and again, closing to within a few feet before being beaten back. When the wounded men were aboard, Maj. Pless maneuvered the helicopter out to sea. Before it became safely airborne, the overloaded aircraft settled four times into the water. Displaying superb airmanship, he finally got the helicopter aloft."

On January 16, 1969—four days before leaving office—President Lyndon B. Johnson presented Maj. Stephen W. Pless with the Medal of Honor in a ceremony at the White House. Recognizing the teamwork that made the daring helicopter rescue possible, the Department of Defense awarded all of Pless's crewmembers with the Navy Cross, the second highest Naval award for valor; together, they are most highly decorated helicopter crew to fly in the Vietnam War.

Tragically, thirty-year-old Stephen Pless, the Medal of Honor recipient who had survived 780 combat helicopter missions in Vietnam, was killed in a motorcycle accident on July 20, 1969, just as the Apollo 11 crew were landing on the moon. Apollo 11 grabbed the headlines that day, and so most Americans were unaware of the passing of a Marine hero, who, six months earlier, had dared to make his own moonshot to save the lives of others in Vietnam. Two months after her husband was killed, Stephen's wife, Jo Ann, gave birth to their fourth child.

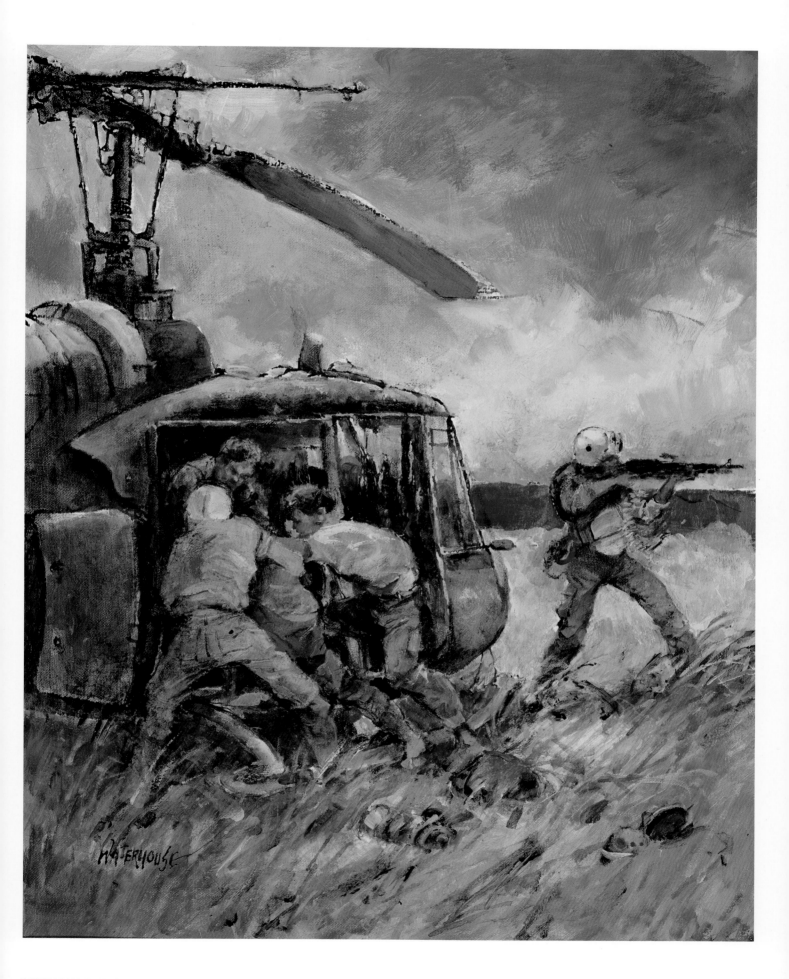

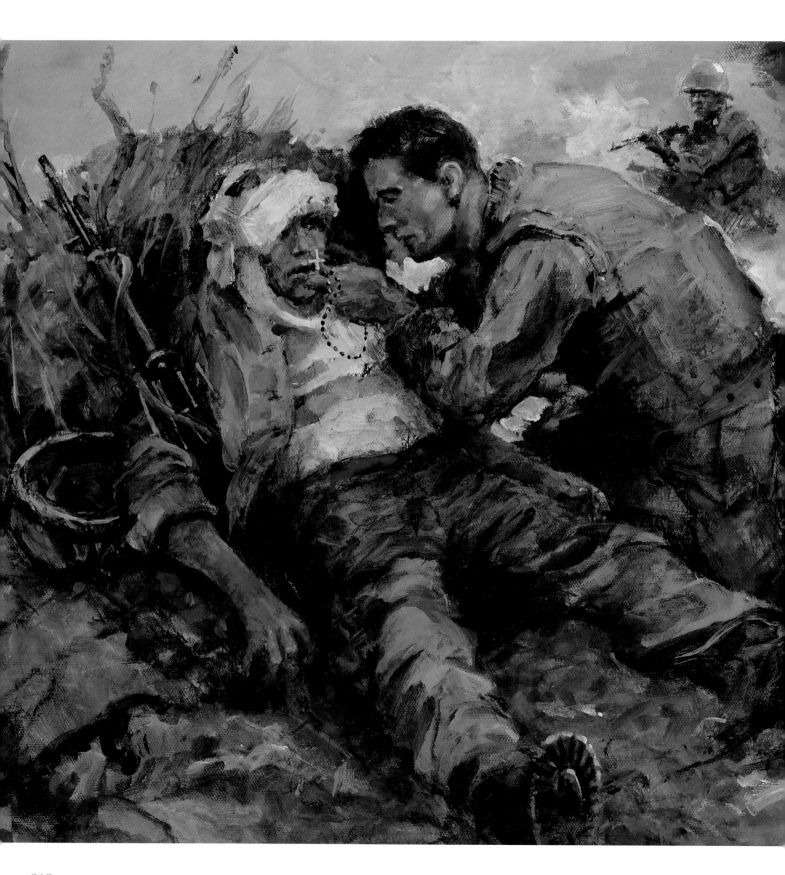

LT. VINCENT R. CAPODANNO JR., NAVY CHAPLAIN CORPS[21]
Que Son Valley, Vietnam, September 4, 1967

Vincent Capodanno, Jr., was born on February 13, 1929, in Staten Island, New York, the youngest of ten children in an Italian immigrant family. Three of Vincent's brothers fought for their country during World War II, and their service left a big impression on young Vincent, fostering in him a sense of patriotism that was enhanced by a profound, and unshakeable faith. Every morning before heading to his classes at Curtis High School, Vincent attended Mass at his home parish, a practice that he continued while attending Fordham University. After his freshman year, Capodanno decided that he wanted to devote his life to serving others through God, and he left Fordham to join the seminary.

Capodanno trained with the Maryknolls of the Catholic Foreign Mission Society of America, not only in ministry but—prophetically—in emergency medical care and survival tactics: already he was preparing to carry the rugged cross of his Lord into situations fraught with peril. After being ordained a priest in June 1957, Father Capodanno was assigned as a missionary, priest and teacher among the aboriginal Taiwanese, and later as a teacher at a Maryknoll school in Taiwan. But with America's involvement in Vietnam steadily increasing, Fr. Capodanno, like his patriotic brothers before him, felt the urge to serve, so he asked to be sent to the Navy Chaplain Corps to minister to the growing number of Marines in Vietnam.

Fr. Vincent Capodanno was commissioned a lieutenant in December 1965. In a letter to his division chaplain, the priest described the way he approached his ministry: "I am just there with them—I walk with them and sit with them; I eat with them and sleep in holes with them—and I talk with them—but only when they are ready to talk. It takes time, but I never rush them."

By choosing to live among, and alongside, the enlisted men, the so-called "grunts"—visiting them as they kept vigil in their dangerous, remote posts … sharing his rations … keeping their spirits up … and hearing their confessions, whether they were Catholic or not—the beloved priest earned the nickname, "the Grunt Padre." A former Marine remembered the Grunt Padre coming to his side, as he lay wounded on the battlefield. "In a quiet, calm voice, he cupped the back of my head and said, 'Stay quiet, Marine. You will be OK. Someone will be here to help you soon. God is with us all this day,'" the Marine later said, adding, "A peace came over me that is unexplainable to this day."

At 0400 on September 4, 1967, during his second tour of duty in Vietnam, Fr. Capodanno was with the 3rd Battalion, 5th Marines in the Que Son Valley of Quang Tin Province when he learned that two platoons of M Company from his battalion were taking heavy casualties and about to be overrun by the enemy. Without hesitating, the Grunt Padre left the safety of the company command post, running through hostile fire until he reached to the besieged 2nd Platoon. Wounded and dying Marines were everywhere. Fr. Capodanno moved through the active battlefield, tending to his flock and administering last rites. Even after fragments from an exploding mortar bore into his flesh, inflicting wounds to his arms and legs, and severing a portion of his right hand, the Grunt Padre steadfastly refused all medical aid. With calm but purposeful vigor, he directed the corpsmen toward the fallen, overseeing the evacuation of many wounded while continuing to minister and inspire his Marines.

When a wounded corpsman fell in the direct line of fire of an enemy machine gunner, Fr. Capodanno rushed to his aid, stepping between the hostile machine gun and the young medic in order to protect him from further harm. Lt. Vincent Capodanno, the Grunt Padre was killed by a burst of gunfire, his body riddled with twenty-seven bullets. He was thirty-eight years old. The day after Fr. Capodanno's death, his regimental commander received a letter from the priest. "I humbly request that I stay over Christmas and New Year's with my men," the priest wrote. "I am willing to relinquish my thirty days leave."

Lt. Vincent Capodanno, Jr is one of nine military chaplains to have earned the nation's highest military honor. In 1973, the USS *Capodanno* (FF-1093) was named in his honor. Although since decommissioned, it was the first ship in US fleet to receive a Papal blessing by Pope John Paul II.

On May 19, 2002, Fr. Vincent Capodanno's Cause for Canonization was officially opened, and he is now referred to as a Servant of God. In 2017, at the annual Memorial Day Mass held in Capodanno's honor at the Basilica of the National Shrine of the Immaculate Conception in Washington, DC, Military Archbishop Timothy Broglio said that Fr. Capodanno should be a role model for all because he exemplified many virtues. "He teaches us fidelity," Broglio said. "He teaches us perseverance. He teaches us immense charity …"

In a letter written to the Philippians, St. Paul wishes his fledging congregants, "the peace of God, which passeth all understanding." On a battlefield in Vietnam thousands of years later, a saintly priest put that same sentiment into words of comfort to his wounded and dying grunts: "Stay quiet, Marine," he said. "God is with us all this day."

LCpl. Jedh Colby Barker, USMC[22]
Con Thein, Vietnam, September 21, 1967

Born June 20, 1945, in Franklin, New Hampshire, you could say that serving in the Corps was part of Jedh Colby Barker's birthright. His father, Colby, had served in the Marines during World War II, and he'd combined the first initials of three Leatherneck buddies—John Ezekial, Donald, and Herbert—to fashion a name for his new baby boy. The third of six siblings, Jedh soon moved with his family to Park Ridge, New Jersey. At Park Ridge High School, he captained the football and baseball teams, played basketball, ran track, and sang in the school choir. Under his photograph in the Park Ridge High School's 1964 yearbook are the words: "Jedh ... Most athletic senior ... ladies' man ... loves to have a good time."

After getting his diploma, Jedh attended Fairleigh Dickinson University in East Rutherford, NJ, before transferring to Truman State University (then Missouri State College) in Kirksville, Missouri. But by 1966, with his older brother, Warren, already heading to Vietnam, Jedh decided it was time to claim his birthright and follow in his family's footsteps, so he left Truman and enlisted in the Marine Reserves. Three months later, Jedh Barker was a regular Marine.

By June 1967, PFC Barker was in Vietnam serving as a machine gunner with Company F, 2nd Battalion, 4th Marines, 3rd Marine Division. While 'in country,' Jedh and his brother Warren were able to meet several times. They'd grown up hearing their father's war stories, but daily life as a Marine in a combat zone had made them older and wiser; still, neither realized that these would be the last moments they would share together.

On September 1, 1967, Jedh Barker was promoted to lance corporal. On September 21, while participating in Operation Kingfisher,

LCpl. Barker's squad was on reconnaissance near Con Thien when his platoon came under attack by North Vietnamese forces. After deploying to a combat formation, the squad boldly advanced toward the fortified enemy positions, taking casualties from intense NVA small arms and automatic weapons fire.

Despite having been wounded in the initial burst of hostile firepower, Barker remained in the open, training devastating and accurate machine gun fire at the enemy. Realizing that this one bold Marine could very well thwart their efforts, the North Vietnamese focused the preponderance of their fire on Barker, wounding him again, this time in his right hand: the hand he vitally needed to operate his machine gun.

What happened next is recorded in the words of Barker's citation: "Suddenly, and without warning, an enemy grenade landed in the midst of the few surviving Marines. Unhesitatingly and with complete disregard for his own personal safety, Cpl. Barker threw himself upon the deadly grenade, absorbing with his own body the full and tremendous force of the explosion. In a final act of bravery, he crawled to the side of a wounded comrade and administered first aid before succumbing to his grievous wounds."

In 1969, the Barker family was invited to the White House to accept Jedh's posthumous Medal of Honor, which was presented to them by Vice President Spiro T. Agnew.

Jedh Barker—the athlete and ladies man who liked to have a good time—has a street in Park Ridge, New Jersey, named after him, and the little boy whose very name was a Leatherneck acronym now has his own building, Barker Hall, at Marine Corps Base Quantico, Virginia.

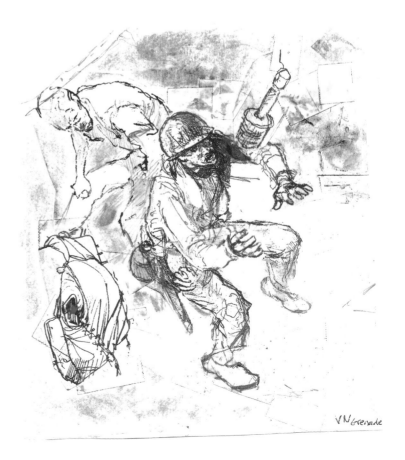

VN Grenade

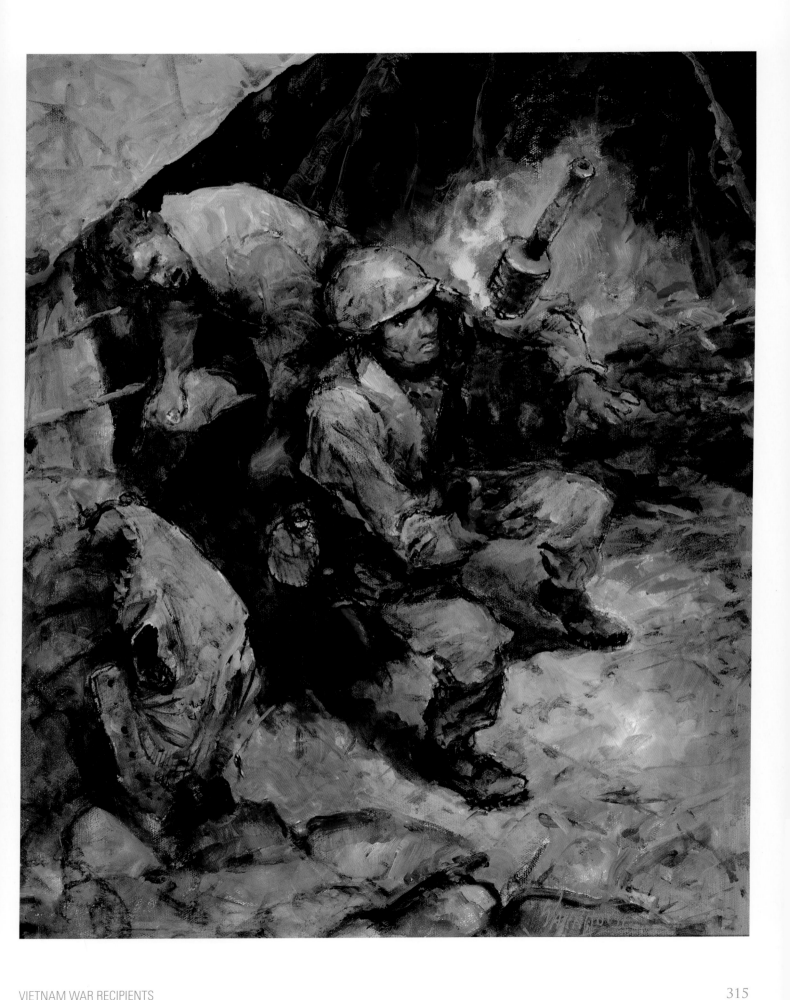

CPL. LARRY F. SMEDLEY, USMC[23]
Quang Nam Province, Vietnam, December 21, 1967

Larry Eugene Smedley was born on March 4, 1949, in Front Royal, Virginia. The Smedley family later moved to Orlando where Larry's mom worked as a waitress at Walgreen's, and his dad—an Air Force man—was assigned to a local air base. He left Colonial High School in his junior year to join the Marines, successfully completing his training and working his way up the ranks to private first class, and then lance corporal, but at age seventeen Smedley was too young to be sent into combat so he was assigned to the Marine base at Guantanamo Bay, Cuba.

In 1967, the eighteen-year-old LCpl. Larry Smedley was deployed to Vietnam as a rifleman and squad radioman with Company D, 1st Battalion, 7th Marines, 1st Marine Division, a reinforced rifle company in operations at Hill 41, in the area that the Marines nicknamed Happy Valley. Part of the so-called Rocket Belt, this thickly vegetated basin was where stealth infiltrators from the People's Army of Vietnam (PAVN) came to launch their Soviet-made 122 mm rockets toward the Da Nang complex. Each evening squad-sized Marine patrols would leave Hill 41 and set up ambush positions along routes likely to be used by PAVN soldiers attempting to penetrate the area.

Engagements with the enemy were frequent and often deadly, and Delta Company was already at half strength when it received intelligence that a PAVN force was expected to filter into Happy Valley on the night of December 20, 1967, to rocket Da Nang. Three squads were sent into ambush positions across the mouth of the valley and only two of them had machine gun teams. Leading the six-man squad without a machine gun was eighteen-year-old Larry Smedley, now a corporal. From his position behind a thicket on the valley floor, Smedley radioed his platoon commander that he had movement to his front: over 100 enemy troops, armed with rockets and mortars, were approaching.

As soon as the PAVN force passed by, Smedley and his six Marines stepped out of the thicket and opened fire, killing about ten of the enemy infiltrators. Surprised by the ambush, the rest fled, with Smedley and his men in hot pursuit. Eventually, Smedley's team linked up with the other two squads, but by then the enemy rear guard had opened up fire on the Marines. A PAVN rifle grenade exploded close to Smedley, taking off part of his left foot, shredding his lower leg and knocking him off his feet, but he jumped back up and continued to lead his squad toward the invaders.

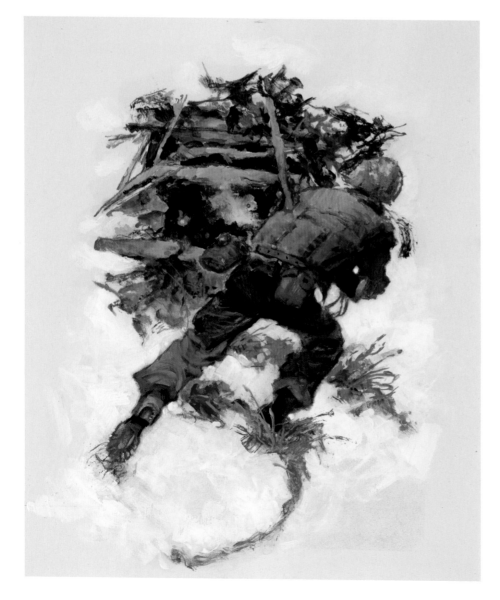

As they were closing the distance, a hostile machine gun opened up on their left flank, hitting Cpl. Smedley in the upper body and sending him sprawling. Again Smedley rose, launching into a fierce one-man assault against the enemy machine gun that had hit him and was inflicting so many casualties among his fellow Marines. Many of his comrades were lying helplessly on the ground, waiting for the next burst of machine gun bullets to finish them off, but Cpl. Smedley wasn't going down without a fight. With a grenade in his hand, he hobbled past his fallen companions, heading directly at the PAVN machine gun position. The machine gun opened fire, striking Smedley a second time in the chest. Although this wound would be fatal, somehow eighteen-year-old Marine Larry Smedley found the strength to lob his grenade directly into the mouth of the machine gun, destroying the enemy position as he drew his final breath.

Cpl. Larry Smedley is the only resident of Orange County, Florida, to have received a Medal of Honor. Although Larry didn't graduate from high school, in 2008, the Orange County school board posthumously awarded him an honorary diploma. The Corporal Larry E. Smedley National Vietnam War Museum in Orlando, Florida, is named in his honor.

CPL. WILLIAM T. PERKINS JR., USMC[24]
Quang Tri Province, Vietnam, October 12, 1967

William Perkins Jr. was born in Rochester New York, on August 10, 1947. When he was just a boy, the Perkins family moved to Sepulveda, California, a neighborhood of Los Angeles that is now known as North Hills, close enough to the glitter and dazzle to suit a creative kid with an interest in acting. While the majority of his fellow Medal of Recipients were, at that age, scoring points on the playing field, young Billy Perkins was scoring roles as a child actor in West Coast productions of Broadway plays, appearing with famous stars like Vincent Price.

But theater wasn't Bill's only passion. When he joined the school photography club, he soon found a new hobby. His supportive father bought him a Kodak camera, which he took it everywhere. In 1965, after graduating from James Monroe High School, Perkins enrolled at Los Angeles Pierce College to study photography. But Bill couldn't quite see a path forward. He loved photography but felt restless. He'd grown up hearing exciting stories of his family's military service in the Civil War and World War II. The Vietnam conflict was raging. He figured it was time to find out what he could do for his country, so in 1966, William Perkins enlisted in the Marine Corps.

During boot camp, the young recruit expressed a desire to be a combat photographer. He was eventually sent to the US Army Signal Center at Fort Monmouth, New Jersey, for training in motion picture photography. "I can't believe how lucky I am to be doing exactly what [I want] to be doing," he wrote home to his family.

And, as it turned out, being a combat photographer *was* something Perkins could do for his country. The Vietnam War was the nation's first televised war, and scenes of young men in uniform in the jungles of South Vietnam played out across the TV screens of every household in America. Twenty-year-old Cpl. William T. Perkins Jr. was among those capturing the nightly news footage as a combat photographer attached to Company C, 1st Battalion, 1st Marines, 1st Marine Division. Armed with a Bell and Howell 16 mm motion picture camera, and his personal 35 mm still camera, Cpl. Perkins tirelessly documented the everyday actions of his fellow Marines

On October 12, 1967, Perkins's unit was involved in Operation Medina, a major reconnaissance being conducted southwest of Quang Tri Province. That day, Company C came into heavy combat contact with a massive North Vietnamese Army (NVA) force, estimated in size at two to three companies. The focal point of the intense fighting was a helicopter landing zone, which also served as the Company C command post. During the intense attack, an enemy grenade landed in an area occupied by Perkins and three other Marines. Reacting swiftly, Perkins shouted a warning, "Incoming Grenade!" and hurled himself on the grenade, absorbing the impact of the explosion with his own body

Cpl. William Perkins Jr. is he only combat photographer to receive the Medal of Honor for "gallantly giving his life for his country."

The last footage that Perkins shot was taken during Operation Medina. Now part of the National Archives, it chronicles the activities of his fellow Company C Marines on October 11, 1967, and on the day of Perkins's death, October 12. Perkins captures them celebrating Mass in an open field, bowing their heads in prayer, shuffling up to receive the Host from the priest and propping up their weapons as they kneel. He holds for a moment on the chalice and crucifix.

The next shot shows Marines running toward a helicopter pad, the chopper's rotor blades moving, but eerily silent as the men board and take off. Taken from inside the helicopter are shots of softly rolling hills, lush with vegetation and, off in the distance, a puff of white smoke: danger up ahead. Perkins documents the Marines as they talk on the radio, patrol through jungles, climb up inclines and walk single-file along paths, looking exposed and vulnerable. We see them fording rivers, holding their weapons up as they wade waist deep, pulling themselves across on a line that skips the water like a rope—captured for all time by Bill Perkins, and his trusty Bell and Howell motion picture camera, positioned above, peeking through a lacy curtain of foliage.

In the next few frames the celluloid film is polka-dotted with light leaks across an over-exposed sky. The final footage shot by Cpl. Perkins shows Marines moving a wounded buddy through enemy fire to a hovering helicopter. They struggle with the stretcher. The wind blows the leaves upward in the trees around them. Then the chopper takes flight, silently. Not long afterward, the body of Cpl. William Perkins, tagged KIA, would be evacuated in the same way.

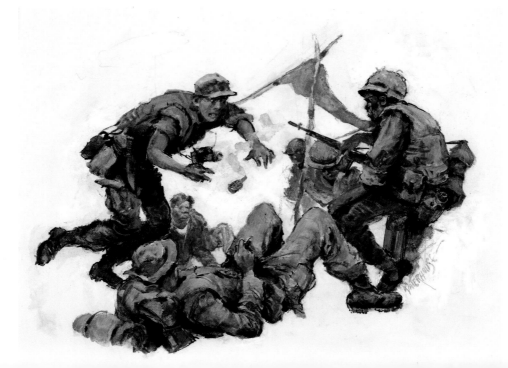

CPL. LARRY L. MAXAM, USMC[25]
Quang Tri Province, Vietnam, February 2, 1968

Burbank. This San Fernando Valley city in southern California is home to movie studios and the corporate headquarters of Disney. It's also the hometown of a young man named Larry Leonard Maxam, but not a lot of Burbank's residents know his name, despite the fact that once upon a time—not in Hollywood, but in a jungle thousands of miles away from this entertainment mecca—twenty-year-old Larry Maxam did something so heroic that it sounds like a scene from an epic war film made on one of the city's studio back lots.

Born in Glendale on January 9, 1948, Larry Maxam might have had a movie star name, but his childhood days in Burbank were far from entitled and glamorous. He was an active member of the Church of Jesus Christ of Latter-day Saints and an avid Boy Scout, who had

been initiated into scouting's highest organization, the Order of the Arrow. His mother Alice described Larry as a husky, beautiful, outdoorsy boy who, "loved to go hiking in the hills with his friends."

Larry Maxam was also patriotic. He left Burbank High School in his junior year to enlist in the Marines in 1965. By July 1967, Maxam was a lance corporal, serving as a rifleman and squad leader with Company D, 1st Battalion, 4th Marines, 3rd Marine Division in Vietnam. After three months in country he was promoted to corporal. His fellow Marines soon found out that Larry Maxam considered his Mormon faith to be far more important than his corporal stripes. His foxhole buddy, Larry Clinessmith said, "Other guys would go out, get rowdy, whatever, but not him. He was quiet, always looking to help the new guys coming into the platoon."

On the night February 2, 1968, while participating in Operation Kentucky in an area south of the demilitarized zone in Quang Tri Province, Cpl. Maxam was in charge of a fire team of four men that was protecting part of a defensive perimeter set up around the Cam Lo District Marine Headquarters. Things were quiet until around midnight when the Viet Cong attacked, throwing the full force of everything they had at the perimeter. During the fierce fighting, Maxam spotted a hole in their line where the enemy was gathering for a full frontal attack.

Maxam ran to an abandoned machine gun where he successfully, and singlehandedly, rained down fire upon the Viet Cong assailants. In an attempt to silence Maxam's weapon, the enemy threw hand grenades and directed recoilless rifle fire against him. According to his citation: "A direct hit from a rocket-propelled grenade knocked him backwards, inflicting severe fragmentation wounds to Maxam's face and right eye." Stunned and in immense pain, the quiet kid from California got back up and kept firing. The citation goes on: "The North Vietnamese threw hand grenades and directed recoilless rifle fire against him, inflicting more wounds." Too weak to reload his machine gun, Maxam fell to a prone position, but still valiantly continued to deliver effective fire with his rifle. After an hour and a half, during which time Maxam was hit repeatedly by fragments from exploding grenades and concentrated small arms fire, the twenty-year-old corporal succumbed to his wounds, having successfully defended nearly one half of the perimeter on his own.

Maxam's valiant last stand didn't make headlines back in Burbank. He was just another young man who'd died in a jungle in an unpopular war. But Cpl. Larry Maxam mattered to his Corps and country, and, for his bravery, he was posthumously awarded the nation's highest military decoration. In his hometown, however, the name of Larry L. Maxam—Burbank's only Medal of Honor recipient—has been largely forgotten.

Sgt. Alfredo "Freddy" Gonzalez, USMC[26]
Thua Thien, Vietnam, February 4, 1968

Alfredo "Freddy" Gonzalez was born on May 23, 1946, in Edinburgh, Texas. When he was a little boy, his mother took him to a John Wayne movie, and he whispered in her ear, "Someday I'm going to be a Marine like that."

After enlisting in the Marine Corps in 1965, Gonzalez quickly worked his way up the ranks. He served a one-year tour of duty in Vietnam as a rifleman and squad leader and, upon his return, became an instructor at Camp Lejeune.

When Gonzalez learned that an entire platoon—including men who had served under him—had been killed in ambush in Vietnam, he requested to be sent back for a second deployment.

On January 31, 1968, during the advance into Hué City, Sgt. Gonzalez was the platoon commander for 3rd Platoon, Company A, 1st Battalion, 1st Marines, 1st Marine Division. His unit came under sniper attack, and when one of the Marines riding on a tank was hit, the 135-pound sergeant ran to the man and slung his 170-pound frame over his shoulder, carrying him to safety. Despite being wounded during the rescue, Gonzalez dashed across the fire-swept road to destroy a fortified machine gun bunker with hand grenades.

Wounded again on February 3, the sergeant refused medical treatment and continued to lead his men. On February 4, during the brutal room-to-room fighting around the church and school of St. Joan of Arc, Gonzalez grabbed a handful of M-72 light antitank weapons and moved fearlessly from window to window, firing at enemy positions and silencing a rocket emplacement before a rocket hit him in the midsection. A fellow Marine dragged Gonzalez inside the church, where he died.

His men described Sgt. Gonzalez as a cool, confident old-timer; in reality, Freddy Gonzalez was a small, soft-spoken twenty-one-year-old who'd always wanted to be a Marine.

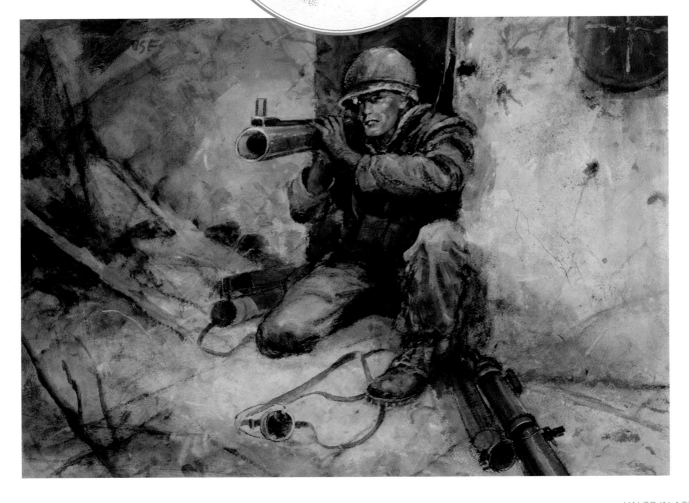

2Lt. Terrence C. Graves, USMC[27]
Quang Tri Province, Vietnam, February 16, 1968

Terrence Graves was born on July 6, 1945, in Corpus Christi, Texas. When his father, a former Navy officer, began a career in public school administration, the family moved to Groton, New York. Terry, as he was called, was a senior patrol leader of the Boy Scouts of America, the president of his Methodist Youth Fellowship, and a superb athlete. At Edmeston Central High School, where his father was supervising principal, Terry played football and earned All-County honors in baseball and basketball. His coach and mentor described the young man as "Confident, determined, and able to back it all up. That was Terry. The best of things in the worst of times."

After high school, Graves attended Miami University in Oxford, Ohio, on a Naval Reserve Officer Training Corps scholarship, serving as battalion commander of his NROTC unit and playing varsity baseball in his junior year. In 1967, Graves graduated with a BA in history and English. Along with his degree, the standout student received the American Legion Award for Military Excellence and the Bruce W. Card Memorial trophy for the top-ranking senior USMC option student.

And the USMC was exactly where he was headed. After completing the Basic School in Quantico, Graves was commissioned as a second lieutenant. A month later, 2Lt. Graves was deployed to the Republic of Vietnam and assigned duty as platoon commander of "Team Box Score," 3rd Force Reconnaissance Company, 3rd Reconnaissance Battalion, 3rd Marine Division.

On February 16, 1968, Graves and an eight-man team were on a long-range reconnaissance patrol in Quang Tri Province when they came under attack by two companies of the North Vietnamese army. With decisiveness well beyond his twenty-two years, Graves directed fire from his team while using his radio to call for air support and helicopter gunship fire on the enemy. Despite being wounded in the thigh, Graves refused medical attention, insisting that the corpsman focus his attentions on the other wounded Marines. The second lieutenant then moved his patrol through heavy fire to a landing area for extraction. Once all had boarded, Graves realized one of the wounded men was not on the helicopter. He jumped off, ordering the pilot to depart without him. Inspired by his actions, another Marine followed suit.

After dragging the wounded man into a less vulnerable position, 2Lt. Graves radioed for fire support and another helicopter. The three Marines continued to fight until they were almost out of ammunition and a second chopper had arrived. Dashing through heavy fire, they made it to the extraction zone and climbed onboard, but as the aircraft was lifting off it was hit by a burst of enemy fire and crashed into flames. Everyone onboard—with the exception of the man whose life Graves had saved by staying behind—was killed. That Marine was eventually rescued.

One of the survivors who had been evacuated on the first helicopter later said, "What Lieutenant Graves did was the bravest thing I've ever seen."

PFC RALPH H. JOHNSON, USMC[28]
Quan Duc Valley, Vietnam, March 5, 1968

Ralph Johnson was born on January 11, 1949, in Charleston, South Carolina. Known as "the good one" among the mischievous Johnson brothers, his sister recalled that when they were staying with their grandparents, the bedtime ritual was for each child to recite the Lord's Prayer. Hearing seven-year-old Ralph stumble through it, his grandpa teased that the little boy better learn the words . . . or else. The following morning, while his brothers were out playing baseball, Ralph sat under a tree and studied the Bible. That evening he volunteered to say his prayers first, his face beaming with pride.

While faith was the underpinning of Ralph's short life, his dream was to wear the uniform of a Marine.

After enlisting in 1967, the newly promoted private first class was deployed to Vietnam, where he served as a reconnaissance scout with Company A, 1st Reconnaissance Battalion, 1st Marine Division. His best buddy remembered that when he wasn't working, Ralph loved to listen to the radio, turning it up whenever his favorite song, Smokey Robinson's *I Second That Emotion*, was playing.

On duty, however, PFC Johnson remained totally focused. On his final patrol mission, Johnson discovered two mines hidden in an area where US helicopters would have landed to pick up the recon team; without this discovery, they might have all been lost.

In the predawn hours of March 5, 1968, while his reconnaissance patrol was occupying an observation post, a grenade landed in the foxhole Johnson was sharing with two fellow Marines. Shouting out a warning, he threw himself on the device, absorbing the impact of the explosion with his body. The nineteen-year-old Marine was instantly killed, but his comrades survived

Although Col. Waterhouse didn't live long enough to capture Ralph Johnson on canvas, he left behind a painting called *He Ain't Heavy, He's My Brother*, which captures the spirit of this humble hero who gave up his life for his brothers.

Marines everywhere will *Second That Emotion*.

HC2c DONALD BALLARD, USN[29]
Quang Tri Province, Vietnam, May 16, 1968

Donald Ballard was born on December 5, 1945, in Kansas City, Missouri. The Ballards were builders in the area, and while young Don pitched in with the family business, he had his sites pinned on a different future: he dreamed of becoming a dentist. Already married by his teens, and working in a dental lab, Ballard figured the best way to pay for his education, and realize his dreams, would be to join the Navy. He enlisted in 1965, only to be told that they had a surplus of dental corpsmen; instead, Donald Ballard was "volunteered" to serve as a frontline corpsman with the Marines in Vietnam.

In 1967, after completing his Field Medical Service School training, HC2c Donald Ballard was transferred to Vietnam, assigned as a corpsman with M Company, 3rd Battalion, 4th Marine Regiment, 3rd Marine Division in Quang Tri Province.

On May 16, 1968, Doc Ballard was returning to his platoon from the casualty evacuation helicopter pad after administering routine treatment to two Marines suffering from heat exhaustion, when his rifle company came under attack by a unit of North Vietnamese (NVA) soldiers. HC2c Ballard rushed through heavy enemy fire to provide medical aid to a casualty, organizing a team of four Marines to carry the patient to a position of safety.

As the men were moving their wounded comrade, an enemy soldier hurled a grenade at them. Doc Ballard fearlessly threw himself on the missile, wrapping his body around it to cushion the five Marines from the blast. For what seem like an eternity, Ballard waited for the explosion to go off and tear him to pieces but, miraculously, the grenade failed to detonate. He scrambled to his knees and threw it out of harm's way of the Marines, where it exploded. Doc Ballard had saved at least five lives, and his own, but there were other lives to save in that battle, which would rage on for several days. So he rose to his feet and set off to treat other M Company casualties.

On May 14, 1970, Donald "Doc" Ballard received the Medal of Honor from President Richard M. Nixon and commander of US forces in Vietnam, Gen. William Westmoreland, in a ceremony at the White House. "I don't think I did anything spectacular," Ballard said later. "I was basically just doing my job, the best I could do it."

Capt. Jay R. Vargas, USMC[30]
Dai Do, Vietnam, April 30–May 2, 1968

Jay Vargas was born on the kitchen table of his family home in Winslow, Arizona, on July 29, 1937. His mother had been cooking dinner for twenty people when Jay precipitously arrived.

An outstanding athlete, after graduating from a Los Angeles college on a full athletic and academic scholarship, Jay played for an Los Angeles Dodgers farm team but "couldn't hit the slider," so like his three older brothers, Jay joined the Marines.

On April 29, 1968, serving as the company commander of Company G, 2nd Battalion, 4th Marines—affectionately known as the Magnificent Bastards—near the demilitarized zone between North and South Vietnam, then Capt. Vargas and his men crossed the Bo Dieu River to recover mortars and came under heavy enemy fire. It was too dangerous for helicopter evacuation, so Vargas and his Marines fought their way out on foot. Severely wounded by shrapnel, Vargas warned the corpsman not to write a report: it would have been his third Purple Heart, and three times you were out—transferred out of Vietnam.

Beat up and suffering from lack of sleep, Company G was immediately called back into action. Two Marine companies were under attack from a North Vietnamese regiment near the village of Dai Do. Vargas was tasked with leading the assault across 700 yards of fire-swept terrain to take the village. Pinned down by heavy machine gun fire, Vargas rallied his reserve platoon and charged the entrenched positions. He personally destroyed three machine guns. Despite suffering more shrapnel wounds, Vargas continued the assault and set up a defensive perimeter.

But the NVA wanted their village back, and over the next two days thousands of them closed in for repeated counterattacks. Taking refuge in the cemetery, Vargas directed his men to lie in freshly dug graves. They weren't deep, and they were filled with water and rotting corpses, but they provided cover while Vargas called in artillery from nearby Dong Ha, raining down fire on the enemy and effectively erecting a steel barrier around his Marines. When the sun came up on the morning of May 3, there were over 3,000 dead bodies around them.

Vargas requested that his mother's name be engraved on the back of his Medal of Honor. "The medal could have gone to sixty-eight others guys that day," he later said

Capt. James E. Livingston, USMC[31]
Dai Do, Vietnam, May 2, 1968

The Marine Corps has its own lexicon of terms. *Gung ho*, from the Chinese word for 'pull together,' has come to mean a highly motivated Marine. *Gungy*, its derivative, is used to describe a Leatherneck who is particularly hardcore and driven. Look up either of these words in the USMC dictionary, and there's bound to be a reference, "*See retired Major General James E. Livingston.*" But it didn't start out that way.

Born on January 12, 1940, in Towns, Georgia, Livingston's youth was spent working on his father's 3,000-acre farm, playing sports and studying. In his own words, Livingston, "didn't know a doggone thing about the Marine Corps," until a Marine major showed up at Auburn University, where Jim was enrolled as civil engineering student, and convinced him to attend a twelve-week summer training program with the Marines at Quantico, Virginia. The rest, as they say, is history. By June 1962, Livingston had earned his Bachelors of Science degree from Auburn and a commission as a second lieutenant in the Marines.

In May 1964, by then Capt. James Livingston was on his second tour of duty in Vietnam as commanding officer of Company E, 2nd Battalion, 4th Marines, 9th Marine Amphibious Brigade. On May 2, Livingston's unit was tasked with launching an assault on Dai Do, a heavily fortified village that the enemy had seized on the preceding evening, isolating a Marine company from the rest of the battalion. The mission was to retake the village and rescue the stranded unit. From Livingston's perspective, the way to do that was by leading his men from upfront, and leading by example. "I pushed my Marines hard," he said. "I was hard on them because not only was I looking to complete the mission, but I was looking to bring those boys home."

With hostile rounds whizzing through the humid air around them, Capt. Livingston spearheaded the advance, ralling his men forward into the very teeth of the enemy resistance. Hit twice by grenade fragments, the gungy captain shook off medical treatment, continuing to lead Echo Company in a rout of more than 100 hostile bunkers and driving the enemy from their positions, before pressing ahead to aid the besieged company of Marines. After consolidating the two companies and evacuating the wounded, Livingston was given word to continue the assault and clean out the village. A third company was sent join them, but when they were within 300 yards of Livingston's position they came under enemy attack from a battalion-sized enemy force.

By then Livingston only had about thirty-five able bodies left from his 180-man company. But there were young Marines out there, surrounded and about to be overrun, and so without orders, Capt. Jim Livingston gathered his small, battered team together and said, "We gotta go help those kids." Call it gungy, call it courageous—to Livingston it was a simple fact of life. "As long as there's one Marine still kicking, it's never hopeless," he said.

Again, Livingston took the lead, charging headfirst into battle, encouraging the remnants of Echo Company forward. They reached the surrounded Marines in time to halt the enemy counterattack and beat back the North Vietnamese force.

Unable to walk, Livingston remained in an exposed position until all of the wounded and fallen were evacuated and his Marines were guided to safety, before allowing himself to be carried off the battlefield. "You don't leave any Marines in battle," he said. "They were my responsibility and bringing them home was my mission."

Of the Medal of Honor that was bestowed upon him, Livingston said, "I don't wear it for Jim Livingston. I wear it based on the fact that I had the opportunity to lead a lot of wonderful eighteen and nineteen-year-old Marines."

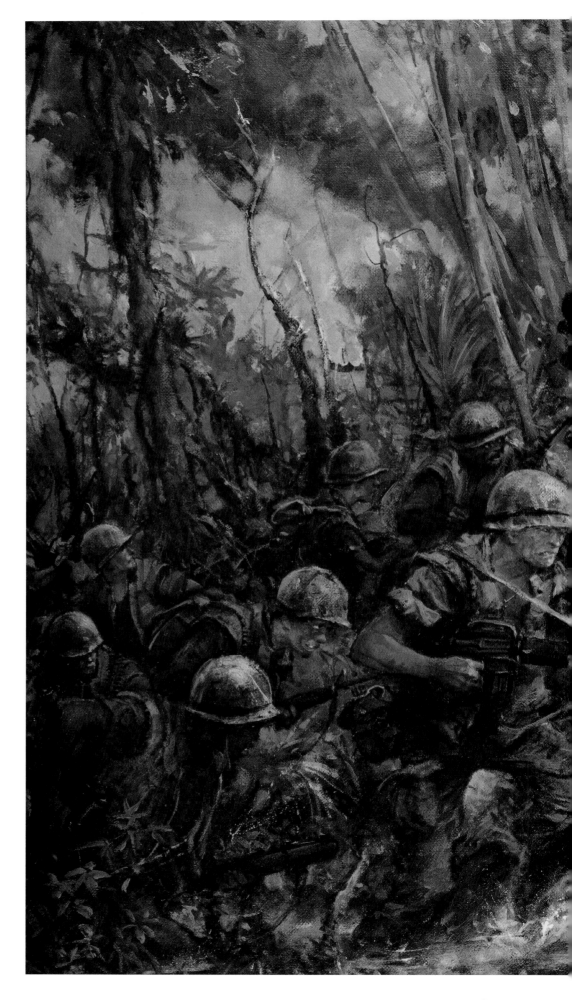

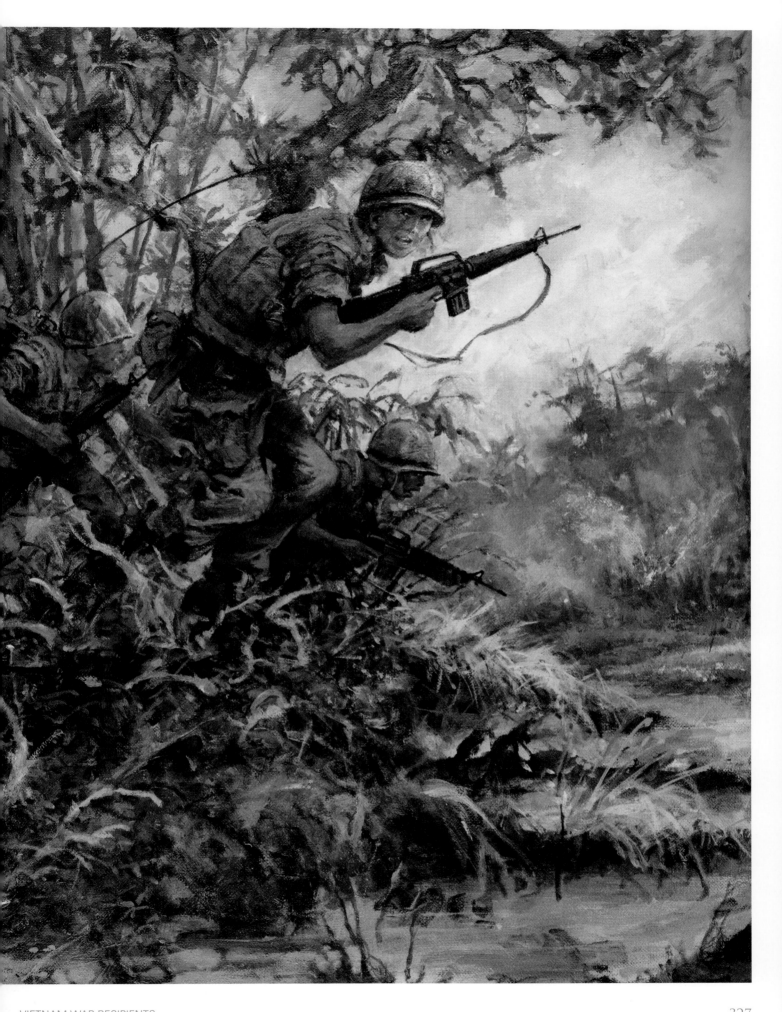

PFC ROBERT BURKE, USMC[32]
Le Nam, Vietnam, May 17, 1968

Robert Charles Burke was born November 7, 1949, in Monticello, Illinois. Robert was the kind of mischievous kid who routinely tightened his big sister's thermos so she couldn't open it, and couldn't resist a good practical joke. To baby sister Marilyn, he was the big brother who watched out for his younger siblings. It was Robert who first taught Marilyn to ride a bike and who taught younger brother, John, to drive a car. "He was our great defender and protector and took great care of us," Marilyn said.

But Robert wasn't just protective of his siblings. He stood up for the underdogs, as well.

If someone was being bullied or picked on in class, Robert Burke made it his business to intervene. "He was a very effective peacemaker," said one of his teachers at Monticello High School, adding with a twinkle, "He had an outstanding right hook." Doing the right thing was important to Robert Burke, and in 1967, a few months before he turned eighteen, he decided the right thing to do was to drop out of high school and serve his country. He chose the Marine Corps because the Marines demanded the best, and Burke wanted to prove he could make the grade and deliver.

And the young recruit set out to do just that, throwing himself into his training, earning both a promotion to private first class and his GED, and serving as a motor vehicle mechanic at Camp Pendleton, California, before being deployed to Vietnam, in February 1968, as a machine gunner with Company I, 3rd Battalion, 27th Marines, 1st Marine Division.

On May 17, 1968, while on Operation Allen Brook in Southern Quang Nam Province, the Marines of India Company were approaching a dry river bed fronted by a heavily wooded tree line that bordered the hamlet of Le Nam, when they came under intense fire from enemy mortars, small arms, automatic weapons and rocket propelled grenades. Reacting immediately, PFC Burke seized his machine gun and began series of one-man charges against the fortified emplacements.

"It wasn't just a split-second decision," his sister Marilyn Burke Spurlock later said. "It wasn't just one time. He stepped forward over and over."

During these repeated single-handed assaults, Robert Burke—the young boy who had stood up to bullies, always protecting his own, and the young Marine who wanted nothing more than to give his best—is credited that day with saving the lives of up to three dozen injured Marines before he was gunned down and killed by the North Vietnamese.

PFC Burke's bullet-riddled body was brought back to his hometown for burial at Monticello Cemetery. Before they closed the casket, Marilyn asked if she could take one thing—the medal off Roberts's Marine cover—so she keep her brother always close to her heart. At age eighteen, PFC Robert Burke was the youngest Medal of Honor recipient of the Vietnam War.

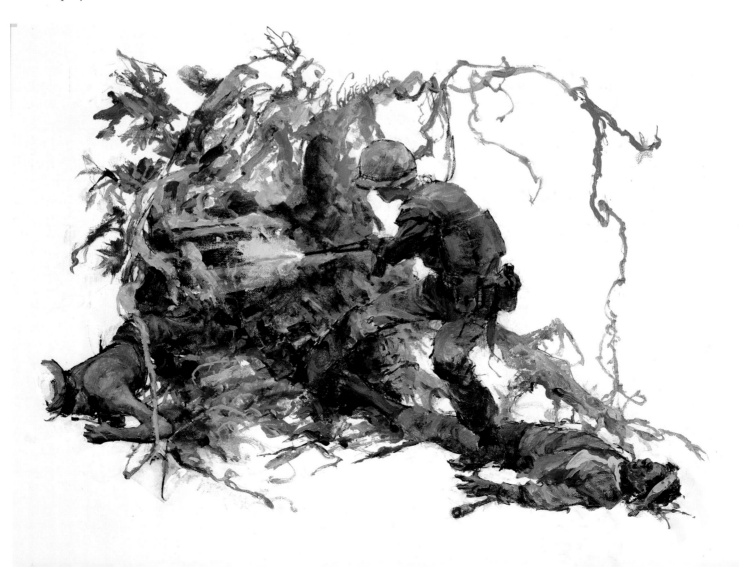

HC3c WAYNE M. CARON, USN[33]
Quang Nam Province, Vietnam, July 28, 1968

He could tap dance. You wouldn't expect this virile young corpsman, who dodged bullets and raced through hellfire to aid his wounded comrades, to be a tap dancer. But he was. At the end of a long day of training at the Naval Hospital Great Lakes (NHGL), Illinois, Wayne Caron often slipped on his tap shoes and entertained his fellow corpsmen with a Gene Kelly-style dance routine. "His steel heels resounded through the barracks," one of them recalled later. But Wayne was more than just a talented hoofer. Retired Medical Corps captain, Frederick L. Austin, Maryland, of the Ophthalmology Department at NHGL called Caron "one of my finest corpsmen."

Wayne Maurice Caron was born on November 2, 1946, in Middleborough, Massachusetts, to parents Aime Joseph and Lorraine (née Paradise). After graduating from high school in 1966, Wayne joined the Navy, seeing it as a step toward the future he wanted to build for himself and his pretty young fiancée, Theresa (Terry) Louise Haid. 1967 was a momentous year for Caron: he completed his training at the Field Medical Service School at Camp Pendleton, California; earned a promotion to hospital corpsman third class; and married the girl of his dreams. Seven months after their wedding, on January 16, 1968, HC3c Wayne Caron was deployed to the Republic of Vietnam, serving first with Headquarters and Service Company, 3rd Battalion, 7th Marine Regiment, 1st Marine Division (Reinforced), before being attached as a platoon corpsman with K Company, 3rd Battalion, 7th Marines.

On July 28, 1968, Doc Caron was with his K Company Marines in Quảng Nam Province. While on a sweep through an open rice field, Caron's unit started receiving enemy small arms fire. Two Marines were hit in the first moments of the attack. Caron raced toward them to render aid, but it was too late: by the time he reached them, they were already dead. By now the platoon was under intense fire, and the enemy had added automatic weapons to the mix, inflicting additional casualties. While administering aid to one of the wounded, Caron was hit in the arm by hostile fire and knocked to the ground. He quickly regained his feet, and set off through a blizzard of enemy bullets to answer the cries for "Corpsman! Corpsman!"

The next Marine he reached was grievously wounded, and the medical aid that Caron rendered proved instrumental in saving his life. Once that patient had been moved to safety, HC3c Caron ran toward another wounded Marine, but before he could get to him, an enemy bullet caught him in the leg, tearing through flesh and bone, stopping him in his tracks. Now Caron had been wounded twice, and the wound to his leg made it impossible for him to stand, but that didn't stop him from performing his duties. If he couldn't run, he could still crawl, and so Doc Caron inched his way across the ground to administer aid to the fallen Marine. As he was crawling to a third patient, he was struck again by enemy small-arms fire. With steely determination, the corpsman continued to struggle toward the wounded man until an enemy rocket round killed him. Wayne Caron was twenty-one years old.

That day in Quảng Nam Province, the 3rd Battalion, 7th Marines lost eighteen Marines and one courageous corpsman. Caron's pregnant wife, Terry, was living on Guam when she got the news that Wayne had been killed. A son, Scott Wayne, was born three months after his father's death. On April 20, 1970, in a ceremony at the White House, Vice President Spiro Agnew presented Caron's posthumous Medal of Honor to his wife, Terry, his seventeen-month-old son Scott, and his grieving parents.

On October 1, 1977, the Navy christened a Spruance-class destroyer, the USS *Caron* in his honor. Through the years, Wayne's parents would see the ship off, and be there upon its return from every major deployment. According to one of the ship's "docs," Mrs. Caron would walk through the passageways, talking to her son, which unnerved some of the sailors. The corpsman went on to say that if Doc Caron's spirit roamed the ship, he was only there to help: in the sixteen years following its commissioning, the USS *Caron* was involved in many danger-fraught engagements and conflicts, yet, "not ONE crewman had lost their life while onboard."

And it would be nice to think that maybe sometimes, in the still of the night, the figure of a young man moves like a cool breeze through the barracks of the Naval Hospital Great Lakes, tapping his toes with the exuberance of a sailor-suited Gene Kelly, his steel heels echoing in the darkness, inspiring new generations of corpsmen to be fleet of foot in carrying out their duties and nimble in caring for the wounded men in their trust.

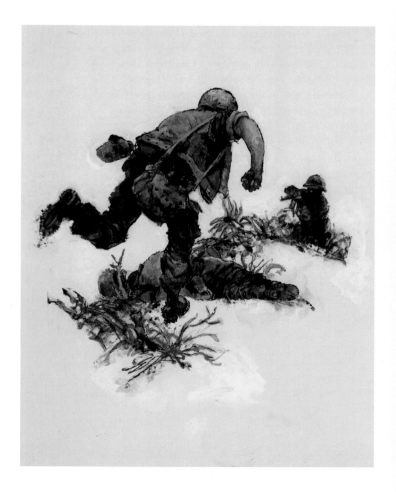

The tall, handsome stranger calling himself Kenneth Lee Worley arrived in Modesto, California, in the autumn of 1966. He quickly found seasonal work driving one of the big diesel trucks that hauled Christmas trees out of the mountains, but he broke his foot on the job and couldn't drive until his cast was removed. All alone, living in a small camper without running water, electricity or heat, things looked bleak for Ken—then a stroke of luck in what had been, up until now, a tough and luckless life. Intrigued by this good-looking newcomer who, beneath his self-sufficient demeanor, seemed to be somewhat of "lost soul," sixteen-year-old local girl, Quonieta Feyerherm, invited him to a hot meal with her family.

It didn't take Quonieta's parents, Don and Rosemary Feyerherm, long to lose their heart to this "wild, impetuous, wonderful kid;" by the end of the meal Don told Ken to collect his belongings and move in with them, never mind that they already had eight kids living at home. Though they knew little about his past, they welcomed their new foster son into their family. Ken was overjoyed, but insisted on paying his own way by working—even with his foot in a cast—in the gas station that Don Feyerherm managed. To Ken Worley, on his own since the age of eleven, meeting the Feyerherms was like reaching a port after a long storm.

Born April 27, 1948, in Farmington, New Mexico, baby Kenneth had been conceived, as the saying goes, on the wrong side of the sheets. While between marriages, his mother, Marie Worley, had an affair with her brother-in-law. Nine months later Kenneth arrived, and a little over a year after that, Marie died, leaving little Kenneth in the care of an overwhelmed stepfather and abusive aunts who, angered by the boy's dubious paternity, burned his fingers when he bit his nails and left permanent scars on his body, treating the child "like a dog." Although Ken took his stepfather's surname, Peace, there would be little peace or security for him. By his teenage years, Kenny Peace was in trouble with the law, ending up in a youth correction center. Released just before sixteenth birthday, instead of returning to his family, he headed west, turning up in Modesto as Kenneth Lee Worley.

Christmas 1966 with the Feyerherms was the happiest time of Kenneth Worley's young life. When the family started handing out presents, and Ken realized there were wrapped packages for him under the tree, his eyes filled with tears. The gift Ken treasured most was the Seiko watch that his foster parents gave him, and he seldom took it off.

A few months later, when Quonieta learned she was pregnant, Ken offered to marry her and raise the child as his own, but Mrs. Feyerherm insisted that her daughter marry the presumed father, a boyfriend who was serving in the Navy. On June 14, 1967, Kenneth Worley enlisted in the Marines. For the first time, he had something to come back to—a family who would miss him and anxiously await his return. But Ken would not live long enough to celebrate another Christmas with the Feyerherms.

By November 1967, Kenneth Worley was in Vietnam, serving as a machine gunner with Company L, 3rd Battalion, 7th Marines, 1st Marine Division. Remembered by his M-60 trainer as "the most focused guy I ever met," Worley saw a great deal of combat while in country, earning four bronze campaign stars on his service medal and a promotion to lance corporal. With the Marines, he also found a family, a brotherhood.

In January 1968, Quonieta gave birth to a baby boy named Robert. Years later she would learn that Robert was actually Kenneth's son—a son that he would never meet.

In the late hours of August 11, 1968, Worley's unit was in the Bo Ban Hamlet of Quang Nam Province. After establishing a night ambush position in thatched hut, or hooch, security was set up and the remainder of the patrol members retired until their respective watch. As he prepared to hunker down, Ken gave his Seiko wristwatch to his companion and buddy, LCpl. Charles G. Black, so he could to keep track of time during sentry duty. In the early hours of August 12, a warning shout rang through the still air: "Grenades!" The enemy had detected the ambush and somehow slipped past security.

In the darkness, a hostile grenade flew into the hooch, rolling next to Worley and five of his fellow Marines. In a valiant act of heroism, Worley threw himself on the grenade, absorbing the full impact of the explosion with his body.

Don Feyerherm kept vigil at his twenty-year-old foster son's funeral. Dressed in his Marine Dress Blues and lying in an open casket, Ken lay underneath a glass cover. On April 20, 1970, the family traveled to Washington, DC, to witness Vice President Spiro Agnew present Ken's Medal of Honor at a ceremony the White House.

Thirty-six years after Worley threw himself on the grenade, his buddy Charles Black, who was injured in the blast, but saved from certain death by his buddy's actions, returned Ken's Seiko watch to Quonieta and her son. The crystal had shattered in the explosion and it never worked again but the treasured gift was back where it belonged, in the only real home Ken Worley had ever had known.

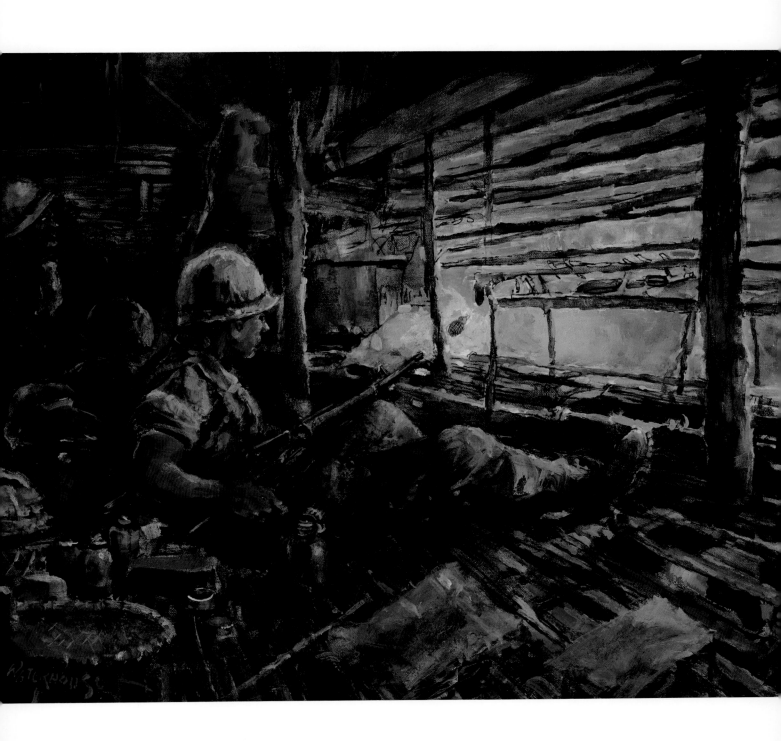

Karl Taylor was born on July 14, 1939, in Laurel, Maryland. He left Arundel Senior High School in his junior year to work as a heavy equipment operator for a local construction company. Three years later, on January 15, 1959, Karl and his brother, William, enlisted in the Marines. He attended recruit training at Parris Island, South Carolina, and in 1961, earned his high school equivalency diploma from the Armed Forces Institute in Madison, Wisconsin.

Taylor returned to Parris Island to attend the drill Instructor School then served as a drill instructor until January 1963. After being assigned to several duty stations, including a one-year tour of duty as rocket section leader and platoon guide with Company G, 2nd Battalion, 3rd Marines, in Vietnam, Taylor returned to the States, assigned to Marine Corps Schools, Quantico, for duty as Candidate Company Platoon Sergeant and Platoon Sergeant of Company A, 2nd Platoon, Officer Candidate School.

A young corporal assigned to OCS at the time, future Lt. Gen. Martin R. Steele, recalled meeting Sgt. Taylor for the first time, describing him as "a cut of granite in his size and demeanor." While serving together, Steele and Taylor forged a lasting bond of friendship, built on professional respect.

On September 1, 1966, Taylor was promoted to staff sergeant. "Karl loved the Corps, but he found time for family," his wife Shirley said. "He was considerate, a disciplinarian, a very good father." The Taylors bought a house in the small western Pennsylvania town of Avella. It had seemed the perfect place to raise their three children. "He often said of Avella, 'This is God's country,'" Shirley recalled, wistfully, "'We'll retire here.'" But for this "cut of granite" Marine, it was not to be.

In February 1968, Karl Taylor received the news that he was being deployed to Vietnam as a platoon sergeant and company gunnery sergeant with Company I, 3rd Battalion, 26th Marine Regiment. On December 8, 1968, during Operation Meade River, SSgt. Karl Taylor was leading a small team of four Marines across fire-swept terrain in attempt to rescue some wounded comrades. With their advance halted by hostile machine gun fire, Taylor took his grenade launcher and charged through an open rice paddy toward the enemy machine gun position, firing as he ran. Although wounded several times, the tough-as-nails sergeant succeeded in reaching the enemy bunker and neutralizing its machine gun moments before he was killed.

In a White House ceremony on February 16, 1971, President Richard Nixon presented Taylor's posthumous Medal of Honor to widow, Shirley, his daughter and two sons.

Twenty-eight years later, in February 1999, SSgt. Taylor's name was aboard the *Stardust*, a first-of-its-kind robotic space probe launched by NASA that collected cosmic dust samples before successfully returning to earth in January 2006.

In June of that same year, the Officer Candidates School at Quantico dedicated its newly constructed OCS Bachelor Enlisted Quarters, Taylor Hall, in Karl Taylor's honor. Lt. Gen. Steele spoke of his friend at the dedication ceremony. "He is my hero and the epitome of what it is to be a Marine," said Steele. "Taylor is the first thing I think of when I wake in the morning and the last conscious thought I have as I pray for his mortal soul"—the soul of a brave Marine, who like the *Stardust*, would go above and beyond to complete his mission.

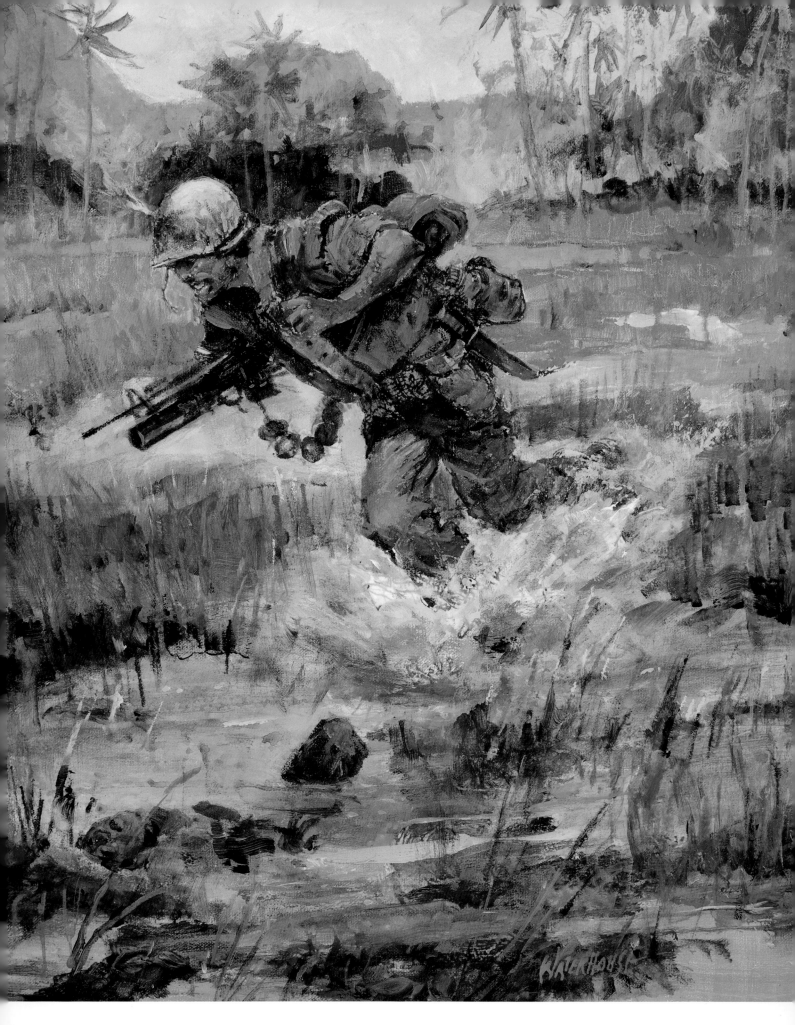

Thomas Patrick Noonan, Jr. was born on November 18, 1943, in Brooklyn, New York, and grew up in Woodside, Queens, attending the same school and church as his neighborhood buddy, future fellow Medal of Honor recipient, Robert Emmett O'Malley. After high school, the two friends parted ways: Bobby O'Malley joined the Marines and Tommy Noonan joined the seminary. When it became clear that the priesthood was not his calling, Tom Noonan enrolled in Hunter College where he earned a bachelor's degree in physical education.

"Noonan was built like a gorilla," said Tommy Maher, a Korean War leatherneck who was also from Woodside. "And the story goes that after O'Malley got the Medal of Honor, Noonan was at a neighborhood party and said, 'I better join up before this war ends because if they gave O'Malley one of those medals, they oughtta give me two.'"

Hankering to serve and ready to earn some medals, Thomas Noonan enlisted in the Marine Corps Reserve on the day after Christmas 1967. By July 1968, LCpl. Tommy Noonan was in Vietnam, serving as fire team leader with Company G, 2nd Battalion, 9th Marines, 3rd Marine Division in operations against the enemy in Quang Tri Province.

In February 1969, Company G was directed to move from the position they had been holding southeast of the Vandegrift Combat Base in A Shau Valley. Their new objective was Hill 1175, a 3,000-foot "hill," with a steep incline rendered slippery from recent heavy rains. Weighted down by their weapons and equipment, the Marines slogged up the muddy slopes, through sheeting rain and pockets of dense fog that reduced visibility to less than twenty-five meters, until they reached the summit. After two nights on the hilltop, they were running out of food and taking sniper fire. Weather conditions made it impossible for a helicopter to carry in supplies and evacuate casualties, so on the morning of February 5, the decision was made to pull Company G back to the Da Krong River to link up with another company for resupplies.

As the unit was commencing its slow, slippery descent down the side of the hill, the leading element came under a heavy fire from a North Vietnamese Army unit hidden among the rocks and trees. Four Marines were wounded, but intense enemy fire had thwarted repeated attempts to rescue them.

Noonan took action, maneuvering his way down the treacherous slope toward his fallen comrades. With the same compassion that had once inspired young Tommy Noonan to enter the seminary, he shouted out words of encouragement to the wounded Marines, telling them to hang on; but it was the other side of Tom Noonan—the physical education major and Tarzan of Woodside, Queens—that emboldened him with the courage to dash across the kill zone, and imbued him with the strength to continue in his selfless mission, even after being knocked to the ground by an enemy round, enabling him to drag the most seriously wounded Marine toward the relative safety of a rock, before he fell, mortally wounded.

In a 2005 post on the VVMF virtual Wall of Faces, a Company G Marine writes to Noonan: "We carried you and sixteen other Marines for three of the longest, most terrible days when we all learned first-hand what 'Semper Fi' means and the absolute true meaning of 'Brotherhood.'"

Medal of Honor recipient LCpl. Noonan is buried in Calvary Cemetery in his beloved Queens, where a Veterans Administration clinic bears his name, as does the Woodside playground where he and Bobby O'Malley played as children.

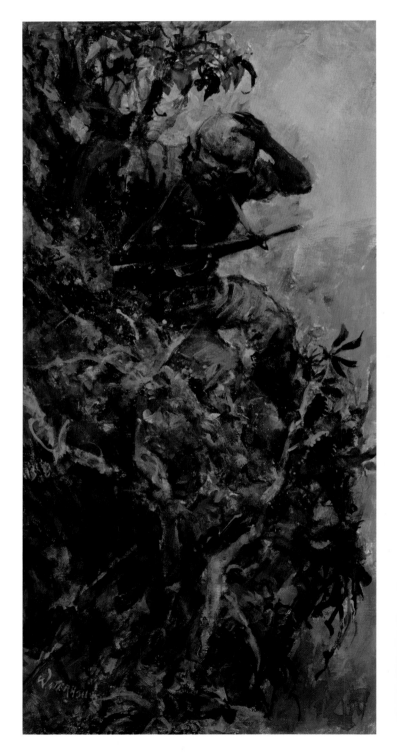

LCpl. William R. Prom, USMC[37]
Operation Taylor Common, Vietnam, February 9, 1969

William Raymond Prom was born on November 17, 1948, in Pittsburgh, Pennsylvania, growing up in the neighborly suburb of Reserve Township, where he enjoyed fishing in the Allegheny River and deer hunting with his father, Fred. Billy dreamed of being a professional baseball player and was a standout on the diamond during middle school and high school. In early December 1967, Bill Prom enlisted in the Marine Corps Reserve. Two days after Christmas, he joined as a Regular Marine. Billy's mother broke down in tears when she heard the news, and his older brother, Fred, had some parting advice for the young Marine before he went off to boot camp. "Don't be a hero," his brother said.

Trying to ease his family's concerns, Billy wrote home from basic training, "Don't worry about anything. It's a whole lot of fun down here. Just like Boy Scout camp."

On March 1, 1968, after completing his training at Parris Island, South Carolina, Prom was promoted to private first class. By June, he was in Vietnam, serving consecutively as ammunition man, assistant gunner, machine gun team leader, and machine gun squad leader with Company I, 3rd Battalion, 3rd Marines, 3rd Marine Division. By September 1968, Prom had been promoted to lance corporal. "I'm now a full-time gunner," he wrote in a letter home. "I carry a M-60 and a .45 … I haven't been anywhere near civilization since I got here." Between December 31, 1967 and January 23, 1969, Bill Prom wrote seventy letters to his family, telling them how much he missed his beagle, Lola, and the times spent deer hunting and trout fishing with dad, asking them to send clippings from the *Pittsburgh Post-Gazette* sports pages and fishing columns.

LCpl. Prom would serve a total of eight months in combat before his final action.

On February 9, 1969, while participating in Operation Taylor Common, Prom and his unit were returning to base after a two-day reconnaissance mission near An Hoa when they were ambushed by a North Vietnamese force, heavily concealed in the thick jungle canopy. The sudden attack left several Marines wounded. Prom immediately assumed control of one of the machine guns and began to deliver return fire, providing cover for medics administering aid to the wounded. It became apparent that the casualties couldn't be moved to safety until the enemy was destroyed, Prom didn't hesitate. In the words of his citation, he "moved forward and delivered a heavy volume of fire with such accuracy that he was instrumental in routing the enemy." When a second round of attacks began on his platoon, and a fellow Marine was wounded, Prom moved forward to protect the man. Wounded by enemy fire, and no longer able to fire his weapon, Prom "continued to advance to within a few yards of the enemy positions. There, standing in full view of the enemy, he accurately directed the fire of his support elements until he was mortally wounded." Prom was twenty years old. Inspired by his courage, his fellow Marines launched one last assault and destroyed the enemy.

Two weeks after he was killed, LCpl. William Prom was buried in Allegheny County Memorial Park, McCandless, Pennsylvania. In April 1970, his parents and sister traveled to Washington, DC, to receive Billy's posthumous Medal of Honor from Vice President Spiro Agnew.

Forty-three years later, dozens of people who knew and loved Bill Prom gathered together in solemn ceremony in his hometown neighborhood of Reserves to rename a bridge in honor of the brave young Marine. "I am so happy today," said Billy's then eighty-one-year old sister, Clara Prom Burns. "I will never get complete closure, but I have wanted this for so long."

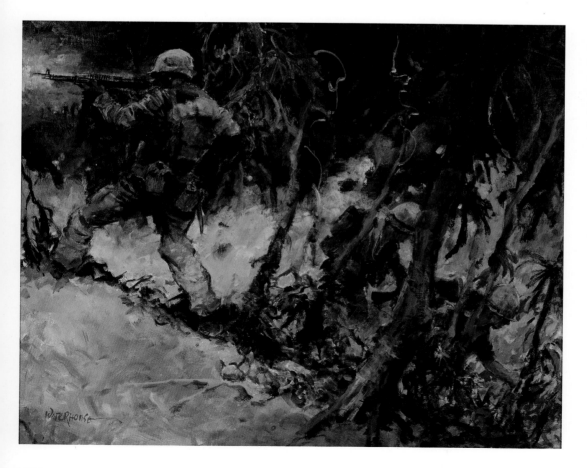

LCpl. Thomas E. Creek, USMC[38]
Vandegrift Combat Base Area, Vietnam, February 13, 1969

Thomas Creek came into the world on April 7, 1950, in Joplin, Missouri, one of three sons born to young parents who struggled and often failed to keep their family's heads above the poverty line. While their boys were still young, the Creeks moved to Amarillo, Texas, to be closer to their grandparents. Tom attended the local schools and helped his father and older brother, who, by then, were working as roofers. One day while they were on the job, Tom's brother lost his footing and slipped. He slid down the roof and was about to go over the side, when Tom reached out and grabbed him, pulling him to safety. Young Tom went back to what he'd been doing, as though it were nothing.

The boy worked all through high school, driving an ice cream truck, pumping gas, and bussing tables before dropping out in his junior year to enlist in the Marines.

On July 4, 1968, PFC Creek arrived in Vietnam, first seeing duty as a rifleman with Company E, 2nd Battalion, 27th Marines, 1st Marine Division. A few months later he was assigned as a fire team leader with Company I, 3rd Battalion, 9th Marines, 3rd Marine Division, and promoted to lance corporal. The baby-faced Marine with the Steve McQueen attitude soon earned the nickname of "Billy the Kid."

When writing to his mother, Tom's tone was always optimistic and reassuring. His letters to his brothers were more frank. Fearing for their safety, Creek urged them not to enlist. "I have scars all over my face from bombs & gun powder & I look like I am 40 years old," he wrote.

On Friday, February 13, 1969, LCpl. Creek volunteered as one of six Marines who would ride with, and provide support for, a truck convoy taking supplies to Vandegrift Combat Base. En route, they were ambushed. Under heavy attack, the young fire team leader jumped out of his truck to return fire and was hit in the neck.

With blood pouring from his wound, Creek started to run back to the convoy. As he was doing so, he saw an enemy grenade land in the midst of Marines. Shouting, "I've got it, Mac!," eighteen-year-old LCpl. Creek dived on the exploding grenade, saving the lives of five of his comrades. Inspired by Creek's courage, the Marines were able to defeat their attackers, allowing the convoy to continue its vital mission.

Tom Creek's two brothers would go on to serve in the USMC.

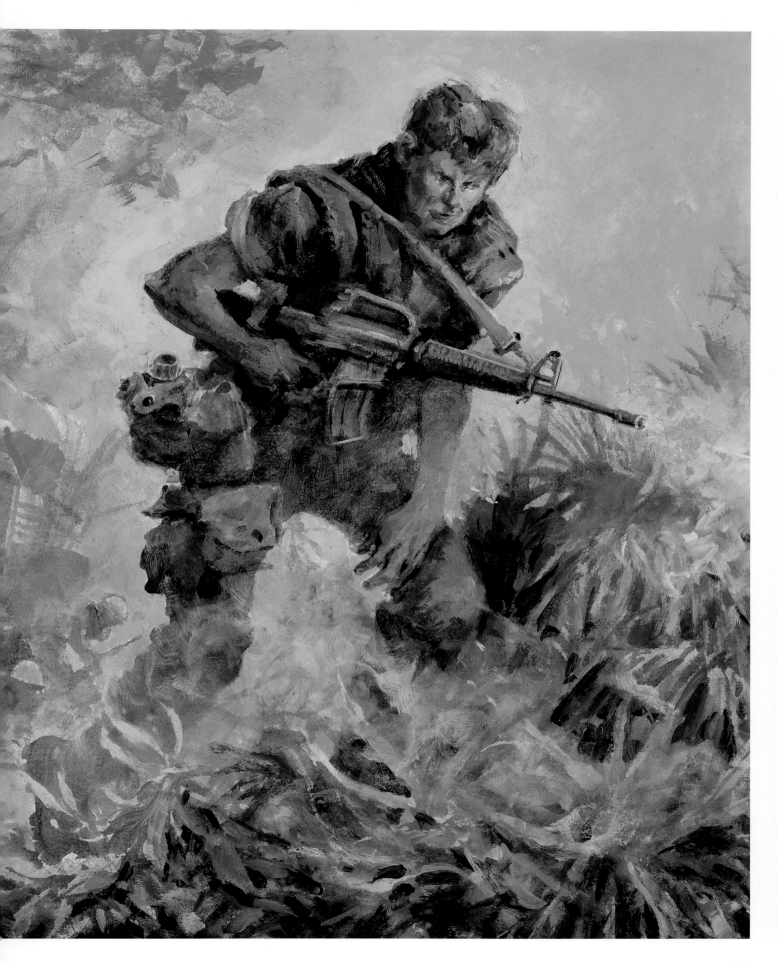

CAPT. WESLEY L. FOX, USMC[39]
Quang Tri Province, Vietnam, February 22, 1969

Wesley Lee Fox was born on September 30, 1931, the first child of parents John Wesley and Desola Lee Fox who raised their oldest son, along with his nine younger siblings, on a farm outside of Herndon, Virginia. Wesley loved working the land, but he couldn't see how "book learning" could help a future farmer, so he dropped out of school in the eighth grade. His cousins were fought in World War II and although he was then too young to enlist, Wesley dreamt of a time when he might wear the uniform of his country.

That time came in August 1950. With tensions in Korea mounting, Fox was anxious to serve but, as he explained to a Marine recruiter, he was having trouble deciding between the Marines and the Airborne. The recruiter replied, "Hell boy, what's wrong with the Paramarines?" Fox thought the Paramarines sounded like just the ticket. What he didn't find out until he signed up was Paramarines had been disbanded in 1944.

By January 1951, Fox was serving in Korea, where he was wounded twice. All thoughts of being a farmer or Paramarine were long gone

from his head. Fox was now a proud Leatherneck, through and through. "My first four years as a Marine I didn't own one stitch of civilian clothes," he said. "Everything I did was in a Marine uniform."

Over the next ten years, Wesley Fox served as drill instructor, a recruiter, a member of the 1st Force Reconnaissance Company (where he actually did jump out of airplanes), in the Pathfinders, and at Okinawa. After his first tour as an advisor to a South Vietnam Marine battalion in September 1967, Fox volunteered for a second tour of duty with the Marines in the north.

On February 22, 1969, then 1Lt. Fox was serving as the company commander of Company A, 1st Battalion, 9th Marines in Quang Tri Province during Operation Dewey Canyon when his company came under intense fire in the A Shau Valley from a battalion-sized North Vietnamese force. Fox was wounded in the shoulder during the initial stages of the attack, which left all of his platoon leaders either wounded or killed. His 240-man rifle company had been re-

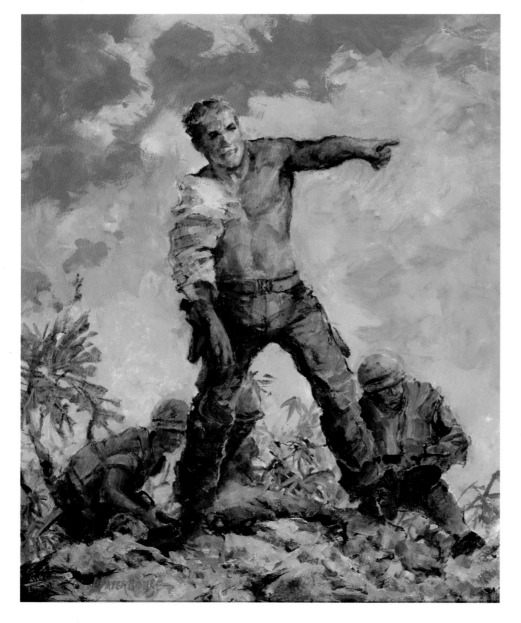

duced to less than ninety Marines. Evacuating the wounded by helicopter was out of the question because of the weather conditions. "It was nothing but a rifleman's fight," Fox said, "and in that thick jungle where you could never see more than the Marine on your right and your left." Unable to spare his able bodies to carry out the wounded, and steadfastly refusing to leave any of his men behind, Fox made a decision to "win this fight," saying, "we'll either walk out or we'll all stay in the valley."

Despite his painful shoulder wound, 1Lt. Fox directed the activity of his small group of fighting Marines, advancing through heavy enemy fire to personally neutralize an enemy position before calmly ordering an assault against other hostile emplacements. When his executive officer was mortally wounded, Fox reorganized the company, directing the fire of his men as they hurled grenades against the enemy and drove them into retreat. Wounded again in the final assault, Fox refused medical attention, establishing a defensive position and supervising the preparation of casualties for medical evacuation when the skies finally cleared. For his actions that day, by then Capt. Wesley Fox was presented with a Medal of Honor. "There were more medals of honor deserved in that fight than the one I wear," he later said.

Wesley Fox retired from the Marine Corps as a colonel, passing away at his home in Blacksburg, Virginia, at the age of eighty-six. He is buried in Arlington National Cemetery.

PFC OSCAR P. AUSTIN, USMC[40]
Da Nang, Vietnam, February 23, 1969

Oscar Palmer Austin was born on January 15, 1948, in Nacogdoches, Texas. Oscar grew up in Phoenix, Arizona, where he attended Booker T. Washington Elementary School and Phoenix Union High School. One of his high school classmates remembered those times well. "His family was going through a divorce; mine had gone through a divorce. So as kids we were just working a lot to help out the families," he recalled. "Oscar was throwing papers, working at a laundromat." That classmate later joined the Air Force, while Oscar Austin chose to enlist in the Marines rather than be drafted.

After completing his training, Austin was promoted to private first class and transferred to South Vietnam as an assistant machine gunner with Company E, 2nd Battalion, 7th Marines, 1st Marine Division, arriving in country at the end of October 1968. PFC Austin would spend the majority of the next few months in combat operations with his company in the area outside Da Nang.

During the early hours of February 23, 1969, PFC Austin was manning his company's observation post when it came under fierce attack by a large North Vietnamese army force. In the midst of the fighting, Austin noticed that one of his fellow Marines had been wounded and was lying in an exposed position, where, without help, he would surely be killed. Without hesitating, Austin left the relative security of his foxhole and raced across the fire-swept terrain to the man's side.

As he was attempting to drag the Marine to safety, an enemy grenade landed next to them. Throwing his body on top of his wounded comrade, Austin absorbed the brunt of the blast. Although bleeding heavily from the force of the explosion, Austin ignored his own injuries, continuing to attend to his friend. At that moment he spotted a North Vietnamese soldier advancing toward them—too far away for Austin to engage in hand-to-hand combat, but close enough that the enemy weapon aimed at the fallen Marine would hit its mark. For the third time that morning, Austin stepped between the shadow of death and his companion, shielding the Marine and taking the bullet for him. Austin's heroic final act inspired the Marines of Company E to hold their positions and repel the enemy forces.

In 2000, the destroyer USS *Oscar Austin* (DDG-79)—the first ship of a highly lethal subclass of the Arleigh Burke guided-missile destroyers—was named in honor of the brave twenty-year-old Marine.

In 2016, at a Phoenix Navy Week service commemorating Oscar Austin, senior pastor Warren H. Stewart of the First Baptist Church cited the gospel passage "a greater love does not exist than when a man lay down his life for his friends," adding, "Oscar Austin is one who did just that."

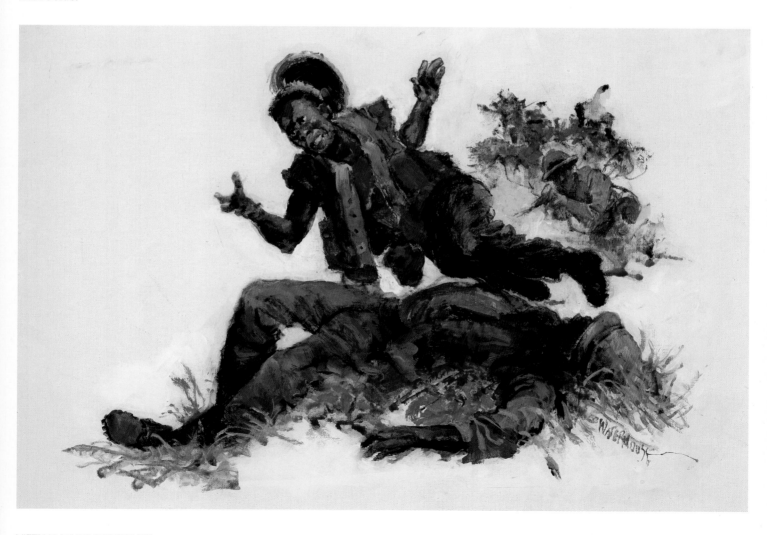

CPL. WILLIAM D. MORGAN, USMC[41]
Quang Tri Province, Vietnam, February 25, 1969

William David Morgan was born on September 17, 1947, in Pittsburgh, Pennsylvania. The second son of a Welsh immigrant and a former nurse, Billy was raised in the upper middle class suburb of nearby Mt. Lebanon. A popular boy, described by his classmates as "smart and funny," Billy Morgan was a natural athlete who ran track and captained the football team at Mt. Lebanon High. Decades later, one of the smallest and least athletic members of his team posted on Morgan's VMMF Virtual Wall, remembering a time when he'd been injured during a game while recovering a fumble, and Bill had led the other players in a team cheer for him. "That little kid hasn't forgotten," he added.

Patriotism ran deep in the Morgan family. Bill's older brother joined the Marines in 1964, and had already completed officer school as a second lieutenant and served in Vietnam by the time his younger brother graduated from high school, but Bill decided to take a different route, leaving Mt. Lebanon to attend Hiram Scott College, in Scottsbluff, Nebraska. Although he was a natural athlete, he proved not to be a natural academic, and after struggling in his classes for a few months, Bill went back home, took a job at a local department store and joined the Marine Corps Reserve.

A year later, Morgan enlisted in the Regular Marines. He served a tour of sea duty with the USS *Newport News*, working his way up the ranks to private first class and then lance corporal. By April 1968, LCpl. Billy Morgan was itching to get off a ship and get a taste of the action that was going on in Vietnam. During a heart-to-heart talk while on leave, Bill told a friend that he "didn't think he'd done his part yet, he hadn't done enough." To his way of thinking, he was young and single, and if he "reupped" for another tour, it might spare a family man from combat.

So in July 1968, LCpl. Bill Morgan was transferred to Vietnam. By February 1969, Morgan was now serving as a squad leader with Hotel Company during Operation Dewey Canyon, the last major offensive by the 3rd Marine Division in the Vietnam War.

On February 25, Morgan raced through the dense jungle undergrowth to assault an enemy bunker that had pinned down his unit and prevented the evacuation of two wounded Marines who were lying out in the open. Fully aware of the consequences of his actions, but thinking only of the welfare of his fallen companions, Morgan shouted words of encouragement to them as he charged across the open road toward the hostile emplacement. The North Vietnamese soldiers immediately turned their fire on Morgan, mortally wounding him, but his diversionary tactic enabled members of his squad to rescue the wounded Marines and overrun the North Vietnamese Army position.

Bill Morgan, who just a year earlier had feared he hadn't "done enough," had gone above and beyond, making the ultimate sacrifice to save the lives of fellow Marines.

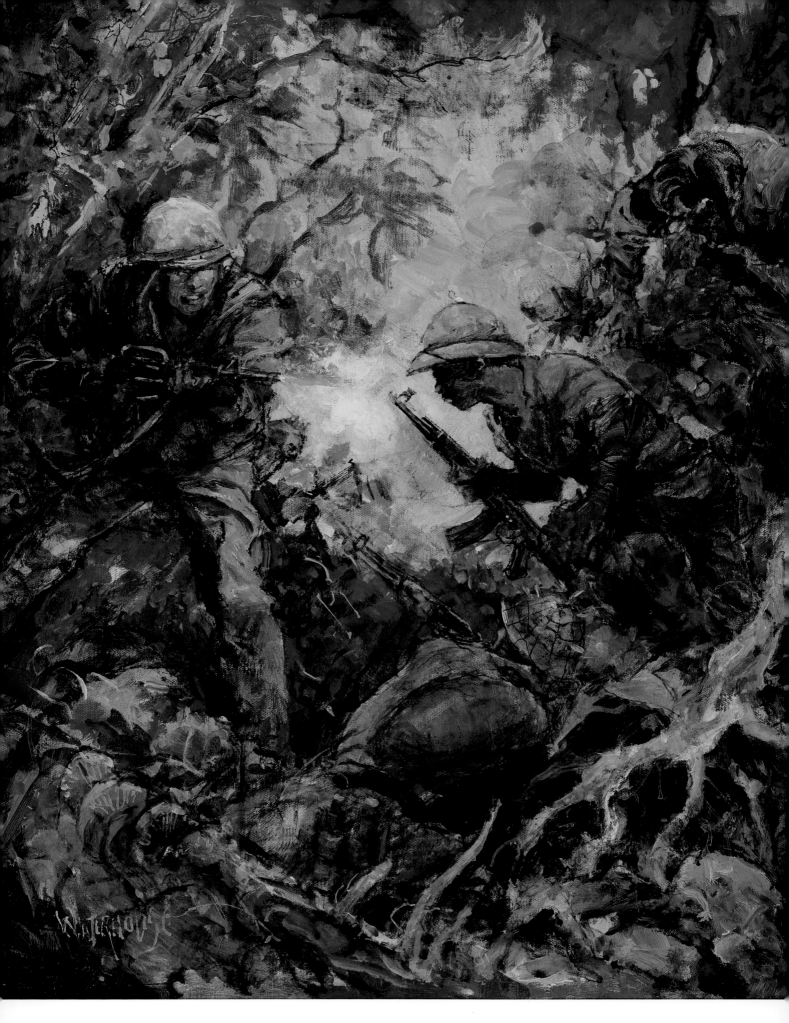

LCpl. Lester W. Weber, USMC[42]
Quang Nam Province, Vietnam, February 23, 1969

Lester Weber was born on July 30, 1948, in Aurora, Illinois. After his parents' divorce, Les and his brothers moved with their mother to Hinsdale, a suburb of Chicago. Les is remembered as an outgoing, athletic, competitive boy who played Little League and was a member of the Cub Scouts. In his second year at Hinsdale High School, however, this otherwise good boy started hanging around with the wrong crowd and landed into trouble, culminating in a New Year's Eve heist of the local liquor store. Weber and pals stole a bottle of whiskey and were promptly busted. The sheriff, who was a lieutenant colonel in the USMCR, told Weber that the charges against him would be expunged if he was accepted into the Reserve.

The recruiter remembered meeting with the slim seventeen-year-old and his mother. Lester said earnestly, "Sir, please give me a chance to be a Marine; it has always been my life's dream. I promise you, sir, I will be the best Marine you ever recruited."

Mrs. Weber worried that, at 5 foot 7 and 120 pounds, her son would be too small to make it through boot camp. But Lester did, finishing his training as a private first class and the honor graduate of his platoon. The following year, Weber enlisted in the Regular Marine Corps.

In July 1967, Weber was ordered to the Republic of Vietnam, initially assigned duty as an ammunition carrier and squad leader with Headquarters and Service Company, 1st Marines. After serving out his tour of duty, now LCpl. Weber requested to have his time in Vietnam extended six months and was reassigned to Company M, 3rd Battalion, 7th Marines, as a squad leader and machine gunner.

On February 23, 1969, with his tour of extended duty winding down, Weber's platoon was called in to help extract a squad of Marines that had come under guerrilla attack in the area near Bo Ban. As his men were moving through a rice paddy covered with tall grass, they came under heavy fire.

Reacting immediately, Weber plunged into the tall grass, killing one of the enemy and forcing eleven others to withdraw. Encountering a second North Vietnamese army soldier, Weber overwhelmed him in fierce hand-to-hand combat.

As the battle around him continued, the lance corporal observed two NVA soldiers firing at his comrades from behind a dike. He raced across the hazardous area, dived into their position, and wrestled their weapons away, overcoming them.

By now Weber had become the primary target for NVA riflemen; still, he remained in the open, shouting encouragement to his fellow Marines. Spotting another enemy soldier, Weber ran toward him, firing his weapon. He was killed in a burst of hostile fire. Lester Weber was twenty years old.

The Marine who recruited Weber, 1Lt. Henry Frank Walker, USMC (Ret.), later wrote that he was proud to have known the courageous young man who had kept his promise: "I will be the best Marine you ever recruited."

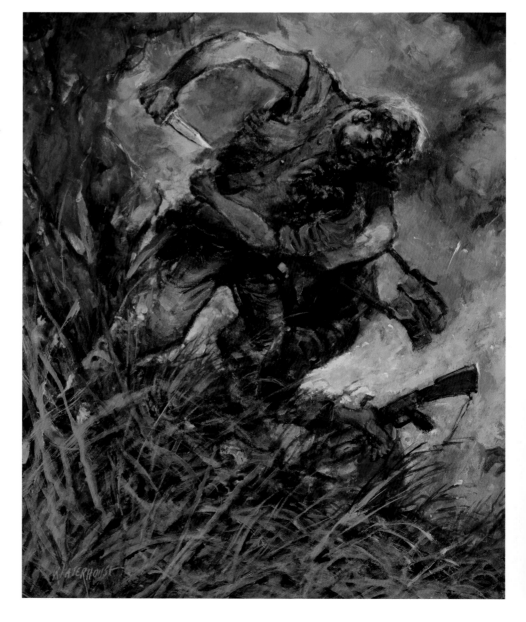

PFC. DANIEL D. BRUCE, USMC[43]

Quang Tri Province, Vietnam, March 1, 1969

Daniel Bruce was born on May 18, 1950, in Michigan City, Indiana. By his teens, Danny had already shown that he had the makings of a hero, going to the rescue of a drowning swimmer then diving back into the water to save another. While attending Elston Senior High School, Bruce met his future wife, Carol. Carey—as she was then called—and Danny quickly became inseparable. They married in 1968, shortly before Danny joined the Marine Corps.

After completing his recruit training, Bruce was promoted to private first class and deployed to the Republic Vietnam where he was assigned as an anti-tank assault man with HQ and Service Co., 3rd Battalion, 5th Marines, 1st Marine Division.

During the early hours of March 1, 1969, while on night watch at Fire Support Base Tomahawk in the Quang Nam Province, PFC Bruce heard the ominous sound of movement out in the darkness. Seconds later an enemy satchel charge was thrown at his position. Reacting instantly, Bruce caught it. Cradling it in his arms he ran as fast as he could to put distance between the exploding charge and his fellow Marines. He was killed in the blast.

The day after eighteen-year-old Daniel Bruce gave his life for his comrades, his young wife Carol gave birth to a daughter. She wouldn't find out until days later that the child she'd borne would never meet or get to know her father.

But PFC Bruce's sacrifice would not be forgotten. Forty-three years after his death, over 1,000 people gather at Prairie Meadow Park in Westville, Indiana, to honor his memory. In the patriotic and deeply emotional ceremony that followed, Danny's daughter, Stacey, and her mother, Carol, helped to lay a brick inscribed with his name in a memorial walkway commemorating local veterans who had served their country, all the way back to the Civil War.

Two of the men whose lives had been saved by Bruce's actions stood at his daughter's side, passing the brick reverently from their hands to hers. Once it was laid, Daniel's granddaughters came forward, each placing a rose on the spot.

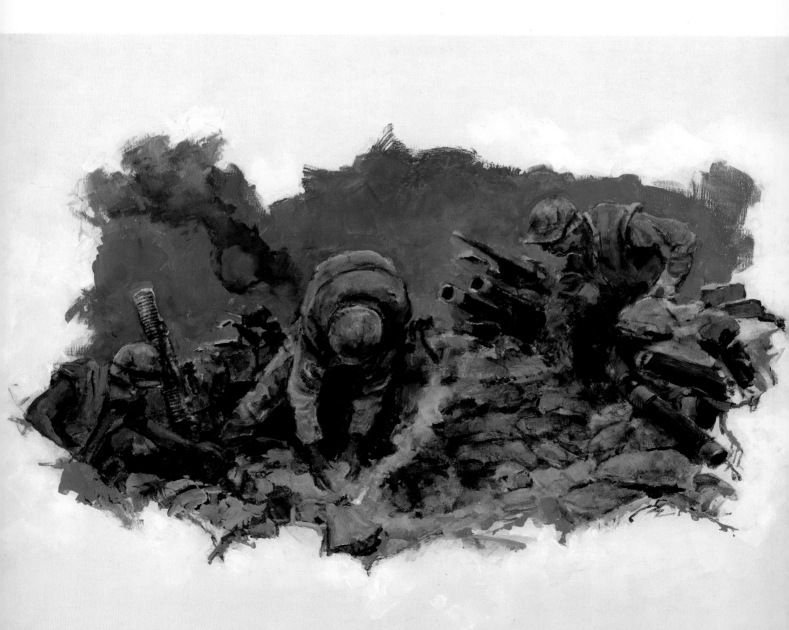

PFC ALFRED "MAC" WILSON, USMC[44]
Quang Tri Province, Vietnam, March 3, 1969

Alfred Mac Wilson was born on January 13, 1948, in Olney, Illinois. Two years later his family moved to Odessa, south of Amarillo, Texas, and Mac—as the boy liked to be called—considered himself Texan to the core. More than anything, he loved being out of doors. As a child, he'd play soldiers with the neighborhood kids. Later, he'd learn to shoot for real. Hunting and fishing were a way of life where he lived. Mac was also a gifted athlete, playing football and running track at Odessa Senior High School, and squeezing in a game of tennis whenever he could. He enjoyed the camaraderie of physical activity and being part of collegial groups such as the school's distributive education club, so it's no surprise that Mac was drawn to the Marine Corps.

Wilson joined the Reserve in 1967, becoming a regular a few months later. After recruit training in San Diego, he was transferred to Camp Pendleton, where he completed his training and was promoted to private first class.

PFC Wilson arrived in Vietnam in July 1968, serving for a period of months as a rifleman with Company D, 1st Battalion, 27th Marines, 1st Marine Division, before being reassigned as a rifleman with Company M, 3rd Battalion, 9th Marines, 3rd Marine Division, in Quang Tri Province.

In the first months of 1969, the 9th Marines played an active role in Operation Dewey Canyon, with a mission of driving the North Vietnamese army out of sanctuary areas near the Laotian border. By early March, Phase III was winding down. On March 3, the last official day of the operation, Mike Company was returning from a patrol in the vicinity of Fire Support Base Cunningham—coincidentally, the base was then under the command of Capt. Harvey Barnum Jr., who had been recognized with a Medal of Honor three years previously—when it was ambushed. During the fierce fighting that followed, the 1st Platoon lost its machine gunner and assistant gunner.

As squad leader of the embattled 1st Platoon, PFC Mac Wilson knew they needed that weapon. He charged across the fire-swept terrain with another Marine close at his heels. Before they could reach the machine gun, an NVA soldier popped out from behind a tree and threw a grenade. Reacting instantly, Wilson fired a burst from his M-16 rifle, killing the enemy soldier. The enemy grenade landed between the two men. Shouting out a warning, Wilson kicked the missile away from his companion and threw his body over it, perishing in the blast. He was twenty-one years old.

His heroic act inspired First Platoon to rally and defeat the enemy.

Wilson's mother didn't live long enough to receive her only son's posthumous Medal of Honor. She died of a heart attack only months after Mac was killed, and is buried beside him in Odessa's Sunset Memorial Park.

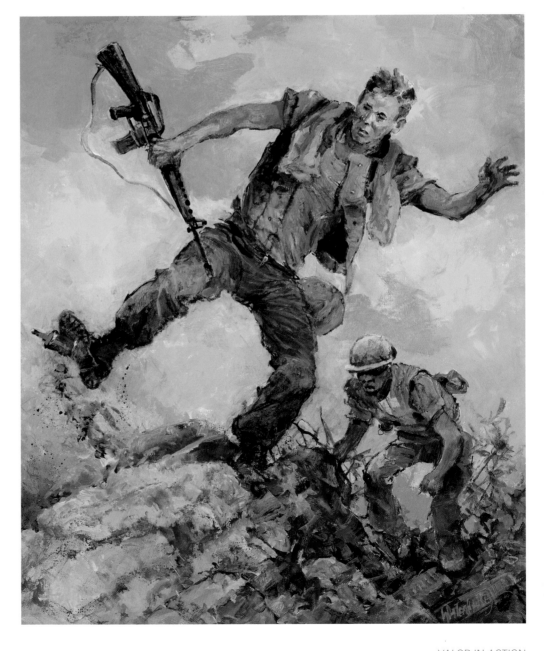

PFC ROBERT H. JENKINS JR., USMC[45]
Quang Tri Province, Vietnam, March 5, 1969

Robert Jenkins Jr. was born on June 1, 1948, in Interlachen, Florida. After graduating from high school, Robert enlisted in the Marines. He came out of recruit training as a private first class and underwent individual combat and infantry special training before being deployed to Vietnam.

On the night of March 4, 1969, PFC Jenkins was part of a twelve-man reconnaissance team from Company C, 3rd Reconnaissance Battalion, 3rd Marine Division, reconning an old abandoned US Fire Support Base, FSB Argonne, in an enemy-held area less than 5 miles from North Vietnam and a mile from Laos. The Marines had formed a perimeter in a depression at the top of Hill 1308. Jenkins, who was the machine gunner, and his best friend, Fred Ostrom, his assistant machine gunner, built a two-man defensive position and hunkered down. Before dawn on March 5, with the sky lightened only by a full moon, an attack began.

Jenkins jumped into position and began firing his M-60 machine gun. It was only then he noticed that Ostrom had been seriously wounded by grenade shrapnel. Before Jenkins could move him, two more grenades landed next to Ostrom. Knowing that even if he could manage to lob one away, the other would still go off, twenty-year-old Robert Jenkins chose to lie on top of his friend, absorbing the explosion from both grenades into his body.

Ostrom lived, but he never forgot the ultimate sacrifice made by his buddy. Decades later, he made a pilgrimage to Jenkins's grave and was appalled to find it overgrown and neglected. He set out to change that, contacting the Marines, the VA, the media, and even the late Sen. John McCain for help.

On Veterans Day 1996—after clearing over 7,000 pounds of debris and erecting a gold-inlay MOH headstone—the refurbished gravesite was rededicated. Robert's family and Fred Ostrom were in attendance. An anonymous donor gifted a grave cover with the words from John's Gospel: "Greater love hath no man than this, that he lay down his life for his friends."

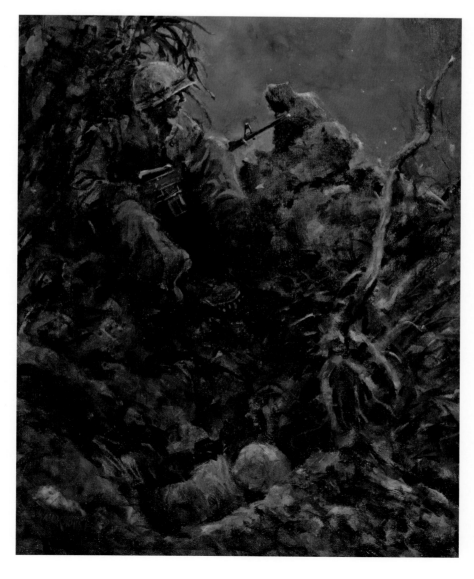

Ronald Coker was born on August 9, 1947, in Alliance, Nebraska. Growing up on his family's farm, Ron enjoyed fiddling around in the garage and baking in the kitchen. Friends dropping by often found him with his hands covered in flour. Lean and muscled after years of farmwork, Ron cut a figure, riding around town on his motorcycle in his signature black cowboy hat. Locals dubbed him "the Cisco Kid." In 1968, young men Ron's age were getting letters from the draft board. When his came, Coker became a Marine. The Cisco Kid was headed east—far east.

On March 24, 1969, serving as point man of a 2nd Platoon, Company M, 3rd Battalion, 3rd Marines, 3rd Marine Division patrol in the embattled Quang Tri Province of Vietnam, PFC Coker encountered five enemy soldiers on a narrow jungle trail. He fired his M16 rifle, wounding one, but the others retreated into a cave. As the squad neared it, the enemy opened fire, seriously wounding one Marine who lay helplessly in the open. PFC Coker crawled toward his comrade. Despite being wounded, he skillfully threw a grenade into the cave and began dragging his buddy out of the kill zone.

When a grenade was lobbed at them, Coker grabbed it and tried to throw it back into the cave, but the charge detonated, blowing off those hands that were so adept at baking and tinkering with engines. It didn't stop him. Coker ran his stubs into the suspenders of the wounded man's cartridge belt and dragged him until he was close enough to be pulled to cover. A corpsman worked on both Marines to no avail.

Coker was buried in the family cemetery, surrounded by prairie grass stretching to the horizon. The Cisco Kid had come home.

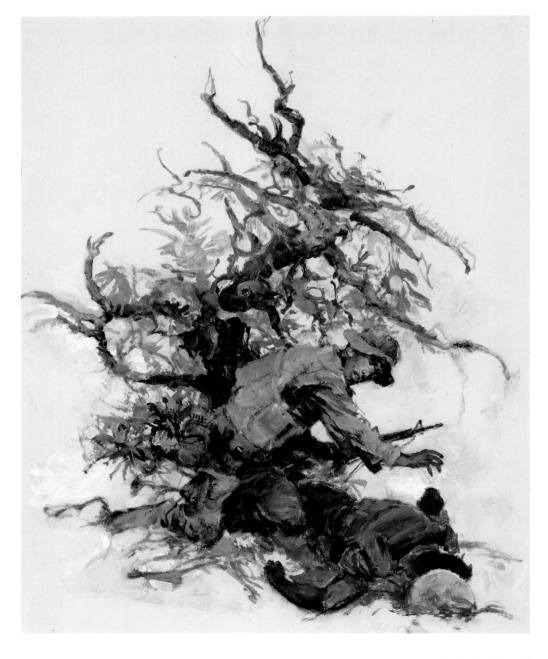

PFC Jimmy W. Phipps, USMC[47]
An Hoa, Vietnam, May 27, 1969

He lived for only nineteen years, not long enough to change the world but enough to save the lives of at least two of his friends. The only thing permanent that remains of him is the name "Jimmy W. Phipps" inscribed in black granite on Panel 23W, Row 002 of the Vietnam Veterans Memorial in Washington, DC. Posting on the Vietnam Veterans Memorial Fund virtual Wall of Faces in 2001, Phipps's platoon commander, Neal Mier—one of the Marines whose lives he saved—paraphrased the old folk song, *Johnny I Hardly Knew Ye?*, writing: "Jimmy, We hardly knew you. Your life for mine. I've tried for strength and honor."

Strength and honor would be the watchwords of Jimmy Wayne Phipps's short life. Born on November 1, 1950, in Santa Monica, California, Jimmy was the second oldest of three boys raised in a loving, happy family. Remembered by sister, Cordy, as an outgoing, kind-hearted boy who always made time to help his kid sister with her homework, Jimmy was less focused when it came to his own education, dropping out of Venice High School at age seventeen and convincing his parents to give their permission to join the Marine Corps Reserve.

On January 7, 1968, four days after receiving a discharge from the Reserves, Phipps enlisted in the Regular Marine Corps. After completing his training, Phipps attended the Marine Corps Engineer Schools at Camp Lejeune, NC. By December 1968, now PFC Jimmy Phipps was in Vietnam, serving first as a combat engineer with Company B, 1st Engineer Battalion, 1st Marine Division, based near Da Nang, before transferring to Company C, 1st Battalion, 5th Marines.

Charlie Company—which had earned the nickname Suicide Charley back in the days when Chesty Puller commanded the company during some of the bloodiest battles of World War II—was living up to its reputation in Vietnam. While serving with Company C from February to April 1969, PFC Phipps was wounded twice. He returned briefly to Bravo Company, but after being attached to a rifle company, daily life with an engineer company seemed too predictable and constricted, and a month later Phipps volunteered to return to the field a second time.

He rejoined Charlie Company as it was conducting patrols in the "Arizona Territory," an area of flooded rice paddies near An Hoa hamlet where two North Vietnamese Army regiments were known to be operating. On May 27, 1969, while on patrol with 1st Platoon, C Company, PFC Phipps was part of a two-man combat demolition team assigned to locate and destroy enemy artillery ordinance. After using all of his explosives and blasting caps, Phipps located a 175 mm high-explosive artillery round in a rice paddy. Suspecting that the round was attached to another explosive device that would act like a booby trap, Phipps warned his fellow Marines to move to protected positions; then, moving carefully as he'd been trained to do, he prepared to destroy the round with a hand grenade. As he was fixing the grenade to a stake beside the artillery round, the enemy's secondary explosive device ignited. Knowing it would detonate before he could move out of range, and that the imminent explosion would kill his team assistant and platoon commander who were standing only a few meters away, Phipps cradled the hand grenade to his chest and dived onto the artillery round and secondary device, taking the full force of the multiple explosions and protecting his fellow Marines.

Just seven months past his eighteenth birthday, PFC Jimmy Phipps became third youngest Marine to receive a Medal of Honor. Vice President Spiro Agnew presented Phipps's posthumous medal to his parents in a ceremony held on April 20, 1970, in the East Room of the White House that was attended by the families of twelve other Marine recipients.

And now there is just his name on the Wall, and the memories of fellow Marines who will, in turn, fade and slip away like morning mist off the Santa Monica pier.

Jimmy, we hardly knew you.

Col. Waterhouse did not live long enough to paint Jimmy Phipps. I like to think Jimmy's was one of the pictures he was trying to finish in his head as he lay dying.

Bruce Wayne Carter was born on May 7, 1950, in Schenectady, New York. Throughout his childhood, Bruce moved around a lot with his family, attending schools in Pasadena, Texas; Gretna and Wego, Lousiana; and Hialeah and Miami Springs, Florida, but he never let being the new kid stand in his way. A little guy with a big attitude, he always wanted to be the first in line and the best at everything he did. "When the kids signed up for band, he was the only kid to get off the bus with a tuba," his mother, Georgie Carter Krell, said. "I took one look at him and said, 'Bruce, that tuba's bigger than you are.' He said, 'Yeah, but nobody can carry it but me.'"

Although he was a typical 1960s teenager—crazy about cars and girls—Bruce Carter had a lifelong dream of becoming a Marine, so on August 12, 1968, at the age of seventeen, he left high school and enlisted in the Marines. Before Bruce left for the service he gave all his toys to the neighborhood kids. Having put away those childish things, Carter put on his uniform and set out to be the first in line and the best Marine he could be.

Upon completing his training at Camp Lejeune, North Carolina, Carter was promoted to private first class and then sent to the Vietnamese Language Course at Monterey, California. It would be the last in the list of schools that he attended all around the country. But his toughest, most intense schooling was still ahead.

In April 1969, PFC Bruce Carter was in Vietnam, serving as a grenadier and radio operator with Company H, 2nd Battalion, 3rd Marines Division. The corpsman with his unit, Louis Salamon Jr., saw Carter's "first in line" spirit in action, "Bruce always wanted to take the point on the patrols that he was assigned to," Salamon said. "He was respected as a Marine by everyone. We knew he was hard-core dedicated to what he was doing."

On August 7, 1969, while maneuvering against the enemy during Operation Idaho Canyon, Carter's unit came under enemy attack, starting a raging brush fire that cut off the lead element, separating it from the main body of the squad, and putting Carter and his fellow Marines in the middle of the enemy's vicious crossfire.

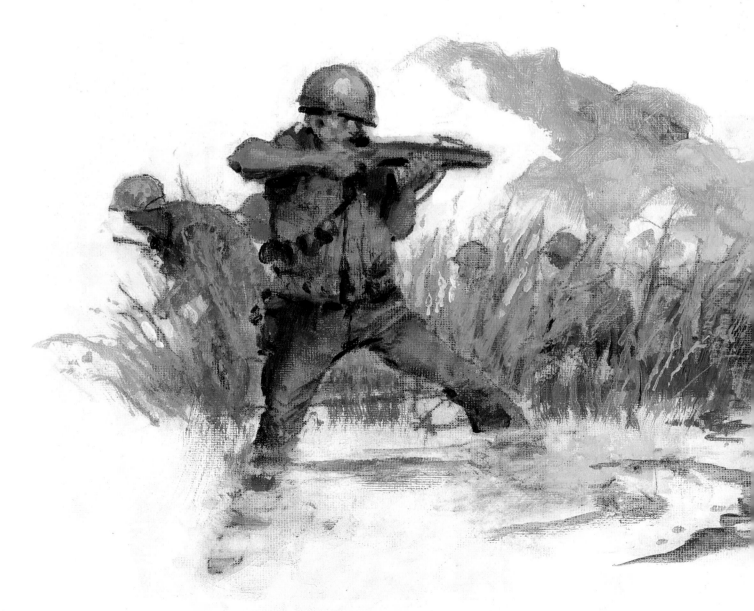

With complete disregard for his own safety, PFC Carter stood in full view of enemy and let loose a devastating volume of fire at the North Vietnamese positions, causing several enemy casualties and forcing the remainder of the hostile force to retreat from the area. Shouting directions to his fellow Marines, PFC Carter began leading them away from the path of the rapidly approaching brush fire, when a hostile grenade landed between him and his companions. Determined to protect the men following him, nneteen-year-old PFC Bruce Carter threw himself on the grenade, smothering the blast with his body.

For his actions, Carter would receive a posthumous Medal of Honor.

Carter's body came home two years later in a sealed coffin, but his mother, Georgie, refused to believe her son was dead. She held out hope that Bruce was still somewhere in Vietnam and kept his room exactly as it was, so it would be ready when he came home to her. It wasn't until years later, when she heard from the corpsman in her son's unit, Louis Salamon Jr., that Carter's mother was able to let go and truly grieve. In one of his letters, Salamon described the day that her son died, explaining that he, along with a couple of Marines, had carried Bruce's body back to camp. Although it was wet and cold, the corpsman had made sure that Bruce was kept dry and covered until the weather cleared and they were able to get a chopper in. "So, Georgie," the kind corpsman wrote, "please know that Bruce did come home to you."

While hearing those words paved the way to place of healing and acceptance for Georgie Carter Krell, she continued to work tirelessly to keep her son's memory alive as an active member, and past president, of the American Gold Star Mothers.

"Dying for freedom isn't the worst thing that can happen," she said. "Being forgotten is."

He didn't have to fight. He was a Mexican national. But although he wasn't born an American, he felt like one, so he volunteered to wear a US Marine uniform. And he wore it proudly. His sister later said, "He felt like he owed this country much."

José F. Jiménez—often called by his middle name, Francisco, or later, by his Marine nickname, JoJo—was born on March 20, 1946 in Mexico City. As a child in Mexico, Francisco attended Benito Juárez School and José María Morelos School in Morelia, Michoacán.

At the age of ten, Francisco moved to Arizona where his mother, Basillia Jiménez, was employed by the Mexican government. There, Francisco attended Red Rock Elementary School in Red Rock, and Santa Cruz Valley Union High School in Eloy. In high school, Francisco was an active member in the Eloy Chapter of the Future Farmers of America, serving as FFA president and being chosen as Star Chapter Farmer during his senior year. In 2005, a fellow classmate wrote on Jiménez's virtual wall: "He was one of the finest young men I knew. Always quiet and respectful with a desire to do his best," adding, "he is still missed."

After graduating from high school, with many of his buddies from the Class of 1968 being drafted, Francisco felt a call to serve, enlisting in the Marine Reserve at Phoenix on June 7, 1968. Two months later he was discharged to enlist in the Regular Marines.

In October 1968, after completing recruit training at Marine Corps Recruit Depot, San Diego, California, Jiménez was promoted to private first class and sent to Camp Pendleton to undergo individual combat training with Company G, 1st Battalion, 2nd Infantry Training Regiment.

By February 1969, PFC JoJo Jiménez was in Vietnam serving as a guide and fire team leader with Company K, 3rd Battalion, 7th Marines, 1st Marine Division. Over the next several months, Jiménez proved his mettle in combat situations, and in June he was promoted to lance corporal.

On August 28, 1969, while participating in action against the enemy south of Da Nang, Quảng Nam Province, Jiménez's unit came under heavy attack from a force of North Vietnamese Army soldiers hiding in wait in well-camouflaged emplacements. Jiménez took action immediately, charging toward the enemy positions, personally destroying several enemy personnel and silencing an antiaircraft weapon.

Shouting encouragements to his comrades, Jiménez pressed forward until he was within ten feet of an enemy trench that was the source of some of the heaviest automatic fire. Jiménez single-handedly destroyed the position. By now he'd become the target of concentrated fire from enemy gunners intent on halting this seemingly unstoppable Marine. Still, Jiménez continued his assault. As he was moving to attack another North Vietnamese soldier, Jiménez was mortally wounded.

For his actions that day, LCpl. JoJo Jiménez was awarded a posthumous Medal of Honor. Jiménez's mother, Basillia, requested that her son be buried in Morelia, Michoacan, outside of Mexico City, where he was born. When Basillia passed away, she was buried in Glendale, Arizona, and the family expressed a desire to lay their brother to rest next to her. Thanks to donations from various organizations his sister was able to move Francisco's remains. On January 17, 2017, LCpl. José Francisco Jiménez was reinterred at Glendale Memorial Park Cemetery with his mother. JoJo Jiménez—dream, doer and heroic US Marine—is back home in the country he fought for and loved.

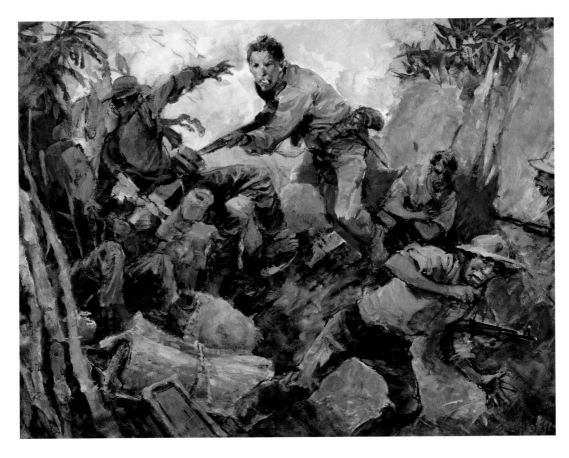

LCPL. RICHARD A. ANDERSON, USMC[50]
Cam Lo Area, Vietnam, August 24, 1969

Richard Allen "Tex" Anderson was born on April 16, 1948, in Washington, DC. At an early age, Richard moved with his parents to Houston, Texas, where he attended elementary and middle school. After graduating with the M. B. Smiley High School Class of 1966, Richard headed to San Jacinto Junior College in Pasadena. A year and a half later, he and a friend went to Houston to enlist in the Marines under the "Buddy System," which allowed them to be assigned to the same recruit platoon.

PFC Anderson was ordered to Vietnam in October 1968. By the following year he was serving as a scout, and later, assistant team leader with Company E, 3rd Reconnaissance Battalion, 3rd Marine Division. On 1 June 1969 he was promoted to lance corporal.

Between the time of his arrival and his Medal of Honor action, Anderson spent about 290 days in a war torn country where danger lurked behind curtains of bamboo, in thickly vegetated jungles and seemingly friendly villages. Twenty-four hours in a hot zone could feel like an eternity, yet Richard's service during this period is summed up in less than sixty-one words in his official USMC biography. From the few other references on record, we know that Anderson earned four bronze stars on his Vietnam Service Medal, indicating that he'd participated in four campaigns. We can surmise that his buddies called him Tex because that nickname is engraved on his granite tombstone in Houston's Forest Park Cemetery, right under the Marine Corps emblem and the five-pointed Medal of Honor star. A Kodachrome snapshot shows him sitting in a camp chair, shirtless and tan, and looking pensive. And then the trail runs cold until …

August 24, 1969: the Marines of the 3rd Recon Battalion were participating in combat approximately twelve miles northwest of Vandergrift Combat Base in Quang Tri Province. Anderson's unit was on an early morning patrol when it came under attack by a large enemy force that had been hiding in wait. Early on in the assault, LCpl Anderson was wounded in both legs and knocked to the ground, but that didn't stop him. Assuming a prone position, Anderson continued to skillfully fire his weapon, repulsing his attackers. Wounded a second time by a hostile soldier who had approached to within eight feet of his team's position, LCpl Anderson continued to pour a relentless stream of fire, not letting up even while a comrade was treating his leg wounds. When an enemy grenade land in their midst, Anderson immediately rolled over and covered the lethal weapon with his body, absorbing the

explosion and giving his life so that his companion might live. He was twenty-one years old.

On September 15, 1971, Vice President Spiro Agnew presented Richard's posthumous Medal of Honor to his family. In October 2018, a new Texas State Veterans Home in Houston was named in honor of the brave Texan, and Medal of Honor recipient, LCpl. Richard A. Anderson.

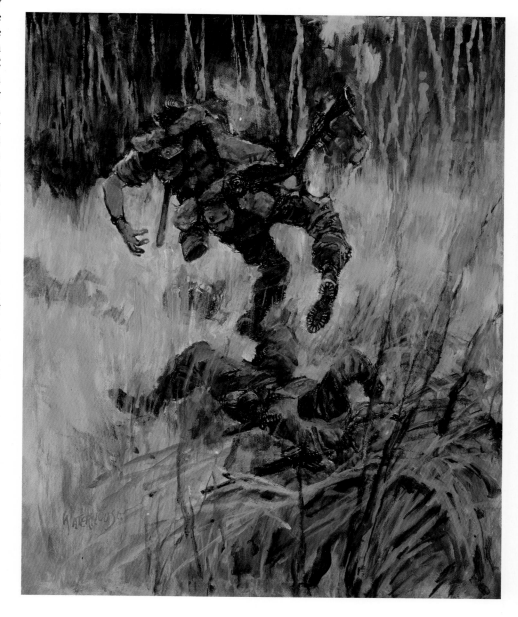

PFC RAYMOND M. CLAUSEN JR., USMC[51]
Da Nang Area, Vietnam, January 31, 1970

Raymond Michael Clausen Jr. was born on October 14, 1947, in New Orleans, Louisiana. "Mike," as he was called, would later say that one of his early memories was jumping into a swimming hole to save his brothers from drowning. Although not a strong swimmer himself, Mike somehow managed to pull them both out, foreshadowing the courage that he would show many years later in Vietnam.

After having served one tour of duty as a jet engine mechanic in Vietnam in 1967, PFC Clausen volunteered for a second tour of duty in November 1969. His mother, who had lost a brother in the Korean War, tried to dissuade him, but Mike told her, "There's something I gotta do. I haven't done it yet. There's something I gotta do."

On January 31, 1970, serving as a crew chief with Marine Medium Helicopter Squadron 263, Marine Aircraft Group 16, 1st Marine Aircraft Wing, PFC Clausen participated in a helicopter rescue mission to extract elements of a platoon that had inadvertently entered an old minefield while attacking enemy bunkers hidden deep in a treeline. After expertly guiding his pilot to a safe landing spot, Clausen leapt off the helicopter with a stretcher and, in the face of enemy fire, dashed across the minefield to assist in carrying casualties to the waiting chopper.

When Clausen saw that a Marine stretcher-bearer had tripped on another mine, he disobeyed orders and ventured back into the heavily mined area. Carrying a wounded Marine in his arms, Clausen led the others through a maze of mines, back to the helicopter. In all, Mike Clausen made six trips into the minefield that day and would be credited with saving the lives of eighteen fellow Marines. Only when certain that all of the men were safely aboard did he signal the pilot to lift off.

Shortly after leaving the Marine Corps, Clausen was involved in a car accident that left him in a coma for several months. Still recovering, and barely able to walk, he hobbled to the mailbox one day and found a letter telling him that he would be receiving the Medal of Honor. "I was so excited," he later said, "I actually crawled from the mailbox to the house."

PFC Clausen is the only enlisted helicopter crew chief from Vietnam to be recognized with the Medal of Honor.

In 2004, Mike Clausen died of liver failure. He was fifty-six. In his obituary, the Clausen family expressed gratitude for the assistance of Ross Perot during Mike's final years, calling it "a true act of patriotism and loyalty from one former military man to another in need."

In 2007, the CH-46D Sea Knight helicopter from which Clausen rescued his fellow Marines was installed as a permanent exhibit at the Carolina Aviation Museum in Charlotte, North Carolina. It had been in active service until a hard landing in Iraq during Operation Iraq Freedom forced it out of commission. The chopper has been restored to the way it looked on that long-ago day in Vietnam.

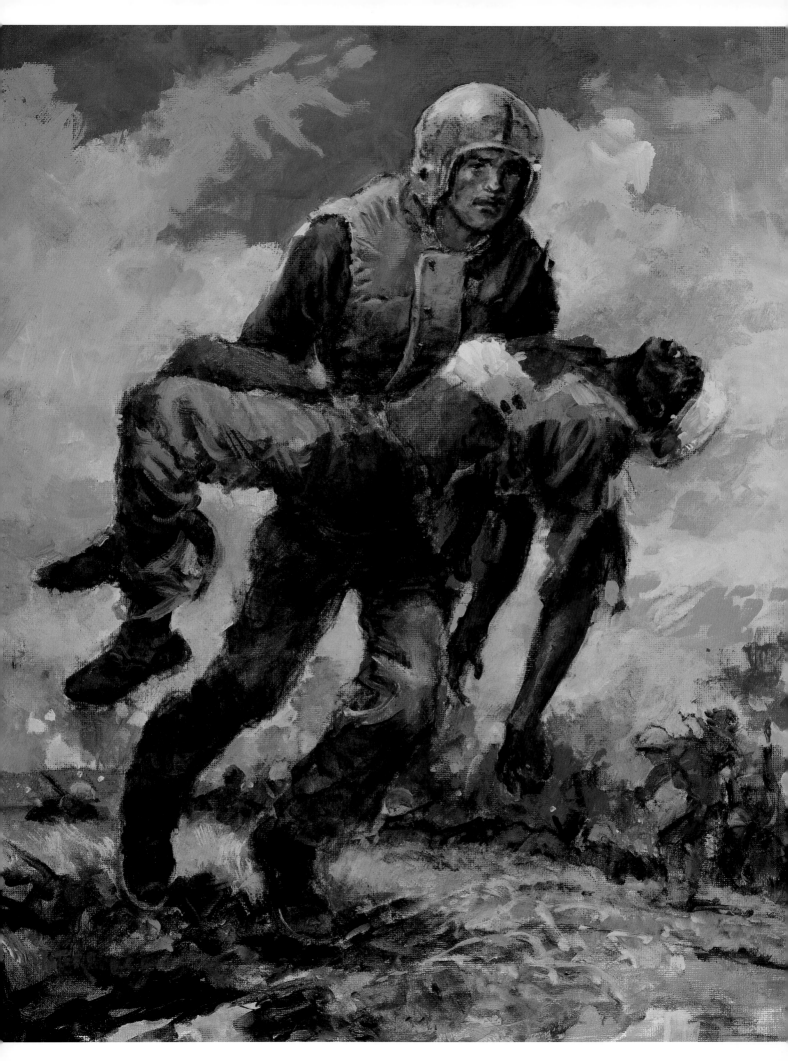

LCpl. Emilio De La Garza Jr., USMC[52]
Da Nang Area, Vietnam, April 11, 1970

Emilio De La Garza Jr. was born on June 23, 1949, in East Chicago, Indiana. After graduating from E. C. Washington High School in 1968, he married his high school sweetheart, had a daughter, and took a job with the Inland Steel Company before enlisting in the Marine Corps in 1969.

Upon completing his training, De La Garza was promoted to private first class and deployed to the Republic of Vietnam, where he served for a time as a machine gun team ammo carrier and a Marine Corps exchange man with Headquarters and Service Company, 2nd Battalion, 1st Marines, 1st Marine Division, until being reassigned as a machine gunner with Company E, 2nd Battalion, 1st Marines.

Emilio and his wife, Rosemary, had married young; with money tight, they hadn't been able to afford a honeymoon, so when the newly promoted lance corporal was given a brief leave (R&R), Rosemary put their two-year-old daughter into the care of her parents and flew to Hawaii for the honeymoon they'd never had the chance to have.

Two days after returning to her home in East Chicago, a unit of Marines knocked on Rosemary's door, delivering the worst news that any military family could ever receive.

On April 11, 1970—only forty hours after the idyllic getaway with his wife—LCpl. De La Garza was returning from a night patrol with his company in an area a few miles south of Da Nang. As morning broke, their rifle squad came under hit-and-run fire. De La Garza, along with his platoon commander and another Marine, went in search of the attackers, who had taken cover among the reeds and rushes on the banks of a pond. LCpl. De La Garza spotted one of them, crouched in the brush, and alerted his companions. As the Marines were dragging the enemy soldier out of his hiding place, he pulled a pin on a grenade. De La Garza shouted, "Grenade!," and stepped in front of his comrades, throwing himself on the exploding missile, saving the lives of his fellow Marines. Emilio De La Garza Jr. was twenty years old.

In 1970, President Nixon presented his posthumous Medal of Honor to the De La Garza family—one of 154 posthumous Medals of Honor to be awarded during the Vietnam War.

When De La Garza's two-year-old daughter, Renée, grew to be a teenager, she remembered thinking that she would have traded the medal for time with her father. It wasn't until she was older that Renée began to understand the choice that her father made to sacrifice his life for his platoon mates that day. "I know that was just the way he was," she said. "He would have done anything for anyone."

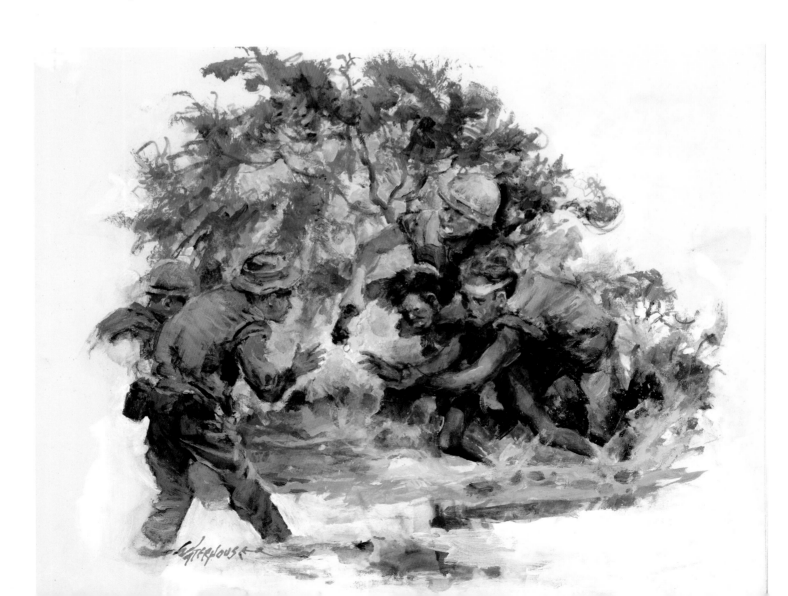

LCpl. James D. Howe, USMC[53]
Viem Dong, Vietnam, May 6, 1970

James Donnie Howe was born on December 17, 1948, in Six Mile, South Carolina, the first child and only son of Frances (née Pilgrim) and Odis Samuel Howe. Jimmie, or "Mouse" as he was sometimes called, grew up in Pickens County, receiving his early education in Six Mile and nearby Cateechee before leaving school at the age of thirteen to make his own way in the world. Over the next seven years Jimmie worked for a local paint contractor, married and started a family. On Halloween 1968, Howe enlisted in the Marine Corps Reserve. The regimentation and camaraderie must have appealed to him because just a few days after Christmas, Howe was discharged from the Reserves, to enlist in the regular Marine Corps the following day.

By June 1969, Jimmie "Mouse" Howe—married man, father and now private first class—had been transferred to Vietnam, where he served as a rifleman, and later, a radio operator with Company I, 3rd Battalion, 7th Marines, 1st Marine Division. Howe was promoted to lance corporal on December 27, 1969, a little less than a year to the day that he enlisted as a regular Marine.

On May 6, 1970, India Company was in the "rocket belt" area outside of Da Nang, hunkered down for the night in the sand dunes outside the village of Viem Dong, not far from the South China Sea. On that sultry, almost moonless night, LCpl. Howe and two other riflemen were occupying a sleeping hole behind a thicket of bamboo on the beach. In the early morning hours, the enemy attacked. With the first grenade detonation, the three Marines sprang into action, crawling on their elbows across the sand toward a more advantageous position from which to return fire. In the bamboo-dappled darkness, a grenade landed among them. Jimmie "Mouse" Howe—who had never held his newborn child and was only two months away from the end of his tour of duty—shouted out a warning and dived on the grenade, saving the lives of his fellow Marines.

In 2005, G. C. Klecker, who'd served with the young lance corporal, posted on the VVMF virtual Wall of Faces that Jimmie Howe, "loved his wife and family, the Corps and Country Western Music," adding, "I will never forget his honor, courage and sacrifice."

Howe's remains were returned to the Blue Ridge Mountains of South Carolina, and buried at Liberty Memorial Gardens Cemetery, in Pickens County, where his father, mother and three sisters now also are at rest.

Four Pickens county native sons have earned the Medal of Honor: Pvt. Furman L. Smith and PFC William A. McWhorter—who both served in the Army during World War II; Army PFC Charles H. Barker, who fought in Korea; and—the only Marine—LCpl. James D. Howe, who died in the bamboo thickets of a sandy beach in Vietnam when he was just twenty-one years old.

LCpl. Miguel Keith, USMC[54]

Quang Ngai Province, Vietnam, May 8, 1970

Miguel Keith was born June 2, 1951, in San Antonio, Texas. At an early age he moved with his family to Omaha, Nebraska. In January 1969, at the age of seventeen, Miguel left Omaha's North High School and enlisted in the Marine Reserve. A few months later, he was discharged and joined the Regular Marines. On August 1, 1969, having completed his recruit and individual combat training, Miguel Keith was promoted to private first class.

On November 6, 1969, PFC Keith arrived in Vietnam, serving as a machine gunner with Combined Action Platoon 132, III Marine Amphibious Force. Five months later, on April 1, 1970, Keith was promoted to the rank of lance corporal.

On the morning of May 8, 1970, LCpl Keith was severely wounded when his platoon came under a heavy-ground attack in Quảng Ngãi Province. Despite his painful wounds, Keith ran across the fire-swept terrain to check the security of vital defensive positions, and in full view of the enemy, proceeded to let loose a hail of devastating machine gun fire against the North Vietnamese attackers. Determined to stop five hostile soldiers from approaching the command post, Keith rushed forward, firing as he advanced, successfully disposing of three of the attackers and dispersing the remaining two. At that point, a grenade detonated near Keith, knocking him to the ground and inflicting additional wounds. Bleeding profusely, but fighting back the pain, Keith once again ran through hostile fire in a one-man charge against at least twenty-five enemy assailants who were massing to attack. Before he fell, mortally wounded, Keith managed to eliminate four of them and his bold assault caused the rest to flee for cover.

Keith's actions, in the face of overwhelming odds, paved the way for his platoon to defeat a numerically superior enemy force and earned him the nation's highest military decoration, the Medal of Honor.

LCpl. Miguel Keith, the last Marine Medal of Honor recipient of the Vietnam War, was laid to rest at Forest Lawn Cemetery, in his hometown of record: Omaha, Nebraska.

In October 2019, the Navy christened the Expeditionary Sea Base USNS *Miguel Keith* (ESB-5) during a ceremony at General Dynamics NASSCO, San Diego. Miguel's mother, then eighty-five, broke the bottle of sparkling wine across the bow to formally christen the ship.

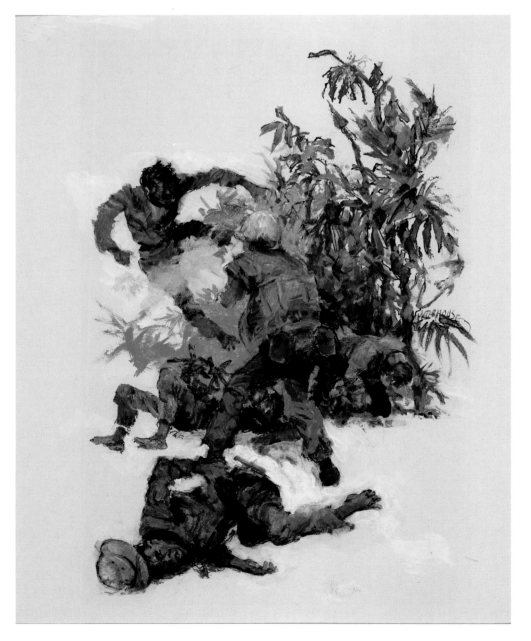

CPL. DAKOTA L. MEYER, USMC[1]

Afghanistan, September 8, 2009

Medal of Honor Citation

For conspicuous gallantry and intrepidity at the risk of his life above and beyond the call of duty while serving with Marine Embedded Training Team 2-8, Regional Corps Advisory Command 3-7, in Kunar Province, Afghanistan, on 8 September 2009. Corporal Meyer maintained security at a patrol rally point while other members of his team moved on foot with two platoons of Afghan National Army and Border Police into the village of Ganjgal for a predawn meeting with village elders. Moving into the village, the patrol was ambushed by more than 50 enemy fighters firing rocket-propelled grenades, mortars, and machine guns from houses and fortified positions on the slopes above. Hearing over the radio that four US team members were cut off, Corporal Meyer seized the initiative. With a fellow Marine driving, Corporal Meyer took the exposed gunner's position in a gun truck as they drove down the steeply terraced terrain in a daring attempt to disrupt the enemy attack and locate the trapped US team. Disregarding intense enemy fire now concentrated on their lone vehicle, Corporal Meyer killed a number of enemy fighters with the mounted machine guns and his rifle, some at near point-blank range, as he and his driver made three solo trips into the ambush area. During the first two trips, he and his driver evacuated two dozen Afghan soldiers, many of whom were wounded. When one machine gun became inoperable, he directed a return to the rally point to switch to another gun truck for a third trip into the ambush area, where his accurate fire directly supported the remaining US personnel and Afghan soldiers fighting their way out of the ambush. Despite a shrapnel wound to his arm, Corporal Meyer made two more trips into the ambush area in a third gun truck accompanied by four other Afghan vehicles to recover more wounded Afghan soldiers and search for the missing US team members. Still under heavy enemy fire, he dismounted the vehicle on the fifth trip and moved on foot to locate and recover the bodies of his team members. Meyer's daring initiative and bold fighting spirit throughout the 6-hour battle significantly disrupted the enemy's attack and inspired the members of the combined force to fight on. His unwavering courage and steadfast devotion to his US and Afghan comrades in the face of almost certain death reflected great credit upon himself and upheld the highest traditions of the Marine Corps and the United States Naval Service.

To learn more about Dakota Meyer, read his story in chapter 9.

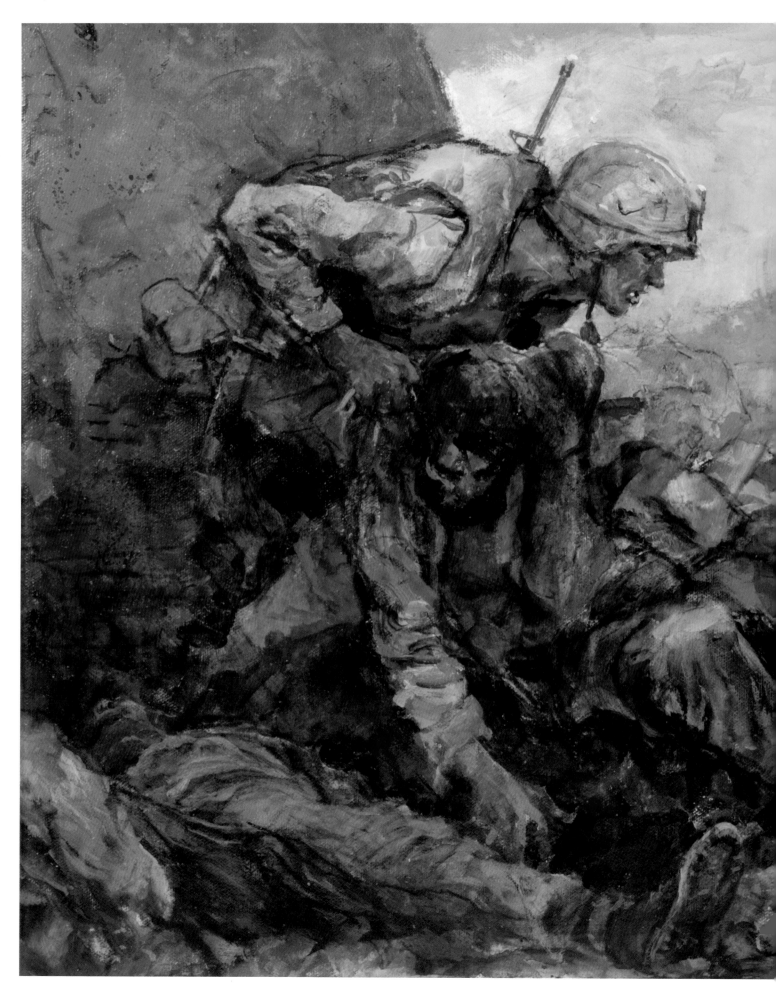

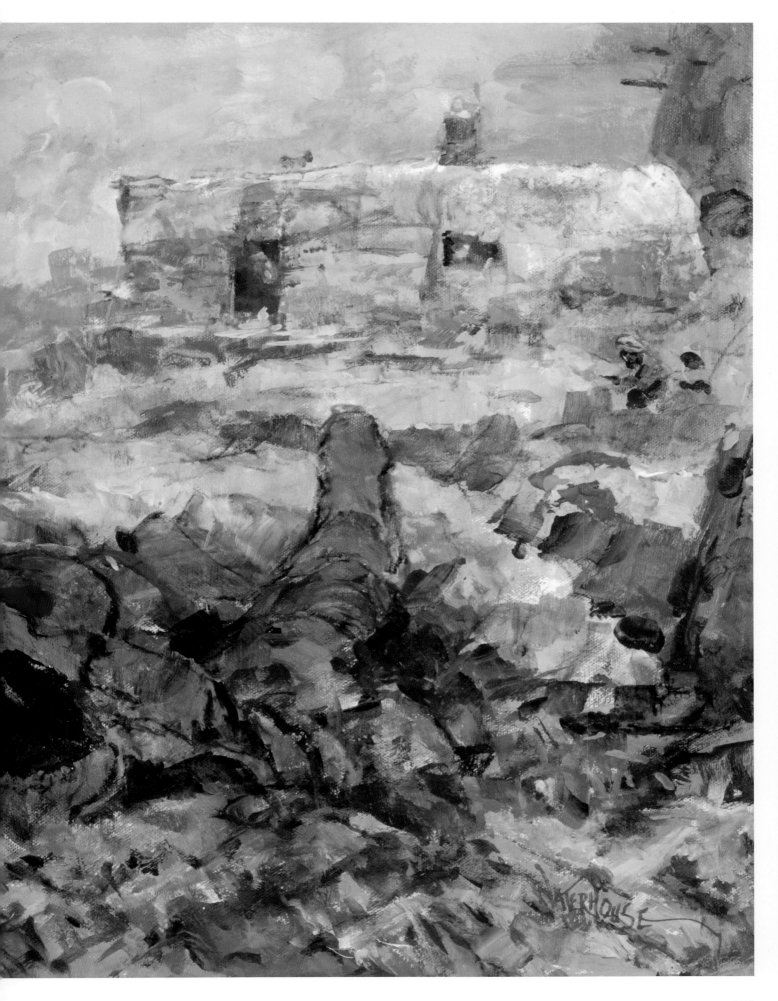

AFTERWORD

It's only a palm-sized sliver of buffed, oxidized brass and a piece of moiré silk ribbon. The weight of it in one's hand is negligible. The weight of it for a recipient upon whom the Medal of Honor has been bestowed is something else entirely.

Those who live to wear it around their neck carry the weight of all those who didn't.

"Every time that I wear my medal," Mitchell Paige said, "people ask where did I get it, and I say, 'It belongs to thirty-three other men.'"

"I took the medal for those who fought and didn't come back," Jefferson DeBlanc maintained, "We got it together."

"I'm proud of it. But I am prouder yet of the men who were with me," said Robert Dunlap at the end of his life. "I can still see their faces."

"I look at it as though I'm a custodian for those who died," said Robert Bush.

Jay Vargas put it simply: "I wear it for anyone who's ever served."

Some of the recipients who survived to wear the medal struggled to find their footing as civilians. For Jack Lucas, the five-point star became an anchor in an otherwise chaotic life. "I have never brought shame to the Medal of Honor and pray I never do," he wrote. "I must not, for it represents too much."

The responsibility of shouldering all that the medal stands for, and all that it means, can sometimes prove too much to bear. Five of the recipients whose paintings appear on the pages of this book took their own lives. Others battled alcoholism, drifted from job to job, or struggled with pressures of unsought celebrity. John Basilone decided he'd rather face the enemy in battle than face another crowd as the perfect Medal of Honor poster Marine.

Add to it remembered or repressed memories of combat, guilt, and trauma, and the weight of the medal can bring a recipient to his knees. For recipients such as Woody Williams, John McGinty III, and Joe McCarthy, to name just a few, faith and service to others were what carried them through.

There is no one "Medal of Honor" experience. For every recipient such as Robert Bush who went home after the war, married his hometown sweetheart, raised a family, and became a leader in his community, there is a Robert Robinson who died a hermit in a remote cabin, having so isolated himself from others that not even his closest neighbors knew he was a legendary World War I flying ace and Medal of Honor hero.

If the responsibility of wearing the medal is heavy, to those who are presented with it posthumously, its weight can be crushing. It's all that remains of a son, a husband, a father, a brother—this sliver of brass on a silk ribbon—and while the pride and honor are everlasting, so are the grief and the cost of sacrifice. "War is a terrible thing," James Swett said, "But freedom is not free, and sometimes you have to fight for it."

My father felt a deep responsibility to these brave Medal of Honor recipients, their families, and their descendants. It was what drove him to his easel every day, as his time—and, yes, even his talents—ebbed away. I made a decision to include some of his unfinished paintings. For me, they're difficult to look at on many levels; they're not representative of his art, but they *are* representative of his will and commitment to honor these men. I know that in his last days, he was tormented by the canvases that were unfinished or unstarted. I came to know his anguish, personally, the deeper I got into this book. I've cried over the men whose profiles are not accompanied by paintings done in their honor. I've immersed myself in their stories. I carry them in my heart, as I know my father did.

His easel has found a place in my home. It's battered and covered with specks of paint, just as he left it, except for one thing: it's empty. I never saw it so, in all the years of my life, but I'm slowly coming to terms with that now. I think.

Jane Waterhouse
Fair Haven, New Jersey
June 1, 2019

Waterhouse's paint splattered palette rests on his empty easel.

ACKNOWLEDGMENTS

A battalion of people helped during the writing of this book. Their eyes, ears, and expertise can be read between every line of narrative.

My sister, Amy Waterhouse Lotano, lived the story along with me, memory by memory, painting by painting, word by word. When it comes to our family, Amy and her amazing husband, Gary Lotano, have ever been the embodiment of the Marine motto, *Always Faithful*. Their names aren't on the dedication page, but they know in their hearts that this book is for them, their children, and their grandchildren.

My sister and I will never live long enough to fully thank Chief Warrant Officer 4, Gunner Ed Sere, for coming into our lives. A Marine and firefighter, with the soul of an artist, Ed became a guiding force at the Waterhouse Museum and a guardian angel to our parents. It was Ed who first encouraged his "buddy and hero, the Colonel" to paint the Medal of Honor series; they spent countless hours together, placing citations next to paintings and designing spreads—whereupon my dad (a self-professed computer genius) would invariably hit the wrong command key on his overloaded, ancient Mac, causing all their hard work to disappear into the ether. Ed, God bless him, would simply calm the colonel down and patiently begin again. Ed—this book would never have seen the light of day without you.

For years I'd listened to my father sing the praises of a talented *Leatherneck Magazine* special feature writer named Mary Karcher, who'd driven all the way from Virginia—in a blinding snowstorm no less—to interview him at the Waterhouse Museum. Dad felt that Mary sensed his love for his work, and for the Corps, and translated it beautifully onto the page. The admiration was mutual. She later described walking around the museum that day: "The Colonel took my hand and guided me through his mind and heart—his life's work. It was quite a gift." Mary Karcher has been a gift to *me*. We bonded over a wonderful cover story she wrote for *Leatherneck* about the Medal of Honor paintings and my book; from that point on, she—like my dad—became intrinsically interwoven with the plot. Mary has been a trusted collaborator, editor, advisor, and, most especially, friend. As an added bonus, her husband, Col. David Karcher, acted as a sounding board, offering valuable insights and the all-important, tell-it-to-the-Marines perspective. They are the unsung heroes of *Valor in Action*.

I can't underestimate how much this book benefited from the knowledge, editing, and guidance I received from Mary's *Leatherneck* mentor, Col. Walt Ford, USMC (*Ret.*). A Marine Corps historian, author, and a former editor of *Leatherneck Magazine* and Marine Corps Association publisher, Col. Ford is universally admired and respected by Marines, and by those who have had the good fortune of working with him. My father was among his biggest fans. When I approached Walt, out of the blue, asking him to take a look at the first draft of my manuscript, he kindly accepted, carving out time from his own writing and research to help me hone the text and "Marine-ify" the language. When I came up with the crazy idea of writing profiles on each of the recipients, Walt became my comrade in arms, correcting all my mistakes, infusing his encyclopedic arsenal of facts, and helping to make my "stories" credible—but, most of all,

telling me I could do it when my courage failed. Thank you, Walt, for seeing beyond my mistakes and into the heart of the book.

Valor in Action also benefited from the eagle eyes of Maj. Gen. Drew Davis and the brilliant strategic advice of his wife, Margaret Davis, former CEO of the Marine Corps Scholarship Foundation. My father painted the last chronological painting in the Medal of Honor series for Margaret and the MCSF.

Maj. Gen. Davis put me in touch with another fine Marine Corps artist, Col. H. Avery Chenoweth, USMCR. Now in his nineties, Avery Chenoweth remains a true force of nature. I will always be grateful for his passion and relentless determination to see this book into print. Col. Chenoweth, I salute you for going above and beyond.

A big thanks goes to interim director Charlie Grow, and, most especially, senior art curator and lifesaver, Joan Thomas, at the National Museum of the Marine Corps for all their help and support; USMC History Division historian Kara Newcomer, for providing high-resolution photos and sharing her experience of actually holding Gy. Sgt. Fred Stockham's World War I Medal of Honor; Diane Hawkins, niece of John Basilone and director of the Sgt. Basilone Foundation—Diane is currently on her own journey, working to finish her compelling documentary film called *Back to Basilone*; talented photographer Bart Lentini, who used my father's old easel to photograph my dad's paintings and early illustrations; Terence Barrett, author of *The Search for the Forgotten Thirty-Four*, a book I found both helpful and eye-opening; Allison Nicks at the Delaware Art Museum for allowing me to reprint the paintings of the master, Howard Pyle; Judy and Laurence Cutler and Sara Bliss, at the National Museum of the American Illustration, for helping me track down Mr. Aylward's paintings . . . and former commandant Gen. James Amos, USMC, and his beautiful wife, Bonnie, for their kindness to our family—Mrs. Amos, you know my father adored you.

On the home front, I am eternally grateful to my college mentor and lifelong friend Dr. James P. McGlone, and his lovely bride, Virginia, for offering tea and sympathy whenever I needed it; for the fathomless generosity of spirit of my friend Kevin Murray; for the enduring friendship of the Albrecht and Samsoe families—although my dad's oldest friend, Skip Samsoe, didn't live long enough to see this book published, he read an early draft of the manuscript, and I keep his kind words tucked in a corner of my heart; for the enthusiasm and keen insights of Scott Fichten; and for my personal cheer squad, Michele Armour and Carol Clayon, who never stopped telling me, "You got this, Jane."

Previously, I'd had only mystery novels published, so I underestimated the courage it would take for a publisher to commit to a book with over 400 full-color illustrations. I count my lucky stars that Schiffer Publishing stepped up to the (full-color) plate. I've been blessed to have Bob Biondi, editor extraordinaire; Schiffer president Pete Schiffer; and the team at Schiffer in my corner, guiding me along the path to publication.

Last but not least, I want to thank my son, Baylen, for being my rock and unflagging supporter. I can't imagine what it's like to have a mother who—when asked how it's going—is likely to sob, "I'm in

Vietnam with Donald Cook; he's locked in a bamboo cage, shivering with malaria, and tomorrow they're going to make him march through the jungle, and he's going to die, and we're never going to find his body" . . . a mom who steadily transformed before his very eyes into his gramps—scribbling notes onto scraps of paper and then losing them, talking out loud to people who aren't there, and inserting the phrase "Did I tell you what this guy did?" into every conversation.

Baylen devoured the first draft of my manuscript in chunks as I wrote it. Upon finishing the final chapters, I handed them over and went off to busy myself in the kitchen (those who know me will see the irony in that) while he hunkered down to read. After what seemed an eternity, I heard the front door slam. I glanced out: Baylen was standing on the porch, looking up at the sky. When he came in, his face was shiny with tears. "I had to compose myself," he said hoarsely. Then he gave me one of his big bear hugs and whispered, "It's amazing, Mom." It was all the validation I needed to keep on going. Thanks for all your love and support, Bay. I know Gramps is smiling.

ENDNOTES

PART ONE

Chapter 1
1. Larry Smith, *Beyond Glory: Medal of Honor Heroes in Their Own Words* (New York: W. W. Norton, 2003), 137.
2. Ibid., 132.
3. "Medal of Honor Recipient Hector Cafferata." Extended interview from *America's Rifle: The MI Garand* (documentary), www.youtube.com/watch?v=igKjri-96SIM.
4. Smith, *Beyond Glory*, 132.
5. Don Moore, "Fox Company Saved the Day," War Tales, May 24, 2010, https://donmooreswartales.com/2010/05/24/cafferata-bonelli/.
6. Marc Cerasini, *Heroes: U.S. Marine Corps Medal of Honor Winners* (New York: Berkley Books, 2002), 300.
7. Smith, *Beyond Glory*, 132.
8. Ibid., 142.
9. Moore, "Fox Company Saved the Day."

Chapter 2
1. Cerasini, *Heroes*, 196.
2. William Douglas Lansford, "The Life and Death of 'Manila John,'" *Leatherneck Magazine* 85, no. 10 (October 2002).
3. Duane A. Vachon, "First Medal of Honor in WWII: Gunnery Sergeant John Basilone," *Hawaii Reporter*, January 18, 2011.
4. James Brady, *Hero of the Pacific* (Hoboken, NJ: John Wiley & Sons, 2010), 4.
5. Ibid., 44.
6. MassCentral, "Valor Friday: The Legend of John Basilone," *Military Times*, September 25, 2018, http://masscentral.com/valor-friday-the-legend-of-john-basilone-military-times/.
7. Brady, *Hero of the Pacific*, 142.
8. Jim Proser and Jerry Cutter, *I'm Staying with My Boys* (New York: St. Martin's Griffin, 2013), 281.

Chapter 3
1. Richard F. Newcomb, *Iwo Jima* (Garden City, NY: Nelson Doubleday, 1983), 27.
2. Brady, *Hero of the Pacific*, 4.
3. Proser and Cutter, *I'm Staying with My Boys*, 292.

4. Lansford, "The Life and Death of 'Manila John.'"
5. Ibid.
6. Larry Smith, *Iwo Jima: World War II Veterans Remember the Greatest Battle of the Pacific* (New York: W. W. Norton, 2008), 157–71.
7. Charles Waterhouse, *Marines and Others* (Hong Kong: Sea Bag Productions, 1994), 183.
8. Lansford, "The Life and Death of 'Manila John.'"
9. Chuck Tatum. *Red Blood, Black Sand: Fighting alongside John Basilone from Boot Camp to Iwo Jima* (New York: Berkley Caliber, 2012), 169.
10. Tatum, *Red Blood, Black Sand*, 170.
11. Lansford, "The Life and Death of 'Manila John.'"
12. Ibid.
13. Waterhouse, *Marines and Others*, 190.
14. Brady, *Hero of the Pacific*, 226.
15. "The Battle for Iwo Jima," http://archive.defense.gov/home/features/2015/0315_iwojima/.
16. www.recordsofwar.com/iwo/dead/dead.htm.
17. Robert S. Burrell, *The Ghosts of Iwo Jima* (College Station: Texas A&M University Press, 2006), 83.
18. Context for the Robert Dunlap and Jack Lucas story has been drawn from accounts in *Uncommon Valor on Iwo Jima* by James H. Hallas, *Indestructible* by Jack H. Lucas and D. K. Drum, *The Battle for Iwo Jima* by Derrick Wright, and *Iwo Jima* by Richard F. Newcomb, all which are listed in the bibliography. Specific quotes and details are cited throughout.
19. Jack H. Lucas and D. K. Drum, *Indestructible: The Unforgettable Story of a Marine Hero at the Battle of Iwo Jima* (Cambridge, MA: De Capo, 2006), 72.
20. James H. Hallas, *Uncommon Valor on Iwo Jima* (Lanham, MD: Stackpole Books, 2016), 75.
21. Ibid., 65.
22. Ibid., 77.
23. Newcomb, *Iwo Jima: World War II's Bloodiest, Most Glorious Marine Invasion*, 22.

24. Hallas, *Uncommon Valor on Iwo Jima*, 78.
25. Wright, *The Battle for Iwo Jima, 1945*, 66–67.
26. Hallas, *Uncommon Valor on Iwo Jima*, 80.
27. Lucas and Drum, *Indestructible*, 97.
28. Hallas, *Uncommon Valor on Iwo Jima*, 82.
29. Ibid., 83.
30. Ibid., 83.
31. Lucas and Drum, *Indestructible*, 204.

Chapter 4
1. Henry C. Pitz, *The Brandywine Tradition* (Boston: Houghton Mifflin, 1969), 176.
2. Charles Waterhouse, *Illustrations in Black, White and Gray by Steven R. Kidd* (Glenbrook, CT: Art Direction Book), 7.
3. Stephen T. Bruni, Betsy James Wyeth, Theodore F. Wolff, and Christopher Crosman, *Wondrous Strange: The Wyeth Tradition* (Boston: Bullfinch Press Book, 1998), 11.
4. Vincent Van Gogh letter to his brother Theo (September 11, 1882), http://vangogh-letters.org/vg/letters.html.
5. Bruni et al., *Wondrous Strange*, 22–23
6. Henry C. Pitz, *Howard Pyle* (New York: Clarkson N. Potter, 1975), 216.
7. Waterhouse, *Illustrations in Black, White and Gray*, 7.
8. Pitz, *The Brandywine Tradition*, 238–39.
9. Pitz, *Howard Pyle*, 138.
10. Waterhouse, *Illustrations in Black, White and Gray*, 10.
11. Waterhouse, *Marines and Others*, 229.
12. Cerasini, *Heroes*, 305.
13. "Carl Sitter: A Profile in Courage," Home of Heroes (website for Medal of Honor and Military history), July 23, 2014, www.homeofheroes.com/profiles/profiles_sitter.html.
14. Cerasini, *Heroes*, 305, 306.
15. Edwin H. Simmons, *Frozen Chosin: U.S. Marines at the Changjin Reservoir*, Marines in the Korean War Commemorative Series (Collingdale, PA: Diane, 2003), 73.
16. "Carl Sitter, Captain, U.S. Marine Corps, Chosin Reservoir, November, 1950," *Medal of Honor Book* (video series), September 27, 2011, www.youtube.com/watch?v=SqVH4L7e_jU.

17. Ibid.

18. Marine Corps University, "Commandership at the Chosin Reservoir: A Triumph of Optimism and Resilience" (Quantico, VA: Lejeune Leadership Institute, November 2018).

19. "War: Retreat of the 20,000," *Time*, December 18, 1950, http://content.time.com/time/magazine/article/0,9171,858986,00.html.

20. Brad Padula, dir., "Carl Sitter: The Captain, Marine Corps, Korea," in *Beyond the Medal of Honor* (Pueblo, CO: Media Center Video, 2011), www.beyondthemedal.com/?page_id=108.

21. Ibid.

22. "Carl Sitter," Home of Heroes.

23. William J. Aylward to Charles Waterhouse, January 14, 1956, in the author's possession.

24. Aylward to Waterhouse, November 12, 1951, in the author's possession.

25. Aylward to Waterhouse, August 14, 1952, in the author's possession.

Chapter 5

1. Source for information on Captain Donald Cook: Donald L. Price, *The First Marine Captured in Vietnam: A Biography of Donald G. Cook* (Jefferson, NC: McFarland, 2007).

2. Price, *The First Marine*, 34.

3. Ibid., 52.

4. Ibid., 18.

5. Ibid., 74.

6. Ibid., 57.

7. Ibid., 125.

8. Ibid., 207.

9. Ibid., 175.

10. Ibid., 156.

11. Ibid., 174.

12. Ibid., 219.

13. Ibid., 134.

14. Ibid., 158.

15. Ibid., 129.

16. Ibid., 248.

17. Ibid., 228.

18. Ibid., 231.

19. Ibid., 246.

20. Ibid., 236.

21. Ibid., 254.

22. Ibid., 258.

23. Ibid., 256.

24. Waterhouse, *Marines and Others*, 239.

25. Charles Waterhouse, *Vietnam War Sketches from the Air, Land and Sea* (Rutland, VT, and Tokyo: Charles E. Tuttle, 1970), 6.

26. From the private papers of Col. Charles Waterhouse.

27. "Jay R. Vargas," Revolvy (website), www.revolvy.com/page/Jay-R.-Vargas.

28. Waterhouse, *Marines and Others*, 19.

Chapter 6

1. Pitz, *Howard Pyle*, 160.

2. Ibid., 209.

3. Aylward to Waterhouse, August 14, 1952; William J. Aylward notebook, November 7, 1942, both in the author's possession.

4. Waterhouse, *Illustrations in Black, White and Gray by Steven R. Kidd*, 132.

5. Waterhouse, *Marines and Others*, 10.

6. Ibid., 9.

7. Ibid., William Manchester book jacket quote.

8. Waterhouse, *Marines and Others*, Walt Reed book jacket quote.

9. Waterhouse, *Marines and Others*, 11.

10. Marine Corps University, "Sergeant Major Daniel "Dan" Joseph Daly, USMC (Deceased)" (Quantico, VA: Marine Corps University), www.usmcu.edu/Research/Marine-Corps-History-Division/Information-for-Units/Medal-of-Honor-Recipients-By-Unit/Sergeant-Major-Daniel-J-Daly/.

11. Larry James, "Giants of the Corps: John Mackie," *Leatherneck Magazine* 58, no. 11 (November 1975), www.leatherneck.com/forums/showthread.php?115023-Giants-Of-The-Corps-John-Mackie/.

12. James, "Giants of the Corps."

13. Gerald S. Henig, "Marines Fighting Marines: The Battle of Drewry's Bluff," *Naval History Magazine* 23, no. 3 (June 2009): 56.

14. Ibid.

15. "John Freeman Mackie: First Medal of Honor Recipient," Warfare History Network, October 25, 2018, https://warfarehistorynetwork.com/daily/civil-war/john-freeman-mackie-first-marine-medal-of-honor-recipient/.

16. Henig, "Marines Fighting Marines," 56.

17. "John Freeman Mackie," Warfare History Network.

18. Stephen W. Scott, *Sergeant Major Dan Daly: The Most Outstanding Marine of All Time* (PublishAmerica, April 13, 2009), 26.

19. "Common Terms for U.S. Marines," www.usmcpress.com/heritage/usmc_terms.htm.

20. Marine Corps University, "Sergeant Major Daniel "Dan" Joseph Daly."

21. David T. Zabecki, "Paths to Glory: Medal of Honor Recipients Smedley Butler and Dan Daly," *Military History Magazine*, January–February 2008.

22. Ibid.

23. Michael Mink, "'Fightingest Marine' Daniel Daly Won Highest Honors, Coined Legendary Phrase," *Investor's Business Daily*, November 4, 2017.

24. Jim Michaels. "At Belleau Wood, Marines Saved Paris, Proved Mettle during WWI," *USA Today*, April 3, 2017.

25. Mink, "Fightingest Marine.'"

Chapter 7

1. Proser and Cutter, *I'm Staying with My Boys*, 292.

2. Mitchell Paige, *A Marine Named Mitch* (Palo Alto, CA: Bradford Adams, 1999), 146.

3. Paige, *A Marine Named Mitch*, 138.

4. Smith, *Beyond Glory*, 10.

5. Paige, *A Marine Named Mitch*, 148.

6. Smith, *Beyond Glory*, 11.

7. Paige, *A Marine Named Mitch*, 151.

8. Ibid., 152.

9. Ibid., 154.

10. Ibid., 153.

11. Ibid., 158.

12. "Mitchell Paige, Platoon Sergeant, U.S. Marine Corps, Guadalcanal, Western Pacific, October 1941," Medal of Honor Book *(video series)*, September 27, 2011, www.youtube.com/watch?v=FA3jz6H3H0k.

Chapter 9

1. Source for information on Dakota Meyer: Dakota Meyer, *Into the Fire* (New York: Random House. 2013).

2. David Martin, "Never Seen the Like" (Dakota Meyer interview), *60 Minutes*, September 18, 2011.

3. Ibid.

4. Ibid.

5. Amy Waterhouse Lotano remarks, Library of Congress, 2012.

6. "Waterhouse Collection Donated to NMMC," *More Than Scuttlebutt . . .* (Triangle: VA: National Museum of the Marine Corps, 4th Quarter FY 2011), 1.

Chapter 10

1. Source for information on John Ripley: John Grider Miller, *The Bridge at Dong Ha* (Annapolis, MD: Naval Institute Press, 1989).

PART TWO

First Marine Recipients
Civil War
Spanish-American War
Boxer Rebellion
Banana Wars

1. Cpl. John F. Mackie, USMC
Battle of Drewry's Bluff, May 15, 1862
SOURCES:
Medal of Honor citation
For Cpl Mackie's story, see chapter 6.

2. Sgt. John Henry Quick, USMC
Battle of Cuzco Well, Cuba, June 14, 1898
SOURCES:
Medal of Honor citation
Stephen Crane, "Marines Signaling Under Fire at Guantanamo," https://public.wsu. edu/~campbelld/crane/marines.htm.
Maurice A. Buford, *The Servant Way: Leadership Principles from John A. Lejeune* (Cork, Ireland: BookBaby, 2019).
MCA-Leatherneck, "The Haze of War at Cuzco Well, 1898," June 14, 2018, https:// mca-marines.org/leatherneck/the-haze-of-war-at-cuzco-well-cuba-1898.

3. Sgt. Alexander Foley, USMC
Tianjin, China, July 13, 1900
SOURCES:
Medal of Honor citation
Stu Richards, *Schuylkill County Military History Blogspot*, Tuesday, November 27, 2007, http://schuylkillcountymilitaryhistory. blogspot.com/2007/11/marines-marine. html.
Historical Society of Schuylkill County, "Pennsylvania, a Proud Medal of Honor State," http://pamoh.homestead.com/files/ PAMOHD.htm.

4. Sgt. Clarence Sutton, USMC
Tianjin, China, July 13, 1900
SOURCES:
Medal of Honor citation
Virginia Military Institute records, www. vmi.edu/archives/genealogy-biography-alumni/vmi-alumni-in-the-military/ vmi-medal-of-honor-recipients/.

5. Pvt. Daniel J. Daly, USMC
Boxer Rebellion, August 14, 1900
SOURCES:
Medal of Honor citation
For Dan Daly's story, see chapter 6.

6. Capt. Hiram Bearss, USMC
Samar, Philippine Islands, September 11, 1901
SOURCES:
Medal of Honor citation
Vern McLean, "'Hiking Hiram Bearss' Burnished Corps Wartime Image," *Fortitude: Bulletin of the Marine Corps Historical Program* 23, no. 1 (Summer 1993).
"Hard Drinking Fellows," Fix Bayonets! Mostly Stories about American Marines, June 30, 2017, WordPress.com, https:// fixbayonetsusmc.blog/2017/06/30/ hard-drinking-fellows/.

7. Maj. Albertus W. Catlin, USMC
Vera Cruz, April 22, 1914
SOURCES:
Medal of Honor citation
Michael E. Ruane, "The Battle of Belleau Wood Was Brutal, Deadly and Forgotten but It Forged a New Marine Corps," *Washington Post*, May 31, 2018.
Albertus W. Catlin, *"With the Help of God and Few Marines": The Battles of Château Thierry and Belleau Wood*, (Yardley, PA: Westholme, 2013).
Minnesota Medal of Honor Memorial: Albertus W. Catlin Bio, www.minnesota-medalofhonormemorial.org/wp-content/ uploads/2017/12/Catlin-Albertus-W.-Catlin-Bio-July-16.pdf.

8. Gy. Sgt. Daniel J. Daly, USMC
Fort Liberté, Haiti, October 22, 1915
SOURCES:
Medal of Honor citation
For Dan Daly's story, see chapter 6.

9. Capt. William P. Upshur, USMC
Fort Liberté, Haiti, October 24, 1915
SOURCES:
Medal of Honor citation
Virginia Military Academy rosters, https:// archivesweb.vmi.edu/rosters/record. php?ID=4839.
Lyon Gardiner Tyler, *Men of Mark in Virginia: Ideals of American Life; A Collection of Biographies of the Leading Men in the State*, vol. 5 (San Bernardino, CA: Ulan, 2012).

10. Cpl. William R. Button, USMC
Fort Liberté, Haiti, October 31–November 1, 1915
SOURCES:
Medal of Honor citation
Marine Corps University: Cpl. William Robert Button, www.usmcu.edu/Research/ Marine-Corps-History-Division/Information-for-Units/Medal-of-Honor-Recipients-By-Unit/Cpl-William-Robert-Button/.
"Sgt William R. Button," Fix Bayonets! Mostly Stories about American Marines, April 16, 2016, WordPress.com, https:// fixbayonetsusmc.blog/2016/04/16/sergeant-william-r-button-usmc/.

11. 2Lt. Herman Hanneken, USMC
Fort Liberté, Haiti, October 31–November 1, 1915
SOURCES:
Medal of Honor citation
Maj. Edward F. Wells, USMC, "Legendary Hero Honored Here," *Fortitude: Newsletter of the Marine Corps Historical Program* 10, no. 4 (Spring 1981).
Marine Corps History Division, Medal of Honor Recipients: Sgt. Henry Hanneken, www.usmcu.edu/Research/Marine-Corps-History-Division/Information-for-Units/Medal-of-Honor-Recipients-By-Unit/Sgt-Herman-Henry-Hanneken/.

12. Maj. Smedley D. Butler, USMC
Vera Cruz, April 22, 1914
Fort Rivière, Haiti, November 17, 1915
SOURCES:
Medal of Honor citation
Capture of Fort Rivière, Haiti, 1915, www. leatherneck.com/forums/archive/index. php/t-16333.html.

13. Sgt. Lindsey R. Iams, USMC
Fort Rivière, Haiti, November 17, 1915
SOURCES:
Medal of Honor citation
Keith A. Milks, "The Lore of the Corps: Bold NCO Led Charge in Tough Haiti Battle, *Leatherneck Magazine*, March 1, 2004, http:// www.leatherneck.com/forums/showthread. php?12875-Bold-NCO-led-charge-in-tough-Haiti-battle.

14. Pvt. Samuel Gross, USMC
Fort Rivière, Haiti, November 17, 1915
SOURCES:
Medal of Honor citation
The Jewish Veteran, vol. 32, "A Special Dedication," https://books.google.com/ books?id=TETjAAAAMAAJ&pg=RA13-PA23&lpg=RA13-PA23&dq=samuel+gross+medal+of+honor+har+nebo+cemetery+philadelphia&source=bl&ots=1FIn2tmSjA&sig=ACfU3U-3VetZ0UdtxkkY7DftOKAvuTSn-

VeA&hl=en&sa=X&ved=2ahUKEwjzw4i-NobLiAhVtk-AKHXPyCvEQ6AEwB3oE-CAkQAQ#v=onepage&q=samuel%20gross%20medal%20of%20honor%20har%20nebo%20cemetery%20philadelphia&f=fals.

15. 1Sgt. Roswell Winans, USMC
Dominican Republic, July 3, 1916
SOURCES:
Medal of Honor citation
Roswell Winans, "Campaigning in Santo Domingo," *Recruiters Bulletin*, March 1917.

16. 1Lt. Christian F. Schilt, USMC
Quilali, Nicaragua, January 6–8, 1928
SOURCES:
Medal of Honor citation
David F. Ellrod, "Christian F. Schilt," *Fortitude: Newsletter of the Marine Corps Historical Program* 37, no. 1 (2012).
"Christian Schilt Dies," *Washington Post*, January 14, 1987.
LCpl. Scott L. Tomaszycki, "A Giant of Marine Aviation," *The Windsock* 69, no. 43 (October 27, 2011).

World War I Recipients

1. LCdr. Alexander G. Lyle, USN Dental Corps
French Front, April 23, 1918
SOURCES:
Medal of Honor citation
"Vice Admiral Alexander G. Lyle, Dental Corps, US Navy, Deceased," www.history.navy.mil/content/dam/nhhc/research/histories/bios/Lyle-Alexander-Gordon/Lyle,%20Alexander%20Gordon%202.pdf.
Together We Served, "Lyle, Alexander Gordon, VADM," https://marines.together-weserved.com/usmc/servlet/tws.webapp.WebApp?cmd=ShadowBoxProfile&type=Person&ID=154548.

2. Lt. JG Weedon Osborne, USN Dental Corps
Battle of Belleau Wood, June 6, 1918
SOURCES:
Medal of Honor citation
Thomas Sheppard, "Extraordinary Bravery: Lieutenant Weedon Osborne and the Battle of Belleau Wood," Histories Branch, Naval History and Heritage Command, www.history.navy.mil/browse-by-topic/wars-conflicts-and-operations/world-war-i/people/extraordinary-bravery--lieutenant-weedon-osborne-and-the-battle-.html.

3. Gy. Sgt. Ernest A. Janson, serving under the name Charles Hoffman, USMC
Château-Thierry, France, June 6, 1918
SOURCES:
Medal of Honor citation
Patrick K. O'Donnell, *The Unknowns* (New York: Atlantic Monthly Press, 2018.
Dan Doyle, "The True Story of the Man Who Went AWOL, Changed His Name, and Earned Two Medals of Honor," *The Veterans Site* blog, https://blog.theveteranssite.greatergood.com/ernest-janson/.
Col. Richard Goldenberg, NY National Guard, "Two WWI Medals of Honor, Two Names, One Marine," DVIDS, Saratoga Springs, May 30, 2018, www.dvidshub.net/news/278857/two-wwi-medals-honor-two-names-one-new-york-marine.

4. Lt. Orlando Petty, USN Medical Corps
Battle of Belleau Wood, June 6, 1918
SOURCES:
Medal of Honor citation
"Dr. O. H. Petty Ends His Own Life" (obituary), *Philadelphia Inquirer*, June 3, 1932.

5. Gy. Sgt. Fred W. Stockham, USMC
Battle of Belleau Wood, June 13–14, 1918
SOURCES:
Medal of Honor citation
Belleville Sons: "Fred W. Stockham Awarded the Medal of Honor," www.bellevillesons.com/Belleville-WW1-Fred-W-Stockham-KIA.html.

6. Gy. Sgt. Matej Kocak, USMC
Soissons, France, July 18, 1918
SOURCES:
Medal of Honor citation
David Von Drehle, "Immigrants, and Real American Heroes," *Washington Post*, May 26, 2018.
"Advancing at Soissons," Leatherneck.com, posted on June 14, 2018, https://mca-marines.org/leatherneck/advancing-at-soissons/.

7. Sgt. Louis Cukela, USMC
Viller-Cottertes, France, July 19, 1918
SOURCES:
Medal of Honor citation
Maj. Allan C. Bevilacqua, "Captain Louis Cukela, USMC," *Leatherneck Magazine*, October 2006.
Bethanne Kelly Patrick, "Maj. Louis Cukela," Military.com, www.military.com/history/maj-louis-cukela.html.

8. Lt. Joel Thompson Boone, USN Medical Corps
Vierzy, France, July 19, 1918
SOURCES:
Medal of Honor citation
Marine Corps History Division, "Vice Admiral Joel Thompson Boone, USN," www.usmcu.edu/Research/Marine-Corps-History-Division/People/Whos-Who-in-Marine-Corps-History/Abrell-Cushman/Vice-Admiral-Joel-Thompson-Boone/.
Naval History and Heritage Command: "Boone, Joel T.," www.history.navy.mil/our-collections/photography/us-people/b/boone-joel-t.html.

9. PhM1c. John Balch, USN
Vierzy, France, July 19, 1918
SOURCES:
Medal of Honor citation
Together We Served, "Balch, John Henry, CDR," https://marines.togetherweserved.com/usmc/servlet/tws.webapp.WebApp?cmd=ShadowBoxProfile&type=Person&ID=154651.

10. HA1c David Hayden, USN
Thiaucourt, France, September 15, 1918
SOURCES:
Medal of Honor citation
Marine Corps University, "Pharmacist's Mate Third Class David E. Hayden," www.usmcu.edu/Research/Marine-Corps-History-Division/People/Whos-Who-in-Marine-Corps-History/.

11. Cpl. John Henry Pruitt, USMC
Blanc Mont Ridge, France, October 3, 1918
SOURCES:
Medal of Honor citation
Glenda Farley, "Verde Heritage: Corporal John Henry Pruitt," *Verde Independent Bugle*, November 7, 2018.

12. Pvt. John J. Kelly, USMC
Blanc Mont Ridge, France, October 3, 1918
SOURCES:
Medal of Honor citation
Blake Stilwell, "This Marine Earned Two Medals of Honor by Age 19," We Are the Mighty, June 20, 2017, www.wearethemighty.com/articles/this-marine-earned-two-medals-of-honor-by-age-19.
Declan O'Kelley, "Strong Irish Presence among Medal of Honor Recipients," IrishCentral.com, May 28, 2010.

13. Gy. Sgt. Robert Guy Robinson, USMC
1st Marine Aviation Force, France, October 8–14, 1918
SOURCES:
Medal of Honor citation
 Fred L. Borch and Robert F. Dorr, "Bravery over Belgium," *Military History Magazine*, March 2012.
 Together We Served, "Robinson, Robert Guy, 1tLt," https://marines.togetherweserved.com/usmc/servlet/tws.webapp.WebApp?cmd=ShadowBoxProfile&type=Person&ID=352825.

14. 2Lt. Ralph Talbot, USMC
1st Marine Aviation Force, France, October 8–14, 1918
SOURCES:
Medal of Honor citation
 Emma Dumont, *Finding Ralph Talbot: The Unpublished Poems of a World War One Pilot* (Middletown, DE, May 11, 2019).

World War II Recipients

1. 1Lt. George H. Cannon, USMC
Midway Islands, December 7, 1941
SOURCES:
Medal of Honor citation
 Battle of Midway 75th Commemoration, http://midway75.org/the-battle/.

2. Capt. Henry Talmage Elrod, USMC
Wake Island, December 8–23, 1941
SOURCES:
Medal of Honor citation
 Blake Stilwell, "This Marine Pilot Took 22 Japanese Fighters Head On—Then Led an Infantry Charge," We Are the Mighty, December 20, 2016, www.wearethemighty.com/articles/henry-elrod-took-on-22-japanese-fighters-then-led-an-infantry-charge.

3. Capt. Richard Fleming, USMC
Battle of Midway, June 4–5, 1942
SOURCES:
Medal of Honor citation
 Terence W. Barrett, *The Search for the Forgotten Thirty-Four*, CreateSpace, 2011.
 "Captain Richard E. Fleming, Phi Epsilon," Delta Kappa Epsilon, Phi Epsilon Chapter, at the University of Minnesota, May 30, 2005.

4. Maj. Robert Galer, USMC
Solomon Islands, August–September 1942
SOURCES:
Medal of Honor citation

 Erik Lacitis, "Robert Galer, Hero Just Doing His Job" (obituary), *Seattle Times*, July 1, 2005.

5. Maj. John L. Smith, USMC
Solomon Islands, August–September 1942
SOURCES:
Medal of Honor citation
 Terence W. Barrett, *The Search for the Forgotten Thirty-Four*, CreateSpace, 2011.
 Jon Seal and Michael Ahn, "Interview with Joe Foss: The Man, the Legend, " March 2000, https://ww2aircraft.net/forum/threads/joe-foss-interview-the-man-the-legend.511/.

6. Maj. Gen. Alexander Vandegrift, USMC
Defense of the Solomon Islands, August 7–December 9, 1942
SOURCES:
Medal of Honor citation
 Marine Corps University, "General Alexander A. Vandegrift."

7. Sgt. Clyde A. Thomason, USMCR
Makin Island, August 17–18, 1942
SOURCES:
Medal of Honor citation
 Bill Lansford, "Clyde Thomason: The Forgotten Hero, Part 2," *Leatherneck Magazine* archives, posted November 27, 2013, https://mca-marines.org/leatherneck/page/174/.
 "WWII Marines Buried at Arlington," Associated Press, August 17, 2001.
 https://www.military.com/history/wwii-marines-buried-at-arlington.html.

8. Maj. Kenneth D. Bailey, USMC
Guadalcanal, September 12–13, 1942
SOURCES:
Medal of Honor citation
 Kevin Cullen, "Bailey Earned His Accolades," *Commercial News* (Danville, OH), October 14, 2012.
 Parker Sands, "Named after Marine Kenneth D. Bailey," Kenneth D. Bailey Academy: About Us, http://kdba.danville118.org/about_us.

9. Col. Merritt A. Edson, USMC
Guadalcanal, September 13–14, 1942
SOURCES:
Medal of Honor citation
 William Manchester, *Goodbye Darkness* (Boston: Little, Brown, 1980).
 "The Fight for Edson's Ridge," *Leatherneck Magazine*, January 30, 2019.

 Kendall Wild, "A Legacy of Leadership: Marine Hero Merritt Edson Made His Mark in War and Peace," *Rutland Herald Online*, September 14, 2012, www.rutlandherald.com/a-legacy-of-leadership-marine-hero-merritt-edson-made-his/article_55adb3db-bc5a-5bbc-85e9-0b80f9dd517e.html.

10. Capt. Joseph J. Foss, USMC
Guadalcanal, October 9–November 19, 1942
SOURCES:
Medal of Honor citation
 Jon Seal and Michael Ahn, "Interview with Joe Foss: The Man, the Legend, "March 2000, https://ww2aircraft.net/forum/threads/joe-foss-interview-the-man-the-legend.511/.
 Sons of the American Revolution, "Joseph Jacob Foss," www.sar.org/joseph-jacob-foss.

11. Sgt. John Basilone, USMC
Guadalcanal, October 24–25, 1942
SOURCE:
Medal of Honor citation
For John Basilone's story, see chapter 2.

12. PltSgt. Mitchell Paige, USMC
Guadalcanal, October 26, 1942
SOURCE:
Medal of Honor citation
For Mitchell Paige's story, see chapter 7.

13. Cpl. Anthony Casamento, USMC
Guadalcanal, November 1, 1942
SOURCES:
Medal of Honor citation
 Ethan Marshall, "Anthony Casamento: Held His Ground despite Severe Injuries," *Newsday*, May 15, 2018, https://projects.newsday.com/long-island/medal-of-honor-recipients/.

14. Lt. Col. Harold L. Bauer, USMC
Guadalcanal, November 14, 1942
SOURCES:
Medal of Honor citation
 Stephen Sherman, "Lt. Col. Harold W. Bauer: Guadalcanal Hero, CO VMF-212, Medal of Honor Recipient," AcePilots.com, July, 1999, updated December 14, 2016, http://acepilots.com/usmc_bauer.html.
 https://ww2aircraft.net/forum/threads/joe-foss-interview-the-man-the-legend.511/.
 "Harold W. Bauer, LTCOL USMC," US Naval Academy Virtual Memorial Hall, from the 1930 *Lucky Bag*, https://usnamemorial-hall.org/index.php/HAROLD_W._BAUER,_LTCOL,_USMC.

15. **1Lt. Jefferson DeBlanc**, USMC
Solomon Islands, January 31, 1943
SOURCES:
Medal of Honor citation
 Interview with Jefferson DeBlanc, Medal of Honor Book (video series), www.youtube.com/watch?v=ZWrrYtlgMao.
 Richard Goldstein, "Jefferson DeBlanc, Hero Pilot, Dies at 86" (obituary), *New York Times*, December 6, 2007.

16. **1Lt. James E. Swett**, USMC
Solomon Islands, April 7, 1943
SOURCES:
Medal of Honor citation
 Richard Goldstein, "James Swett, Who Downed 7 Planes in Attack, Dies at 88" (obituary), *New York Times*, January 25, 2009.
 Duane A. Vachon, "First-Day Ace—Col. James E. Swett, US Marine Corps," *Hawaii Reporter*, September 3, 2011.

17. **1Lt. Kenneth A. Walsh**, USMC
Solomon Islands, August 15, 1943
SOURCES:
Medal of Honor citation
 Lisa Richardson, "Kenneth Walsh, World War II Hero, Dies," *Los Angeles Times*, August 2, 1998.
 "First Lieutenant Kenneth A. Walsh, USMC," Leatherneck.com Forums, www.leatherneck.com/forums/showthread.php?62016-First-Lieutenant-Kenneth-Ambrose-Walsh-USMC.

18. **1Lt. Robert M. Hanson**, USMCR
Bougainville, November 1, 1943
SOURCES:
Medal of Honor citation
 United States Navy Memorial, "Robert Murray 'Butcher Bob' Hanson," http://navylog.navymemorial.org/hanson-robert-8.
 Naval History and Heritage Command, "1st Lt. Robert M. Hanson, USMCR," www.ibiblio.org/hyperwar/OnlineLibrary/photos/pers-us/uspers-h/r-hanson.htm.
 "Hinduism and Pacifism," BBC.co.uk, www.bbc.co.uk/religion/religions/hinduism/hinduethics/war.shtml.

19. **Sgt. Robert A. Owens**, USMC
Bougainville, November 1, 1943
SOURCES:
Medal of Honor citation
 Together We Served, "Owens, Robert Allen, Sgt.," https://marines.togetherweserved.com/usmc/servlet/tws.webapp.WebApp?cmd=ShadowBoxProfile&type=Person.
 Allan Bourdius, "Sergeant Robert A. Owens, USMC, *Their Finest Hour*, November 1, 2013, http://theirfinesthour.net/2013/11/tfh-111-sergeant-robert-a-owens-usmc/.

20. **Sgt. Herbert J. Thomas**, USMC
Bougainville, November 7, 1943
SOURCES:
Medal of Honor citation
 Ned Forney, "Two Medal of Honor Recipients, One Small Town," nedforney.com, February 8, 2018.

21. **PFC Henry Gurke**, USMC
Bougainville, November 9, 1943
SOURCES:
Medal of Honor citation
 World War II Today, "US Marine Henry Gurke's Self Sacrifice on Bougainville," http://ww2today.com/9th-november-1943-u-s-marine-henry-gurkes-self-sacrifice-on-bougainville.

22. **SSgt. William J. Bordelon**, USMC
Tarawa Atoll, November 20, 1943
SOURCES:
Medal of Honor citation
 Marc Cerasini, *Heroes: US Marine Corps Medal of Honor Winners* (New York: Berkley Books, 2002).
 Joseph H. Alexander, *Utmost Savagery: The Three Days of Tarawa* (Annapolis, MD: Naval Institute Press, 1995).

23. **1Lt. William D. Hawkins**, USMC
Tarawa Atoll, November 20–21, 1943
SOURCES:
Medal of Honor citation
 Marc Cerasini, *Heroes: US Marine Corps Medal of Honor Winners* (New York: Berkley Books, 2002).
 Joseph H. Alexander, *Utmost Savagery: The Three Days of Tarawa* (Annapolis, MD: Naval Institute Press, 1995).

24. **1Lt. Alexander Bonnyman Jr.**, USMC
Tarawa Atoll, November 20–22, 1943
SOURCES:
Medal of Honor citation
 Clay Bonnyman Evans, *Bones of My Grandfather* (La Vergne, TN: Skyhorse, 2018).
 Marc Cerasini, *Heroes: US Marine Corps Medal of Honor Winners* (New York: Berkley Books, 2002).

25. **Col. David M. Shoup**, USMC
Tarawa Atoll, November 20–22, 1943
SOURCES:
Medal of Honor citation
 Marc Cerasini, *Heroes: US Marine Corps Medal of Honor Winners* (New York: Berkley Books, 2002).
 Joseph H. Alexander, *Utmost Savagery: The Three Days of Tarawa* (Annapolis, MD: Naval Institute Press, 1995).

26. **PFC Richard B. Anderson**, USMC
Roi-Namur, February 1, 1944
SOURCES:
Medal of Honor citation
 "Warriors and Remembrance: Sequim WWII Hero's Memorial to Be Dedicated," *Sequim Sun Local* via Associated Press, May 28, 2001.
 Duane A. Vachon, "Greater Love Hath No Man: PFC Richard B. Anderson, USMC," *Hawaii Reporter*, July 3, 2011.
 Paul Gottlieb, "A Tribute to Four Peninsula Residents Who Have Received the Medal of Honor," *Peninsula Daily*, November 11, 2018.

27. **1Lt. John Power**, USMC
Roi-Namur, February 1, 1944
SOURCES:
Medal of Honor citation
 Lester K. Paquin, "Above and Beyond," *Worcester Magazine*, May 22, 2008.
 Melissa Hanson, "Worcester Remembers War Hero Lt. John Vincent Power on Eve of Veterans Day," *Mass Live: Worcester*, November 20, 1916.

28. **Lt. Col. Aquilla Dyess**, USMC
Roi-Namur, February 1–2, 1944
SOURCES:
Medal of Honor citation
 "Memorial Day: Remembering Local Hero Jimmie Dyess," Kirby's Augusta, May 21, 2015, www.youtube.com/watch?v=u8ho4WSxxHE.
 "Salute to Service—Jimmie Dyess," Bob Richards Automotive Group, August 22, 2017, www.bobrichards.com/blogs-1834-salute-to-service-salute-service-jimmie-dyess/.
 "Aquilla James Dyess," The Clemson Corps, https://soh.alumni.clemson.edu/scroll/aquilla-james-jimmie-dyess/.

29. **Pvt. Richard K. Sorenson**, USMCR
Roi-Namur, February 1–2, 1944
SOURCES:
Medal of Honor citation

INDEX